The Body of the Artisan

THE
UNIVERSITY
OF CHICAGO PRESS
CHICAGO AND
LONDON

THE

Art and Experience

BODY

in the Scientific Revolution

OF THE

Pamela H. Smith

ARTISAN

PAMELA H. SMITH is the Edwin F. and Margaret Hahn Professor in the
Social Sciences, Department of History, Pomona College. She is the author of
The Business of Alchemy: Science and Culture in the Holy Roman Empire and the coeditor
of *Merchants and Marvels: Commerce, Science, and Art in Early Modern Europe*.

The University of Chicago Press, Chicago 60637
The University of Chicago Press, Ltd., London
© 2004 by The University of Chicago
All rights reserved. Published 2004
Printed in China

Published with the assistance of the Getty Grant Program

13 12 11 10 09 08 07 06 05 04 1 2 3 4 5
ISBN: 0-226-76399-4 (cloth)

Library of Congress Cataloging-in-Publication Data
Smith, Pamela H., 1957–
 The body of the artisan : art and experience in the scientific
 revolution / Pamela H. Smith.
 p. cm.
 Includes bibliographical references and index.
 ISBN 0-226-76399-4 (cloth : alk. paper)
 1. Art and science—Europe—History—16th century. 2. Art and
 science—Europe—History—17th century. I. Title.
 N72.S3 S65 2003
 509′.4′0903—dc21 2003012364

This book is printed on acid-free paper.

‡‡‡

Contents

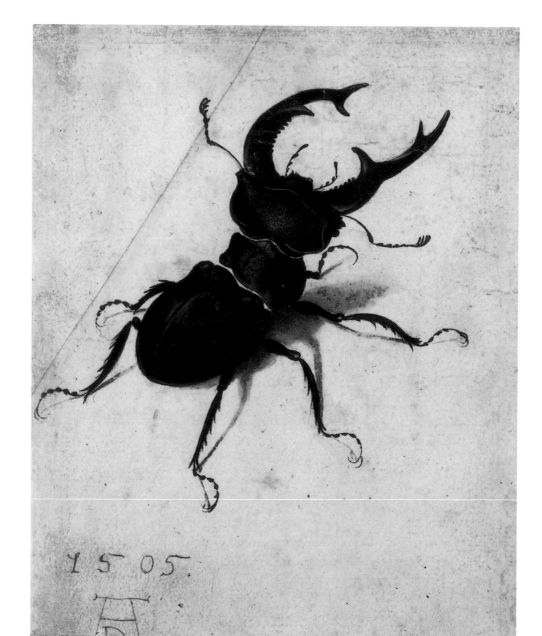

‡‡

Acknowledgments

Verisimilitude and Illusion

When I was young, I spent long moments absorbed with naive delight before my postcard reproductions of Albrecht Dürer's *The Great Piece of Turf* (1503) (plate 12) and his watercolor studies, such as those of a stag beetle (fig. A.1) and a hare. Part of my fascination with these paintings was the reality of representation; I loved the careful description of nature, its beauty and copiousness. But more than the realism of these paintings, I marveled at their depiction of particularity: this *one* dandelion gone to seed, the hair of an animal standing up in *this* particular way. Later I discovered the first generation of Flemish panel painters and the genre and still-life painters of seventeenth-century Holland and experienced a similar delight and wonder in their naturalism. Again, it was not so much their "realism" as their illusionism that sparked my interest, their extreme artifice of catching "daily" life in motion, whether it was a petal falling from a flower, a pear spotted with rot and crawling with worms not at first visible to the superficial glance, or a seventeenth-century Dutch street, with clearly distinguishable individuals absorbed in their own doings and rendered in exquisite detail. They were all richly evocative and at the same time frustratingly enigmatic—what did they mean? But, most of all, they always teetered so tantalizingly and cleverly on

FIGURE A.1 (*facing page*). Albrecht Dürer, *Stag Beetle*, ca. 1505, watercolor and gouache, upper left corner added, with tip of left antenna painted in by a later hand, 14.2 x 11.4 cm, The J. Paul Getty Museum, Los Angeles.

the line between natural and artificial. And these paintings indicated spectacular self-consciousness about this balancing act on the part of their makers. Some of the central themes of this book will deal precisely with the particularity of northern naturalism, the line between art and nature in early modern made things or artifacts, and artisans' self-awareness not only of their artistic virtuosity but also of their social status.

My wonder at these paintings has endured over the years, as has my interest in the representation and understanding of nature, and now as a historian of science, I wanted to explore questions such as: Do these paintings tell us how their makers understood nature? Why did naturalism in painting arise simultaneously with the new science? What was the relationship between artistic and scientific representations of nature in early modern Europe? This book is my answer to these questions. Although it was my twentieth-century experiences that first impelled me to the investigation of the subjects contained in this book, it is the momentousness of the advent of naturalism and the new science that forms the scholarly raison d'être and framework for this book. My main aim here is to provide a delineation of what I call an "artisanal epistemology" and its incorporation into the new science of the sixteenth and seventeenth centuries. To do this, I examine three moments, set in fifteenth-century Flanders, the southern German free imperial cities in the sixteenth century, and the seventeenth-century Dutch Republic. Each of these moments centers on microstudies of individuals to form a whole that paints in broad strokes the developments of three centuries. This is not a narrative that has been told before, and while the chronological breadth inevitably leaves out much of great importance, it contains, I think, an important addition to our understanding of the Scientific Revolution. I hope, too, that the broad brush of this account will stimulate further explorations of artisanal and material culture and that such investigations will flesh out and refigure the outlines sketched here.

The work of scholars who have already explored the themes of verisimilitude and illusion in art forms a foundation of my own study. This is particularly true of the great art historians Erwin Panofsky, Ernst Gombrich, Otto Pächt, and Ernst Kris, as well as those who have written so beautifully on northern art, among them Michael Baxandall, Svetlana Alpers, Norman Bryson, Eddy de Jong, Hans Belting, Thomas DaCosta Kaufmann, Larry Silver, Eric J. Sluijter, Celeste Brusati, and Walter Melion. Of special importance to my work are those who have been particularly interested in the intersections in art and science, including James Ackerman, Horst Bredekamp, Martin Kemp, Peter Parshall, Barbara Stafford, and David Summers. It is through all these authors that I received my education in art history, but I hasten to add that any

deficiencies in that education are entirely of my own making. Because I am not an art historian and I approach paintings with the tools of a cultural historian, I owe a special debt to the art historians who have aided me in this project, especially Malcolm Baker, Thomas DaCosta Kaufmann, Larry Silver, and Claudia Swan.

This book would never have been written without three essential gifts: First, the gift of time from the Pomona College Steele Leave program, the Wissenschaftskolleg zu Berlin, the National Endowment for the Humanities, the Sidney and Mildred Edelstein Foundation, the John Simon Guggenheim Memorial Foundation, and the Getty Research Institute; second, the gift of stimulus and stimulation (not to mention the brute fact of deadlines) from the many workshops and conferences where I have discussed my work, and in this connection I would like especially to thank the Dibner Institute, the William Andrews Clark Memorial Library and the UCLA Center for Seventeenth- and Eighteenth-Century Studies, the Einstein Forum, the Center for Advanced Study in the Visual Arts at the National Gallery, Christopher Sellers for inviting me to give a paper at a conference on body and place, Michael Heyd for inviting me to take part in a seminar at the Jerusalem Institute for Advanced Studies on the history of the emotions, and Liliane Weissberg for including me in a conference on the culture of exchange at the University of Pennsylvania. Finally, I am grateful for the gift of conversation (virtual and face-to-face) with my students at Pomona College, in which some of the central ideas of the book occurred to me; with the authors and actors of the past, a gift that was made possible by many libraries and archives and their staffs, among whom I must mention the staff of the Edelstein Collection in Jerusalem and the J. Paul Getty Museum and Research Institute. I am especially happy to have had the great gift of yearlong conversations with my fellow Scholars and Fellows at the Wissenschaftskolleg and the Getty Research Institute. My conversations with them as well as with many, many good friends and colleagues were essential to the final shape of this book. Among those friends and colleagues, I owe a special debt to Caroline Bynum, whose ideas on the role of the body in culture and whose generosity have been instrumental in so many ways at several stages of this book, and to those who have provided especially inspiring conversation or read and commented on parts of the book, including James Amelang, Malcolm Baker, Jim Bennett, Ann Blair, Mario Carpo, Karine Chemla, Lisa Cody, Harold Cook, Robert Dawidoff, Peter Dear, Michael Dennis, Lori Anne Ferrell, Paula Findlen, Mary Fissell, George Gorse, Anthony Grafton, Deborah Harkness, Mary Henninger-Voss, Margaret Jacob, Lisa Jardine, Adrian Johns, Stephen Johnston, Thomas DaCosta Kaufmann, Pamela O. Long, Amy Meyers, Cris Miller, Chandra Mukerji, Dick Olson, Roberta Panzanelli, Katharine

Park, Lisa Rosner, Michael Roth, Ingrid Rowland, Ulinka Rublack, Simon Schaffer, Larry Silver, Claudia Swan, Mary Terrall, Klaas van Berkel, Robert van Langh, Robert Westman, Helena Wall—to whom I owe so much—and Peggy Waller, whose friendship sustains me in so many ways. I owe Norm Hines a debt of a special currency, namely, hands-on instruction in bronze casting from life, and I am grateful to my research assistants for their dedication and efficiency, in particular Stacey Loughrey, Emily Klancher, Elizabeth Siegel, and Emily Heddleson. Finally, I owe a singular debt to the staff at the University of Chicago Press, especially my editors Susan Abrams and Susan Bielstein, as well as Erin DeWitt and Jennifer Howard.

As we all know by now, gifts are part of a great cycle of exchange, and while I hope I have reciprocated for the help and friendship I have received in writing this book—although I fear it was sometimes in wholly inadequate ways—I myself make a completely asymmetrical return on all these gifts by dedicating this book with love and the appreciation of other gifts to Zori, Ady, and Muki.

The Body of the Artisan

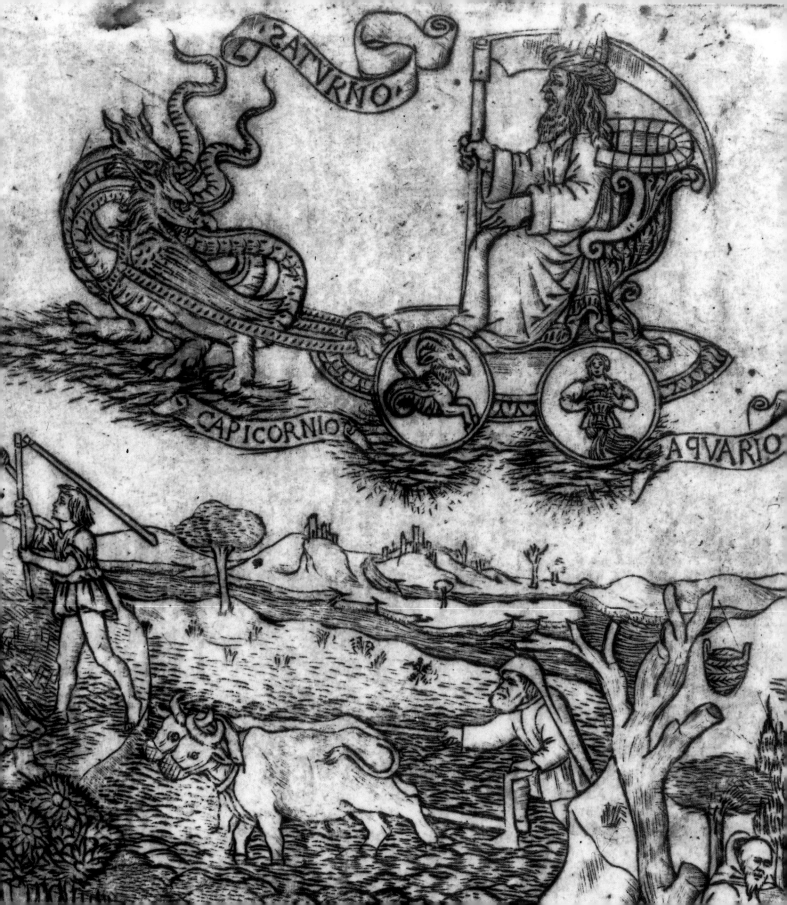

‡‡‡

Introduction

One would suppose, to hear you speak, that some philosophy is needed by laborers—a thing I find strange.
"THEORY" SPEAKING TO "PRACTICE" IN BERNARD PALISSY, *RECEPTE VÉRITABLE* (1563)[1]

The Body of the Artisan

In about 1770 an eccentric and unlearned sculptor began an uncommissioned series of sixty-nine character heads, which art historians have always regarded as something of a curiosity (figs. I.1–I.3). Franz Xaver Messerschmidt (1736–1783) was popular among the German nobility, for whom he produced numerous portrait busts and monumental statues[2] (fig. I.4), so when Friedrich Nicolai, the German *Aufklärer*, visited Messerschmidt's workshop in 1781 and gave a detailed report of what he saw, it aroused some interest.

> His entire furniture consisted of a bed, a flute, a tobacco pipe, a water jug, and an old Italian book on human proportions. This was all he had wanted to keep of his former possessions. Besides this he had hanging near the window a drawing on a half sheet of paper of an Egyptian statue without arms which he never looked at without admiration

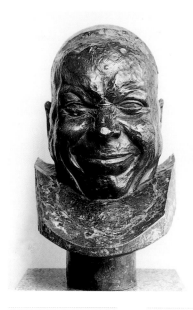

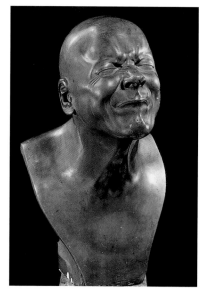

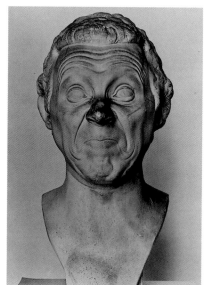

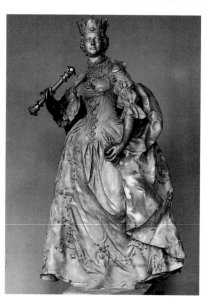

FIGURE 1.1.
Franz Xaver Messerschmidt, character bust called *A Happily Smiling Man*, ca. 1770, limewood and wax, Österreichische Galerie Belvedere, Vienna. One of the sixty-nine busts that attests to Messerschmidt's bodily struggle to attain mastery of proportion. This bust, like the others, was allegedly modeled by Messerschmidt's pulling the face in a mirror and copying it precisely.

FIGURE 1.2.
Franz Xaver Messerschmidt, character bust called *The Smell*, ca. 1770, bronze, Victoria and Albert Museum, London. Copyright V&A Picture Library. One of Messerschmidt's sixty-nine uncommissioned character busts, made by self-observation.

FIGURE 1.3.
Franz Xaver Messerschmidt, character bust called *The Satirist*, ca. 1770, plaster, Österreichische Galerie Belvedere, Vienna.

FIGURE 1.4.
Franz Xaver Messerschmidt, *Empress Maria Theresia as Queen of Hungary*, 1766–67, bronze, Österreichische Galerie Belvedere, Vienna. Messerschmidt's bronze statue of Empress Maria Theresia, queen of Hungary and Bohemia from 1740 until her death in 1780, shows Messerschmidt's monumental style of statuary portraiture before he began his series of character busts.

and reverence. This was connected with a specific folly of his which he carried to aston-
ishing lengths.[3]

This "folly" was Messerschmidt's belief that he saw the invisible—namely, ghosts—and
that they tormented him at night. He pondered long about why they should trouble
him, a pure and simple man, until finally in a flash he understood how he could master
them. Messerschmidt presented his method to Nicolai in the following way: "Every-
thing in the world is ruled by proportion and whoever awakens those proportions in
himself that correspond to or are masters of the proportions of another person will
cause effects that correspond to or which are masters of the effect of the other per-
son." Messerschmidt believed

> that the true secret of proportion actually lay in the relationship of the limbs of Egyptian
> statues, particularly in the drawing that he had hung on his window, that supposedly was
> the result of measuring different parts of various statues. . . . He imagined at the same
> time that the proportional relationship that could be found on the head of a person was
> spread throughout the whole human body.

Nicolai was scornful of the practice that resulted from Messerschmidt's ideas:

> If he felt a pain in the lower part of his body or in his joints . . . so he imagined this came
> from the fact that he worked on a particular place in the face of a marble or metal por-
> trait that was the analog of a certain position on the lower part of the body. He imagined
> that he had made observations about these proportional relationships. . . . He imagined,
> because his fantasy was filled with spirits, that there was a particular spirit of proportion.[4]

This spirit, according to Messerschmidt, was jealous of his new discoveries about pro-
portion and its effects, especially because he had come so near to the full truth about
the subject, and so it caused particular pains while he worked. Messerschmidt resolved
to become master of this envious spirit.
 As he recorded further, Nicolai no longer bothered to conceal his scorn about
Messerschmidt's practice:

> He went so far in the practice of this nonsensical theory that he imagined that if he
> pinched himself on different parts of the body, especially on the right side under the ribs,
> and at the same time combined it with a grimace of the face that had the correct Egypt-

ian proportional relation with the pinching of the ribs, he had reached the highest per-
fection in the subject. . . . Now he actually went to work: he pinched himself, he made
faces in the mirror, and believed to experience the most admirable effects of his mastery
over the spirits. Happy with his system, he resolved to represent these grimacing propor-
tions for posterity. He opined there were sixty-four different variations of grimaces. He
had there with him already sixty different heads completed, some from marble, some
from an alloy of tin and lead, most of life-sized proportions.[5]

When Nicolai watched him working on the sixty-first head, Messerschmidt had al-
ready struggled for eleven years on this project. Every single one of the heads was of
his own face, and Nicolai recorded his mode of working: "Every half minute he looked
into the mirror and with the greatest accuracy he pulled the face he needed."[6]

There are several remarkable points to notice about this odd story: First, the
bodily struggle of the artisan to create these busts; second, his view that matter and na-
ture are alive and that he must work with or against them to produce naturalistic rep-
resentations; third, his search for "laws of proportion," although in a manner we would
now regard as unscientific, because they were somehow known "in the body" of the
craftsman; and, finally, the articulation of Messerschmidt's ideas and actions by an in-
termediary, and, typically, one from a higher level of society who was not entirely sym-
pathetic to the artisan's mode of understanding. The issues of the body and bodily
knowing, naturalism, and the articulation of tacit artisanal knowledge form the com-
plex knot of issues I shall tug at in this book. One of the main aims of this book is to
provide the outlines of the artisanal experience of matter and nature. I argue that for
artisans, experience and the production of things were bound up with their own bod-
ies. And, further, that they articulated in their writings and in their works of art a view
that certainty is located in matter and nature and that knowledge can be gained by ob-
serving and experiencing—often by bodily struggle—the particularity of nature.

Artisans

A distinction has often been drawn between the theoretical knowledge of scholars or
scientists, which draws knowledge into a system, and practical craft knowledge, which
is usually seen to be composed of a collection of recipes or rules that are followed more
or less mindlessly. Although there is a useful distinction to be made between theory
and practice, investigation into the workshop practices of artisans belies such a view of

craft knowledge.[7] Indeed, the expertise of craftspeople still astounds museum conservators as well as the art historians who have recently begun a more intensive examination of workshop practices. Research now being undertaken in this area has revealed that the methods of the artisan "were not merely an accumulation of shop formulas, but a carefully thought-out technology."[8] The use by sculptors of consistent alloys, for example, indicates that they knew their metals and went to some trouble to procure what they needed.[9] Under technical analysis, paintings attest to a remarkable level of knowledge on the part of their creators about the physical and chemical behavior of materials.[10] Iron founders made judgments about the quality of their raw materials and finished products by examining the unique appearances of fracture in the texture of their metals.[11] A mid-sixteenth-century humanist marveled that an illiterate locksmith constructed and set into motion a model of the planets through his knowledge of astronomy, and that an unlearned carpenter with no knowledge of mathematics could build a set of gears that was perfect in all proportions and measurements.[12] One might say that in their knowledge of the behavior of matter, early modern artisans were experts on natural processes.

A particularly persistent feature of Western culture has been a division between those who work with their minds—scholars—and those who work with their hands—artisans. Throughout most of Western history, these two groups have been separated by a social and intellectual chasm. The Greek disdain for manual work as deforming to mind and body was carried on in Western culture up into the seventeenth century and beyond.[13] Aristotle maintained that craftsmen could not be full citizens because "no one can practice virtue who is living the life of a mechanic or laborer" and because "there is no room for moral excellence in any of their employment."[14] In the early seventeenth century, the courtier and scholar Henry Peacham (1576?–?1643) wrote:

> . . . whosoever labour for their livelihood and gaine have no share at all in Nobilitie or Gentry. As painters, stageplayers, Tumblers, ordinary Fiddlers, Inne-keepers, Fencers, Iugglers, Dancers, Mountebancks, Bearewards and the like. . . . The reason is, because their bodies are spent with labour and travaile. . . .[15]

Artisanal knowledge was separated from school knowledge by the fact that the mechanical arts were traditionally neither taught in the schools nor written down; they were "illiberal," not being suitable in the ancient world for study or practice by the *homo liber*, the free man. The knowledge of artisans was transmitted by imitation of practice and manual work, rather than by the study of books. Artisanal guilds, their

rituals, apprenticeship training, and unwritten techniques constituted the means by which artisanal knowledge was reproduced.

Such training led to what might be called an "artisanal literacy," which had to do with gaining knowledge neither through reading nor writing but rather through a process of experience and labor. Rather than producing a "lettered man," such literacy had the goal of making knowledge productive. We might regard this as a nontextual, even a nonverbal literacy.[16] If scholars conceived of problems, or indeed of reality, primarily in terms of words and the manipulation of words, artisans might see reality as intimately related to material objects and the manipulation of material, which could be thought about and understood as a "material language." A lettered man, or a scholar, on the other hand, was one who had committed to memory and could call to mind a corpus of knowledge contained in texts. His language was Latin, the lingua franca of scholars. If artisans often formulated their knowledge and processes of cognition not in words but instead in works, how do we get at this knowledge at the distance of centuries and over the great divide of the Scientific Revolution, at which time scientists assumed the place of experts on nature? We can make use of the craftsperson's artifacts,[17] his (or her) materials,[18] and his texts.[19] These texts are obviously not as plentiful as the books of scholars, but even the most fragmentary of texts—an inscription around a frame or a signature—can give us insight into the artisan's mode of understanding. We can also look to "style" or the mode of depiction, and for this reason I focus on naturalism. Naturalism emerges, I argue, at moments of most intense artisanal self-assertion, and in early modern Europe, artisans employed naturalism in order to make claims about their status as active knowers, about their knowledge of nature, and about their mode of working. In fact, we can find in their works both epistemological claims—what I call the "artisanal epistemology"—as well as a vernacular "science" of matter. The articulation of this epistemology through naturalistic objects and paintings in turn influenced patrons and scholars in their attitudes toward nature.

Naturalism, Verisimilitude, and Illusion

Naturalism does not, of course, offer an unmediated glimpse of artisanal attitudes toward nature. On the contrary, naturalistic representation emerges equally out of a desire to deceive. The mechanical arts, including painting, were great deceivers for people of the Middle Ages, but in the early modern period, they came increasingly to be seen as great opportunities for displaying learning and skill, as well as for making

claims about knowledge of nature.[20] One of the most striking changes that occurred in the Renaissance was the development of visual perspective and the striving to imitate nature more precisely or, put another way that would have been accepted by early modern artisans, to create a more effective illusion of perceived reality. Early observers captured the uneasiness felt at this conjoining of verisimilitude and illusion. The new depiction of space was greeted enthusiastically, and its true-life appearance made spectators feel that they "saw the actual scene when [they] looked at the painting,"[21] but it could also seem to someone like Francesco Petrarch (1304–1374) that these "images bursting from their frames, and the lineaments of breathing faces, so that you expect shortly to hear the sound of their voices" held a danger, "for great minds are greatly taken with this."[22] It is difficult to know where to begin a discussion of naturalism (which can encompass the striving for "verisimilitude," "illusionism," "realism," and the "imitation of nature") in the early modern period, for the secondary literature in art history alone is vast. David Summers has defined naturalism as the attempt to make the elements of the artwork (in his account, primarily painting) coincide with the elements of the optical experience.[23] This is a useful starting point, but in this book I shall be more concerned with the ways in which naturalism in art (and particularly in the naturalistic representation of nature itself) coincided with the deployment of nature as a resource in a variety of ways by artisans and by others, for example, in the spheres of politics, scholarly discourse, and, eventually, philosophy. Nature increasingly came to be regarded as an authority to which to make appeal when other traditional sources of legitimate authority either failed or were not available, and naturalism in the arts did much to further this development. Much more will be said about naturalism further on in this book, but it is useful to consider here the various forms that naturalism could take and the significance with which it could be infused by examining two examples.

Verisimilitude and the Production of Things

In 1338 the Sienese artisan Lando di Pietro (d. 1340) completed a Crucifixion. The fragments of this statue that survived the 1944 bombing of Siena display profound naturalism (fig. I.5), heightened by the fact that Lando used joints, paste, and parchment to achieve the similitude of a suffering and specific person. The wrinkles in the skin could be imitated through the use of such materials, and the gore of Christ's wounds, for example, could be heightened. Although the realism of the sculpture was

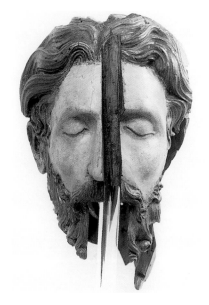

FIGURE 1.5.
Lando di Pietro, fragment of
Crucifixion, 1338, polychrome
wood, Osservanza, Siena.
Photo: Testi. This fragment of
Lando's life-size carving of the
Crucifixion was salvaged from
the 1944 bombing of Siena.
Even in its current condition,
the ambition to represent a real
person is evident. The meticu-
lous carving of head and beard
hair is particularly striking. One
of Lando's inscriptions was
found inside the head and the
other rolled up inside Christ's
nostril.

new, the pastiche was not unknown in other works at the time, as is evi-
denced by a crucified Christ that had skin formed from leather and by
jointed life-size wooden statues meant to be dressed and ornamented. But
even more interesting is the fact that when the crucifix was split open in
the bombing, two inscriptions on parchment were found that Lando had
placed inside the head of Jesus.[24] One states, "The Lord God made it pos-
sible for Lando di Pietro of Siena to carve this crucifix in this wood in the
similitude of the real Jesus to remind people of the passion of Jesus Christ
Son of God, and of the Virgin Mary, therefore you true and holy cross of
Jesus Christ Son of God, render the said Lando to God." The prayer asks
the Virgin, Saint John the Evangelist, Saint John the Baptist, Mary Mag-
dalene, and all the saints, "men and women," to recommend Lando to
God. He completes his prayer with the statement: "The year of our Lord
January 1337 [n.s. 1338] this figure was completed in the similitude of Jesus
Christ crucified Son of God living and true. And it is he one must adore
and not this wood." The second inscription, which Lando rolled up and
placed in Christ's nostril, repeats the date and reads, "Jesus Christ through your mercy
let the soul of Lando di Pietro, who made this crucifix, be recommended."[25] Caroline
Walker Bynum has pointed out the bodily quality of spirituality in the late Middle
Ages during which physicality became a means to the divine.[26] Emphasis was placed on
the humanity and thus the body of Christ, and this devotional practice seems to have
informed Lando.[27]

Another clue to Lando's actions is suggested by a sixteenth-century magical
tract, entitled *De arte crucifixi*, attributed to Pelagius. This treatise purports to teach a
magical art by which one can acquire the seven liberal arts and all of theology, as well
as resolve any intellectual query, and summon angels and spirits to foretell the future
and know the past. The reader is instructed to

> make with your own hands a carved image of our Lord hanging on the cross with his arms
> outstretched—the wood must be new and unblemished oak, olive or laurel-wood, and
> must not have been previously used for any manual purpose, or have come from any filthy
> or unclean place. . . . The more naturalistic and beautiful the image, the more effective it
> will be—it should be a complete and perfect image.

After a series of rituals of purification and penitence, the petitioner should recite the
prayer "O most sweet Lord Jesus Christ. O eternal, omnipotent God, in the presence
of this crucifix attend to my prayers and operations, and allow the desired effect to

truthfully appear to me. . . ." Then the crucifix, in its wax retainer, was to be placed under the pillow with a schedule of questions. If all this was completed correctly, the answers to the questions would appear in a dream.[28]

The ritual described here constitutes an imitation in two senses. First, it entails an imitation of nature by manual art (the instructions emphasize the craft of making the crucifix, an emphasis also found in Lando's notes). Second, the ritual constitutes an imitation of Christ, both in emulating his working of wood as a carpenter and in making an exact similitude of Christ's body. In such a way, the devotional principle of *imitatio Christi* is given a craft significance.[29] Like other magic tracts, this one calls the operations performed with the crucifix an "experiment" (*experimentum*), connoting the efficacy that would become the hallmark of the new science.[30] It would appear, then, that the act of manually engaging with matter to produce a realistic image, whether artisanal or magical, could lead to both spiritual and natural knowledge, and, importantly, to works of art that were themselves efficacious, that is, works that could produce effects. Producing tangible objects or "effects" by bodily labor proved the spiritual devotion and/or natural knowledge of the maker. Similarly, Lorenzo Ghiberti (ca. 1378–1455), the goldsmith and sculptor whose relief panels on the doors of the Florence Baptistry show a naturalism and an attention to nature without precedent in Italy (figs. I.6, I.7), wrote about the naturalism of his second set of panels (1425–52), the Gates of Paradise, as the creation of "effects."[31] Indeed, he viewed himself as an imitator and knower of nature.[32]

FIGURE I.6.
Lorenzo Ghiberti, detail from *The Resurrection*, north portal doors, Baptistry, Florence, 1403–24, gilded bronze. Copyright Foto Marburg/Art Resource, N Y. Pictured here is the right upper corner of the quatrefoil panel that depicts Jesus' resurrection. Ghiberti probably cast a tree branch from life in order to render this naturalistic tree. In his writings, Ghiberti emphasized the striving for realism and the naturalism of his own and others' works.

FIGURE I.7.
Lorenzo Ghiberti, salamander, north portal doors, Baptistry, Florence, 1403–24, bronze. Copyright Scala/Art Resource, N Y. This detail from the frame around the north doors of the Florence Baptistry shows Ghiberti's attention to nature and his unprecedented ability to realize his ambitions to naturalism in cast bronze.

The comparison of Lando di Pietro's crucifix to the fabrication of the cross in the magic tract provides the first angle of access by which we can explore what art making meant to an artisan, or, to paraphrase Bernard Palissy as quoted above, to investigate the strange idea that laborers possess a philosophy. Lando's votive crucifix and the magical crucifix illuminate the way in which naturalism could constitute a mode of representing, and, more importantly, the way in which naturalism carried meaning as an expression of active, productive knowledge. Paying attention to the significance of naturalism for the artisan who employed it can help us understand how artisans regarded their own work and their relationship to the nature they imitated.

Naturalism and the Powers of Nature

If the naturalism of Lando's *Crucifixion* appears to have been connected to efficacy, then in another setting, naturalistic representation can be construed as a claim about the primacy of nature and the way in which art was founded on a knowledge of nature. Such a declaration about the primacy of nature appears to be made in the illustrations of a manuscript dated 1403, described by Erwin Panofsky as "Pre-Eyckian realism." He sees them as "pervaded and illumined by a sense of reality which spurns prettification." The manuscript itself is an astrological treatise, allegedly written by a Georgius Zothari Zopari Fenduli, but in reality is a translation from the Arabic of Albumazar (Abū Ma'shar, d. 886), "whom the Middle Ages revered as a Prophet of Christ, considering him the Islamic counterpart of Virgil." The first illustrated version of this manuscript going under the pseudonymous authorship of Fenduli was produced in south Italy in the first half of the thirteenth century and contained conventional classical images of the planetary divinities. This manuscript was copied near Bruges in the early fourteenth century, and some changes were made in the classicized images of the planets. The moon, depicted as the goddess Luna or Diana in the Italian version, was changed to a vigorous man roaming the woods, a change that assimilated the moon to vernacular Germanic language and beliefs in which the moon is masculine (*der Mond*) and is connected with vegetation and growth. In 1403 a copy of this version was commissioned by the abbot of St. Bartholomew's in Bruges, and further changes were made to produce these illustrations. Mercury, who in the thirteenth- and fourteenth-century versions had been represented as an idealized scholar and musician, was now represented as, in Panofsky's happy description, a "decrepit, bald-headed professor . . . , busily reading with glasses on his nose; or in his 'exaltation,' as an elderly composer, his

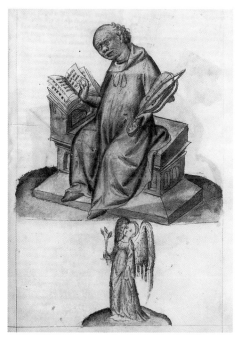 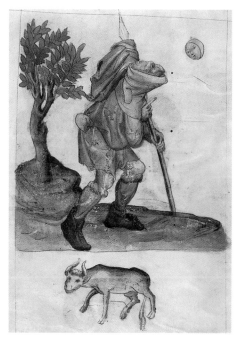

FIGURE I.8.
"Mercury in Exaltation," from an astrological treatise produced in Bruges ca. 1403, The Pierpont Morgan Library, New York, MS M. 785, f. 50v. Unlike idealized depictions of Mercury based on classical mythology, this one shows Mercury as a plump, balding monk and musician. The illuminator of this manuscript appears to portray a specific, or at least a plausibly specific, humble musician absorbed in the unidealized activity of making real music.

bald head fringed by curly locks, listening to the inner voice with an absorption bordering on mild insanity" (fig. I.8). The moon became a bent and ragged peasant, trowel in his pocket, "his upturned, hook-nosed, hatchet face slyly evoking the idea of a crescent"[33] (fig. I.9).

What do we make of these remarkable and unprecedented illustrations, both of which are naturalistic insofar as they depict plausibly specific individuals and which constitute such a break from the generic representation of classical figures? Panofsky notes their naturalism and the humanization of the deformed peasant in accord with the teachings of the *devotio moderna*, insightfully remarking that the illustrator "looks upon the lowly, the ugly and even the grotesque, not as a special stigma of inferiority or wickedness, but as a necessary element in God's creation."[34] German mysticism and the Brotherhood of Common Life similarly emphasized the humility and humanity of Jesus and the Virgin Mary. One mark of this can be found in the fourteenth- and fifteenth-century depictions of Mary in which she is no longer portrayed as sitting regnant in heaven but instead has been brought down to earth, dressed in the clothes of the period, and seated on the ground when she receives news of her divine destiny, or holding the dead Christ in her lap. Similarly, Christ is portrayed as the man of sorrows or shown suffering on the cross. The personal piety of the *devotio moderna*, in which the

FIGURE I.9.
"The Moon in Exaltation," from an astrological treatise produced in Bruges ca. 1403, The Pierpont Morgan Library, New York, MS M. 785, f. 48. In contrast to depictions of the moon as the hunter Artemis or Diana, this illuminator portrayed the moon in its exaltation as a bent old man, dressed in ragged clothing and leaning heavily on his stick, walking through the woods. What appears to be a small trowel sticks out from the man's pocket. The old man's countenance is strikingly reminiscent of the moon, the crescent of his face seemingly reflecting the crescent moon. The depiction of this humble and specific individual, perhaps a pilgrim or beggar—in any case, a wanderer—begs for explanation as a personification of the moon.

miracle of Incarnation is supposed to occur at every moment in each individual soul, both "demoted" the divine beings and raised the humble. The poor and ragged, previously "nonsubjects," now were believed to take part in humanity; indeed, they were seen to be closer to God and to have become subjects fit for representation.[35]

On another level, the move from classical to naturalistic images in the astrological text indicates a new relationship to classical antiquity; "natural" images have replaced classical models. It is also possible that for the anonymous artisan-illuminator of this manuscript, the bent figure was an artisan's attempt to associate the moon with the forces of transformation in nature. The moon, in both Aristotelian cosmology and in popular practices, was seen to dominate all alterable things and to control generation and growth. The importance of the moon in artisanal practices, for example, can be gleaned from the account of the humanist Cipriano Piccolpasso (1523/24–1579) about the practices of potters after loading the kiln:

> Prayers are offered to God with the whole heart, ever thanking Him for all that He gives us. Fire is taken, having an eye however to the state of the moon, for this is of the greatest importance, and I have heard from those who are old in the art and of some experience that, if the firing happens to take place at the waning of the moon, the fire lacks brightness in the same manner as the moon its splendour.[36]

In the same way that Lando's crucifix reminds us of the religious dimension of artisanal work, the Bruges manuscript's illustrations give us access into the world of cosmic forces to which the artisan saw himself subjected.

More intriguingly still, the image of the moon in the Bruges manuscript appears to be related to depictions of the children of Saturn in astrological texts from the fifteenth century (fig. I.10) and to the portrayal of an alchemist in the Ripley Scrolls of the sixteenth century (fig. I.11). The theme of the children of the planets was common in popular calendars that included information on the activities appropriate to each month,[37] and this might have been the source for both these images. Saturn—the planet that oversaw the peasants' work of cultivation, the transmutation of metals by alchemists, and, somewhat later, the divinely inspired artistic frenzy of melancholics—was often depicted with a trowel or shovel in hand. He presided over all kinds of transformation, so this particular image of the moon may have been resonant with the cosmic forces of transformation at many different levels.

While the connection between the figure of the moon in the Bruges manuscript and alchemy remains necessarily speculative, it raises three important points that give

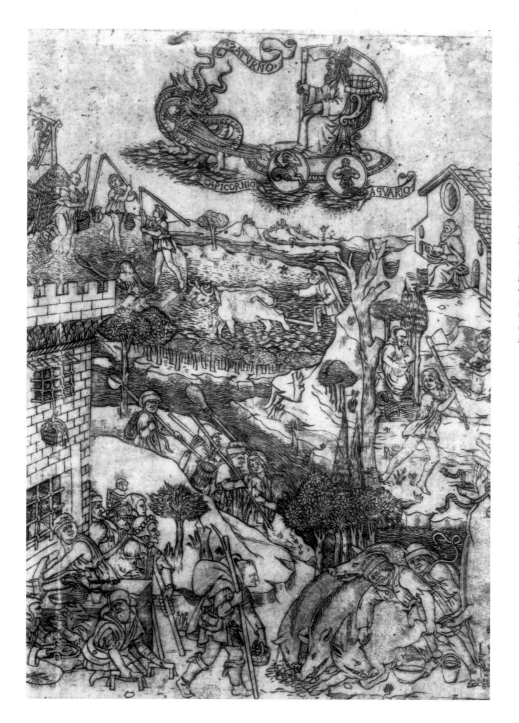

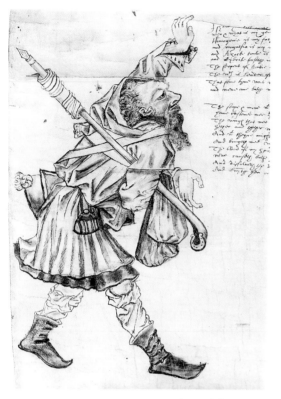

us further insight into the worldview and "philosophy" of ar-
tisans. First, it highlights the way in which naturalistic art
might in fact be tied to the *processes* of nature rather than sim-
ply to the *representation* of nature. When artisans looked to na-
ture, they were interested, not surprisingly, in its powers of
generation and transformation, for they themselves worked
with the materials of nature and struggled to manipulate and
control them in order to produce objects. The association
with alchemy is not as far-fetched as it might at first appear,
for today we associate alchemy mainly with the transmuta-
tion of base metals into gold, but in the early modern period,
it was indistinguishable from what we would today call met-
allurgy, chemistry, or the science of matter. Indeed, it even
encompassed what we know as organic chemistry, for al-
chemists sought the composition of the vital principle
through which they could effect transformations of matter of
all kinds as well as heal disease and prolong life. From the
Middle Ages, alchemy was a source for describing and ex-
plaining the transformations that matter underwent and, in
particular, for explicating the most profound forces of na-
ture, those of generation and creation. Artisans often en-
gaged in alchemy and employed the language of alchemy. As will be discussed at
greater length in the fourth and fifth chapters, alchemy also epitomized the redemp-
tive dimension of all artisanal handwork. "*Ars imitatur naturam*" [art imitates nature] be-
came the central ambition of the visual arts, but it had always formed the operating
principle of alchemy.

The Bruges images also open up a third vista that foreshadows one of the im-
portant themes of this book. The lack of desire to classicize evident in the Bruges
manuscript images would become even more developed in the north as humanists
tried to re-create the ancient world in fifteenth- and sixteenth-century Europe.
Northern Europe's relationship to the ancient world and to the corpus of classical
texts raised problems for the humanists of the Holy Roman Empire. Northern Eu-
rope, in contrast to Italy, did not have abundant evidence of ancient Roman civiliza-
tion. Furthermore, the Romans wrote about the Germanic peoples as barbarians, al-
beit frequently as noble barbarians, but savages all the same. Inhabitants of the Holy
Roman Empire looked at their own prosperous and civic-minded societies and de-

spaired at the Romans' description. Their despair led them to sometimes desperate language that eventually merged with anti-papal sentiment, causing northerners to accuse the Italians of hiding the other books of Tacitus that dealt more fully with the north and to claim that German, or even Swedish, was the original language from which Greek and Latin were derived. In northern Europe, nature seemed to take on a primacy that was not as insistently developed in Italy,[38] and it became a source of primary authority, taking precedence at times over classical authorities. In the visual and cultural world shaped by this lack of a direct connection to the classical world, the artisan sought his images partly in his own experience of work and in the imitation of nature.

The naturalism of the pre-Eyckian drawings highlights the northern focus of this book. The history of art has traditionally focused on Italy as the birthplace of naturalism in the form of perspective construction.[39] The Italian story is well known and has been told in detail. In this book, I take my examples mainly from northern Europe because the relationship of northern Europeans to nature and to classical antiquity was markedly different than in Italy, a fact that would have important consequences for the history of art and of science.

The Scientific Revolution

The intellectual corollary of the social divide between scholars and artisans discussed above can be located in the Aristotelian scheme of knowledge that held, with some minor changes, up to the seventeenth century. In it, theory was separate from practice. Theory (*episteme* or *scientia*) was certain knowledge based on the logical syllogism and geometrical demonstration. Practice (*praxis* or *experientia*), on the other hand, could be of two kinds—things done and things made. Things done were comprised of human knowledge such as history, politics, ethics, and economics. *Praxis* was studied in the particular (by collection of experiences); it could not be formed into a deductive system, and thus was not as certain as theory. The other type of practice was comprised of things made, or *technē*, that involved bodily labor. *Technē* had nothing to do with certainty but instead was the lowly knowledge of how to make things or produce effects, practiced by animals, slaves, and craftspeople. It was the only area of knowledge that was productive. By the late seventeenth century, however, all this would change. The ancient scheme would be turned inside out, and the production of effects and real things came to prove the certainty of theory. A completely new model of scientific

knowledge emerged with the result that a man, learned in the sciences, went out of his library into his laboratory or into the field and accumulated knowledge by new methods in new places. The production of scientific knowledge came to include the production of effects, or productive knowledge. Thus, the three areas of knowledge, *episteme*, *praxis*, and *technē*, which had been separate in the Aristotelian scheme, became linked in an entirely new way in the early modern period.[40]

The emergence of a new philosophy—what eventually came to be called "science"—represents a momentous transformation in attitudes toward nature and toward the material world. This transformation involved a whole new set of beliefs about and practices involving nature. One of the most important components of this shift was that in the sixteenth and seventeenth centuries the pursuit of natural knowledge became *active* and began to involve the body; that is, one had to observe, record, and engage bodily with nature. Until recently the story of the Scientific Revolution was largely told as a narrative about theoretical change: the move from an earth-centered to a sun-centered universe, the transition from animate nature to a de-souled nature made up of atomic corpuscles in random motion. Although the story of the invention of experiment was also important, it has been written as the intellectual history of a practice.[41] Despite the scope and value of this story, it leaves out the large numbers of individuals who began to show interest in and to practice the "new philosophy" but who did not contribute directly or explicitly to theoretical change. I would argue, however, that it was the actions of these people that brought about the institutionalization of the new philosophy and, more importantly, made the new method of pursuing knowledge part of the habits of mind and action of European scholarly culture.

This new view of the Scientific Revolution has been informed by the increased interest in science as a cultural activity that can be studied not just as a set of theories but also as a set of practices. The recent consideration by historians, sociologists, anthropologists, and philosophers of the *practice* of science has yielded important insights.[42] Indeed, one of the most fruitful new perspectives to have come out of the turn of historians of science to cultural history and the social construction of knowledge has been the focus on practices. Science has come to be studied as practice, rather than a set of theories. This new approach has made us see how science became active in the sixteenth and seventeenth centuries. In 1620 Francis Bacon called for a "New Philosophy; or Active Science,"[43] a phrase that for him was a contradiction in terms, for "science" was by definition contemplative and theoretical, not active. In this book, I focus on the process by which such an active science was formed: how did scientific knowl-

edge become something that was produced actively, that one had to go out and look for and to engage with nature to obtain? This view of science as practice has also allowed us to see how much the development of science depended upon the construction of a new identity—the new philosopher—as someone who could manipulate real things, produce items of value, and act as an adviser to rulers. The practice of this individual looked more similar in many ways to a practitioner or artisan of previous centuries than to a true philosopher. Thus, we have been impelled to ask: How did the methods, goals, and *episteme* of art come to be those of the new philosophy, hence central to an understanding of the Scientific Revolution? *The Body of the Artisan* is a partial answer to that question.

An important source for this new epistemology was the entry into the knowledge-making process of a new group of people, practitioners, drawn from all social strata but often liminal between scholars trained at university in texts and artisans trained in the workshop by imitation. These practitioners often saw natural knowledge as an arena in which they could gain new authority and legitimacy, for it brought them the attention of humanists, gave them access to the republic of letters, and bestowed upon them the favor of princes, all based not upon their birth nor upon their knowledge of elite learning but instead upon their ability to undertake particular practices and produce tangible effects or objects. Thus, I focus here on figures who traditionally have not been central to the story of the Scientific Revolution. I use these so-called "marginal" figures to illuminate the process of historical change—especially the way in which the old inheres in or creates a framework for the new. These individuals are central to understanding the complexity of the past, and they assist us in transcending received narratives about the development of modernity (most especially the positivist history of the rise of modern science). They can also tell us what it was about the new philosophy that made it so exciting to early modern people. In light of recent work in the history of science, I think it is safe to say that it may well have been the new practices of natural philosophy, rather than the theory of Copernicus, that made the new science so appealing to such a wide range of people in the sixteenth and seventeenth centuries.[44] Examining the lives and motives of these marginal figures thus shows us how the new practices—or the scientific epistemology—came to have social and intellectual authority.

Artisans or craftspeople were, I believe, central in establishing and articulating the epistemology that gave such liminal practitioners authority and that helped bring about this new philosophy. In discussing marginal scientific practitioners in the eighteenth century, Simon Schaffer has noted that they "worked hard to make a direct ac-

cess to nature count and then make it clear that they had such access."[45] In this book, I argue that artisans in the fifteenth and early sixteenth centuries were already engaged in the work of making direct access to original nature count, both socially and intellectually. Their epistemology, as articulated in texts, in conversations with scholars and their patrons, and in naturalistic works of art, suggested that direct access to nature was both possible and necessary, that knowledge was gained through bodily engagement with matter, that "scientific" knowledge (in Aristotle's sense of "*scientia*") could be extracted from nature, and that the imitation of nature yielded productive knowledge. The articulation of this epistemology (in part by artisans themselves and in part by intermediaries) created an identity through which practitioners could express claims to authority on the basis of their knowledge of nature.[46]

The articulation of artisanal expertise and epistemology assumed particular importance in the sixteenth century because scholars began to be interested in it as a way to obtain knowledge of nature. For these scholars, it was not at all clear how one came to know nature, how one used one's senses, or how one produced things, and the artisans' bodily encounter with matter provided a model in the formation of the new scientific method. In the late sixteenth and early seventeenth centuries, a type of person emerged who began to call himself a "new philosopher" and to declare himself a knower of nature. This represents a process of transition by which the artisanal epistemology was incorporated into a new discourse about nature. But in the late seventeenth century, the new natural philosophers expressed an ambivalence toward the role of the body and the senses that came to a head during the institutionalization of the new philosophy into the university curriculum. These late-seventeenth-century new philosophers were unsettled by the involvement of the body in cognition, and they sought to control the bodily dimension of empiricism at the same time that they began to distance themselves from artisans and practitioners. This is the trajectory I trace over the course of *The Body of the Artisan*.

Genealogies

Naturally, other historians have also been interested in similar questions, and historians of science have extensively considered the problem of the place of artisans in the Scientific Revolution. Historians of science who have written recently on artisans in the Scientific Revolution have justifiably challenged Thomas Kuhn's postulation of two "traditions," the mathematical and experimental. Writing in the Anglophone tra-

dition, and with similarities to A. R. Hall, Kuhn distinguishes sharply between the classical, mathematical sciences and the experimental sciences more akin to "craft practices," which he regards as not influential in the Scientific Revolution.[47] This view has been replaced by two different models of artisanal influence on the rise of the new science, one that posits direct influence and the other a development of shared values. The first narrative that argues a direct influence of artisans on "scientists" can be found in the histories that examine René Descartes's borrowings from the writings of Isaac Beeckman,[48] or Galileo's conceptual debt to Leonardo da Vinci's work on mechanics,[49] or, more broadly, pictorial artists who helped to develop the notion of the infinite universe.[50] The second model, which examines how the goals and values of the arts—particularly machines and mechanical processes—contributed to the formation of the new science, was sensitively formulated by Reijer Hooykaas and Paolo Rossi in the 1950s and '60s.[51] Their work has been followed particularly in the last two decades by a large number of historians of science and technology, who have focused on various aspects of practical contributions to the Scientific Revolution.[52] My work differs from these crucial studies of the recent past in that it seeks to explore how artisans understood their own manipulation of nature both in the materials they worked and in their own processes of creation. I take seriously Rossi's underdeveloped point that the craftspeople in the workshops considered their operations to be "a form of cognition."[53] In outlining an artisanal understanding of their own work, I want to emphasize the epistemological status of craft operations.[54]

There is a large and interesting literature that has emerged out of social history and the legacy of E. P. Thompson that considers the world of craft and labor. Historians such as James Farr, James Amelang, and Hans Medick, while telling us much about artisanal culture, do not treat the attitudes of artisans toward nature.[55] This is not surprising, perhaps, because it is a difficult task to extract materials from the documents usually employed by the social historian of the artisan's attitude toward nature and toward the ability to manipulate the natural. One famous exception to this is Carlo Ginzburg's miller from *The Cheese and the Worms*, who provides us with an unusual glimpse into a craftsperson's worldview.[56]

Art historians, not surprisingly, have contributed much to the question of the relationship between art and science, but they have rarely made their focus the artist's understanding of the process of making works of art.[57] Literature on the interconnections between art and science has often focused on perspective construction[58] and scientific illustration.[59] In *Painting and Experience in Fifteenth-Century Italy*, Michael Baxandall writes, "An old picture is a record of visual activity. One has to learn to read it, just as

one has to learn to read a text from a different culture." Paintings are "a distinct kind of fact: what they offer is an insight into what it was like, intellectually and sensibly, to be a Quattrocento person."[60] I would extend such lucid thoughts to note that paintings are also the products of artisanal *activity* and, as such, are not just records of visual activity but also of *productive* activity and the beliefs and categories of thought that went into that producing and creating. In his work on the sculptors of Renaissance Germany, Baxandall points the way for trying to understand "what is art to the artist in the making," as Svetlana Alpers has phrased it.[61] The examination of workshop practices by art historians and conservators has also begun to shed new light on what materials and the process of art making meant to artists.[62]

In part, the orientation of both historians of art and science has been determined by working from a model in which the dissemination of knowledge moves from natural philosophers "down" to artists, similar to the way in which Ernst Cassirer, in *The Individual and the Cosmos in Renaissance Philosophy*, sees "art theory" as converging with mathematical idealism to temper the new naturalism and give birth to a recognizably modern science. In discussing the influence of Neoplatonic ideas on Florentine artists, he states:

> Many of the great artists of the Renaissance embraced the basic speculative doctrines of the Florentine Academy with great fervour. That they should have done so is explainable if we remember that, for them, the doctrines signified a great deal more than mere speculation. They saw in them not only a theory of the cosmos very compatible with their own basic view; but even more important, they found the secret of their own artistic creation interpreted and expressed in these doctrines.[63]

What if we were to see the influence as going the other way, that is, as one in which the humanists embraced the ideas of the artists (articulated both in treatises and works of art)? Or, in a more open-ended way, if we were to investigate the influence as reciprocal and dialectical, flowing both "up" and "down"? In this book, I attempt to show such mutual influence: that the artisans' own understanding of matter and their creative acts, as well as their attempts to articulate their "process of cognition" (sometimes using the terms of humanists and scholars), coincided with humanists' interest in *ars* and practice in order to reform education and philosophy. Throughout it should be kept in mind that such influence runs both ways, although at times I will stress one side of the equation more than the other.

In *The Body of the Artisan*, stories of science and art are woven together and examples are drawn from the literature of both disciplines. Part of my aim is to show that the history of naturalistic representation and the rise of modern science are interconnected. The study of the development of naturalism has been central to the work of art historians, and while the concurrent rise of naturalism in art and the emergence of the new philosophy have often been noted, they have infrequently been the work of monographic study. Explanations for the simultaneity of naturalism and the new philosophy have ranged from Erwin Panofsky's remark that "perspective, more than any other method, satisfied the new craving for exactness and predictability"[64] to the historian of technology Bert S. Hall's suggestion that realism and perspective construction were better means of conveying information in technical treatises.[65] There are three important exceptions to this situation: David Summers has argued in *The Judgment of Sense: Renaissance Naturalism and the Rise of Aesthetics* that the rise of naturalism in painting brought about the notion that art can be a model of vision and perception. The significance of art was thereby magnified, and art was defined as a new mode of thought and investigation.[66] Leonardo da Vinci saw painting as an unmediated experience of nature, something that even language could not give, and those after him believed that imitative painting could be a universal language. Images became more important in knowledge making, and this in turn gave rise to the ideas that a materially real, physical world could be known by viewing from a single universal point, and that once gained, this knowledge could be mathematicized. The laws of vision became the laws of nature.[67] Thus, Summers regards both modern science and modernist aesthetics to have their origin in the rise of naturalistic panel painting and the theorizing that went on around it.

Barbara Stafford, in *Voyage into Substance: Art, Science, Nature, and the Illustrated Travel Account, 1760–1840*, sees the attempt to represent reality in an unmediated way (i.e., naturalism) as part of "the larger preoccupation with the nature of truth that engaged seventeenth-century thinkers." The simultaneous emergence of empiricism and rise of artistic naturalism contributed to "the fashioning of a 'scientific gaze'" that sought to make realistic pictures and words match their referents in order to create an accurate model of the physical world. This alliance between empirical science and naturalistic art culminated in travel accounts of the eighteenth century, which "suggested that accurate text wedded to precise image would offer a progressivist paradigm for understanding the physical processes at work in the universe."[68] Although Summers and Stafford are mainly concerned with the visual dimension of naturalism, they certainly explore, albeit with different emphasis, some of the same territory that I do. Similarly,

they both chart the same trajectory of increasing distrust of the senses that took place over the course of the seventeenth century.

In Martin Kemp's sweeping account of the interaction of art and science in the emergence of perspective construction, *The Science of Art: Optical Themes in Western Art from Brunelleschi to Seurat*, the scope is focused, as in Summers's and Stafford's work, on the visual dimensions of naturalism. Kemp provides a complex and plausible account of the rise of perspective art, which includes practical mathematics, the interaction of humanists and artisans, new modes of religious devotion, and the annexing of classical aesthetic values, especially the proportional system of architectural design, by painters. He comes to a rather different conclusion, however, than Summers or Stafford, arguing that there is no parity and no causal link between "art" and "science" because science is an explanatory model and art is not.[69] He notes, however, that once Renaissance scientists and artists began to work on the same project of constructing a visual model of the world as it appears to an observer, they opened up a very rich dialogue.[70] That said, Kemp believes art and science share a "set of means" in the making of communicative objects. While Kemp's observation about the goals of science and art is no doubt true today, I would argue that in the fifteenth and sixteenth centuries, when the methods of science were in a process of construction, artist/artisans were engaged in a kind of philosophizing about nature, and while so engaged, they articulated a body of claims about nature and about the nature of authority that helped form the basis of the new science. Artisanal attitudes and practices were thus constitutive of the new science.

The Body of the Artisan explores the reciprocal and complex relationship among artisans, practitioners, and scholars through three moments, each of which tells us about the artisanal mode of knowing nature and its eventual incorporation into the new philosophy. The three studies are separated by roughly a century and located in some of the most important commercial centers in northern Europe: fifteenth-century Flanders, sixteenth-century southern Germany, and seventeenth-century Amsterdam and Leiden. In each of these centers, attitudes toward nature, art, and knowledge evolved in particular ways, shaped by the social processes at work in each locale. In fifteenth-century Flanders, an interest in nature and naturalism and a high level of artisanal self-consciousness developed in the context of a forced integration of nobles and merchants and in the theater of state that the Burgundian dukes founded in order to rule this fractious mix. In the busy trading cities of sixteenth-century Germany, Flemish

naturalism and the artisanal self-declaration contained in it flowered into a full artic-
ulation of an artisanal epistemology as artisans, working between noble patronage and
the commercial forms of the marketplace, grew more self-confident and began to re-
gard themselves as knowers of nature. This artisanal declaration attracted the atten-
tion of scholars, humanists, reformers, nobles, and, most importantly, the physician
Theophrastus Bombast von Hohenheim, known as Paracelsus. Finally, in the market
environment of the seventeenth-century Dutch Republic, artisans, practitioners, and
entrepreneurs took up the identity that Paracelsus had made available by his articula-
tion of the artisanal epistemology, and, in the lively exchange about material things
that went on among members at all levels of this society, they began to convert this
identity into that of experimental philosopher.

In the first chapter, I consider how and why artists (or, as they would have re-
ferred to themselves, artisans) began to articulate their worldview in the fourteenth
and fifteenth centuries. I begin by examining the emergence of naturalism in painting
in the fourteenth and fifteenth centuries. This new aesthetic points to an increasing
self-consciousness among panel painters, particularly Flemish painters in the first half
of the fifteenth century, that led eventually to an articulation of their own processes of
creation and to claims that they possessed special access to knowledge about nature.
Naturalism became a means by which artisans could make claims about the primacy of
nature and the certainty of knowledge that comes out of imitating nature. I examine
these issues by focusing on the works of the first generation of Flemish painters,
Robert Campin, Jan van Eyck, and Rogier van der Weyden.

As artisans began to narrate their experience of matter and their knowledge of
nature, an identifiable epistemology began to be expressed in their works of art. In the
second chapter, I follow the development of the naturalistic aesthetic and the articu-
lation of this epistemology among German artists, using the examples of Martin
Schongauer, Albrecht Dürer, and Wenzel Jamnitzer. This chapter then takes up the
articulation of this epistemology in the writings of the religious and medical reformer
Theophrastus Bombast von Hohenheim, called Paracelsus (1493–1541), whose
(al)chemical philosophy I view as the first in European culture to give scholarly voice
to an artisanal understanding of the material world. Paracelsus not only articulated the
artisanal epistemology but also established a persona under which practitioners and
artisans could claim authority. Chapter 3 turns to the central place of the body and of
bodily processes in the artisanal epistemology, arguing that the process of imitating
nature constituted a type of cognition. The works and writings of the French potter
Bernard Palissy and the metalsmiths Benvenuto Cellini and Adriaen de Vries, as well

as the painter of the Danube school Albrecht Altdorfer, illustrate the significance of bodily labor to the artisan. Nature, matter, and the human body were bound up together and were the source of the power of art. The fourth chapter examines the intersections between alchemy and artisanship, noting the overlap between alchemical theory and artisanal epistemology and suggesting the ways in which alchemy functioned as a vernacular science of matter.

The fifth chapter shifts away from painters and sculptors to examine three practitioners who exemplify how Paracelsus's legacy—both his alchemical theory and the identity he created—was employed. I focus particularly on Johann Rudolf Glauber (1604–1670), a liminal figure between scholars and artisans, who represents a moment of transition in which the artisanal epistemology was incorporated into a new discourse about nature. Glauber, a German court apothecary, moved to Amsterdam, where he established a large laboratory and became wealthy as an independent apothecary, selling his medicaments—as painters sold their works of art—for private consumption. His position as an entrepreneur and seller of natural commodities in the commercial environment of Amsterdam helped to carve out a new position as experimental philosopher, thus implicating the new empiricism in commercial networks. Glauber became famous for his panacea known as "Glauber's salts," based on a Paracelsian preparation. He saw these salts simultaneously as an incarnation of the prophet Elias, returned to earth as an artisan, and as a commercial commodity. Such a vision reveals the extraordinary complication of feeling about nature in the moment at which a new understanding of the material world (and of human salvation) was coming into being. Glauber's progeny evoke even more clearly the intersections between art and natural philosophy, for his children did not, in contrast to the normal course of the artisanal world, follow him in his trade; instead, his two sons and only daughter became painters. Painters and apothecaries often shared the same Guild of St. Luke, but, more significantly, both described themselves as "imitating nature" (or painting and working "after life"); however, this shared epistemology began to separate in the seventeenth century.

In chapter 6, I examine the painting collection of the Leiden professor of practical medicine Franciscus dele Boë, called Sylvius (1614–1672), the son of a French noble degraded into commerce, who established clinical teaching at Leiden University and formulated a radically materialistic understanding of physiological processes drawn in part from the chemical theories of Paracelsus. At the same time, he was a patron and friend of the Leiden fine painter Frans van Mieris, and he built up a large collection of paintings. Sylvius epitomizes the way in which, by the seventeenth century,

the persona of the new philosopher was becoming established and, in the process, how he was distancing himself from artisans. As a medical practitioner, Sylvius engaged in the practice of demarcating his own experiential and practice-based medicine from that of mere manual operators and separating his own controlled sensory investigation from sensuality. He asserted that, as a new philosopher and through his self-knowledge, he had a privileged vantage point on the world of the senses. At the same time, vestiges of the artisanal beginnings of the epistemology of the new philosophy remained in his practices and interests.

Taken together, the three moments of the book form a roughly chronological study of the artisanal understanding of nature, its incorporation into natural philosophy, as well as the subsequent dividing of the ways between science and art. *The Body of the Artisan* attempts to illuminate an important moment in the reorientation of western European attitudes toward the material world, one that is defined by the rise of artistic naturalism and modern science. A few qualifications are in order. First, in what follows, I refer to many individuals as artisans, rather than as artists. Art, understood as the imitation of nature, came to have new significance and new uses in the Renaissance, not just in the realm of what we now call the fine arts, but also in the realm of *ars*, that of practical knowledge employed by the busy urban citizen or knowledge produced by craftspeople that helped shape and control the material conditions of everyday life. Much more will be said about *ars* in what follows, but it is important to note here that "fine art" and "artist" are modern terms. Into the seventeenth century, "*artista*" connoted a student of the liberal arts in a university[71] and "art" continued to refer to manual operations. Thus, the early modern connotations associated with the term "art" are much more tied to what we would call "craft" today, and those to whom we refer today as artists would generally have been viewed as artisans. Over the entire span of time that I am considering, goldsmiths, painters, sculptors, architects, and other "high" artisans were remaking themselves as practitioners of the liberal arts[72] and struggling to make clear their knowledge of nature. Although they succeeded in raising their status from that of manual workers to, in some cases, individual "divine geniuses," they ultimately lost their status as experts on the processes of nature. Because the history of art has often neglected the manual practices of artists and thus not examined this side of the artisans' rise to the position of creative geniuses, I think it is useful to hold the manual dimension of art in mind by the use of the term "artisan."

Second, the regions on which I focus—Flanders, the southern German free imperial cities, and the Dutch Republic—all became important centers of religious reform during the sixteenth century. It is tempting to draw a connection between the

level of self-consciousness of artisans and the likelihood of religious reform, or, as Max Weber did, between Protestantism and capitalism, or, with Robert K. Merton, between science and religion. These are enormously powerful ideas and there is no question that religious authority is crucially important to any consideration of the transformations of early modern Europe. It is against this implicit background that I have chosen to focus on the way in which artisans and eventually other individuals turned to *nature* as a new source of social and intellectual authority in this period.

Finally, in delineating the artisanal epistemology of the fifteenth and sixteenth centuries, I draw examples from widely spread geographical regions and chronological periods. This is necessary in part because of the scarcity of documents that relate to artisanal practices, let alone that allude to artisans' understanding of nature. The benefit of this expansive geographical and chronological view, however, has been to suggest the continuities and the pervasiveness of this epistemology. Although the ways artisans understood matter and their own workings in the material realm were articulated in different ways at different times and places, it is still possible to trace some continuities over distance and time. The pervasive character of the epistemology of handwork arose largely out of the experience of training by apprenticeship and its basis in the bodily techniques of observation, imitation, repetition, and active doing.

‡‡

FLANDERS

The Artisanal World

Artisanal Self-Consciousness

In seeking out an artisanal worldview, we can look to the objects artisans fashioned, to the texts they wrote, and, as we saw in the case of Messerschmidt, to literate intermediaries who put their actions into a form both comprehensible and accessible to a wider audience. Before the beginning of the fifteenth century, we have very few texts written by artisans, but around 1400 artisans appear suddenly, in the words of one historian of technology, to "resort to pen and paper in a field where their fathers had been satisfied with memory and the spoken word."[1] The result was a veritable explosion of technical treatises between 1405 and 1420. The artisans of northern Italy and southern Germany seemed to have felt particularly compelled to write down their modes of working, especially those in architecture, fortification building, and gunnery.[2] Historians have largely accounted for this sudden shift from oral transmission to the medium of written treatises by pointing to new methods of warfare and the greater fragmentation of Europe into competing noble territories. A new political culture emerged out of these changes that gave artisans and their handwork a newly perceived importance in society.[3] Furthermore, these writing artisans stood at the intersection of courtly and commercial forces. Freed from (or never possessing) guild membership by the rise of

the courts and the greater intensity of commerce, artisans were forced to become more self-conscious about their practices and to make explicit claims for their skill and power because they were competing for patronage, livelihood, and *fama*.

The number of practicing artisans who combined craft with authorship is striking in this period, even if we consider only a few of the best-known "high" artists of Italy: Lorenzo Ghiberti (ca. 1378–1455), who created the relief panels of the Florentine Baptistry doors, wrote a treatise on sculpture in 1447; Antonio Averlino (ca. 1400–ca. 1469), called Filarete, who was trained as a goldsmith, dedicated an architectural treatise to Francesco Sforza in the early 1460s; Piero della Francesca (ca. 1420–1492) wrote tracts on perspective and practical mathematics; and, finally, Leonardo da Vinci (1452–1519) wrote notes and treatises that were never published and, like many of the others, painfully taught himself Latin.[4] These artisan-authors represent one stream of a confluence of humanist and artisanal interest (often in the service of the same noble courts) in architecture, fortification, mechanical problems, practice, *praxis*, and the common good. Scholars began expressing interest in the crafts for at least two reasons. First, because artisans had become economically and politically powerful and their products had come to be regarded as integral to the common good, and, second, because humanists saw the practical knowledge of artisans as a model of *praxis* that could be set against contemplation. The result of this confluence was a set of shared values: an emphasis on the union of practice and theory, and on the need to relate mathematics to practice and experience. As Pamela O. Long puts it, artisans' books enabled the mechanical arts to become "central features of moral and political life, as they also began to take part in the construction of knowledge itself."[5] Long makes the argument that humanists and artisans shaped a set of values for the pursuit of knowledge[6] and that the treatises and books of artisans contributed substantially both to the formation of these values and to the construction of new knowledge.

Self-Consciousness and Naturalism

At about the same time, another type of artisan began to articulate his mode of working, not by writing, but by producing a new naturalistic representation of nature (plate 1, figs. 1.1, 1.2). Fourteenth-century Italian artists had "developed a wide variety of stratagems for the evoking of space and for the depiction of solid forms in a more or less convincing manner,"[7] culminating in about 1340 in a rudimentary system of perspective construction. By 1400 Filippo Brunelleschi (1377–1446) was beginning his

experiments with *perspectiva* to represent the buildings of Florence on small panels using painters' perspective. The aim of art was shifting from evoking an image of the form of the thing depicted to, as Leon Battista Alberti (1404–1472) put it in about 1435, making a picture that was an "open window" through which the world was seen.[8] The development of perspective in the Italian Renaissance has been extensively studied, but the almost contemporaneous development of naturalistic depictions of nature has not inspired nearly the same interest. This naturalistic art—beginning in northern Italy and spreading to Flanders, aided by close commercial ties—does not show the use of mathematical perspective construction (although the use of the vanishing point appeared in the north in about 1370), but instead employed a particularizing light and multiple points of observation, and, especially in the portraits, exhibited an interest in individual detail unmatched in Italy at this time.

Otto Pächt has traced the new depictions of nature back to a tradition of botanical illustration, the ultimate source for which was an eleventh- and twelfth-century revival of medicine under the influence of Arabic medical and scientific activity in Salerno. An herbal produced in Padua around 1400, called the Carrara herbal, emerged out of this tradition, but the naturalism of its illustrations (plate 1, figs. 1.1, 1.2) was without precedent in earlier herbals.[9] It is a vernacular Italian translation

FIGURE 1.1.
"Ear of Grain," from the Carrara herbal, 1375–1400, Egerton 2020, f. 21r, by permission of the British Library. Here the anonymous artisan depicts the progression of ripening wheat, starting on the left with delicate green, tightly nestled kernels and ending on the far right, where the open, mature kernels are on the verge of drying (indicated by yellow and white highlights) and some grains have already fallen from the stem.

FIGURE 1.2.
"Convolvulus," from the Carrara herbal, 1375–1400, Egerton 2020, f. 33r, by permission of the British Library. Like the ears of wheat, the depiction of the convolvulus, or morning glory, is concerned with the plant's progression from bud to flower. The artist's focus seems to be more on painterly illusion than on the full botanical information that would have been provided had the artist represented the full plant including the roots.

made in the closing years of the fourteenth century of the *Liber Serapionis aggregatus in medicinis simplicibus* by the ninth-century Arab author Serapion the Younger (Ibn Sarabi) on medicinal plant simples. The illustrations in this codex all include close observation and some are drawn from pressed specimens (plate 1), practices probably partly associated with the medical faculty at the university in Padua. Yet these illustrations are not strictly descriptive, that is, they do not always adhere to the function of an illustration in a medicinal herbal, as they do not represent complete botanical specimens, often lacking root, stalk, leaf, flower, or fruit.[10] As Pächt notes, this is significant because it indicates the dawning of a painterly aesthetic, in that it both begins "to see in plant portrayal an aesthetic problem" and deliberately confuses painted and real space (thus is illusionistic). It is also significant as an expression of empiricism; as Pächt puts it: the illustrator "is an illusionist who prefers the empirical truth of the one-sided view to the lifeless completeness of an abstract image."[11] Pächt goes on to speak of this illustrator's "courage to turn his back on all patternbooks and to look nature straight in the face."[12] I would argue that this empiricism comes not so much out of the heroic mix of science and art posited by Pächt, but, rather, out of a new self-consciousness on the part of the artisan. Caught between patronage and market forces similar to those that operated on fortification builders and gunners,[13] this artisan articulated his methods not in treatises, but in paint.

The Carrara family, rulers of Padua from 1318 to 1405, commissioned what came to be known as the Carrara herbal, and their interests contributed to the self-consciousness of the artist and the new attitude toward nature evident in it. Besides employing the artist who illustrated the Carrara herbal, they commissioned remarkably naturalistic portraits, and their funerary monuments show evidence of the sculptors having worked from death casts of their faces and hands. Their palace was painted with lifelike animals. Under their patronage, the painter Cennino d'Andrea Cennini penned *Il libro dell'arte*, a manual for painters, in which he states that painting is the imitator of nature and describes the technique for exact replication by casting from life for the first time since antiquity.[14] Much more will be said about Cennini and casting from life in the following chapters, but it is important to note here that Cennini's treatise signals both a self-aware artisan concerned with justifying the mechanical arts and a potent interest in nature at the Carrara court. The interest in nature on the part of the Carrara family was undoubtedly related to their own precarious and "unnatural" hold on power. The family had risen through the communal government of the city, from which they had subsequently seized power, with the result that they possessed political legitimacy neither from pope nor emperor. Instead they based their authority

on the language of the jurists at the university in Padua who claimed that government must imitate nature; the same kind of language the commune had employed when it originally separated itself from the local seigneury. Claiming the natural reasonableness of their rule, the Carrara family thus walked an uneasy course between the claims of the commune that they were unnatural tyrants and the assertions of the pope that they stood outside any divinely ordered hierarchy.[15] They appear to have employed nature (and artisans) to construct a theater of state that would make authoritative their claims to legitimate rule, or, at the very least, they used nature as a way to display their mastery. The naturalism of the Carrara herbal was an artisan's response to this discourse about nature and also a statement of the importance of his own part in the construction of this theater of state. In this respect, the herbal's illustrations are analogous to Cennino Cennini's written treatise on painting. Both come out of the elevation of the artisan and of nature in the theater of state that constituted a central mode of governing at the Carrara court.

As Pächt notes, the fruits of this attention to the details of nature were not reaped in Italy, where only Pisanello made more frequent use of this "discovery of the non-human world,"[16] but in the north, particularly in the Burgundian Netherlands. Here again, a noble family foreign to the Lowlands attempted to "naturalize" their right to rule. The wealthy and independent Flemish cities, grown rich from their textile production, had always been difficult to control, for the indigenous counts as much as they would be for the Burgundian dukes. From the marriage on 19 June 1369 of Philip the Bold, brother to the king of France and duke of Burgundy (duke since 1363, ruled the Netherlands 1384–1404), and Margaret of Male (ruled jointly with Philip 1384–1405) that joined Burgundy and the Netherlands, the conflict between the cities and the dukes was nearly constant, as both attempted to pursue their own goals in the Lowlands. Out of the forced integration of foreign nobles and urban burghers resulting from their rule, a great efflorescence in music, panel painting, and elaborate court celebrations emerged, especially under the rule of Philip the Good (d. 1467) from 1419 to 1467. The wealth of rich Netherlandish cities, containing some of the densest population in Europe, and the intensive agriculture of the countryside provided Philip with the means to assert an autonomous position from which he could contend with the emperor and the warring kings of England and France. After he moved his court to Flanders in 1420, Philip spent much of the first half of his reign consolidating his power within the Lowlands, dealing with conspiracies by the indigenous noble estates and urban rebellions (Ghent from 1432 to 1436 and Bruges in 1436). The force by which he kept his subjects sometimes only tenuously under control was a mix of armed

might and theater of state.[17] The duke's effort to hold rich and powerful local urban dwellers, nobles, and self-assertive artisan guilds under his control while at the same time claiming his right to status within the Holy Roman Empire engaged him in an escalating contest of patronage and cultural production that employed visual display to maintain authority.[18] The culture of display and "living nobly" that he engendered at his court became a model for all of Europe, especially after 1454, when he had sworn a crusade in Lille with a spectacle of unprecedented proportions, known as the Feast of the Pheasant, and had attended the 1454 Reichstag in Regensburg, during which he vaunted his luxurious lifestyle before the eyes of the higher-ranking but less splendorous (and poorer) German princes.[19] The gains made by this journey to Regensburg were reaped in 1477 when Philip's son Charles the Bold (ruled 1467–77) married off his daughter Mary of Burgundy to Maximilian, heir to the Holy Roman Empire. Philip's journey to Regensburg also mobilized a discourse on the relationship of nature and art that reverberated throughout Europe, but especially in the lands under Habsburg rule[20] and among the urban patriciate, eager to imitate the consumption of the nobility. From the beginning of the dukes' reign in the Netherlands, the Burgundians had patronized the highly skilled Flemish artisans and their humble and sometimes earthy subjects. In manuscript illuminations, sculpture, and eventually panel paintings, these artisans often took their subjects from peasant life and from the natural world. This subject matter arose partly from the new religious ideas and practices of the *devotio moderna*, which emphasized the imitation of Christ in his humility.[21] Under the dukes of Burgundy, these "low" genre subjects came to constitute a noble aesthetic.[22] The dukes encouraged the local aesthetic of depicting nature, and they collected natural curiosities and wonders, because nature had a heightened meaning in their realm.[23] Even the *ars nova* of Flemish polyphonic music, such as that of Guillaume Dufay and Gilles Binchois, employed nature in its imitation of birdsong.[24] Through a discourse elaborated in lavish court banquets, "joyous" city entries, tapestries, stained-glass windows, panel paintings, and all manner of rich objects of nature and art, they organized a narrative that articulated the naturalness and rightness of their own rule in the Netherlands. In so doing, they desired to make autochthonous their reign in a homeland that was not their own.[25]

The amalgam of court nobility and urban bourgeoisie that shaped this culture of display gave power to the artisans who made possible its operation, and Netherlandish artisans were aware of the power they possessed. A declaration of their self-consciousness and their power—both in the sense of artisanal virtuosity and social power—can be found in the illusionism of a joke played by the Limburg brothers, Pol, Hermann, and Jehanequin, on Jean de France, duc de Berry, on New Year's Day in

1411. The brothers, born into a family of artisans in Nijmegen, had entered the duke's service in 1404. As a New Year's gift in 1411, they presented him with a block of wood painted to precisely resemble a book.[26] This simulacrum of a book not only reaffirmed the social bonds of patronage and homage between the duke and his court painters, but also demonstrated the Limburg brothers' power of representation, made clear their wit, and alluded to the artisanal virtuosity of their "real" books, the *Belles Heures* and their great masterpiece, the *Très riches heures* (1411–16) produced for the duc de Berry. This last manuscript achieved its fame through its apparently precise depictions of courtly scenes and natural landscapes (plate 2, fig. 1.3). Naturalism of this kind was meant to inspire wonder, and its ability to do so through illusionistic representation had long been an essential part of the valuation of the mechanical arts.[27] Such a capacity was especially appreciated and validated by nobles like the duc de Berry and the Burgundian rulers of the Netherlands in this period.

The type of naturalism embodied in the Limburg brothers' gift to the duke points to their consciousness of their skill. This kind of self-awareness was especially apparent among goldsmiths. The Limburg brothers, famous today for their manuscript illuminations, had begun their careers apprenticed to a Paris goldsmith. Many goldsmiths in this period turned from working metal to other kinds of activities by which they demonstrated their artistic virtuosity in less precious media. From the thirteenth century, an increasing emphasis on the worth of the artistic virtuosity, or skill, of a piece rather than of its material began to be articulated. For example, in 1241 King Henry III commissioned a golden shrine for Edward the Confessor in Westminster Abbey. Matthaeus Parisiensis described it: "In qua fabrica, licet materia fuisset preciosissima, tamen secundum illud poeticum: Materiam superabat opus." [In such a work, however precious the material may be, as the poet (Ovid) says, the work stands higher than the material.][28] The valuation of artistic skill would only increase in the late fourteenth century, and many goldsmiths would migrate from metalworking to become architects, sculptors, and, like the Limburg brothers, painters.[29] The painted wooden box of the Limburg brothers could not be a clearer or more self-aware assertion of the value of skill over material.[30] Naturalism would become the favored mode of expressing artisanal claims to skill, power, and value in the work of the panel painters of Flanders.

Panel Painters in Flanders

In the first third of the fifteenth century, the Flemish painters Robert Campin (ca. 1378–1444), Jan van Eyck (born before 1395–1441), and Rogier van der Weyden (ca.

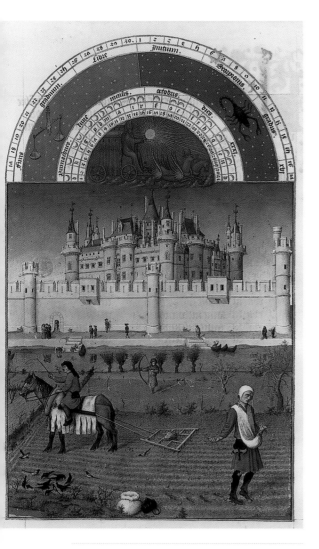

FIGURE 1.3. Limburg brothers, "October," from *Très riches heures*, ca. 1411–16, pigment on paper, 28 x 19 cm, Ms. 65, f. 10v, Musee Condé, Chantilly. Copyright Giraudon/Art Resource, NY. In the depiction of October, this illumination from the duc de Berry's *Très riches heures* features the Louvre, prior to its sixteenth-century reconstruction, as seen from the Hôtel de Nesle. In the distance, courtiers gather in front of the castle wall, a scarecrow dressed as an archer in the middle ground watches over the fields, and tilling and sowing go on in the foreground. The ambition to portray a specific moment and a distinct place inhabited by individuals makes these illuminations distinctive.

1399/1400–1464) brought forth a new level of naturalism and illusionism. Campin, a master painter in Tournai, made a break with the International Style of his day, apparently drawing upon the lifelike solidity and emotional intensity of fourteenth-century Flemish sculpture, as embodied in the work of Claus Sluter (ca. 1350–1406), and upon the realism of particularity and specificity in early manuscript illumination.[31] Jan van Eyck's naturalism was long regarded as the result of an invention of the process of mixing seed and nut oils with pigments to produce oil paints (in contrast to the temperas produced by mixing egg whites with pigments), and, more recently, of a new method of applying oil paints and varnishes to create luminous colors. But new scholarship suggests that instead of any technical innovation, van Eyck's stunning works of art are the result of his "acute power of observation of the subtle nuances and interplay of light, shade and tone, coupled with a gift for re-creating them within the already extant wide spectrum of paint qualities, offered by the infinitely flexible combination of drying oil, subtly blended with pigments."[32] Van Eyck was employed from 1422 to 1424 at the court of John of Bavaria, count of Holland, in The Hague, and then in 1425 he was made court painter and became a trusted *varlet de chambre* to Philip the Good, duke of Burgundy, at his court in Lille. When Philip moved to Bruges in 1430, van Eyck began to paint for the city burghers there. Rogier van der Weyden moved to Brussels in the mid-1430s, where he had been appointed official painter to the city. His work for the city included secular and sacred paintings and, unlike van Eyck, he appears to have had a large workshop with numerous assistants and pupils. His paintings and their copies were sent all over Europe. Campin, van Eyck, and van der Weyden all produced for both the nobility and burghers of the Flemish cities.

These artists used naturalism to assert their self-consciousness and skill, but they also began to make new claims about their knowledge of nature and their power to represent that knowledge. Their mode of representing nature did not employ the perspective construction of the Italian artists, but rather emphasized

illusionism, as had the Limburg brothers, such as in van Eyck's *Portrait of Man with a Ring* (fig. 1.4). The sitter convincingly proffers the ring out over the frame of the picture as he would over the lintel of a window. These artists also strove to capture individual particularity and temporal specificity in their portraits. They paid special attention to the surface appearance of the things of nature and of the human face. Robert Campin's portrait of Robert de Masmines (fig. 1.5) depicts the stubble on his cheek, pointing to a specific moment at which the portrait was produced. Van Eyck's preparatory sketch of Niccolò Albergati records, and his painted portrait reproduces, the bluish halo around one of his sitter's eyes, a common symptom of old age (fig. 1.6).[33] Van Eyck's portrait of Canon Joris van der Paele (fig. 1.7) epitomizes the attempt to represent a particular and specific individual at an identifiable moment in his life. These paintings seem to capture a real moment, one that was experienced by the sitter and was observed and then rendered by the painter. By means of such stratagems, these painters appear to be making several novel claims in their works.

These artisans came out of a milieu in which panel painters were only one among a group of artisans belonging to the Guild of St. Luke, which included illuminators, leather gilders, jewelers, tapestry weavers, goldsmiths, sculptors, saddle makers, and often physicians and apothecaries. In keeping with this, Jan van Eyck's panel painting was just one of his media. He also illuminated books of hours (fig. 1.8), produced coats of arms and organized festival decorations for the Burgundian nobility, and even gilded the statues on the Bruges town hall. Van Eyck's versatile activity was typical for the type of artisan in the Guild of St. Luke, although he was himself not registered in the guild in Bruges. Campin was a master in the Guild of St. Luke in Tournai, and while he made reference to sculptural innovations in his work, he aimed to display the power of panel painting to produce lifelike simulacra (fig. 1.5). Panel painting, and particularly portraits, became exceedingly popular first among the merchants and then the nobility of the Lowlands, and as these painters came to recognize their own economic power and success, they declared themselves to be unique among the various trades of their guild. Panel painting became their way of demarcating themselves off from their fellow artisans. Through this sought-after medium of panel painting, Campin, van Eyck, and van der Weyden claimed they were artisans of a higher order than their diverse fellows with whom they shared a culture and a guild.[34] They did not denigrate their origins as artisans, however, as they might have, but instead used their paintings to explicate the growing cultural value and power of panel painting in the worlds of the courts and the towns.

These artisans displayed a heightened self-consciousness of themselves as panel painters, emphasizing the medium in which they worked. They began portraying

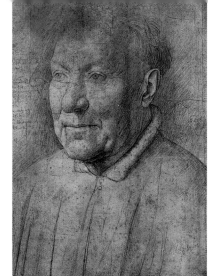

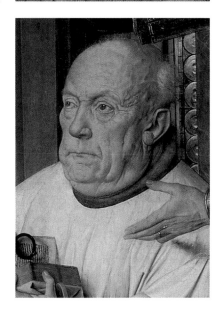

FIGURE 1.4 (*top left*). Jan van Eyck, *Portrait of a Man with a Ring*, ca. 1429, oil on panel (with restorations), 22.5 × 16.6 cm (original measurements 19.1 × 13.2 cm), Muzeul Naţional de Artă al României. In one of Jan van Eyck's earliest illusory masterpieces, the sitter seems to inhabit both the worlds inside and outside his portrait. His left hand sits on the realistically rendered frame of the painting, while he proffers his ring over the threshold to the beholder. This kind of illusionism draws the painting's viewer into the space of the painting. Van Eyck's realism in depicting the sitter's eyes, lined face, left ear, and stubble on the chin gives the impression of capturing a distinct moment in a specific individual's life.

FIGURE 1.5 (*middle*). Robert Campin, *Portrait of a Stout Man (Robert de Masmines?)*, ca. 1425–30, oil on panel, 35.4 × 23.7 cm, Museo Thyssen-Bornemisza, Madrid. Campin's portrait of Robert de Masmines, a military commander of the duke of Burgundy, is very lifelike, depicting wrinkles, scars, and a faint hint of stubble ringing his lower face. Robert de Masmines's hair and the fur collar on his cloak have been painted with particular attention.

FIGURE 1.6 (*top right*). Jan van Eyck, *Cardinal Niccolò Albergati*, preparatory drawing, 1431?, silverpoint, 8-3/8 × 7-1/8 in., Gemäldegalerie Alte Meister, Staatliche Kunstsammlungen Dresden. Niccolò Albergati was made cardinal of Bologna in 1426; this preparatory sketch for a still-extant portrait (plate 15) was presumably finished sometime following his appointment. Van Eyck focused his energy on capturing an accurate representation of Cardinal Albergati's face. The wrinkled and roughened skin is meticulously depicted, and the colors for the final painting are indicated in van Eyck's handwriting on the drawing.

FIGURE 1.7 (*bottom right*). Jan van Eyck, detail from *Virgin and Child with Canon Joris van der Paele*, ca. 1434–36, oil on panel, Stedelijke Musea Brugge, Groeningemuseum. In this detail from an altarpiece (plate 3), van Eyck portrayed Canon Joris van der Paele looking up from his prayer book in the collegiate Church of St. Donatian in Bruges, where van Eyck was canon. Van der Paele has interrupted his reading, looking up to behold a vision of the Virgin Mary as his intercessor Saint George commends him to the Virgin. Van Eyck contrasted the idealized faces of the Virgin and the saints (Saint Donatian is pictured on the other side of the painting) to the canon's wrinkles, white hair, and fleshy jowls. In this painting, van Eyck portrayed a distinctive individual at a specific moment in a real location.

themselves in their own paintings with great frequency and in a variety of ways. For example, they often indicated themselves with a signature, as when Jan van Eyck painted a *vera icon* image of the face of Christ. This iconic image was called an *archeiropoietos*, an image not made by human hands, and was represented as the unmediated face of Christ. But in this image, traditionally unsigned as if not made by human handwork, van Eyck called attention to himself as maker by signing and dating it, "Johes de eyck me fecit et apleviit anno 1438, 31 January," even including his motto "als ikh kan." Here he not only made clear that this image was the work of a specific painter at a precise moment, but also called especial attention to himself by doing so in an icon allegedly not created by human hands.[35] These artisans also depicted their own presence as hidden images in reflective surfaces,[36] the most spectacular being van Eyck's presence as painter holding his brush and reflected in the polished shield of Saint George in his painting of the *Virgin and Child with Canon Joris van der Paele* (plates 3–5). "Shield," or "*schild*" in Dutch, also meant panel painting, as "*schilder*" meant painter.[37]

These painters also asserted their presence by painting their own faces staring boldly out of the frame at the viewer (plate 6).[38] The scholar Nicholas of Cusa (1401–1464) recalled Rogier van der Weyden's self-portrait (now lost except as a copy in a tapestry) in the Brussels town hall, the eyes of which seemed to follow the observer no matter where one stood. The importance of such self-portraiture and the attention it gained in the Lowlands are indicated by the fact that Cusa used van der Weyden's self-portrait to explicate the relationship he believed existed between God and every individual. As he wrote in *De visione Dei*, God could both stand face-to-face with every particular individual and at the same time collect them all in the unity of His vision.[39] It is telling that Cusa's point of reference for this all-seeing and all-knowing vision was the work of a panel painter.

These artists also declared themselves as unique in their ability to observe and render by portraying the act of painting itself. First Robert Campin and then Rogier van der Weyden represented Saint Luke making a silverpoint study of the Virgin (fig. 1.9), thereby making a claim that Saint Luke, patron saint of their guild, extended special and exclusive protection to panel painters.[40]

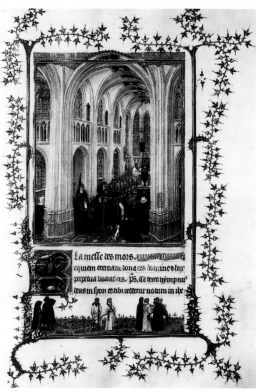

FIGURE 1.8.
Jan van Eyck, *Mass for the Dead, a Funeral*, f. 116r, ca. 1420, vellum, 28 × 19 cm, Torino, Museo Civico d'Arte Antica e Palazzo Madama. This illumination from a mass for the dead demonstrates van Eyck's work in various media. Besides panel painting, he organized court festivals and gilded the figures on the Bruges town hall. The astounding depth and realism of this illumination attests to van Eyck's skill as a miniaturist, a skill that carried over into his panel painting.

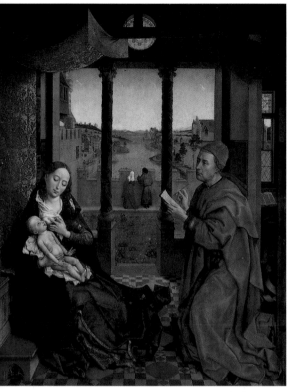

FIGURE 1.9.
Rogier van der Weyden, *St. Luke
Drawing the Virgin*, ca. 1435–40,
oil and tempera on panel, 137.5
x 110.8 cm, Gift of Mr. and
Mrs. Henry Lee Higginson
(93.153). © 2002 Museum of
Fine Arts, Boston. Saint
Luke—patron saint of painters,
physicians, and apothecaries,
among other trades—is pic-
tured here making a silverpoint
study of the Madonna and
child. The painting can be un-
derstood as attesting to van der
Weyden's devotion to the Vir-
gin as well as indicating the dis-
tinctive relationship of panel
painters to Saint Luke.

Flemish panel painters also maintained that they possessed spe-
cial abilities to observe and imitate precisely. Mirrors appear fre-
quently in their paintings (plate 7, figs. 1.10, 1.11), attesting to their
goal of and ability to render mirrorlike representations. Jan van Eyck,
for one, claimed to be able to produce a legally authentic likeness of a
person. For example, in the portrait of a man, perhaps a scribe or no-
tary, van Eyck has "inscribed" "LÉAL SOUVENIR" beneath the por-
trait (fig. 1.12). "*Léal*" today connotes loyal, but in van Eyck's day, it had
connotations of authentic or even "legal" memory. This interpreta-
tion of the painting is reinforced by the contractual style in which van
Eyck signed it: "Transacted on the 10th day of October in the year of
our Lord 1432 by Jan van Eyck."[41]

These painters claimed "autoptic authority," or the authority of
eyewitness. This was the kind of authority that anatomists claimed in
their *autopsia* and to which authors writing about the novelties of the
New World would make appeal when they had no textual *auctoritates*
(authorities) to back them up.[42] The appeal to autoptic authority
would gain momentum and become especially frequent in the six-
teenth century. For example, Bartholomé de Las Casas (1474–1566),
in arguing his case in the first quarter of the sixteenth century about
the maltreatment of the native inhabitants of the Caribbean islands
and the Americas by the Spanish, constantly made reference to the evidence of his
own eyes and the testimony of witnesses. This kind of appeal constituted an assertion
about the accuracy of an individual's representation based on his or her own presence
and experience at the scene. The author's or painter's act of eyewitnessing was made
palpable with phrases such as "I saw with my own eyes," "I did," and by means of a re-
counting of experienced details of the site and circumstances of witnessing. When ar-
tisans wrote autobiographies in the sixteenth and seventeenth centuries, they often
employed such strategies.[43] A remarkable visual example of these claims from the six-
teenth century can be found in the work of the aristocrat Gherardo Cibo
(1512–1600), an early botanist and follower of Netherlandish landscape painting. In
compiling a manuscript herbal, Cibo included himself, the botanist and depicter, in his
representations of the various plants. He portrayed himself in one image searching for
plants (fig. 1.13), in another as a tiny figure uprooting a plant, in yet another compar-
ing the plant he has just found to a description in a book, or painting a plant he has
just discovered, resting after his labors, being surprised by an eagle soaring overhead as

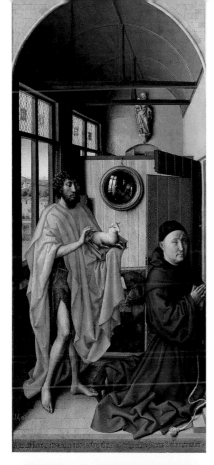

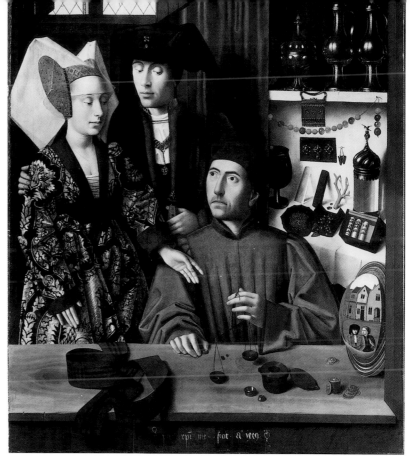

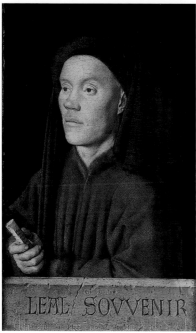

FIGURE 1.10 (top left). Follower of Robert Campin, *Saint John the Baptist and the Franciscan Master of Arts Heinrich von Werl*, left panel, 1438, oil on panel, 101 × 46 cm, Museo del Prado, Madrid. Copyright Scala/Art Resource, NY. Saint John the Baptist introduces the donor Heinrich von Werl, a Franciscan theologian from Cologne. The mirror reflects the interior scene and includes an additional figure standing outside the picture plane.

FIGURE 1.11 (top right). Petrus Christus, *A Goldsmith in His Shop, Possibly Saint Eligius*, 1449, oil on panel, 98.1 × 85.2 cm, The Metropolitan Museum of Art, Robert Lehman Collection, 1975 (1975.1.110). Commissioned by the goldsmith's guild of Bruges, this painting depicts a goldsmith in his shop (possibly Saint Eligius, patron saint of goldsmiths) and a young couple purchasing a ring. The mirror to the goldsmith's left reflects the street outside the shop where two stylishly dressed individuals are passing by, one holding a falcon.

FIGURE 1.12 (bottom left). Jan van Eyck, *Portrait of a Man* ("*Léal Souvenir*"), 1432, oil on panel, 33.3 × 18.9 cm, © National Gallery, London. This portrait is perhaps meant to be a "*léal souvenir,*" or faithful and authentic remembrance of the subject depicted. The sitter is pictured in front of an illusionistic stone windowsill on which van Eyck has inscribed the exact date of completion.

he and a companion are digging up a black hellebore plant (fig. 1.14), and, finally, in yet another killing a snake (fig. 1.15). Cibo carefully recorded the location, day, and hour in which the specimen was collected, as well as the persons who had accompanied him on the herb-gathering expedition. In addition, he provided a written description of each of the plants and the circumstances under which he found them. Thus, he depicted not only the plant, but also recorded his own particular experience of coming to know each plant.[44]

To return, however, to fifteenth-century Flanders, we find Jan van Eyck making similar claims of witnessing in his 1434 *Portrait of Giovanni (?) Arnolfini and His Wife* (plate 7) A mirror behind the couple reflects two figures who appear to be eyewitnesses, perhaps in a legal capacity, to the event represented in the painting, which may be a betrothal or marriage ceremony. Van Eyck himself states that he, too, witnessed the scene he painted and perhaps was present *in* the ceremony as one of the legal witnesses, for he signed his painting over the mirror "Johannes de Eyck fuit hic 1434" [Jan van Eyck was here 1434] (fig. 1.16).[45] In the Middle Ages, it was not unusual to find artisans, particularly silver- and goldsmiths, signing their work with, for example, "Theophilus me fecit" [Theophilus made me], but in van Eyck's 1434 painting, the medieval "*me fecit*" has become an assertion of a different kind, one that makes a claim to having been actually present at the event and to have witnessed, mirrored, and produced a legally accurate representation of it.

Van Eyck's claim to the capacity for authentic representation came out of his highly developed sense of himself as an artisan. He was the first Flemish panel painter to sign his works and the first to adopt a motto, written by him in Flemish with pseudo-Greek letters as "ΑΛΣ. ΙΧΗ. ΧΑΝ" (or "als ich kan," which literally means "as well as I can") (plate 6). "*Kan*" comes from the verb *können*, which is also the root verb of *Kunst* and which connoted power (*Können*).[46] The phrase "as well as I can" ultimately derived from "ut potui, non sicut volui" [as well as I can, not as well as I wished], a rhetorical tradition of antiquity carried on by medieval scribal copyists well into the fifteenth century.[47] They ended their texts, the products of laborious handwork, with this phrase. The pseudo-Greek form of van Eyck's inscription was also a common means in medieval colophons to conceal the copyist's name at the end of a text. With a bit of transposition, van Eyck's inscription can be read as an anagram of his name, as it contains all the letters of his name except the V and the Y.[48] It is perhaps also a play on his name: "als ich, or eyck, can."[49] Van Eyck thus interestingly drew from the manual practice of the scribal copyist (who was laboring to carry on a textual tradition) and transposed it into a visual declaration of his ability to document, witness, and mirror in paint.

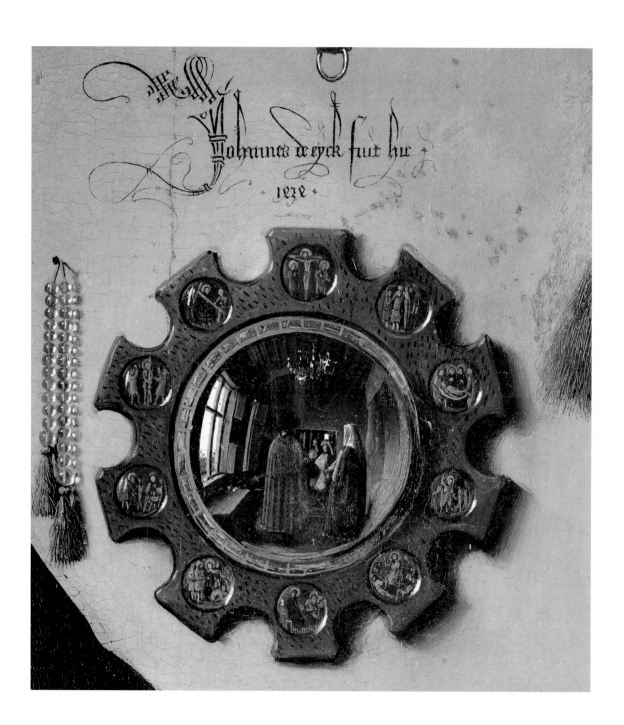

One can see in this self-consciousness and the adoption of noble forms, such as a motto, an analogy to the kind of ipso facto claim to legitimacy evident in the portraits of the city burghers whom van Eyck painted. This powerful urban commercial group portrayed themselves as recognizable, not by ancient *Stand*, or title (although many of them adopted coats of arms or mottoes), but instead by a distinctive individual physiognomy set within a new urban milieu. These new portraits became so popular that even nobles began to imitate this kind of self-representation.[50] This signals the beginning of a search by this new urban class for modes of expression and models—above all, in the works of the ancients—that so much influenced the course of the study of nature also.

In their works of art, Robert Campin, Jan van Eyck, and Rogier van der Weyden made claims about their social status as artisans and panel painters, and about their ability to witness and represent. But they also commented on the nature of vision and cognition, both their own cognition and representation of reality, as well as the effects that their works of art could provoke in a viewer. For medieval people, reality consisted in the supernatural realm while the material world was transient and insubstantial. They thus distinguished between the inner spiritual eye and the external vision that perceived the tangible world.[51] This can be illustrated by van Eyck's *Madonna in the Church*, in which all parts of the church architecture and of the Virgin's clothing are minutely and realistically depicted (fig. 1.17). Only gradually do we come to see how far oversize the figure of the Virgin stands in comparison to the architecture. In the 1499 copy made for Christian de Hondt, however, it becomes clear that this depiction can be viewed as representing the donor's *vision* of the Madonna that the worshiper sees with his inner eye (fig. 1.18). Similarly, in van Eyck's *Virgin and Child with Canon Joris van der Paele*, the donor Joris van der Paele takes off his glasses to "see" the Virgin (fig. 1.7).[52] The divide between tangible and spiritual reality is even more clearly portrayed in the *Book of Hours of Mary of Burgundy* (painted 1467–80), in which precious objects—a jewel box, a perfume bottle, a jeweled rosary, rich fabrics, and a book of hours open to a scene from Christ's Passion—rest on the stone sill (plate 8). Through the arched window we see the scene "observed" by the inner eye of the devotee.[53] Indeed, Mary of Burgundy (1457–1482), heir to Charles the Bold and wife of Maximilian I, appears in her mind's eye to be present bodily at the Crucifixion. One woman in the group at lower left looks back over her shoulder out across the threshold. Through reading and observation of the images in the book of hours, the eye of the body enables her to attain an active experience of the Passion. In another of the illuminations from this

FIGURE 1.16 (*facing page*). Jan van Eyck, detail of mirror from *Portrait of Giovanni (?) Arnolfini and His Wife* (NG 186), 1434, oil on oak, National Gallery, London. Copyright Erich Lessing/Art Resource, NY. The convex mirror allows the viewer a comprehensive look at the side of the room not represented in the painting itself. Two figures and the backs of the couple are clearly reflected in the mirror's face. The two figures looking out of the mirror are witnesses to the scene. Jan van Eyck's inscription proclaiming that "Johannes de Eyck was here 1434" indicates that one of them was probably van Eyck himself. Pictured around the mirror are ten scenes from the Passion of Christ.

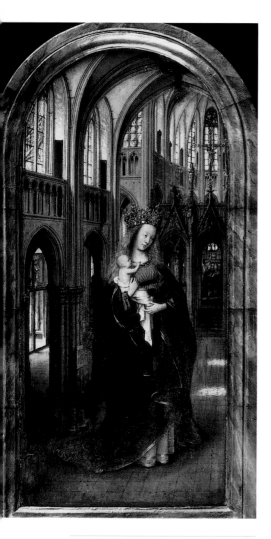

FIGURE I.17.
Jan van Eyck, *Madonna in the Church*, ca. 1425, oil on
panel, 31 x 14 cm, © 2003 Bildarchiv Preußischer
Kulturbesitz, Berlin (Gemäldegalerie). This tiny
panel exhibits depth and exquisite detail in its vi-
sion of the Virgin towering in the church.

manuscript, the reader both sits outside the frame and enters bodily into
the spiritual drama being enacted in the realm across the frame's threshold
(fig. I.19).

At first glance, it seems that through the framing of this-worldly and
otherworldly experience, these artists were trying to depict the ideas of the
late medieval mystics who attempted to gain access to spiritual knowledge
"by means of a threefold process of visionary contemplation. One began
with bodily seeing, mere physical contemplation of a pious image, itself no
more than an indicative sign of supernatural reality; one then intensified
the contemplation into a form of devout 'seeing' without a physical image,
a seeing in the mind's eye; and finally one attained an imageless devotion, a
direct apprehension of the divine."[54] However, if we consider the care lav-
ished on the depiction of the natural objects portrayed on the earthly side
of the vision, we see, as Panofsky does, that these paintings "emphasized
and glorified the earthly materiality of the picture"[55] and are more properly
regarded as part of a shift taking place in attitudes toward the use of im-
ages in devotion and, more significantly, toward bodily experience. The
kind of imageless devotion described by Saint Augustine, according to Jef-
frey Hamburger, had become mostly theoretical by 1400.[56] Aspirations to
visionary experience as a means of coming to know God became more
common among the laity from the late thirteenth and early fourteenth
centuries, and, as a result, a new use of the senses and corporeal images in
attaining visions emerged. The value of the senses in tasting "the sweetness
of spiritual delights through the likeness of bodily things"[57] was high-
lighted, and the sight of the inner eye came to be assimilated to bodily ex-
perience. In the devotional diptych that copied van Eyck's *Madonna in the
Church* and in the *Book of Hours of Mary of Burgundy*, the value of sensory per-
ception is brought to the fore at two levels. First, the importance of the
senses in attaining visions by means of the images in the book of hours—
that is, the use of the senses to obtain knowledge of the divine—and, sec-
ond, in the similarity of the visionary experience to sensory experience. For
example, in the *Book of Hours of Mary of Burgundy*, the donor's vision is de-
picted as a kind of active bodily apprehension of the divine mediated
through the senses, indicated both by the material objects in the liminal
space between the viewer and her divine vision and by the very fact of the
laborious care lavished on the physical object of devotion, the book of

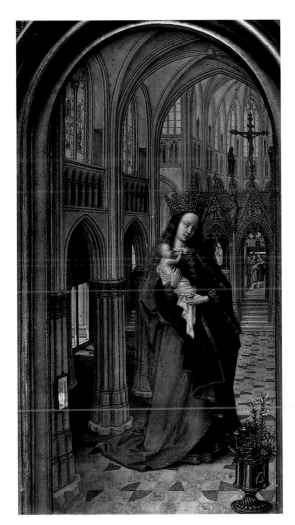 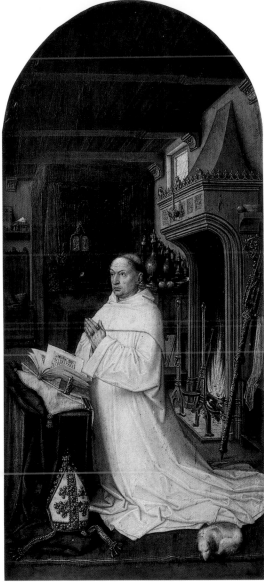

hours itself. Second, the painter appeared to regard as self-evident his ability to repre-sent the visionary experience on the far side of the frame as naturalistically as the care-fully rendered objects of art and nature on this side of the frame; the naturalism of his art is adequate to describe the visionary experience.[58] At both levels, the role of the painter is crucial, for he creates the devotional objects that guide the beholder's path to a higher knowledge and he represents the elements of that higher knowledge. In both, the painter's naturalistic representation conveys the potential of sensory experi-ence for attaining knowledge and argues for the power that lies in seeing and repre-

FIGURES 1.18A + 1.18B.
Anonymous copy of Jan van Eyck's *Madonna in the Church*. Diptych made for Christian de Hondt, 1499, oil on panel, Koninklijk Museum voor Schone Kun-sten Antwerpen. Christian de Hondt commissioned this copy of van Eyck's *Madonna in the Church*. It shows him kneel-ing before a vision of the Virgin, the view of his spiritual eye made visible in the copy of van Eyck's panel painting.

FIGURE 1.19.
Anonymous, *Book of Hours of
Mary of Burgundy*, 1477, Cod.
1857, fol. 14v., Österreichische
Nationalbibliothek, Wien.
Photo: Bildarchiv, ÖNB, Wien.
The devotee reading her book
of hours is represented as ac-
tively worshiping by means of
objects—the book of hours it-
self, the jeweled rosary, and the
vase of irises, symbol of Mary's
sorrow—on the temporal side
of the window's frame. On the
far side of the window, she has
been transported bodily
through the vision of her inner
eye into a church where she is
being received by Mary. By
employing her senses, the wor-
shiper can attain active appre-
hension of sacred doctrine.

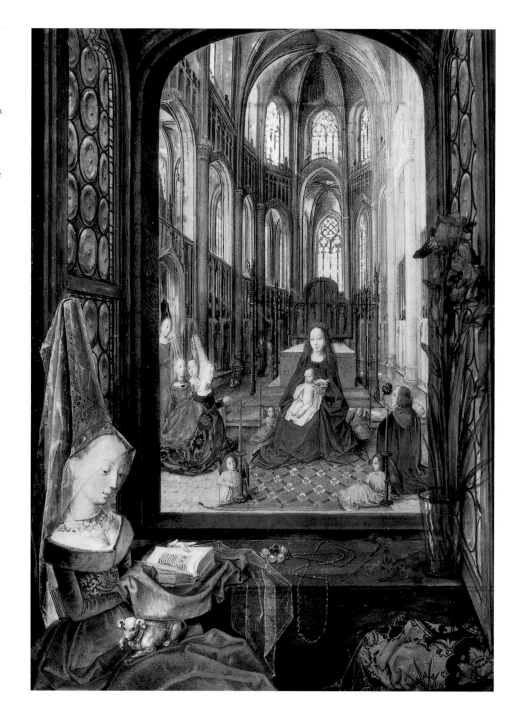

senting. This is just one way in which fifteenth-century Flemish painters communicated with and implicated their viewers in "the experience of their images in a new way,"[59] thereby making new claims for the significance and function of their art.

The right panel from Robert Campin's *The Annunciation Triptych* (*Mérode Altarpiece*) (ca. 1425) expresses this new artisanal self-consciousness and some of its claims (fig. 1.20). Joseph the carpenter is shown at work, surrounded by his tools, in a workshop that looks out onto a lively Flemish commercial scene (plate 9). As in Campin's other paintings, the elements of carpentry and joinery are rendered with exquisite attention to detail. For example, in Campin's *Worship of the Shepherds* (fig. 1.21), the lath emerging out of the disintegrating wall shows attention to the actual method of construction, and the supports of the structure are depicted as if salvaged from a previous use.[60] Such particular and specific details enhance the realism of this religious scene, but they also indicate a view of the profound significance of craft and handwork. In the *Mérode Altarpiece*, Joseph in his workshop employs all the tools of the carpenter. This painting imbues Joseph the carpenter, the father of Jesus, with the "modest dignity of a good craftsman and breadwinner."[61] The depiction of Joseph as a dignified individual had first appeared in Netherlandish manuscript illuminations in the late fourteenth century; before this he had been portrayed as a pathetic and marginal figure, ridiculous and impotent. Campin gave Joseph not just a quiet dignity, but portrayed him in an artisanal setting for the first time. In Campin's painting, Joseph as craftsman has come to occupy a central role in the drama of salvation. Artisanship is here portrayed as part of the redemption of nature. After the Fall, humans had to labor in the sweat of their faces in order to produce by *art* the things of nature they would have enjoyed without toil in Paradise. Art was thus a distinctively human work, placed firmly by Robert Campin in this painting at the center of the story of salvation, with all that this implied about the artisan's ability to know and to redeem nature.[62]

Mirroring Nature

As noted above, the first generation of Flemish artists claimed to be able to mirror nature, but by examining another of Jan van Eyck's paintings, a much deeper significance than simply holding a mirror up to nature can be given to this ideal. In his *Portrait of the Goldsmith Jan de Leeuw* (1436), van Eyck inscribed in the frame a verse that played on the notion of the painter imitating the act of Creation in his work. He noted the birth date of the goldsmith and the starting date of his painting: "Jan de Leeuw on St.

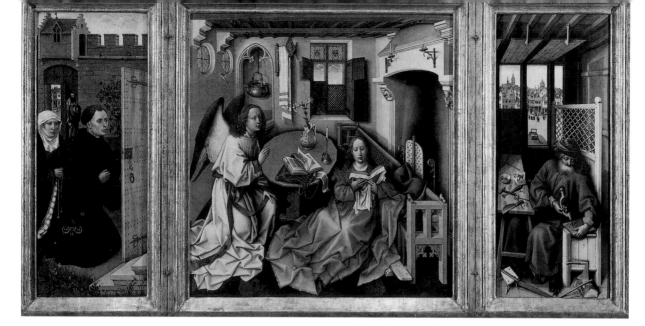

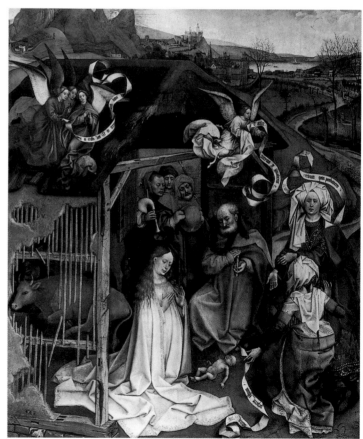

FIGURE 1.20.
Robert Campin, *The Annuncia-
tion Triptych* (*Mérode Altarpiece*),
ca. 1425–30, oil on wood,
central panel: 64.1 × 63.2 cm,
each wing: 64.5 × 27.3 cm,
The Metropolitan Museum
of Art, The Cloisters Collec-
tion, 1956. (56.70). The cen-
tral panel of this small altar-
piece depicts the Annunci-
ation. Mary sits on the
ground in an attitude of hu-
mility and has yet to notice
the angel Gabriel. The left
panel depicts Peter Engel-
brecht, patron of the altar-
piece. His wife and the mes-
senger leaning against the
gate in the background were
added later, perhaps after
their marriage. The Engel-
brecht coat of arms adorns
the left window in the central
panel. The right panel shows
Joseph working at his bench,
as if in a room adjoining that
where the sacred drama of
the Annunciation is in
progress.

FIGURE 1.21.
Robert Campin, *Worship of the
Shepherds*, ca. 1420, oil on
wood, 86 × 72 cm, © Musée
des Beaux-Arts de Dijon. In
this depiction of the Nativity,
Campin gave much care to
the authentic representation
of details of construction.
The broken fragments of lath
emerge from the disintegrat-
ing wall, as do the wooden
shingles from below the
sparse and patchy thatch. The
central supports of the stable
are salvaged from a prior use,
indicating Campin's artisanal
observation as well as signify-
ing the birth of Jesus as the
transition from the old law of
the Jews to the new law of
the Christian era.

Ursula's Day / saw the light of the world with his eyes 1401 / Jan van Eyck portrayed me now / it is well known when he began 1436" (fig. 1.22). Hans Belting and Christiane Kruse have pointed out the novelty of inscribing the date of commencement rather than of completion. They believe van Eyck was asking the observer to compare the origin of the person by the Creator to the origin of the work by the painter and to understand the painter as imitating Creation.[63] Van Eyck's mirroring of nature was an imitation that was reconstructive and creative. As Panofsky states, "A picture by Jan van Eyck claims to be more than 'just a painting.' It claims to be both a real object—and a precious object at that—and a reconstruction rather than a mere representation of the visible world. . . . [Van Eyck] builds his world out of his pigments as nature builds hers out of primary matter. The paint that renders skin, or fur, or even the stubble on an imperfectly shaved face seems to assume the very character of what it depicts."[64]

This kind of imitation carries further meaning. From the start of Flemish naturalism, the painters' efforts to render precise and detailed representations of nature and of reality were viewed by their contemporaries as a striving after exact replication of nature, not just as it appears to the human eye, but also as the source of generation and production, comprising a kind of double imitation of nature. In Alain Chartier's (ca. 1385–ca. 1433) poem *Le Livre des quatre dames*, we find a portrayal of the way painting and nature replicate each other:

> I saw the trees blossom, / And hares and rabbits run. / Everything rejoiced at the Spring. / Amour seemed to hold sway there. / None could age or die, / It seemed to me, so long as he was there. / From the grass rose a sweet smell, / Which the clear air made sweeter still, / And purling through the valley / A little brook passed / Moistening the lands / Of which the water was not salty. / There drank the little birds / After they had fed upon crickets, / Little flies and butterflies. / I saw there lanners, hawks, and merlins, / And flies with a sting / Who made pavilions of fine honey / In the trees by measure. / In another part was the enclosure / Of a charming meadow, where nature / Strewed flowers on the

FIGURE 1.22.
Jan van Eyck, *Portrait of the Goldsmith Jan de Leeuw*, 1436, oil on panel, 33.3 × 27.5 cm, Kunsthistorisches Museum, Vienna. Jan de Leeuw, a goldsmith active in the Bruges goldsmith guild, holds a ring, emblem of his vocation or a reference to his approaching marriage, over the threshold of the painting while he gazes out at the viewer. Around the frame van Eyck inscribed "Jan de Leeuw on St. Ursula's Day / saw the light of the world with his eyes 1401 / Jan van Eyck portrayed me now / it is well known when he began 1436."

verdure / White, yellow, red, and violet. / It was encircled by blossoming trees / As white as if pure snow / Covered them, it looked like a painting, / So many various colors were there.[65]

Similarly, the oldest description of the *Ghent Altarpiece* from 1495 comments, "And all this is painted with such wondrous ingenuity and skill that you would suppose this to be, not merely a painting, but the whole art of painting."[66] But it is in the very first description of a Flemish painting (probably of a work by Rogier van der Weyden) by Cyriacus of Ancona in 1449 that the processes of art and those of nature are most clearly seen as identical:

> All this is admirably depicted with what I would call divine rather than human art. There you could see those faces come alive and breathe which [the painter] wanted to show as living, and likewise the deceased as dead, and in particular, many garments, multicolored soldier's cloaks, clothes prodigiously enhanced by purple and gold, blooming meadows, flowers, trees, leafy and shady hills, ornate halls and porticoes, gold really resembling gold, pearls, precious stones, and everything else you would think to have been produced, not by the artifice of human hands but by all-bearing nature herself.[67]

"All-bearing nature" was regarded as prolific and copious, imbued with a creative force that might be imitated by art. Although the idea of art imitating nature or God's Creation (*ars imitatur naturam*) goes back to antiquity,[68] it could mean more than just producing a mirrorlike image of created nature. Imitating nature could mean knowing not just how to mirror nature but could also mean imitating, reproducing, or harnessing the creative power of nature itself. As we have seen, the Flemish artisans asserted their ability to reproduce created nature (*natura naturata*) through their emphasis on the mirroring power of their art, but van Eyck also signaled his ability to imitate the creative power of nature itself (*natura naturans*).[69] He perhaps also went so far as to claim an understanding of the generative processes by which nature produces. In the *Ghent Altarpiece* of the van Eyck brothers, the fountain of life clearly possesses a spiritual dimension, ultimately deriving from the source of waters and flowing rivers described in the Garden of Eden (Genesis 2) (plate 10). But it also possessed material meaning for early modern people, for a vivifying principle was disseminated throughout nature; it fell with the rain and penetrated the earth with the sun's rays, causing all things to grow and flourish. Minerals and metals grew in the earth, just as insects and reptiles were generated out of mud and rotting materials. Leonardo da Vinci would write of a

"spirit of growth" that permeated all of nature.[70] Even artistic creativity itself could be understood as a fluid dispensed by the heavens; artists repeatedly characterized artistic talent as a fluid endowed by *natura generans* (creative nature).[71] The essence vivifying all of nature was a central tenet of Neoplatonism and Hermeticism but had existed throughout the Middle Ages in popular pantheism and in alchemical texts. In alchemical theory and practice, the conception of nature as an active creative force, and of *ars* as able to imitate the natural processes of creation and generation, had long predated the arrival of the Hermetic corpus.[72] Leonardo da Vinci would come to regard artistic creation as part of the natural order, and the artist's imitation of nature as "an active ability to remake natural effects in the work of art through a deep understanding of natural causes."[73] This idea of the artist mirroring or imitating the processes of nature through his knowledge of natural materials, articulated in texts by later artists such as da Vinci, was contained in germinal form in the paintings of Jan van Eyck.

Out of a remarkable consciousness of their own skill as artisans, the first generation of Flemish panel painters claimed special abilities to observe and represent the things of nature. They not only asserted their own powers of observation and claimed knowledge and authority based on those powers, but they also made claims about the power of sensory apprehension more generally: the objects of nature perceived by the senses and human engagement with those objects—artisanship—could lead to profound knowledge and redemption. Artisans in the later fifteenth and sixteenth centuries would build on this self-consciousness and these claims to begin to articulate in words a view of themselves as knowers of nature.

PART TWO

‡‡‡

SOUTH GERMAN CITIES

Artisanal Epistemology

By means of their art, the first generation of Flemish painters claimed to be central actors in human society. They claimed to imitate and know nature. In the late fifteenth and sixteenth centuries, their techniques of observation, their naturalism, and their artisanal self-consciousness traveled down the Rhine to the southern reaches of the Holy Roman Empire of the German Nation. In the lively commercial centers of the free imperial cities, where craftspeople had a clear view of their own economic and social power, artisans began to express their belief that their experiential knowledge was as certain as deductive knowledge. They articulated ideas about the pursuit of natural knowledge—an epistemology—as well as theories about the operations of nature and of their own imitation of nature by art more fully, and in written form, than the painted declarations of the Flemish panel painters. As in the work of the Flemish painters, these sixteenth-century artisans employed naturalism as a means of articulating their claims, but these claims were now embedded in a more fully developed philosophy that was articulated in texts as well as works of art. Nuremberg artisans like Albrecht Dürer and Wenzel Jamnitzer claimed that nature is the primary source of knowledge, that certain knowledge can be extracted by engaging with nature, and that this engagement takes place through a bodily encounter with matter. The medical and religious reformer Paracelsus took up this artisanal epistemology and incorporated it

into his philosophical reform. This chapter and the next will examine the development and articulation of this artisanal relationship with nature, first in the work of artisans and then in the writings of Paracelsus.

South German Naturalism

Martin Schongauer (ca. 1450–1491), the great engraver and painter of Colmar, brought Flemish particularism and naturalism to the Rhine. Schongauer's father was an Augsburg goldsmith who settled in Colmar in about 1445 and headed a workshop in which Martin and his four brothers were trained and then continued to work. Schongauer probably traveled in Flanders, where he became especially familiar with the work of Rogier van der Weyden. Schongauer's engravings show an intense attention to detail employed in the service of a new painterly illusionism and naturalism, such as in the remarkably meticulous engraving of a church censer (fig. 2.1). And his paintings evidence a close and sensitive observation of nature, achieved by preparatory nature studies such as that of peonies (plate 11). His depiction of objects manufactured by handwork points to the artisanal consciousness of the Flemish panel painters, and his study of peonies indicates Flemish workshop methods of observing nature.[1] Schongauer's background as a goldsmith probably turned his focus naturally to engraving, for the technique of engraving had emerged out of the practices of goldsmiths, and he began to make engravings unlike any seen before. Schongauer had a clear consciousness of the commercial possibilities of engravings; his plates are deeply incised, making them able to stand up to many printings.[2] Moreover, his prints have complex compositions and he strove for a high degree of naturalism. His prints were disseminated more widely than his paintings (for which he was also well known), and they spread his fame and his name, quite literally, for he employed a monogram of his initials, in the form of a goldsmith's mark, on his engravings. Monograms like that of Schongauer, and Dürer after him, emerged in the context of engravings and imitated the mark of goldsmiths that had indicated maker and guaranteed precious metal content since the Middle Ages.[3] Schongauer was among the very first engravers to mark his prints with his initials, and in doing so, he indicated a strong awareness of his own creative work.[4]

In 1492 Albrecht Dürer (1471–1528) sought Schongauer out in Colmar, but by the time Dürer arrived, Schongauer had died. Schongauer's brothers passed on some of Schongauer's study sheets to Dürer, however, and Dürer's engravings and nature

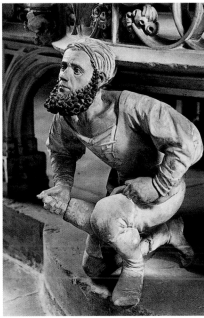

studies, such as that of *The Great Piece of Turf* (plate 12), in turn, would become avidly sought after in his own lifetime and in the later sixteenth and early seventeenth centuries. Dürer's art would form a founding moment for nature studies in Europe and for art making in the north. In the power of his observation of nature, Dürer was building on the workshop methods of Schongauer and ultimately the Flemish panel painters. But three additional factors in early-sixteenth-century Germany are important to an understanding of Dürer's naturalism: the patronage of the Holy Roman Emperor Maximilian I (ruled 1493–1519), the particular character of German humanism, and the fertile urban culture of the southern German towns, such as Dürer's hometown of Nuremberg, filled with economically powerful and self-conscious artisans. The pride and self-awareness of just one of these artisans can be seen in the sculptor Adam Kraft's remarkable life-size self-portrait that he placed as the foundation of the Tabernacle in the St. Lorenz Church in Nuremberg (fig. 2.2).[5] In these cities a lively exchange between printers, humanist scholars, and artist/artisans took place.[6] Scholars and artisans of all types—including wood carvers, glass painters, engravers, and panel painters—collaborated on numerous projects. One such project was the *Weltchronik* (1493), for which the publisher Anton Koberger put into place a complex team of financiers, the author Hartmann Schedel, block cutters, and painters, in-

cluding Albrecht Dürer's teacher Michael Wohlgemuth (1434–1519), among others, to design the thousands of woodcut illustrations in it.[7]

Maximilian I

Maximilian's ascension to the imperial throne in 1493 marks a new era in the history of the Holy Roman Empire. Maximilian established an idea of the empire (*Reichsidee*) that would have profound reverberations down through the following centuries. He implemented this idea in the declaration of Pax Imperialis, which outlawed private feuds between the noble houses of the empire, and by the reorganization of the empire's governing structures. He founded a *Reichskammergericht* (Imperial Cameral Tribunal) at the diet in 1495 to settle conflicts among the German nobility (to make it possible to enforce the Imperial Peace), and he organized the empire into districts (*Kreise*) for the collection of taxes to support the tribunal and to mount an imperial army. He attempted to unite the German Estates against the rising force of the Ottoman Empire. In addition, he sought to restructure the bases of the emperor's power within the empire, looking toward the citizens of burgeoning imperial cities rich with international trade, such as Nuremberg, rather than exclusively toward his German Estates. He also founded the cult of the imperial ancestors, which created the mythos of the Habsburg dynasty and which would eventually result in the image of "Pietas Austriaca," giving the house of Habsburg its sense of destiny and, to a large extent, its power to rule (because the house lacked real, centralized power and force of arms). Through Maximilian's efforts, his grandson Charles I, king of Spain, would become emperor, not only giving the Habsburgs vast resources, but also solidifying both the autocratic centrality of the emperor and the hereditary position of the Habsburgs in the empire. Maximilian's renovation of the Order of the Golden Fleece, founded by the duke of Burgundy, Philip the Good, epitomizes the way he sought to create a culture similar to and, in many cases, directly imitative of the Burgundian theater of state.[8] Making use of new technologies, such as the printing press, woodcut, and engraving, Maximilian employed all the leading artisans and humanists of the German territories to create this culture. For example, his *Prayer-Book* (1513), in direct imitation of the sumptuously illuminated (manuscript) Burgundian books of hours, was *printed* to resemble a manuscript, and all the leading painters of the empire were commissioned to produce designs for the woodcuts. Maximilian was thereby able to print multiple copies of a presentation book of hours.[9] In projects such as these, he was instrumental in promoting and carrying on the discourse about the relationship between

art and nature that had been central to cultural production in Flanders under the Burgundians.

Descriptions of Nature: German Humanism

The place of Germany and the Germans in the classical world gave sixteenth-century German humanism its peculiar form. Although the humanist strivings of German scholars to re-create and imitate the ancient world might have been similar to those of their southern counterparts, they were faced with a strikingly meager picture of the ancient German world in the classical sources in comparison with that which existed for other parts of Europe. The ancient record of Germany was scanty and circumscribed largely by what could be found in the texts of the ancient geographers Ptolemy (fl. 130 C.E.) and Strabo (ca. 64 B.C.E.–after 23 C.E.), whose works were translated into Latin in the early fifteenth century before being printed at the end of the century, first in Latin and then, in the sixteenth century, in Greek. Ptolemy described Germany as being bounded on the west by the Rhine, on the east "by a space which is between [a bend in the river Arabon] and the Sarmatian mountains," on the south by the Danube, and on the north by the Germanic ocean.[10] Strabo's books filled out this bare picture somewhat, as did those of Tacitus (ca. 56–120 C.E.), the most informative ancient source on the lands of the Germans. Tacitus's *Germania* was rediscovered circa 1429 in a German monastery and circulated in manuscript until it was printed in Venice in 1470 and in Nuremberg in 1473. The humanist Pope Pius II, Aeneas Silvius Piccolomini, was the first to employ Tacitus to describe the Germans in an open letter written in 1458 and printed in 1496 under the title *Germania*.[11] The portrait of the physical and social landscape that Tacitus drew of Germany was not a happy one:

> Who . . . would have left Asia or Africa or Italy to look for Germany? With its wild scenery and harsh climate it is pleasant neither to live in nor look upon unless it be one's home. (ii) . . . a land of bristling forests and unhealthy marshes. (v)

> . . . You will not so readily persuade [the Germans] to plough the land and wait for the year's returns as to challenge the enemy and earn wounds. (xiv)[12]

Piccolomini exploited this picture of Germany and Tacitus's depiction of the Germans as savages—sometimes noble savages but leading brutish lives, all the same—to show the Germans how their lot had improved since the advent of the universal Christian

Church. As tensions increased between the papacy and the German lands in the following generations, Albert Krantz would call for Italy to "give back to us the entire History of Tacitus which they have hidden away . . . let them return Pliny's twenty books on Germany."[13] In immediate response to Piccolomini, however, German humanists put forth a veritable flood of works of history and geography to show the vigorous and creative nature of their own wild land that had, for example, resulted in the thriving metropolis and trading center of Nuremberg.

Only history and geography could link Tacitus's ancient picture of Germany to the manifestly different world of the humanists' contemporary Germany. A description of places and a comparison with ancient sources could demonstrate that the flourishing towns of Germany were once Roman encampments, while a comprehensive history of the Germans could show how the indigenous Germans described by Tacitus fit into Christian history.[14] A history of Germany after the fall of the Roman Empire was needed to show how the imperial power of Rome had devolved first on Charlemagne and then by direct descent to the German kings and emperors. A new geography would clarify what the boundaries of Germany extended by imperial power actually encompassed.[15] Only these descriptive disciplines could show how Germany fit into the classical world, how modern Germany was related to that classical past, and what lessons the German as well as the Roman imperial past might hold for the German territories of their own day.

The place of geography in the German humanist project tells us much about the relationship of northern Europe to nature. Scholars drew upon two distinct, ancient models of geography in the Renaissance, both in Italy and Germany: the mathematical science of Ptolemy and the descriptive practical science of Strabo. The latter—in its emphasis on the active life, practical wisdom, and the utility of geography—proved attractive to humanists, although Ptolemy's lists identifying the positions of places helped them to discover the ancient locations of regions and towns. Humanists followed Strabo's advice to concentrate first on civilized, urban places; their main concern being to link ancient to modern in these places. To some extent, they followed the model set by the Italian humanist and geographer Flavio Biondo (1392–1463), who identified the sites of the ancient streets, squares, and buildings of Rome in *Roma instaurata*. In *Italia illustrata*, he attempted to recover the "lost" regions and cities of Italy, those places of which the founders and origins had fallen from memory in the barbaric times past. In *Roma triumphans*, he asserted the connection between ancient Rome and the Rome of his day: the consul had become pope and the *magister militum*, the emperor. Biondo drew out the threads emanating out from Rome that had bound Europe in the

glorious Roman past and along which he believed Rome continued to bring civiliza-tion to Europe.[16]

The German scholar Conradus Celtis (1459–1508), determined to pursue the same sort of work of resuscitation for Germany and to respond to Pope Pius II's ac-cusations, shepherded Tacitus through the presses of Nuremberg in 1473 and then had it reprinted in 1500 when he appended to it a part of his own work on Nuremberg, *De origine, situ, moribus et institutis Norimbergae libellus*. Following in the footsteps of Flavio Biondo, Celtis planned a "Germania illustrata." He envisioned the work as a monu-mental project involving many other scholars, each contributing a section on his own region, and he began by publishing his own now-completed history and description of Nuremberg in 1502. After Celtis's death in 1508, individuals such as Johannes Aventi-nus, Beatus Rhenanus, and others joined in this project; however, like so many other projects started by these ambitious scholars, it was never completed. It did spur a number of individual geographies and histories into publication, however, including Dürer's friend Willibald Pirkheimer's *Germaniae explicatio* of 1530.[17] Although it was never completed, Celtis's project gives insight into the attempt among German schol-ars around 1500 to link the manifestly new appearance of the German Empire to the classical world. For the German humanists, geography and history involved not only the reading and annotating of ancient works (in order to form an accurate picture of the ancient world) but an active investigation of their contemporary environment. They left their libraries to collect topographical data on their surroundings, and they searched city archives and the papers of local nobility in order to assemble chronicles of historical events.[18] This descriptive work would take on an increasingly visual form as the woodcut cityscapes of the *Weltchronik* (1493) were followed by mapping projects in various territories.[19] Nuremberg became a center of map- and globe making, and it was largely due to the map publisher Johann Schöner that Copernicus's *De revolutionibis* was given to a Nuremberg printer to publish in 1543.[20] For the citizens of Nuremberg, these mapping projects had immediate practical interest. In 1505 the Nuremberg fam-ilies of Imhof and Hirschfogel were the first to answer the Portuguese call for foreign capital to explore the New World.[21]

Mapmaking was closely associated with another Nuremberg specialty, the pro-duction of astronomical instruments. The best-known astronomer of Europe, Johann Regiomontanus (1436–1476), made Nuremberg his home, as he remarked around 1471, "because I can easily procure here all necessary instruments, particularly those which are indispensable for the study of astronomy, and also because I can easily keep up a connection with scholars of all countries from here, for this city, on account of its

concourse of merchants, may be considered the central point of Europe."[22] Instrument making in Nuremberg, along with mapmaking, timepiece manufacture, surveying, and bookkeeping, made use of practical mathematics, which reached a highpoint in Nuremberg.

German humanist projects thus involved a mix of German particularism, attention to the descriptive disciplines of history and geography, and the mechanical arts. They also typically took place in an environment marked both by noble desires and by market forces. Among the latter, an important component was the printing press, key to these humanist projects. Nuremberg already had several printers operating by the early 1470s; the foremost among them, Anton Koberger, was publishing Latin editions of the Vulgate, some with woodcuts from 1475.[23] Printing furthered a new kind of vernacular literature that experienced wide and rapid dissemination and purported to make available "the secrets of nature." From the 1480s, some of the most frequently reprinted books off the new printing presses were vernacular medical treatises and books of secrets (including medical and craft recipes). The foremost publisher of vernacular translations and popularizer of German technical treatises and books of secrets was Walther Hermann Ryff (ca. 1500–1548), or, as he Latinized his name, Gualterius Rivius, who published forty-three books between 1538 and 1548 alone. Trained as an apothecary and working out of Strasbourg, he published translations of Vitruvius's *De architectura* (Nuremberg, 1548) as well as numerous vernacular books of secrets and medical treatises.[24] The dissemination in print of humanist editions of ancient authors and vernacular books of secrets was instrumental in the exchange that took place between scholars and artisans.

The Parisian pedagogical reformer Petrus Ramus (1515–1572) believed that a way to unify theory and practice could be drawn out of the mix of practical mathematics and artisanal activity going on in Nuremberg.[25] He visited the workshops of artisans in Nuremberg for four days (he said he wished it had been four years) in 1568, perhaps following the advice of Juan Luis Vives (1492–1540), who remarked in 1531 that scholars should not "be ashamed to enter into shops and factories, and to ask questions from craftsmen, and to get to know about the details of their work."[26] When living in the southern Netherlands, Vives also advised his students to imitate the example of the fifteenth-century Louvain scholar Carolus Virulus, who sought out the fathers of his students in order to learn from them about their trades.[27] In 1538 Vives published a Latin exercise book in which one of the twenty-five dialogues features Albrecht Dürer besting two learned pedants who busied themselves with analyzing his portrait of Scipio. In this fictional dialogue, one of the scholars, Velius, notes that

Dürer covered the top of Scipio's head with "many and straight hairs when the top is called *vertex*, as if a vortex, from the curling round of the hair, as we see in rivers when the water rolls round and round (convolvit)." Dürer answers, "Stupidly spoken; you don't reflect that it is badly combed." This parrying between the wordy scholars and the plain-speaking painter goes on until Dürer insists they leave; the scholars protest that he should let them write a distich whereby the picture would be more easily sold. Dürer responds that his art is about things not words: "My art has no need of your commendation. Skilled buyers who understand pictures do not buy verses but works of art."[28] Vives's textbook went through at least two hundred editions, and it indicates a new attitude toward artisans and their works, as it also helped disseminate these attitudes to the schoolboys who used it.

The result, in turn, of Ramus's visits to the workshops would be an enormously influential new method of "natural" or "practical" reasoning.[29] Scholars began to take an interest in *ars* as the source of civic prosperity and because powerful highly self-conscious artisans began to articulate their art making and their capacity to transform nature. Out of this interaction between artisans and humanists in cities like Nuremberg, new ideas about how to obtain knowledge of nature emerged.

Albrecht Dürer

Dürer is the exemplar par excellence of the effects of the exchange between artist/artisans and humanists. As an artisan intensely concerned with articulating—both visually and textually—his knowledge and mode of working, Dürer's whole life exhibits the nexus of forces present in Nuremberg at the height of its power. He was both a free citizen of a free imperial city (although not of the status that gave him a seat on the governing council) and client of the emperor; he turned from painting on commission to the freedom and profit of engravings printed on his own printing press and sold on the market (or given as gifts to important patrons).[30] Throughout his life, Dürer was a part of humanist circles, becoming particularly intimate with Willibald Pirkheimer, and his scholar friends translated classical authors into German for him. Dürer's intense self-awareness is indicated above all by his well-known self-portraits, but also, like Schongauer, in his use of a monogram. Conscious of its intellectual and economic worth, he employed the A. D. monogram on almost all his works, including drawings, self-consciously creating a signed and dated retrospective record of his artistic development. Dürer's monogram, like that of Schongauer before him, referred to

the authenticating mark of goldsmiths.[31] Like many of the other artisans examined here, Dürer's father was a goldsmith, and as a boy, Dürer was apprenticed first to his father in goldsmithing and then to the painter Michael Wohlgemuth from 1486 to 1490.[32] In 1490 he set off on his *Wanderjahre*, traveling first to Schongauer's workshop in Colmar. Upon learning of Schongauer's death, however, Dürer moved on to Basel, Strasbourg, and, in 1494, back to Nuremberg, where he married Agnes Frey (ca. 1475–1539), the daughter of a successful Nuremberg metalworker. Before the year was out, he set off for Venice again, returning to Nuremberg in a little less than a year. On his return, he bought his own printing press and put out a book of his woodcuts, *The Apocalypse* (1496–98), the first book designed and published by an artisan completely on his own undertaking.[33] He subsequently made journeys to Venice, Bologna, and Padua in 1505–7 and to the Netherlands in 1520 upon Maximilian I's death in order to petition for a renewal of his annual hundred-guilder imperial pension from Maximilian's successor, Charles V. Other than these travels, Dürer resided as an honored and wealthy citizen in Nuremberg until his death in 1528.

Dürer manifested extraordinary skill and ambition throughout his life, coming to see himself as a new kind of artist, described in his epochal statement of artisanal self-consciousness of 1525:

> Only the powerful artists will be able to understand this strange speech, that I speak the truth: one man may sketch something with his pen on half a sheet of paper in one day, or may cut it into a tiny piece of wood with his little iron, and it turns out to be better and more artistic than another's big work at which its author labors with the utmost diligence for a whole year. And this gift is miraculous [wunderlich]. For God often gives the ability to learn and the insight to make something good to one man the like of whom nobody is found in his own days, and nobody has lived before him for a long time, and nobody comes after him very soon.[34]

From an early age, Dürer showed interest in the processes of his own art making, in nature, and in the relationship between the two.[35] His first self-portrait dates from 1484, when he was only thirteen years of age, finished finely in silverpoint, a notoriously difficult technique. Joseph Leo Koerner has commented that Dürer's early self-portraits are more like "embodiments of the work of seeing" than self-portraits per se.[36] Such bodily work of seeing and observation is especially clear in Dürer's study of his own face when he was twenty (fig. 2.3). The drawing records Dürer's observation of the interaction of hand and cheek, probably as a study for Joseph leaning on his

hand in a pen-and-ink drawing of the holy family finished in the following year or so (fig. 2.4).[37] In his self-portrait at age twenty-two, Dürer makes a connection between the eyes and hands of the artist and the object depicted, suggesting again his own work of observing and representing (fig. 2.5). Koerner argues that Dürer radically reformulated what it meant to make art in early modern Europe, articulating a new idea about the status and mission of the individual artist and asserting that art is an image of its maker.[38] Dürer was not just interested in the processes of his art making, however, but also in the source of those processes—nature. He began the observation and study of nature in the same period as his first self-portraits, in the early 1490s. He first painted landscapes he had observed from life (fig. 2.6), and from the 1490s to the first decade and a half of 1500, produced exquisitely wrought animal and nature studies (plate 12, figs. 2.7, 2.8).[39]

After his trips to Italy in the early 1500s, Dürer's work turned in a new direction, as he attempted to integrate antique classical principles into his northern particularism, and as he became progressively more focused on engraving. Historians have dated this change to the moment at which Dürer saw two nudes, male and female, portrayed using geometrical methods by the Venetian painter Jacopo de' Barbari (1440–1516). After seeing these, Dürer burned with a desire to discover the methods of perspective construction and the secret of human proportions, and he pursued this work for the remainder of his life. Despite his contact with the universal ideals of Italian art theorists such as Alberti and his interest in mathematical perspective, Dürer remained fascinated with the particular. He began to study human proportion around 1500, the same time that he "became all the more deeply engrossed in the minute details and individual differences of God's Creation" and produced the most spectacular and important of his self-portraits.[40] Around 1500 he also began reading Vitruvius, and in 1517–18 he was employed by a Nuremberg order of the Clarissas to evaluate the reconstruction of their convent church's roof. He began a work on architecture, *Etliche Underricht zu Befestigung der Stett, Schloss und Flecken*, which was, however, never published. Like so many other ambitious artisans, Dürer turned to architecture because he saw it as a means to redefine his practice as craftsman.[41]

In about 1512 Dürer began to formulate a theoretical articulation of his artisanal experience. He began by composing a book for painters' apprentices, the "Speis der Malerknaben," which eventually became the *Underweysung der Messung* (*Lesson in Measurement*), first published in 1525 (revised, 1538; first Latin edition, 1532). His two works, *Underweysung* and *Vier Bücher von menschlicher Proportion* (*Four Books on Human Proportion*; published posthumously in 1528), are remarkable for their attempt to combine, as he

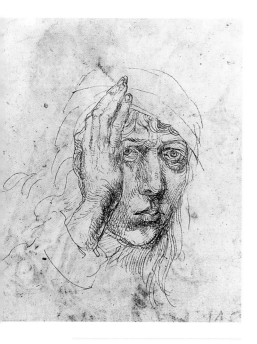

FIGURE 2.3.

Albrecht Dürer, *Self-Portrait*, ca. 1491, pen
and dark brown ink, 20.4 × 20.8 cm, Univer-
sitätsbibliothek Erlangen-Nürnberg. Judging
by the position of the hand, this self-portrait
of Dürer at age twenty is probably a study for
his later depiction of Joseph in one of his
drawings of the holy family (fig. 2.4). Dürer
has depicted himself with his hand pressed
against his cheek. The hand and the face are
the only fully realized portions of the drawing;
the remainder of the details—his cap, hair,
shirtsleeve—are faint sketches.

FIGURE 2.4.

Albrecht Dürer, *Holy Family*, ca. 1492–93,
pen and ink, 29 × 21.4 cm, © 2003 Bildarchiv
Preußischer Kulturbesitz, Berlin (Kupfer-
stichkabinett). In this drawing depicting the
holy family in a landscape, Mary is seated in
the center with the Christ child in her lap.
Joseph is seated on the ground, partially ob-
scured by the bench and Mary's robe, leaning
his cheek on his hand. Dürer's self-portrait of
1491 may have formed a study drawing for
Joseph's hand position.

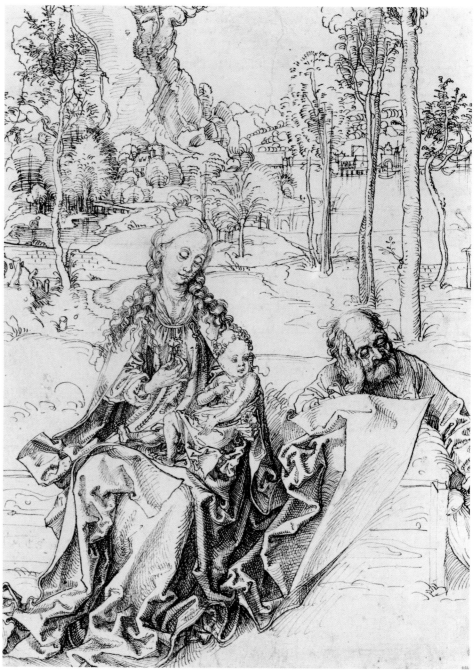

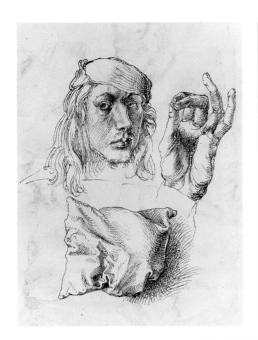

FIGURE 2.6.
Albrecht Dürer, *Alpine Landscape*, 1495, pen on paper, 21 × 31.2 cm, Ashmolean Museum, Oxford. This scene, one of Dürer's impressive landscape studies, depicts a prospect in the Italian Alps and was probably created on his way home to Nuremberg after his brief stay in Italy in 1494 and 1495. Some of Dürer's landscapes depict identifiable locations.

put it, "Kunst" (meaning art informed by "intellectual understanding"—note that he did not call it "Theoria") and "Brauch" (practical skill). For Dürer, "Brauch" without "Kunst" was a "deception" or a "prison" (confined and without light), while "art" without practice could not "grow" and would "remain hidden." The result of a union of "Kunst" and "Brauch" was to be the production of visible and tangible effects, in other words, works of art. For Dürer, such works proved the artist's "Gewalt," or power.[42]

In the *Underweysung*, he struggled to find an adequate language to express abstract mathematical concepts in German and ended up using "the graphic expressions which had been handed down from generation to generation of artisans," such as *Fischblase* (fish bladder) and *der neue Mondschein* (the crescent moon) for the sicklelike figures resulting from the intersection of two circles.[43] Dürer asked Willibald Pirkheimer and other learned friends for help in composing the prefaces to his books, but the results were not satisfactory to Dürer.[44] In its techniques and proofs, the *Underweysung der Messung* drew from Ptolemy, Euclid, Piero della Francesca, various German mathematical tracts, and the traditional practices of builders. Dürer's stated aim in this work was to "show the inner understanding by external work." For example, he makes clear that although he knows from Euclid that a point and line have no "size, length, width, or thickness" and in fact are "invisible," he will represent them and everything he describes in images in order that the students of building, painting, and the other arts will "see an image before their eyes and apprehend [begreiffen] it better."[45] Through this book, Dürer wished to convey the methods of perspective construction and the idea of demonstrative knowledge in geometry to his fellow German artisans, but he did not hesitate to note that some practices, such as that of constructing nine-, eleven-, and thirteen-sided figures, could not be accomplished geometrically, but could only be

undertaken as builders had traditionally carried them out, "mechanice" (by practice).[46] Dürer attempted in this work to articulate artisanal practice in a theoretical manner, but in such a way that could encompass both the particular and the universal.

His treatise on human proportions is a similar mix of theoretical mathematics and experience. To find the proportional relationships of the human body, he studied two or three hundred living individuals. The result was not a work of idealized mathematical principles but rather a book of "mathematical rules." Dürer made use of the compass and a multitude of proportional relationships among the parts of the body, so that any artisan wanting to follow his method would have had to pore over his examples, measuring and dividing furiously. Whether an artisan could actually derive a simplified or quantitative method from Dürer's book is questionable. The point is, however, that in this work, Dürer attempted to mathematicize his art, thereby lending it greater certainty and scholarly legitimacy, and expressing his ideas in terms scholars could understand so they, too, could grasp the certainty that he, as an artisan, found in nature.

Erwin Panofsky regards Dürer's *Underweysung* as showing "*in vitro*, as it were, the transition from a convenient code of instructions to a systematic and formulated body of knowledge."[47] While it is accurate to describe some of the German artisanal treatises Dürer had available to him as abbreviated codelike sets of instructions, they often seem more like a means to jog the memory than directions to be followed, for they are frequently anything but convenient. Dürer's treatise, in contrast, seems to have a different aim. Interested and aware of his own processes of making, he believed he possessed a kind of knowledge that was as certain as geometry, but difficult to articulate as a coherent body, and it was this knowledge (and this certainty) that he sought to convey in his treatises. This knowledge was gained from nature:

> But life in nature manifests the truth of these things. Therefore observe it diligently, go by it and do not depart from nature arbitrarily, imagining to find the better by thyself, for thou wouldst be misled. For, verily, "art" [i.e., *Kunst*, or theoretical knowledge, as opposed to *Brauch*, or simple practice] is embedded in nature; he who can extract it has it.[48]

There is no doubt that Dürer felt intense excitement about the notion of ideal proportions as well as about combining mathematics with his practice,[49] but he was never satisfied with the idea of universal principles abstracted from nature. His own knowledge could not be contained within the model of geometrical demonstration alone. What he struggled to attain in his books was the articulation of the certain knowledge

he felt he possessed in art and the certainty that he had found in the variety of nature. The difficulty of articulating such particularistic principles derived from all-bearing nature is exemplified in Dürer's struggles with the principle of beauty in the *Four Books on Human Proportion*. He could not accept that a single principle of beauty would be drawn from a single individual, nor did he think it possible to find a perfectly beautiful person, nor, again, that such a principle could be established a priori:

> Some talk about how human beings ought to be . . . ; but I consider nature as master and human fancy as a fallacy; once for all the Creator has made men as they should be, and I hold that the true shapeliness and beauty is inherent in the mass of all men; to him who can properly extract this I will give more credence than to him who wants to establish a newly thought-up proportion in which human beings have had no share.[50]

Similarly, Dürer offered more than a single ideal example of each Roman capital letter in the *Underweysung der Messung*. In contrast to Italian art theorists, Dürer was not satisfied with the concept of a single perfect form.[51] The certain knowledge residing in nature—there to be extracted by the artist—could not be divorced from matter itself. For Dürer, art rested on a knowledge of the variety and particularity of matter and nature.

Dürer seems to have seen particular potential in the practice of the arts because they were founded upon nature. He wrote that the famous Vitruvius had "searched out" and found many good things, "but that does not mean others that are also good may not be found; especially in the things which cannot be proven that they are made in the best way." The arts, because they were not capable of the kind of absolute proof possible in geometry, had more creative potential than provable knowledge.[52] Their certainty and their creative potential derived directly from nature and resulted in inventions and works.

Casting from Life

The Nuremberg master goldsmith Wenzel Jamnitzer (1508–1585) also combined *Kunst* and *Brauch*. Born in Vienna, Jamnitzer learned goldsmithing there under his father, then became both a member of the Nuremberg goldsmiths' association and citizen of Nuremberg in 1534, six years after Dürer's death. During his life, Jamnitzer was best known for his extreme naturalism. He achieved an exact imitation of nature by "casting from life" (fig. 2.9). This technique involved capturing a small animal alive,

FIGURE 2.9.
Wenzel Jamnitzer, *Pen Case*,
1560–70, cast silver, 6 x 22.7
× 10.2 cm, Kunsthistorisches
Museum, Vienna. This pen
case is ornamented with
small animals and delicate
plants, all cast from life. The
top of the box is divided into
ten squares, each adorned
with a separate small crea-
ture, and the sides are en-
crusted with plants and small
insects and reptiles.

FIGURE 2.10.
Wenzel Jamnitzer, *Two
Lizards Cast from Life*, ca.
1540–50, silver, 7 × 4.1 cm,
Germanisches Nationalmu-
seum, Nürnberg. The tech-
nique of casting from life al-
lowed Jamnitzer to capture
unprecedented detail.

FIGURE 2.11 (*bottom left*).
Wenzel Jamnitzer, *Four Na-
ture Casts of Plants*, ca. 1540, sil-
ver, 6.5 cm, 5.5 cm, 5.8 cm, 4.2
cm, Germanisches National-
museum, Nürnberg. The first
specimen on the left, with its
featherlike leaves, is yarrow;
the second is marsh marigold;
the third can be identified as
dyers chamomile; and the
fourth is scotch heather.

killing it by immersing it in vinegar and urine so that it was not deformed by blows, and
then posing it in a lifelike manner by attaching it with threads to a clay base.[53] A thin
plaster-and-sand solution was painted over the animal, and the whole thing was then
fired in a kiln, which hardened the plaster and burned out the organic matter. This
formed a mold that was first cleaned out with a warm oil (and probably subsequently
refired) and then poured with metal (fig. 2.10).[54] Jamnitzer cast many animals, but he
achieved particular fame for his ability to cast delicate flowers and grasses (fig. 2.11).

Jamnitzer was also known for his book *Perspectiva corporum regularium* (1568) as well
as for producing instruments. Jamnitzer's portrait expresses his ambitions and reputa-
tion (plate 13). In one hand, he holds his invention for calculating the mixtures of met-

als (with the specific weights of the metals inscribed on it), in the other, a pair of compasses. Behind him stand his signature plants, cast from life, and before him on the table is his Neptune figure, both in his design on paper and fully executed in gold.[55]

A favorite goldsmith of four Habsburg emperors, Jamnitzer played on the theme of natural and human artifice (fig. 2.12).[56] Playing with the divide between nature and art became a favorite conceit of artisans in the sixteenth century, who claimed by their *ars* both to imitate and even to rise above the artifice of nature.[57] Their patrons, especially the Habsburgs, continuing a discourse about the relationship of art and nature that they inherited from the culture of the Burgundian dukes and Maximilian I, commissioned such works with increasing frequency in the sixteenth century. Habsburg *Kunstkammern* overflowed with these objects, and the free imperial city of Nuremberg was one of the foremost sites of their production (fig. 2.13). Life-casting embodied the polyvalent intersections of art and nature, but to some observers it also proved the superiority of the moderns over the ancients. Giorgio Vasari comments:

> And what is more, some clays and ashes used for this purpose are actually so fine, that tufts of rue and any other slender herb or flower can be cast in silver and in gold, quite easily and with such success, that they are as beautiful as the natural; from which it is seen that this art is more excellent now than it was in the time of the ancients.[58]

Jamnitzer was held in high regard by his fellow Nuremberg citizens, and nobles and scholars, smitten with the exact imitation of nature, visited his large and prosperous workshop.[59] Nuremberg humanist Johann Neudörfer (who provided the inscriptions for Dürer's *Four Apostles*) praised Wenzel and his brother Albrecht Jamnitzer:

> They both work in gold and silver, are masters of proportion and perspective, cut coats-of-arms and seal-dies in silver, stone and iron. They use beautiful colors of glass and they have brought the technique of silver etching to the highest pitch. Their skill in casting little animals, worms, weeds and snails in silver and decorating silver vessels therewith has never been heard of before and they have presented me with a solid silver snail cast with all kinds of flowers and grasses; and the said flowers and grasses are so delicate and thin that they move when one blows on them.[60]

The ambitious scope of Jamnitzer's imitation of nature can be seen in a fountain commissioned in 1556 by Emperor Maximilian II and finally completed twenty-two years later in 1578 in which Jamnitzer attempted to replicate the entire divine, human,

FIGURE 2.12.
Wenzel Jamnitzer, *Nautilus Ewer*, ca. 1570, Residenz München, Schatzkammer. Bayerische Verwaltung der Staatlichen Schlösser, Gärten und Seen. This ornamental ewer blurs the divide between nature and artifice. At the bottom, a slug sits atop several writhing serpents that have been cast from life. An eagle, crouching above the slug, supports a natural nautilus shell. A harpy forms the spout of the pitcher.

FIGURE 2.13.
Nuremberg or Augsburg masters, working in Prague, *Rhino Horn Vessel*, 1611, rhinoceros horn, tusk of a young boar, silver-gilt, 49.7 cm, Kunsthistorisches Museum, Vienna. The cup and stem of this chalicelike vessel are carved from a rhinoceros horn. The cup has been shaped to resemble coral, and the cover is silver-gilt in the shape of a monstrous head. Within the head is contained a fossilized shark's tooth, and the whole is topped with two African warthog tusks. The shark's tooth (thought to be a viper's tongue), the rhino tusk, and coral were all believed to guard against poison or to promote healing. The monstrous head of the lid of the chalice is echoed by carved hounds' heads pushing through the coral on the stem of the cup. This cup possessed multilayered symbolism and healing powers, and it pointed to the transformative powers of nature and art.

and political cosmos. Ten feet high and five feet wide and enclosed by a huge crown, it articulated an allegory of imperial rule. The entire piece was supported by four large bronze figures representing the seasons. Within this crown was a platform divided between water (presided over by Neptune) and earth (overseen by Cybele), with earth represented by hills dotted with gold and silver-containing ores. Water ran from four sides (representing the four sources of the Danube, Rhine, Elbe, and Tiber) and drove tiny grinding, saw, hammer, and stamp mills. On the banks of these streams waved flowers and grasses cast from life. Above the platform was the element of air, filled with birds, clouds, and the four winds. Fire, represented by the emperor as Jupiter holding a fiery thunderbolt and sitting astride an eagle (symbolizing the empire) strangling a basilisk (symbolizing sin), was positioned above air, outside the crown. At the point where the crown's arches intersected, a mechanical celestial globe hung, showing the course of the sun and moon through the zodiac. There were other mechanisms driving the figures that represented the history of the house of Habsburg, the stars that moved around the heads of the emperors, as well as the peasant dances taking place in the middle of the platform.[61] In the early 1640s, this fountain was described as not only touching upon things physical and metaphysical but also political,

FIGURE 2.14.
Wenzel Jamnitzer, *Merckel Table-Center*, 1549, silver, cast, chased, and stamped, etched, gilded, and painted, 100 cm, Rijksmuseum, Amsterdam. Named for the Nuremberg merchant who purchased the table decoration at auction in 1806, the *Merckel Table-Center* is Jamnitzer's most complex extant work. The table piece, which is encrusted with small animals and plants cast from life, is a paean to Mother Earth and her fertility. Plants and small reptiles cluster on the base on which stands Mother Earth. She supports a basin, originally designed to hold fruit, around the rim of which snakes and lizards writhe. The floor of the basin is decorated with cornucopias and moresques. Three Siren-like figures form the base of the egg-shaped vase filled with plants and flowers, also cast from life, that sits atop the basin.

and making clear and visible to the eye many pretty philosophical and poetical secrets.[62]

Jamnitzer undertook such philosophizing in his other works as well. For example, in a writing casket he completed in 1562, Jamnitzer set a figure of Philosophy atop a traditional Renaissance casket with classical architectural forms. Less conventional was his placement of Philosophy on an uneven rocky mound alive with crawling lizards and insects cast from precious metals. At her feet sits a rock-crystal vase containing a tiny twig cast in silver. She holds a tablet that reads "Science [litere] resurrects mortal things, she builds enduring monuments to the arts; she recalls to life what has sunk into darkness." On the reverse side of the tablet is an arithmetical table inscribed "Tabula Pythagorea."[63] In this work, Jamnitzer combined classical forms and the imitation of nature. In contrast, in what has come to be known as the *Merckel Table-Center* of 1549, now in the Rijksmuseum, Amsterdam, the imitation of nature dominates (fig. 2.14). This piece appears to be a *unicum*, having no precedent in earlier life-casting in Nuremberg. The Nuremberg City Council bought it in 1549, presumably as a gift to honor the emperor, although it was never used as such.[64] It features Jamnitzer's specialty: grasses and flowers, cast from life, springing from an egglike vessel at the top while, around the base, reptiles, also cast from life, creep forth from the earth. The central female figure represents Mother Earth, and the whole piece symbolizes the fertility and generative powers of nature. It bears an inscription: "I am the Earth, mother of all things, beladen with the precious burden of the fruits which are produced from myself."[65] These verses apparently form part of a medieval hymn to the fecundity of Mother Nature, indicating Jamnitzer drew less from classical sources than from nature in this bravura piece of artisanal invention. Jamnitzer clearly meant to display his own powers of creation in this work as well as his ability to imitate nature, both in the sense of producing an accurate representation of nature and in understanding the processes of smelting and metallurgy (or alchemy) in order to create this representation. As the publisher and popularizer of medical and arti-

sanal knowledge Walther Hermann Ryff wrote in 1547 about casting: "This part of sculpture, casting, has its origin in the true natural alchemy (not the deceptive art of seeking the philosophers' stone, which these days is called alchemy)."[66]

Jamnitzer, like Dürer, gave his practices and expert knowledge of nature a mathematical frame by publishing a book on perspective, *Perspectiva corporum regularium*, in 1568. Engraved by Hans Sachs, this work depicts the five regular, or Platonic, solids and their manifold variations. Following Euclid and Plato, Jamnitzer believed the five solids made up the elements of nature. Fire was a tetrahedron, air an octahedron, earth a hexahedron, water an icosahedron, and the fifth element, heaven, a dodecahedron.[67] All things, including all living creatures, were composed of combinations of these five solids, as Jamnitzer maintained could be seen in the 140 different solids he drew "with his own heavy hand." Each of the title pages that head the sections on the five solids makes plain the diversity and copiousness of nature within this geometrical framework (fig. 2.15). Knowledge of the five solids was also the foundation to any understanding of cosmology.[68] The same ambitions to represent the cosmos that Jamnitzer displayed in the fountain and the cabinet were also at work in this book.

Jamnitzer made clear his philosophizing in his works, but he was also at pains to recount to his reader his many years of hard work and struggle as a "Werckmann" and "arbeyter." It was only through such labor that he gained a God-given knowledge of the five solids, knowledge that had its origin in "Geometria." He claimed to have spent forty years studying perspective, or, as it was called by scholars, "Optica."[69] Perspective, he enthused, allows such a degree of accuracy in representing objects, that "to portray so similarly and exactly by hand almost appears impossible."[70] There is very little text in his *Perspectiva*; it attests visually rather than verbally to Jamnitzer's skill in executing figures with exceedingly complex surfaces, and it constitutes an ocular proof—an effect—of his knowledge of perspective (figs. 2.16, 2.17). The book also makes clear that Jamnitzer did not view himself as striving simply for the abstract representation of solid bodies but rather

FIGURE 2.15.
Wenzel Jamnitzer, from *Perspectiva corporum regularium*, 1568, engraved by Hans Sachs, Library, Getty Research Institute, Los Angeles. Title page from "Earth," represented by the hexahedron, or cube. Although Jamnitzer is dealing with manifestations of the regular solids in this book, he aims to show the copious variety of nature as well.

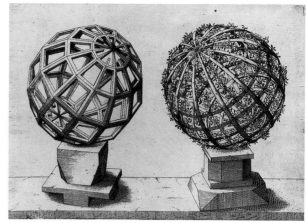

Two illustrations of polygonal solids from Jamnitzer's treatise on perspective, in which he claims that the five Platonic solids and all their myriad permutations make up nature and its structures. As in these illustrations, Jamnitzer's skillful perspective renderings of solid bodies include living plants bursting out over them. For Jamnitzer, both mimetic and mathematical approaches to nature yielded natural knowledge.

had ambitions of a much more profound kind. His book is a demonstration of his ability to imitate and represent the cosmos, both in its deep underlying structure as well as in its copious variety.

Jamnitzer was also a skilled instrument maker; he invented several instruments, one for rendering perspectival images (fig. 2.18), another for comparing the specific weights of metals (fig. 2.19), and a new type of proportional compass for increasing the size of images.[71] Jamnitzer's long manuscript description of all kinds of instruments for use by goldsmiths, geometers, and astronomers makes clearer the relationship he saw between the precise imitation of nature in his life-casting and his mathematical endeavors. In reference to an instrument that he calls an "astronomical" or a "cosmographical mirror," he says, "In a mirror we see our own appearance or our portrait. But in this [astronomical] mirror we see the portrait or painting of the whole world, that is the appearance of the earth." It turns out that this mirror is a combination projection map and perpetual calendar by which any city can be located and the time of sunrise and sunset and the length of the day and night in it can be calculated.[72] For Jamnitzer, a mirror, a painting, and a mathematical representation are all ways of representing and knowing nature. Nature, and its processes, could come to be known both through imitation and through mathematical representation.

The Articulation of Experience

When Walther Ryff attempted to describe Jamnitzer's technique of casting from life, he ended in frustration: "How much easier it is to understand from instruction on the

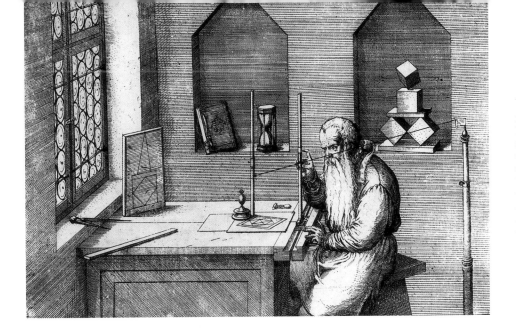

FIGURE 2.18.
Hans Sachs, *Jamnitzer Using His Perspective Instrument*, ca. 1568, engraving, 17.7 × 25.8 cm, Germanisches Nationalmuseum, Nürnberg. Jamnitzer is pictured at work using his "perspective table" to transform a sketch (against the window frame) into a perspectival drawing. Jamnitzer's perspective instrument was based on that of Dürer published in the *Underweysung* in 1525, but Jamnitzer's instrument had several features that made it far more practical to use.

FIGURE 2.19.
Wenzel Jamnitzer, *Measure and Calibration Tool for Metals*, 1565–66, silver, length: 41.6 cm, diameter: 2 cm, Museum für Kunst und Gewerbe Hamburg. One of several instruments Jamnitzer devised during his life. Scales showing the specific weights of the seven metals are inscribed around the staff. By moving the circular piece, this instrument could be used to compare and calculate weights and amounts of metals and alloys. The two decorative covers on either end can be removed to reveal a silver cylinder for measuring mercury. Jamnitzer holds this instrument in Neufchatel's portrait (plate 13).

spot than from written report."[73] Pomponius Gauricus, in his work on sculpture of 1503, the book on which Ryff had based his treatise, had said that he would pass over the ugly, smoky part of bronze casting—or "Chemike," as he called it in Greek—because it dealt with clay, coals, dung, and bellows. Besides, he was sure that his readers would be better off seeing the process than reading about it. Despite his distaste for the dirty handwork of casting, he was certain that his readers would have visited workshops where war machines and bells were cast.[74]

The failure of the written word—part prejudice against handwork and part lack of a language to describe experience—comes through in many attempts to describe artisanal understanding. Articulation of artisanal modes of working and thinking in writing was uncharted territory in the fifteenth and sixteenth centuries.[75] This is indicated, for example, by Leonardo's remark that for apprentices, what is seen is more

quickly apprehended than what is read or described.[76] In his book on human proportions, Dürer also complained that "it is difficult to write about these things and still more burdensome [verdrossener] to read and learn about them because of the many words, dots, and symbols."[77] Chief superintendent of mines under Emperor Rudolf II, Lazarus Ercker (ca. 1530–ca. 1594), whose book on ores and assaying was directed at practitioners, writes, "These things cannot be pictured on paper in such a way that they can be understood and judged by merely reading about them. Reading shows you the way, but the work of your own hands gives you the experience."[78] While Ercker's work was produced for apprentices and practitioners, Cipriano Piccolpasso's *The Three Books of the Potter's Art* (ca. 1558) was produced for a very different audience and makes clear one dimension of his and many other humanists' agenda. In this book, he declares that he is making public the art of ceramics against the "ill-will of those in whose hands these secrets have been" so that it would move from "persons of small account, [to] circulate in courts, among lofty spirits and speculative minds."[79] Do not "wonder at or make a jest of these my particular narrations concerning things of clay," he implores his gentle reader.[80] Giorgio Vasari also was reluctant to speak about techniques, sometimes simply giving up in frustration; for example, in trying to describe how to translate a complex perspective construction to a large-scale cartoon, he writes that it is "a tiresome thing, and difficult to explain, I do not wish to speak further about it."[81] Many observers were baffled about how to clearly describe techniques that were learned by observation and imitation, much less how to transmit the nonverbal components of artisanal practices. Until the late sixteenth century and beyond, however, most scholarly observers attributed their own bafflement to the messiness and nontheoretical character of manual work, rather than to their own lack of ability to articulate artisanal processes. They assumed without question that their own verbal ingenuity far outstripped the material ingenuity of the artisan.[82]

Paracelsus and the Articulation of Artisanal Epistemology

Not all scholars assumed this lofty vantage point, however. The fullest articulation of artisanal attitudes appeared in the work of Theophrastus Bombast von Hohenheim, called Paracelsus (1493–1541), who passed through Nuremberg in 1529.[83] Paracelsus was a self-consciously new philosopher, and in his reform of medicine, philosophy, and religion, he took the methods of the artisan to be the ideal mode of acquiring all

knowledge. Born in the Swiss town of Einsiedeln, Paracelsus apparently was taught by his father, a member of a minor noble house from Swabia who practiced medicine from 1502 to 1534 in the Carinthian town of Villach, treating miners in the Fugger mines in nearby Hutenberg. Paracelsus's life was marked by constant travel. He probably studied at Italian universities and then worked as a military surgeon in the service of Venice, among other places, traveling all over Europe and possibly as far as the Middle East. In 1525 he was in Salzburg, and after successfully treating the humanist and printer Johann Froben, he was made municipal physician and professor of medicine at Basel in March 1527. He offended civic authorities and his fellow professors alike by leading his students in revolt against medical authorities and lecturing in German. From 1528, when he was driven out of Basel, he became a kind of wandering lay preacher and physician, sporadically practicing medicine and writing. Only a few of Paracelsus's works were published during his lifetime, among them astrological prognostications, works on the treatment of syphilis (1529/30), a work on the spa Bad Pfäfers (1535), and a book on surgery, *Die große Wundarznei* (1536). His work on the treatment of syphilis, which criticized the use of *guaiacum* (a Brazilian tree bark), caused his hasty departure from Nuremberg, where the Fuggers and the physicians in their employ controlled the New World trade in *guaiacum*. His treatises on syphilis were both published in Nuremberg *and* subsequently banned there.[84] The great majority of his works were published by his followers in the decades after his death in 1541, with publication reaching a peak in the 1570s.

Paracelsus criticized the ancient medical framework of the humoral theory in which human health was maintained by keeping a balance among the four humors. In its place, he declared that diseases came from outside the person, mainly from influences of the celestial bodies. Each of these diseases had its unique and individual seed, course of development, and specific cure. Thus, Paracelsus regarded the traditional purgings and bloodlettings of the physicians as useless. Rather, the physician must seek the particular simples in nature that matched specific diseases and, in doing so, isolate the virtues and powers of each natural thing. This isolation was carried out largely by means of analysis and distillation and understood within an (al)chemical framework. Paracelsus clearly gained much practical knowledge of the production of acids, distillation, and the working of metals through his experience in the laboratory, and his system of nature is shaped by the framework of alchemical theory and practice. Indeed, Paracelsus sought to supplant the philosophy of the ancients with a chemical cosmology. The most influential of these ideas was that of the connection between the cosmos (the macrocosm) and human beings (the microcosm). Humans incorporated

in miniature all parts of the greater world, and the entirety of nature formed a "portrait," "model," or "mirror" for humankind.

The core of Paracelsus's philosophy was human art. Indeed, he maintained that artisans, by effecting works from the things of nature, fulfilled the destiny of humanity after the Fall. For Paracelsus, knowledge of nature, gained through experience and manual labor, was also a form of worship, giving humans an understanding of God's Creation. By working in the "light of nature," human beings came to "experience the miracles of God through nature."[85] God gave the light of nature to humans so they might gain knowledge of Him, and the light of nature was embodied particularly in the working processes of craftspeople.[86] The art of the craftsman "reformed" nature by creating noble objects from the dross of fallen nature.[87] The work of artisans, like the practices of agriculture and medicine, worked to redeem the body and life of humans after the Fall. The labor of refining nature for human needs, common to all manual work, brought about the reformation and ultimately the redemption of the world and humankind.[88] Indeed, God created humans (the microcosm) so that by understanding and making manifest His works, they could make His previously invisible knowledge visible:

> To reveal the hidden through human work, as well as reveal all natural mysteries of the elements. None of this could happen without human beings. God wishes that the things that are invisible should become visible. Man should take this to heart: that God has created him for this purpose and said to him, all is subject to you. Because God has ordered man to do this, God does not want him to quit working, to be lazy, to stand still, to drink, to whore, and so on, but instead He wants man to do daily practice [übung] in order to investigate the secrets of nature and all the gifts that God has created in nature . . . for where we do not perfect, by means of the light of nature, what God wants to accomplish through us, then there will be a reckoning made on the day of judgment.[89]

Humans were the instruments by which God revealed himself in the world; or, more correctly, the human body was the instrument that effected God's revelation: the knowledge of nature could not be complete "without hands and feet, without ears and eyes, etc., for through the eyes we see into nature, etc., and they are instruments through which we perfect that which is in us and what God gave us. Therefore they are created as instruments, without which no wisdom may exist."[90] Because humans were created in the image of God, the creative power of humans is similar to God's but it lay in the human body, rather than in the word. What God created by the word, a human being creates "mit seinem leib und mit seinen instrumenten" [with his body and his

instruments (i.e., his senses)]. The artisan, by means of his art, makes the invisible manifest ("die kunst des [das] unsichtbaren offenbar machet").[91]

Paracelsus learned from those who worked with their hands; he queried and worked alongside peasants and artisans, questioned miners on their knowledge of diseases and remedies, and drank with peasants, gaining knowledge of their wine making and distilling practices. He returned repeatedly to mines in the Tyrol, where he studied miners' diseases and spas, both of which "were to him nature's laboratories revealing her hidden virtues and powers."[92] In all places, he said, he sought out the art of healing by research and by assiduously questioning "not only doctors, but also barbers, bath attendants, learned physicians, old wives, magicians (or *schwarzkünstlern*, as they call themselves), among the alchemists, in the cloisters, among the nobles, the common people, among the clever and the simple."[93] He placed "doing" higher than "knowing" and praised the process of learning by experience, such as that of an artisan's apprentice.[94] Paracelsus lectured in the vernacular, admitted barber-surgeons to his courses, and in 1527 issued a broadside against traditional medical education, advocating instead a curriculum based on firsthand experience of nature. He conceived of the process of learning about nature on the model of the craftsman's *Wanderjahre* as a journeyman: "He who would explore [nature], must tread her books with his feet."[95] For Paracelsus, "Erfahrung," or experience, was knowledge gained by traveling with open eyes. He often referred to artisans and artisanal views in his natural works. For example, in discussing his theory of the three elemental principles, mercury, sulfur, and salt, he writes:

> These three have in themselves the force and power of all perishable things. In them lie hidden the mineral, day, night, heat, cold, the stone, the fruit, and everything else, even while it is not yet formed. It is even as with wood which is thrown away and is only wood, yet in it are hidden all forms of animals, plants, of instruments, which anyone who can carve what otherwise would be useless, invents and produces.[96]

More significantly, he often used artisanal knowledge and know-how as models for understanding nature.

> How can a carpenter have any other book than his axe and his wood? How can a bricklayer have any other book than stone and cement? How can a physician thus have any other book than the book that makes humans healthy and sick [i.e., the body and nature]? Understanding must thus flow out of what one is, and the appearance of what one is must be tested [probirt].[97]

Thus, skill is integral to identity (which itself is based upon the vocation in which one is trained), and this identity can only be proven in practice, by doing.

Paracelsus assures the readers of *Die große Wundarznei* that even the notoriously uncertain discipline of surgery could be as certain as the art of carpentry and its certainty would proven in effects:

> It is a certain art and a true art, exactly as skillful as a carpenter in his carpentry. The carpenter needs to learn carpentry properly. If he can do it properly, then he needs no advice. If he cannot do it properly then he might ask advice all night and day, but nothing good will result. Everything will collapse in the end.[98]

Paracelsus was concerned above all with perfecting medicines, drawing out from nature, by means of art, the knowledge that God had hidden in it. In describing how a physician must perfect the art of reading a natural thing from its external character in order to gain understanding of the virtue and power in it—what he called "chiromancy"—Paracelsus points to the example of woodworkers: "People who work wood, carpenters, joiners and such, have to understand their wood by the chiromancy of it, what it is apt and good for." It is important to understand that the kind of expertise to which Paracelsus refers here is a deep knowledge of the behavior of materials, for example, that by which carpenters of his day knew how to choose, cut, and prepare wood panels, so that even after centuries very little warping or twisting takes place.[99] In the same way, Paracelsus states, a miner will know the chiromancy of the mine.[100] A person did not have to be literate to be able to do chiromancy; even a peasant could learn this knowledge of nature.[101] Chiromancy, or the reading of signs, was the artisan's expertise, which Paracelsus took as a model for gaining knowledge about nature.

Paracelsus sought to do more than simply refer to the experience of artisans. Rather, he regarded them in their strivings to imitate nature and to represent nature realistically as coming closest to a true and unmediated knowledge of nature:

> Nature's Maker is so skilled that he does not frame the soul to fit the form, but the form to fit the soul: that is, the shape of a man is formed after the kind of his heart; and Nature does not practice her art like a painter, who produces an image and gives it no Sign, and indeed can give it none. For there is nothing *in* the picture, and so it has no Sign; it is like a shadow with no power [kraft] in it. However, those craftsmen who are skillful, who work in sculpting and make similitudes [etwas gleichförmigs], which although they are without such inner power [kraft], yet their art does proceed from the Maker of animate

images. And the more such a craftsman wishes to make perfect images, the more he must discern the Sign, for the reason that Nature's art prefigures the operations by which the Sign is discerned—what soul is in a person. To this belong the three types of signatum, as discussed [i.e., three of the four types of the science of *signatum*, the four being *chiroman-tia*, *physionomia*, *substantina*, and *mos et usus*], without which no artist in sculpting, painting, or woodworking can do anything well-grounded. For in these three lie the basic principle of all their arts. Note also the fourth type, which perfectly portrays the manner and gestures to people. The one who knows and can do this is, as remarked above, a signator perfectus and can carry out the whole perfect art.[102]

True knowledge of nature is obtained by reading the signs of material things through the four methods of the science of signs; indeed, it is the way any artisan knows about his material: "In such a way the physician recognizes medicines [i.e., the material of his profession], the astronomer his astronomy, the cobbler his leather, the weaver his cloth, the carpenter his wood, the potter his clay, the miner his metal."[103] The science of signs made the invisible visible, which was the mission of humans on earth. Based on this artisanal cognition of nature, Paracelsus formulated a philosophy of nature. In the process, he articulated the artisanal epistemology that had first begun to be expressed in the fifteenth century by the Flemish painters and Martin Schongauer in their works of art and by the sixteenth century in the treatises of artisans such as Albrecht Dürer and Wenzel Jamnitzer.

To grasp this clearly, consider Paracelsus's discussion of "experience," one of the most important components of his epistemology. By this term, he did not mean the experience of the humanists involved in the active practice of public life. For him, knowledge of nature was gained, not through a process of reasoning, but by a union of the divine powers of the mind and the body with the divine spirit in matter. He called the process of this union "experience." In explaining this concept, Paracelsus drew on the terminology of theory and practice but inverted the traditional understanding of these terms in a remarkable way. Paracelsus defined *scientia*, not as a body of knowledge formed into a discipline by its logical structure, but as the divine power in natural things that the physician must "overhear" and with which he must achieve union in order to gain knowledge of medicines.[104] Observation with the eyes was not enough, for "seeing is only like a peasant sees when he looks at a psalter. He sees only the letters, and cannot say anything more about it."[105]

Thus, for Paracelsus, science (or certain knowledge) was contained in nature, and experience was the process by which the physician united with nature and learned

this science. The success of the physician's imitation of the processes of nature (analogous to the artist's naturalism) is then measured by the efficacy of the medicines he produces and the cures he makes:

> Now note the difference between *experientia* and *scientia.* . . . *Scientia* is inherent in a thing, it is given by God; *experientia* is a knowledge [kuntschaft] of that in which *scientia* is tested [probirt]. For instance, the pear tree has *scientia* in itself, and we who see its works have *experientia* of its *scientia.* Thus we pass on knowledge [kuntschaft] through experience [experienz] as that same tree has perfect *scientia* in itself. Thus in this book, I show that in this way *scientia* enters into you; that you transmit to your patients knowledge [kuntschaft] through the works you bring about in them, and [you show] that you possess this perfect *scientia.* Now, whatever goes perfectly with one mind in the right course of nature, that is *scientia.* Where that is not the case, that is only *experimentum* or *experientia* without science.[106]

This is an extraordinary inversion of the concepts of theory and practice. In the organization of knowledge that held from antiquity up through the seventeenth century, theory was certain knowledge based on syllogistic logic and geometrical demonstration. In contrast, experience was particular knowledge that could not be formed into a deductive system and thus could never possess the same certainty as theory. Paracelsus inverted this, finding certainty in nature and the unmediated experience of nature.[107]

Paracelsus's use of "*kuntschaft*" in this passage is telling because in his day "*Kundschaft*" connoted the oral knowledge of the artisan. Paracelsus's use of the term "*Kundschaft*" in close proximity to "*experientia*" thus suggests that when he employed the word "*experientia,*" he meant to evoke artisanal knowledge and its productivity. The physician showed that he possessed *scientia* by transmitting his knowledge, or *kuntschaft*, to his patients, thereby effecting change in their physical states. The knowledge of the physician was proven by his works. To understand this more fully, it is important to note that Paracelsus distinguished "experience" from "experiment." "Experiment" was simply the external appearance of things that humans see with their eyes, but about which they did not also possess certain knowledge through *experientia.* Paracelsus considered the phrase "a gun shoots towards a wall" to be an example of experiment, while science was the ability to aim and to shoot straight so that the shot always hits the wall. This, of course, might be aided by mathematical calculations, but Paracelsus seems not to have thought in these terms but rather emphasized the ability of the artisan to effect works instead of simply spout words. A scholar might make a statement about the behavior of a projectile, but Paracelsus makes the point here that if the scholar does not

know how to effect his statement, he does not possess *scientia*. This is one of Paracelsus's clearest statements that knowing is doing. For Paracelsus, a master is someone who demonstrates his possession of *scientia* by his works. And it is by these works that experiment is transformed into a powerful union of science and experience.[108]

> Note this example: Scammonea [a purgative herb] purges. It does so with *scientia*, that God has given it, as well as what and how it should purge. Now when you replicate [ablernest] the *scientia* of scammonea, so you have *experientia cum scientia*, and not *experimentum*. If, however, you do not know the manner and essence [art und wesen] of scammonea in all its characteristics, so you have *experimentum* without *scientia*. If you only know that it makes you shit, you do not have anything more than a word, and you do not know what it is.[109]

In locating *scientia* in nature and in emphasizing the productive aspects of the knowledge of nature, Paracelsus sounds remarkably like artisans, including Leonardo da Vinci (1452–1519):

> Experience does not err. . . . Men wrongly complain of experience, which with great abuse they accuse of falsity. . . . They say that knowledge born of experience is mechanical but that knowledge born and ending in the mind is scientific . . . but to me it appears that those sciences are vain and full of error that have not been born of experience, mother of every certainty and which do not likewise end in experience; that is to say, those that have neither at their beginning, middle or end passed through any of the five senses.
>
> True sciences are those which have penetrated through the senses as a result of experience and . . . always proceeding successively from primary truths and established principles, in a proper order towards the conclusion.[110]

Leonardo's views manifested themselves in his acute observation of natural objects and processes and in his nature studies (figs. 2.20, 2.21, 2.22).[111]

Leonardo believed that even geometry—which was regarded as the most certain science and a model of pure theoretical knowledge because it rested purely upon principles abstracted from, but not found within, changeable nature—had its roots in nature because it dealt with the surfaces of real objects. Similarly, Paracelsus referred to geometry as preexisting in nature.[112]

Leonardo states, "Nothing can be found in nature that is not a part of science." What did he mean by this? Nature (mother) brought forth visible things (daughter),

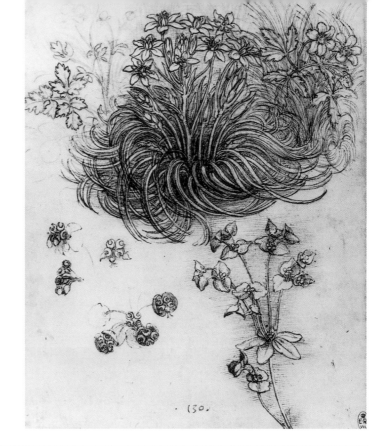

FIGURE 2.20.
Leonardo da Vinci, *The Star of Bethlehem and Other Plants*, ca. 1508, red chalk, pen, and ink, 19.8 × 16 cm, The Royal Collection © 2001, Her Majesty Queen Elizabeth II (RL 12424). Leonardo used this sheet to record several different plant species. The star-of-Bethlehem, with its whorl of leaves and six-petaled flowers, is in the center at the top. Leonardo sketched a wood anemone to the right and crow's-foot to the left. Below them two stages of the plant *Euphorbia helioscopia*, as well as its flowers and seeds, are depicted.

FIGURE 2.21.
Leonardo da Vinci, *Horizontal Outcrop of Rock*, ca. 1510–13, pen and ink over black chalk, 18.5 × 26.8 cm, The Royal Collection © 2001, Her Majesty Queen Elizabeth II (RL 12394).

FIGURE 2.22.
Leonardo da Vinci, *Studies of
Water Passing Obstacles and Falling
into a Pool*, ca. 1508–9, pen and
ink over traces of black chalk,
29.8 × 20.7 cm, The Royal
Collection © 2001, Her
Majesty Queen Elizabeth II
(RL 12660v). In this study,
Leonardo observes and com-
ments upon the behavior of
water in three different situa-
tions: water flowing past an
obstacle placed at the side of
the flow, one positioned in the
middle of the flow, and water
cascading out of an opening
into a pool. In the three nature
studies pictured here, Leonardo
sought both to depict the ap-
pearance of natural things as
well as to study the action of
forces and the processes of
nature.

of which painting (granddaughter) was one.[113] Thus, for Leonardo, painting was a science, a part of nature itself, and the artist/artisan engaged in nature through experience, learning the essence of nature to produce effects.[114] Because it was the "sole imitator of all the apparent works of nature," Leonardo viewed painting as "a subtle *inventione* which with philosophy and subtle speculation considers the natures of all forms." It gives an unmediated access to nature that words cannot give; painting communicates, "not otherwise than do the things produced by nature."[115] Painting is a part of nature. It can be extracted by the painter/inventor, but, in order to do so, the mind of the inventor must "transmute itself into the very mind of nature."[116]

The resemblance of Paracelsus's ideas to those of Dürer in the 1520s is even more striking. As we have seen, Dürer states that certain knowledge, Paracelsus's *scientia*, lay in nature, and that this certainty was expressed by realistic representation:

> But life in nature manifests the truth of these things. Therefore observe it diligently, go by it and do not depart from nature arbitrarily, imagining to find the better by thyself, for thou wouldst be misled. For, verily, "art" [i.e., *Kunst* as opposed to *Brauch*] is embedded in nature; he who can extract it has it. If thou acquirest it, it will save thee from much error in thy work.[117]

This is a crucial passage for understanding Paracelsus's articulation of an artisanal epistemology in the 1530s. For Dürer, as for Paracelsus, nature, in all its variety and temporality, contained certain knowledge. Nature was primary. The artisan or physician extracted this certain knowledge from nature by imitating it ("do not depart from it arbitrarily"). This imitation was carried out through the body, the limbs and the senses, in the practice of art. Part of the extraction of true *scientia* from nature involved reading the signs of things. When one considers Dürer's attempt to work out a system of human proportions by observing many different people, it is significant that Paracelsus believed that the signs could be recognized through studying the proportions of individual persons.[118]

For Paracelsus, the aim of the physician/natural philosopher was to make visible those invisible virtues that God had hidden in Creation. For Dürer, art brought out what lay hidden in nature. Both men emphasized that the proof of an artisan's or physician's successful extraction of *scientia* from nature lay in the production of effects. Dürer believed that the power (*Gewalt*) of the artist lay in producing effects and that the very uncertainty of the arts (due to their location in the material world of nature) made them more productive than the more certain theoretical sciences. Similarly,

Paracelsus writes, "without practice and experience all arts are dead, for through practice and experience comes power [künden]."[119] He believed that there was no end to invention in the arts because the celestial bodies continually rained down their creative influences.[120] According to Paracelsus, the creative influences of the heavens were, in fact, particularly concentrated in Dürer and he was therefore especially powerful. Paracelsus called him an "adoptive son" of the stars in art.[121]

Michael Baxandall reads Paracelsus for insight into the world of the limewood sculptors of Renaissance Germany because Paracelsus "throws a more penetrating light on the characteristic forms of sculpture than anything else available."[122] This is a characteristically brilliant insight, but the foregoing discussion allows us to see that the connection between Paracelsus and artisans goes even deeper than Baxandall suspected. Paracelsus articulated the relationship of artisans like Dürer and Jamnitzer to nature. These artisans believed they possessed a species of knowledge, based on nature and extracted through bodily work, which was as certain as any demonstrative proof. In their texts and their works of art, they aimed to give this experiential, embodied knowledge philosophical form and to convey it to their fellow craftspeople and to the humanists visiting their workshops. Paracelsus, working alongside artisans and understanding their work partly through the writings of his fellow scholars, grasped their effort and gave it voice as part of an overarching philosophical reform, a story to which we shall return in chapters 4 and 5.

‡‡‡‡‡‡‡‡‡‡‡‡‡‡‡ *3* ‡‡‡‡‡‡‡‡‡‡‡‡‡‡‡‡

The Body of the Artisan

Read alongside sixteenth-century German artisanal writings, Paracelsus's texts provide a view into artisans' attitudes toward nature and their own art. This chapter shows the ways in which his works also give insight into the place of the body and the importance of bodily processes in artisanal epistemology. "Imitation of nature" plays a central role in artisans' writings and in their understanding of their working processes, and this chapter addresses some of the meanings that imitation and replication could hold. For an artisan, imitation could denote both copying the bodily techniques of a master as well as reproducing the appearance and processes of nature. But it also constituted a bodily form of cognition and was connected to a view that matter and nature are alive and exist in synergy with the human body.

Replication as Cognition

In Paracelsus's view, a master was someone who possessed *scientia*,[1] and a student learned *scientia* from the plant itself by copying or replicating nature (Paracelsus uses the word "*ablernen*"—to learn through copying).[2] Copying after nature and self-conscious observation of particulars were also the basis of the artisan's training as an

apprentice. The naturalism of northern artists did not depend upon the construction of mathematical perspective, as it did in Italy, but instead upon the modeling of light and shadow that resulted from the careful mixing of varying shades of a pigment and the selective application of white highlighting. It is possible to see this technique especially in the paintings of the first generation of Flemish painters (plates 14 and 15). Apprentices learned to study the play of light and the surface of objects and to mix and grade pigments to attain precise gradations of shadow and highlighting.[3] The process of learning to copy "after life" was one of bodily labor and experience and consisted in learning to know materials (similar to Paracelsus's concept of chiromancy). Just the process of producing the different shades of a pigment represented a long bodily labor. Cennino Cennini's late-fourteenth-century painting manual gives a sense of the extended physical labor usual in the painter's workshop, and it is worth quoting at length:

When you have this [lapis lazuli] powder all ready [i.e., ground up finely], get six ounces of pine rosin from the druggists, three ounces of gum mastic, and three ounces of new wax, for each pound of lapis lazuli; put all these things into a new pipkin, and melt them up together. Then take a white linen cloth, and strain these things into a glazed washbasin. Then take a pound of this lapis lazuli powder, and mix it all up thoroughly, and make a plastic of it, all incorporated together. And have some linseed oil, and always keep your hands well greased with this oil, so as to be able to handle the plastic. You must keep this plastic for at least three days and three nights, working it over a little every day; and bear in mind that you may keep it in the plastic for two weeks or a month, or as long as you like. When you want to extract the blue from it, adopt this method. Make two sticks out of a stout rod, neither too thick nor too thin; and let them each be a foot long; and have them well rounded at the top and bottom, and nicely smoothed. And then have your plastic in the glazed washbasin where you have been keeping it; and put into it about a porringerful of lye, fairly warm; and with these two sticks, one in each hand, turn over and squeeze and knead this plastic, this way and that, just as you work over bread dough with your hand, in just the same way. When you have done this until you see that the lye is saturated with blue, draw it off into a glazed porringer. Then take as much lye again, and put it on to the plastic, and work it over with these sticks as before. When the lye has turned quite blue, put it into another glazed porringer, and put as much lye again on to the plastic, and press it out again in the usual way. And when the lye is quite blue, put it into another glazed porringer. And go on doing this for several days in the same way, until the plastic will no longer color the lye; and then throw it away, for it is no longer any good. Then arrange all these porringers in front of you on a table, in series: that is, the yields,

first, second, third, fourth, arranged in succession; and with your hand stir up in each one the lye with the blue which, on account of the heaviness of this blue, will have gone to the bottom; and then you will learn the yields of the blue. Weigh the question of how many grades of blue you want: whether three or four, or six, or however many you want; bearing in mind that the first yields are the best, just as the first porringer is better than the second. And so, if you have eighteen porringers of the yields, and you wish to make three grades of blue, you take six of the porringers and mix them together, and reduce it to one porringer; and that will be one grade. And in the same way with the others.[4]

All apprenticeships began in manual labor, and Cennini's manual gives insight into the laborious and bodily course of the entire apprenticeship. His account shows that apprentices learned not just about techniques, however, but also about materials. He begins, strangely it seems, with chicken bones. The first part of the art that an apprentice had to master was recognizing which bones were best for coating the little panel used to practice drawing. "Take bone from the second joints and wings of fowls, or of a capon; and the older they are the better. Just as you find them under the dining-table, put them into the fire; and when you see that they have turned whiter than ashes, draw them out, and grind them well on the porphyry" (p. 5). Then the bones must be ground for at least two hours. Following this, Cennini moves through the roasting of charcoal for drawing, the manufacture and character of all grounds and pigments, the making of brushes, working in fresco, the making of oils (in order to paint "as the Germans are much given to do" [p. 57]), glues, and pastes. Amongst all this material production, he states that copying from nature is the "triumphal gateway" that must guide the apprentice (p. 15) after he has stayed with his master as long as he can ("do not leave the master until you have to" [p. 3]). He advocates serving as a shop boy and practicing drawing for one year, then spending six years learning to make pigments, grounds, gessoes, and other materials, then six more years working in fresco, "drawing all the time, never leaving off, either on holidays or on workdays." Only then was the apprentice *possibly* ready to begin to paint on panel (pp. 64–65). Cennini suggests that the aspiring painter copy from nature: "to acquire a good style for mountains, and to have them look natural, get some large stones, rugged, and not cleaned up; and copy them from nature" (p. 57). Cennini ends his manual with a section on "a very useful" means of "copying and imitating things from nature . . . called casting" (p. 123). By this, he meant casting from life, in particular casting the faces of living persons in plaster. He included instructions on casting a whole figure from life and "how to make a cast of your own person."[5] An apprenticeship in the imitation of nature in-

volved not only observing and representing nature precisely but also working for many years in coming to know the properties of materials. Significantly, the apprenticeship ended in producing images of precise verisimilitude by casting from life.

Leonardo da Vinci and Dürer also regarded imitation as a learned bodily habit that became a cognitive practice and, finally, led to knowledge and the production of effects. Leonardo advocated that the apprentice should first learn by tracing and pouncing, among other mechanical means of copying, and then by copying after life. All this was done with the aim of developing "giuditio d'ochio" [judgment of the eye],[6] a kind of bodily judgment that not only governed the images the painter produced but actually shaped the painter's own body.[7] By means of intensive training in observation, Dürer believed the painter developed his own "Augenmass" (measure, or sense of proportion) in his eyes. This training consisted in much "Abmachen," by which he meant copying from nature or reproducing nature from life. Note here the similarity to Paracelsus's "ablernen," or learning by copying.[8] By such copying, the painter filled his mind full, thus accumulating a "secret treasure of the heart," from which he could pour forth in his work what he "has gathered in from the outside for a long time." For Dürer, the painter's training and aim was the "direct and faithful representation of a natural object."[9] Michelangelo, too, saw repetitious bodily practice as the key to knowledge, even providing a kind of model of repetition in his directive to an apprentice written on a study sheet for a Madonna and child. Over some attempts by his apprentice, Michelangelo scrawled: "draw Antonio, draw Antonio / draw and do not waste time."[10]

The final result for which the artisan strove was an imitation of nature much more profound than the reflection of nature in a mirror; beyond verisimilitude, the artisan sought a knowledge of materials and an ability to produce. This type of imitation of nature involved constant trial and retrial.[11] It was a kind of cognition that led to a deep knowledge of nature, out of which flowed an ability to manipulate materials resulting in the production of tangible effects, or works of art. Michelangelo's knowledge of human anatomy can illustrate the potential of such imitation to function as cognition and lead to knowledge. According to James Elkins, the common view that Michelangelo's knowledge of anatomy flowed from his human dissections is simply wrong. Although Michelangelo did perform dissections, they would not have helped him depict the complex forms of muscle groups he included in his drawings, paintings, and sculptures. The muscles of a dissected body are flaccid, not active, and the appearance of inactive muscles is completely different from muscles in a flexed state. As Elkins writes:

We slight Michelangelo's achievement if we ascribe the forms in his figures to a knowledge of dissection or (what is even less tenable) to expressive and free distortion and invention. Where Michelangelo excelled beyond what we can do was in a quality so simple it escapes the sieves of scholarship: the ability to observe. The anatomic accuracy of his figures is not due to dissection but to observation, and in fact the observation is so penetrating that it blocks attempts to isolate the other sources of forms, dissection and the Antique.[12]

These techniques of close observation and accurate representation were developed in artisanal workshops. We can see this, for example, in one of the first naturalistic herbals, *Herbarum vivae eicones ad naturae imitationem*, published in Strasbourg in the early 1530s. The draftsman and block cutter Hans Weiditz's detailed record of observation and his realistic woodcuts in this herbal evince an entirely new attitude toward nature, in contrast to the scholar Otto Brunfels's text, which is borrowed from classical authorities. Weiditz's original watercolor studies for the woodblock drawings describe the plants in minute detail and include annotations that name the plant; note the day, month, and year the drawing was carried out; and describe the size, color, and texture of the plant.[13] Such techniques had been developed, disseminated, and transmitted in Flemish workshops since the earliest years of the fifteenth century. They were the basis of the imitation of nature for which Flemish panel painters gained such renown, and they spread by way of Schongauer and then Dürer to German lands. Such bodily techniques of copying, observing, and imitating were the basis of artisanal cognition. They did not originate in scholarly pursuits.

Even today, the expertise gained by observation through repetition is still not entirely lost among craftspeople trained by apprenticeship. A modern Japanese swordsmith remarks on the importance of learning through experience:

> Remember, our work is not done by measuring and talking. The hammering, the forging, all the processes are performed by intuition. It's the split-second intuitive decision to remove the iron from the fire, when and how to bring up the flame, to immerse the blade in the water now—it is these acts of intuition that produce a sword.[14]

Similarly a modern stoneworker comments on the way in which his bodily knowledge came from getting to know his tools through repeated use: "It is a curious thing, but I have never met a smith who could temper chisels as well as a stonie. They never get to know the steel like a man who is using it. . . . It took me years to find out that it is best not to temper chisels on a frosty morning."[15]

Knowledge in the Body

As we have seen, Paracelsus's writings give insight into the immediacy and primacy of nature for artisans. The things of nature, not the words of books and disputations about the behavior of nature, constituted the certain *scientia*, which craftspeople came to know through an individual struggle with the material. This comes through in Paracelsus's theory of bodily union between the physician/natural philosopher and his object of study, as well as in his notion that the creative power of humans was similar to God's but lay in the human body rather than in the Word.[16] As Paracelsus puts it, in order to produce effects, "humans must bring their bodies into the work."[17]

The bodily aspect of artisanal experience emerges with particular clarity in the work of Bernard Palissy (ca. 1510–1590). This Huguenot potter produced many objects and three published texts. Palissy apprenticed as a glass painter, traveled as a journeyman gaining experience in his craft, learned to draw and survey, and settled in Saintes, southeast of La Rochelle. In the 1540s, apparently after seeing a white enameled cup probably produced in Italy or Germany in imitation of the recently introduced Chinese porcelain, he taught himself pottery making. Pieces from his own hand are rare, but Palissyware, as it is called, is based upon extraordinary models of Palissy's design: large-scale tableware—sauceboats, ewers, and large platters, all covered with life-size ceramic reptiles, amphibians, and plants and glazed in deep greens, blues, browns, and pure white—produced for the tables and curiosity cabinets of the highest nobility of France. Most of these pieces, which he began producing in about 1555, imitate a shoreline or a marshland. Some have a deep blue center with fish thrusting out of the plate, swimming down the length of the platter. On others, snakes coil on small islands protruding from the surface of the dish, every scale of the wet reptiles perfectly imitated from nature. Indeed, since the remarkable finds from the excavations of his workshops in the Tuileries and under the Louvre, it is clear that his plants (plate 16) and animals were molded from life (fig. 3.1).[18] Around the rims of the platters are snails, salamanders, and crabs, all amphibious creatures creeping along the edges of the water, surrounded by deep green vegetation (plate 17, fig. 3.2).[19] Palissy's larger works, the grottoes and pleasure gardens he designed and built for his noble patrons, no longer exist, but he describes one such garden of delight in his 1563 text *Recepte véritable*.

> And above the said mosses and herbs there will be a great number of serpents, aspics, vipers, and lizards, which will appear to run over the said rock, some upwards, some to

one side, some downwards, disposed in many pleasant gestures and agreeable contortions; and all the said animals shall be modelled and enamelled so like to nature, that the natural lizards and serpents shall come often to them with wonder, as you see that there is a dog in my workshop, that many other dogs have growled at seeing, thinking that it was natural.[20]

For Palissy, his grottoes were not just places of pleasure. His ability to re-create a grotto and the freshwater spring it contained demonstrated his understanding of the most fundamental processes of nature. Grottoes and their springs were considered primary sites of nature's generative and transformative powers.[21] Their imitation was an attempt to mimic the generative forces of nature. They were regarded as holding the key to knowledge about the processes by which rocks, minerals, and fossils were formed. Palissy's natural philosophy, published in two treatises, was concerned with precisely these processes.

After seeing his work in provincial Saintes, Catherine de Médicis, the queen mother, called Palissy to Paris in 1567 to decorate the halls and gardens of the Tuileries palace, naming him *inventeur des rustiques figulines du Roy.* Palissy went to Paris to

FIGURE 3.1.
Bernard Palissy and his workshop, *Mold of a Hymenoptera,* after 1567, terra-cotta, 8.2 × 5.3 cm, Musée de la Renaissance, Écouen. Photo: R. G. Ojeda. Copyright Réunion des Musées Nationaux/Art Resource, NY. A terra-cotta mold for a wasp from the order Hymenoptera found in the remains of Palissy's Paris workshop. While many lizard and frog molds made from life were found at this site, this is the only insect molded from life found.

FIGURE 3.2.
Bernard Palissy and his workshop, *Oval Plate,* ca. 1556, glazed ceramic, 38 × 37 cm, Louvre, Paris (inv. MR 2295). Photo: J. G. Berizzi. Copyright Réunion des Musées Nationaux/Art Resource, NY. Amphibious creatures, reptiles, fish, and other shoreline creatures, all molded from life, populate this teeming plate, suggesting an abundant capacity for reproduction and regeneration.

build the grotto and continued to work in Paris, with short interruptions, for the rest of his life.

Palissy's texts—two published in 1563 and one in 1580—are as interesting as the remarkable objects he created. In 1563 he published a short description of a grotto planned or built for the duke of Montmorency[22] and a book, *True Recipe by which all the men of France would be able to multiply and augment their treasures.* The *Recepte véritable*, organized as a dialogue between unnamed interlocutors, contains a diversity of subject matter ranging from farming and fertilizing methods to an account of the Reformed Church in the town of Saintes. It includes a plan for the garden of delight (which was also a refuge from the persecutions of war and religious conformity) and a design for a fortress, shaped after nature in the protective form of a shell. The book also contains observations of nature and theories about the genesis of rocks, crystals, metals, springs, and other natural formations. This work of natural history was also, perhaps primarily, a religious testament, and in it Palissy is concerned to make clear his commitment to the Reformed faith and to the promulgation of its tenets. He appears to have helped found the Reformed Church in Saintes, and he even viewed his garden as a work of worship.[23] Palissy's contemporaries Charles Estienne and Jean Liébault, authors of *Maison rustique* (1582) and Huguenot gardeners, expressed similar ideas: "Husbandrie . . . wherin we doe not only see with our eies and handle with our handes the works of nature: but (which is more) wee finde out thereby the incomprehensible power and greatness of God."[24]

Palissy published his second book, *Admirable Discourses on the nature of waters and fountains, either natural or artificial, on metals, salts and salines, on rocks, earths, fire and enamels. With many other wonderful secrets about nature. Plus a treatise on marl, very useful and necessary, for those who practice agriculture. The whole arranged as dialogues, in which are included theory and practice*, in 1580. The *Discours admirables* is similar to the *Recepte véritable*, containing treatises on springs and fountains, metals, alchemy, potable gold, theriac, ice, salts, rocks, clay, potting, and marl, and it assembles the material that Palissy presented in public lectures in Paris between 1575 and 1584. While public lectures by practitioners were not wholly unknown in the 1570s, Palissy's lectures, according to his own evidence, drew not just practitioners but also physicians and surgeons of the court as well as nobles and gentlemen and perhaps even Francis Bacon.[25] Palissy kept a collection of rocks, fossils, and earths that he employed to illustrate his lectures and demonstrate his theories, and he included a list of the labels from his collection in the *Discours admirables*. He regarded the objects in the museum as proving his written theories by satisfying the bodily senses.[26]

The *Discours admirables* as a whole discusses processes of generation, growth, and change. Palissy wrote on springs and waters, alchemy, ice, salts and their central place

in the generation of terrestrial bodies, on stones, clays, and marl earths as well as on their generative potential for agriculture. Palissy regarded salt as the generative principle of all things and springwaters imbued with these salts to be the cause of generation.[27] Between Palissy's chapters on clays and on marl earths is the "Art of the Earth," a dialogue in which Theory attempts to pry out of Practice the secret of his glaze making.[28] Theory begins by accusing Practice of attempting to divert him from his goal of learning the art of the earth. Practice scoffs, "Do you believe that a man of sound judgment would thus wish to give away the secrets of an art that has cost dearly to the man who has invented it?" Theory responds that Practice is "misusing the gifts of God," but Practice contends that while "the word of God" and the "sciences that serve the whole state must not be kept secret," his "charming invention" will become common and cheap if he yields to Theory. When Theory promises to keep it secret, Practice tells him instead that he is not "wide awake, quick, sympathetic and hard working" enough to carry it out nor does he have the requisite capital needed to bear the losses incurred in practicing the art of the earth. Theory retorts that if Practice teaches him *in writing* the fruit of his experience, he will not need these prerequisites. To this Practice replies:

> Even if I used a thousand reams of paper to write down all the accidents that have happened to me in learning this art, you must be assured that, however good a brain you may have, you will still make a thousand mistakes, which cannot be learned from writings, and even if you had them in writing, you would not believe them until practice has given you a thousand afflictions.

Palissy here asserts that knowledge comes not from writing or reading but must be gained by doing and labor. In this assertion, he opposes the consuming, barren, and written culture of theory to the productive, active world of practice. Practice finally agrees to tell Theory his secrets, but not before he has told him "the calamities I have endured before attaining my goal . . . because you will see that nothing can be attempted or completed, to render it in beauty and perfection without great and extreme labor, which never comes singly but is always accompanied by a thousand anxieties." In telling the story of his calamities, Practice makes clear to Theory what he means when he says that knowledge must be learned by labor; in fact, Practice means nothing less than a Paracelsian union with his material. The result of this union is a perfectly rendered object.

In the guise of Practice, Palissy begins his own story by relating his encounter with the porcelain vessel, an "earthen cup, turned and enameled with such beauty that

I was immediately perplexed." At once he "started to look for enamels, like a man who gropes in the dark." He began by crushing all sorts of things that might be used; he bought earthen pots and painted them with his glazes, writing down which mixture he applied to each piece. But nothing worked. "For several years, with sadness and sighing," it went on this way, first sending off "three or four hundred pieces" to a nearby pottery, then putting them into the kilns of glassworks, until finally "God willed that just as I began to lose hope, and for the last time had gone to a glass works with a man carrying more than three hundred kinds of experiments, it happened that one of them melted within four hours of being put into the kiln which was so white and polished as to cause me such joy that I thought I had become a new man." For Palissy, the enamel's melting in this way signaled a rebirth, both of himself and his hopes. He spent "seven or eight months" making earthen vessels, building his kilns by his own "incredible labor," mixing his mortar, drawing the water, fetching the brick on his own back. As he describes it, he worked "like a desperate man," spending six days and nights (the span of Creation) at the kiln tending the fire. Still, the enamel would not melt. He crushed new materials for the enamel, fired up his kiln again, whereupon running out of wood, he began to burn the wood of his garden and then his own house: "I was forced to burn the tables and the floor of my house, in order to melt the second mixture." He describes his situation vividly: "I was in such anguish as I could not describe: for I was quite dried out because of the work and the heat of the kiln; for more than a month my shirt had not dried on me, and moreover, to console me I was jeered at, and even those who should have helped me, went about the town shouting that I was burning up the floor: and thus I was made to lose my credit, and I was thought to be crazy." At the end of his nine-month labor, he had yet to bring forth progeny.

He fell into a "sad and puzzled mood," finally hiring a potter to turn the vessels. Ripping apart his last kiln in order to build a new one, the flesh of his hands was so torn that he was "forced to eat with my fingers wrapped in bandages." But this kiln ruined an entire load of pots when the pebbles in the brick exploded and stuck to the glaze. The next kiln-load was ruined by ash blowing into the glaze, followed by a batch whose enamels would not melt all at the same time until "all these mistakes have caused me such labor and mental anguish that before I had made my enamels fusible at the same degree of fire, I thought I would be at death's door." And, indeed, his body suffered the ravages of his unsuccessful labor: "Also as I worked at such things for more than ten years my body was so wasted away that my arms and legs had no form or trace of muscles, but on the contrary my legs were like sticks." His home was no refuge, for "I could obtain no patience, nor do anything that was con-

sidered good. I was despised and jeered at by everyone." He ends his lament dwelling on this sad situation:

> For several years, having nothing to roof over my kilns, I was every night at the mercy of rains and winds, with no succor, aid or consolation, except for the owls hooting on one side and the dogs howling on the other; sometimes winds and storms sprang up which blew so hard over and under my kilns that I was forced to leave everything, losing my labor; and it happened often that having left everything, without a dry rag on me, because of the rains that had fallen, I went to bed at midnight or at dawn, dressed like a man who has been dragged through all the mud holes of the city; and in retiring thus, I stumbled about without light, and falling on one side or another, like a drunkard, filled with great sadness: because after having worked a long time I saw my labor lost. Now, in retiring thus dirty and wet, I would find in my bedroom a second persecution worse than the first, which makes me wonder now that I did not die of sadness.

But Theory knows Practice eventually attained success, and so, impatient with Practice's stories, Theory demands that Practice tell him in a straightforward way what his secrets are. Practice responds with the ingredients of his enamels but not the precise doses, saying, "The mistakes I made while I found out the dose for my enamels taught me more than the things that were easy to learn: therefore I judge that you should work to find this dose, just as I have done; otherwise you would esteem the knowledge too lightly."[29] Theory gives up in disgust, calling the art too mechanical to be prized in any case. Practice expostulates that it is an art far from mechanical, and, in addition, it is useful to all facets of human civilization. And there, although not for the last time, the dialogue between Practice and Theory breaks off.

In this vivid account of his trials, Palissy identified the foundation for his authority in speaking. As Practice, he possessed knowledge inaccessible to Theory, for despite Theory's superior status, Theory did not have the requisite habits of observation, the material skills, nor the stamina. Practice possessed productive knowledge by which he could earn his bread, and this economic reality gave him power over Theory. In this, Palissy echoed the claims of artisans from Cennini to Robert Campin and Dürer, all of whom insisted on the power and sanctity obtained by earning a living through artisanal labor. Practice gained his knowledge of clays and glazes through experience, literally through trial by fire. His body and his home are consumed in the process, forming a unity, like Paracelsus's experience, with the materials he works. In the end, Practice's labor redeems him and his household, an ex-

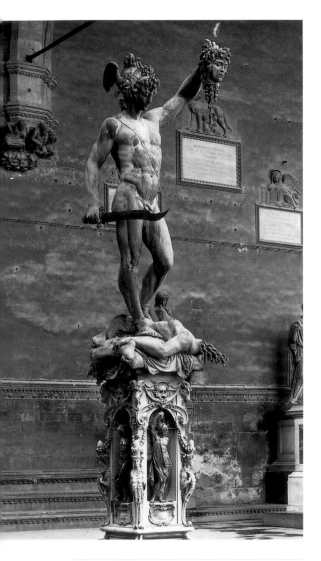

FIGURE 3.3.
Benvenuto Cellini, *Perseus with the Head of Medusa*, ca. 1545–54,
bronze with marble base, 320 cm in height, Loggia dei Lanzi,
Florence. Copyright Alinari/Art Resource, N.Y. Perseus stands
atop Medusa's lifeless body, holding aloft her freshly severed
head from which blood pours. Blood spurts as well from
Medusa's neck. In his lifelike depiction of blood, Cellini alludes
to the life force that he employed in his imitation of nature (or
his *ars*) to achieve this feat of bronze casting.

perience denied to Theory because Theory does not labor.[30] Palissy's ceramic amphibians, fish, and reptiles show the naturalistic effects of Paracelsian experience, and they display the knowledge of nature that made Palissy capable of producing such works of art.

A similar bodily involvement in the entire process of creation appears in the sculptor and goldsmith Benvenuto Cellini's (1500–1571) account of casting his statue *Perseus with the Head of Medusa* in 1545–54 (fig. 3.3). Before Cellini began the final work of casting, he felt troubled in spirit but managed to rid himself "of all those troublesome thoughts" and "with renewed strength and all the resources . . . [of his] limbs and . . . pocket," he commenced to work on the *Perseus* statue. He clothed his wax model in clays that had been in preparation for months; then he armed the clay investment with iron supports, melted out the wax, and built a funnel-shaped furnace around the clay mold from bricks. After the mold had baked for two days, he lifted it into a pit. He then prepared the metals and heaped on the pine logs; he "was soon rushing from one side to another, exerting [himself] so much that [he] became worn out." The roof of the workshop caught on fire, and rain and wind swept through the room. Suddenly Cellini was attacked by a fierce fever and he threw himself on his bed, sure that those hours were his last. His fever increased in violence, and he kept shouting out, "I'm dying." A wraith entered his bedroom to proclaim the ruin of his work, at which Cellini sprang from his bed to find the metal "curdled" in the furnace. He told his assistants standing dejected around the mold, "from my knowledge of the craft I can bring to life what you have given up for dead, if only the sickness that is upon me shall not crush out my body's vigour."[31] He piled young oak onto the fire, and the metal began to "glow and sparkle." As the "corpse" of the metal came back to life, Cellini recovered from his fever. The furnace cracked from the heat, and Cellini opened the mouths of the mold to let the metal flow in, but still the metal would not flow, so Cellini ordered all his pewter plates, bowls, and salvers thrown into the molten mass. While his body and his house were consumed, the

bronze melted and the mold filled. He fell to his knees in prayer, calling out, "O God, who by infinite power raised Yourself from the dead and ascended into heaven!" On this, the mold was filled in an instant.[32]

Through his art, Cellini was able to capture the spirits that had resuscitated the dead metal to flowing corporeal vitality. His successful deployment of this vivifying force had sent life coursing back through the dead metal just as it had reentered his own veins. His finished sculpture, in which the realistic blood gushing from Medusa's head and torso alarmed and fascinated Cellini's contemporaries, reflected this. In 1552 Bernardetto Minerbetti wrote, "I cannot get enough of watching the blood that pours impetuously from [Medusa's] trunk. This, although it is metal, seems nonetheless to be real, and it drives others away out of fear that they will be soaked with it."[33] For Cellini, his lifelike imitation of blood appears to be based on an imitation of nature that mimicked the creation of life by coition as well as by God's infusion of matter with spirit.[34] By his understanding of materials and their manipulation (his *ars*), itself founded on his "deeper knowledge of the principles of the art," Cellini mastered nature's powerful forces.[35]

The Dutch apothecary's son and sculptor Adriaen de Vries (1556–1626) displayed a similar understanding of the flow of metal and the flow of blood. De Vries, born in The Hague, probably first apprenticed as a goldsmith, then set off for Italy, where he worked in a shop run by the sculptor Giambologna (1529–1608). From there, de Vries went on to create spectacular bronzes for patrons in Italy, Germany, and Bohemia, producing virtuoso works especially for Emperor Rudolf II. De Vries's sculptures were groundbreaking in their complexity of composition, attention to anatomical detail, and their exploration of movement and balance. De Vries left evidence of his working processes and knowledge of natural materials not in writing like Cellini but instead in his sculptures themselves. For example, instead of clipping off the sprues on some of his most difficult finished statues, he left small sprue ends to indicate that the piece had been created by a single casting (sprues are the channels by which the metal enters the mold; in casting, they fill with bronze and harden, and they must be clipped off and filed down). In the large sculpture of *Naïade with Wheat* (1615–18, Drottningholm Palace, Stockholm), a delicate stalk of ripened wheat was cast as one with the large sculpture, an artisanal feat that de Vries made clear by leaving a small sprue fragment almost hidden in the wheat grains. In his last statue, a large depiction of Hercules (*Hercules Pomarius*, 1626–27), de Vries left the sprues (concealed as vines) feeding directly into the figure's veins, thereby preserving "the very channels through which the master metalsmith infuse[d] the figure with life."[36]

De Vries alluded to his mastery of metalworking in many sculptures, including one in which he draws a connection between himself and Vulcan (fig. 3.4). But in the *Juggling Man* (fig. 3.5), he makes reference also to the processes of transformation that formed the basis of his knowledge of metalworking. This sculpture, which may be based on the ancient model of a dancing faun, substitutes plates, which appear to be magically attached to the hands of the juggler, for the cymbals that had been strapped to the fingers of the ancient dancing faun. Even more revealing, de Vries has replaced the faun's foot organ with a pair of bellows, a tool de Vries would have been entirely familiar with in bronze casting. Juggling was sometimes seen as inhabiting the same realm as alchemy, and both alchemy and casting had the aim of *Kunststücke machen*, or the production of effects.[37] By such allusions, de Vries made clear his own virtuosity (*Kunststücke machen*) in casting bronze and alluded to the processes of transformation articulated by the theories of alchemy that underlay it.

By the late sixteenth century, artisan-authors such as Palissy and Cellini were themselves responding to the evolution of the tradition of the artisan as an interpreter of nature, which had begun in the work and writings of figures like Dürer and da Vinci, but their view of the functions and processes of nature shows continuity with the earlier period. As we saw, Leonardo and Dürer also used similar "bodily" language in recounting their own processes of creation. Somewhat later, Karel van Mander would say of Pieter Brueghel the Elder (ca. 1525–1569) that "when he was in the Alps he swallowed all those mountains and rocks which, upon returning home, he spat out again onto canvases and panels" (fig. 3.6).[38] Even the early artisanal tract of the metalworker Theophilus (fl. ca. 1100) expresses this experience of knowing the nature of matter through bodily experience. Beginning by quoting Paul (Eph. 4:28), "Let him labor, working with his hands the thing which is good, that he may have to give to him that needeth," he continues:

> Therefore longing to be an imitator of this man, I drew near to the forecourt of holy Wisdom and I saw the sanctuary filled with a variety of all kinds of differing colors, displaying the utility and nature of each pigment. I entered it unseen and immediately filled up the storeroom of my heart fully with all these things. I examined them one by one with careful experiment [diligenti experientia], testing them by eye and by hand, and I have committed them to you in clarity and without envy for your study. Since this method of painting [on glass] cannot be obvious, I worked hard like a careful investigator [curiosus explorator] using every means to learn by what skilled arts [artis ingenio] the variety of pigments could decorate the work without repelling the daylight and the

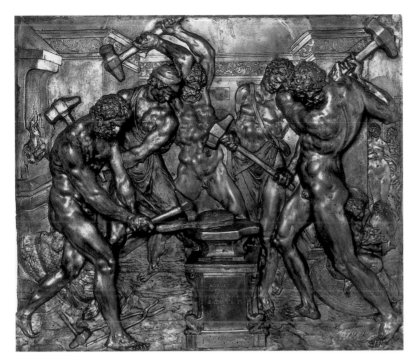

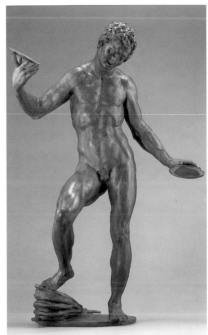

FIGURE 3.4.
Adriaen de Vries, *Vulcan at the Forge*, 1611, bronze, 47 × 56 cm, Bayerisches Nationalmuseum (inv. no. 69/57). In this relief, de Vries depicts Vulcan making armor for Aeneas, a reference to Virgil's *Aeneid* in which Venus asks Vulcan to make armor for her son. Vulcan is the center figure, poised with hammer high over his head before bringing it down on the forge bearing de Vries's name and birthplace. Venus and her servant stand to the right of the scene, overseeing Vulcan's progress. Cupid is pictured on the right, holding the finished helmet and sitting on Aeneas' shield. By placing his name at the center of the bodily labor of Vulcan's workshop, de Vries equates his own artisanship with the mythic work of Vulcan.

FIGURE 3.5.
Adriaen de Vries, *Juggling Man*, ca. 1610–15, bronze, 77 × 51.8 × 21.9 cm, The J. Paul Getty Museum, Los Angeles. Where the ancient statue of a dancing faun, on which this statue of a juggler is probably based, held small cymbals attached by straps to his fingers and worked a small accordion with his foot, this juggler's plates seem magically attached to his fingertips and his foot is positioned on a bellows. The work appears to allude to de Vries's own virtuosity at *Kunststücke machen* in his bronze casting.

FIGURE 3.6.
Pieter Brueghel the Elder, *Alpine Landscape with an Artist Sketching*, ca. 1555–56, pen and ink on paper, 27.7 × 39.6 cm, Courtauld Gallery, Courtauld Institute, London. Brueghel's sketches formed the basis for his naturalistic landscapes painted after his journey across the Alps.

rays of the sun. By devoting my efforts to this task I have come to understand the nature of glass, and I see that this effect can be achieved by the use of glass alone and in its variety. I have made it my concern to hunt out this technique for your study as I learned it by looking and listening.[39]

The stress Theophilus puts on looking and listening calls to mind Paracelsus's open eyes and method of "overhearing."

We might even regard a scholar-artisan such as Peter Paul Rubens as pointing to the body as the source of his creativity. On the basis of his painting *The Drunken Silenus*, Svetlana Alpers has argued that Rubens identified with the feminine creative power, representing it, as a male artist, in the image of the drunken Silenus (fig. 3.7). Silenus, who had been rendered impotent by drink, instead poured out his creative power in song and poetry. Alpers sees in Rubens's emphasis on Silenus's body and the painter's cross-gendering of men and women a statement that the creative power is located in the flesh.[40] It is possible to understand Rubens's painting, as Alpers does, not only as an identification with female creativity, but also perhaps as an attempt to reconcile his artisanal understanding—formed by working in matter with the hands—and his scholarly training in texts (analogous to Paracelsus's inversion of *scientia* and *experientia*). Like other artisans, Rubens viewed flesh and active matter as the creative force with which he was imbued and with which he struggled, and he found a suitable representation of this artisanal experience in Silenus, the obscure creator of song and poetry from classical texts.

These artisans all had in common an "individual struggle with reality,"[41] and this struggle—this bodily experience of the particulars of matter—resulted in a knowledge of matter and its transformations, proved by the artisan's creation of "effects," or works of art.

Bodily Labor in the Workshop

Viewing works of art in the pristine setting of a museum today, it is easy to overlook the bodily labor of the painter's workshop, where the grinding and production of colors might take days. Cennini's manuscript instructions for the painter indicates just how labor intensive the preparation of materials, such as paints, brushes, gessoes, plaster, and varnishes, could be.[42] Just to *begin* to practice drawing, he recommends that the apprentice wash down a little boxwood panel, nine inches square, rub and smooth it

FIGURE 3.7.
Peter Paul Rubens, *The Drunken
Silenus*, ca. 1610, oil on canvas,
205 × 211 cm, Bayerische
Staatsgemäldesammlungen,
Alte Pinakothek Munich.
Rubens depicts a fleshy, nude,
and drunk Silenus stumbling
forward, simultaneously sup-
ported and mocked by his com-
panions in revelry. Mating
goats and a woman giving suck
to two young satyrs emphasize
fertility and generation, while
the black man pinching
Silenus's ample thigh calls at-
tention to the fleshly basis of
Silenus's power of creation.

thoroughly with a cuttle, then coat it with a ground of finely powdered bone that had been worked diligently on the grinding stone for two hours.[43] He generally advises grinding up pigments "as much as ever you can stand grinding them, for they can never be done too much; because the more you grind them, the more perfect tint it becomes" (pp. 9–10). He goes on to note, "Even if you were to grind it every day for twenty years, it would still be better and more perfect" (p. 24). This was not the case, however, for blue-green *verde azurro* (malachite) or blue azurite, for too much grinding of these minerals would spoil their brightness (which occurred when the crystals were ground too fine; p. 31). The making of *gesso sottile* could take a month: "It is purified for

a whole month by being soaked in a bucket. Stir up the water every day, so that it practically rots away, and every ray of heat goes out of it, and it will come out as soft as silk (p. 71)." Painstaking, time-consuming processes were not limited to the painter's workshop. For investing the mold of *Perseus*, Benvenuto Cellini used a certain clay mixed with cloth frayings that needed to rot for at least four months until the clay became "like an unguent."[44]

One contract between a sculptor and a patron who was concerned that the master sculptor would give the job to an apprentice specifies that the sculptor "must work with his own body."[45] The labor of the workshop was not done with hands alone. Before beginning the delicate work of drawing on gilded glass, Cennini advises the artisan to "not work with haste—rather with great enjoyment and pleasure. . . . [T]he day before the day you want to work at this job, you hold your hand to your neck, or in your bosom, so as to get it all unburdened of blood and weariness" (p. 113). To begin making enamels, Cellini tells his reader, "You must take a nice clean piece of paper, and chew well between your teeth." He goes on to note that he could not do so because he has no teeth left and so must beat the paper with a little hammer.[46] As Michelangelo allegedly proclaimed, "In my works, I shit blood."[47]

As Michelangelo's remark indicates, bodily labor in the workshop was more than just hard work; it also involved bodily fluids and processes. In the manuscript of the twelfth-century metalworker Theophilus, his reader is instructed to polish niello (blackened silver) by rubbing it all over with saliva and then to "take some wax from your earhole and after wiping the niello smear the wax all over it with a fine linen cloth."[48] He also recommended the use of urine for many processes; indeed, for tempering steel, he deemed most effective the urine either of "small red-headed boys" or of goats fed solely on ferns.[49] Benvenuto Cellini maintained that the urine of little children was purer and warmer than that of adult men and thus was better for cleaning precious metals.[50]

The workshop was never far from the kitchen, and the bodily dimension of workshop labor is apparent in Cennini's analogies to cooking, such as in his instructions for working over the mass of lapis lazuli, pine rosin, gum mastic, wax, and lye in "just the same way" as bread dough to make ultramarine blue[51] or in tempering *gesso sottile* by mixing it "as if you were making a batter for pancakes, smoothly and deftly, so that you do not get it frothy."[52] His recipe for goat glue sounds not unlike food preparation:

> And there is a glue which is known as leaf glue; this is made out of clippings of goats' muzzles, feet, sinews, and many clippings of skins. This glue is made in March or January,

during those strong frosts or winds; and it is boiled with clear water until it is reduced to less than a half. Then put it into certain flat dishes, like jelly molds or basins, straining it thoroughly. Let it stand overnight. Then, in the morning, cut it with a knife into slices like bread; put it on a mat to dry in the wind, out of the sunlight. (p. 67)

Beer could be used in gilding,[53] flour and water were boiled together to make glue, and the soft, moist inside parts of bread were used to erase or clean a drawing.[54] Garlic juice was mixed with a little white lead and bole to make a fast-drying mordant for gilding. When the artist was ready to use it, he mixed it with a little urine.[55] Soft bacon fat was used to grease molds.[56] Cennini suggested the yolk of a town egg as the binder for tempera paint in rendering a young person of fresh complexion. Due to its darker color, a country egg should be used for painting the flesh of aged or swarthy persons.[57] Early modern people were known to eat the ingredients of artists' pigments, while others, such as the brilliant blue lapis lazuli and a brown pigment called "mummy," were regarded as medicaments.[58] In regard to lapis lazuli, Theodore Turquet de Mayerne (1573–1655), a Paracelsian physician who collected pigment recipes and experimented with varnishes, writes that "it is the diamound of all colours by reason of his never fading perfectione. It also comforteth the brayne, and therefore is very proffitable agaynst frensies, vertigo, palpitatio cordis, melancholia and other sicknesses of the spirit."[59] Palissy theorized that earths used for pigments and those used for medicines were both the result of substances putrefied and then petrified by the generative principle of the fifth element.[60] Indeed, certain clays were used to cause skin ulcers to scab over.[61] High-grade oils were eaten, lesser ones were used for lighting, and both were specified in all manner of artists' processes.[62] Color makers, apothecaries, and frequently physicians all belonged to the same Guild of St. Luke, and all often produced and sold both medicaments and paints.[63] Moreover, an artisan's body was often marked by his labor. The fumes inhaled in a metalworking shop or a gilding shop could contain mercury vapors, lead, and a number of trace metals, which caused Cellini to observe that men involved in amalgam gilding lived but a very few years.[64] The Genoese sculptor Domenico Parodi, who had a rich library full of alchemical works, died after inhaling fumes from his distillation furnace.[65] Artisanal manuals advised those who worked with lead (in refining silver, for example) or mercury (in gilding) not to carry out their tasks on an empty stomach and to immediately eat a large slice of bread and butter whenever they felt hungry during the process.[66] These instructions and the processes to which they refer all suggest how deeply implicated the whole body was in artisanal labor.

That the principles of intellectual activity, such as those promulgated by rhetoricians or art theorists, did not precisely coincide with the experiential knowledge of the arts, no matter how desperately an artisan wished to promote his art as liberal, is evident in early writings about artistic creativity. Artisans used metaphors of parturition and biology to describe their own artistic creation. The goldsmith and architectural writer Filarete, for example, employed a gestation and birth metaphor to describe the processes by which an architect creates a design for and eventually gives birth to a new building.[67] Leonardo commonly called upon verbs connoting biological generation—*creare*, *partorire*, *nascere*, and *generare*—to describe the work of artistic production, when he did not use the standard "*fare*," which, as Martin Kemp notes, "could be applied as readily to pasta as to painting."[68] In the early seventeenth century, Karel van Mander equated the process of artistic imitation, or "begetting a likeness," and the urge to procreate.[69] Given the bodily dimension of artisanal practice, it is not surprising that Dürer titled his first sketch for a painter's manual "Speis der Malerknaben," or "Food for Painters' Apprentices."[70] Paracelsus's view of medical knowledge was similar to the embodied knowledge of the artisan: "The art of medicine cannot be inherited, nor can it be copied from books; it must be digested many times and many times spat out; one must always rechew it and knead it thoroughly, and one must be alert while learning it."[71]

Active Matter and Naturalism

Artisans engaged in a bodily struggle with and against matter itself. Matter was not dead but alive, and it behaved in idiosyncratic ways, which artisans had to come to know—and master—through experience. Cennini writes about white lead and verdigris as each other's "mortal enemies in every respect" (p. 33) and azurite as being "very scornful of the [grinding] stone" (p. 36). Varnish is "a powerful liquid . . . and it wants to be obeyed in everything. . . . And immediately, as you spread it out on your work, every color immediately loses some of its resistance, and is obliged to yield to the varnish, and never again has the power to go on refreshing itself with its own tempera" (p. 99). Size (used to prepare wooden panels for paint) could be lean or fat (p. 68), and size with a water base could give the wood panel a good appetite: "Not being so strong, it is just as if you were fasting, and ate a handful of sweetmeats, and drank a glass of good wine, which is an inducement for you to eat your dinner. So it is with this size: it is a means of giving the wood a taste for receiving the coats of size and gesso" (p.

THE BODY OF THE ARTISAN

70). In explaining why a stone figure must be varnished and coated with mordant and charcoal before gilding, he writes: "Stone always holds moisture, and when gesso tempered with size becomes aware of it, it promptly rots and comes away and is spoiled: and so the oil and varnish are the instruments and means of uniting the gesso with the stone, and I explain it to you on that account. The charcoal always keeps dry of the moisture of the stone" (p. 119).

Magnets in particular exhibit active behavior: "The lodestone loves iron, and iron loves the lodestone so passionately that the lodestone hungers for the iron and seeks to attract it with all its strength, while the iron, in turn, acts toward it as if it were alive, leaps up to meet it and clings to it."[72] Gold can be "fastidious" about the stone with which it is burnished (p. 83). Indeed, burnishing gold is delicate work:

> Take your burnishing stone, and rub it on your breast, or wherever you have any better clothing that is not greasy. Get it nice and warm; then sound out the gold, to see whether it is ready to be burnished; sound it out cautiously, always with hesitation. If you feel any dust under the stone, or feel it grit at all, like dust between your teeth, take a minever tail, and sweep lightly over the gold. And so burnish up a flat gradually, first in one direction, then, holding the stone quite flat, in the other direction. And if, while rubbing with the stone, it ever strikes you that the gold is not as even as a mirror, then take some gold, and put it on, by the leaf or the half leaf, at the same time blowing with your breath to begin with; and immediately burnish it with the stone. (p. 84)

The artisan had to sound out his materials, to be attuned to them, or, as Paracelsus expressed it, to "overhear" matter.[73] Some parts of the artisan's body were better for this than others; for example, Cennini directs his readers to

> sound out these productions [mordant-coated panels or ornaments] with the ring finger of your right hand, that is, with the fingertip; and if you find it a little bit tacky or adhesive, then take the pincers; cut a half leaf of fine gold; or alloyed gold, or silver, though these do not last; and lay it over this mordant. Press it down with cotton, and then, with this finger, gradually stroke up some of this gold, and lay it over the mordant which has none. And do not do it with any other fingertip, for that is the most sensitive one you have. And see that your hands are always clean. (pp. 96–97)

Bernard Palissy's list of the powers of salt (the generative principle of his fifth essence) suggests that he saw all parts of nature active and alive and imbued with a

vital principle. He viewed salt as, for example, giving tone to all sounding metals as well as giving song to humans. Indeed, his list is so diverse and unexpected that it is best read in its entirety:

> Salt is the cause of the flavor of all kinds of fruits and plants.
> The salt in all plants, metals and minerals causes the virtue that is in them.
> Salt whitens all things.
> It gives tone to all things.
> Makes all things transparent.
> Causes the action of mirrors and spectacles.
> It causes friendship and generative virtue.
> It is cause of the voice and incorruption.
> It attracts dyes.
> It takes from the one to give to another.
> And as it gives tone to metals, so it does to the songs and hymns made by humans, even makes glad men and animals.
> Without salt it is impossible to make glass.
> Common salt is an antivenom.
> Without salt no blade would have strength to cut or even to be hardened.
> It is impossible for the tongue to find flavor in anything, unless it is first dissolved and attracts some part of the salt which is in the thing that it touches.
> In the bark of the wood is contained almost all the salt of the tree.
> If there were no salt in wood-bark it could not tan leather, nor clean cloth and would be useless in lye.
> If there were no salt in straw and hay, manures could in no way improve the soil.
> If it were not for the salt in spices, embalmed corpses would putrefy.
> Without the effect of salt nothing would have an odor.
> Sealed earth has no power against poison except because of the action of salt or congelative water.
> The ashes of all kinds of wood, trees and bushes are suitable for making glass because of the salt which is in these woods through hay and straw.
> If there were no salt in rocks, they could not be used, when calcined, by the tanners to prevent rotting of leather.
> The shells of marine fishes are very good for making lime, and this is evidence of the saltiness that is in them.
> The salt of grapes destroys copper, turning it into verdigris.

There is in human things a beginning of form held up by the fifth element, and other-
wise all natural things would remain jumbled up together without any form.
The number of the various kinds of clay is incalculable.
The effects of these earths are marvelous, even indescribable.[74]

Caroline W. Bynum has suggested that the deep interest in the body in Europe
in the high Middle Ages sprang from a view that matter, and particularly the body, was
pregnant with creative potential.[75] Many artisans shared this view of nature and sought
through their work to make clear the creative power of matter and the copiousness of
nature, while at the same time proving their ability to play on nature's potential.[76] The
naturalism they strove for in their work was related to their view of matter as active.[77]
This can be seen in their focus on the diversity and copiousness of nature and espe-
cially in the exact representation of insects and reptiles. Why these particular crea-
tures? The careful rendering of insects of all kinds in a late-fourteenth-century trea-
tise on the virtues[78] might be related to Aristotle's statement that "things which in
themselves we view with distress, we enjoy contemplating when they are represented
with very great accuracy—the forms of the lowest animals, for instance, and also of
dead bodies" (fig. 3.8).[79] Insects could also signify the greatness of God; in Joris Hoef-
nagel's *The Four Elements*, a luxury manuscript made for Emperor Rudolf II, insects em-
bodied the element fire (*Ignis*). The opening text of this segment of Hoefnagel's vol-
ume declares, "Of all the miracles made by man, a greater miracle is man. Of all visible
miracles, the greatest is the world. Of those invisible, God. If we see that the world ex-
ists, we believe God exists." Elsewhere he states that insects demonstrate the artifice of
the Creator: "They shall speak of the magnificence of the glory of thy holiness; and
shall tell thy wondrous works."[80]
 The common denominator of these carefully rendered insects was the fact that
they had all emerged from dead and rotting matter. They could symbolize the regen-
erative power of nature because they emerged spontaneously from decay. The anony-
mous record that depicts a plant growing out of a snake can be understood as being in-
formed by the same belief in the creative potential of putrefying matter (fig. 3.9).[81]
Thus, insects and reptiles appear to be both embodiments of decay and harbingers of
regeneration and even of redemption, at least for Hoefnagel. Once again, Paracelsus
offers insight into this question. One of the central components of his matter theory
is putrefaction. He regarded all generation as taking place through a process of putre-
faction, that is, decay and subsequent regeneration. In putrefaction, all manner of life
was produced, but first came "serpents, toads, frogs, salamanders, spiders, bees, ants,

FIGURE 3.8.
Anonymous, border with
insects, from the *"Cocharelli"*
Treatise on the Virtues and Vices, late
fourteenth century. By permis-
sion of the British Library, Ms.
Add. 28841, f. 4. The margins of
this Genoese manuscript, pro-
duced ca. 1380, teem with some
of the first naturalistic depic-
tions of insects made in western
Europe. Such insects possessed
polyvalent significance.

and many worms."[82] This theory of generation is commonly depicted in alchemical il-lustrations, such as that in figure 3.10. The marginal creatures of the fourteenth-century manuscripts as well as the reptiles cast from life in Jamnitzer's metalworking (fig. 3.11) and in Palissy's ceramics (fig. 3.12) take on new significance in light of this theory. These small creatures indicated nature's transformations and powers. They were thus resonant with meaning for the artisan who was able to render them per-fectly, for he thereby demonstrated his ability to imitate nature (and nature's powers) and alluded to his knowledge of the most profound of natural processes.

Even the lowly fly could have such resonance as a harbinger of putrefaction and regeneration. Artists included flies in their paintings, such as that in Dürer's 1506 *Feast of the Rose Garlands*, in which a fly has alighted on the white cloth of Mary's dress just in front of Maximilian I's praying hands. The fly probably also referred to Pliny's account of Apelles, court painter to Alexander the Great, who painted a fly so realistic that all who saw it attempted to brush it away.[83] Dürer thus made a double allusion in

FIGURE 3.11.
Wenzel Jamnitzer, *Lifecast of a Lizard*, sixteenth century, lead, Staatliche Museen zu Berlin–Preußischer Kulturbesitz (Kunstgewerbemuseum). Photo: Jörg P. Anders.

FIGURE 3.11.
Wenzel Jamnitzer, *Lifecast of a Lizard*, sixteenth century, lead, Staatliche Museen zu Berlin–Preußischer Kulturbesitz (Kunstgewerbemuseum). Photo: Jörg P. Anders.

FIGURE 3.12.
Attributed to Bernard Palissy, *Oval Basin*, mid-sixteenth century, lead-glazed terra-cotta, 33 cm in width, The J. Paul Getty Museum, Los Angeles.

FIGURE 3.13.
Michael Maier, "Salamander in the Fire" from *Atalanta Fugiens*, 1617, Library, Getty Research Institute, Los Angeles. Salamanders were thought to be immune to fire or capable of regenerating when burned.

his depiction of the fly, both to his knowledge of the powers of nature and to the power of his illusionistic art. Cellini makes a similarly multivalent statement in his autobiography, when he recalls that one of his very first childhood memories was of seeing a salamander in the fire. Salamanders were believed to be capable of surviving or regenerating in fire and were often used as a symbol of regeneration through destruction, for example in Michael Maier's use of a salamander in an alchemical text (fig. 3.13).[84] Cellini recalls this event in his autobiography because it was marked on his body: after his father called him and his sister in to see the salamander, he gave Benvenuto such a "violent box on the ears that I screamed and burst into tears." At this, his father "calmed me as kindly as he could and said: 'My dear little boy, I didn't hit you because you had done wrong. I only did it so that you will never forget that the lizard you saw in the fire is a salamander.'"[85] The salamander was a very suggestive point of beginning for this quintessential Renaissance artisan's account of his own creative (and virile) powers. It probably also had much to do with the fact that the salamander was the noble emblem of Francis I, for whom Cellini worked in Paris and Fountainbleau from 1540 to 1545.

The Powers of Nature

A study drawing from the workshop of Martin Schongauer and his three goldsmith brothers gives insight into the multivalent significance these creatures and their accurate representation could carry (fig. 3.14). The drawings on this sheet of a snail, asp,

lizard, and frog were probably done after study of dead and possibly dried specimens. The observation of the artisan is faulty in some instances, such as that of the snail shell, which is a physical impossibility. This is probably an apprentice's study sheet. It appears to have been corrected for verisimilitude; for example, the master has corrected the snail's antennae (although not the shell) and the lack of webbed feet on the frog and also has admonished the apprentice to make the animals more lifelike and less desiccated. Finally, in the right lower corner, the master alludes to the purpose of these images: they probably served as models for amulets cast in metal and perhaps were filled with the dried and pulverized animal, for, as the inscription reads, they were "to be placed on the head of a 29-week pregnant woman." Frogs and other amphibious animals were often used as amulets in childbirth.[86] These drawings of amulets give us insight into a web of connections: the verisimilitude of the apprentice's drawings mattered because knowledge and efficacy resided in nature. Nature had to be imitated to bring into operation natural processes; processes that were bound up with the workings of the human body. In the artisan's attempt to imitate nature, he strove to create effects by employing the powers that inhered in nature.

 The lizard on the study sheet appears again in Schongauer's engraving *The Flight into Egypt*, where it scurries up a dragon tree (fig. 3.15).[87] In a woodcut of the same subject, Dürer portrayed these reptiles around a spring, the source of all generation, past which the holy family journeys (fig. 3.16). These prints, like Dürer's *Madonna with a Multitude of Animals* (1503) (plate 18), allude to the correspondence between divine and natural powers. The spiritual drama enacted by the holy figures in Dürer's drawing—Mary and Jesus in the foreground as well as the angel and the shepherds in the far distance—resonates with the generative powers of nature, indicated by the variety and copiousness of animals surrounding Mary in the foreground (all of which were studies from life). Nature and nature's powers are shot through with the presence of the divine, and the creatures that creep forth from rotting matter, evidence of nature's generative and transformative powers, indicate best the presence of the divine in nature.

FIGURE 3.14.
Martin Schongauer (workshop of), *Snail, Snake, Lizard, and Frog*, ca. 1495, pen and black ink with traces of green watercolor, 21.7 × 18.4 cm, © 2003 Bildarchiv Preußischer Kulturbesitz, Berlin (Kupferstichkabinett).

Martin Schongauer, *The Flight
into Egypt*, ca. 1470, engraving,
© 2003 Bildarchiv Preußischer
Kulturbesitz, Berlin (Kupfer-
stichkabinett). In flight from
Herod, the holy family journeys
through the wilderness on their
way to Egypt. Schongauer por-
trays Mary, Joseph, and Jesus
briefly resting under a canopy
of trees. Mary sits on the don-
key, her arms around the Jesus
child. Joseph is reaching up to
take the dates miraculously of-
fered by the tree, a story
counted in the apocryphal
Gospel of Matthew. Three
lizards scurry up the dragon
tree, a tree native to Africa that
was later used by painters to
symbolize the Tree of Life in
the Garden of Eden. Schon-
gauer's accurate depiction in
this engraving is the first Euro-
pean description of any kind—
written or visual—of this tree,
although the tree had been
known since antiquity for its
translucent red resin that
seeped from wounds in its bark.
This resin was held to be the
blood of a true dragon and was
used for magic. It was also re-
garded as especially potent in
stopping the flow of blood.
There are two other plants in
this print that Schongauer ob-
served closely from nature, the
thistle in the lower right and
the *Königskerze* or *Marienkerze*
(mullein or Jacob's staff in
English) that is just touching
the hem of Mary's robe. This
was a wild-growing medicinal
herb that was gathered on the
feast of the Assumption of the
Virgin to be blessed in church.
Particular powers of healing
and protection were ascribed to
these sanctified plants.

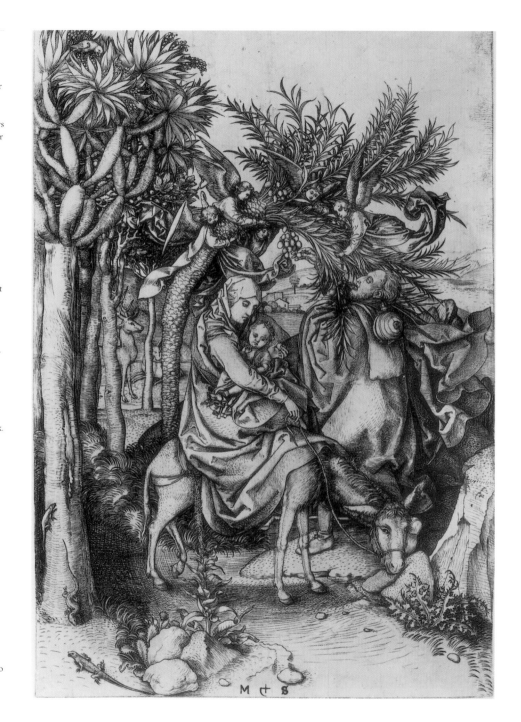

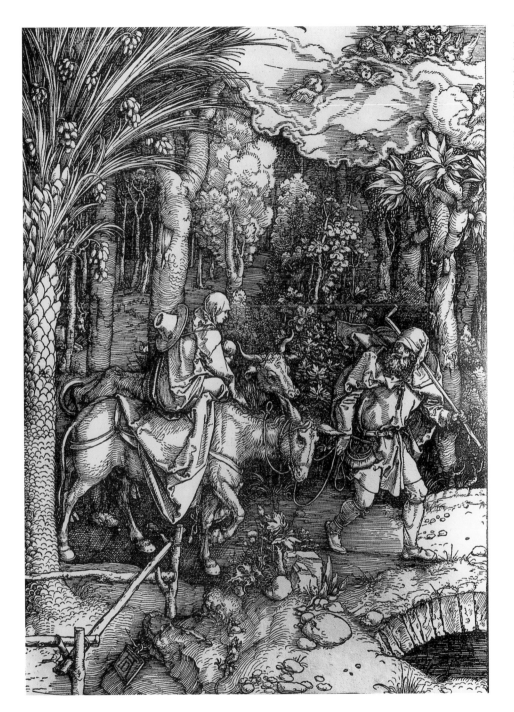

FIGURE 3.16.
Albrecht Dürer, *The Flight into Egypt* from the Life of Mary series, 1511, woodcut, Staatsbibliothek, Munich. Copyright Foto Marburg/Art Resource, NY. With angels overlooking their progress, Joseph, dressed in traveler's attire with a stick in his hand and a pouch at his belt, leads a donkey, on which Mary and Jesus are seated, and an ox. The holy family passes a spring to the left of which two lizards scurry. The rich mixture of exotic foliage includes a grapevine, date palm, and dragon tree.

Albrecht Altdorfer

Further evidence of the connection between naturalism and the powers of nature and art can be found in the work of the Regensburg painter Albrecht Altdorfer (ca. 1480–1538). Altdorfer, known to art historians as one of the Danube school of painters, is a key artist in southern German naturalism. Altdorfer came from a patrician family in the free imperial city of Regensburg, where he even served as *Bürgermeister* in 1528. He stepped down from this position in 1529 to paint the epic battles of Alexander and Darius for the elector of Bavaria. As a member of the city council, Altdorfer ordered the expulsion of the Jews in 1519 and the razing of their synagogue, producing, before it was torn down, precise and evocative etchings of the building (fig. 3.17). He then made various images of the *schöne* Maria for the church that was built on the site of the synagogue as it became an increasingly tumultuous site of miracle and pilgrimage.[88] His painted image combined with the Regensburg city arms adorned the large flag hanging outside the church, recorded in Michael Ostendorfer's woodcut (fig. 3.18). Altdorfer also decorated the letter of indulgence and designed the pilgrim medal produced by the city in connection with the indulgence that Pope Leo X issued for pilgrimages to the church. A scant thirteen years later, still part of the city council, Altdorfer called a Lutheran pastor to the same church when Regensburg went over to the Reformed religion. Like his fellow panel painters from southern Germany, including Dürer, Lucas Cranach the Elder (1472–1553), Matthias Grünewald (ca. 1475–1528), and Hans Baldung called Grien (1484/85–1545), Altdorfer combined panel painting with the practice of architecture, also serving as *Baumeister* in Regensburg.

Altdorfer's painted forests dwarf the human figures in them (fig. 3.19), and his paintings of families of *wildes Volk* are set within the wild space of these forests (fig. 3.20). Altdorfer's forests and the vivid colors he used in his paintings—for example, in a watercolor of a sunset (plate 19)—point to the special role nature played in his thinking. Larry Silver and Christopher Wood have interpreted these paintings as a product of German patriotic humanism that looked back to and elaborated on the books of Tacitus that describe the German forest.[89] As Wood makes clear, this was a complex process that had much to do with the identity of the artist. Altdorfer's paintings also appear to articulate the artisanal epistemology this chapter has been concerned with so far.

Altdorfer recorded his own experience of nature and he endowed his paintings with whole networks of meanings. This is especially true of Altdorfer's unusual private

FIGURE 3.17.

Albrecht Altdorfer, *The Interior Nave of the Synagogue in Regensburg*, 1519, etching, 17 × 12.5 cm, © 2003 Bildarchiv Preußischer Kulturbesitz, Berlin (Kupferstichkabinett). As a member of the Regensburg city council, Altdorfer was involved in the 1519 expulsion of Regensburg's Jews and the destruction of their synagogue. In the five days between the council's decision and the demolition of the synagogue, Altdorfer recorded the site in a series of precise etchings. Pictured here is the synagogue's interior nave.

FIGURE 3.18.

Michael Ostendorfer, *Pilgrimage to the Schöne Maria in Regensburg*, ca. 1520, woodcut, 55 × 38 cm, © 2003 Bildarchiv Preußischer Kulturbesitz, Berlin (Kupferstichkabinett). A rendering of the church built on the site of the destroyed Regensburg synagogue. In the background on both sides of the church, Ostendorfer depicts the ruins of Regensburg's Jewish quarter. And in the foreground, he records the frenzied worship of the pilgrims of the miracle-working statue of the Madonna. Altdorfer's painted image of the Virgin and child with the Regensburg city arms adorns the large flag that hangs from the church's steeple.

FIGURE 3.19.
Albrecht Altdorfer, *Saint George
and the Dragon*, 1510, oil on
parchment, affixed to wood
panel, 28.2 × 22.5 cm, Bay-
erische Staatsgemäldesamm-
lungen, Alte Pinakothek Mu-
nich. Copyright Scala/Art
Resource, NY. The impenetra-
ble greenery of the forest over-
whelms the figures of Saint
George and the dragon.

FIGURE 3.20.
Albrecht Altdorfer, *Wild Family*,
1507–10, pen and white height-
ening on gray-brown paper, 19.3
× 14 cm, Graphische Sammlung,
Albertina, Wien. Four wild
people—a woman clutching a
child to her breast, a bearded
man with his stick planted
firmly in the inert perhaps life-
less figure below—are nearly en-
gulfed by the looming forest.

devotional work, *The Rest on the Flight into Egypt* (1510) (plate 20). Mary allows the Christ child to play in a fountain filled with cherubs, out of which rises Apollo with Amor at his feet and a phoenix egg in his hand.[90] Altdorfer dedicated his painting to the Virgin by inscribing the base of the fountain with his name and a votive prayer: "A[l]b[er]tus Altorffer [p]ictor Ratis / ponen[sis] In salutem a[nima]e hoc tibi / munus diva maria sacravit / corde fideli: 1510" [Albrecht Altdorfer, painter of Regensburg, dedicated this gift to you, divine Mary, with faithful heart in (hopes of) the health of his soul: 1510]. Although Altdorfer's *Rest on the Flight into Egypt* contains neither insects, lizards, nor salamanders, the winged phoenix egg held by Apollo signifies the very same process of regeneration through destruction, for the phoenix, like the salamander, emerged res- urrected out of fire.[91] The painting as a whole refers to the fountain of life, both in a spiritual and material sense. At the same time, Mary, mirror of God and fountain of life,[92] is the vehicle making possible the cosmic transmutation of the world, the process of redemption set in motion by Christ's birth, life, and death.

Altdorfer's votive picture possesses three overlapping themes: the correspon- dence between spiritual and natural powers, the transformative power of nature and of the entire Creation, and art's vital place in the great work of material and spiritual redemption. In microcosm, the individual artisan replicates these processes of trans-

formation and redemption. By giving over his painting to the Virgin, Altdorfer alludes to the role that the practice of his art plays in redeeming the "health of his soul." He employs his knowledge of nature, gained by a bodily experience, to imitate nature's creative processes and to transform natural materials into a work of art. The powers of nature—inextricably intertwined with divine power—were the wellspring of his own artistic creativity, and the painting as a whole conveys the message that, as an artisan, he is both a knower and a redeemer of matter.

FORTESFORTVNAIVVAT

1513

‡ ‡ ‡ ‡ ‡ ‡ ‡ ‡ ‡ ‡ ‡ ‡ ‡ ‡ ‡ 4 ‡ ‡ ‡ ‡ ‡ ‡ ‡ ‡ ‡ ‡ ‡ ‡ ‡ ‡ ‡

Artisanship, Alchemy, and a Vernacular Science of Matter

The Fountain of Life

Altdorfer's votive painting of the miraculous fountain, sporting Apollo and his Phoenix egg at its center, suggests another important dimension of artisanship: alchemy.[1] Dürer, too, employed egglike objects in his drawings. An egglike vessel with wings and webbed feet appears in Dürer's drawing for a bookplate or emblem of 1513 (fig. 4.1), inscribed with the motto "Fortes Fortuna Iuvat" [Fortune assists the strong]. In another drawing, made during his first stay in Venice, circa 1495, Dürer also shows Apollo, a lion, and a turbaned figure holding a skull with a book at his feet (fig. 4.2). On a small tripod between the god and the savant sits a smoking globe, labeled "lutus." "*Lutus*" could refer to *lutum sapientiae*, the mixture of clay, hair, straw, and horse dung that was used to seal and protect glass vessels from breakage when they were placed in the flames of the distilling furnace, but it could also refer to a metaphorical "seal of wisdom" to be gained through alchemical processes.[2] In their associations with Apollo and with themes of resurrection, both Altdorfer's and Dürer's eggs suggest alchemical connections.

FIGURE 4.1 (*facing page*). Albrecht Dürer, *Device for a Bookplate (?)*, *Fortes Fortuna Iuvat* [Fortune assists the strong], aquarelle, brown, and black ink on paper, 27 × 21.5 cm, © 2003 Bildarchiv Preußischer Kulturbesitz, Berlin (Kupferstichkabinett).

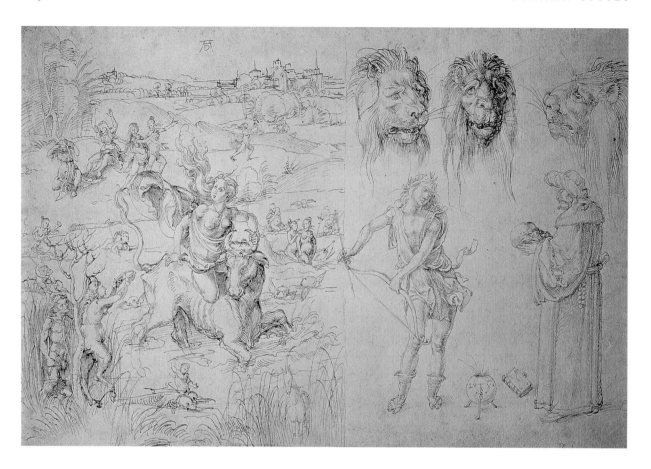

As the son of a goldsmith, Dürer's familiarity with the processes of metalwork-
ing might account for such connections. For example, in one of his most enigmatic and
debated engravings, *Melancholia I* (fig. 4.3), he depicts a small crucible, very similar to
that in Martin Schongauer's print of two metalworking apprentices fighting (fig. 4.4).
Historians have argued that Dürer's *Melancholia I* should be read as an illustration of
the first stage of the alchemical process, the "*Nigredo*."[3] The most important stages in
the transformation of materials, whether for transmuting base metals into gold or
other kinds of metallurgical activities, were *Putrefactio* (dissolution through decay, cor-
responding to the first stage of the transmutation), *Calcinatio* (pulverization), *Sublimatio*
(vaporization), *Destillatio* (which included distillation in today's sense as well as other
operations in which matter changes place or form), *Solutio* (in which a solid body is
made liquid, whether by acid or fire), *Digestio* (slow dissolution by heating), *Cohabatio*

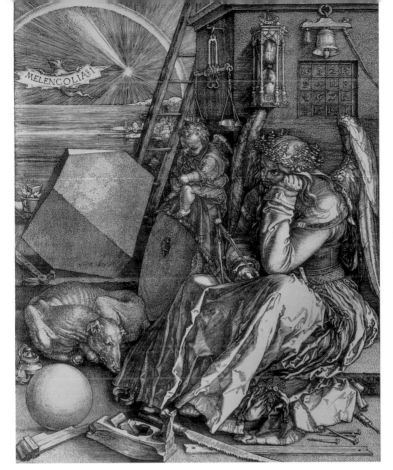

(repeated distillation), and *Fermentatio* (processes analogous to wine or bread making in which a quickening activity takes place).[4]

 Alchemical manuscripts and books proliferated in the early years of the sixteenth century.[5] Dürer and Altdorfer could have been familiar with alchemical themes from alchemical, distillation, and pharmaceutical writings both in German and in Latin, and it is certainly possible to further elaborate the allusions in Dürer's drawings and Altdorfer's painting in the terms of alchemical theory. For example, their use of Apollo, the classical sun god, points to the use of planetary analogies in alchemical terminology and theory. The sun was identified with the metal gold and with a generative male principle, or fiery spirit, that joined with matter.[6] Sulfur, sometimes identified as that fiery spirit and one of the two principles of alchemical transmutation by which base metals were ennobled, also carried connections with the sun, gold, and nobility (fig. 4.5). Moreover, the eggs depicted by both Dürer and Altdorfer held special significance as a model for the generation of life out of inanimate matter. The "philosophical egg" of alchemical theory could both symbolize a model of the cosmos as well

FIGURE 4.3.
Albrecht Dürer, *Melancolia I*, 1514, engraving, © 2003 Bildarchiv Preußischer Kulturbesitz, Berlin (Kupferstichkabinett). The crucible heats over a fire to the left of the polygonal object.

FIGURE 4.4.
Martin Schongauer, *Apprentices Fighting*, engraving, © 2003 Bildarchiv Preußischer Kulturbesitz, Berlin (Kupferstichkabinett). The crucible, surrounded by flames similar to those of Dürer's *Melancholia I*, heats perilously near to two young boys, probably goldsmith apprentices, engaged in a fierce skirmish.

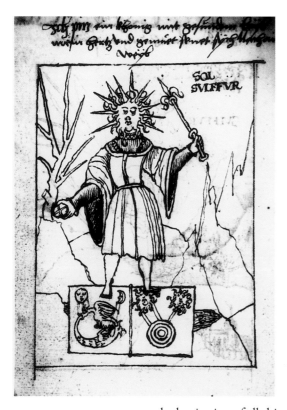

as denote the source of the philosophers' stone, the material that alchemists employed to transmute base metals into gold and silver, among other transformations of matter. In addition, a laboratory vessel with a rounded shape and short neck known as an "egg," or Hermetic vase, was supposed to be particularly effective in generating the philosophers' stone. When artists depicted the alchemical process by which the philosophers' stone was produced, they often portrayed it as taking place within such egglike vessels.[7] One of the most fully articulated depictions of the making of the philosophers' stone is Salomon Trismosin's alchemical florilegium, in the "Splendor Solis," produced in Nuremberg in the 1530s, possibly by Albrecht Glockendon or his workshop. It shows the progress of an alchemical transmutation as the material in the vessel moves from a black putrefying mass to the multicolored "tail of the peacock" and finally to red, when the mass in the "egg" is suddenly transformed into gold.[8]

Another of the illustrations in the "Splendor Solis" displays a hermaphrodite holding an egg in one hand while in the other it holds the cosmos, symbolized by the four elements of earth, water, air, and fire (fig. 4.6). The egg signifies the beginning of all things, out of which the entire universe develops. The figure of the hermaphrodite represents the unification of the dual principles involved in alchemical transmutation, sulfur and mercury. Since at least the thirteenth century, alchemical writers had regarded sulfur and mercury as the primary components of all metals, and they continued to do so well into the seventeenth century.[9] Both sulfur and mercury had ordinary forms found in nature that could be handled by alchemists. Sulfur appears in a pure form in nature, which, on heating, turns a dark red color, and then, when cooled rapidly, forms a glassy red substance. Similarly, mercury is also found in a pure form in nature. In alchemical theory, however, these two substances were understood not as substances per se, but as principles that gave rise to the qualities possessed by natural sulfur and mercury. Sulfur was viewed as the hot, fiery, male principle, representing the qualities of fire and air and giving metals their combustibility. It combined with the wet, cold, female principle of mercury, which possessed the properties of earth and water. Alchemical writers identified mercury as the ingredient in metals that gave them their "metallic" qualities, because of its silvery glitter and the

fact that it is liquid at room temperature, analogous to the liquidity of metals when heated. In addition, mercury forms amalgams, or alloys, with other metals, particularly gold and silver, in such a way that it is difficult to distinguish the alloy from the pure, noble metal. Mercury also possesses a solid state and a silvery, fluid state and becomes a volatile spirit when heated. To alchemical writers, it thus appeared capable of uniting the qualities of matter and spirit and fixing the volatile, which was a common goal of alchemists.[10] Because of its unique qualities, alchemical authors believed mercury played a central part in transmutation, and in the late thirteenth century, some alchemists theorized that it was the principle of mercury alone, rather than sulfur and mercury, which accounted for transmutation. By the sixteenth century, although both theories continued to coexist, the two-principle theory had once again become accepted by most alchemical writers, as the hermaphrodite in the "Splendor Solis" illustrates.[11]

The two-principle theory is also illustrated in the "alchemical wedding" of mercury, the female principle, with sulfur, the male principle, which resulted in a child, the mercury of the philosophers, the main ingredient in the philosophers' stone. A sixteenth-century illustration in a manuscript version of the *Turba philosophorum* shows a naked female figure crowned with a phoenix, standing on the sun and the moon, wings extending from her feet (fig. 4.7). In this *Mercurius genetrix*'s hands are representations of the moon and a chalice out of which shoots flames, conflating the sun, Apollo, gold, and Christ (by reference to the chalice of the Eucharist). The verse above this figure reads, "Here is born Sun and Moon's child / the equal of which no one on earth can find / but in the world it's nevertheless well known / it is called *Mercurius philosophorum*."[12] A seventeenth-century engraving also shows the marriage of Sol (sulfur) and Luna (mercury), from which issues the mercury of the philosophers in a philosophical egg (fig. 4.8). The flowers springing from the neck of the egg denote the generative qualities of the philosophers' mercury that led the alchemical author Rhazes (ca. 865–923/35) to call it the "water of life." One of the most famous of all alchemical illustrations, the green lion devouring the sun out of which runs red blood (fig. 4.9), signifies a similar process. This illustration represents the process by which raw antimony ore draws in the universal generative spirit to produce a vivified

FIGURE 4.6.
Salomon Trismosin, "Hermaphrodite with Egg," from the "Splendor Solis," fol. 17v, ca. 1530. © 2003 Bildarchiv Preußischer Kulturbesitz, Berlin (Kupferstichkabinett). The hermaphrodite holds a representation of the cosmos in one hand and an egg in the other. The egg stands for the beginning of all things, from which the entire cosmos unfolds.

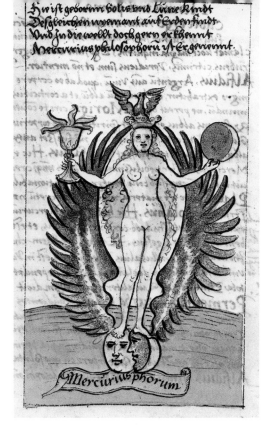

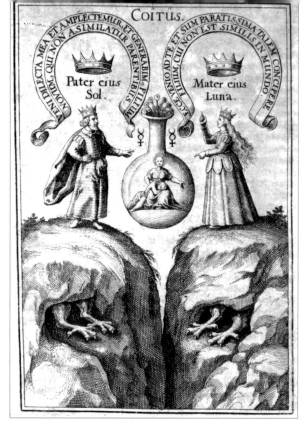

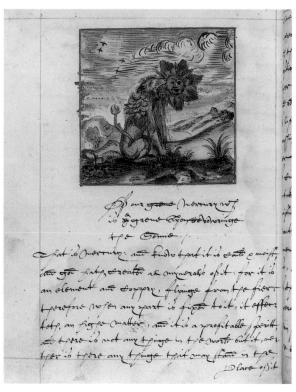

FIGURE 4.7.
"Mercury of the Philosophers," from *Turba philosophorum*, sixteenth century, ms. lat. 7171, fol. 16, Bibliothèque nationale de France, Paris. Instead of the usual figure of the winged god Mercury, the mercury of the philosophers is represented as a woman, indicating the feminine principle of mercury, as contrasted to the masculine principle inherent in sulfur. The moon in her left hand, representing silver, and the chalice, probably conflating the sun, gold, and Christ, in her right refer to the ennobling presence of the philosophical mercury in gold and silver. The bird rising from the figure's crown symbolizes the volatility of mercury and can also be viewed as a phoenix, indicating the regenerative capacity of the philosophical mercury.

FIGURE 4.8.
Johann Daniel Mylius, "Coitus," from *Anatomiae auri sive tyrocinium medicochymicum*, 1628, University of Wisconsin, Madison. The mercury of the philosophers is created by conjoining the opposites sulfur (Sol) and mercury (Luna). The female figure in the vessel is crowned with flames and holds a lifeless body in her lap, reminiscent of a *pièta* of the Madonna and Christ. This and the flowers springing from the neck of the vessel indicate the regenerative qualities of the mercury. The claws visible in the earth below symbolize the *prima materia*, the material to which all things must be reduced in order to bring about regeneration or transmutation.

FIGURE 4.9.
"Green Lion Devouring the Sun," from *The Booke of the Rosary of Philosophers*, Lübeck, 1588. By permission of the British Library, London, Additional MS 29,895, f. 119v.

mercury, the vital character of which is denoted by the red blood. This living mercury could dissolve and then revivify gold to make it grow and multiply. To produce such a substance was the common goal of alchemists from Rhazes to Newton.[13] The fountain in Altdorfer's painting (plate 20) also runs with the water of life. As discussed above, the water of life had both a spiritual and material dimension, but as the philosophical mercury, it was also the center point of alchemical theory, the source of all generation, including the generation and multiplication of metals.

Alchemical Imagery

Historians have identified many possible alchemical motifs in the works of early modern artists. They have often depicted early modern artists and their manipulation of esoteric symbols as a kind of internal transformation in accord with the Jungian interpretation of alchemy, in which the alchemist himself undergoes a transformation in his subconscious.[14] In an effort to understand the enigmatic works of Hieronymus Bosch and his follower Pieter Brueghel the Elder, for example, Jacques van Lennep and Laurinda Dixon have tried to explicate Bosch's and Brueghel's works by looking at them alongside alchemical texts available during their lifetimes. For example, van Lennep has argued that the myth portrayed in the painting *Landscape with the Fall of Icarus*, by Pieter Brueghel the Elder (ca. 1525–1569) had close connections to alchemy (fig. 4.10).[15] As the myth is told, the Athenian architect Daedalus and his son Icarus were shut up in a labyrinth by King Minos, but the ingenious Daedalus made them wings from wax and feathers and they escaped. In his enthusiasm, however, Icarus flew too close to the sun, the wax melted, and he fell into the sea. Daedalus, whose name in Greek signifies "clever craftsman" or "adept," symbolizes the devotee of alchemy, according to van Lennep. The names of both father and son were used as *Decknamen*, or code words, for alchemical materials: "Daedalus and Icarus are symbols of the solid part of the magisterium that is volatile. Daedalus represents the first sulfur from which the second arises, which then is sublimated, and rises in the vessel then afterwards falls back into the sea of the philosophers."[16] This signifies the precipitation or the fixing of volatile matter. In addition, the theme of the labyrinth also appears frequently in alchemical texts, and the sea in this myth might be a symbol for mercury, while the ships could signify the shipwreck of the alchemist. Another reading of Brueghel's *Fall of Icarus*, according to van Lennep, might be drawn from the peasant and his agricultural practices, which are associated with Saturn, the planet that also ruled alchemists, min-

FIGURE 4.10.
Pieter Brueghel the Elder, *Land-
scape with the Fall of Icarus*, 1553, oil
on canvas, 275 × 337 mm,
Musées royaux des Beaux-Arts
de Belgique.

ers, and beggars. Alchemical transmutation was seen to operate on the same model as
that of sowing seeds—the seed first putrefied into the *prima materia* and then regener-
ated and multiplied into a more noble material. Or, as one alchemical text had it, "The
philosophers' stone is a field that the Adept ploughs and in which Nature and Art has
laid down the seed so that it will provide fruit." A third reading is based on yet another
alchemical text that advises the adept not to fly too high, like the son of Daedalus, but
rather to seek the gold of the philosophers in the decomposed earth.[17] As is obvious,
the possibilities of such readings can proliferate almost endlessly.

 Van Lennep identifies many other alchemical motifs in Brueghel's works, such as
in the print entitled *Luxuria*, or *Unchastity* (1557) (fig. 4.11). At the center of this bizarre
scene stands a hollow oak (the philosophers' tree) in which gold is made through the
union of two contrary materials, sulfur and mercury, represented by a monster caress-
ing a beautiful woman. On the back of their seat perches a rooster, symbol of Hermes.
The branch in the shape of a stag's head with a fruit in its mouth symbolizes mercury,
the volatile material, and the fruit itself symbolizes the gold that comes from it.
Throughout the print, one sees symbols of *conjunctio* (or coitus) between mercury and
sulfur, the stage that begins all alchemical transmutation. One of the oddest objects in
this field of strange things is the vine-covered structure, shaped like an alchemical dis-

tilling vessel, or athanor, inside of which a couple embraces and another alchemical vessel warms over slow heat. Brueghel took over many of these motifs from Hieronymus Bosch (1450–1516). Bosch used both the hollow oak and the egg, which van Lennep equates here with the philosophical egg (made from the four elements and symbolic of ripening and regeneration, as well as of the alchemical vessel in which transmutation takes place). Bosch also employed numerous types of *conjunctio*—the alchemical union in which male and female disappear to make the androgyne, symbolized in *The Garden of Earthly Delights* (ca. 1500) (fig. 4.12), according to van Lennep, by the Y formed by the legs of the upside-down man.[18] Another Bosch work, the *Saint Anthony Altarpiece* (ca. 1500–5) (fig. 4.13), depicts a colossal athanor in the form of a building. A black woman at a table lifts up a platter on which stands a frog holding an egg aloft. Von Lennep suggests that these may symbolize the stages of transmutation: the woman's color stands for the pure *nigredo* (the black stage, marked by putrefaction), the frog stands for the first stage after putrefaction, and the egg presumably for final rebirth.

FIGURE 4.11.
Pieter Brueghel the Elder, *Luxuria*, or *Unchastity*, 1557, engraving, 225 × 296 mm, copyright Biblothèque royale Albert I^er, Brussels (Cabinet des Estampes).

Laurinda Dixon has offered similar alchemical analyses of Hieronymus Bosch's paintings. She regards the whole of *The Garden of Earthly Delights* as representing the story of Creation told as a process of distilling the Elixir of Life. In Bosch's great altarpiece, Dixon sees Adam and Eve (with the fountain of life behind them) as representing the initial conjunction that leads to the stage of multiplication in the central panel (around a larger fountain), also known as "child's play." The third panel of the triptych symbolizes putrefaction, purification, and ultimately resurrection through the hottest fires.

Dixon enumerates some of these hidden symbolic elements: the fountains in the left and middle panels symbolize the fountain of life; the various figures' handstands represent the rising and falling through condensation in alchemical distillation flasks, called "turning on its head" in alchemical treatises; the crystal sphere in which a man and woman embrace symbolizes the alchemical "marriage of opposites"; the transparent cap in which birds are caught symbolizes the trapping of vapors in the distilling vessel known as a *bain-marie*; the black birds flying up through a mountain, becoming white, and then coming back to earth again symbolize the process of vaporization and condensation in distillation; the numerous eggs throughout the panel stand for the

philosophical egg. On the right panel, the grotesque egg-man with black feet, a white body, and a red retort or bagpipe suggests the colors of putrefaction and resurrection, as might be drawn from the instructions in an alchemical text: "Put our material in an egg. There will happen a chicken with red crest, white body, and black feet."[19] The outer panels of this painting, according to Dixon, depict a cosmic process of distillation and purification in a round sphere, the vapor rising and falling with the dry mass just beginning to appear.

Dixon connects her readings of Bosch's enigmatic paintings to contemporary apothecaries' practices and to the alchemical and pharmaceutical texts that would have been available to Bosch (although we know almost nothing about his life—nothing about his education, his library, if he had one, who his fellow artists and friends might have been, or his religious practices). Particularly suggestive is her claim that illustrations in a popular pharmaceutical tract reprinted at least ten times in the fifteen years after its first publication (1485), the *Hortus sanitatis*, were possible models for many of the fantastic creatures in *The Garden of Earthly Delights*. In addition, she cites Hieronymus Brunswyck's *Distillierbuch* (published in 1500), another practical vernacular work containing distillation procedures and illustrations of distillation equipment.[20]

FIGURE 4.13.
Hieronymus Bosch, *Saint Anthony Altarpiece*, ca. 1500–5, oil on panel, middle panel: 131.5 × 119 cm, wings: 131.5 × 53 cm each, Museu Nacional de Arte Antiga, Lisbon. Photo: José Pessoa, Instituto Português de Museus.

Joseph Leo Koerner, a recent reader of Bosch's paintings, is skeptical of alchemical interpretations and instead regards Bosch as having appropriated popular symbolism in an utterly unique way. His paintings direct the viewer, within the context of a *Weltlandschaft*, to despise the world and to look into their own interior selves in accord with the *devotio moderna* practiced by Bosch's contemporaries (and perhaps by Bosch for all we know). He is right to point out that we do not have contemporary comments about Bosch's work; we only know that his paintings were much sought after and much copied in the sixteenth and early seventeenth centuries. In 1567, more than a generation after Bosch's death, Lodovico Guicciardini called him an "inventor of devils, a painter of things fantastiques, & bizares."[21] But more than simply pointing to this problem of establishing contemporary viewings of Bosch (which is, in the final analysis, historiographically impossible unless new documents surface), Koerner is skeptical of an alchemical key to Bosch's work because he regards it as an esoteric key.[22]

What Dixon suggests and what is worth taking from her investigation of Bosch's works is that alchemy, in addition to being an esoteric quest, was also a purely practical art that provided a description of and a theory about the transformation of matter. While Dixon, like van Lennep and other investigators of art and alchemy, identifies extremely multivalent alchemical motifs about which it is difficult to draw any definitive conclusions,[23] she is right to look to the practical knowledge and instruments of alchemy to which Bosch may have been exposed in the apothecary's distillation chambers and the many popular works of medicine available to him. While historians will no doubt go on debating the exact meaning of these artists' alchemical imagery,[24] it is clear that artisanal and alchemical practices intersected.

Artisanry and Alchemy

The works of Jan van Eyck have also been combed for alchemical symbolism; more interesting is van Eyck's knowledge of pigments, varnishes, and techniques of laying on glazes that gave his paintings their particular lucidity, for example, in *The Annunciation* (plate 21). In the 1560s Giorgio Vasari stated that Jan van Eyck had discovered oil pigments through his assays (*provare*) in "alchemy."[25] While it is now clear that van Eyck did not discover oil pigments, it is not surprising that Vasari associated van Eyck with alchemy,[26] for in his 1390 painting manual, Cennino Cennini states that certain pigments were produced by "alchemia," including vermilion and verdigris,[27] some of the colors van Eyck used to such stunning effect, for example, in the Dresden altarpiece

(plate 22). Indeed, vermilion was made by heating mercury and sulfur together until they became a black paste; the paste was then mixed together until "dark blue on the outside, and, on the inside, an even silver colour." Finally, after prolonged heating, the mixture "sublimed" (formed a vapor that condensed) as a bright red cake on the walls of the clay pot.[28] Mercury and sulfur, of course, were the two principles that formed the philosophers' stone, thus the manufacture of vermilion was "alchemical" in at least three senses: it was made by alchemical methods, the process of its manufacture unfolded in accord with the theories of alchemy, and it pointed toward the possibility of producing the philosophers' stone. In making vermilion, the black paste turned a series of colors, finally showing itself perfected by its transformation to a splendid red hue. These color changes also marked the successful manufacture of the philosophers' stone, as was illustrated, for example, in the "Splendor Solis." The process of making vermilion reinforced alchemical theory while at the same time producing a usable and impressive product. In such a process, artisanal practice both informed and supported alchemical theory.

Other artisans, such as assayers and metalworkers, used the language of alchemy to describe the processes of transformation in their materials.[29] Franz Matthias Ellmayr, a brass worker in Rosenheim, employed alchemical terms to explain his understanding of the production of brass. He compared the production of brass to the union of matter and soul through which a new being is created, analogous to the creation of human beings by God. The new entity suffered, died, was purified, and finally was resuscitated as brass.[30] We have seen how ubiquitous goldsmiths were among the most accomplished artists of the sixteenth century. Martin Schongauer was trained as a goldsmith and his three brothers were practicing goldsmiths. Dürer began as an apprentice to his goldsmith father and Dürer's two surviving brothers became goldsmiths. Albrecht Altdorfer designed numerous vessels for gold- and silversmiths.[31] Many of the artists discussed so far were apprenticed to goldsmiths, and there is evidence that goldsmiths owned alchemical books.[32] Several other early modern artists, including Bartholomeus Spranger, Il Parmigianino, and Hendrik Goltzius, associated their work self-consciously with alchemy.[33] In some cases, this clearly had to do with the tastes of their patrons, some of whom, such as Cosimo and Francesco de Medici and Emperor Rudolf II, were interested in both the speculative and practical aspects of alchemy.[34]

For Paracelsus, alchemy and the arts were one and the same: "A baker is an alchemist when he bakes bread, the vintner when he makes wine, the weaver in that he makes cloth. Thus the individual who harvests natural fruits useful to humans in ways

prescribed by nature is an alchemist."[35] Carpenters were "alchemists of wood," as were "sculptors [biltschnitzer] who do away with the unnecessary parts of wood so that they make an image out of it." Alchemists were all those artisans who knew how to separate the useful from the useless.[36] For Paracelsus, the principles and processes of nature were alchemical processes,[37] and all crafts sought to imitate the generative and productive principles of nature: "Now all crafts are founded on imitating nature and experiencing the properties of nature, so that craftspeople know that in all their work they follow in the path of nature and bring out of nature what is in her."[38] Alchemy redeemed nature through fire.[39] Like the artisan, alchemy made manifest the invisible knowledge and virtues of nature.[40] Moreover the (al)chemist, like the artisan, was directly engaged with nature. He used all his five senses in the great work, and (al)chemists often remarked on the toll their practice took on their whole bodies.[41] Paracelsus used "alchemy" to denote the active knowledge of artisans; they practiced knowing that involved doing, and more than this, knowing that constituted a bodily engagement with nature.

Vernacular Epistemology

What do these repeated intersections between alchemy and artisanship suggest? When artisans in the fifteenth and sixteenth centuries made claims to knowledge of nature, they often expressed these claims and articulated their knowledge and their modes of working in a language that at least *resembles* that of alchemy. Painters' claims—to authority based on eyewitnessing, to the ability to mirror nature (fig. 4.14), and to imitate natural processes of generation (fig. 4.15) and, indeed, to imitate Creation itself—are all familiar as well from alchemical texts and illustrations of the same period. What may be concluded from such an overlap? Throughout the early modern period, alchemy seems to have provided a language for artisans who wanted to articulate their working processes, as well as for scholars who were trying to understand how artisans created things from matter. The fact that artisans worked with their hands and learned by apprenticeship separated them socially and intellectually from most scholars, who regarded the mechanical arts as existing across a deep social and intellectual divide. As has been previously noted, the late fifteenth and early sixteenth centuries were crucial in the development of a new relationship between scholars and craftspeople. Because alchemy was one of just a few disciplines in which people worked both with texts and with their hands, scholars and craftsmen alike had practiced it since the Middle Ages, and it played a central role in articulating this new relationship.

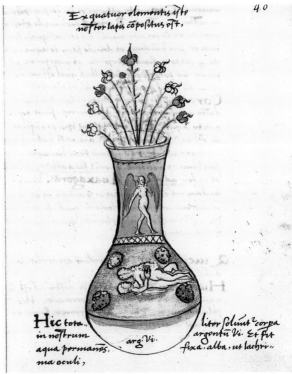

One reason alchemy may have been central in artisanal thinking is indicated by Vannoccio Biringuccio's (1480–ca. 1539) description of humankind's discovery of bricks and mortar. For Biringuccio, alchemical processes were tantamount to the workings of nature. Finding that they could not build houses simply with iron and stones dug out of the earth, the first humans

turned their thought toward the study of natural phenomena to see whether they might perceive one that would enlighten them so that they could attain their end by imitating it. Seeing the rocks and their hardness, they began to think about these and whether in some way they could soften them, and they began to examine how the art of Nature did this thing, persuading themselves that if they too should take some of those things that she took they could do the same thing with time and art. This substance would be of such a kind that it would not only make a binding for parts of things, but every structure would also become a very hard body of pure stone. With this hope, they proceeded to seek the possibility of having some of these same elemental substances that Nature makes use of for composing and engendering stones. It is very difficult for men to have these

FIGURE 4.14.
A mirror labeled "speculum" in the margin of a fifteenth-century alchemical text. The circle with a point at the center is the alchemical symbol for gold. Alchemy was known as a *speculum naturae,* a mirror of nature, because its processes imitated those of nature. By permission of the British Library, London, Sloane MS 976, f. 84v.

FIGURE 4.15.
"Coitus," from *Turba philosophorum,* sixteenth century, ms. lat. 7171, f. 40, Bibliothèque nationale de France, Paris. Alchemical processes were viewed as occurring on the model of natural processes of generation.

things, in my opinion, and especially to have them in the quantity that would be neces-
sary for building.

Despairing at the time that nature took to manufacture these stones, these men

> abandoned it and instead of this way, not without the semblance of reason, they entered
> into the way that alchemists follow today with metals in the production of gold and sil-
> ver. As the foundation and primary matter in making their blessed Stone, they say that
> they take the substances of both of these and prepare them in such a way that they make
> use of their seminal virtue and vegetability in producing and increasing them. In the
> same way, these men, in order to make stone and to soften them, or to return them to
> their first principles, burned them as do the said alchemists. When they found them then
> to be a dry earth, they made a paste of it with water in order to build. And trying to do
> the same with pure earth [clay], they found, to their astonishment, that instead of burn-
> ing up it became hard, produced an effect opposite to that of stones, and became a thing
> that greatly resembled stones. Finding both these things in this condition, they first took
> the calcine [lime], and when they had built it with the stones, they saw that sun or the air
> had returned it to powder and to its first condition after they had caused the moisture of
> the water that was in it to evaporate, so that the stones were forced to fall in ruins since
> they could not stand by themselves. Men thought to remedy this with a viscous and cold
> moistness which would protect itself from dryness by its natural property, so that when
> Nature found it intrinsically moist and disposed to become stone it would effect its
> processes in appropriate periods of time. Therefore they mixed with this, in a certain
> proportion, some kinds of river or cave sand.[42]

Biringuccio is well known for his dismissive attitude toward attempts to transmute
base metals into gold, yet he clearly believed that natural processes could be described
in alchemical terms and that alchemical methods imitated the processes of nature. In
his view, humans invented the arts by observing natural processes and speeding them
up through the processes that would come to be called alchemical.

Artisans also employed alchemical language because from the Middle Ages up
through the seventeenth century, alchemy was the focal point of the debate about the
power of art to imitate nature.[43] Furthermore, alchemy and artisanry possessed a com-
mon essence: the ennobling of matter through manual work. Alchemy described the
most basic manifestations and transformations of the active matter with which arti-
sans struggled.[44] Alchemy also sought the vital principle, and this bound it up inti-

mately with medical theory and practice. In the early modern period, alchemy supplied a theory about the transformation of matter of all kinds as well as having a very wide application in many different crafts. Alchemy also had much in common with medicine. Processes observable in the human body—generation, fermentation, digestion, and separation of the dross, for example—formed a common currency for alchemists and artisans. Paracelsus called digestion the inner alchemist.[45] Like other early modern people, artisans were involved in their bodies in a different way than we are today, for they were aware of their bodies (and their effluvia) in a way that modern medicine does not encourage its patients to be.[46] Artisans such as Dürer, dependent upon their body and their senses for their livelihood, might focus particularly on their body. Dürer recorded his own bodily state, once by providing an annotated drawing indicating with his finger where he had pain (fig. 4.16). This drawing has been read as a self-aware statement of his own melancholic nature, but could just as well be the correspondence between patient and physician. During another illness, Dürer drew a vivid portrait of the dead Christ and then noted his own bodily state on the drawing, thus linking his own bodily condition to the moment of his artistic production (fig. 4.17).[47] The patient-centered, "subjective" components of early modern medicine reinforced the bodily dimensions of artisanal knowledge and epistemology.

Finally, alchemical principles were used to explain the natural workings of God's Creation.[48] James Bennett has suggested that stories from the Old Testament gave early modern people resources for thinking about nature.[49] Similarly, alchemy provided resources that could indicate the spiritual meaning of material things. Alchemical texts and practices, like religious texts and practices, comprised a discourse on the relationship of matter to spirit.[50] Indeed, on a cosmic scale, alchemy was the epitome of all artisanal activity, for it redeemed matter just as the practice of the arts and medicine did. All such activities resulted from the Fall and helped to redeem humankind after its expulsion from Eden.[51] In short, then, alchemy in the early modern period both articulated *and* sometimes formed the resources for a vernacular science of matter.

We might think about this vernacular science of matter as forming a kind of common intellectual currency in the early modern period that can be found in alchemical treatises, medical therapies, and all practices associated with changes of state and transformations of matter, including those found in artisanal works of art and artisanal writings about art and nature. Historians of medicine have posited a common medical worldview that extended to almost all members of society and medical practitioners at this time.[52] According to John Henry, the medical hierarchy in the Renaissance was more a matter of social distinction than theoretical or intellectual divisions,

FIGURE 4.16.
Albrecht Dürer, *Self-Portrait of the Sick Dürer*, ca. 1512–13, pen and ink with watercolor, Kunsthalle, Bremen. Dürer indicates a spot on his abdomen and has written above: "Do der gelb fleck ist vnd mit dem finger drawff dewt, do ist mir we" [There where the yellow spot is and the finger points, there it hurts me].

as no specialized body of theory had yet emerged that was the exclusive preserve of the certified medical practitioner. The only truly specialized knowledge in medicine at this time was mathematical astrology. It was not until the eighteenth century, when university-trained medical practitioners came into possession of a specialized body of theory, that they were able to distinguish themselves in any way but socially from the myriad medical practitioners available at the time. And, in terms of efficacy of treatment, university-trained physicians were not distinct from other practitioners until

much later. Henry notes that the first Caesarean section performed on a living mother (in which both the mother and child survived) was carried out by the Swiss sow-gelder Jakob Nufer in the 1580s.[53] Similarly, knowledge of medicinal herbs lay largely with herb gatherers and old women. Up until the eighteenth century, most people shared a common medical worldview constructed out of medical precepts (some of them filtered down into popular consciousness from university texts) and a set of beliefs about humoral pathology, herbal remedies, and therapeutic manipulations. While folk practitioners *may* have thought about their remedies in a less theoretical manner (but even this might be doubted), their practices were probably equally as efficacious and successful as university-trained physicians. Alchemical theory could form the underpinnings of such a shared worldview. All the artisanal beliefs and practices discussed in chapter 3—the belief in the powers of nature, in the active virtues of matter, the implication of the body in processes of transformation, as well as the view that artisanal work was redemptive—were in accord with such an alchemical worldview. While artisans may have shared such a worldview with other members of their society, they were, without doubt, experts in the knowledge of nature. In the early modern period, specialist knowledge about manipulating nature to create effects was the province of artisanal practitioners. The results of their knowledge are visible in their works of art.

FIGURE 4.17.
Albrecht Dürer, *Head of the Dead Christ*, 1503, charcoal. Copyright The British Museum. This graphic portrait of the dead Christ includes Dürer's notation of his sickness when he created it. The inscription at the bottom of the page reads: "Dis 2 angsicht hab ich uch er[furcht?] gemacht in meiner kranckheit" [These two faces I made in awe (?) during my illness].

 The techniques of nature study, both of observation and of representation, transmitted through painters' workshops and the experimentation with natural materials that went on in sculptors' workshops have not been considered the site of philosophizing or theorizing. These workshops have instead been considered the place where rote learning and slavish imitation took place. Such a view is in accord with a hierarchy that contrasts, on the one side, handwork and "everyday" thought and practices with, on the other side, ratiocination and "scientific" thought. Jean Lave maintains that in much psychological and anthropological work, "everyday thinking" has taken on the characteristics that were previously assigned to "primitive thought." She argues against a view that assigns higher cognitive functions only to a disembodied mind that is "further away from the body and from 'intuitive, concrete, context-

embedded' experience"[54] and sees the source of this hierarchy as the division of mind and body.[55] Her study demonstrates that everyday techniques of quite complex mathematical calculation can be transmitted in practice, although these calculations are sometimes confined to a local context and are not always made verbally explicit. Moreover, her study shows that the cognitive processes involved in practical knowledge do not in any way preclude change in techniques or new discoveries. The practices of the early modern artisanal workshop were not precisely congruous with "everyday thinking" as Lave defines it, but her conclusions do ask us to reconsider the views that artisanal practices were carried out in a "rote" fashion and that something like a theory did not underpin them. In order to understand what went on in artisanal workshops and how artisans understood their own vocation, we must be careful not to replicate the hierarchy of cognition and knowledge that emerged from nineteenth-century positivist views of science and colonialist views of primitive societies. Work on indigenous knowledge systems also indicates the importance of taking seriously cognition in practice. One study of vernacular potato taxonomies among Andean farmers has found that the farmers classify potatoes according to a four-tiered taxonomic system. This system is based on characteristics of the potatoes and is consistent over large areas. The farmers make crucial decisions about cultivation of the potatoes based on "the information matrix underlying the folk taxonomy."[56] Similarly, in East Africa, indigenous practices of "inter-cropping," or growing crops in mixed stands to promote complementary interactions between plants, have often been disregarded by development agencies in favor of planting crops in pure stands. Recent research indicates, however, that the indigenous techniques were consistently applied and may well have been more effective within the local settings than pure stand planting.[57]

In their survey of traditional knowledge systems, Helen Watson-Verran and David Turnbull argue that science should be viewed as one more indigenous knowledge system. They compare it to other integrated bodies of natural knowledge, such as that possessed by Gothic cathedral builders, the Anasazi, the Inca, and the Polynesian navigators, that were employed to bring about complex organizational systems. These "assemblages" of practices, devices, and conceptual systems connected local knowledge into stable, highly effective bodies of knowledge that were capable of being taught and passed on.[58] Whether or not these knowledge systems can be equated with modern science, such studies point to understanding early modern artisanal practices as the result of a vernacular epistemology and a vernacular "science." They indicate how modern science emerged at least partially from the "bottom up" of artisans' workshop practices. This understanding does not belittle or debunk science nor the usefulness of

theoretical formulations of knowledge but rather seeks to understand the complex in-
teraction in early modern Europe between, on the one hand, the active knowledge of
artisans and other handworkers and, on the other hand, the textual knowledge of
scholars.

The Culture of Nature

In the last three chapters, I have argued that the claims made in paint by the Flemish
painters in the fifteenth century about mirroring, imitating, and acting as eyewitnesses
to nature became the subject of artisanal theorizing, such as that of Albrecht Dürer in
the sixteenth century. Dürer felt himself to be an expert on the processes and trans-
formations of nature, and he used this position to confer the status of "certain" knowl-
edge, or "science," on the artisans' direct access to nature and their production of ef-
fects. Dürer, like the other artisans examined in these chapters, desired to give voice to
his knowledge and his certainty in his texts and works of art so that he would be rec-
ognized as such an expert. In the course of their theorizing about nature, these artisans
articulated a body of claims about nature and about the bases of knowledge that would
be carried on by various means in the following centuries. Four claims in particular
emerge as common denominators. First, nature is primary, and certain knowledge re-
sides in nature. Second, matter is active, and one must struggle bodily with and against
this active matter to extract knowledge of nature. Third, this process of struggle is
called experience, and it is learned through replication. And, finally, this imitation of
nature produces an effect—a work of art—that displays the artisan's knowledge of na-
ture and in itself constitutes a kind of knowledge. The background to all these claims
was the conviction that knowledge is active and knowing is doing. Paracelsus articu-
lated the claims of this artisanal epistemology in his writings, and in the century and a
half following his death, many practitioners would take up these claims, proclaiming
their authority by means of their direct access to nature and their ability to produce
effects.

 Naturalistic representation is central to this story, for it reinforced the claims of
the artisanal epistemology at the same time that this epistemology was being dissemi-
nated by artisans and individuals such as Paracelsus (and eventually many others).
Naturalism was, of course, important as a new means of visual communication.[59] It
transmitted technical information, for example, more efficiently than words, as
Georgius Agricola notes in his 1556 book on mining, *De re metallica*, illustrated with

woodcuts by Blasius Weffring of St. Joachimsthal. As a humanist physician interested in classical antiquity, Agricola felt he had to justify his departure from the practices of the ancients:

> I have not only described them [the objects, tools, and processes of mining], but have also hired illustrators to delineate their forms, lest descriptions which are conveyed by words should either not be understood by men of our own times, or should cause difficulty to posterity, in the same way as to us difficulty is often caused by many names which the Ancients . . . have handed down to us without any explanation.[60]

In a similar, although less apologetic vein, Leonard Fuchs proclaims the usefulness of naturalistic images in his 1543 botanical treatise:

> Though the pictures have been prepared with great effort and sweat we do not know whether in the future they will be damned as useless and of no importance and whether someone will cite the most insipid authority of Galen to the effect that no one who wants to describe plants would try to make pictures of them. But why take up more time? Who in his right mind would condemn pictures which can communicate information much more clearly than the words of even the most eloquent men? Those things that are presented to the eyes and depicted on panels or paper become fixed more firmly in the mind than those that are described in bare words.[61]

While the importance of naturalism for scientific illustration, whether in botanical, geographical, technical, or anatomical treatises, has been treated extensively, the effects of naturalism in the realm of epistemology have been less studied. James Ackerman has argued that Renaissance artists realized "a new perception of the natural world . . . and of new ways of communicating that perception," thereby giving legitimacy to observation and empiricism.[62] Peter Parshall has very interestingly pointed out the important development in sixteenth-century German prints by which images came to be understood as witnesses to facts. Images that increasingly invoked claims of factuality reinforced the techniques of observation and eyewitness as modes of acquiring knowledge.[63]

In addition, it is important to realize that over the course of the fifteenth and sixteenth centuries, objects of art and nature became sought-after trade and patronage goods. In this lively global trade in natural goods, naturalistic representation became a fashion.[64] The works of art and nature that were the objects of this trade constituted a

sustained consideration of the boundary between art and nature and of the human capability of transcending this boundary.[65] This discussion went on in artisans' workshops and increasingly in collectors' *Kunstkammern* and *studioli*. In the sixteenth century, artisans were often called upon as experts in settling disputes of authenticity and aesthetics.[66] The patronage and the commodity value of these goods of nature and art created a climate favorable to the investigation and representation of nature and helped to raise the status of those who knew and could imitate nature. The visual claim in naturalistic artworks that art imitated nature was a statement about the powers of both art and nature. Dürer's closely observed nature studies and his writings—like Palissy's stunning naturalistic ceramic productions and his lectures and museum, or Jamnitzer's sculptures, or Altdorfer's landscapes—helped transmit these claims about the possibility of knowing nature and the power of art that resulted from this knowledge. Dürer's artworks and Palissy's museum objects both embodied the premise that knowledge of nature is gained through direct observation of particular objects and that nature is known through the hands and the senses rather than through texts and the mind. The fascination with natural goods and artificial objects made after nature that painters, sculptors, and the numerous collectors and merchants both fostered and facilitated had the effect of training a taste for naturalism and verisimilitude, disseminating images of nature, and, most significantly, reinforcing the epistemological status of sensory experience, legitimizing claims to certainty that called upon an unmediated bodily experience of nature, and articulating a conviction about the powers of nature and art. In the late fifteenth and early sixteenth centuries, artisans were experts on the processes and transformations of nature, and individuals who wished to know (and take possession of) nature looked to *ars* as the medium through which to accomplish this. This was true not only of physicians and scholars, like Paracelsus, but also of princes and city governors who came to regard artisans as holding a key capable of unlocking the productive powers of nature. Out of the dynamic that formed between artisans and these others, new attitudes toward nature and a new discourse about it emerged. From the sixteenth century on, nature came to be deployed as a resource by which a great variety of individuals made claims to authority and intellectual legitimacy.

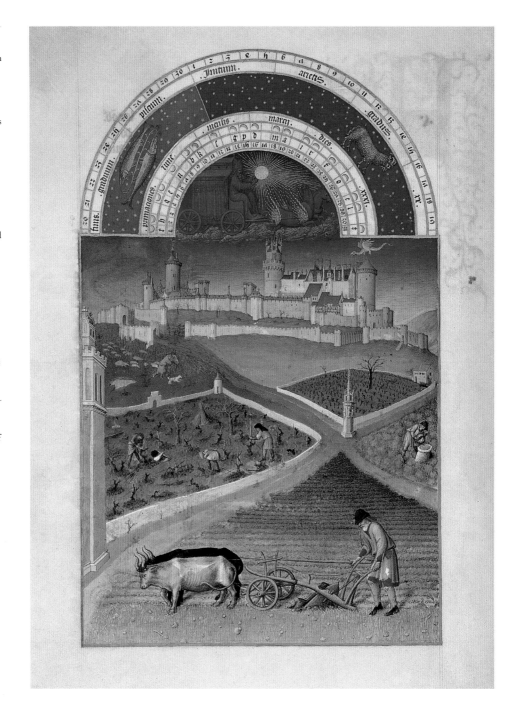

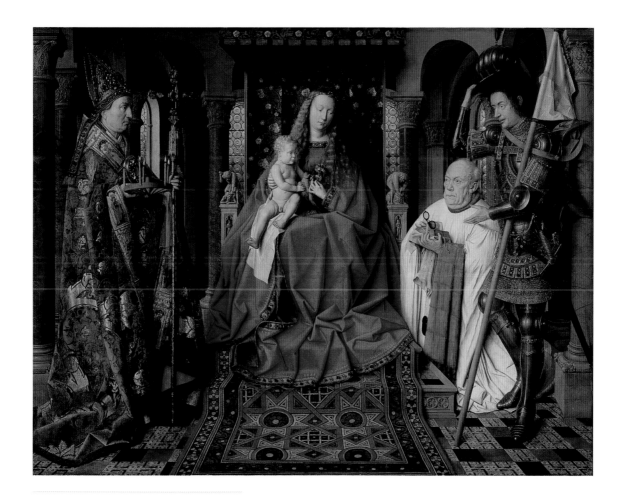

PLATE 3.
Jan van Eyck, *Virgin and Child with Canon Joris van der Paele*,
ca. 1434–36, oil on panel, 140.8 × 176.5 cm, Stedelijke
Musea Brugge, Groeningemuseum. Canon Joris van der
Paele is shown here in the choir of the now-destroyed
collegiate Church of St. Donatian in Bruges, where the
painting itself is said to have hung. He kneels below the
throne of the Virgin and child, absorbed in a vision of the
holy pair. To the left stands Saint Donatian, patron saint
of Bruges, and, on the right, Saint George clad in shining
armor, making literal reference to the mirror formed by
the panel of the painter.

PLATE 5.
Jan van Eyck, detail from *Virgin and Child with Canon Joris van der Paele*, ca. 1434–36, oil on panel, Stedelijke Musea Brugge, Groeningemuseum. A painter reflected in Saint George's shield.

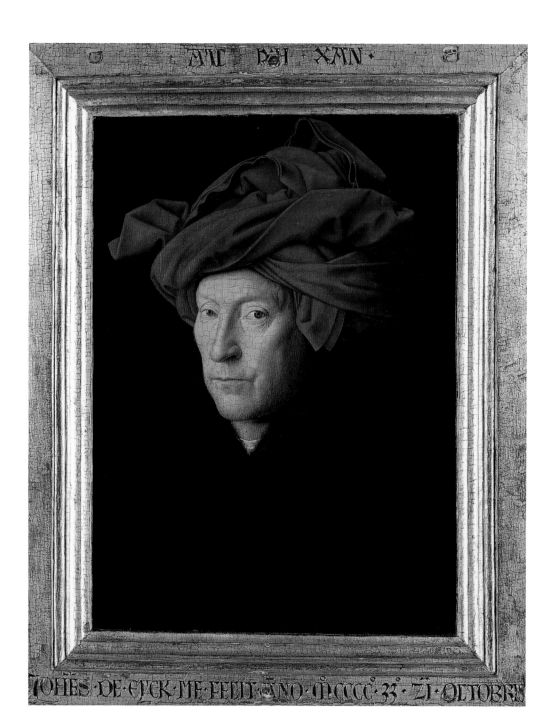

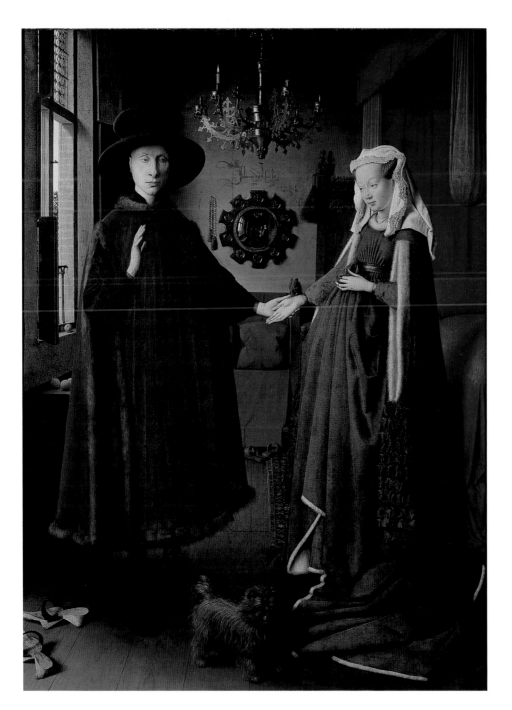

PLATE 6 (*facing page*). Jan van Eyck, *Portrait of a Man (Self-Portrait?)*, 1433, oil on panel, 33.3 × 25.8 cm, © National Gallery, London. This painting, probably a self-portrait of the artist, depicts the subject staring directly out from the frame, meeting the onlooker's gaze boldly. The red turban matches that of the figure reflected in Saint George's shield in the portrait of Canon van der Paele with the Madonna and child. On the frame above is inscribed van Eyck's motto, "ΑΛΣ. ΙΧΗ. ΧΑΝ" [as well as I can], and below, "JO[HANN]ES DE EYCK ME FECIT. AN[N]O. MCCCC.33. 21 OCTOBRIS" [Jan van Eyck made me on 21 October 1433].

PLATE 7. Jan van Eyck, *Portrait of Giovanni (?) Arnolfini and His Wife*, 1434, oil on oak, 82.2 × 60 cm, National Gallery, London. Copyright Erich Lessing/Art Resource, NY. The artist has depicted one of the Italian merchants of the Arnolfini family and his bride. Whatever else the various objects in this much-discussed painting may signify, it is indisputable that van Eyck emphasized the position and role of the mirror.

Anonymous, *Book of Hours of Mary of Burgundy*, 1477, Cod. 1857, Österreichische Nationalbibliothek, Wien. Photo: Bildarchiv, ÖNB, Wien. This leaf from a book of hours belonging to Mary of Burgundy represents both the objects seen by the bodily eye and those seen with the inner eye of the devotee. Precious objects—a jewelry box, a richly embroidered pillow, a book of hours open to a scene of the Passion—stand on the earthly side of the threshold while a vision of the Crucifixion is represented in the same detail through the archway. One of the group of women at lower left looks back over the threshold at the viewer.

PLATE 10.
Hubert and Jan van Eyck, center panel, *The Adoration of the Lamb*, detail from the *Ghent Altarpiece*, 1432, oil on panel, center panel: 375 × 260 cm, Cathedral St. Bavo, Ghent. Copyright Scala/Art Resource, NY. In front of the altar depicting the sacrifice of the holy lamb is the "fountain of life," spurting delicate streams of holy water. Crowds of figures, ancient and modern, emerge from all four corners to adore the lamb. The towers of the holy city can be seen in the background while flowers carpet the foreground. At least thirty botanical specimens have been identified among these flowers.

PLATE 11.
Martin Schongauer, *Studies of Peonies*, ca. 1472–73, bodycolor and watercolor, 25.7 × 33 cm, The J. Paul Getty Museum, Los Angeles. This delicate study of peonies was made for Schongauer's panel painting *The Madonna of the Rose Garden* (1473) now in the Dominican Church, Colmar. It is the earliest extant preparatory nature study in the north, and it shows the close observation of nature that must also have been undertaken by the first generation of Flemish painters. This sheet was owned by Albrecht Dürer, probably having been given to him by Schongauer's brothers in 1492, and he integrated the study into his *Madonna with a Multitude of Animals* (1503) (plate 18).

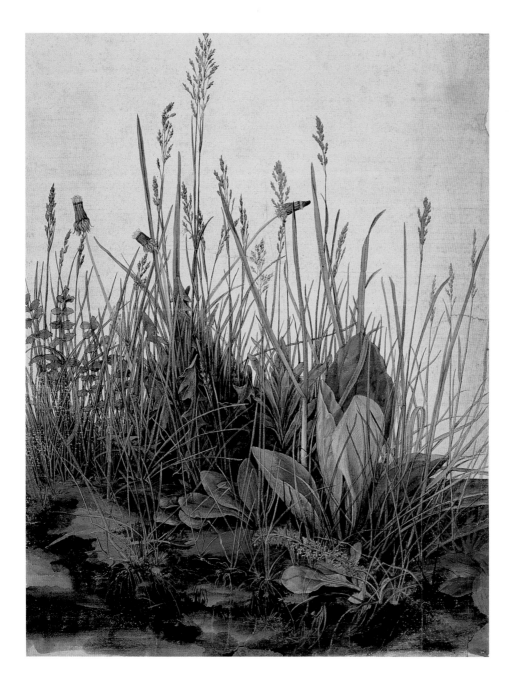

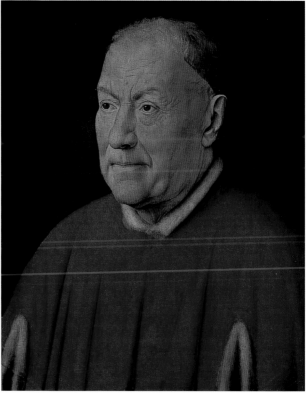

PLATE 14.
Follower of Robert Campin, Saint Barbara, *Altar for Heinrich von Werl*, right panel, 1438, oil on panel, 101 × 46 cm, Museo del Prado, Madrid. Copyright Scala/Art Resource, NY. Saint Barbara sits reading. Her tower, which is in the midst of construction, can be glimpsed through the window. The modeling of light and shadow by the application of white highlighting can be seen particularly in the surfaces that are depicted as reflecting and refracting light, such as the pewter ewer and basin in the corner of the room and the vessel on the mantel shelf, containing a translucent liquid and stoppered by a wadded piece of white paper. The virtuoso rendering of the reflection of the glass vessel and the liquid on the wall of the chimney shows the close observation of the play of light over surfaces.

PLATE 15.
Jan van Eyck, *Cardinal Niccolò Albergati*, 1438, oil on panel, 34.1 × 27.3 cm, Kunsthistorisches Museum, Vienna. Van Eyck achieved the naturalism of this portrait by applying successive grades of the same pigments, as described by Cennino Cennini, and selective application of white highlighting.

PLATE 16.
Attributed to Bernard Palissy,
*Rustic Ewer Ornamented with Ce-
ramic Roses Molded from Life*, ca.
1575–1600, *faïence*, 34.7 cm
high, Louvre, Paris (inv. MR
2336). Photo: M. Beck-
Coppola. Copyright Réunion
des Musées Nationaux/Art
Resource, NY. Delicate flowers
and plants were among the
most difficult objects to cast
from life. This ewer is deco-
rated with rose flowers, buds,
leaves, and rose hips. Each piece
of the rose plant was likely
molded separately and
mounted onto the ewer. The
large rose pictured near the top
of the basin is noticeably flat-
tened, suggesting that heavy
plaster was used in its mold.

PLATE 17.
Attributed to Bernard Palissy
and his workshop, *Rustic Basin*,
ca. 1556–90, enameled ceramic,
75.5 × 45.5 cm, Musée des
Beaux-Arts de Lyon, © Studio
Basset. Like much of Palissy's
work, this basin is adorned with
specimens molded from life.

PLATE 18 (*facing page*).
Albrecht Dürer, *Madonna with a
Multitude of Animals*, 1503, ink
and watercolor, 32.1 × 24.3 cm,
Graphische Sammlung, Al-
bertina, Wien. Copyright Erich
Lessing/Art Resource, NY.
Surrounded by a contemporary
village landscape, Mary holds
the Christ child and a book in
her lap. In the far distance, an
angel announces the birth of
Jesus to the shepherds tending
their sheep, while the star of
Bethlehem shines above all.
This drawing functions almost
as a catalog of Dürer's nature
studies. It contains not only
Schongauer's study of peonies
(plate 11) but also Dürer's
famed study of an iris, several
other carefully observed plants,
a stag beetle (fig. A.1), a mayfly,
a snail (with the shell and an-
tenna of the Schongauer study
sheet [fig. 3.14]), a crab, a dog, a
fox, and various birds.

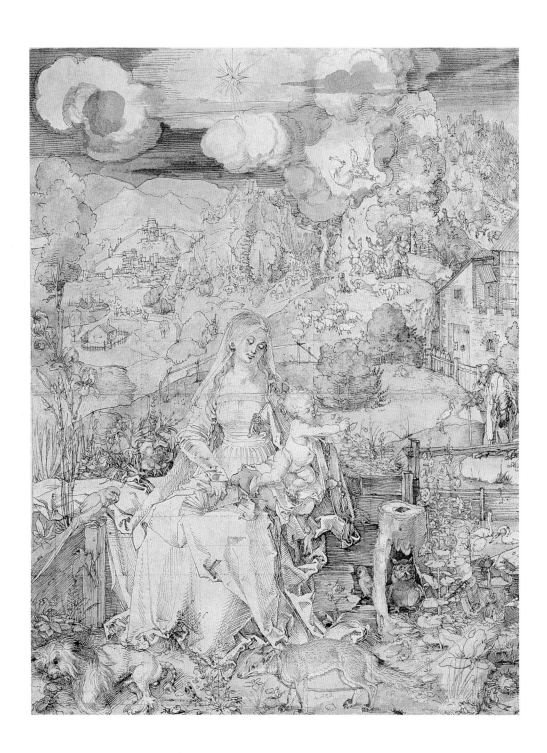

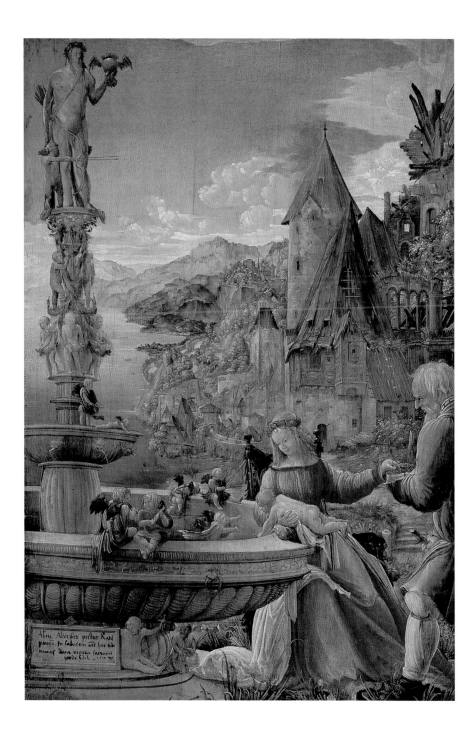

PLATE 20.
Albrecht Altdorfer, *The Rest on the Flight into Egypt*, 1510, oil on panel, 57 × 38 cm, Staatliche Museen zu Berlin, Gemälde-galerie. © 2003 Bildarchiv Preußischer Kulturbesitz. Photo: Jörg P. Anders. The holy family rests at an astonishing fountain before a mountain village. In an act of personal devotion, Altdorfer dedicated his painting to the Virgin in the inscription at the base of the fountain. Apollo and Amor stand atop the fountain's center, with Apollo holding a phoenix egg, a symbol of regeneration.

PLATE 21.
Jan van Eyck, *The Annunciation*,
ca. 1434/36, oil on canvas trans-
ferred from panel, 90.2 × 34.1
cm, Andrew W. Mellon Collec-
tion (1937.1.39). Photograph
© 2002 Board of Trustees, Na-
tional Gallery of Art, Washing-
ton, D.C. Jan van Eyck's mas-
tery of materials and techniques
is visible in the rich colors of
the wing and brocade cloak of
the angel Gabriel and of Mary's
robe, as well as in the appear-
ance of translucence in the win-
dows. Divine light shines onto
Mary from the windows above,
and daylight is diffused through
the windows behind her.

PLATE 22 (*facing page*).
Jan van Eyck, *Enthronement of the
Virgin*, 1437, oil on panel, middle
panel: 33.1 × 27.5 cm, wings 33.1
× 13.6 cm each, Staatliche Kun-
stsammlungen, Dresden,
Gemäldegalerie Alte Meister.
Copyright Erich Lessing/Art
Resource, NY. Vermilion and
verdigris, two colors used
prominently by van Eyck, were
produced by "*alchemia.*" The in-
scription around the frame of
the painting includes a quota-
tion from the Book of Wisdom
VII 29, 26, as well as van
Eyck's signature and his device,
"ALC IXH XAN." The pas-
sage from the Book of Wisdom
makes reference to the Virgin
as a mirror of God and of cre-
ation: "She is more beautiful
than the sun, and above all the
order of the stars . . . spotless
mirror of God's majesty."

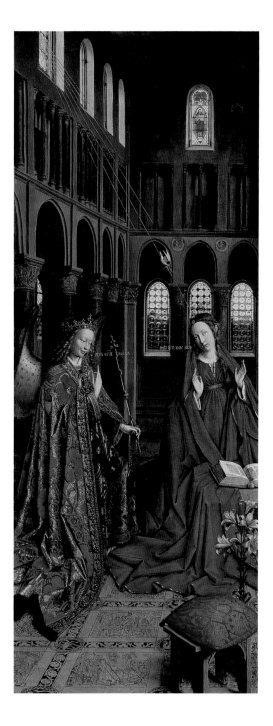

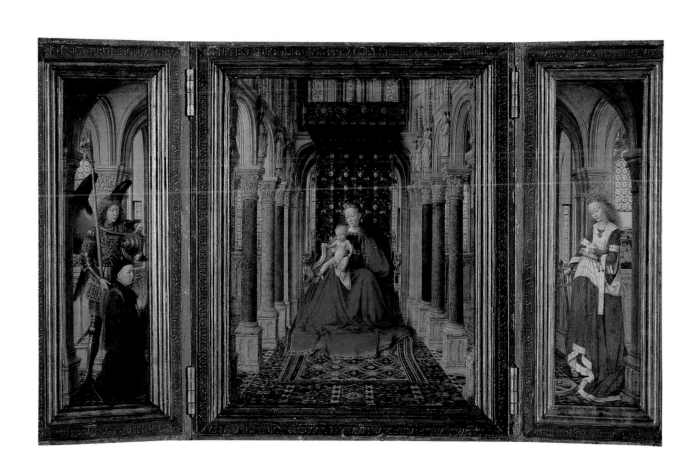

PLATE 25.
Frans van Mieris, *Franciscus dele Boë Sylvius and His Wife Magdalena Lucretia Schletzer Tuning the Lute*, 1672, oil on panel, 41 × 31 cm, Staatliche Kunstsammlungen Dresden (Gemäldegalerie Alte Meister). Painted by van Mieris after the death of Sylvius's wife, this painting hung in the master bedroom. The lute alludes to marital harmony.

PLATE 26.
Frans van Mieris, *The Cloth Shop*,
1660, oil on panel, 55 × 43 cm,
Kunsthistorisches Museum,
Vienna. Sylvius may have as-
sisted van Mieris with the com-
position of this painting, and he
certainly recommended the
artist to Archduke Leopold
Wilhelm of Austria, who paid a
thousand guilders for this
painting in 1660.

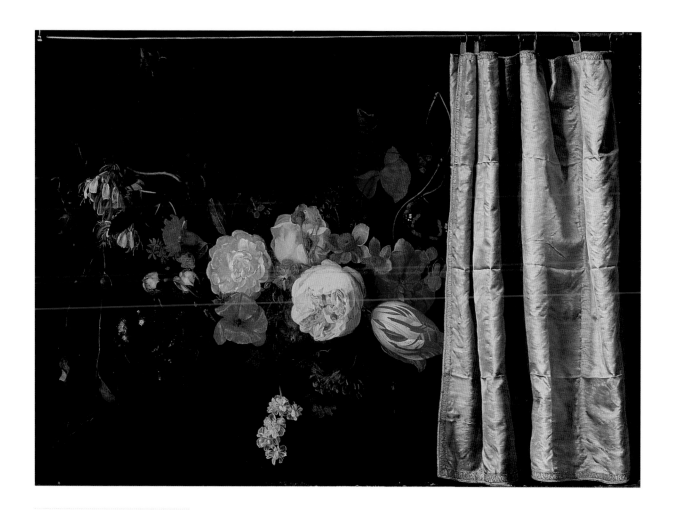

PLATE 27.
Adriaen van der Spelt and Frans van
Mieris, Dutch, *Trompe-l'oeil Still Life with a
Flower Garland and a Curtain*, 1658, oil on
panel, 46.5 × 63.9 cm, Wirt D. Walker
Fund, 1949.585, reproduction, The Art
Institute of Chicago. This stunning
trompe l'oeil was owned by another
prodigious Leiden collector and contem-
porary of Sylvius, Hendrick Bugge van
Ring.

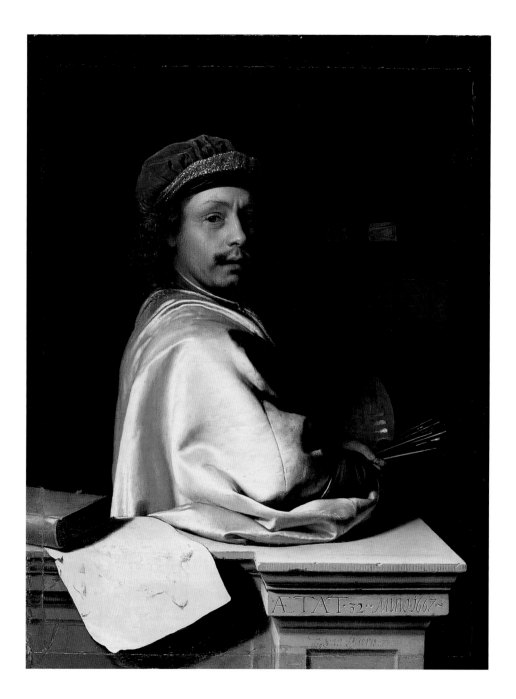

PART THREE

‡‡

THE DUTCH REPUBLIC

AN. ÆT. XXVIII

M.D.XLII

The Legacy of Paracelsus

PRACTITIONERS AND NEW PHILOSOPHERS

In the artisanal epistemology articulated by Paracelsus, certainty was to be extracted from nature through bodily experience. This direct engagement with nature would in fact lead to *scientia*, or theory. Palissy maintained that peasants laboring on the land engaged in philosophy. Not surprisingly, Palissy's old nemesis Theory scoffs at this, "One would suppose, to hear you speak, that some philosophy is needed by labourers—a thing I find strange."[1] What Palissy attempts to convey here, however, was that labor on the land—humankind's first vocation in the struggle for redemption—demanded, like other arts, an understanding and harnessing of nature's generative powers. The peasant knew and read nature; therefore, Palissy says, this peasant engaged in philosophy. Similarly, when Paracelsus discusses his theory of medicine, in which every disease has its own unique seed that grows and bears fruit, he states that "a physician must recognize and understand all the seeds of sickness, and then he will be able to theorize [theorizirn] about them like a peasant about the plantings he has sown."[2]

Medical Practitioners and Certainty

The claim to acquire certain knowledge through bodily engagement with nature was also made by many medical practitioners. This is not surprising, as they, too, were trained by apprenticeship and directly engaged with the bodies of their patients. Surgeons, in particular, began to articulate their mode of knowing in the sixteenth century. Although not identical to Dürer's (and Paracelsus's) claim that certain knowledge must be extracted from the materials of nature, the surgeons' praise of experience learned by bodily engagement is similar.[3] One advocate of "experience," Heinrich Cornelius Agrippa von Nettesheim (1486–1535), contrasts the certainty of surgeons to the work of physicians, who practiced an "Arte of manslaughter" that presumed "to passe under the title of Philosophie." Surgery, he says, is a part of "Physicke"

> that cureth the diseases of the body which are in the fleshe, the practices whereof be apparaunte and sure remedies, for the counsailes of other Phisitions be uncertaine. The Surgeans see and feele what thei do, and accordinge as neede requireth they chaunge, laye to, and take away: this among all the Arts of Phisick was the firste that came in use.

In spite of surgery's certainty, Agrippa could not fully reconcile himself to its material "filthines of poysonous mattier and blouddy crueltee."[4] Ambroise Paré (1510–1590) established his authority in surgery by recounting his own lived experience (in all its gory particularity), especially in the account of his life.[5] Indeed, in his *Ten Books of Surgery* (1564), he discusses fractures by recounting the cure of his own compound fracture that occurred when his horse kicked him.[6] For him, practice produced not only more certain knowledge;[7] it also conveyed that knowledge in a more unmediated and authentic manner, claiming not just autoptic authority but authority of lived real experience:

> Thou shalt fare more easily and happily attaine to the knowledge of these things by long use and much exercise, than by the reading of Bookes, or daily hearing of Teachers. For speech how perspicuous and elegant soever it be, cannot so vively express any thing, as that which is subjected to the faithfull eyes and hands.[8]

Similarly, Andreas Vesalius (1514–1564), the renowned Flemish anatomist and physician to Charles V, pronounced new claims for manual work by making a similar

appeal to the legitimacy of autoptic authority and engaging with the matter of nature itself. His portrait from his great work of naturalistic modern anatomy, *De humani corporis fabrica* [About the fabric of the human body], published in 1543, makes these claims explicitly (fig. 5.1). For Vesalius and other anatomists, *autopsia* were manual, historical, descriptive, and, in contrast to the Aristotelian tradition, more certain than "scientific" *doctrina*.[9] In the early seventeenth century, William Harvey (1578–1657), for example, would continue to regard anatomy as direct engagement with "things themselves" and would extend the method to reading the entire "book of nature." It is, he writes,

> unsafe and degenerate to be tutored by other mens commentaries without making tryal of the things themselves; especially since Natures Book is so open and legible . . . what we discover by the senses is more clear and manifest to us than that which we discover by the mind, because the latter springs from these sensible perceptions and is illuminated by them. . . . Wherefore it is that without the right verdict of the senses controlled by frequent observations and valid experience, we make our judgements entirely on phantoms of apparition inhabiting our minds. . . . We must, I say, rely on our experiences and not on those of other minds. . . . Therefore, gentle Reader, take on trust nothing that I say on the generation of animals. I call upon your eyes to be my witnesses and my judges.[10]

The statement Vesalius makes in his self-portrait by placing his hand on the flesh of the anatomized body is not an afterthought. For Paracelsus, anatomy was not just observing with the eyes but experiencing the material substance of the elements and of the human body in the light of nature to bring forth certain knowledge.[11] Like artisans, medical practitioners were an important part of the story of experience, and in part 3 we turn away from painters and sculptors to focus on an apothecary and a professor of practical medicine, both individuals with important connections to painters but who, more importantly, employed and disseminated the artisanal epistemology as articulated by Paracelsus.

FIGURE 5.1.
Andreas Vesalius, *Portrait of the Author*, frontispiece, *De humani corporis fabrica*, 1543, Library, Getty Research Institute, Los Angeles. Vesalius demonstrates the muscles of the fingers.

After Paracelsus

The claim that certainty is located in nature and that it is accessible especially to those involved in direct contact with nature resounded throughout the sixteenth and early seventeenth centuries. We can find it in the work of numerous practitioners, writers, and religious radicals, to whom it gave justification and legitimacy. It resonated in Palissy's claim to "read earth and sky":

> Theory: And how do you know that, and what is your basis for undertaking to contradict so many learned philosophers who have written such fine books on alchemy? You who know neither Greek nor Latin, nor scarcely good French.
>
> . . .
>
> Theory: And where have you found this written down? Or tell me, what school have you been to, where you could have heard what you say?
>
> Practice: I have had no other book than the sky and the earth, which is known to all, and it is given to all to know and to read in this beautiful book.[12]

The claim that literacy in the book of nature is superior to literacy in texts and that sky and earth are given to all to know and to read were radical social and intellectual claims. We can see this in a trial argued before the Paris Parlement in 1579, just a year before Palissy's book appeared. In this contest, the plaintiff was the Medical Faculty of the University of Paris, which charged the defendant, a Paracelsian chemist, with practicing medicine without a license. On the first afternoon of the trial, the defendant stated that he could not speak Latin, and for the rest of the day, the court debated this assertion. Because the chemist refused to express himself in Latin, the plaintiffs maintained they could not examine him in French, for medical knowledge was expressed only in Latin. Against this, the chemist asserted that disease was not healed in Latin nor in Greek, and, as Hippocrates had spoken Greek and Avicenna had healed in his native tongue of Arabic, as a native of France, he could pursue his art in French.[13]

 The Faculty of Medicine did not recognize this argument and turned instead to the education of the defendant. How could he be a true doctor, if he couldn't speak Latin, for medicine was taught in Latin? He could not possibly have passed the disputations and examinations in medicine. The court granted him a chance to translate a sen-

tence from Latin. At first he refused. Under pressure, he admitted he could read Latin better than speak it. After much discussion, the judge allowed him to present a written translation to the court, but with the stricture that he perform it on the spot with no time to take it away or study it. The chemist's Latin translation was so bad that the court burst into laughter when the judge read it out. The court recorder noted all the mistakes in translation, and then, by analogy, listed the illnesses treated incorrectly by the chemist. The court finally concluded that a man who did not know even the basic rules of Latin conjugation and declension could hardly understand anything about medicine and, consequently, must be irresponsible and lacking in good character.[14]

The claim to literacy in the language of nature in the sixteenth century represented a social and intellectual threat. The language of learning was Latin, and a person had to be literate in this language in order to make claims to legitimate knowledge and to the authority that this knowledge conferred. An institutional structure embedded within a political and social hierarchy mediated and guarded this literacy. Palissy's statement that he read earth and sky, and that this book was open to all, challenged established educational structures and a social elite educated by texts in ancient languages. It opened an epistemological controversy about the aims and methods of knowledge, and it raised the specter of religious confrontation between personal illumination and institutionalized intercession.

Practitioners such as the Paracelsian chemist tried by the Paris court and the three individuals examined below were encouraged in their claims to knowledge of nature by the writings of alchemists and chemists, who emphasized the necessity of artisanal expertise in the laboratory. Above all, however, it was Paracelsus who gave these practitioners such confidence. Paracelsus's work seems to have struck a chord among artisans as well as radical religious and social reformers.[15] The following three Paracelsian practitioners in the late sixteenth and early seventeenth centuries illustrate the different trajectories of Paracelsus's effect.

The Illuminated Artisan: Jakob Böhme

Jakob Böhme (1575–1624), a cobbler from the Lusatian city of Görlitz, located on the Neisse River on the present-day border of Saxony with Poland, related that he was "illuminated" in 1600. From that time on, he recounted, he spent his time in studying God and nature and, after 1612 when he was thirty-seven, writing works of intense religious mysticism.[16] These writings are first and foremost about God, but they all begin

in nature, and his religious and natural principles form a unity. Reading the book of nature as a religious text was, by the time Böhme composed his works, a familiar trope. The apostle Paul had charged that the pagan Romans had no excuse not to worship the God of the Christians; even if they had not read of him, his works stood open to their sight:

> All that may be known of God by men lies plain before their eyes; indeed God himself has disclosed it to them. His invisible attributes, that is to say his everlasting power and deity, have been visible, ever since the world began, to the eye of reason, in the things he has made. There is therefore no possible defence for their conduct; knowing God, they have refused to honor him as God, or to render him thanks (Romans 1:19–21).

Augustine echoed this sentiment, calling for Christians to praise God through His Creation.[17] Luther and Calvin reiterated and brought back into prominence the idea that a Christian can come to knowledge of the Creator through His Creation.[18] Martin Luther, for example, writes that "we are now again beginning to have the knowledge of the creatures which we lost in Adam's fall. Now we observe the creatures rightly, more than popery does. . . . We, however, by God's grace are beginning to see his glorious work and wonder even in the flower. . . . We see the power of his word in the creatures. As he spoke, then it was, even in a peach-stone."[19] This gave powerful impetus to those advocating direct engagement with nature as a way to gain knowledge. Interest in the particulars of nature (and in the practice and experience connected to the particular and ephemeral, rather than the general and demonstrable) grew in part out of nominalist ideas that fueled Martin Luther's belief in the utter impotence of human beings to know God in a comprehensive or certain manner and partly from a Pauline emphasis on knowing God through His Creation, a trend that became particularly strong in Calvinism.

Böhme declared that his search for God had begun in the observation of nature because he had no other access to knowledge of God and because he did not know any other way of writing: "So once again we must examine the things of nature, otherwise I cannot write about [the Holy Trinity]."[20] Indeed, he believed, as the title of his work of natural philosophy, *Aurora*, proclaims, that "the description of nature" was the "root or mother of philosophy, astrology and theology." All theological principles had their corollary and their proof in nature: "I must show you in your body and in all natural things—in humans, animals, birds, worms, even in wood, stone, herbs, leaves, and grass—the image of the Holy Trinity in God."[21] For Böhme, there was nothing in nature that did not bear the imprint and likeness of God. Böhme's heliocentrism, for ex-

ample, proceeded from his conviction that the central sun was the material image of Christ and that the life-giving rays of the sun were the likeness of the Holy Spirit.[22] Similarly, the life-giving vital principle that was diffused throughout the world emanated from God, thus God was omnipresent in the world.

Böhme believed everything had a corporeal and a spiritual nature that could be known through the senses and sensory experience: "Every being in this world consists in that which is known by the eyes and through experiences."[23] Like other Paracelsians, he described God's creation of the world in alchemical terms, giving central place to Paracelsus's three principles: salt, sulfur, and mercury. His notion of an omnipresent divine and corporeal substance, the *Salitter*, which he "identified with the corporeal determinacy of things, with their origin or [Paracelsian] 'seed,' and with the powers of fertility in them," apparently resulted in part from his practical alchemical work. In its purely terrestrial form, the *Salitter* corresponded to the essential component (potassium nitrate) in saltpeter and gunpowder.[24] Böhme's writings show clearly the conjunction of artisanal convictions, Paracelsian alchemical practice and theory, and religious beliefs.

In all of Böhme's writings, the human body is central, a view probably related to his belief that the body of God resides on earth.[25] In one curious passage, he provides the bodily meaning of the sentence "Am Anfang schuf Gott Himmel und Erde" [In the beginning God created heaven and earth], by describing the movements of the body on forming each syllable. The word "Am" pushes out of the heart to the mouth, but in the middle the lips close tightly together so that the word is half in and half out of the mouth. This denoted that God was disgusted by the ruination of the world brought on by Adam and Eve, so he pushed the world away, but then midway through he caught and held it.[26] Böhme further assigned symbolic material meanings to various parts of the body: the heart connoted fire; breath, air; the liver, water; and the lungs, earth. His artisanal self-consciousness comes through particularly in his discussion of the meaning of the hands:

> The hands symbolize the omnipotence of God, because just as God can transform everything in nature and make whatever he wants out of it, so the human being, with his hands, can transform anything in nature that grows or becomes, and can make with his hands whatever he wants; he rules the whole work and being of nature with his hands, and they rightly symbolize the omnipotence of God.[27]

Böhme's works were confiscated in Saxony, and he was prevented from publishing in his native land; his texts were mainly brought out on the printing presses of Am-

sterdam. After the confessionalization of the Holy Roman Empire following the Thirty Years' War, his followers would largely be found in the Dutch Republic.

The Projecting Artisan: Cornelis Drebbel

An exact contemporary of Jakob Böhme, Cornelis Drebbel (1572–1633) was apprenticed to the Haarlem engraver Hendrik Goltzius. Drebbel eventually married Goltzius's younger sister and in 1595 settled in Alkmaar as a master engraver. Drebbel soon began applying for patents for perpetual motion clocks and pumps, very quickly finding his way first to the court of James I in London, where he worked on court entertainments, and then to the court of Rudolf II in Prague, where he continued his work in alchemy and experimented with making gold alloys for the German mint. He returned to London around 1617, where he gained fame for his submarine, a mobile version of a diving bell capable of remaining underwater for hours at a time. The secret of this feat seems to have been Drebbel's ability to separate oxygen, what he called "a nitrous spirit of air" or the "quintessence of air," from saltpeter and bottle it, releasing it when the air in the submarine grew stale.[28] The production of oxygen inspired Robert Boyle and Robert Hooke, whose work formed the basis for John Mayow's "De sal-nitro et spiritu nitro-aereo,"[29] a mechanistic statement of the theory of an aerial life-giving spirit. Drebbel invented all manner of other machines and instruments, including a furnace with a thermostat and self-regulating damper, and he was involved in a great variety of schemes for drainage, brewing, dyeing, alchemy, and perpetual motion.[30]

Drebbel's treatise *Tractaet von de Naturere der Elementen* (1604) shows the way he based his authority on nature as well as his use of alchemy. He begins by recounting his observations of the elements:

> I sought the elements which taught me the nature of earth: its crystal spirit I saw as a fog, its colored soul I saw as blood, its solid body, like crystal. I saw the spirit fight and overcome the body and the soul, which had joined. The body served the spirit and the soul for a solid residence; the spirit illuminated the body and the soul like a crystalline heaven. The soul ornamented body and spirit with its heavenly ruby red color. I saw death, resurrection, and eternity before my eyes. I was thankful to God and loved nature.[31]

After this experience of enlightenment, he decided to write a book that would explain the workings of visible nature, hoping he would not be scorned for his lack of

knowledge about the ancient authors. He claims to give the reader "exactly what he had received from nature" (preface). As indicated by the language of the preface, the entire book constantly refers the reader back to the activity of the alchemist to explain the transformations of nature. The goal of all who study nature should be to gain an understanding of matter and to work toward its purification (chap. 1). Drebbel explains the effect of the sun on the earth by the workings of a distillation flask (chaps. 2 and 4); he draws an analogy between the movement of air to produce thunder and the mechanics of gunpowder (chap. 7); and he elaborates on the manner in which water falling on earth causes earth to putrefy, which in turn nourishes all things, after which everything returns to earth again by means of another cycle of putrefaction (chap. 8).

Although Drebbel's book purported to be natural philosophy, it was seen by at least one reader as a recipe for the alchemical tincture, as indicated by the marginalia in the British Library copy (1608).[32] His work on the perpetual motion machine, which again emphasizes the aim of knowing God through His creation, maintains that the machine derives its motion from the eternal movement of all things. Drebbel swore that in constructing the machine, he had not "had any assistance from the books of the ancients, nor any other kind of help, but had discovered these things solely through constant, untiring carefulness, attention to, and investigation of the elements" ("Achthabung/ Aufmerckung und Erforschung der Elementen").[33]

Constantijn Huygens (1596–1687) bought telescopes and a camera obscura from Drebbel, indicating that Drebbel was also an expert glassblower and lens grinder. In 1622 Huygens wrote home from England:

> I have that other instrument of Drebbel's with me, which really produces marvellous re-sults in the shape of pictures reflected in a dark room. It is impossible to express the beauty in words. The art of painting is dead, for this is life itself, or something higher, if we could find a word for it. For both shape and outline, as well as movements are de-picted by it so naturally and in such an amusing way. The de Gheyns will be marvellously entertained by it, but our cousin Carel will be furious about it.[34]

Many other learned men sought Drebbel out, including the prodigious French corre-spondent Nicolas-Claude Fabri de Pereisc (1580–1637), who wrote to Peter Paul Rubens asking for the particulars of Drebbel's perpetual motion machine. Interest in Drebbel's "secrets" continued into the late seventeenth century as his daughters and their draper and dye-maker husbands, the Kufflers, attempted to sell Drebbel's recipes for oxygen, self-regulating ovens, and tin salt to fix cochineal red dye to the king of En-

gland and to the Royal Society. On his travels, Balthasar de Monconys sought out Drebbel's son-in-law (a Kuffler) in 1665–66 to learn more about the submarine and the self-regulating furnace, but Monconys could not obtain the secret of the furnace: "This doctor, who was very pleasant and was rather good-looking although he had but one eye, was not willing to lay bare the secret, which he declared his father-in-law had considered as important as the Great Work [i.e., alchemical transmutation], saying repeatedly that he would reveal it to him alone who should reveal to him the Great Work."[35]

Drebbel is an exemplar of the shared purpose and interchange among artisans, practitioners, and scholars in the late sixteenth and early seventeenth centuries who could be found everywhere in Europe among those interested in the investigation of nature and who was especially typical among those in the Lowlands.[36] Drebbel was one of a myriad of Dutch practitioners like Simon Stevin (1548–1620), who began as a clerk in a merchant firm in Antwerp, moved to Leiden in 1581, and began publishing works in Dutch, including a book on the calculation of interest, practical mechanics, and hydrodynamics. He was appointed engineer and quartermaster in the service of the *Stadhouder*, Prince Maurits (1567–1625), and, finally, private tutor to the prince. Similar practitioners at this time also included Willem Jansz. Blaeu (1571–1638), a carpenter and countinghouse clerk who apprenticed himself to Tycho Brahe and then returned to Amsterdam to become hydrographer to the Dutch East India Company and the foremost globe and mapmaker in Europe, and Isaac Beeckman (1588–1637), a candle maker who developed a philosophy from which Descartes drew his most important ideas.[37] Prince Maurits himself was deeply interested in practical activities and established an engineers' school connected to Leiden University in 1600 for which he commissioned Stevin to design the course of study. A school for engineers also existed at Franeker that taught navigation, surveying, fortification, and construction.[38] Navigation instructors taught in almost every harbor town in Holland, reckon masters were widespread, and every city employed a surveyor. The necessity of regulating the ebb and flow of waters and the life of the cities encouraged the concern for teaching practical subjects and gave abundant opportunity for practitioners and scholars to mix. For example, Stevin and Blaeu sat on a patent commission with Rudolf Snel van Royen, also known as Snellius (1546–1613), a follower of Petrus Ramus and professor of mathematics at Leiden, and Joseph Justus Scaliger (1540–1609), professor of Greek at Leiden from 1593 until his death and son of the eminent physician and humanist Julius Caesar Scaliger (1484–1558).[39]

This confluence of theory and practice can also be found in Prince Maurits's study of fencing as a combination of science and art, his reorganization of the army on

mathematical principles, and the meticulous record-keeping of his equine breeding program, which recorded the servicing of mares, the birth of their foals, and the foals' characteristics. The practical interests of the *Stadhouder* and the Dutch city governments, not to mention the myriad printing presses and publishing houses, as well as the relative religious tolerance, brought practitioners from far and wide to try their luck in the free city air of the Dutch Republic. One of those was the German court apothecary Johann Rudolf Glauber.

Elias Artista *in the Marketplace: Johann Rudolf Glauber*

Johann Rudolf Glauber (1604–1670) was born the son of a barber.[40] No document attests in any way to a completed school course, university degree, or apprenticeship training. He describes his education as gained by travel, experience, reading, and conversing with scholars. He appears to have learned metalworking and states that he supported himself before the 1630s by mirror making. Perhaps he spent time in Vienna in 1625/26, and in 1632 he claimed to have been selling mirrors in Frankfurt a.M. Documentary evidence of his travels is first found in 1635/36 when he worked in some capacity in the court apothecary in Giessen. In 1641 we find him in Amsterdam, where he married Helena Cornelisdr. of Flensburg, with whom he would have at least eight children,[41] and where he called himself an apothecary, although he was not listed in the Collegium medicum in Amsterdam.[42] He may have remained in the service of the Margrave of Hessen-Darmstadt until 1644, perhaps returning to the apothecary in Giessen, but in 1646 it is clear he was living in Amsterdam and had begun the activities that he was to carry on for the rest of his life, namely, working in his laboratory and publishing works of chemistry and alchemy. His first book, *Furni novi philosophici* (1646–49), describes a new type of distilling furnace that had a smokestack at the top (an iron pipe five to twelve feet high) instead of bellows to control the draught and heat. He called these "Philosophical Furnaces," and in them, he carried out new distillations of metals and organic matter, trying a wide variety of substances in order to experiment with different distillates. Over the next twenty-four years, he published almost thirty books, all containing in different measure practical processes, advertisement of secret preparations, and a theoretical framework for his inventions and recipes. Glauber described his furnaces in enough detail for replication, as he did with some of the other tools of his own invention, such as the "safety tube," which was a U-shaped tube filled with mercury that allowed gases to escape, and glass vessels with ground

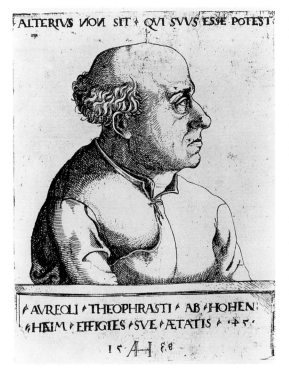

ALTERIVS NON SIT ‡ QVI SVVS ESSE POTEST

‡ AVREOLI ‡ THEOPHRASTI ‡ AB ‡HOHEN‡
‡HEIM ‡ EFFIGIES ‡SVE ‡ÆTATIS ‡ ‡45‡

1 5 A H 88 ·

FIGURE 5.2.
Portrait of Paracelsus, anony-
mous broadsheet, 1538, Well-
come Library, London. Paracel-
sus is simply dressed and his
motto is inscribed overhead
"Alterius non sit qui suus esse
potest" [He who is able to be
his own man shall not belong to
another].

glass stoppers in which strong acids could be stored. He also provided clear directions for preparing some mineral acids.[43] Besides descriptions of his inventions, his works are full of self-defense and biblical citations, and he praises and calls constantly upon the authority of Paracelsus and Jan Baptista van Helmont. A list of his library attests to his interest in the century's new discoveries, primarily those in geography and natural history, but the number of these works is surpassed by the far more numerous chemical and alchemical volumes in his collection.[44]

His published works and the self-advertisement found in them indicate his position in Amsterdam (and later, tem-porarily, in Wertheim and Kitzingen) as a private practi-tioner selling his products and his processes on the market instead of producing them for a patron or within a guild. He often quoted approvingly the mottoes taken over by Paracel-sus to the effect that a man must be his own master: "Omnia mecum porto" [I carry all things with me] and "Alterius non sit qui suus esse potest" [He who is able to be his own man shall not belong to another]. Contemporary broadsheet por-traits of Paracelsus carry these mottoes (fig. 5.2). More than anything else, Glauber promised the production of things; he saw himself as an "experienced Artist," one bet-ter able to imitate nature in its generative processes and thus to know nature. He maintained that only work in the laboratory could teach about nature: "It is only through fire and not from Aristotle that learning and studying should and must take place. And fire is the correct schoolmaster of all natural arts."[45]

His books are clearly meant to advertise his processes and products. The recipes they contain are given only in part; Glauber only rarely provides instructions for the entire process. His writings often include a declaration that he will reveal the process personally only to those who come to his laboratory. Such self-advertisement is an in-dication of his liminality, for his position impelled him to advertise his products and to reveal enough of the recipe to establish his expertise in the subject but at the same time to keep his processes secret enough to protect his economic interest. This forced Glauber to walk a finer line than either a guild member, who had a clear and over-riding economic interest (and often guild regulations on secrecy), or a scholar, who had no economic interest to protect in publishing his books, and who, indeed, gained reputation precisely through his publishing.

Glauber was clearly an entrepreneur in a commercial society. He even regarded his books as products. When he dissolved his laboratory and library in 1668, he had a large number of books on hand that he attempted to sell at discount prices.[46] He apparently produced mineral acids and tartaric acid on a large scale, selling them for manufacturing processes.[47] He also offered processes and recipes for sale. For example, when Samuel Hartlib sent him a sample of lead ore and tin scoria, Glauber claimed to be able to extract silver and gold (besides lead and tin) from both but demanded a thousand ducats for the lead-ore extraction technique and two thousand ducats for the process of extracting gold from the remains of tin ore (or scoria).[48] Another example of his entrepreneurial activities can be found in his 1649 contract with the natural philosopher Otto Sperling in which Glauber sold the recipes for and privilege to manufacture in Denmark, Norway, Sweden, and "other northerly lands" a brandy half as expensive as French brandy and a long-lasting fruit wine as well as the process for making good wine out of bad. In return, Sperling promised to pay Glauber four hundred *Reichsthaler*, and a further thousand-*Thaler* fine if Glauber were to find that Sperling had communicated the processes to anyone outside the area for which he had purchased the privilege.[49]

Glauber's laboratory in Amsterdam formed a way station on many a grand tour. From at least 1655, he had a large laboratory in a house on the splendorous Keizersgracht, and in the summer of 1660, Glauber moved to a house on the Looiersgracht belonging to the well-known Swedish-Dutch silver- and goldsmithing family of Anthoni Grill. The house was under the care of one Cornelis le Blon,[50] and the Grills' financial trouble led their creditors, including Quirijn Spranger,[51] to seize possession of the house and sell it in January 1661.[52] Glauber was forced to move out hastily, and five months later he was still trying to retrieve the furnaces, mills, kettles, vessels, and other tools that he had left behind.[53] Among these were a bellows four and a half feet long, a lead workbench, and cast-iron plates.[54] Glauber protested to the notary Joost van de Ven that these included materials relevant to the war against the Turks and that greater and more significant damage would be in store if they were not returned to him.[55]

In 1656 the Danish king Frederick III sent his chemical adviser Caspar Herbach to pay a visit to Glauber,[56] and Samuel de Sorbière (1615–1670), scholar and royal historian to King Louis XIV, called in on Glauber at the height of the chemist's health and prosperity in the Looiersgracht. Sorbière was impressed with Glauber's modesty and the grandness of his four laboratories that occupied the back of his house and employed five or six workers.[57] Sorbière noted approvingly Glauber's humble but dignified bearing, commenting on Glauber's poor Latin, for which Glauber did not apologize, and Glauber's unembarrassed answers to Sorbière's questions. Glauber showed

him a plot of the most barren beach sand, which Glauber had "prepared" (probably with his salt) and which was now full with foot-high grain sown only six weeks before. Glauber believed he had found the way to make the rockiest soils and arid deserts bloom. Two years earlier Glauber had published the process for heating his *sal mirabile* and gold together to produce a deep green liquor that, besides being a panacea, acted as an aphrodisiac and a fertilizer. When added to sand, this liquid caused "seeds of all plants to acquire such a strong attractive power that these have the force to magnetically pull the astral powers to themselves and thereby to be strengthened so that they could then be used for all sicknesses without further preparation."[58] Glauber also showed Sorbière a flask capable of holding volatile fluids with no evaporation. Sorbière also heard about a spirit of wine that could be transported and then reconstituted with water, which, as he noted, would effect a great savings in commerce and the transport of merchandise. Glauber's visitor wished to buy some of his medicaments and his panacea, but Glauber was saving them for a public demonstration to be held three weeks later.[59] Sorbière, who visited almost every important practitioner and new philosopher in the Netherlands, wondered at the grandeur of Glauber's laboratories, the walls of which were covered with the vessels and instruments of his invention. Further, he speculated that Glauber must have some metallic secret or some other unknown means of income because he was able to sustain both his family *and* his own curiosity.[60]

Visitors in 1662 saw Glauber after he had fallen ill and his laboratories in a different house on the Looiersgracht had collapsed into disrepair.[61] After Glauber's fall from a wagon in 1666, Robert Boyle reported that Glauber was "spitting much blood, and if the fever prevail upon him he fears his life; which I pray God may be yet continued for giving many good hints, at least to the studiers of nature and arts."[62] Glauber lived for another four years after this fall, and when he died on 10 March 1670, he was buried in Amsterdam's Westerkerk.

Men like Sorbière made Glauber's laboratory a stop on their itineraries because he was a producer of knowledge about nature, an experienced artist who could call himself a new philosopher, although he clearly did not have the same educational background (and thus the same position in the social hierarchy) as they did.[63] Above all, they saw him as a producer of works and things: "If [Glauber] can make good but halfe of what hee promiseth, he will deserve to be admired not only by Germany, but by all Mankinde as a man raised up by God in a peculiar maner for the advancement of the Publick Good."[64] Referring to Glauber's productive ability, Boyle described Glauber's work on saltpeter as a "most substantial rational *et real* piece."[65]

Paracelsian Salt

In his youth, Johann Rudolf Glauber passed through Basel, where he met a philosophically minded man who showed him his own dead child preserved in the water from a nearby spring. Although this child had died some time before, its body had not putrefied. Glauber never saw the source in Switzerland from which this water came, but he happened upon a similar spring in Vienna-Neustadt. The water in this spring transmuted everything placed in it into stone, preventing all things from rotting. Moreover, it cured Glauber of a long and difficult fever.[66] Glauber stayed the whole winter observing this spring and found that it prevented the swamps from freezing, kept the grass green around its edge, and supported numerous turtles and other amphibious animals.[67]

Later, after many years of reading and experimenting, Glauber claimed to have discovered the makeup of the salt that gave this spring its powers. He called it *sal mirabile* for the wonders it could work and claimed that he produced it from common salt and sulfuric acid. He first announced his discovery in 1658, publishing a book about the nature of salts in general. In it he praised the manifold virtues of salt: it was the nutriment of all things, a symbol of eternity, the crucial ingredient in alchemical transmutation and in *aurum potabile* (potable gold), the cause of spontaneous generation, and the principle of all life. All salts, including common cooking salt, partook in the wondrous qualities of the elemental salt, but the *sal mirabile*, as its name implies, was truly miraculous. It could be taken internally or applied externally on wounds, and it caused both poisons and medicines to work with more efficacy.[68] It was, in fact, the universal spirit by which the generating power and heat of the sun were conveyed to earth. In earlier writings, Glauber had believed this spirit to be a niter of some sort, but after 1658 he claimed to have discovered the vital spirit in his new salt.[69]

According to Glauber, Paracelsus had known of this salt and had called it *sal Enixum*. It had also been described by the author of *De re metallica*, Georgius Agricola (1494–1555), as occurring naturally in the salt springs, but neither of these authorities had known the composition of this salt nor had been able to produce it in the laboratory.[70] In contrast, Glauber claimed to be able to produce it on a large scale. In announcing his discovery, Glauber immediately proclaimed his authority in this matter of salts. Despite his lowly origins as a barber's son who had apprenticed as an apothecary and had never been to university, he was proud of his capabilities as an artisan: "Why should an experienced *Artist* not come closer [to the truth about the salt]

when he industriously considers the matter? A scholar is good for preaching but not much else."[71]

Two years after proclaiming his discovery, Glauber wrote more fully about his *sal mirabile*, this time calling it the *sal artis*—the salt of art—that, along with its "brother," saltpeter, was the true *Elias artista*, and indicated the return of the prophet Elias, in the guise of an artisan, to earth as a herald of the coming millennium. The prophet's return signaled the beginning of the millennium and the institution of a new regime of goodness and plenty,[72] and in the form of salt, Elias would bring about a great reformation in medicine and alchemy, making possible alchemical transmutation.[73] In this work, as in so many others, Glauber coyly states his intention of discussing only the uses, not the preparation of the salt.

In 1667 Glauber prophesied again that the *Elias artista* would arrive soon after his own death,[74] and a year later he explained in more detail what he had meant by this prediction. *Elias artista* would come to earth as a great light, good would replace evil, great changes in kingdoms would take place—especially in the Holy Roman Empire—and rulers would be overthrown. Glauber was quick to deny the literal meaning of his prophecy, recalling the social tumult that had taken place when Paracelsus had made a similar prediction. At that time, some people had taken Paracelsus's prophecy literally and had rioted, apparently trying to bring about the coming overthrow of their governors immediately. No, Glauber assured his readers, his own prophesying should be understood in its anagrammatic meaning, which could be discovered with some rearrangement of the letters in *Elias artista*, namely as *Et artis salia*, or the "salts of art," of which *sal artis*, or his *sal mirabile*, was the most important.[75] This salt, he asserted, would change the world because it contained, like all salts but far more powerfully, the vital spirit that caused generation in the cosmos.

Despite this salt's cosmic significance as a tool of redemption, there is more than a hint of self-advertisement in Glauber's accounts of it, especially after he became unable to work in his laboratory due to illness in 1662. This advertisement was important, for Glauber's livelihood depended on the sale of his chemical products. When he moved from Giessen, where he was court apothecary, to Amsterdam in 1640, he entered a world in which it was possible to make one's fortune by selling goods on the market. Until he became incapacitated in the mid-1660s, Glauber seems to have been highly successful in marketing his salts, mineral acids, and their recipes. The story of Glauber's salt gives insight into the emergence of the new philosophy and its relationship to artisans. Glauber was a practitioner, claiming authority as an "experienced artist," and he advertised his products in the framework of a commercial market. His

sal mirabile—simultaneously a product of manual work, a part of alchemy, an instrument of redemption, and a valuable commercial commodity—represents a particular moment in the development of the new philosophy, a moment brought about by the entry of a new sort of person into the production of knowledge about nature. Practitioners such as Glauber were encouraged in their claims to knowledge of nature by the writings of alchemists and chemists, who emphasized the necessity of artisanal expertise in the laboratory, but above all it was Paracelsus who gave these practitioners such confidence. Paracelsus not only believed the millennium would be ushered in by *Elias artista*, by artisanal work and the products of art, but, more fundamentally, articulated the artisanal epistemology that gave legitimacy and an identity to practitioners such as Glauber.

Glauber's life history brings out the particular tensions to which this new sort of philosopher was subjected and the manner in which he negotiated a place in his social and intellectual world. Glauber was trained as a practitioner but desired to gain acceptance as an independent and disinterested natural philosopher. Because he sold his products, he was anxious to represent himself as untainted by commerce, understanding his work instead as part of the redemption of the world. It was, however, precisely this commercial context that made his livelihood as independent practitioner possible. And it was the emergence of the new philosophy that made possible Glauber's authority on natural questions as well as the attention paid to him by the *curiosi* of Europe. At the same time, practitioners helped form the practices of the experimental philosophy. The entry into the knowledge-making process of a new group of people, such as Glauber, who were practitioners and often liminal between scholars trained at university in texts and artisans trained in the workshop by imitation was an important source for this new epistemology. These practitioners often saw the new philosophy as an opportunity to attain an authority not possible for them in any other sphere, for natural philosophy gave them entry into the republic of letters by drawing not upon their knowledge of the classics, but upon their ability to undertake particular practices and produce tangible effects or objects. Glauber's life illustrates the new concerns and aims as well as the new epistemology that such new figures brought with them into the making of the new philosophy.

Glauber employed Paracelsus's chemical theory of three principles, but he made salt the most important of them. More importantly, Glauber took over Paracelsus's belief that work in the laboratory, especially chemistry, was a labor of redeeming fallen nature. For Paracelsus, this work of redemption involved the production of medicines, but for Glauber, it was bound up with the production of goods that would contribute

to material plenty. Glauber's entire chemical philosophy was shot through with this re-
demptive understanding of art and alchemy, and the chemical and metallurgical
processes he worked and described had significance in the scheme of salvation. He
stated several times that knowledge of nature leads to knowledge of God.[76] Glauber's
early practical activity of mirror making appears to have contributed to one aspect of
his belief in the religious significance of metalworking. In 1651 he claimed that the
sun's warmth penetrates to the center of the earth, which, along with the astral pow-
ers, heats and vivifies the water there, forcing it to the surface, where it appears as
healing mineral springs. When the astral powers mix with wetness and earth, they also
cause metals to grow.[77] Mirrors could be used to concentrate and capture the rays of
the sun and their vital principle.[78]

His later chemical theories also reflect this redemptive understanding of natural
knowledge. For example, Glauber believed that the color of metals indicated their
"soul," or essence. If metal ashes were added to glass, the metal's true color or soul
would be revealed. If this color could then be extracted, one would possess the spirit of
the metal and hence effect real alchemical transmutation. Working according to this
theory, Glauber rediscovered the process for red-tinged glass (*Rubin-Glas*), in which he
claimed the soul of gold was captured. Glauber and others believed the process for
Rubin-Glas was akin to the process of alchemical transmutation.[79] Glauber's interest in
Rubin-Glas attests to the stimulus alchemical principles gave to practical chemical activi-
ties and utilitarian projects, for *Rubin-Glas*, its red color caused by the admixture of gold,
could be seen as representing the last stage of transmutation in which the mass turned
red before being transformed to gold. It was also regarded as demonstrating the multi-
plication of gold, for only a small amount of gold tinged a large quantity of glass.

Commerce

Although Glauber adopted Paracelsus's understanding of natural knowledge as re-
demptive and of artisanal labor as a form of worship, his world was not Paracelsus's.
Glauber lived in a commercial society, and this subjected him to particular tensions,
while also giving him an opportunity to shape himself as a new philosopher. As a fig-
ure liminal between artisans and scholars with no established qualifications in the re-
public of letters and no clear estate in society, Glauber was always in danger of slipping
down to a purely mechanical or mercantile level. He was anxious to make clear that his
activities were not just carried out in the pursuit of wealth. He was particularly sensi-

tive to being called a gold-making alchemist, as he said his neighbors in Amsterdam had called him.[80] He argued against this charge, maintaining that gold-making alchemy was completely different from his own alchemical practices. According to Glauber, a gold-seeking alchemist could be a simple laboratory worker who knew nothing significant or someone who had learned about transmutation only from reading books. Both activities had nothing to do with true alchemical knowledge. Glauber described transactions frequent in Amsterdam between two types of fortune hunters, whom he called "laborer" and "investor," as a kind of cottage industry. Producing gold as a cottage industry resulted in nothing, however, for

> the *Laborant* knows nothing and the principals or investors know even less. It is not enough that one is a highly schooled, knowledgeable man, for such schooling or learning has nothing to do with alchemy. Alchemy requires people who understand the ways and characteristics of metals.[81]

But gold making was only the worst of fortune hunting; commerce, too, was distasteful to a natural philosopher. Glauber was also in danger of being seen as a common merchant who sold his goods for private profit, something no true natural philosopher would do.[82] When George Starkey was trying to attract Robert Boyle as his patron, he wrote to Boyle, "I avoid the selling of nature's secrets and for this reason alone is Glauber so antithetical to me. . . ."[83] Glauber was anxious to show himself as a disinterested participant in the marketplace. When Monsieur de Sorbière came to visit, he wanted to buy some of Glauber's products, but Glauber said he did not have any at present because he was occupied with plans for performing a transmutation in public. Sorbière later communicated to a correspondent that he had news that Glauber had carried out his public performance "without any profit, but only to show the possibility of the thing."[84] What more convincing proof of his purely philosophical interests (and perhaps better advertisement for his products) than to perform in public?

In 1647 Henry Appelius reported a conversation to Samuel Hartlib that reveals the interesting mix of commercial entrepreneurship and altruism that characterized Glauber's self-presentation:

> Glauberus, last week when I visited him, was ready as to day to goe to Arnheim with his family, which is a cittie upon the Rhyne not very farr above Utrecht, where the Kufflers dwell & exercise their dying of cloath/ Glauber would faine goe higher, in Germany, & set up their such workes whereby hee might maintaine his family most liberally, by the In-

ventions especially in metallicis, whereof hy saith hee hath most certaine proofes. . . . And
because hee will bee freed of much acquaintance, leters en the like, hee writes his books,
for the benefit of all men. . . . [H]eertefore he taught the furnaces et the mannour of dis-
tilling for monyes, now hy communicats them to the whole world: as soone as there bee
men to beare the printing charges, then it . . . may bee printed. . . . 3 weeks agoe a Doctour
from Mets asked leave that his booke might bee translated into Latÿn et French, Glauber
answered; there was no necessity to aske leave of him, seing the book was no more his,
but all mens.[85]

Glauber sought to support himself by marketing mineral products much like the Kuf-
flers, who had achieved great commercial success in the cloth trade by employing their
father-in-law Cornelis Drebbel's discovery that tin mordant fixes red cochineal dye.[86]
But at the same time, Glauber presented himself as making his discoveries freely avail-
able to all men (although the contents of his books often belie such intentions). In the
same conversation, Hartlib's correspondent noted that Glauber had reaffirmed his
commitment to experience and ocular demonstration: "Whether there bee a book
written against [Glauber], we know not certainly, he is threatned with his [symbol for
gold] [potab?] but he is not afraid, if they wil refute him, they must doe with experi-
ence, not with words et speculations, also with better inventions et compendiums."[87]

 Glauber wanted to make clear that his activities were of a different order than
those of a merchant or indeed anyone else engaged in commercial transactions, for the
possession of his processes and products was the key to an honest livelihood and was
necessary to prevent a man from becoming a slave to another. His practical knowledge
was a type of wealth that could neither be sinfully hoarded nor stolen by thieves. But
most important, this type of knowledge made commerce completely unnecessary to
those who possessed it:

> We do not need to seek the necessaries of life by usury or trickery or by other sinful
> means. For all commerce, whether large or small, cannot occur without sin, as the highly
> experienced Jesus Syrach said, the sins between the buyer and the seller stick as tight as a
> nail in the wall. And not only sin grows in the buyer and seller but in all those who are
> not their own masters, but instead have learned their livelihood under another and must
> seek [their livelihood] through others. Included in these are physicians, surgeons, apothe-
> caries, jurists, lawyers, procurators and other high or low learned men. When they have
> only studied and learned an art or craft in order to make money, then sin is rooted in the
> making of profit and is transformed into an evil habit that will not be extinguished ex-
> cept by death.[88]

Glauber set himself off from the artisans and scholars with whom he might otherwise have been identified, for he regarded their work as tainted by commerce. It was in fact only an independent man such as himself who could keep from committing the sin of taking from others by the practice of commerce.

Humans could learn to live without sin if they could recognize and learn how to use the "Universale Sal Mundi," for then they would always have plenty, could never slip into poverty, and would remain rich into their graves.[89] Because this salt could give them whatever they desired, be it "health, money, or possessions," those who possessed it would never harm their fellow humans. Moreover, their piety would be both visible to all, and they would get their just rewards here on earth because the godless could not obtain the art of this salt:

> And this is certainly true, that the godless never will come to knowledge of this salt, and much less to its use. For all philosophers testify to this. Among others, the highly experienced philosopher Bonus Lambertus who affirmed this in his dialogue with Lacinius: *Ars ipsa sancta est, & quam non nisi puros ac sanctos homines habere licet. Nam ut divi Thomae utar [sic] sententia, Ars ista vel reperit hominaem sanctum, aut reddet ejus inventio sanctum.* Art does not lodge by the proud misers, but by those who are satisfied with a little.[90]

Because the knowledge of art was granted by God and only the godly could possess it, Glauber seemed to envision the formation of a kind of elect of the artisanal pious. This was, however, not Calvinism, for Glauber was nominally a Catholic, and he had found that in his travels since "one must have to do with [different religions], [he] therefore went into the services of Catholics with Catholics, those of Lutherans with Lutherans, and those of Calvinists with Calvinists, and heard of each his opinions, which seemed good to me."[91] He also read all kinds of religious pamphlets and "over the years heard and saw such quarreling with amazement."[92] He believed instead in seeking God through nature and salvation through work in the laboratory.

In this conviction, Glauber was similar to Johann Moriaen (ca. 1591–ca. 1668), one of Samuel Hartlib's most prolific correspondents and intelligencers. In the 1640s Moriaen became frustrated with pansophical projects, especially those associated with Jan Amos Comenius, and turned instead to the practices of natural philosophy, believing that "the gate of things" would provide a common ground from which all confessions could gain new insight into the principles of divine harmony. He made microscopes and produced medicines (by which both profit and service to the common good could be combined), but he saw especial promise in mathematics and alchemy; mathematics providing a model of method and certainty, and alchemy giving entrance

into the most sublime secrets of natural and divine things. Moriaen regarded alchemy, like pansophy, as giving understanding of the natural world and, at the same time, as enabling human beings to regain dominion over the fabric of Creation. Alchemy "cured" matter and the human soul of their postlapsarian corruption.[93]

Although Glauber made his living from selling his products and their advertisement fills his works, he was at pains to show that it was his labor in the laboratory, rather than his commercial success, that gave him his independence and his position in society. The value of his products was not measured by their worth on the market but by their part in the redemption of the world. This is especially clear in works such as *Des Teutschlandts Wolfahrt* (1656–61), in which he describes many useful processes to make a land fertile (through saltpeter production and composting), to concentrate and preserve surplus agricultural goods, and to protect territories from conquest (by acids that could be fired toward enemy armies). It is telling that part of the stimulus to publish *Teutschlandts Wolfahrt* came directly from the commercial economy in which he found himself. When there is a surplus harvest, he said, the peasants cannot convert their natural goods into money and thus cannot pay their taxes, for their rulers no longer accept their payments in natural goods, requiring cash instead.[94]

In his work *Trost der Seefahrenten* (1657), Glauber claims a desire to provide a service to the hard-worked sailors of his adopted Amsterdam. He sets out a method of making seawater potable and preserving drinking water sweet at sea, a process for concentrating grain in a beerlike drink, a recipe for a concentrated and long-lasting bread, and a "spirit of salt" able to prevent scurvy. Neither of these books, nor any of his others except one, is dedicated to individuals but instead his books are addressed to the "common man," "peasants, vine-growers, and gardeners," or to his "German Fatherland."[95] Such works aspired to demonstrate his devotion to the salvation of humankind.

No doubt sincere piety motivated such works, but they also reflected Glauber's desire to carve out a new identity as something more than an artisan or merchant and different from a scholar. This identity was that of an experimental philosopher, both productive and disinterested, a Paracelsian redeemer of the world through the production of material things. In this guise, Glauber successfully negotiated an independent livelihood. Glauber represents a type of practitioner who did not exist before Paracelsus gave him a language and the rise of the new philosophy made his identity possible.

A profound reorientation in attitudes toward the material world and material things took place in Europe in the sixteenth and seventeenth centuries. One of the

most important markers of this shift was a new understanding of the natural world, which emerged out of a union of scholarly and artisanal ways of thinking about material reality. This new understanding of nature was, however, part of a much larger economic and social transformation in Europe that resulted from the growth of an exchange economy. Glauber, who worked within a commercial market and held a view of labor and art as redemptive, helped both to bring about these new attitudes toward the natural world and to reshape the concept of salvation as material progress.

Glauber's Children: Science and Art

Once, when lamenting the losses over the years that had been caused by his pursuit of chemical medicines, Glauber stated that none of his eight living children chose to follow him into alchemy because they all saw "the danger that they could expect from it."[96] Like so many children of artisans and even of nobles in the Dutch Republic of the seventeenth century, three of Glauber's children became painters: Johannes, Jan Gottliebb, and his daughter, Diana Gertrude. Glauber claimed he did not begrudge them their choices, but these words are contradicted by Johannes Glauber's (1646–1726) biographers, who claim that Johannes had burned with a desire to paint from his youth but was faced with strong resistance from his father, who preferred that he pursue other activities.[97] But after incessant drawing and painting, according to his biographer, Johannes was finally apprenticed to the landscape painter Nicolaes Berchem (1620–1683), with whom he stayed for nine months. The travels he undertook throughout his life typify the development of artistic activity in the Netherlands in the last third of the seventeenth century. After leaving his apprenticeship, Johannes worked under Gerrit Uylenburgh (1626–1690), a painter who had become a dealer of Italian paintings in Holland and who employed several young painters to copy these paintings to increase his stock. Here Johannes worked until 1671, when he undertook a journey with his brother Jan Gottliebb (1656–1703) and two other painter friends, the van Doren brothers. They traveled to Paris, where they worked for a year for Brabant painter Jean-Michel Picart (ca. 1600–1682), a painter of fruit and flower still lifes who had settled in Paris about 1625 and began a very lucrative career as a dealer catering to the booming demand for flower and still-life paintings. His workshop employed large numbers of journeymen painters whom he put to work copying the paintings of artists such as Rubens, Van Dyck, Jan Brueghel the Elder, and Titian, among others.[98] Johannes Glauber then worked two years in Lyon for the Dutch landscape painter and

draughtsman Adriaen van der Kabel (1630/31–1705). In 1674 Johannes and his brother Jan Gottliebb journeyed to Rome, where they both entered the Schildersbent (painters' band), the rowdy confraternity of Netherlandish artists in Rome, where in 1675 they took part in one of the Bent's "baptisms," in which new members were christened with mythological names. This bacchanalian feast, in carnivalesque imitation of the installation ceremonies of the Order of the Golden Fleece, was known to last three days and three nights and involved a mock priest who administered the baptism by wine. After eating and drinking for days on end, the revelers ended with a last libation at "Bacchus's Grave," a massive porphyry sarcophagus for Constantia, youngest daughter of Emperor Constantine, which was decorated with *putti* pressing out grapes to make wine.[99] In his baptism, at which thirty-six Netherlandish artists participated, Johannes adopted the pseudonym Polidor and his brother Jan Gottliebb selected Myrtil. After two years in Rome, the brothers moved on to Padua, then Venice, where they spent two years practicing drawing and painting every day "from nature." They then continued on to Hamburg, where they remained until 1684, with one trip to Copenhagen, where Johannes worked for the regent of Norway. Johannes then returned to Amsterdam, where he shared a house with Gérard de Lairesse (1641–1711), a painter of allegorical and religious subjects who dictated books on the principles of drawing and painting after he became blind. Johannes Glauber and de Lairesse collaborated on many projects, with Johannes painting the landscapes and de Lairesse the human figures, or staffage. Johannes also collaborated in the same way with Dirk Maas (1659–1717), whom he met when they were both apprenticed to Nicolaes Berchem. Johannes Glauber's work was typical of the Italianate landscapes that became popular at the end of the seventeenth century. He painted large trompe l'oeil wall paintings for the palaces of William III of Orange and for numerous other wealthy patrons (figs. 5.3a, b, and c). He joined with other *kunstschilders* (art painters), sculptors, and engravers in their attempt to separate themselves from the glassmakers and *kladschilders* (housepainters) in the Guild of St. Luke.[100] Johannes's brother Jan Gottliebb left Hamburg to work for various German princes, going from Vienna to Prague and finally ending his life in Breslau in 1703. He painted landscapes and harbor scenes. Their sister, Diana (1650–after 1721), was a well-known painter of portraits in Hamburg who apparently went blind in her old age. Not a single painting by her is known today; perhaps her work has been subsumed into that of her brothers.

Although the Italianate landscapes of Johannes Glauber seem far removed from the world of his father, their lives had common components, particularly the importance of the marketplace, which shaped both their identities. In addition, Johannes's

FIGURES 5.3 A, B + C
(*continued on following page*). Johannes Glauber and Gérard
de Lairesse, ca. 1684–90,
Rijksmuseum Amsterdam.
Johannes Glauber provided
the landscape and Gérard de
Lairesse the figures in these
three wall paintings. They were
installed in one room of the
home of Jacob de Flines on the
Herengracht in Amsterdam.
At nearly three meters high,
these paintings in their original
setting would have created for
someone in the room the illu-
sion of looking out on all sides
to a sunny pastoral landscape
filled with people passing by.

part in the panel painters' attempt to separate themselves from the housepainters and glassmakers in the Guild of St. Luke indicates the formation of new identities that ultimately underlies modern perceptions of the different social and intellectual roles filled by artists and scientists. Johannes Glauber and his fellow painters represent the end point of the story that began in the Flemish painters' self-consciousness. Where the Flemish painters began to articulate claims about their knowledge of nature, however, seventeenth-century Dutch painters such as Johannes Glauber were content to proclaim the higher social status they had attained as art painters. Similarly, Johann Rudolf Glauber helped shape a new identity as an experimental philosopher, one that would become more exclusive in the course of the following centuries. Both these new identities were based on the sixteenth-century articulation of the artisanal epistemology by painters, goldsmiths, sculptors, and engravers and its dissemination in the works and persona of Paracelsus and his followers.

Moreover, the life stories of the Glauber children—in the fragmentary manner in which they have come down to us—suggest the way in which art and natural philosophy began to diverge in the seventeenth century. As the roles of fine artist and new philosopher were more clearly articulated, they began to part ways. "Art" came to mean fine art rather than craft. Johann Rudolf Glauber had referred to himself as an "experienced Artist," but over the course of the seventeenth and eighteenth centuries, experimental philosophers would no longer call themselves artists. The experimental philosophers' habits of observation, of imitating nature, and of manual engagement with the objects of nature had their roots in the artisanal epistemology, but in the seventeenth century, natural philosophers began to distance themselves from artisans. This will become clear in the last chapter by examining the art collection of a new philosopher, Franciscus dele Boë, Sylvius.

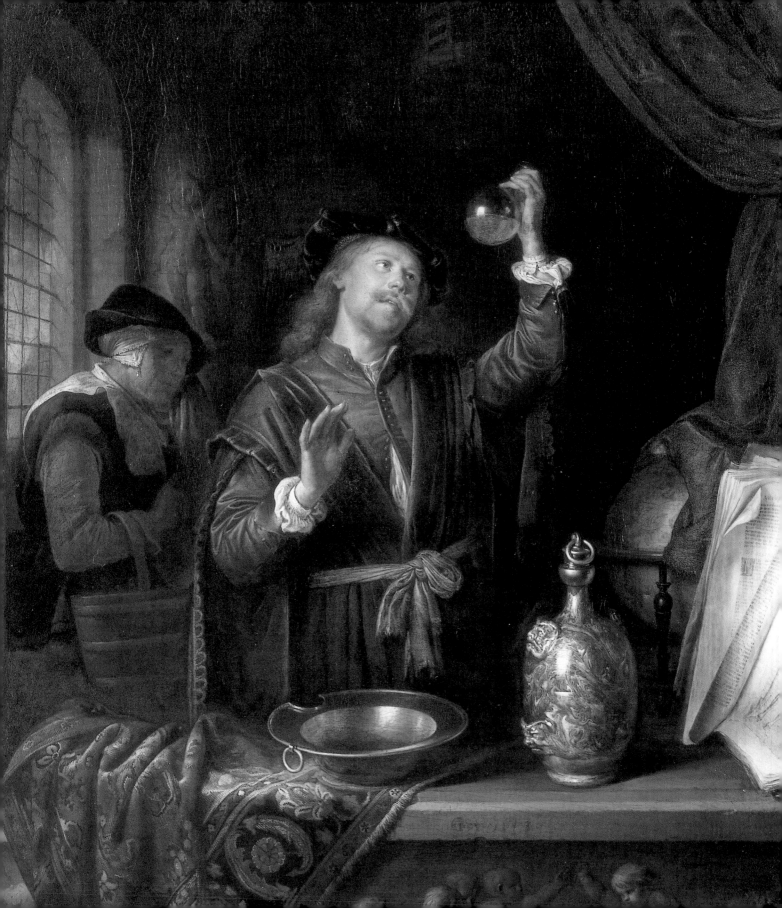

The Institutionalization of the New Philosophy

One of Glauber's admirers in Amsterdam was Franciscus dele Boë, Sylvius (1614–1672), a very successful physician and follower of Paracelsus and Jan Baptista van Helmont (1579–1644). Sylvius swore by Glauber's *aurum potabile*, or potable gold, of which he claimed to have eaten "above 2 lb" when he was "sick to death" in 1646, "fownd it good, as a panacæa, wisely mixed with other medicines, for it is as a fire. penetrat, resolvit, discutit, expellit, attenuat."[1] Sylvius and Glauber experimented with gold making together[2] and Sylvius manufactured a *sal volatile*, possibly with a recipe given to him by Glauber.[3] When Sylvius died, his heirs tussled in court with two women who had been living in Sylvius's house over who had legal possession of the recipe for this salt, his heirs finally paying the women an annual sum if they promised not to manufacture it. His heirs maintained that Sylvius's niece, Anna Maria Rouyers (his sister's daughter), was the only one allowed to distill the salt after his death. Catharina and Johanna Agache, the two sisters who had resided in Sylvius's house, asserted to the contrary that Sylvius had added a codicil to his will allowing them to continue to manufacture the salt.[4] It is not clear whether Sylvius's niece, Anna Maria, or perhaps his nephew Jean Rouyers, a well-to-do cloth merchant in Amsterdam, or perhaps Jacob de Bois,

a Leiden apothecary (and possibly a blood relative) who witnessed Sylvius's will and testified in the suit, eventually manufactured and sold this salt.[5] In any case, the legal battle for control of the salt's manufacture indicates the way in which Glauber's instrument of redemption would be transformed fully into a commercial commodity over the course of the seventeenth century.

Although from the foregoing legal tangles over pharmaceutical substances it is clear that Sylvius resembled Glauber in many of his interests, Sylvius exemplifies not the practitioner's life, as Glauber did, but rather the shape of the new philosophy in the late seventeenth century. Like so many other émigrés in the United Provinces, Sylvius's family had fled north from French Flanders during its revolt from Spanish domination, and Sylvius was born in Hanau, near Frankfurt am Main, in 1614. Originally part of the Flemish Protestant nobility, the family had lost their lands and title and become merchants some generations before Sylvius was born. Their faith, however, was still strong, and they sent the young François to the Calvinist academy at Sedan. From there he moved to Leiden and a series of north German Protestant universities, where he pursued medical instruction, finally receiving his degree from Basel in 1637. He was back in Leiden in 1638, offering private lectures on anatomy and defending William Harvey's new theory of the circulation of the blood. He met Descartes at this time, and although they later parted paths intellectually, they retained a strong mutual respect.[6] In 1641 he opened what would become a lucrative private practice in Amsterdam and soon became a leading physician and experimental philosopher in that city. Leiden University lured him away from Amsterdam to the professorship of practical medicine in 1658 only by paying him twice the normal professor's annual salary.[7]

Sylvius was a new philosopher, indeed; apparently not a modest man,[8] he regarded himself as one of the best exemplars of the new philosophy (fig. 6.1). His clinical teaching and anatomies as a professor of practical medicine at Leiden University between 1658 and 1672 were so successful—drawing students from all over the Continent—that new rooms had to be added in the hospital (St. Caecelia's Gasthuis) where he lectured. Sylvius's medical theories represented a culmination of the new chemical medicine, first promulgated by Paracelsus, and Sylvius was the motive force behind the founding of the first chemical laboratory in a European faculty of medicine in 1669.[9] Sylvius's physiological theories followed those of the Flemish chemist Jan Baptista van Helmont but were entirely material and chemical, based on the binaries of acid spirit and alkaline salt and the effects of their effervescing fermentation.[10] All bodily processes were understood according to the model of digestion (what Paracelsus had

called the inner alchemist)[11] and the processes of human digestion as re-created in the chemical laboratory. For Sylvius, the processes initiated and observed in his laboratories were the processes of nature in microcosm, and his experimental anatomies (including vivisection) were a window onto the workings of nature and of human physiology. Sylvius viewed nature not as a machine, but as a chemical laboratory.

Unlike the Paracelsian practitioners we have examined so far, Sylvius was involved in institutionalizing the new philosophy in the university curriculum. By the second half of the seventeenth century, the use of the senses in obtaining natural knowledge was taken for granted. As Paracelsus had advocated, certainty was seen to emerge from the study of nature, but this focus on matter, the material world, and the senses had unforeseen consequences. At the same time, although manual labor had lost its stigma to some degree and experience had come to be an integral component of the knowledge-making process, bodily involvement in the gathering of experience and the construction of knowledge came to be viewed as problematic. The artisanal appeal to direct access to nature through bodily experience and autoptic authority had provided justification and legitimation to large numbers of practitioners in the beginning of the seventeenth century, but the open-ended potential of these claims to knowledge and authority was threatening to natural philosophers like Sylvius in the late seventeenth century. This situation came to a head in the late seventeenth century when the teaching of the new philosophy caused bodily experience to be transformed. An examination of Sylvius's private sphere reveals a focus on the material world and the senses and a desire to delimit his identity as a new philosopher of nature. Sylvius's house in Leiden exemplified an aesthetic new to Holland in the seventeenth century. He designed it according to new principles, and he owned one of the largest collections of exotica, sculpture, porcelain, and Netherlandish paintings in the city. His collection shows him to have been an avid but careful collector, patronizing the most expensive local painters in Amsterdam and Leiden and concentrating on paintings that were called "modern" to distinguish their naturalistic representation of material objects and daily life from the "antique" style of narrative painting.

Both Sylvius's new philosophy and his collection of modern paintings are expressions of a new anxiety about the body and the senses that arose within a profound shift in the orientation of European culture toward material things in the sixteenth and seventeenth centuries. The growth of commerce and the exchange economy as well as the rise of the new science were part of this shift. In the previous chapter, Johann Rudolph Glauber's self-fashioning and the resulting transformation of the Paracelsian practitioner demonstrated one aspect of the relationship between com-

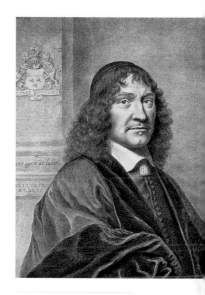

FIGURE 6.1.
Cornelis van Dalen, *Franciscus dele Boë, Sylvius at Age 45*, engraving, 1659, Stichting Iconographisch Bureau, The Hague. In keeping with his social standing, Sylvius wears the black costume typical of Holland's wealthy middle class. Note the coat of arms of the Crevecoeur family in the background.

merce and science. In this chapter, we examine another dimension of this transformation, by which artisanal bodily experience was absorbed into the work of the natural philosopher at the same time that the artisan himself was excised from it. If we linger in Sylvius's house and look closely at his material possessions, especially his painting collection, we gain insight into the common sources of his scientific and epistemological convictions and his aesthetics. Uncertainty about the epistemological status of knowledge gained through the senses and about the practices by which that knowledge was gathered ran through Sylvius's medical work and can also be discerned in the paintings he possessed, and both show a new concern—sometimes conflicted, sometimes playful—with the senses.

The material evidence provided by Sylvius's possessions offers a rich vein for the historian, for these objects and their arrangement in his house give tangible embodiment to his taste and thus shed light on a dimension of his life that would otherwise remain unseen and unknown. Taste embodies a usually tacit understanding and sense of the organization of the world of things as apprehended through the senses and thus can evoke for us the meaning and significance of things in society. Because experimental philosophy was firmly located in the world of material objects and of the senses, such a knowledge of taste can help us understand what was at stake for Sylvius and his contemporaries in the new philosophy. A tour of Sylvius's house gives us insight into what happened to the artisanal epistemology when it was institutionalized in the universities of the seventeenth century, both the problems it raised and the potential it promised.

The House: Consumption and Desire

Not long after Sylvius moved from his highly successful medical practice in Amsterdam to Leiden in 1658 to take up a professorship of practical medicine, he bought a house on the Rapenburg Canal.[12] By the mid-seventeenth century, this canal had become the center of elite cultural life in Leiden, the preferred residence site for city officials, wealthy merchants, and university professors (fig. 6.2).[13] Sylvius commissioned a stone merchant and developer to rebuild the house according to the latest fashions in home design, with the result that his house stood out from those of other upper-class citizens of Leiden, both in its interior design and in the intentional and purposeful organization of its collection of artwork. Sylvius's house still stands in Leiden today and its original floor plan can be reconstructed (fig. 6.3). In contrast to older-style

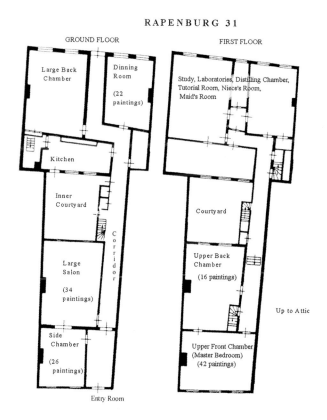

RAPENBURG 31

GROUND FLOOR

Large Back Chamber

Dining Room

(22 paintings)

Kitchen

Inner Courtyard

Corridor

Large Salon

(34 paintings)

Side Chamber

(26 paintings)

Entry Room

FIRST FLOOR

Study, Laboratories, Distilling Chamber, Tutorial Room, Niece's Room, Maid's Room

Courtyard

Upper Back Chamber

(16 paintings)

Up to Attic

Upper Front Chamber (Master Bedroom) (42 paintings)

homes, it contained a separate dining room and a salon to display the owner's collection, one of the few Leiden houses of such distinction. It had no beds in the kitchen; in fact, no beds were let into the walls at all.[14] Sylvius's house was custom-built for his professional needs and included a study, a room in which to hold tutorials, or *Collegies,* and no fewer than three laboratories. He furnished the house with fashionable freestanding canopied beds and high wardrobes,[15] and chose fabrics in contrasting bold colors for his draperies and upholstery, including purple and yellow silk in the master bedroom.[16] When the house was inventoried in 1673, six months after his death, it contained one of the largest painting collections in Leiden,[17] showing Sylvius to have been a patron of the "modern" painters of Amsterdam, including Experiens Sillemans (1611–1653) and Simon Luttichuys (1610–1661), and of Leiden, with works by the likes of Gerrit Dou (1613–1675) and Frans van Mieris (1635–1681).[18] His collection held almost none of the classicizing historical, mythological, or religious paintings

FIGURE 6.2.
View along the Rapenburg Canal. Author's photo.

FIGURE 6.3.
Floor plan of Rapenburg 31. Drawing adapted from *Het Rapenburg: Geschiedenis van een Leidse gracht,* 6 vols., edited by Th. H. Lunsingh Scheurleer, C. Willemijn Fock, and A. J., van Dissel. Leiden: Afdeling Geschiedenis van de Kunstnijverheid, Rijksuniversiteit Leiden, 1986–92.

popular in Italy but was wholly devoted to Netherlandish painting of the late sixteenth and seventeenth centuries with its carefully painted scenes of objects and people drawn from daily life. His taste ran particularly to artists, such as Roelant Savery, Paulus Potter, and Philips Wouwerman, who painted careful, naturalistic renderings of objects, especially animals. He was not an omnivorous collector of northern painting, however, and his collection lacked the moralizing "genre" pieces by Jan Steen and the landscapes of Jan van Goyen that appeared in many of the collections of his Leiden contemporaries.[19] His collecting extended to many other kinds of objects as well: East and West Indian rarities, carved shells, large amounts of silver plate, porcelain, small statuary, and expensive furniture.[20]

A visitor entering Sylvius's house was immediately faced in the entry hall with a sort of self-representation: besides twelve paintings, Sylvius placed his coat of arms and an ornamental calligraphic rendering of his name on the walls. Indeed, the visitor or the student who came to take his *Collegie* with Sylvius would have seen the coat of arms on approaching the house, for it also adorned the house facade (fig. 6.4). In the entry hung Adriaen Brouwer's *Quacksalver*, to which we shall shortly return. The visitor turned left into a side chamber filled with twenty-six paintings, a large mirror, a large table, diverse stools, a small cabinet, and a fireplace. Next he moved into the large salon (*Groot Salet*), built as a receiving room meant for public display and containing some of the most important paintings in Sylvius's collection. Its fireplace was faced in marble, the ceiling may have had a fresco, and the walls held thirty-four paintings and a large mirror. On the table lay a Turkish carpet, and the chairs and stools were upholstered in red. A cabinet made of exotic wood held some of the rarities of Sylvius's collection. This room seems to have been given over entirely to the display of his possessions.

One exited this room into a corridor, containing *snaeckse tronies* (droll character studies), three maps, and a church view, to enter the back of the house, passing on the way the staircase and the kitchen, where, contrary to the usual arrangement in less "modern" houses, no paintings hung and no beds were built into the walls at the sides of the hearth. One then passed directly into the dining room, which looked out onto the garden and was hung with green curtains that matched the upholstery of the chairs arranged around the two tables and along the walls. A hat stand, a chest, and a hanging wall cabinet for glasses ornamented the room; far more exotic, though, was the bird-cage with a live parrot, a rare inhabitant of a seventeenth-century house. Here were more of Sylvius's most outstanding paintings: a series of the five senses by Jan Miense Molenaer, a painting by Gerrit Dou, and a portrait of Martin Luther and his wife,

FIGURES 6.4 A + B.
Rapenburg 31. House facade
with the Crevecoeur coat of
arms. Sylvius's coat of arms also
appears in his engraved portrait
(fig. 6.1). Author's photo.

Katharina von Bora. As in the large salon, there were still lifes, game and animal paintings, and relatively few landscapes. By the mid-seventeenth century, landscapes had come to be fairly inexpensive, and while landscapes made up the majority of Sylvius's collection,[21] the fact that he hung fewer of them in the most representational rooms of his house indicates that he put thought into the hanging of his paintings.[22]

Across the corridor from the dining room was the "lower back chamber" with a freestanding bed hung in green to match the six chairs. It was ornamented with two portraits of Sylvius (fig. 6.5) and a bust of carved ivory as well as two cabinets and a shelf containing porcelain and small statuary.

The decoration of the front room on the *piano nobile*—the master bedroom—was, like the large salon and the dining room, representational. Indeed, it appears to have mimicked a noble receiving chamber, for it contained a canopied bed hung with purple curtains lined in yellow silk and a matching bedspread. A cradle stood nearby, lined in the same material. The square table held a copper pitcher and bowl. This room was arranged as a kind of *Kunstkammer*: large quantities of porcelain, exotica, shells, lacquered boxes, and mother-of-pearl and ivory objects were displayed in cabinets, on

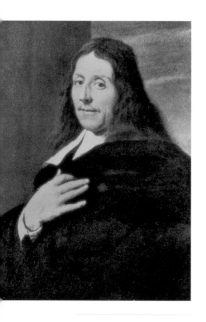

FIGURE 6.5.
Frans van Mieris, *Portrait of a 52-Year-Old Man (Franciscus dele Boë, Sylvius?)*, 1665, oil on panel, 18.8 × 14.2 cm, present whereabouts unknown. This portrait may have hung in the lower back chamber. The identification of the sitter as Sylvius is not entirely secure, although the resemblance is marked.

the mantelpiece, and arranged on shelves. Two books of prints were kept there, and the walls were hung with two large mirrors and more paintings than in any other room—forty-two—among them portraits of Sylvius and his second wife, Magdalena Schletzer; a portrait of van Mieris; a stable with horses by Philips Wouwerman (fig. 6.6); a portrait of King Charles of England by Anthony Van Dyck; a Bathsheba by Pieter Lastman; several flower paintings, including one by Balthasar van der Ast; renderings of insects against a white ground by Magaretha de Heer; and numerous landscapes.[23]

Behind this room was an "upper back chamber" with two bedsteads, a cradle, a linen press, a few paintings, and nineteen terra-cotta statuettes. Above it was the attic, which held various chests, furniture, a sweating stool, and an ivory lathe, on which Sylvius may have turned the ivory objects. Among the other rooms on the main floor, one, ornamented simply with ten "old" paintings, belonged to Sylvius's orphaned niece; an even simpler room was occupied by the maid. Sylvius's professional needs were served by the rest of the rooms. His study contained a bedstead with curtains, a table and four chairs, a standing desk, and two shelves with books. Several chests, including a safe that held rarities, were found here as well as a little doghouse and a timed mechanism for turning the spit in the fireplace. There were four paintings on the walls. Further workrooms included a tutorial chamber furnished only with benches; a distilling room containing telescopes (perhaps a notarial error for microscopes), furnaces, and a large amount of glassware; and two laboratories with at least eighteen large and small furnaces as well as bellows, pots, mortars and pestles, and other chemical instruments.[24] Sylvius's library was huge (the notaries gave up cataloguing after the octavo volumes, simply mentioning that there were still 336 works of medicine and 300 miscellaneous books in smaller formats),[25] and his books must have lined the walls of his workspaces.

Perhaps more than anything else, Sylvius's immersion in the things that appealed to the senses was demonstrated by his table linen. At a time when table linen was still a rarity in other countries, to be seen, if at all, at noble courts, this rich (although not fabulously so) citizen of Leiden possessed 10 large tablecloths, 22 small ones, and no fewer than 185 table napkins. The notary's inventory leaves the impression that the house was overflowing with things—natural, artificial, and painted.[26] This is just one of many such inventories taken in the United Provinces of the Dutch Republic, where, particularly in the commerce-rich province of Holland, burghers lived almost like nobility. The Dutch Republic enjoyed the highest standard of living in seventeenth-century Europe.[27] Simon Schama has written evocatively about the moral contradic-

tions raised by such conspicuous consumption in a Calvinist society, and the mixture of admiration and ethical doubt that commerce provoked for contemporaries is clear in literature from the time.[28] Commerce was still frequently seen as corrupting and parasitical; however, especially in the works of Dutch economic writers, it was beginning to be regarded as part of a cycle of production.[29] Consumption was not just an economic issue; it also raised questions about control, both social and personal. To begin with, it brought about sumptuary problems: if tradespeople dressed in silk and even farmers bought paintings to hang on their walls, as visitors to Holland charged,[30] then how could the different orders and levels of society be distinguished? An anonymous seventeenth-century Amsterdam pamphleteer wrote: "My soul is filled with disgust as I see here a tailor's wife in her plush velvet strolling by. There a shoemaker's or innkeeper's wife wearing her most beautiful silk and plush velvet clothing. Shopkeepers and peddlers imitate lords; there is no difference any more between noble and nonnoble, between rulers and the common people."[31] Moreover, the pursuit of wealth and

possession of the material things of this world led to an unfortunate focus on the temporal and material rather than the spiritual. This tendency was exacerbated by the ideas of René Descartes, whose writings were interpreted by many as positing a purely materialist philosophy that lacked the conviction of God as Final Cause and were regarded as leading university students dangerously astray.[32] Finally, the exotica, the rarities, and beautiful paintings, textiles, and manufactured objects available in Holland thanks to both its home industry and its position as a global entrepôt engendered in its people the burning fire of cupidity, the most violent and dangerous of the passions.[33] Descartes's *Passions de l'âme* [The passions of the soul] (1649) maintains that desire—a species of love that includes both attraction and its opposite, repulsion—is the strongest and most dangerous of the passions:

> The passions of attraction and repulsion are usually more violent than other kinds of love and hatred, because what enters the soul through the senses affects it more strongly than what is represented to it by its reason. At the same time, these passions usually contain less truth than the others. Consequently they are the most deceptive of all the passions, and the ones against which we must guard ourselves most carefully.[34]

For Descartes the passions were by nature good; for the practitioner and author Vannoccio Biringuccio (1480–ca. 1539), desire could even be creative. Biringuccio ended his work of 1540, *De la pirotechnia*—a catalog of all the arts that use fire as an agent of transformation—with a half-facetious chapter on the most consuming fire of all, love. Nothing except the fires of hell could remotely compare to the power of this inferno, and although it has the power to kindle endless torments, Biringuccio maintains that it is a noble and even spiritual power. Like the other fires of which he wrote, Biringuccio claims to know this fire not from "the knowledge of others," but from his own experience. This fire is, in Biringuccio's words, "an imaginative thought fixed on the knowledge of the desired thing. Wherefore our most simple intelligence is often blinded by the senses, becomes entangled, and seizes what it desires, drawn on by beauty or by the immoderate hope of possession." Hence the symbol of this fire is Cupid, which signifies nothing other than desire or "cupidity."[35] This "natural craving of insatiability to desire evermore than we have and never to be satisfied with what we possess" is, according to Biringuccio, a wellspring both of destructive consumption as well as the source of creative production in the arts.[36] What Biringuccio sought to convey was a nexus of material things, their commerce, creation, and consumption, and the desire they provoked in the senses. Nowhere was this nexus more complex and

raised more ambivalence than in the province of Holland where Sylvius lived, and it formed a framework both for his taste in art and his natural philosophy.

The Quacksalver in the Entryway: Deception and Demarcation

The subject of Adriaen Brouwer's *Quacksalver* (fig. 6.7), which hung in the entry room alongside Sylvius's coat of arms and the calligraphic rendering of his name, was an unlicensed medical practitioner selling his wares to a group of brutish peasants at a village fair.[37] Medical practitioners were common subjects for painters (fig. 6.8), and they were often portrayed as engaged in deception. No less a person than Constantijn Huygens (1596–1687)—diplomat and shaper of the Dutch Republic in its early days—following on such models as Erasmus's *The Praise of Folly*, chose the figure of the medical practitioner to exemplify learned deception and ignorance.[38] The lecherous medic attending to the lovesick maid (fig. 6.9) and the doctor peering into a urine glass (fig. 6.10) were stock figures on the Dutch stage and in Dutch painting, and they reminded the viewer that those who rely on the senses or trust in learned experts are easily deceived.[39] Such images highlighted the close connection between sensory curiosity and sensual desire.[40] The medical practitioner was implicated at every stage of his work with the body, in its generative capacities as well as its putrefactive ones, and his interest in the materiality of human life could easily translate into carnality and lust. Perhaps artists' interests in medicine were self-referential as well, for the original calling of Saint Luke, the patron saint of painters, had been as physician. Practitioners in both professions claimed to combine practice and theory, and both relied upon their senses, especially vision, and upon manual experience in the practice of their craft.[41] Both were immersed in the bodily aspects of the visible and material world, and both could use their position as interpreters of the world to deceive their patients or their viewers. By the mid-seventeenth century, painters often mixed with medical practitioners, attending public anatomy lessons and producing such paintings as the *Dead Adonis* by Hendrik Goltzius, which hung in Sylvius's salon (fig. 6.11).

The quacksalver represented in Sylvius's entryway was only one among a broad spectrum of medical practitioners who served the seventeenth-century public; in fact, most medical disputes at this time were in large part about marking off boundaries between these practitioners. Beginning in the late sixteenth century, the different groups active in medicine formed protective corporations, lobbied municipal governments and magistrates for privileges and protection from competition, and strove valiantly,

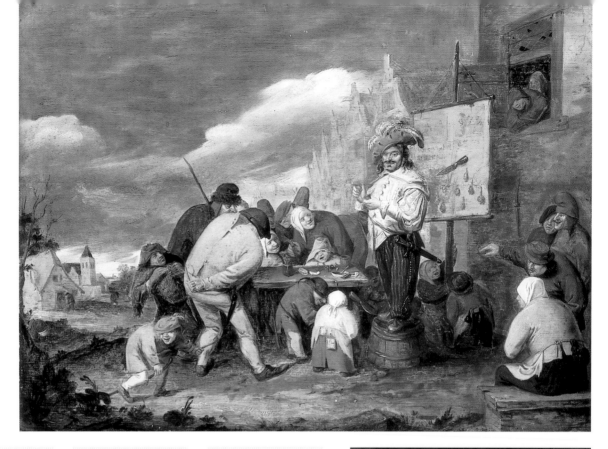

FIGURE 6.7.
Attributed to Adriaen
Brouwer, *Quacksalver*, ca. 1625,
oil on panel, 45 x 50 cm,
Staatliche Kunsthalle Karls-
ruhe. This painting was located
in Sylvius's entry room. The
quack, a dwarf, stands on a bar-
rel, dressed in the clothes of the
Italian comedy, making his
pitch to a group of misshapen
peasants in a market square.
Hanging behind him is a sign
hung with the seals supposedly
testifying to his products or to
his own certification; a painted
knife advertises his talents. He
faces out toward the viewer,
perhaps demonstrating his
wares, perhaps indicating the
group of peasants around him.

FIGURE 6.8.
Gerard Dou, *The Dropsical
Woman*, 1663, oil on panel, 83 ×
67 cm, Louvre, Paris. Photo: H.
Lewandowski. Copyright Réu-
nion des Musées
Nationaux/Art Resource, NY.
There is nothing to indicate
that the sick woman in this
painting suffers from the
swelling of dropsy, but in the
nineteenth century this name
was given to the painting be-
cause it originally possessed
doors by Dou painted as a
trompe l'oeil of a pitcher and
basin in a stone niche (fig.
6.19). Sylvius did not own this
painting. It is recorded, along
with twenty-six other paintings
by Dou, in 1665 in the collec-
tion of the wealthy Leiden col-
lector Johan de Bye.

FIGURE 6.9 (*facing page, top*).
Frans van Mieris, *The Doctor's
Visit*, 1657, oil on copper, 33 × 27
cm, Kunsthistorisches Museum,
Vienna. The precise moral im-
port of van Mieris's portrayal of
a doctor's visit to a sick woman
is unclear. The doctor is dressed
in an outdated theatrical cos-
tume. He has analyzed his pa-
tient's urine and is taking her
pulse. Both of these might indi-
cate his reliance on controver-
sial tests for "love sickness"
and/or pregnancy. The book
open on the woman's lap is the
New Testament. The doctor's
gesture toward his eyes might
indicate that he recognizes folly
or that he has come to a conclu-
sion about the woman's illness
through the evidence of his eyes.
Because the faculty of sight was
viewed as powerful both in
forming conclusions about visi-
ble phenomena as well as a
sense by which people were led
astray, such a gesture could
mean either or, more likely,
both.

FIGURE 6.10 (*bottom left*).
Gerrit Dou, *The Doctor*, 1653, oil on panel,
49 × 37 cm, Kunsthistorisches Museum,
Vienna. Like van Mieris's doctor, Dou's is
dressed in a theatrical costume. The the-
aterlike composition is also reinforced by
the curtain and the *tableau vivant* quality of
the doctor's and the patient's poses. Ob-
serving the urine of the patient was an out-
moded medical technique by the mid-sev-
enteenth century but was still part of stock
representations of physicians. The book,
Vesalius's *De humani corporis fabrica*, propped
open to an illustration of the human skele-
ton, points to the learning of the doctor or
the ultimate *vanitas* of his learning. This
painting was probably in the collection of
the Archduke Leopold Wilhelm in the sev-
enteenth century.

FIGURE 6.11 (*bottom right*).
Hendrik Goltzius, *Dead Adonis*, 1603, oil on
canvas, 76.5 × 76.5 cm, Rijksmuseum Am-
sterdam. This painting hung in Sylvius's
salon on the diagonal, seemingly in imita-
tion of a coat of arms—another indication
of the way in which medical practice was
inscribed in Sylvius's home. Where the
coat of arms in the entry hall stood for
Sylvius's social standing, Goltzius's paint-
ing in the salon signified Sylvius's profes-
sional calling to the viewer.

first, to keep those below them from moving up and, second, to attain the status of those above them. They distinguished themselves mainly by their education and the extent to which they worked with either their minds or their hands.[42]

University-trained doctors of medicine were fluent in Latin and frequently Greek and conversant with the books of the ancients. They practiced mainly in urban areas, where they represented the most expensive and last-sought level of medical intervention. They treated internal diseases with no obvious external causes and performed no manual "operations." They sometimes served a sort of apprenticeship with a practicing doctor, and by the seventeenth century, in Italy and Holland at least, their university training was just beginning to include clinical teaching and attendance at anatomies.

Surgeons, on the other hand, were artisans, trained by apprenticeship, who treated all diseases with visible external causes and any illnesses requiring manual intervention or operation. In the Netherlands, surgeons had succeeded by the second half of the seventeenth century in moving upward to a point where their education included attendance at university and at public anatomies, where they stood behind the governors of the city, the professors, and the physicians. The Leiden surgeons even formed their own guild and possessed their own humanist seal—*Nosce te ipsum*—and, in 1677, perhaps inspired by the *vanitas* ornaments of the Leiden anatomy theater, they bought an hourglass to set up by the skeleton in their guild room above the town weigh house.[43] In Amsterdam, too, the surgeons' guild attained a social status high enough to be proudly proclaimed in numerous group portraits.

The next step down in the hierarchy of medicine was the apothecary, who prepared medicaments but was not supposed to prescribe for or treat patients. In the seventeenth century, this practitioner was most concerned with protecting his turf against encroachments from two different sources: from doctors who manufactured medicines and from barbers, eye doctors, quacksalvers, and "suchlike vagrants, deceivers, and pretenders," with whom the apothecaries felt themselves to be in direct competition.[44] The apothecaries in Leiden formed a guild in 1629 and renewed and extended their letter of guild regulation several times in the course of the century. Like the doctors and the surgeons, these apothecaries were mostly concerned with limiting competition. Their guild regulations reveal that all apothecaries were required to be citizens of Leiden and to be examined in their art by the guild inspectors, paying twenty guilders for the privilege. The examination, which was conducted in Latin, included listing the medical *simplicia* and manufacturing medical composites before the inspectors.[45]

Below these incorporated medical practitioners there existed a great variety of uncontrolled technicians who carried out procedures—sometimes highly skilled ones—not usually undertaken by the incorporated practitioners. Members of this

group, which included eye doctors, tooth pullers, bladder-stone cutters, and quack-salvers, had to petition the guilds and pay a fee for the right to practice. For example, the Amsterdam Collegium medicum (founded in 1638 as an umbrella organization for doctors, surgeons, and apothecaries), in which Sylvius registered when he arrived in Amsterdam in 1641 and in which he served as an inspector a decade later, performed such a boundary-setting activity.[46] All practitioners had to be licensed by the Collegium. A Dr. Zacutus Cuptanus wrote to the Collegium that in his flight from the tyranny of the Inquisition in his native Spain and then in Belgium, his diploma—along with his children and his "ample library"—got left behind; perhaps, he suggested, his diploma could be obtained from his native land. Similarly, in 1678 the Collegium recorded a resolution from the surgeons' guild allowing a certain Hans Jurgen to limit his practice to eye doctoring, teeth pulling, and the manufacture of oils and poultices for their treatment, for which privileges he would pay twenty-four guilders yearly to the guild. Hans signed the agreement with his mark.[47]

In other towns in the United Provinces, similar battles of demarcation continued throughout the seventeenth and eighteenth centuries. In Groningen, guild and church members joined forces to petition city authorities to limit the practice of irregular medical practitioners, such as quacksalvers, exclusively to the period of annual fairs and even there to restrict them to the area marked off for entertainers such as jugglers and tightrope walkers. In city ordinances, such "quacks" were lumped with beggars, hawkers, blanket traders, and songsters, among other vagrant groups.[48]

In seventeenth-century Holland, panel painters were just as busy as medical practitioners in drawing lines of demarcation, as they attempted to set themselves off from other artisans in the guilds of St. Luke, including housepainters, tapestry weavers, jewelers, apothecaries, paint makers, and a host of others.[49] Brouwer's *Quack-salver* alludes to these themes of demarcation. Brouwer's other paintings (one of which was also in Sylvius's possession) almost exclusively portray peasant scenes—lowlifes—in which the peasants are shown as absorbed in the pleasures of the senses, smoking or drinking in a tavern. His most powerful paintings, however, convey a different kind of absorption in the senses, the experience of pain (fig. 6.12). His panels of foot and back operations conducted by a village surgeon (figs. 6.13, 6.14) seek to portray the complete absorption of the patient in his pain, the surgeon in his task, and the onlookers in lusty curiosity and sensory experience. All the figures in his paintings are immersed in bodily experience of one kind or another.

Brouwer's later biographers, Arnold Houbraken and Gérard de Lairesse, believed that the painter himself became swallowed up in scurrilous scenes like those he painted (for so they understood his subjects), leading a scandalous life given over to

satisfaction of the senses.[50] In fact, Brouwer's life (1605/6–1638), as best we can tell from surviving documents, was plagued by recurring debt (with some time in debtor's prison); he died in poverty, and in one of his self-portraits, he depicts himself with fellow artists in a peasant tavern. But we also know that he was a member of the Antwerp Rhetoricians' Chamber and of the Guild of St. Luke. The information provided by another biographer, Cornelis de Bie, who may have known Brouwer personally, gives us an alternative picture of the artist's life and sheds light on the reasons why he was one of the most sought-after and imitated painters of the early seventeenth century.[51] De Bie named Brouwer as one of the best painters of his day, noting his "witty" (*aerdighe*) and "strange" (*vremde*) portrayals of peasant *conversatien*. In contrast to Houbraken and de Lairesse, however, who see Brouwer as a degenerate, de Bie regards him as a moralizing painter. He recounts a story to illustrate Brouwer's ethos and his art. On his way to Amsterdam, Brouwer was robbed by pirates and arrived in the city naked and broke. He bought some sackcloth, cut it into a suit, primed it like a canvas, painted it into the "best and most expensive material in the world," and proceeded to promenade in the streets. The fashionable ladies of Amsterdam searched the stores fruitlessly for this cloth until Brouwer used the occasion of a comedy in the Amsterdam Academy to unmask himself and his unwitting audience. He sprang to the stage at the end of the play, holding a wet sponge in each hand, and said to the audience:

> Friends of the world, do not wonder over the rare costliness of my clothing, which so many people, including the Amsterdam maidens and noblewomen, desired and sought out. The cloth will never be found because I alone am the weaver and inventor. And I will show you it is nothing other than dirt, deception, and vanity, so you shall discover and be forced to admit that the world is as deceptive and false as this suit.

With that, he wiped away the paint with his sponges so all could see that the suit was nothing but sackcloth. "See how far the understanding of these perfect masters soars," concludes de Bie.

> How far their mind searches for material in order to keep the vanity of the world before the eyes of proud humankind. *Mundus exteriora rerum ostendit, interiora tegit.* Truly the world shows herself as comfortable and nice from the outside as she is horrible and shameful from the inside. All of which she knows how to hide until the last, when man has sunk so deep in her pleasure that it is impossible to pull him out. The world is vain appearance / False and vicious at the core.[52]

FIGURE 6.12 (*top left*). Adriaen Brouwer, *Bitter Medicine*, ca. 1635, oil on panel, Städlesches Kunstinstitut, Frankfurt am Main.

FIGURE 6.13 (*bottom left*). Adriaen Brouwer, *Arm Operation*, ca. 1635, oil on panel, 23.6 x 20.3 cm, Bayerische Staatsgemäldesammlungen, Alte Pinakothek Munich.

FIGURE 6.14 (*bottom right*). Adriaen Brouwer, *Back Operation*, oil on panel, 34 x 27 cm, Städlesches Kunstinstitut, Frankfurt am Main. Photo: Ursula Edmann, Frankfurt am Main.

Another writer reported that Brouwer, noticing that his relatives scorned him because he dressed with little taste, had a velvet suit made and was immediately invited to the wedding of a cousin. When the party praised the magnificence of his clothing, he smeared two dishes of meat and gravy on his suit, "declaring that his clothes should enjoy the meal, since they, not he, had been invited," showing once again that the world set too much store on outward appearances.[53]

Brouwer's paintings, then, can be read as warnings about the power of the senses to deceive and seduce; portraying peasants also gave him opportunity to represent the harm that could result from immersion in sensory and sensual experience without the tempering control of *ratio*. His tavern interiors, for example, admonish the viewer—ideally someone from the upper middle class of Netherlandish society—to pursue a moderation that would distinguish him from the animal behavior of the peasants.[54] Horst Scholz gives a persuasive reading of Brouwer's *Tavern Interior* (fig. 6.15), a painting once seen merely as a depiction of peasants drinking themselves to unconsciousness. Scholz points out the figure in the middle who is mixing water with wine, an image commonly used to symbolize *temperantia*. Thus, what was previously regarded as a painting of intemperance can be read as an admonishment to temperance, control, and demarcation. Scholz comments further that the portrayal of peasants by writers such as G. A. Bredero (1585–1618), who had begun his career as a painter, consciously aimed to provide moral lessons to the reader. Bredero himself claimed that he set his poetry and songs among the peasants so as not to offend his readers, the "broad middle" of Dutch society to whom his lessons were addressed.[55] For example, he concludes "Boeren Geselschap" [Peasant society] in the *Groot Lied-boeck* of 1622, which vividly describes the progress of a peasant fest from drunkenness to violence and finally to murder, by demarcating the boundaries between peasant and burgher.

> Ghy heeren, gy burgers/ vroom en welgemoet
> Mydt der Boeren festen/ sy zijn selden soo soet,
> Of 't kost yemant zijn bloet/
> En drinckt met mijn/ een roemer Wijn/
> Dat is jou wel soo goet.[56]

> [You gentlemen, you citizens, fine and cheerful
> Avoid the peasant festivals, they are seldom sweet
> And can cost someone his life.
> Drink instead a *roemer* of wine with me
> That will do you good.]

Bredero's portrayal of the peasants, like Brouwer's, is at least partly an effort to draw the line between reason and bestiality, between city and country dweller, and between high and low. Peter Burke's analysis of the "discovery" of the peasants in the early seventeenth century as a process by which the newly installed city dweller sought to define himself against the low culture of the inhabitants of the countryside he had left behind seems to apply in the work of these Dutch painters and poets as well.[57]

As a medical practitioner, Sylvius appreciated the urge to demarcate boundaries expressed in Brouwer's paintings. Many of Sylvius's activities—his dissections, his experiments in alchemy, and his commercial production of iatrochemical preparations—immersed him in the world of the senses in a way indistinguishable from that of Brouwer's peasant surgeons and their audiences. Sylvius sought to distance himself from the brutish behavior associated with this immersion in the senses by his polite and elite style of living. His table linens, his cultivated collecting, the coat of arms emblazoned on the gables of his house, and his separation of the house's rooms according to function all spoke to his ambition to distance himself, while his position as inspector in the Amsterdam Collegium made his professional status and his respect for professional boundaries clear. One of the surest indicators of the imperfection of the discipline of medicine, Sylvius lamented, was the fact that empirics and folk doctors often cured diseases as effectively as university-trained physicians.[58] Sylvius envisaged a perfect medical science as one in which physicians really could be distinguished from empirics.

Sylvius also understood the admonition to temperance contained in Brouwer's *Quacksalver*. Many of the paintings he owned emphasized the importance of self-knowledge and the effort to achieve moderation in all things, like the numerous fruit and flower still lifes in his collection that alluded to the ephemeral nature of human existence and the vanity of the things of the world.[59] The focus on the transience of human life and desire and the view that moderation and control were necessary were the themes of neo-Stoicism. This philosophy, which was revived in the sixteenth century and combined with Erasmus's Christian

FIGURE 6.15.
Adriaen Brouwer, *Tavern Interior*, ca. 1624–25, oil on panel, 34.8 × 26 cm, Museum Boijmans Van Beuningen, Rotterdam. The figure in the center, who mixes water with his wine, is surrounded by intemperance. In the back, a man sings drunkenly, while another smokes, one cries out, and, on the far left, a man vomits; in the foreground, a man guzzles from his jug and another sleeps deeply.

humanism, became very popular in Dutch society in the seventeenth century.[60] It can be found in the books of the Leiden professor Justus Lipsius (1547–1606), the moralizing *Sinne-poppen* (emblem) books of Jakob Cats (1577–1660), and the work of poets such as Dirck Volckertsz. Coornhert (1522–1590) and P. C. Hooft (1581–1647). Lipsius's *De constantia* taught a philosophy for the man active in the affairs of the world, tossed by the storms of *fortuna*, and living in a time of political crisis. This man sought the good life, which meant the virtuous life, even when under severe pressure from the external world. Happiness was to be achieved by developing *virtus*, an indifference to the things of the world and of the senses and a constancy in withstanding both their blandishments and their horrors. The neo-Stoic individual was active in the world without losing himself in it. Indifference and constancy arose from the exercise of reason; the individual must learn to judge things according to their true worth rather than their outward appearance.[61] Self-knowledge, insight into the deceptive essence of the world, and the abandonment of transitory things were the central tenets of neo-Stoicism after Lipsius.[62] To be in the world, but not of the world—to learn the meaning of "*vanitas vanitatum et omnia vanitas*"—was thus the common personal and didactic exhortation of Lipsius's writings and Brouwer's paintings. In his inaugural address on taking up the chair of practical medicine at Leiden, Sylvius alluded to these themes. He lamented the fallen state of humankind and the resultant lack of knowledge, describing the little that was known as "obscurè, et confusè, et imperfectè."[63] He believed, however, that knowledge could be achieved if groups of scholars worked together using the method of "ratio" and "experientia."[64] He had even attempted to set up such a group in Amsterdam. He stressed the importance of knowing oneself, of leading a moderate life, and of finding a middle way between the teaching of the ancients and the evidence of the senses.[65] Indeed, for Sylvius, medicine was a search for self-knowledge and an opportunity to teach moderation.[66]

Did Sylvius then hang Brouwer's *Quacksalver* in his entry room as a didactic admonition to his students coming to take their tutorials? This may well have played a part in it, but Sylvius appears to have been more concerned with demarcation than with moralizing. For example, he owned numerous still lifes, only one of which the notary labeled as a "vanitas." The majority of his still lifes were by Simon Luttichuys, who was known to paint such clear *vanitas* themes, but the Luttichuys paintings in Sylvius's collection seem to have been those that represented objects without an obvious moral component. The notary noted them simply as "roemer with an orange, or lemon" and "golden bowl" (fig. 6.16). Do they celebrate the world of things or warn against its vanity? They are ambiguous. Similarly, the largest number of Sylvius's seascapes were

not tempest or shipwreck scenes, which alluded to the dangerous vessel of the human body and human desire, but were instead by Experiens Sillemans, who specialized in exact renderings of harbor scenes, fishing fleets, and sea battles (fig. 6.17).[67]

Sylvius's favorite painters, Gerrit Dou and Frans van Mieris, both painted quacksalvers. Dou's famous painting of a quack doctor (plate 23), which Sylvius may have owned and hung in his salon,[68] gives us further insight into Sylvius's reasons for hanging Brouwer's *Quacksalver* in his entry room. The thorough interpretative analysis to which Dou's painting has been subjected has elucidated its theme of the vain and deceptive nature of the world.[69] As in Brouwer's painting, the large seal that dangles from the table, intended to lend credibility to this vagrant medical practitioner, points to the way in which external appearances can deceive. Here, too, the peasants are absorbed in the deceptive words of the quack: their mouths hang open; the woman in the right foreground with the basket is so absorbed that she does not notice her pocket being picked. Other figures are absorbed in the tangible world, most prominent among them the pancake baker cleaning her baby's bottom. The pot of porridge to her left alludes to the meaningless pap of human concerns. The monkey sitting on the quacksalver's left and the boy catching the bird refer to the snares of deception. In contrast to the Brouwer *Quacksalver*, the main figure of the quack does not look out of

FIGURE 6.16.
Simon Luttichuys, *Still Life with Golden Bowl*, Christie's Picture Archive.

FIGURE 6.17.
Experiens Sillemans, *Sea Battle*, 1649, pen on canvas, 77 × 106 cm, Rijksmuseum Amsterdam. Sylvius owned works by artists known for their accurate rendering of events and objects, whether of sea scenes or of animals.

Dou's painting but is wholly involved in his work of deception. Instead, it is the painter leaning out the window directly behind the quack who looks out to the observer. He holds the tools of his trade, making clear his own participation in the deceptive practices of the world. Is he proud of his ability to deceive in paint, or uneasy with it? I believe that Sylvius made a similarly ambivalent gesture when he hung Brouwer's quack in his entry room. It is both the "*nosce te ipsum*" of an educated Christian neo-Stoic who recognized his own immersion in the world of the senses and a distancing gesture by which he distinguished his own socially and intellectually legitimized and institutionalized position from the catch-as-catch-can existence of this vagrant charlatan empiric. As a medical practitioner, Sylvius engaged in the practice of demarcating reason from folly, distinguishing his own experiential and practice-based medicine from that of mere manual operators, and distancing his controlled sensory investigation from indulgence in sensuality. In his painting, Dou proclaimed his own ability to deceive the senses (with all that implied about both his artisanship and his artifice), but he set himself above the scene, making eye contact with his elite and wealthy viewer and asserting that, through their self-knowledge, they stood above and had a privileged vantage point on the world of the senses.[70] As we shall see, Sylvius also claimed similar high ground as a new philosopher.

Experiencing and Representing Nature in the Workshop and the Laboratory

Sylvius's inventory shows that he owned more paintings by the Leiden artists Gerrit Dou and Frans van Mieris than by any other painters: eleven works by Dou and seven by van Mieris. These two painters were the founders of what some art historians have called the Leiden school of *fijnschilders*. This anachronistic rubric (for in the seventeenth century a *fijnschilder* was any panel painter, as distinguished from a *kladschilder*, or housepainter) alludes to their style of tiny, careful, highly realistic (or illusionistic) painting, what their contemporaries called their *netticheydt* (cleanness of line) and *zuiverheydt* (meticulousness). Their paintings are concerned with the things visible to the eye and tangible to the senses, and they attest to the power of observing and representing. Both also allude to the passion of desire, carnal and material. These two *fijnschilders* exemplified a practice of craft that informed both Sylvius's taste and his new philosophy.

Sylvius hung the paintings by Dou all over his house, but the most expensive ones were found in the large salon, where a portrait, a large panel, a Mary Magdalene

by candlelight (fig. 6.18), and the *Woman at Her Toilette* (plate 24) hung. *Woman at Her Toilette*, like several others by Dou, was enclosed in a case painted as a trompe l'oeil (fig. 6.19).[71] A hermit (fig. 6.20) and two candlelight scenes by Dou hung in Sylvius's richly ornamented master bedroom (figs. 6.21, 6.22), and a night scene adorned the dining room. Such night pieces were virtuoso paintings meant to display the artist's ability to represent the play of light and shadow (the fundament of the art of painting) and the quality, refraction, and reflection of different kinds of light (e.g., moonlight, candlelight, candlelight in moonlight, light reflected by different sorts of materials).[72] These paintings testified to the artist's skill to observe and represent objects precisely as they appeared to the sense of sight.[73] Of Sylvius's other paintings by Dou, a *trony* was located in the upper back room, an "old woman" in the side chamber, and a small piece in his study.

Sylvius hung his van Mieris paintings exclusively in the salon and in his bedroom. Two *tronies* and a portrait of van Mieris's wife, Cunera van der Cock, hung in Sylvius's salon (fig. 6.23), while two half-length portraits (one certainly of van Mieris with a *roemer* in his hand [fig. 6.24] and the other perhaps also portraying van Mieris [fig. 6.25]), a study of a woman and a man (fig. 6.26), a *trony* (fig. 6.27),[74] and a portrait of Sylvius and his second wife, Magdalena Lucretia Schletzer (plate 25), hung in his bedroom, this last modeled on a self-portrait of van Mieris and Cunera van der Cock (fig. 6.28). The prominence Sylvius gave to van Mieris's paintings as well as the numerous portraits of the painter and his wife in Sylvius's collection point to the close relationship between the two men as patron and client. One source stated that Sylvius paid van Mieris a sum of money for the right of first viewing of all his work. Moreover, Sylvius may have helped the painter to commissions from the grand duke of Tuscany and the archduke of Austria, and it is possible that Sylvius even assisted in the composition of these paintings, such as *The Cloth Shop* (plate 26).[75]

What were Dou and van Mieris trying to accomplish in their paintings? We have already seen in examining Dou's *Quack* that he was self-conscious about the function of his painting, using emblems to make moral statements, but that he was above all concerned to make clear his own skill at imitating nature in a way that deceived the eye. We know from what is apparently a firsthand account by a contemporary that Dou was obsessive about trying to make his picture surfaces smooth as a mirror, a mirror of nature. Joachim von Sandrart reported that on a visit to Dou's workshop, he especially admired a broomstick no larger than a fingernail; though Dou had obviously worked on it with great diligence, he insisted that it still needed another three days' work. In order to create the smooth surface and invisible brushwork, Dou ground his paint

FIGURE 6.18 (top left). Gerrit Dou, *The Penitent Magdalen*, ca. 1635–40, oil on panel, 24 × 18 cm, Staatliche Kunsthalle Karlsruhe. Like the *Hermit* owned by Sylvius (fig. 6.20), the *Penitent Magdalen* emphasizes the important contrast between human life in the world and eternal salvation. Such a painting might have had particular significance for Sylvius because his second wife's name was Magdalena.

FIGURE 6.19 (bottom). Gerrit Dou, *Still Life with Ewer*, 1663, oil on panel, 81.28 × 99.1 cm, Louvre, Paris. Copyright Réunion des Musées Nationaux/Art Resource, NY. This trompe l'oeil formed the exterior panel doors to a case that covered Dou's *The Dropsical Woman. Woman at Her Toilette* (plate 24) is recorded as possessing a case with doors on which were painted a woman nursing by candlelight.

FIGURE 6.20 (top right). Gerrit Dou, *The Hermit*, 1670, oil on panel, 46 × 34.5 cm, Timken Collection (1960.6.8). Photograph © 2001 Board of Trustees, National Gallery of Art, Washington. Sylvius owned one of Dou's paintings of a hermit. This painting is typical of Dou's numerous representations of hermits, which were owned by Catholics and Protestants alike. The symbolism simultaneously emphasizes the contemplation of human mortality, particularly in the burnt-out candle, skull, and hourglass, and the striving for eternal life by means of prayer and reading of the Scriptures, which lie open beneath the hermit's clasped hands.

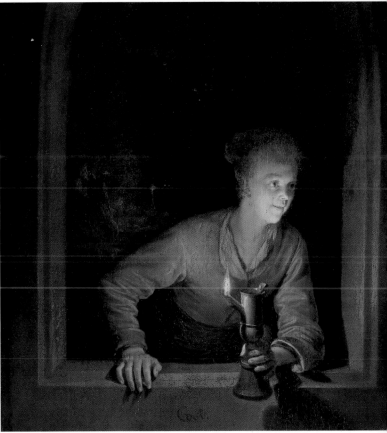

FIGURE 6.21.
Gerrit Dou, *Astronomer by Candle-light*, late 1650s, oil on panel, 12-5/8 × 8-3/8 in., The J. Paul Getty Museum, Los Angeles. Sylvius might have owned this scene illuminated by candle-light. Like the other candlelit paintings by Dou, it is a testa-ment to the artist's skill in de-picting different types of light and their reflections. It also testifies to Dou's attempt to meticulously represent all sorts of visible phenomena.

FIGURE 6.22.
Gerrit Dou, *Girl with an Oil Lamp at a Window*, ca. 1670, oil on panel, 22 × 17 cm, Rijksmu-seum Amsterdam.

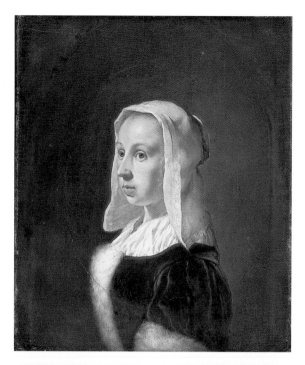

FIGURE 6.23 (top left).
Frans van Mieris, *Portrait of the Artist's Wife, Cunera van der Cock*, ca. 1657–58, oil on vellum, inlaid on oak at a later date, 11.1 × 8.2 cm. Reproduced by courtesy of the Trustees, The National Gallery, London. The numerous portraits of Frans van Mieris and his wife, Cunera van der Cock, hanging prominently in Sylvius's house testify to the friendly relations between van Mieris and Sylvius.

FIGURE 6.24 (top right).
Frans van Mieris, *Man Holding a Large Roemer*, 1668, oil on panel, 11 × 9 cm, present whereabouts unknown.

FIGURE 6.25 (bottom).
Frans van Mieris, *Self-Portrait*, ca. 1657–60, oil on panel, 11 × 8 cm, © 2003 Bildarchiv Preußischer Kulturbesitz, Berlin (Gemäldegalerie). This portrait of van Mieris was probably the pendant to that of his wife in fig. 6.23.

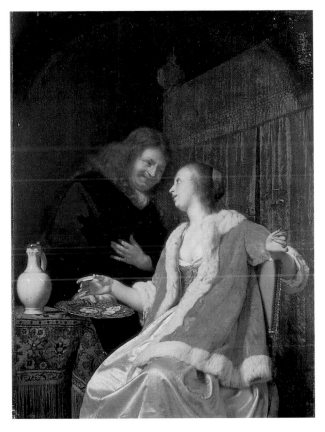

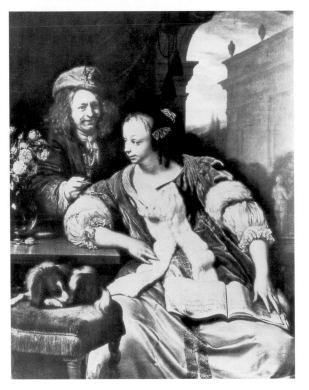

FIGURE 6.26 (*top left*).
Frans van Mieris, *The Oyster Dinner*, 1661, oil on panel, 27 × 21 cm, Het Mauritshuis, The Hague, Stichting Vrienden van het Mauritshuis. Van Mieris's numerous paintings of couples portray the interaction between a man and woman in an often openly erotic situation, such as this one in which they share a plate of aphrodisiacal oysters.

FIGURE 6.27 (*top right*).
Frans van Mieris, *Man in an Oriental Costume*, 1665, oil on panel, 14.3 × 11.3 cm, Het Mauritshuis, The Hague, Stichting Vrienden van het Mauritshuis. A typical *trony*, probably owned by Sylvius, showing the effect of the passions on the body.

FIGURE 6.28 (*bottom*).
Frans van Mieris, *The Song Interrupted*, or *The Painter Presents a Glass of Wine to His Wife*, 1671, oil on panel, 27 × 21.8 cm, Petit Palais, Musée des Beaux-Arts de la ville de Paris. The composition of this painting of van Mieris and Cunera van der Cock may have formed the model for van Mieris's portrait of Sylvius and Magdalena Schletzer (plate 25).

pigments on glass (to avoid the granules that might result from grinding them on stone) with his own hands, made his brushes himself, and kept his tools closed away in a case when he was not painting in order that no dust would fall on them. Furthermore, he painted under a parasol (like that over the figure of the quack in the *Quack*) and waited until all dust had settled before he began his day's work.[76]

Netherlandish art theorists from Karel van Mander through Philips Angel, Cornelis de Bie, Joachim von Sandrart, and Samuel van Hoogstraten all agreed that the goal of art was to "follow nature." Dutch artists sketched outdoors and drew extensively from nature; apprentices were exhorted to imitate nature at every turn.[77] These practices were also commented upon in the paintings themselves. For example, in van Mieris's *Pictura (An Allegory of Painting)* (fig. 6.29), Painting holds the attributes usually associated with imitation: palette in hand and mask around her neck, indicating the painter's ability to deceive through illusion. This representation of Painting was based on Cesare Ripa's emblem of imitation (fig. 6.30). Another aspect of this theme is also alluded to in Dou's triptych, now entitled *Nature and Art* (which survives only in a copy by Willem Joseph Laqui in the Amsterdam Rijksmuseum). In the left panel a schoolmaster oversees the writing practice of young male and female students, while in the middle panel a mother in a richly ornamented room nurses her infant. A scholar sits at

FIGURE 6.29.
Frans van Mieris, *Pictura (An Allegory of Painting)*, 1661, oil on copper, 5 × 3-1/2 in., The J. Paul Getty Museum, Los Angeles.

FIGURE 6.30.
Cesare Ripa, "Naavolginge (Imitatio)," from *Iconologia, of Uytbeeldingen des verstands*, 1644, Library, Getty Research Institute, Los Angeles.

his desk, sharpening his pen by candlelight, in the right panel. This painting has been interpreted as representing the three things necessary to attaining certain knowledge of any art: nature, instruction, and practice. In this case, the young mother stands in for nature, the evening school for instruction, and the scholar for practice. All this seems plausible enough, but what should we make of the dentist pulling teeth in a back room behind the nursing mother? Is it just a contrast, as J. A. Emmens has posited, between passive nature, as humans must suffer it, and active, creating nature represented by the mother, her milk, and her child? The presence of this medical practitioner, who practiced the most painful of operations, seems to point not just to the central place of nature in the practice and mastery of any art but also to the bodily dimension of practice and of human knowledge.[78]

The painter should strive in his art to imitate nature, and, accordingly, panels should be mirrors of nature. All seventeenth-century Netherlandish writers on art referred to the competition, recounted by Pliny, between Zeuxis and Parrhasios that determined who was the best painter of the two. Zeuxis painted such a realistic still life that birds came down to peck at the grapes pictured in it. Since no one expected Parrhasios to do better than this, it was left to Zeuxis to pull aside the curtain covering Parrhasios's painting—whereupon he found that the "curtain" was itself the painting. This was deemed the more successful imitation of nature. For the Leiden *fijnschilders*, the "curtain test" was no abstract standard; indeed, they put special emphasis on the naturalistic execution of textiles and often played with the theme of the curtain. The illusionism of Adriaen van der Spelt and Frans van Mieris's *Trompe-l'oeil Still Life with a Flower Garland and a Curtain* (plate 27) and Dou's *Smoker at a Window* (fig. 6.31) was heightened by the fact that many paintings in the seventeenth century were covered with a curtain to protect their surface. Contemporaries called both Dou and van Mieris the new Parrhasios.[79]

Philips Angel, writing in 1641 to encourage the Leiden town council to allow the foundation of a separate painters' guild, declared *na-bootsen*, or imitation, and the attempt to obscure the

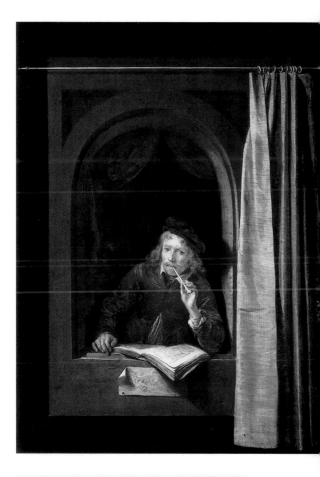

FIGURE 6.31.
Gerrit Dou, *Smoker at a Window (Self-Portrait)*, ca. 1645, oil on panel, 48 × 37 cm, Rijksmuseum Amsterdam.

boundary between reality and appearance to be the highest goals of the painter's art.[80] Joachim von Sandrart, too, believed that once an apprentice had learned to copy, he should turn to natural things and "employ the greatest diligence so that each thing is observed in the closest way possible and that everything agrees completely with nature."[81] Samuel van Hoogstraten states in *Inleyding tot de hooge Schoole der Schilderkonst* (1678) that

> the art of painting is a science to represent all the ideas or images that are given us by the entirety of visible nature, in order to deceive the eye with composition and paint. She is complete when she reaches the end that Parrhasios gave. . . . For a perfect painting is like a mirror of nature, in which things that do not exist appear to exist, and which deceives in an allowably diverting and praiseworthy manner.[82]

Their contemporaries regarded Dou and van Mieris as embodying these ideals of painting. Dirk Traudenius called Dou "den Hollandschen Parrhasios": "If Zeuxis saw this banquet he would be deceived again. Here lies no paint, rather soul and life upon the panel. Dou doesn't paint, oh no, he conjures with the brush."[83] And in 1661 Cornelis de Bie said of van Mieris:

> Om al de suyverheyt en nette cloecke trecken
> Die Mieris uyt den gheest in Landtschap en Figuer
> Weet aerdich met Pinseel als t'leven te ontdecken
> Waer in neit anders schuylt als t'voorbeldt van Natuer.[84]

> [All the meticulousness and clean stout lines / that Mieris, out of his imagination, in landscapes and figures / knows how to invent, wittily, with his brush, as real as life / hide nothing other than the model of nature.]

Their ability to imitate nature, and hence their art, resulted from careful observation of the surfaces of things. Such a mode of observation and particularistic depiction originated in the Flemish panel painting of Robert Campin and Jan van Eyck. In his 1604 *Het Schilder-Boeck*, van Mander made Jan van Eyck's use of oils the "founding moment of northern art," imitating the ancients, in this case Protogenes, who "did not want simply that his works should be true likenesses, but rather strove diligently to make them natural and as if the things themselves."[85] Van Hoogstraten wrote of how a painter should observe:

The special characteristics of all things demonstrate themselves first to us in their form and extension, not as is described by natural philosophers, but more like the shell around an egg that determines the extension of the external form. And the bodies that circumscribe them, as if through an outer limit, mark them off from other things. Just as the wine closed in a bottle takes on the extension of the container, so the form of the bottle becomes the object of the thing that a painter mirrors and thereby he understands all natural things, and each one in particular.[86]

Dutch theorists took over what was apparently a workshop term, "*Houding*," to express the ability to create a realistic painting by a combination of composition, color, placement of figures, and shadow and light to create the illusion of depth; or as one theorist wrote:

Houding is one of the most essential things to be observed in a Drawing or Painting; since it gives the same sensation to the eye, that we enjoy in the contemplation of natural objects. For whenever *Houding* is not found in representational images, such Drawings and Paintings are senseless, and more than half dead.[87]

This mode of observation of objects and its transposition into paint was typical of the Leiden *fijnschilders* and very different from academically trained artists' interests in knowing the inner structure of the object and in building up a figure from the skeletal and muscular system.[88] To attain such exact imitation of nature itself, van Hoogstraten recommended that a painter have knowledge of natural things and practice drawing from life because this would improve his ability to observe.[89] Indeed, if the eye was "strengthened" enough "through practice," the painter would have no need of a maulstick or compasses, for his eye would come to contain them.[90]

The paintings of Dou and van Mieris demonstrated their ability to follow nature and, as such, were proof of a consummate artisanship that they valued above all else. While we have no direct testimony from Dou or van Mieris, we can read in Philips Angel's tract—which emerged out of the same craft milieu—an articulation of Dou's ambitions, which Angel makes the standard for all painters: Dou strove for honor, manifested both by the extraordinarily high prices he could command for his work and by the fact that he was sought out and visited by the rich and famous.[91] It was not noble status Dou sought, however, but honor among his fellow citizens, for when Charles II invited him to become court painter in England, he refused. This was typical of the Leiden *fijnschilder*. Van Mieris refused the call to become court painter to the grand duke

of Tuscany, preferring to stay in Leiden. Even earlier, David Bailly of Leiden had turned down the duke of Brunswick; and in the second generation of the Leiden school, Adriaen van der Werff made an extraordinary contract with the elector of the Palatinate by which van der Werff would remain in the Netherlands, painting for the elector for six months and for himself for six months, rather than move to court.[92] The honor these painters sought—and obtained—was determined by their place within a society organized around guild practices and commerce. Both Dou's and van Mieris's fathers were goldsmiths, guildsmen at the peak of the guild hierarchy, connected through their art to local and foreign ruling elites. Dou and van Mieris had both been brought up with the notion that the practice of their art and the production of valuable trade goods not only brought the means to live honorably but, important still, led to virtue and even salvation. Cornelis de Bie saw laziness as the source of all evil, while exercise, or practice, was the highest virtue, and he regarded painting as an art by which both virtue and honorable profit could be achieved: "Eenen mensch die sy selven oeffent in eenich handtwerck daer hy profijt ende deught can mede doen / moet sy-selven ghelucklich achten" [A person who works in an art by which he can attain both profit and virtue together must count himself lucky]. De Bie noted that painters were especially fortunate in this combination: so many people who enjoyed profit from their work did so while committing great sins that would eventually lead to their damnation.[93] Dou and van Mieris, in virtuous artisanal fashion, reckoned the price of their paintings according to the number of hours they spent on the work, recording their time daily,[94] and both were praised for their industry and patience. Angel saw Dou as a model in this regard, and de Bie played on van Mieris's name, calling him an industrious ant (*mier*).[95] Angel cited Jakob Cats's statement that painting was better than poetry because the painter made a good living. But while Cats had been ironic, Angel quoted him in complete earnestness, demonstrating that such a view was taken for granted in an artisanal milieu in which pride in making good wares that established one's social status was perfectly normal.[96] Van Hoogstraten, too, believed that painterly virtue was furthered by profit—as long as it was moderate—because poverty depressed the spirit.[97]

In their self-consciousness of the economic power they held and of their virtuous artisanship, Dou and van Mieris represent the culmination of the trend in Netherlandish art with which this book began. Like Jan van Eyck, these seventeenth-century Dutch artists argued in their self-portraits (and they appeared in their own works more than any other artists up until this time)[98] for their status as virtuous practitioners of the *liberal* art of painting who were also proud of the manual component of their work.[99] We can see this in van Mieris's *Self-Portrait* of 1667 in which he is posed in imitation of humanist portraits, but holds his palette proudly and prominently (plate

28). Peter Paul Rubens expressed a similar consciousness when he remarked that in his second marriage he chose a woman of "honest but middle-class family" instead of a court lady because he wanted a wife "who would not blush to see me take my brushes in hand."[100] These painters argued both for their social status and for the power of their eyes and hands to witness and to know nature.

Such claims informed Sylvius's new philosophy and its practices as well. Dou's and van Mieris's celebration of manual craft is one important link between Sylvius's taste and his science. As we have seen, the values of the new philosophy had important roots in the intellectual and material exchange between scholars and artisans in the sixteenth and seventeenth centuries. Those who worked with their minds and those who practiced with their hands began to have the same concerns. Sylvius's persona—experimental philosopher, teacher, surgeon-anatomist, and chemist—was a result of the intellectual and social developments of the preceding century and a half.

Particularly in his medical theory, which regarded chemical reactions as the basis of natural processes, Sylvius showed himself an heir to this coming together of scholars and artisans. For chemistry was an art—it was productive of effects—and, as was said of all arts, including painting in seventeenth-century Holland, "*ars imitatur naturam*" (art follows nature). In both his theory and his practices, Sylvius was a follower of Paracelsus and Jan Baptista van Helmont. For these chemical philosophers, the processes initiated and observed in their laboratories were the processes of nature in microcosm, and the art by which they re-created these processes was the key to knowledge of nature.

For new philosophers, knowing involved doing, as it had for Paracelsus; those who created effects by the labor of their hands, eyes, and other senses were able to imitate and thus know the processes of nature. The central principle of both the work of the *fijnschilders* and of Sylvius's theories and practice of chemical medicine was the imitation of nature by manually engaging with matter. We can see this ideal of active knowledge in Sylvius's clinical teaching and his anatomies and vivisections as well as in the art theorist van Hoogstraten's conviction that through the imitation of nature, painters come to understand "all natural things, and each one in particular." The paintings of Dou and van Mieris resonate with all the components of artisanal knowledge that Sylvius affirmed in his new philosophy.

The Body, the Five Senses, and the New Science

Although it had been more than two decades since Sylvius's death when the painter Gérard de Lairesse (who was Johannes Glauber's collaborator) prescribed the suitable

ornamentation for each room of a house, Sylvius might have been following the same conventions de Lairesse later drew on with regard to the hanging of pictures in the most unusual and modern space in Sylvius's house, the dining room.[101] According to de Lairesse, the aim of painting was to represent faithfully the objects of nature by an "experienced and well-practiced brush"; thus, paintings could make up for any lack of natural things in a room. The effect of naturalness was heightened by displaying paintings in rooms that corresponded to their subject matter.[102] We can see in de Lairesse's emphasis on dividing rooms according to their function the same early modern urge toward demarcation that led Sylvius to plan a separate dining room and salon and to keep beds out of the kitchen. The kitchen and dining room, spaces that had most to do with bodily functioning, seem to have been sites of particular concern in this period, and the way in which beds were banished from both indicates the desire to separate and control bodily processes.

Sylvius displayed a mixture of paintings in his dining room. The portraits of Martin Luther and his wife Katharina von Bora apparently had nothing to do with the themes of food and the senses later prescribed by de Lairesse, who recommended representations of Comus, god of mealtimes, along with taste and smell, and Laetitia, the personification of pleasure. More in line with de Lairesse's ideas were the game paintings that Sylvius hung in his dining room, including "a rabbit," "some fish," and a "running horse" by Philips Wouwerman (1619–1668). De Lairesse would have approved of the three fruit and flower still lifes as well as the single "vanitas," so-called by the notary. Two still lifes by Simon Luttichuys in the room each portray a glass *roemer* with an orange or a lemon (figs. 6.32, 6.33). Luttichuys's paintings combine simple composition with close attention to the rich textures and appearances of materials. Like all still lifes, but particularly *pronkstilleven* (ostentatious or banquet still lifes) of this sort, these paintings seem both to celebrate the material world but at the same time to warn against its vanity. In other collections, *pronkstilleven* often included a watch, pointing to the temporality of all visible things, or a mouse, indicating greed, but there is no evidence of such overt moralizing in Sylvius's house.[103]

The most fitting paintings in Sylvius's dining room—according to de Lairesse, if not to modern sensibilities—were a series of the five senses by Jan Miense Molenaer. Sylvius's paintings were framed in octagonal frames, and there is no complete series by Molenaer extant that would have been framed in this manner. Three paintings by Molenaer exist today that may have been framed in this way. In these three paintings, smell (fig. 6.34) is portrayed as a peasant passing wind to the evident dismay of his fellows, hearing is represented by peasants singing (fig. 6.35), and taste is personified by

FIGURE 6.32.
Simon Luttichuys, *Still Life with Lemon*, Christie's Picture Archive.

FIGURE 6.33.
Simon Luttichuys, *Still Life with Oranges*, Christie's Picture Archive.

peasants drinking wine and smoking tobacco (fig. 6.36). While we cannot be certain which set of the five senses Sylvius owned, we can examine a representative series by Molenaer now held by the Mauritshuis.[104] Why did Sylvius place them in his modern dining room? Molenaer's paintings point to the problematic side of the senses. *Hearing* (fig. 6.37) and *Taste* (fig. 6.38) represent the dangerously seductive and fleeting pleasures of the world; *Smell* (fig. 6.39) warns of the carnal body—"this body, what is it but stink and dung?"[105]—while *Touch* (fig. 6.40) shows the harmful contentiousness that can break out between husband and wife.[106] The man peering at the bottom of his wine jug (fig. 6.41)—*Sight* in Molenaer's series—symbolizes avarice, the uncontrollable desire to accumulate material things. Representations of the five senses were quite common in Netherlandish painting of the seventeenth century, and many paintings of peasants as well as higher society can be understood as making reference to this theme. Another of Molenaer's paintings, *An Allegory of Marital Fidelity*, expresses this theme in a more disguised manner (fig. 6.42). In it he both portrays the five senses and shows what they can lead to: wrath is personified by the peasants fighting in the lower left corner, gluttony by the boy peering into the wine jug, lust by the embrace of the monkey and cat, while moderation is advocated by the figure mixing water with wine. While the rich fabrics and the cultured pastimes of the burghers in this painting could be read as a celebration of their status and refinement, we see lurking in all of this a

FIGURE 6.34 (*top left*).
Jan Miense Molenaer,
Smell, from the *Five Senses*,
Christie's East, New York.

FIGURE 6.35 (*top middle*).
Jan Miense Molenaer,
Hearing, from the *Five Senses*,
Sotheby's, London.

FIGURE 6.36 (*top right*).
Jan Miense Molenaer,
Taste, from the *Five Senses*,
Bonhams and Brooks,
London.

FIGURE 6.37 (*middle left*).
Jan Miense Molenaer,
Hearing, 1637, oil on panel,
19.4 × 24.2 cm. Photograph
© Mauritshuis, The Hague,
Stichting Vrienden van het
Mauritshuis. A series simi-
lar to this one hung in
Sylvius's dining room.
Hearing is represented by
peasants singing in a tavern.

FIGURE 6.38 (*middle right*).
Jan Miense Molenaer,
Taste, 1637, oil on panel,
19.6 × 24.1 cm. Photograph
© Mauritshuis, The Hague,
Stichting Vrienden van het
Mauritshuis. In a tavern,
one peasant drinks deeply
from a pewter jug and an-
other "drinks" tobacco.

FIGURE 6.39 (*bottom*).
Jan Miense Molenaer,
Smell, 1637, oil on panel,
19.5 × 24.3 cm. Photograph
© Mauritshuis, The Hague,
Stichting Vrienden van het
Mauritshuis. A woman
wipes her baby's bottom.

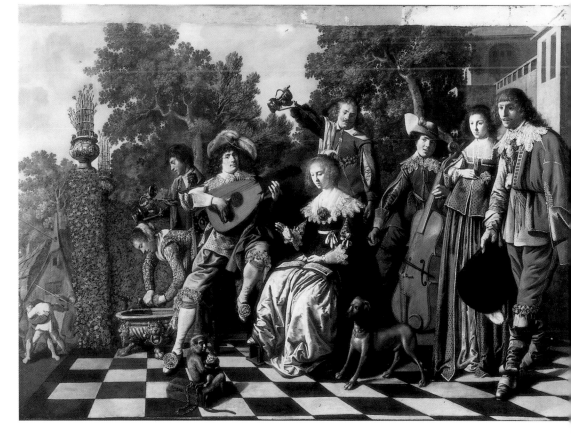

FIGURE 6.40 (*top left*). Jan Miense Molenaer, *Touch*, 1637, oil on panel, 19.5 × 24.2 cm. Photograph © Mauritshuis, The Hague, Stichting Vrienden van het Mauritshuis. A woman beats her husband with a slipper.

FIGURE 6.41 (*top right*). Jan Miense Molenaer, *Sight*, 1637, oil on panel, 19.6 × 23.9 cm. Photograph © Mauritshuis, The Hague, Stichting Vrienden van het Mauritshuis. A man and woman peer to the bottom of a wine jug.

FIGURE 6.42 (*bottom*). Jan Miense Molenaer, *An Allegory of Marital Fidelity*, 1663, oil on canvas, 99.1 × 140.9 cm, Virginia Museum of Fine Arts, Richmond, VA. The Adolph D. and Wilkins C. Williams Collection. Photo: Ron Jennings, © 1992 Virginia Museum of Fine Arts.

deep suspicion of the senses as seductive snares. Why were the senses of such concern? And what would these warnings have meant to Sylvius?

Distrust of the senses, widespread in antiquity, became a matter of great importance in the institutionalization of the experimental philosophy in which Sylvius was a leader.[107] As a new philosopher, Sylvius was fully committed to observing and manually engaging in nature through dissection and experiment and to gathering knowledge about nature through the senses. While the theoretical innovations of the new philosophy in astronomy and physics are better known nowadays, the epistemological shift in the understanding of what knowledge was and how it was to be pursued discussed in previous chapters had a greater impact in the seventeenth century. This new epistemology emphasized practice, the active accumulation of experience, and observation of nature. As we have seen, this emphasis ran counter to ancient views that certain knowledge lay in *theoria* or *scientia,* which could be proved by demonstration in the form of syllogism. Practical knowledge pertained only to the particular (not the general, which was the basis of theory) and was obtained by (often fallible) sensory perception. Thus, it could never be certain and could not be proven by syllogistic demonstration.

Humanists and other pedagogical reformers of the sixteenth century, however, had turned to the writing of histories and geographies for models of the new active gathering of knowledge. This collection of experiences could be an active task; for example, the recovery and recording of inscriptions or the searching out of places named by classical writers. This sort of investigation formed the model for the study of nature—natural history—in which nature was observed, natural exempla were collected, and various means of experiencing nature (including experiment) were pursued. At the same time, Paracelsus had drawn on the epistemology of artisans to articulate a mode of acquiring knowledge that was proven by ocular demonstration and the production of effects. With these new modes of knowledge acquisition, knowledge of nature became an ever-increasing body of "facts," sought by *active* work of the senses: by observation with the eyes and manipulation with the hands and instruments.[108] It was these practices, rather than commitment to any particular theory, that constituted the most widespread manifestation of the new philosophy in the sixteenth and seventeenth centuries.[109]

Such new ideas about the pursuit of knowledge, combined with a strong conservative commitment to the knowledge of antiquity, shaped the founding of Leiden University in 1575. It was established during the Eighty Years' War in the struggle for independence from Spain as a place to train the citizens of the United Provinces in a proper Calvinist atmosphere and with the image of the common good of the republic

before them. Its founding documents established the study of the ancients, particularly Aristotle, as the basis of teaching (a commitment reaffirmed by the ruling of the Synod of Dort in 1607) but also emphasized the importance of practice in preparing students for an active life in the service of the republic. One can see this in the proposal for the curriculum in the medical faculty, which called not only for lectures and disputations but also for practical training in "the inspection, dissection, dissolution and transmutation of living bodies, plants and metals." Clinical teaching was included in the proposal because it was necessary in medicine to "follow a very experienced and learned physician, to see, admire and imitate under his guidance the treatment of the diseased according to the directive of Hippocrates and Galen."[110] In 1593 a botanical garden was founded in the university, for which sailors leaving for the Indies in that year were commissioned to bring back all the plants they could carry for it. In connection with the opening of the garden in 1594, the curators of the university negotiated with Bernardus Paludanus (1550–1633), the city physician of Enkhuizen who possessed a huge collection of naturalia, to come to Leiden bringing with him "'all his collected rarities, such as herbs, fruits, sprigs, animals, shells, minerals, earths, poisons, stones, marbles, corals, etc. and other things that he possesses.'"[111] At about the same time, plans for an anatomy theater were laid. Although Paludanus and his collection never arrived, a great deal of teaching went on in the garden, and in 1599 an extension of the garden opened that housed a collection of *naturalia* and maps. The anatomy theater began functioning in 1593, and clinical medical teaching at Leiden was established in 1636, sixty years after it was proposed. The study of nature was pursued more actively in Leiden than in any other European university in the last decades of the sixteenth century and the first years of the seventeenth, but during Sylvius's tenure at Leiden, practical activities such as anatomies, dissections, experimentation, and clinical teaching would reach an even higher mark. Moreover, at Leiden University, professors of medicine had a close relationship with artists, and images were used extensively in the teaching of botany and medicine. In the years after the founding of the botanical garden, the pharmacist Dirck Outgaertsz. Cluyt (1546–1598), who was responsible for teaching in the botanical garden, produced an entire "winter garden" of over fifteen hundred watercolors for students in the medical faculty.[112] Pieter Paauw, professor of anatomy and prefect of the botanical garden, requested drawings from Jacques de Gheyn II of aborted and malformed babies as well as of dissected calves' heads.[113]

Sylvius epitomized the approach to nature that had emerged out of the sixteenth-century exchange between humanists, scholars, practitioners, and artisans. He had no fewer than three laboratories in his house, and he did not shun the manual

work that had once been the job of the barber-surgeon, personally performing more than three hundred autopsies in his fifteen years as a professor of practical medicine.[114] He was fully committed to observing and engaging in nature—the central tenets of the new philosophy. In this, he appears similar to the many chemical philosophers inspired by Paracelsus, such as his contemporary John Webster, who wrote in 1654 that true knowledge was gained by *ocular*, not mathematical, demonstrations and "by putting hands to the coals and furnace," in order to seek out the virtues of nature.[115] He also expressed ideas similar to those of William Harvey about the "way of the anatomists," which viewed observation as a form of knowledge in its own right, as Vesalius's portrait had claimed.[116] Naturalistically rendered visual images also proclaimed such a view, as the tradition of using images in teaching attests.[117] Sylvius was typical of most empiricists of his day, believing that practice was the basis of medicine and that the observation of one's own senses carried more authority than the books of the ancient medical writers. Much of the experimentation (some of it on live animals) that he conducted or supervised was based on a process of trial and error[118] as he attempted to construct a picture of the workings of the human body in which the reactions of acid and alkali drove all processes—digestive, emotional, and even rational.[119] According to Sylvius, chemical reactions between acid and alkali were responsible for all the workings of nature as well; thus, the experiments he carried out in his laboratories were an imitation of nature by which he gained knowledge of the natural (and human) world.

While the direct engagement with nature through the senses produced compelling knowledge, it had its detractors, for the ancient problem of the reliability of the senses was never quite forgotten: how could the senses produce *certain* knowledge? Many natural philosophers, including René Descartes (1596–1650), Thomas Hobbes (1588–1679), and Gottfried Wilhelm Leibniz (1646–1716), believed that mathematics must be applied to knowledge gathered through the senses in order to give it the certainty of logical or geometrical demonstration.[120] In contrast, Robert Hooke (1635–1703) argued that because the senses were so faulty, they needed the aid of instruments. Hooke took instruments that had been the province of mathematical practitioners and claimed that they could be transformed into natural philosophical instruments that would help to correct the deficiencies of the senses and ultimately lead to certain knowledge.[121]

Sylvius himself attempted to chart a middle way, affirming observation and experiment and, at the same time, attempting to introduce mathematics into medicine. His inaugural lecture reveals this strategy. He began, as was common with many new philosophers, by citing the ancients even as he distanced himself from them. He

agreed with Socrates that the first step in knowledge was recognizing the inborn human impotence to know.[122] Nevertheless, it was both the interest and the duty of humans to gain knowledge about themselves.[123] Sylvius repeatedly emphasized the importance of the senses, claiming that whatever is certain in medicine had been established through them.[124] Nonetheless, he insisted in his lecture that for natural knowledge to be truly certain, *it must be demonstrated mathematically*, though he acknowledged that personally he had only been able to indicate the direction in this regard.[125] Almost a decade later, he was still thinking about the introduction of mathematics into medicine, writing to Henry Oldenburg that he "may embark upon some other things concerning medicine and a new physic to be treated by a new mathematical method."[126] Sylvius appeared to be caught up in the ongoing debates about the status and authority of sensory knowledge, desiring the certainty of mathematics (the model for Aristotelian *scientia*) while still relying on the senses.

As the paintings in Sylvius's dining room indicated, sensory immersion was also problematic because it could lead to an uncontrolled expression of the passions, resulting in precipitate, often harmful, action. Especially powerful (and dangerous) were the senses privileged by the new philosophy, sight and touch. These were the senses by which the most vivid impressions were received by the sense organs and transmitted to the seat of thought, where they could cloud the power of reasoning and arouse turbulent passions. The sense of sight was especially dangerous, and even paintings could be a source of vice. According to Dirk Rafaelsz. Camphuysen in 1647, the art of painting was a "seductress of sight, spellbound by all that is transient." The beholder "wants to do and to have / Everything which one beholds in a painting. / Thus desire is fed by painting, / And vice is generated by these foolish contrivings of the painter's brain."[127] Five prints made by Jan Saenredam (1565–1607) after Hendrik Goltzius (1558–1617) portray the senses as the source of sensual pleasure and thus of seduction and danger. In these prints, the slide is clear from the least dangerous senses of hearing and smell (figs. 6.43, 6.44), through taste (fig. 6.45), and into the pure sensuality and lust of sight and touch (figs. 6.46, 6.47).

Such representations of the senses as depicted in Sylvius's paintings were thus in reality comments about the passions and their dangers. The passions were of particular concern in seventeenth-century Europe, not least because religious passions had led to almost a hundred years of war and destruction. More immediately, the relatively mobile and wealthy society of the northern Netherlands, a society perceived to be overflowing or, as Simon Schama has put it, "drowning" in material goods, held a special danger.[128] I have already quoted Descartes's concerns about desire; his ideas helped

FIGURES 6.43, 6.44, 6.45, 6.46, 6.47. Jan Saenredam after Hendrik Goltzius, *The Five Senses*, engravings, 17.5 × 12.4 cm each, Albertina, Wien. The three most powerful senses—taste, sight, and touch—were considered capable of causing people to throw off the bridle of moderation and reason and to succumb to bodily pleasure and vice. The monkey, cat, and turtle in these prints, along with the captions, indicate the danger the senses represent in leading people astray.

Dum male lascivi nimium cohibentur ocelli,
In vitium præceps stulta iuventa ruit.

Quæ conspecta nocent, manibus contingere noli,
Ne mox peiori corripiare malo.

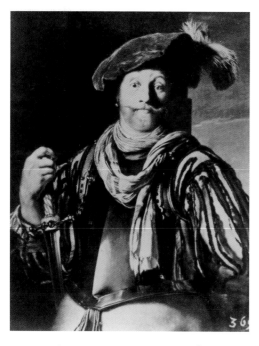

FIGURE 6.48.
Frans van Mieris, *trony*, 1667,
oil on panel, 17.5 × 13.5 cm, de-
stroyed in World War II, for-
merly Gemäldegalerie, Dres-
den. This *trony* probably hung
in Sylvius's salon.

to shape a new view of human action in which desire, the strongest of the passions, came to be regarded as human action's sole motivator.[129] In *The Passions of the Soul*, Descartes recognized the passions as inherently natural and good and laid out practical strategies for controlling them and for keeping the senses in check. The passions were also of interest to Sylvius, both in his medical work and in his collecting. He possessed many paintings that portrayed the passions, or *tronies*, as they were known in seventeenth-century Holland. The *trony*, a typically Dutch type of painting, is a generic portrait showing the expression of the passions and demonstrating the artist's ability to represent this fleeting movement of the soul (fig. 6.48). Samuel van Hoogstraten recommended that the painter observe the passions in himself, noting both their internal and external effects (figs. 6.49–6.52). In order to become accomplished in the "most noble part of art"—the representation of the passions—Hoogstraten maintained that the painter "must transform himself into an actor" by striking poses in front of a mirror.[130]

Sylvius's emphasis on *tronies* in his art collection finds a comparable expression in his medical interests. Sylvius held that the agitations of the human mind caused by the passions of the soul were the proper subject of medicine, and he noted his own ability in making cures in this area.[131] He enumerated seven passions and their opposites that moved the souls of men: love/hate; happiness/sadness; hope/despair; wrath/fear; clemency/cruelty; generosity/jealousy; and empathy (*commiseratio*)/insult.[132] These movements of the soul were excited by external objects and thus connected to the external senses of sight, hearing, taste, touch, and smell.[133] The four functions peculiar to animals and humans—the external senses, the internal senses, the movements of the soul, and the movements of the body—were, in fact, intertwined with one another because their common cause was "animal spirits." This volatile salty fluid, formed in the brain by the rarefaction of blood passing through it, joined the human functions together: the external to the internal senses and the movements of soul to those of the body.[134]

For Sylvius, as for Descartes, human behavior and action were the province of the chemist and new philosopher. But how was the philosopher to escape the havoc wreaked by the passions when he relied so heavily upon the body and the senses and was himself immersed in the sensory world? Natural philosophers in the seventeenth century sought to confront this problem by constructing a "dispassionate *Scientia*,"

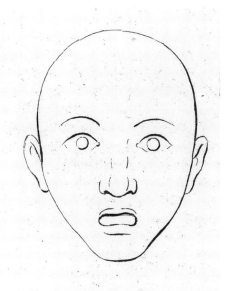

l'Étonnement

l'Admiration

FIGURES 6.49 + 6.50.
Charles Le Brun, "Astonishment" and "Wonder," from *Méthode pour apprendre à dessiner les passions*, Amsterdam, 1702, engravings, Library, Getty Research Institute, Los Angeles. Le Brun's manual for artists claimed to draw upon Descartes's work on the passions.

FIGURES 6.51 + 6.52.
Charles Le Brun, "Anger" and "Extreme Despair," from *Méthode pour apprendre à dessiner les passions*, Amsterdam, 1702, engravings, Library, Getty Research Institute, Los Angeles.

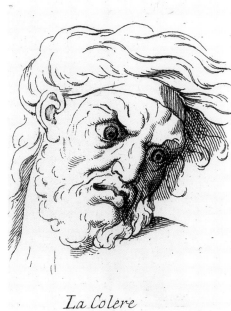

La Colere

Extreme Desespoir

Fig. 33.

that is, certain knowledge based on sensory perception that was not adversely affected by the passions.[135] This meant that a new philosopher would have to construct an "objective" method of investigation and a distinctive identity in order to remove himself from the dangers presented by immersion in the senses.[136] The bodily habits of the natural philosopher came to be of utmost importance. He should be a moderate, even chaste, disinterested, impartial observer who could overcome any distorting effects of desire, both sensual and material.[137] René Descartes and Robert Boyle (1627–1691), self-proclaimed new philosophers, both strove for this ideal.[138] Sylvius's inaugural lecture of 1658 reads like a prescription for such a new philosopher. Owing to the demands of the experimental philosophy, as Sylvius told his listeners, no single individual can incorporate all the qualities necessary for the production of knowledge. Instead, groups of individuals must work together in societies supported by government officials or other patrons, and it was his fervent hope that such groups might be formed. These individuals should be modest, impartial, not overproud, and free from jealousy and contentiousness.[139] They must, like him, be committed to eyewitnessing; they must be able to examine their predecessors fairly and to disagree with them without untoward pride. Similarly, they must discuss the conclusions of their adversaries without contempt. In laying out his ideas about choler, he emphasized his own distance from his experiments and his ability to analyze them without partisanship:

> While I freely acknowledg, as I have testifi'd often both in public and privat, that I cannot fully satisfie my self hitherto in this Matter, and indeed partly by the defect of certain Experiments requisite as yet to resolve some Doubts even now urging me; partly because of sundry Experiments not having the like success in all, nor at all times, but as it were sometimes repugnant one to the other.[140]

Almost ten years later, in 1667, Thomas Sprat would express such sentiments in his account of the founding of the Royal Society. The "true Philosophical Spirit" is known by its "calmness, and unpassionate evenness." The new philosopher

> should first know himself, should be well-practis'd in all modest, humble, friendly Vertues: should be willing to be taught, and to give way to the Judgement of others. And I dare boldly say, that a plain, industrious Man, so prepar'd, is more likely to make a good Philosopher, then all the high, earnest, insulting Wits, who can neither bear partnership, nor opposition. The *Chymists* lay it down, as a necessary qualification of their happy Man,

to whom God will reveal their ador'd *Elixir*, that he must be rather innocent, and vertuous, then knowing. And if I were to form the Character of a True Philosopher, I would be sure to make that the Foundation.[141]

Robert Boyle's persona as gentleman and new philosopher played a central role in the formation of new scientific practices, and his piety informed his view of the role of natural philosophical knowledge in society.[142] While Sylvius also drew on his noble background (as evidenced by the coat of arms adorning the gables of his house), it appears that his carefully cultivated persona as teacher was also of great importance in his self-perception as a new philosopher. When he took up the chair in Leiden, Sylvius promised to efface himself in teaching students and not to cause dissension. Indeed, he stated that he prided himself on drawing inspiration from his predecessors and in being free from demeaning pricks of jealousy. Stating that he "followed God's will" in coming to Leiden, he made it clear that he did so because it was in the common interest, though to his own personal disadvantage.[143] Sylvius appears to have been a dedicated and effective teacher who trained a generation of physicians in clinical medicine and introduced a daily round to observe patients in the city's St. Caecelia hospital. In Leiden he considered his task of consisting in teaching students the practices of the new philosophy within the subject matter of medicine, that is, to demonstrate and prove that life existed in a connection of soul to body. This involved the study of the innate heat that originates in the heart and is carried through the circulatory system to all parts of the body—a topic that opened up an entire "research program" dedicated to determining how blood was renewed through the digestion and absorption of food, how the innate heat was disturbed, and how it could be restored.[144] Sylvius maintained that these subjects should be studied through anatomies, by consulting both old and new writers, and always by relying on what one has observed with the senses.[145]

The dispassionate natural philosopher also sought to hold himself apart from the passions of the market. Tradesmen and merchants might be seduced by desire for gain or avarice (represented in Molenaer's series by the sense of sight) and use their knowledge only in their own self-interest; but natural philosophers, though immersed in material things in the same way, contributed to the common weal.[146] Delineating the difference between tradesmen and new philosophers was one of the most pressing tasks necessary to forming a distinctive identity for the new philosophy. This point of demarcation was perhaps especially important to Sylvius because he seems to have been engaged in the commerce of chemical preparations, as indicated by the dispute over his medicinal salt that took place after he died.[147] The identity of the new philosopher

meant demarcation not just from tradespeople and, as we saw in examining Brouwer's *Quacksalver*, peasants and surgeons, but also from practitioners of all sorts.

Many new philosophers, such as Robert Boyle, Robert Hooke, and Johann Joachim Becher (1635–1682), relied incessantly on the efforts of laboratory workers and on mechanics' know-how as well as quacks' and alchemists' recipes and secrets, but they attempted to distinguish themselves from these lowly practitioners.[148] An especially clear example of this phenomenon can be seen in the Royal Society's attempt to write a history of trades. The history of trades project was inspired by Francis Bacon's list of "Particular Histories" appended to the 1620 edition of *The Great Instauration* that aimed at providing the mass of observations, which by means of induction, would renovate philosophy. The Royal Society's attempt at such a project soon lapsed, partly because some members of the society, such as John Evelyn, could not bear the "many subjections . . . of conversing with mechanical capricious persons."[149] In other cases, the artisans themselves refused to take part and pleaded their own livelihood to the Royal Society—for example, Alexander Marshall, a watercolor painter, who wrote that his knowledge was "pretty secrets, but known, they are nothing. Several have been at me to know how; as if they were but trifles, and not worth secrecy. To part with them as yet I desire to be excused."[150] The printer and mapmaker Joseph Moxon, in discussing why he titled his own history of trades *Mechanick Exercises*, alludes to the difficulty of articulating practice:

> I thought to have given these Exercises, the title of The Doctrine of Handy-Crafts, I found the Doctrine would not bear it; because Hand-Craft signifies cunning, or Sleight, or Craft of the Hand, which cannot be taught by Words, but is only gained by Practise and Exercise; therefore I shall not undertake, that with the bare reading of these Exercises, any shall be able to perform these Handy-Works; but I may safely tell you, that these are the rules that every one that will endeavour to perform them must follow.[151]

Moxon attempted to convey here his conviction that an essential component of his knowledge was embodied and could only be known through manual practice.

Such protestations on the part of seventeenth-century artisans are reminiscent of Palissy's antagonistic dialogues between Theory and Practice as well as Cipriano Piccolpasso's desire to make public the art of ceramics against the "ill-will of those in whose hands these secrets have been" so that it will move from "persons of small account, [to] circulate in courts, among lofty spirits and speculative winds."[152] These

seventeenth-century complaints represent the final stages of the process by which new philosophers came to occupy the place of experts on nature and natural processes, a place that had previously been occupied by craftspeople.

Because natural philosophers resembled artisans in their interests, they were often anxious about making clear the differences in their social and intellectual status. To his chagrin, Robert Hooke, the demonstrator to the Royal Society, was sometimes mistaken for a "Mechanick Artist."[153] Even Robert Boyle, who could not be mistaken for anything but a gentleman and who explicitly stated that people should not "scorn to go into craftsmen's shops," found himself able to write far more on how the natural philosopher could be useful to the crafts than on how craftsmen might be useful to natural philosophy when he came to write the treatise *That the Goods of Mankind may be much increased by the Naturalist's Insight into Trades.*[154]

In his *History of the Royal Society* (1667), Thomas Sprat points to the project of establishing the authority of natural philosophers over artisans when he looks forward to the time at which artisanal manufacture would be subject to control by the new philosophy. He writes that "the weak minds of the *Artists* themselves will be strengthen'd, their low conceptions advanc'd, and the obscurity of their shops inlighten'd . . . the flegmatick imaginations of men of *Trade*, which used to grovel too much on the ground, will be exalted."[155] Another indication of this process is provided by the situation in the Dutch Republic; in contrast to other European countries, the interaction between university professors and practitioners had been particularly close before the seventeenth century, but this changed markedly in the course of the seventeenth century.[156] The problem of what characteristics differentiated a philosopher and a lowly mechanic would continue into the eighteenth century.[157]

Sylvius and Thomas Sprat both looked back to Francis Bacon (1561–1626) as their model in the renovation of philosophy. They took up Bacon with such enthusiasm because he made the natural philosopher the center of reform—a reform of learning and society that was an urgent ambition of almost all scholars in early modern culture. Bacon founded his reform, what he called his "Instauration," or new beginning of philosophy, on the mechanical arts and their productive works based on knowledge of nature. To understand why Bacon's reform was so compelling to Sylvius and Sprat, it is instructive to look in detail at Bacon's view of nature and the mechanical arts. Bacon's new philosophy was founded on nature, his method being drawn "from the very bowels of Nature."[158] A new philosophy was needed because Bacon viewed the traditional disciplines as defunct. "In the mechanical arts, on the other hand," he enthuses, "we see the opposite happening, for they grow and become more perfect by the day, as if

partaking of some breath of life; and in the hands of their first authors they often appear crude and somewhat clumsy and shapeless, yet in the course of time they take on new powers and usefulness. . . . By contrast, philosophy and the intellectual sciences stand like statues, worshipped and celebrated, but not moved forward."[159] This growth was possible because the arts were based on nature: "Signs [of the truth of knowledge] can also be drawn from the increase and growth of philosophies and the sciences. For things that are based on Nature grow and develop. . . . In the mechanical arts . . . based as they are on Nature and the lights of experience, we see the opposite [of decline] happening. So long as they find favour, they are always thriving and growing, as if endowed with a certain spirit; at first, primitive, then useful, finally highly developed, and always improving."[160]

Like Dürer and Paracelsus, Bacon regarded works or effects to be the sign of a true and certain philosophy: "Of all the signs, none is more certain or worthy than that which comes from fruits; for fruits and practical discoveries are, as it were, guarantors and sureties for the truth of philosophies."[161] And "works themselves are of greater value as pledges of truth than as comforts of life."[162] Again, "Just as in religion, we are cautioned that faith is shown by works, the same well applies to philosophy, that it should be judged by its fruits, and be considered barren if it bears no fruit; and all the more so if it yields not the fruits of grape and olive but the thistles and thorns of disputes and contentions."[163]

Bacon viewed his great innovation as the development of an "Active Science," the ultimate end of which was a knowledge of causes that would result in the production of effects. For Bacon, "human knowledge [of causes] and human power [in the production of works] come to the same thing."[164] The aim of natural philosophy was properly the welfare of humankind. The result of the reformation of philosophy would be "a long line of inventions which will in some part alleviate man's wretched and needy condition."[165]

Bacon believed that one of the hindrances to true philosophy arose from the condescension with which the mechanical had been treated, the belief that

> it is beneath a man's dignity to spend much time and trouble on experiments and particulars that come under the senses and are materially bounded, especially since they are usually laborious to look into, too base for serious thought, awkward to explain, degrading to carry out, endless in number and minute in subtlety. So in the end it comes about that the true path is not only untrodden, but actually shut off and barred, experience being not so much abandoned or badly handled as rejected with disdain.[166]

Bacon regarded his own method of induction, which employed observation and experiment to draw up tables of discovery and lists of instances, as incorporating the active methods and works-oriented goals of the mechanical arts. Bacon lavishly praised the fruitfulness and power of the mechanical arts, but when he came to speak about practitioners themselves, his tone changed: "The mechanic, mathematician, physician, alchemist, and magician all immerse themselves in Nature, with a view to works, but all so far with feeble effort and slight success."[167] While alchemists in particular might have achieved some fruits, this was merely incidental, "or by some variation of experiments, such as mechanics are accustomed to make, and not from any art or theory."[168] The cause of this, Bacon says, is that "the mechanic, who is in no way concerned with the investigation of truth, neither directs his mind nor turns his hand to anything unless it serves his work. Further progress in knowledge, in fact, can only be looked for with any confidence when a large number of experiments are collected and brought together into a natural history; experiments which, while they are of no use in themselves, simply help the discovery of causes and axioms. These I will call *light-bearing* experiments, to distinguish them from *fruit-bearing* ones."[169] Bacon viewed the commercial aims of practitioners, the striving after "fruit-bearing" experiments, as getting in the way of their philosophizing: "All those who have laboured in learning from experience have from the outset fixed upon certain definite works, which they have pursued with immoderate and premature eagerness, and have sought, as I say, fruit-bearing, not light-bearing, experiments."[170] Indeed, when Bacon comes to discuss the collection of experience, he does not even mention the work of artisans or mechanicals. He discusses only the "supine" men of learning who accept gossip as the basis of experience and do not gather it firsthand.[171]

The artisan is absent from Bacon's vision of the collective process of knowledge gathering; rather, philosophers armed with a new method will be the producers of the new knowledge.[172] Bacon believed experience had "not yet become literate. But no adequate inquiry can be made without writing, and only when that comes into use and experience learns to read and write can we hope for improvement."[173] In writing these lines, Bacon elides the literate artisanal tradition as exemplified in the works of Dürer and Palissy. In his disregard of the artisan and mechanic as contributors to the reformed philosophy, Bacon provided a model for the self-styled new philosophers, such as Sylvius and Sprat, who took on the goals and values of the arts but distanced themselves from artisans and practitioners.

Although they appealed to the sense of sight, Molenaer's paintings of the *Five Senses* hanging in Sylvius's dining room warned the observer that the senses are not en-

tirely to be trusted; indeed, as Sylvius made clear in his work, they formed only one component in the pursuit of knowledge and had to be constrained and controlled by a new kind of investigator of nature who was armed with a new method.

The Ivory Lathe in the Attic

We end in the attic of Sylvius's house, where the notary found that surprising instrument, the ivory lathe, on which Sylvius may have turned the ivory objects in his collection. Wood and ivory turning takes us back to the woodworking in Robert Campin's depiction of Joseph in his workshop in *The Annunciation Triptych (Mérode Altarpiece)* (plate 9). The presence of the ivory lathe in Sylvius's attic reveals much about the relationship between artisanship and the new philosophy. It was not uncommon for upper-class Dutch boys to have been instructed in turning on a lathe (figs. 6.53, 6.54),[174] perhaps in imitation of German princes who learned a mechanical art as part of their general education (fig. 6.55).[175] The art most often chosen for these princes was carpentry, in imitation of Christ's vocation, and the material turned was often ivory because of its rare and noble qualities (fig. 6.56). In this practice, we get a glimpse of the whole complex history of European attitudes toward manual work and the increasing status of practical knowledge. What the student of lathe working learned, besides the imitation of Christ and the sanctity of labor, was the line between art and nature. For he who crafted a piece of ivory also played with the relationship between nature and art, improving a rare piece of *naturalia* by turning it into a piece of worked *artificialia*. This was both proof of the maker's ability to follow nature and a demonstration of his mastery over nature, which would lead to progress (or *redemption*) in knowledge and material life. By the seventeenth century, the new philosophy had come to incorporate these goals, which had previously belonged only to artisans. Furthermore, the experimental philosophy incorporated the artisanal notions of the primacy of nature and the idea that the practitioner must engage with matter in order to produce certain knowledge about nature. The production of effects and the principle that knowledge is active became a part of science.

There was one element of the artisanal epistemology that Sylvius did not incorporate into his new philosophy, however. In contrast to Paracelsus, Sylvius was unsettled by the "subjective" Paracelsian experience practiced by the artisan. Sylvius was not an opponent of the schools like Paracelsus, nor a religious enthusiast like Jakob Böhme, nor was he a liminal practitioner like Glauber. Sylvius was a respected member of Leiden society and professor in an established university. He was engaged in in-

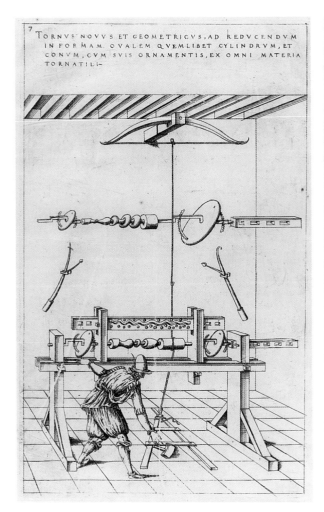

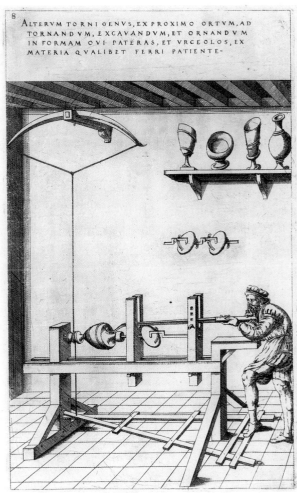

stitutionalizing the new philosophy and did not have to assert his legitimacy on a daily basis, as had been necessary for Paracelsus and Glauber. His persona as teacher and stoic and his noble pretensions were all far removed from the world of Paracelsus. The Paracelsian bodily union with nature was no longer part of his chemical philosophy. Instead, he saw great potential in Descartes's separation of mind from the fallible and passion-ridden body, a theory that simultaneously attracted and alarmed scholars in the seventeenth century.[176] Sylvius's chemical philosophy, like the artisanal understanding of matter examined in chapter 3, still regarded matter as imbued with a vital principle. But Sylvius also relied upon mechanical principles and he strove to emphasize these.[177] Like his desire to mathematicize medicine, Sylvius's mechanical tenden-

FIGURES 6.53 + 6.54. Jacques Besson, "Lathe illustration," from *Theatrum instrumentorum et machinarum*, ca. 1569, engravings, Library, Getty Research Institute, Los Angeles. Two examples of lathes from the sixteenth century.

FIGURE 6.55.
Lathe room, Skokloster Castle, Stockholm, mid-seventeenth century, Skokloster Archive. Carl Gustav Wrangel, an officer in the army of King Gustavus Adolphus of Sweden during the Thirty Years' War, became governor-general of Pomerania in 1648 and built the castle of Skokloster, which included this lathe room. The castle was completed in 1677, a year after Wrangel died.

FIGURE 6.56.
Ivory objects, turned by Duke Maximilian I of Bavaria, ca. 1610, Bayerisches National-museum Munich.

cies differentiated him sharply from Paracelsus, but his search for certainty, in part because he relied upon mathematics, would not have been at all foreign to Dürer and the other artisans upon whom Paracelsus drew in articulating the artisanal epistemology.

In reaching the attic, we have come to the end of our tour of Sylvius's house. By examining his home, we have seen how Sylvius's taste and his science both involved practices of social distinction, demarcation, and control. His art collection and his natural philosophy were both enmeshed in a controversy about the epistemological status of knowledge gained through the senses and about the practices by which that knowledge was gathered, but they also both celebrated the potential of sensory observation and the creative possibility of redemption in this world. Recall that Biringuccio viewed the fire of the craftsman and the fire of desire as creative as well as destructive. Sylvius and other new philosophers sought greater certainty in sensory knowledge that would come to include an epistemology of disciplined observation and "objectivity." Sylvius's students, trained in the practices of the new philosophy, would go on to found laboratories and to institutionalize these practices in the most important Enlightenment universities—Halle, Göttingen, and Edinburgh—throughout Europe. In the process, Enlightenment science would come to elide its artisanal origins. It would also come to elide the bodily epistemology that had been articulated by artisans in their works of art and their treatises and disseminated by Paracelsus and the practitioners who drew upon his work. Like Sylvius's ivory lathe, the raw artisanal epistemology would be hidden away in the attic of the new science.

‡‡‡

Conclusion

TOWARD A HISTORY OF VERNACULAR SCIENCE

The emergence of modern science, of naturalism in art, and of the individual artist are all central components of a powerful narrative about the birth of modernity. The appeal to the authority of nature, which forms the background and the basis of modern science, was unprecedented in Western history, and the use of the human body and the senses in gathering knowledge constitutes a watershed legacy of the Scientific Revolution. This view of nature and this new method of philosophizing redefined culture and society and became the preeminent source for knowledge in the modern world. In the sixteenth and seventeenth centuries, knowledge of nature became a resource that a great variety of individuals drew upon to make claims to authority and intellectual legitimacy. In the eighteenth century, these claims spread to other quarters of society: scholars maintained that their knowledge of nature made their theoretical speculations productive, medical practitioners proclaimed in their broadsheets their remedies to be natural philosophical, and merchants even advertised their products as based on Newtonian principles. "Experience" and the knowledge of nature became the catchphrases of merchant handbills and Lockean philosophy from the late seventeenth century on into the future.

This book has sought to rethink this momentous transformation through the body of the artisan. I have argued that the quickening of global commerce and the rise of urban noble courts opened a space for artisans and practitioners to assert themselves. As they became economically more powerful, they began to show a consciousness of their own productive power and they claimed a new intellectual and social authority for themselves, based on their relationship to nature. They *knew* nature through the practice of their bodily art, and, like Palissy's persona Practice, they asserted their ability, based on this knowledge, to produce works rather than barren words and theories. Their claim of knowing nature was an assertion of authority and certainty in the face of a culture that viewed them as socially and intellectually inferior because of their bodily labor. Some of their claims were articulated in works of naturalistic art. The rise of naturalistic art made possible a new means of visual communication, an exceptionally important development, but I have argued in this book that naturalistic artisans furthered science in an additional and even more profound way than communicating information or making possible the accurate description of the objects of nature. Naturalistic artisans changed the basis of *scientia* (certain knowledge). Their representations of nature and their writings claimed the reality of an unmediated access to nature. The use of images in natural philosophical and medical instruction as well as the autoptic claims of anatomists and practitioners that were furthered by naturalistic illustration gave rise to an enhanced conviction that seeing not only leads to knowledge but also constitutes a mode of understanding. Naturalistic representation of nature became a way of talking about access to truth. In addition, artisans answered in new ways the questions of what the foundations of "scientific" knowledge were and how such knowledge is to be gained. Their techniques of observation and representation were profoundly important in the development of empirical science, but more fundamental were their epistemological claims about the primacy of nature and about the power and promise of natural knowledge and artisanal practice.

In the sixteenth century, individuals seeking to reform philosophy began to employ the terms and modes of proving and validating certain knowledge (*scientia*) that artisans had used. Some of these reformers, such as Paracelsus, incorporated the artisanal epistemology into their philosophical reform. Others, such as Francis Bacon took the goals and values of the mechanical arts and their productive works based on knowledge of nature as the basis of their philosophical reform but excluded the practitioners and artisans themselves from the actual process of knowledge production. Building on the reform of knowledge of both Paracelsus and Bacon, new philosophers in the seventeenth century appropriated to themselves the artisanal expertise about

the processes and powers of nature. At the same time, they began to rework the artisanal bodily engagement with nature into a new disembodied epistemology.

Recently, Stephen Gaukroger has described Francis Bacon's role in the early modern transformation of philosophy by which "cognitive values came to be shaped around scientific values."

> Bacon's main contribution is not one to be described as lasting so much as irreversible. He inaugurated the transformation of philosophy into science, and philosophers into scientists, for even though the ideas of "science" and "scientists" in the modern sense are only really established in the nineteenth century, their genealogy goes back to Bacon's attempt to effect a fundamental reform of philosophy from a contemplative discipline exemplified in the individual persona of the moral philosopher, to a communal, if ultimately centrally directed, enterprise exemplified in the persona of the experimental natural philosopher. In turn, observation and experiment are lifted out of the purview of the arcane and the esoteric, and planted firmly in the public realm. It is this that ultimately is one of the key developments that enables the transformation of scientific activity.[1]

In this view of Bacon, Gaukroger has captured an essential point about the Scientific Revolution and Bacon's place in it. The idea of an "active science," however, goes back not to Bacon, but to the writings of and works of art of Dürer, Leonardo, Palissy, to the makers of the works of art that filled art and curiosity cabinets, and to the writings and persona of Paracelsus. These artisans and practitioners appealed to nature as the basis of their science. Dürer and the other artisans discussed in the foregoing pages laid the foundations for a new epistemology, a new *scientia* based on nature. Paracelsus, Palissy, and others explicitly viewed their new science as part of a reform of philosophy. In this intellectual revolution from the bottom up, these artisans transformed the contemplative discipline of natural philosophy into an active one. Bacon's contribution was to codify the artisanal construction of knowledge that was already going on around him. In the process, he appropriated the empirical experiential knowledge, and transformed and elevated it by declaring it to be philosophy, the task of high intellect, not lowly artisans. As was noted in chapter 3, Bacon may even have been influenced not only by the artisanal discourse, but also by a personal visit to the practitioner lectures in France, and perhaps even to those given by Palissy. There is no question that Bacon's codification constitutes an exceedingly significant part of the transformation known as the Scientific Revolution. I have suggested in this book that the work of artisans must also be given space in the history of that revolution.

Historians of science have often viewed the Scientific Revolution as reaching a culminating phase in England, in Francis Bacon's reformation of philosophy, in the institutionalization of natural philosophy in the Royal Society, and in Isaac Newton's new synthesis of terrestrial and celestial physics. It goes without saying that these are crucial points in the development of modern science, but this book has argued that if we look outside England to the Continent, and if we look outside the traditional natural philosophical disciplines of astronomy and the physics of motion, a new panorama opens onto the history of the development of modern science. Artisans in workshops from Florence to Flanders to Prague and Nuremberg become the founders, the basis, of the reform of philosophy. And the laboratories of practitioners and merchants along the canals of Amsterdam and the medical faculty of Leiden become just two of the places where the new practices and new attitudes toward nature of the experimental philosophy were disseminated and inculcated.

This book argues for a much broader view of the Scientific Revolution, broader in terms of its practitioners, its places, and its practices. It argues, too, for an understanding of the processes of making knowledge as social in the early modern global world. The production of knowledge should be seen as the result of group activity in early modern Europe, whether in workshops, as a result of bureaucratic structures, or of commercial ventures. Discussions of artistic and scientific innovation have traditionally focused on the individual: the artistic genius or the lone scientist. This elevation of the individual genius to center stage, in part a legacy of the social striving by Renaissance artists that I have discussed in this book, has often formed the core of a narrative of modernity and progress. Recent scholarship in the areas of distributed cognition and indigenous or vernacular knowledge systems, however, has begun to portray the production of knowledge as the result of a complex and locally situated relationship among many individuals and groups at different levels of society.[2] While Thomas Kuhn's paradigms and Michel Foucault's discourse analysis have focused historians' attention on group practices and the construction of knowledge as a social process, the tension between the social context and individual agency has remained a source of debate, especially in the history of art. In answer to this dilemma, anthropologists and cognitive scientists suggest that knowledge be studied and understood "in practice," as "inherent in the growth and transformation of identities and . . . located in relations among practitioners, their practice, the artifacts of that practice, and the social organization and political economy of communities of practice."[3] The story of local modes of cognition and the vernacular knowledge systems such as those of the "old women" and "herbalists" mentioned by almost every early modern botanist as the

basis of his specimens and local plant knowledge has yet to be written. Such a history would connect local knowledge and histories to overarching developments, such as the emergence of modern science. I have attempted to contribute to such a history and to partially answer the question of how local ways of knowing, such as, for example, those embodied in workshop practices, became the transcendent, universal knowledge of science. The conventional narrative of the emergence of modern science still often relegates group practices such as the nature studies of an artisanal workshop (or, for example, the knowledge of intercropping in Third World agriculture or vernacular taxonomic systems)[4] to the realm of "rote practice" and the "traditional." This book has striven to point up the shared and collective nature of knowledge making—the interaction between different modes of cognition and people of different social strata—and has sought to delineate the outlines of a new narrative of knowledge production and of human creativity.

Notes

INTRODUCTION

1. "Demande. . . . Il semble, à t'ouïr parler, qu'il est requis quelque philosophie aux laboureurs, chose que je trouve étrange." Bernard Palissy, *Recepte véritable* (1563), ed. Frank Lestringant (Paris: Éditions Macula, 1996), p. 70.

2. See Maria Pötzl-Malikova, *Franz Xaver Messerschmidt* (Vienna: Jungend und Volk, 1982), for an account of Messerschmidt's life and works.

3. My translation from Friedrich Nicolai, *Reisebeschreibung durch Deutschland und die Schweiz im Jahre 1781*, vol. 4, p. 401 ff., included as appendix I in Ernst Kris, "Die Charakterköpfe des Franz Xaver Messerschmidt. Versuch einer historischen und pyschologischen Deutung," *Jahrbuch der Kunsthistorischen Sammlungen in Wien* NF 6 (1932): 225. Also quoted in Rudolf Wittkower and Margot Wittkower, *Born under Saturn: The Character and Conduct of Artists* (New York: W. W. Norton, 1963), p. 126.

4. Kris, "Die Charakterköpfe," p. 226.

5. Ibid., pp. 226–27.

6. Ibid., p. 227.

7. Throughout this book, I will use "artisans" to refer to those trained by apprenticeship. The important criterion, then, for an artisan is manual work that has been inculcated by apprenticeship rather than by texts. This does not, of course, preclude artisanal reading and writing. For a very interesting eighteenth-century example of the expertise of artisans, see Michael Baxandall, "The Bearing of the Scientific Study of Vision on Painting in the 18th Century: Pieter Camper's *De Visu* (1746)," in *The*

Natural Sciences and the Arts: Aspects of Interaction from the Renaissance to the 20th Century, ed. Allan Ellenius (Stockholm: Almqvist & Wiksell, 1985).

8. Richard E. Stone, "Antico and the Development of Bronze Casting in Italy at the End of the Quattrocento," *Metropolitan Museum Journal* 16 (1982): 109.

9. Francesca G. Bewer, "The Sculpture of Adriaen de Vries: A Technical Study," in *Small Bronzes in the Renaissance*, ed. Debra Pincus (Washington, D.C.: Center for Advanced Study in the Visual Arts, 2001), p. 179; and Antonia Boström, "Daniele da Volterra and the Equestrian Monument of Henry II of France," *Burlington Magazine* 137 (1995): 811.

10. For example, in Piero della Francesca's works. See Roberto Bellucci and Cecilia Frosinini, "Piero della Francesca's Process: Panel Painting Technique," in *Painting Techniques: History, Materials and Studio Practice*, ed. Ashok Roy and Perry Smith (London: International Institute for Conservation of Historic and Artistic Works, 1998).

11. Cyril Stanley Smith, "The Texture of Matter as Viewed by Artisan, Philosopher, and Scientist in the Seventeenth and Eighteenth Centuries," in *Atoms, Blacksmiths, and Crystals: Practical and Theoretical Views of the Structure of Matter in the Seventeenth and Eighteenth Centuries*, by Cyril Stanley Smith and John G. Burke (Los Angeles: William Andrews Clark Memorial Library, 1967), pp. 10–11. Only at the end of the eighteenth century did observing the texture of metal lose its place in the iron-making industry.

12. Johann Neudörfer, "Nachrichten von Künstlern und Werkleuten . . . aus dem Jahre 1547," in *Quellenschriften für Kunstgeschichte und Kunsttechnik des Mittelalters und der Renaissance*, 18 vols., transcribed from the ms. and annotated by G. W. K. Lochner (Vienna: Wilhelm Braumüller, 1875), vol. 10, pp. 65 ("*Theoria planetarum*") and 79 (perfect gears).

13. See Arthur Geoghegan, *The Attitude toward Labor in Christianity and Ancient Culture* (Washington, D.C.: Catholic University of America Press, 1945). Scholars who have investigated the increased value placed upon labor and the mechanical arts in the Middle Ages include Elsbeth Whitney, "Paradise Restored: The Mechanical Arts from Antiquity through the Thirteenth Century," *Transactions of the American Philosophical Society* 80 (1990); George Ovitt, *The Restoration of Perfection: Labor and Technology in Medieval Culture* (New Brunswick: Rutgers University Press, 1987); and Jacques Le Goff, *Time, Work, and Culture in the Middle Ages*, trans. Arthur Goldhammer (Chicago: University of Chicago Press, 1980). David Summers, *The Judgment of Sense: Renaissance Naturalism and the Rise of Aesthetics* (Cambridge: Cambridge University Press, 1987), chap. 11, provides an excellent account of the mechanical arts in the late Middle Ages and the Renaissance; see pp. 235–65.

14. Aristotle, *Politics* 1278a1–5 and 1319a20 ff.; quoted in Summers, *The Judgment of Sense*, p. 242.

15. Henry Peacham, *The Compleat Gentleman* (London, 1622), pp. 12–13. It is an interesting measure of the ambivalent attitude toward painting as a mechanical practice that was partly raised to the status of a liberal art by this time, however, that Peacham admitted himself addicted to painting and recalled vividly a beating by his schoolmasters for his practice of drawing, one of them telling him he was meant to be a scholar not a painter. Peacham included a section on the history of painting (drawn from Vasari and van Mander) and even a chapter on the practice of painting in *The Compleat Gentleman*, because he claimed it could be useful to the gentleman in recording enemy customs and weapons in war, in surveying and mapmaking, in preserving the memory of a friend or mistress, and

in providing a "continuall Lecture of the wisdom of the Almightie Creator" (p. 105). The social prejudice against painting as "mechanical" also lived on in France into the seventeenth century. See Donald Posner, "Concerning the 'Mechanical' Parts of Painting and the Artistic Culture of Seventeenth-Century France," *Art Bulletin* 75 (1993): 583–98.

16. On this point, see Eugene S. Ferguson, "The Mind's Eye: Nonverbal Thought in Technology," *Science* (1977): 827–36, and his book *Engineering and the Mind's Eye* (Cambridge: MIT Press, 1992), in which he argues that engineers (and before them artisans) design and work by means of a kind of trained intuition. Marcel Mauss also outlines such a concept of unspoken literacy located in the body, in "Body Techniques," part IV of *Sociology and Psychology: Essays* (1950), trans. Ben Brewster (London: Routledge & Kegan Paul, 1979). Michael Polanyi's concept of "tacit knowledge," in which "knowing-how" is opposed to "knowing-that," is relevant here. My contention is that artisans did not conceive of their knowledge as tacit or as simple "know-how" that could not be articulated, but, rather, they sought to convey their understanding of their skills and of nature in their works of art.

17. One preliminary approach to this subject is provided by Jules David Prown, "Mind in Matter: An Introduction to Material Culture Theory and Method," *Winterthur Portfolio* 17 (1982): 1–19. The work of conservators has been crucial in this question. Their work is cited below.

18. On the meaning of materials, see Günter Bandman, "Bemerkungen zu einer Ikonologie des Materials," *Städel-Jahrbuch*, NF, 2 (1969): 75–100; Thomas Raff, *Die Sprache der Materialien. Anleitung zu einer Ikonologie der Werkstoffe* (Kunstwissenschaftliche Studien, vol. 61) (n.p.: Deutscher Kunstverlag, 1994); Elisabeth Dalucas, "Ars erit Archetypus Naturae. Zur Ikonologie der Bronze in der Renaissance," in *Von allen Seiten schön. Bronzen der Renaissance und des Barock*, ed. Volker Krahn. Katalog zur Ausstellung der Skulpturensammlung der Staatlichen Museen zu Berlin—Preußischer Kulturbesitz im Alten Museum, Berlin (Heidelberg: Edition Braus, 1995); and Wendy Stedman Sheard, "Verrocchio's Medici Tomb and the Language of Materials," in *Verrocchio and Late Quattrocento Italian Sculpture*, ed. Steven Bule et al. (Florence: Casa Editrice Le Lettere, 1992). I will use the masculine pronoun here when I discuss artisans, but I am not ignoring the fact that women did work as artisans and sometimes even became masters in their craft.

19. The transcription and publication of many of these texts have been done over several centuries. Many artisanal treatises were never published during an artisan's lifetime—one has only to think of Leonardo da Vinci.

20. David Summers makes this point about the mechanical arts brilliantly in "Pandora's Crown: On Wonder, Imitation and Mechanism in Western Art," in *Wonders, Marvels and Monsters in Early Modern Culture*, ed. Peter G. Platt (Newark: University of Delaware Press, 1999), where he points out that the capability for producing deceptive representation resulted in an ambivalence toward the mechanical arts that was slowly overcome in the late Middle Ages and Renaissance.

21. Antonio di Tuccio Manetti, *The Life of Brunelleschi*, ed. and trans. Howard Saalman and Catherine Enggass (University Park: Pennsylvania State University Press, 1970), p. 44; quoted in David C. Lindberg, *Theories of Vision from Al-Kindi to Kepler* (Chicago: University of Chicago Press, 1976), p. 149.

22. Quoted in Alfred W. Crosby, *The Measure of Reality: Quantification and Western Society, 1250–1600* (Cambridge: Cambridge University Press, 1997), p. 175.

23. Summers, *The Judgment of Sense*, p. 3.

24. It is not completely unusual to find pieces of paper stuffed into sculpture, although they are seldom as resonant as the one found in the *Crucifixion* by Lando. For example, in the left foot of *Mercury* (ca. 1570–80) by the Nuremberg sculptor Johan Gregor van der Schardt (J. Paul Getty Museum 94.SB.85), fragments of a (probably) sixteenth-century map of northwestern Germany and the Netherlands were found, with some of the towns marked in red. Francesca Bewer, Renaissance Bronze Project, J. Paul Getty Museum, Object Files. In a porcelain leopard (ca. 1732–33) by Johann Gottlieb Kirchner made in the Meissen manufactory (Staatliche Kunstsammlungen, Dresden, P.E. 145), a small fragment of paper with a crudely drawn human figure and lists of calculations was recently found (the paper has not been dated, but the ink is oak gall). I am indebted to Jane Bassett, J. Paul Getty Museum, for making these known to me. One of the most evocative fragments of artisanal labor was found in a secretary desk made in 1716 (now in the Victoria and Albert Museum) for a minister of the prince bishop of Mainz. The two journeymen who designed and constructed the desk left a fragment of paper in a hidden drawer on which they recorded the scarcity of food and wine in the year they made it, as well as the war with the Turks in Hungary. See Michael Stürmer, "Luxusgüter in der Knappheitsgesellschaft. Handwerkskultur und höfisches Leben im 18. Jahrhundert," *Francia* 8 (1978): 319–66.

25. Catherine King, "Effigies: Human and Divine," *Siena, Florence and Padua: Art, Society and Religion 1280–1400*, 2 vols., ed. Diana Norman (New Haven: Yale University Press, 1995), vol. 2.

26. Caroline Walker Bynum, *Jesus as Mother: Studies in the Spirituality of the High Middle Ages* (Berkeley: University of California Press, 1982), esp. chaps. 4 and 5.

27. The prayer has been linked to the thirteenth-century *Meditations on the Life of Christ* by the Franciscan Giovanni de'Cambi of San Gimignano (also known as Giovanni de Caulibus). King, "Effigies," p. 126.

28. Anon., "De arte crucifixi Pelagij Solitarij," sixteenth-century Latin transcription, British Library, Harleian MS 181, ff. 75r–81r. I am exceedingly indebted to Stephen Clucas for informing me about this passage and providing me with a transcription. Another link between magic and fine art can be found in the example treated by Michael Camille, "Visual Art in Two Manuscripts of the Ars Notoria," in *Conjuring Spirits: Texts and Traditions of Medieval Ritual Magic*, ed. Claire Fanger (Phoenix Mill: Sutton, 1998).

29. Another example of the importance of making an image as a simulacrum can be found in "Munich Handbook of Necromancy," Clm 849 in Richard Kieckhefer, *Forbidden Rites: A Necromancer's Manual of the Fifteenth Century* (University Park: Pennsylvania State University Press, 1997), no. 4, pp. 76–77, in a recipe to gain favor with a dignitary:

> . . . rub two soft rocks together to make their surfaces flush, then on one you should carve the image of him whose favor you wish, beginning from the head and proceeding to the feet, making first the front and then the back side, and carving a crown on the head if it is a king, and so forth according to his dignity. When this is carved, you will carve on the [other] stone your own form, *as best you can* [emphasis added], beginning with the head, as before, first the front and then the back. When you have done this, inscribe his name on the forehead of the first [image], in the

manner of a seal, and your name on yours. When you have done this, in the first hour of Sunday under a waxing moon take silver or tin and melt it over a fire. When it is melted, cast it in his form, saying, "I, so-and-so, wishing to obtain favour and be revered by him, and honoured and feared forever, form [this] image, made and carved in his name, by virtue of which he should love me without measure forever." On Thursday in the first hour of the day, do the same with your own image. This image must be larger than the other dignitary's image.

Other examples of magic rituals involving image making can be found in Lynn Thorndike, *A History of Magic and Experimental Science*, 8 vols. (New York: Columbia University Press, 1923–58), vol. 1, pp. 665–66; vol. 4, p. 582; vol. 7, p. 305.

30. Kieckhefer, *Forbidden Rites*, p. 23.

31. He evoked the material dimension of these panels when he called his naturalistic reliefs the "effetti" of the biblical stories illustrated in each one. Julius von Schlosser, *Lorenzo Ghiberti's Denkwürdigkeiten (I Commentarii)*, 2 vols. (Berlin: Julius Bard, 1912), vol. 1, p. 49 (Second Commentary, chap. 22). When he discusses both his own and others' works of art, Ghiberti emphasizes the striving for realism and the imitation of nature (e.g., Second Commentary, chaps. 11, 18, and 22). It appears that Ghiberti cast some of the figures on the north portal doors from life but did not continue this practice on the Gates of Paradise. Norberto Gramaccini, "Das genaue Abbild der Natur—Riccios Tiere und die Theorie des Naturabgusses seit Cennini," *Natur und Antike in der Renaissance* (Frankfurt: Frankfurt Leibighaus, 1985), pp. 208–9. Effects could also denote the products of alchemical processes. In both cases, the production of effects denoted an understanding of the processes of nature.

32. In his Second Commentary, chap. 18, Ghiberti states "ò cercato di investigare, in che modo la natura procede" [I tried to investigate the way in which nature works]. Schlosser, *Lorenzo Ghiberti's Denkwürdigkeiten*, vol. 1, p. 45; and in discussing his panels for the Baptistry doors, he wrote that he tried to respect and imitate nature as far as it was possible (vol. 1, p. 48).

33. Erwin Panofsky, *Early Netherlandish Painting*, 2 vols. (New York: Harper & Row, 1971), vol. 1, pp. 106–7; vol. 2, plate 65.

34. Ibid., vol. 1, p. 106.

35. A similar transformation, I believe, was wrought in representations of the natural world, in which what had previously been nonsubjects—such as crabs, dead bodies, insects, and all the everyday life of "genre" paintings—became the very stuff of painting. A moving example of such a nonsubject is the bust of a man with facial paralysis, ca. 1465, by Nicolaus Gerhaert van Leyden (active 1462–73), now in the Musée de l'Oeuvre, Notre-Dame, Strasbourg.

36. Cipriano Piccolpasso, *The Three Books of the Potter's Art* (ca. 1558), 2 vols., trans. Ronald Lightbown and Alan Caiger-Smith (London: Scholar Press, 1980), vol. 2, p. 109. In this account, Piccolpasso is making known secrets about potters' kilns: "They used to make [these kilns] on the floors of houses which are locked and under close guard, for they look on the manner of making the kiln as an important secret and say that in this consists the whole art" (vol. 2, bk. 2, 89). Piccolpasso intends to divulge these secrets as clearly as he can. See more on this below in chapter 2.

37. G. F. Hartlaub, "'Paracelsisches' in der Kunst der Paracelsuszeit," *Nova acta Paracelsica* 7 (1954): 154–55.

38. In his essay "Dürer and Classical Antiquity," reprinted in *Meaning in the Visual Arts* (New York: Doubleday, 1955), Panofsky argues that it is not the lack of classical monuments that formed the world of the northern artists, but rather the fact that the antique was not an "object of aesthetic experience" in the north. Northern Europe had developed an attitude diametrically opposed to classical art after about 1400 (p. 269). One of the reasons for this, I would argue, is that naturalism as an aesthetic expressed an artisanal attitude toward and claim to knowledge about nature.

39. The work of Svetlana Alpers, Thomas DaCosta Kaufmann, Joseph Leo Koerner, Eric J. Sluijter, and Christopher Wood has gone some way to rectifying this traditional focus. Exhibits such as that which produced Bernard Aikema and Beverly Louise Brown's *Renaissance Venice and the North: Crosscurrents in the Time of Bellini, Dürer and Titian* (Milan: Bompiani, 1999) have been the fruit of a more balanced view of the development of Renaissance art.

40. I treat this in *The Business of Alchemy: Science and Culture in the Holy Roman Empire* (Princeton: Princeton University Press, 1994), esp. pp. 33–41, 45–50.

41. An example of such an orientation is Antonio Pérez-Ramos's excellent book *Francis Bacon's Idea of Science and the Maker's Knowledge Tradition* (Oxford: Clarendon Press, 1988).

42. The literature on the practice of science is now large. Some of its best-known explicators for modern science are Peter Galison, Bruno Latour, and Andrew Pickering. The founding text of this movement for the study of early modern European natural philosophy is Steven Shapin and Simon Schaffer's *Leviathan and the Air-Pump: Hobbes, Boyle and the Experimental Life* (Princeton: Princeton University Press, 1985), and its influence has been profound. For an overview of recent works, see the appropriate sections of the bibliographical essay in Steven Shapin, *The Scientific Revolution* (Chicago: University of Chicago Press, 1996).

43. Francis Bacon, "The Plan of the Work," in *The Great Instauration* (1620). Bacon labeled part 6 "The New Philosophy; or Active Science."

44. Probably the majority of individuals interested in the new philosophy were associated with the practice of medicine. See, for example, Harold J. Cook, "The Cutting Edge of a Revolution? Medicine and Natural History near the Shores of the North Sea," in *Renaissance and Revolution: Humanists, Scholars, Craftsmen and Natural Philosophers in Early Modern Europe*, ed. J. V. Field and Frank A. J. L. James (Cambridge: Cambridge University Press, 1993); and N. Jardine, J. A. Secord, and E. C. Spary, eds., *Cultures of Natural History* (Cambridge: Cambridge University Press, 1996). On other "marginal" figures, see, among others, Paula Findlen, *Possessing Nature* (Berkeley: University of California Press, 1994); and William Eamon, *Science and the Secrets of Nature: Books of Secrets in Medieval and Early Modern Culture* (Princeton: Princeton University Press, 1994).

45. Simon Schaffer, "Augustan Realities: Nature's Representatives and Their Cultural Resources in the Early Eighteenth Century," in *Realism and Representation: Essays in the Problem of Realism in Relation to Science, Literature, and Culture*, ed. George Levine (Madison: University of Wisconsin Press, 1993), pp. 279, 296.

46. Lorraine Daston, "The Nature of Nature in Early Modern Europe," *Configurations* 6 (1998): 149–72, warns that historians should not assume that nature is invoked as an authority in the early modern

period, and while the general point is an excellent one, I would argue that artisans are in the process of formulating a discourse about nature's authority at precisely this moment.

47. Thomas Kuhn, "Mathematical versus Experimental Traditions in the Development of the Physical Sciences," in *The Essential Tension* (Chicago: University of Chicago Press, 1977); and A. R. Hall, "The Scholar and the Craftsman in the Scientific Revolution," in *Critical Problems in the History of Science*, ed. Marshall Clagett (Madison: University of Wisconsin Press, 1959). Paula Findlen and I discuss the reasons for this view in "Introduction: Commerce and the Representation of Nature in Science and Art," in *Merchants and Marvels: Commerce, Science, and Art in Early Modern Europe*, ed. Pamela H. Smith and Paula Findlen (New York: Routledge, 2002). See also Michael A. Dennis, "Historiography of Science: An American Perspective," in *Science in the Twentieth Century*, ed. John Krige and Dominique Pestre (Amsterdam: Harwood Academic Publishers, 1997), who provides a very nuanced evaluation of the effects of the particular circumstances of the postwar United States on the growth and character of the profession of the history of science.

48. Klaas van Berkel, *Isaac Beeckman (1588–1637) en de Mechanisering van het Wereldbeeld* (Amsterdam: Rodopi, 1983).

49. Erwin Panofsky, "Artist, Scientist, Genius: Notes on the 'Renaissance-Dämmerung,'" in *The Renaissance: A Symposium* (New York: Metropolitan Museum of Art, 1953).

50. Erwin Panofsky suggests that the discovery of perspective construction that conceived of space as a free, ideal complex of lines, rather than as a substance that could have no void, might have helped give rise to a new concept of space that would become so fundamental to the new science. Erwin Panofsky, *Perspective as Symbolic Form*, trans. Christopher S. Wood (Cambridge: MIT Press, 1991). See also, for example, Samuel Y. Edgerton Jr., *The Heritage of Giotto's Geometry: Art and Science on the Eve of the Scientific Revolution* (Ithaca: Cornell University Press, 1991); J. V. Field, *The Invention of Infinity: Mathematics and Art in the Renaissance* (Oxford: Oxford University Press, 1997); and Martin Kemp, *The Science of Art: Optical Themes in Western Art from Brunelleschi to Seurat* (New Haven: Yale University Press, 1990).

51. In Reijer Hooykaas, *Humanisme, science et réforme, Pierre de la Ramée (1515–1572)* (Leiden: E. J. Brill, 1958); see also his summary article "The Rise of Modern Science: When and Why?" *British Journal for the History of Science* 20 (1987): 453–73; and Paolo Rossi, *Philosophy, Technology, and the Arts in the Early Modern Era*, trans. Salvator Attanasio (New York: Harper & Row, 1970). Rossi built upon the work of Edgar Zilsel, such as (in English), "The Sociological Roots of Science," *American Journal of Sociology* 47 (1942): 544–62; and "The Origin of William Gilbert's Scientific Method," *Journal of the History of Ideas* 2 (1941): 1–32. See also Diederick Raven, Wolfgang Krohn, and Robert S. Cohen, eds., *Edgar Zilsel: The Social Origins of Modern Science* (Dordrecht: Kluwer Academic Publishers, 2000).

52. For example, Arthur Clegg, "Craftsmen and the Origin of Science," *Science and Society* 43 (1979): 186–201; A. C. Crombie, "Science and the Arts in the Renaissance: The Search for Truth and Certainty, Old and New," *History of Science* 18 (1980): 233–46; and idem, *Styles of Scientific Thinking in the European Tradition*, 3 vols. (London: Duckworth, 1994), especially vol. 1, chap. 8. Some have focused on instrument makers and practical mathematicians, such as James A. Bennett, "The Mechanics' Philosophy and the Mechanical Philosophy," *History of Science* 24 (1986): 1–28; idem, "The Challenge of Practical Mathematics," in *Science, Culture, and Popular Belief in Renaissance Europe*, ed. Stephen Pumfrey, Paolo Rossi, and Maurice Slawinski (Manchester: Manchester University Press, 1991); and Silvio A.

Bedini, *Patrons, Artisans, and Instruments of Science, 1600–1750* (Brookfield, Vt.: Ashgate Variorum, 1999). Others have focused on the integration of artisanal goals and values into the new philosophy, such as Eamon, *Science and the Secrets of Nature*; and Pamela O. Long, "The Contribution of Architectural Writers to a 'Scientific' Outlook in the Fifteenth and Sixteenth Centuries," *Journal of Medieval and Renaissance Studies* 15 (1985): 265–98. In *Openness, Secrecy, Authorship: Technical Arts and the Culture of Knowledge from Antiquity to the Renaissance* (Baltimore: Johns Hopkins University Press, 2001), Long shows the way in which the mechanical arts came to be seen as part of the process of producing knowledge.

53. Rossi, *Philosophy, Technology, and the Arts*, p. x. In a wonderful article, Simon Schaffer suggests the ways in which work of the hand was a way of knowing for tradesmen, and the manner in which this could be turned to natural philosophical ends (both welcomed by and threatening to those whose profession was natural philosophy). Simon Schaffer, "Experimenters' Techniques, Dyers' Hands, and the Electric Planetarium," *Isis* 88 (1997): 456–83. See also idem, "Self-Evidence," *Critical Inquiry* 18 (1992): 327–62.

54. William Newman has done such work for alchemy, showing the way in which medieval alchemy was more than a series of practices and/or obscure metaphors, in *The "Summa perfectionis" of Pseudo-Geber* (Leiden: Brill, 1991).

55. Recent works are James Farr, *Hands of Honor: Artisans and Their World in Dijon, 1550–1650* (Ithaca: Cornell University Press, 1988); and his recent book, *Artisans in Europe 1300–1914* (Cambridge: Cambridge University Press, 2000); James S. Amelang, *The Flight of Icarus: Artisan Autobiography in Early Modern Europe* (Stanford: Stanford University Press, 1998); and Hans Medick, *Weben und Überleben in Laichingen, 1650–1900: Lokalgeschichte als allgemeine Geschichte* (Göttingen: Vandenhoeck & Ruprecht, 1997). See also Heather Swanson, *Medieval Artisans: An Urban Class in Late Medieval England* (Oxford: Basil Blackwell, 1989). Other works that discuss artisans are Thomas M. Safley and Leonard N. Rosenband, eds., *The Workplace before the Factory: Artisans and Proletarians, 1500–1800* (Ithaca: Cornell University Press, 1993); William Sewell, *Work and Revolution in France: The Language of Labor from the Old Regime to 1848* (Cambridge: Cambridge University Press, 1980); and Geoffrey Crossick, ed., *The Artisan and the European Town, 1500–1900* (Brookfield, Vt.: Ashgate, 1997). Keith Thomas, *Man and the Natural World: Changing Attitudes in England, 1500–1800* (London: Penguin, 1984), considers attitudes toward nature, but not specifically the artisans' attitudes toward their ability to transform nature.

56. Carlo Ginzburg, *The Cheese and the Worms: The Cosmos of a Sixteenth-Century Miller*, trans. John Tedeschi and Anne C. Tedeschi (reprint, Baltimore: Johns Hopkins University Press, 1992). See also Domenico Scandella, *Domenico Scandella Known as Menocchio: His Trials before the Inquisition (1583–1599)*, ed. Andrea Del Col, trans. John Tedeschi and Anne C. Tedeschi (Binghamton, N.Y.: Medieval and Renaissance Texts and Studies, 1996); and Paola Zambelli, "'Uno, due, tre, mille Menocchio'?" *Archivio Storico Italiano* 137 (1979): 51–90.

57. Some valuable contributions to the discussion about the relationship of science and art are David Freedberg, *The Power of Images: Studies in the History and Theory of Response* (Chicago: University of Chicago Press, 1989); idem, "Science, Commerce, and Art: Neglected Topics at the Junction of History and Art History," in *Art in History, History in Art: Studies in Seventeenth Century Dutch Culture*, ed. David Freedberg and Jan de Vries (Santa Monica: Getty Center for the History of Art and the Humanities, 1991); and Horst Bredekamp, *The Lure of Antiquity and the Cult of the Machine*, trans. Allison

Brown (Princeton: Markus Wiener Publishers, 1995). See also Peter Parshall, "Imago contrafacta: Images and Facts in the Northern Renaissance," *Art History* 16 (1993): 554–79; and Claudia Swan, "Ad vivum, naer het leven, from the Life: Defining a Mode of Representation," *Word & Image*, 11, no. 4 (1995): 352–72. One early statement was made by Panofsky, "Artist, Scientist, Genius." More relevant works are cited in the following chapters.

58. For example, Edgerton, *The Heritage of Giotto's Geometry*; Field, *The Invention of Infinity*; and Kemp, *The Science of Art*.

59. Giorgio Santillana, "The Role of Art in the Scientific Renaissance," in *Critical Problems in the History of Science*, ed. Marshall Clagett (Madison: University of Wisconsin Press, 1959); James S. Ackerman, "The Involvement of Artists in Renaissance Science," in *Science and the Arts in the Renaissance*, ed. John W. Shirley and F. David Hoeniger (Washington, D.C.: Folger Shakespeare Library, 1985); idem, "Early Renaissance 'Naturalism' and Scientific Illustration," in *The Natural Sciences and the Arts: Aspects of Interaction from the Renaissance to the Twentieth Century: An International Symposium*, ed. Allan Ellenius (Uppsala: Almqvist & Wiksell, 1985); idem, "Science and Visual Art," *Seventeenth Century Science and the Arts*, ed. Hedley Howell Rhys (Princeton: Princeton University Press, 1961); Caroline Jones and Peter Galison, *Picturing Science Producing Art* (New York: Routledge, 1998).

60. Michael Baxandall, *Painting and Experience in Fifteenth-Century Italy* (Oxford: Oxford University Press, 1972), p. 152.

61. In this essay, Alpers speaks eloquently about emphasizing "the maker's rather than the beholder's share. . . . [O]ne might argue that to the artist, and to the beholder who seeks him or her out, there is a sense in which art remains what it was to its first creator. The question still remains, what is art to the artist in the making?" Svetlana Alpers, "No Telling, with Tiepolo," in *Sight and Insight: Essays on Art and Culture in Honour of E. H. Gombrich at 85*, ed. John Onians (London: Phaidon, 1994), p. 340. Michael Baxandall, *The Limewood Sculptors of Renaissance Germany* (New Haven: Yale University Press, 1980). This orientation has informed the work of Svetlana Alpers in *The Art of Describing: Dutch Art in the Seventeenth Century* (Chicago: University of Chicago Press, 1983) and her students Walter Melion and Celeste Brusati. Thomas DaCosta Kaufmann, particularly in *The Mastery of Nature: Aspects of Art, Science and Humanism in the Renaissance* (Princeton: Princeton University Press, 1993), has considered these questions, as has Martin Kemp, particularly in "From 'Mimesis' to 'Fantasia': The Quattrocento Vocabulary of Creation, Inspiration and Genius in the Visual Arts," *Viator* 7 (1977): 347–98. Kemp combines the social historical evidence with a more conventional art historical approach in *Behind the Picture: Art and Evidence in the Italian Renaissance* (New Haven: Yale University Press, 1997). David Summers, in *Michelangelo and the Language of Art* (Princeton: Princeton University Press, 1981), has grappled with the way in which artisans and others have discussed making and the relationship between theory and practice. In *The Judgment of Sense*, he has extended this work to provide a sweeping account of the rise of naturalism and its relation to natural science and aesthetics. Recently, Michael Cole has produced very interesting work on Cellini's understanding of his own processes. Michael Cole, "Cellini's Blood," *Art Bulletin* 81 (1999): 215–35.

62. One of the most important texts in this regard remains the germinal article by Michael Baxandall, "Hubert Gerhard and the Altar of Christoph Fugger: The Sculpture and Its Making," *Münchner*

Jahrbuch der bildenden Kunst, ser. 3, vol. 17 (1966): 127–44. More recent work has been done by Stone, "Antico and the Development of Bronze Casting"; Suzanne B. Butters, *The Triumph of Vulcan: Sculptors' Tools, Porphyry, and the Prince in Ducal Florence*, 2 vols. (Florence: Leo S. Olschki, 1996); Carmen C. Bambach, *Drawing and Painting in the Italian Renaissance Workshop: Theory and Practice, 1300–1600* (Cambridge: Cambridge University Press, 1999); the contributors to *Looking through Paintings: The Study of Painting Techniques and Materials in Support of Art Historical Research*, ed. Erma Hermens (Leids Kunsthistorisch Jaarboek, vol. 11) (London: Archetype Publications, 1998); and the Adriaen de Vries exhibition catalog, Frits Scholten, ed., *Adriaen de Vries (1556–1626), Imperial Sculptor* (Zwolle: Waanders, 1998). Several important essays are published in Pincus, *Small Bronzes in the Renaissance*. For a recent review of the literature with regard to sculpture, see Malcolm Baker, "Limewood, Chiromancy and Narratives of Making: Writing about the Materials and Processes of Sculpture," *Art History* 21 (1998): 498–530. See also James Elkins, "Histoire de l'art et pratiques d'atelier," *Histoire de l'Art* 29/30 (1995): 103–12. Other work in this area is cited in chapter 3 below.

63. Ernst Cassirer, *The Individual and the Cosmos in Renaissance Philosophy*, trans. Mario Domandi (Philadelphia: University of Pennsylvania Press, 1963), pp. 134–35.

64. Erwin Panofsky, *The Life and Art of Albrecht Dürer* (Princeton: Princeton University Press, 1955), p. 261.

65. Bert S. Hall, "Der Meister sol auch kennen schreiben und lesen: Writings about Technology ca. 1400–ca. 1600 A.D. and Their Cultural Implications," in *Early Technologies*, ed. Denise Schmandt-Besserat (Malibu: Undena Publications, 1979), p. 53.

66. Summers, *The Judgment of Sense*, p. 15.

67. Ibid., p. 323.

68. Barbara Stafford, *Voyage into Substance: Art, Science, Nature, and the Illustrated Travel Account, 1760–1840* (Cambridge: MIT Press, 1984), pp. 31, 52, 59.

69. Kemp, *The Science of Art*, pp. 340–41.

70. See the coda to ibid., esp. pp. 340–41. Svetlana Alpers, discussing seventeenth-century Dutch art and Baconian natural philosophy in *The Art of Describing*, asserts a version of the same argument, writing, "There is a two-way street here between art and natural knowledge. The analogy to the new experimental science suggests certain things about art and artistic practice, and the nature of the established tradition of art suggests a certain cultural receptivity necessary for the acceptance and development of the new science. . . . Didn't northern viewers find it easier to trust what was presented to their eyes in the lens, because they were accustomed to pictures being a detailed record of the world seen?" (p. 25).

71. Francis Ames-Lewis, *The Intellectual Life of the Early Renaissance Artist* (New Haven: Yale University Press, 2000), p. 3.

72. On this development, see the extremely useful ibid.; and Emma Barker, Nick Webb, and Kim Woods, eds., *The Changing Status of the Artist* (New Haven: Yale University Press, 1999); and for an acute examination of the increasing importance of the artistic process of creation to a whole range of artists, collectors, and dealers over this period, see Peter Parshall, "Unfinished Business: The Problem of Resolution in Printmaking," in *The Unfinished Print*, exhibition catalog (Washington, D.C.: National Gallery of Art, 2001).

CHAPTER ONE

1. Bert S. Hall, "Der Meister sol auch kennen schreiben und lesen: Writings about Technology ca. 1400–ca. 1600 A.D. and Their Cultural Implications," in *Early Technologies*, ed. Denise Schmandt-Besserat (Malibu: Undena Publications, 1979), p. 48.

2. Bert Hall also discusses this in "Der Meister," p. 53.

3. Martin Kemp, *The Science of Art: Optical Themes in Western Art from Brunelleschi to Seurat* (New Haven: Yale University Press, 1990), discusses this. Pamela O. Long, "Power, Patronage, and the Authorship of Ars: From Mechanical Know-How to Mechanical Knowledge in the Last Scribal Age," *Isis* 88 (1997): 1–41; idem, "The Contribution of Architectural Writers to a 'Scientific' Outlook in the Fifteenth and Sixteenth Centuries," *Journal of Medieval and Renaissance Studies* 15 (1985): 265–98; and idem, *Openness, Secrecy, Authorship: Technical Arts and the Culture of Knowledge from Antiquity to the Renaissance* (Baltimore: Johns Hopkins University Press, 2001), esp. chaps. 3, 4. Mario Carpo, *L'architettura dell'età della stampa. Oralità, scrittura, libro stampato e riproduzione meccanica dell'imagine nella storia delle teorie architettoniche* (Milan: Jaca Book, 1998), and in English, *Architecture in the Age of Printing* (Cambridge: MIT Press, 2001), argues that changes in organization and division of labor on the building site helped lead to the Renaissance architect's new conception of himself.

4. Long, "Power, Patronage, and the Authorship of Ars," pp. 30–39.

5. Ibid., p. 41.

6. Michael Baxandall, "Guarino, Pisanello and Manuel Chrysoloras," *Journal of the Warburg and Courtauld Institutes* 28 (1965): 183–204, also makes such an argument about the formation of a common art theory (which he sees beginning in Alberti). Paolo Rossi, *Philosophy, Technology, and the Arts in the Early Modern Era*, trans. Salvator Attanasio (New York: Harper & Row, 1970), articulates most clearly the view that artisans and scholars considering the works of artisans helped shape a set of values that came to characterize modern science. See also the excellent article by R. Hooykaas, "The Rise of Modern Science: When and Why?" *British Journal for the History of Science* 20 (1987): 453–73; and William Eamon, *Science and the Secrets of Nature: Books of Secrets in Medieval and Early Modern Culture* (Princeton: Princeton University Press, 1994).

7. Kemp, *The Science of Art*, p. 9.

8. Leon Battista Alberti, *On Painting*, trans. Cecil Grayson (London: Penguin, 1991), p. 54.

9. It should be noted that Pächt also finds a new attitude toward nature in the fourteenth-century Italian poetic treatments of the seasons and months. He views these texts as prefiguring the naturalistic landscapes and animal studies of Lombard painters as well as the famous books of hours of the Limburg brothers in the service of the duke of Burgundy; see Otto Pächt, "Early Italian Nature Studies and the Early Calendar Landscape," *Journal of the Warburg and Courtauld Institutes* 13 (1950): 13–46. See also James S. Ackerman, "Early Renaissance 'Naturalism' and Scientific Illustration," in *The Natural Sciences and the Arts: Aspects of Interaction from the Renaissance to the Twentieth Century: An International Symposium*, ed. Allan Ellenius (Uppsala: Almqvist & Wiksell, 1985), traces the beginnings of this naturalism from Giovannino de' Grassis's late-fourteenth-century model book, and usefully discusses the various forms that "naturalism" took from the fourteenth to the sixteenth centuries.

Lynn White Jr., "Natural Science and Naturalistic Art in the Middle Ages," *American Historical Review* 52 (1947): 421–35, pushes the whole development back to the 1230s, as manifested in the naturalistic capitals carved by stonemasons in French churches and the Naumburg choir statues (ca. 1260) (p. 427).

10. On the Carrara herbal, see Felix Andreas Baumann, *Das Erbario Carrarese und die Bildtradition des Tractatus de herbis* (Bern: Benteli Verlag, 1974).

11. Pächt, "Early Italian Nature Studies," pp. 31–32. This aesthetic became a fixture in scientific illustration; see Martin Kemp, "'The Mark of Truth': Looking and Learning in Some Anatomical Illustrations from the Renaissance and Eighteenth Century," in *Medicine and the Five Senses*, ed. W. F. Bynum and Roy Porter (Cambridge: Cambridge University Press, 1993). However, as Sachiko Kusukawa points out in a study of herbal illustrations, we should not assume that "naturalistic depiction implies a theoretical commitment to observing nature for its own sake." Sachiko Kusukawa, "Leonhart Fuchs on the Importance of Pictures," *Journal of the History of Ideas* 58 (1997): 427.

12. Pächt, "Early Italian Nature Studies," p. 31. The advent of artistic naturalism, like the Scientific Revolution, is often described in a heroic mode.

13. The art trade in Italy and Flanders was already very lively by the first half of the fifteenth century. See, among others, Hanns Floerke, *Die Formen des Kunsthandels, das Atelier und die Sammler in den Niederlanden vom 15.–18. Jahrhundert* (Munich: Georg Müller, 1905); and, more recently, Michael North and D. Ormrod, eds., *Art Markets in Europe, 1400–1800* (Brookfield: Ashgate, 1998); Maryan W. Ainsworth, "The Business of Art: Patrons, Clients, and Art Markets," in *From Van Eyck to Bruegel: Early Netherlandish Painting in the Metropolitan Museum of Art*, ed. Maryan W. Ainsworth and Keith Christiansen (New York: Harry Abrams, 1998); Richard Goldthwaite, *Wealth and the Demand for Art in Italy, 1300–1600* (Baltimore: Johns Hopkins University Press, 1993); Lisa Jardine, *Worldly Goods: A New History of the Renaissance* (New York: W. W. Norton, 1996); AHR Forum on the Renaissance, *American Historical Review* 103, no. 1 (1998); Frits Scholten, "The World of the Late-Medieval Artist," in *Netherlandish Art in the Rijksmuseum 1400–1600*, by Henk van Os, Jan Piet Filedt Kok, Ger Luijten, and Frits Scholten (Amsterdam: Waanders, 2000); and Reindert Falkenburg, Jan de Jong, Dulcia Meijers, Bart Ramakers, and Mariët Westermann, eds., *Kunst voor de Markt, 1500–1700* (Zwolle: Waanders, 2000). Many valuable contributions to this discussion will appear in Liliane Weissberg, ed., *The Culture of Exchange: Real and Imagined Markets in the Low Countries, 1500–1800* (forthcoming).

14. Cennino d'Andrea Cennini, *The Craftsman's Handbook; the Italian "Il Libro dell'Arte,"* trans. Daniel V. Thompson Jr. (New York: Dover, 1960), p. 123. It is notable that Cennini regarded some human occupations, although all flawed and uncertain after the Fall, as more theoretical—hence more worthy—than others. His own occupation, painting, of course, "justly deserves to be enthroned next to theory, and to be crowned with poetry," because "the poet, with his theory, though he have but one . . . makes him worthy" (pp. 1–2). While Cennini spoke in a rather indistinct way about theory and imagination, the bulk of his text is about attaining bodily knowing through practice. Georges Didi-Huberman, *L'Empreinte* (Paris: Centre Georges Pompidou, 1997), pp. 63–72, discusses the early casting from life done by Ghiberti and Donatello. He regards these artists as working in an "experimental" mode.

15. Norberto Gramaccini, "Das genaue Abbild der Natur—Riccios Tiere und die Theorie des Naturabgusses seit Cennini," in *Natur und Antike in der Renaissance* (Frankfurt: Frankfurt Leibighaus, 1985), pp. 211–14. For a close analysis of the innovative nature of Cennini's treatise, see Christiane Kruse, "Fleisch werden—Fleisch malen: Malerei als 'incarnazione.' Mediale Verfahren des bildwerdens in Libro dell'Arte von Cennino Cennini," *Zeitschrift für Kunstgeschichte* 63 (2000): 305–25. A more precise study of the phenomenon of rulers seeking legitimacy by means of mobilizing a discourse on nature is warranted. The Hohenstaufen emperor Frederick II of Sicily, the Carrara family, and the Burgundian dukes all fostered an efflorescence of cultural production, one aspect of which appears to have been a new place and significance given to nature.

16. Pächt, "Early Italian Nature Studies," p. 32. See Baxandall, "Guarino, Pisanello and Manuel Chrysoloras," about Guarino's efforts at *ekphrasis* learned from his Greek tutelage in *progymnasmata* under Manuel Chrysoloras and how it interacted with Pisanello's descriptive painting to bring about a reinforcing of both endeavors. On the function of Pisanello's (and other Milanese artisans) drawings as model books, see Robert W. Scheller, *Exemplum: Model-Book Drawings and the Practice of Artistic Transmission in the Middle Ages (ca. 900–ca. 1470)*, trans. Michael Hoyle (Amsterdam: Amsterdam University Press, 1995).

17. Wim Blockmans and Walter Prevenier, *The Promised Lands: The Low Countries under Burgundian Rule, 1369–1530*, trans. Elizabeth Fackelman (Philadelphia: University of Pennsylvania Press, 1999), passim, but clearly stated on pp. 216–18.

18. Jean C. Wilson, *Painting in Bruges at the Close of the Middle Ages* (University Park: Pennsylvania State University Press, 1998), pp. 2–6. Wilson argues that the profession of panel painting emerged out of this environment.

19. Blockmans and Prevenier, *The Promised Lands*, pp. 105–7, 138.

20. Maximilian I, who did so much to shape the Holy Roman Empire politically and culturally, was, of course, ruler of the Netherlands before he became emperor; Charles V was brought up in Mechelen by his aunt, regent of the Netherlands. Ibid., p. 73. See also Marina Belozerskaya, *Rethinking the Renaissance: Burgundian Arts Across Europe* (Cambridge: Cambridge University Press, 2002). For the long trajectory of this discourse on art and nature, see the extensive literature on Habsburg art and culture, especially on the courts of Maximilian I and Rudolf II. A good starting point is provided by Thomas DaCosta Kaufmann, *The Mastery of Nature: Aspects of Art, Science, and Humanism in the Renaissance* (Princeton: Princeton University Press, 1993); idem, *Court, Cloister, and City: The Art and Culture of Central Europe, 1450–1800* (Chicago: University of Chicago Press, 1995); and R. J. W. Evans, *Rudolf II and His World: A Study in Intellectual History 1576–1612* (Oxford: Oxford University Press, 1973); and idem, *The Making of the Habsburg Monarchy* (Oxford: Clarendon Press, 1984).

21. Blockmans and Prevenier, *The Promised Lands*, p. 227.

22. The classic account of this development remains Erwin Panofsky, *Early Netherlandish Painting*, 2 vols. (1953; reprint, New York: Harper & Row, 1971). See also Blockmans and Prevenier, *The Promised Lands*, p. 134.

23. Lorraine Daston and Katharine Park, *Wonders and the Order of Nature* (New York: Zone, 1999), pp. 100–8.

24. Panofsky, *Early Netherlandish Painting*, vol. 1, pp. 150–51.

25. Nature was not the only way they accomplished this; they also elaborated a genealogy of their rule that linked them to the Roman emperors, the Bible, and chivalry. See Jeffrey Chipps Smith, "The Artistic Patronage of Philip the Good, Duke of Burgundy (1419–1467)" (Ph.D. diss., Columbia University, 1979); idem, "Venit Nobis Pacificus Dominus: Philip the Good's Triumphal Entry into Ghent in 1458," in *"All the World's a Stage . . .": Art and Pageantry in the Renaissance and Baroque*, ed. Barbara Wich and Susan Munshower (University Park: Pennsylvania State University, 1990), 2 vols., vol. 1; idem, "Portable Propaganda: Tapestries as Princely Metaphors at the Courts of Philip the Good and Charles the Bold," *Art Journal* 48 (1989): 123–29.

26. Panofsky, *Early Netherlandish Painting*, vol. 1, p. 62. Such a joke no doubt also had its origins in the courtly atmosphere of entertainments that the Limburg brothers helped organize, as Jan van Eyck would at the court of Philip the Good.

27. See David Summers, "Pandora's Crown: On Wonder, Imitation and Mechanism in Western Art," in *Wonders, Marvels and Monsters in Early Modern Culture*, ed. Peter G. Platt (Newark: University of Delaware Press, 1999).

28. Peter Cornelius Claussen, "materia und opus—Mittelalterliche Kunst auf der Goldwaage," in *Ars naturam adiuvans. Festschrift für Matthias Winner*, ed. Victoria V. Flemming and Sebastian Schütze (Mainz: Verlag Philipp von Zabern, 1996), p. 45.

29. Ibid., p. 46. Elisabeth Dalucas, "Ars erit Archetypus Naturae. Zur Ikonologie der Bronze in der Renaissance," in *Von Allen Seiten Schön. Bronzen der Renaissance und des Barock*, ed. Volker Krahn. Katalog zur Ausstellung der Skulpturensammlung der Staatlichen Museen zu Berlin—Preußischer Kulturbesitz im Alten Museum, Berlin (Heidelberg: Edition Braus, 1995), points out that all of the major artists of the early Florentine Renaissance, whether they became architects, painters, or sculptors, had completed apprenticeships as goldsmiths and began their careers as goldsmiths (p. 78). Michael Baxandall also makes the point about artistic skill in *Painting and Experience in Fifteenth-Century Italy* (Oxford: Oxford University Press, 1972), p. 15. Leon Battista Alberti, *On Painting*, trans. John R. Spencer (New Haven: Yale University Press, 1966), p. 64, states that painting could enhance the value even of gold.

30. Although the box was inventoried at the very low worth of two livres ten sous, the duke gave a countergift to the Limburg brothers of forty-seven gold coins and he appears to have cherished this box, keeping it in his treasury until the end of his life. Brigitte Buettner, "Past Presents: New Year's Gifts at the Valois Courts, ca. 1400," *Art Bulletin* 83 (2001): 612, 622 n. 58.

31. Maurits Smeyers and Bert Cardon, "Campin and Illumination," in *Robert Campin: New Directions in Scholarship*, ed. Susan Foister and Susie Nash (Turnhout, Belgium: Brepols, 1996).

32. Raymond White, "Van Eyck's Technique: The Myth and the Reality, II," in *Investigating Jan van Eyck*, ed. Susan Foister, Sue Jones, and Delphine Cool (Turnhout, Belgium: Brepols, 2000), p. 104. See also Ashok Roy, "Van Eyck's Technique: The Myth and the Reality, I," in ibid. Both these essays cite examples of the "new" techniques that predate the van Eycks by as much as two centuries. Evidence from the mid-thirteenth century shows that some painters possessed and employed a full knowledge of the binding properties of oils and glazes.

33. A. L. Dierick, "Jan van Eyck's Handwriting," in *Investigating Jan van Eyck*, ed. Foister, Jones, and Cool, p. 80.

34. Hans Belting and Christiane Kruse, *Die Erfindung des Gemäldes: Das erste Jahrhundert der niederländischen Malerei* (Munich: Hirmer Verlag, 1995), make this argument.

35. See Joseph Leo Koerner's discussion in *The Moment of Self-Portraiture in German Renaissance Art* (Chicago: University of Chicago Press, 1993), pp. 106–7, where he comments: "Instead of a miraculous self-portrait of Christ, we have an image produced by one man in history (hence the panel's insistence on date), an image, that, however, through the magic of the artist's *kunnen* appears to be 'made without human hands.'"

36. D. G. Carter, "Reflections on Armor in the 'Canon van der Paele Madonna,'" *Art Bulletin* 36 (1954): 60–62.

37. Carol Purtle has suggested that by painting himself—the *schilder* (or painter)—on Saint George's shield ("*schild*" also meant panel painting), van Eyck was reflecting on his own position as mediator between the court of heaven and the court of Burgundy. The entire painting is thus a meditation on his own status as a painter and about the power of painting. Lecture delivered at the 2002 meeting of the Historians of Netherlandish Art, Antwerp, 15 March 2002.

38. See Michael J. Liebmann, "Künstlersignatur im 15.–16. Jahrhundert als Gegenstand soziologischer Untersuchung," in *Lukas Cranach. Künstler und Gesellschaft*, ed. Peter H. Feist et al. (Wittenberg: Staatliche Lutherhalle, 1972); Hans-Joachim Raupp, *Untersuchungen zu Künstlerbildnis und Künstlerdarstellung in den Niederlanden im 17. Jahrhundert* (Hildesheim: Georg Olms, 1984), p. 245; and Martin Warnke, "Filaretes Selbstbildnisse: Das geschenkte Selbst," in *Der Künstler uber sich in seinem Werk: Internationales Symposium der Bibliotheca Hertziana, Rom, 1989*, ed. Matthias Winner (Weinheim: VCH, Acta Humaniora, 1992). For a wonderfully rich discussion especially of Italian artists, see Joanna Woods-Marsden, *Renaissance Self-Portraiture: The Visual Construction of Identity and the Social Status of the Artist* (New Haven: Yale University Press, 1998). See also Victor I. Stoichita, *L'Instauration du Tableau* (Paris: Méridiens Klincksieck, 1993), pp. 236–40.

39. Recounted in Ernst Cassirer, *The Individual and the Cosmos in Renaissance Philosophy*, trans. Mario Domandi (Philadelphia: University of Pennsylvania Press, 1979), pp. 31–32.

40. Like other Netherlandish paintings, this one operates at a number of levels of meaning. It can also be read as displaying Rogier van der Weyden's devotion. For a full discussion of the painting, see *Rogier van der Weyden: St. Luke Drawing the Virgin. Selected Essays in Context* (Turnhout, Belgium: Brepols, 1997).

41. Belting and Kruse, *Die Erfindung des Gemäldes*, p. 49. Lorne Campbell notes that van Eyck's use of "*actum*," part of the closing sentence on legal deeds, was not absolutely unique in paintings. Jan and Hubert van Eyck also used it on the *Ghent Altarpiece*. Lorne Campbell, *The Fifteenth Century Netherlandish Schools* (London: National Gallery Publications, Yale University Press, 1998), p. 222.

42. Anthony Pagden, *European Encounters with the New World: From Renaissance to Romanticism* (New Haven: Yale University Press, 1993).

43. See examples and discussion in James S. Amelang, *The Flight of Icarus: Artisan Autobiography in Early Modern Europe* (Stanford: Stanford University Press, 1998), pp. 140–49.

44. Such a portrayal in an herbal no doubt had roots in the *tacuina sanitatis* texts of the Middle Ages. See Pächt, "Early Italian Nature Studies," on early herbals and *tacuina sanitatis*. From the Middle Ages, the illustrations in these manuals often showed the herbalist digging up the plants, or in some other way making clear his personal eyewitnessing or handling of the plant, even when the herbs themselves were not rendered realistically. On Cibo, see Lucia Tongiorgi Tomasi, "Ghirardo Cibo: Visions of Landscape and the Botanical Sciences in a Sixteenth-Century Artist," *Journal of Garden History* 9 (1989): 199–216, esp. 202.

45. This portrait has occasioned a large body of scholarship. See Campbell, *The Fifteenth Century Netherlandish Schools*, pp. 174–211. For examples of medieval artisans' inscriptions in their works, see Peter Cornelius Claussen, "Nachrichten von den Antipoden oder der mittelalterliche Künstler über sich selbst," in *Der Künstler*, ed. Winner.

46. Panofsky, *Early Netherlandish Painting*, vol. 1, p. 179.

47. R. W. Scheller, "Korte bijdragen: ALS ICH CAN," *Oud Holland* 83 (1968): 135–39.

48. Dirk de Vos, "Nogmaals ALS ICH CAN," *Oud Holland* 97 (1983): 1–4.

49. Campbell, *The Fifteenth Century Netherlandish Schools*, p. 214.

50. Belting and Kruse, *Die Erfindung des Gemäldes*, pp. 39 ff.

51. According to Augustine, there were three forms of vision: corporeal, intellectual, and spiritual. At the same time, a long-standing tradition held that vision was a means of access to supernatural reality for the unlearned. In this tradition, extending back to Pope Gregory the Great in the ninth century, visual images were "books of the common people." Bob Scribner, "Ways of Seeing in the Age of Dürer," in *Dürer and His Culture*, ed. Dagmar Eichberger and Charles Zika (Cambridge: Cambridge University Press, 1998), pp. 98–99.

52. Bret Rotstein, "Vision and Devotion in Jan van Eyck's *Virgin and Child with Canon Joris van der Paele*," *Word & Image* 15 (1999): 262–75, argues that this painting encourages its viewer to transcend the realm of the senses to reach the real world of the spirit.

53. Belting and Kruse, *Die Erfindung des Gemäldes*, pp. 50–52.

54. Scribner, "Ways of Seeing," p. 99. Another example of such division between tangible and spiritual reality can be found in the early-fourteenth-century manuscript "La Sainte Abbaye," treated in Jeffrey F. Hamburger, *The Rothschild Canticles: Art and Mysticism in Flanders and the Rhineland circa 1300* (New Haven: Yale University Press, 1990), p. 6 and fig. 187. Hamburger also makes a very interesting argument about the viewing of images in works of devotion that are meant to give experiential access to a world that lies "beyond ordinary experience," that is, on the other side of the window frame. Jeffrey F. Hamburger, *Nuns as Artists: The Visual Culture of a Medieval Convent* (Berkeley: University of California Press, 1997), p. 215.

55. Panofsky, *Early Netherlandish Painting*, vol. 1, p. 181, describes the "sculpted" and incised frames of Jan van Eyck as having this effect.

56. Jeffrey F. Hamburger, "The Visual and the Visionary: The Image in Late Medieval Monastic Devotions," *Viator* 20 (1989): 169.

57. Gertrude of Helfta, *Revelations*; quoted in Hamburger, "The Visual and the Visionary," pp. 179–80.

58. See Panofsky, *Early Netherlandish Painting*, vol. 1, p. 160, for the idea that careful observation of these paintings conveys an emotional intensity.

59. James H. Marrow, "Symbol and Meaning in Northern European Art of the Late Middle Ages and the Early Renaissance," *Simiolus* 16 (1986): 158.

60. The ruined building in this painting of the Nativity refers to the transition from the old law of the Jews to make way for the new law of the Christian era. See Carol J. Purtle "Assessing the Evolution of van Eyck's Iconography through Technical Study of the Washington *Annunciation*, II: New Light on the Development of van Eyck's Architectural Narrative," in *Investigating Jan van Eyck*, ed. Foister, Jones, and Cool, p. 68.

61. Panofsky, *Early Netherlandish Painting*, vol. I, p. 165. See also Ainsworth and Christiansen, eds., *From Van Eyck to Bruegel*, pp. 89–96.

62. It should be noted here that labor and earning a livelihood through labor were spiritually sanctioned activities. Cennino Cennini, for example, ends his late-fourteenth-century painter's manual with a prayer to "God All-Highest, Our Lady, Saint John, Saint Luke, the Evangelist and painter, Saint Eustace, Saint Francis, and Saint Anthony of Padua," which the students of his book will "study well and . . . retain it well, so that by their labors they may live in peace and keep their families in this world, through grace, and at the end, on high, through glory, *per infinita secula seculorum.*" Cennini, *The Craftsman's Handbook*, trans. Thompson, p. 131.

63. "Ian de (Leeuw) op Sant Orselen Dach / Dat claer eerst met oghen sach. 1401 / Gheconterfeit nu heeft mi Jan / van Eyck. Wel bliict wann eert began. 1436." Belting and Kruse, *Die Erfindung des Gemäldes*, p. 50. It has become a commonplace that the Renaissance artist saw himself as a divine genius. This has been revised by Martin Kemp, "From 'Mimesis' to 'Fantasia': The Quattrocento Vocabulary of Creation, Inspiration and Genius in the Visual Arts," *Viator* 7 (1977): 347–98. In 1436 Alberti wrote in *On Painting* that the artist should consider himself an "alter deus," probably making reference to the medieval idea of the *deus artifex*. As Kemp points out, only Alberti held this view in the fifteenth century. In the 1490s, Leonardo da Vinci made "more speculative and less precisely formulated" statements about the divine human creativity, such as, "The divinity which is the science of painting transmutes itself into a semblance of the divine mind in such a manner that it discourses with free power concerning the generation of the diverse essences of various plants, animals, and so on" (Urb. Fol. 36 [McM. 280]); quoted in Kemp, "From 'Mimesis' to 'Fantasia,'" p. 383. Later on, however, Leonardo moved toward a "more disciplined interpretation of invention and judgment" that was mathematically grounded (pp. 383, 394). Although Kemp is correct to point out the later origin of the idea that the artist imitated the Divine, van Eyck may well be making a lesser claim about his ability to imitate the powers of nature.

64. Panofsky, *Early Netherlandish Painting*, vol. I, pp. 180–82.

65. Quoted in Johan Huizinga, *The Autumn of the Middle Ages*, trans. Rodney J. Payton and Ulrich Mammitzsch (Chicago: University of Chicago Press, 1996), pp. 340–41. Huizinga finds an analogue to van Eyck in the Flemish-born chronicler Georges Chastellain, about whom Huizinga writes, "Whenever Chastellain describes an event that particularly captivates his Flemish spirit, an entirely direct, plastic earthiness enters into his narrative, all ceremonial elements notwithstanding, which makes it extraordinarily suitable for its task" (p. 343). As in Panofsky's analysis of early Netherlandish painting, Huizinga equates Flemishness with earthy directness, out of which it is implicitly argued that this naturalism sprang.

66. Otto Pächt, *Van Eyck and the Founders of Early Netherlandish Painting*, trans. David Britt (London: Harvey Miller, 1994), pp. 11–12.

67. Panofsky, *Early Netherlandish Painting*, vol. 1, p. 2; see also n. 4.

68. Aristotle, *Physics*, II, 2:194a 21 ff.; *Meteorologica*, IV, 3:381b 3–7; Hans Blumenberg, "Nachahmung der Natur," *Studium Generale* 10 (1957): 266–83; Jan Bialostocki, "The Renaissance Concept of Nature and Antiquity," in *The Renaissance and Mannerism: Studies in Western Art*, Acts of the Twentieth International Congress of the History of Art, 4 vols. (Princeton: Princeton University Press, 1963), vol. 2, pp. 19–30; E. H. Gombrich, "'The Style All' Antica: Imitation and Assimilation," in *The Renaissance and Mannerism*, vol. 2, pp. 31–40; Ernst Kris, "Georg Hoefnagel und der wissenschaftliche Naturalismus," in *Festschrift für Julius Schlosser zum 60. Geburtstag*, ed. Arpad Weixlgärtner and Leo Planscig (Zurich: Amalthea, 1927); Pächt, "Early Italian Nature Studies"; A. J. Close, "Commonplace Theories of Art and Nature in Classical Antiquity and in the Renaissance," *Journal of the History of Ideas* 30 (1969): 467–86. See also A. C. Crombie's discussion of the imitation of nature in *Styles of Scientific Thinking in the European Tradition*, 3 vols. (London: Duckworth, 1994), esp. vol. 1, chap. 8.

69. Bialostocki, "The Renaissance Concept of Nature and Antiquity," makes the distinction and traces the history of these two conceptions of nature. As will become apparent, I differ with him on the sources for the explosion of interest in and the development of the *natura naturans* conception of nature in the sixteenth century. For an investigation of the active understanding of the "imitation of nature" in the treatises of Italian artists, see Anne Eusterschulte, "Imitatio naturae. Naturverständnis und Nachahmungslehre in Malereitraktaten der frühen Neuzeit," *Künste und Natur in Diskursen der Frühen Neuzeit*, 2 vols., ed. Hartmut Laufhütte (Wiesbaden: Harrassowitz Verlag, 2000), vol. 2.

70. Quoted by Bialostocki, "The Renaissance Concept of Nature and Antiquity," esp. p. 25, as an atypical statement of Leonardo, taken from Neoplatonic views that the world was animated. Although this idea was certainly expressed, particularly by Marsilio Ficino, much older sources were available to artisans. An author who regards Leonardo's comments on the vital forces of nature as extremely significant, though he does not precisely know how to categorize them (he calls them "myth"), is James Ackerman, "Science and Art in the Work of Leonardo," in *Leonardo's Legacy*, ed. C. D. O'Malley (Berkeley: University of California Press, 1969), pp. 222ff. See also Martin Kemp, *Leonardo da Vinci: The Marvellous Works of Nature and Man* (Cambridge: Harvard University Press, 1981), esp. pp. 263, 277, on the earth as an organism in geological flux; and pp. 312–19, on the relationship between this geology and the system of the four elements.

71. In 1512 Dürer wrote that the gifted painter's creative talent comes from *obere Eingiessungen*, the influences of the stars as conduits of divine power. Erwin Panofsky, *The Life and Art of Albrecht Dürer* (Princeton: Princeton University Press, 1955), p. 280. Vasari, too, stated that the greatest gifts in human bodies result from celestial influences, as noted by David Summers, *The Judgment of Sense: Renaissance Naturalism and the Rise of Aesthetics* (Cambridge: Cambridge University Press, 1987), p. 124. Karel van Mander, *The Lives of the Illustrious Netherlandish and German Painters from the First Edition of the Schilder-boeck (1603–04)*, 5 vols., trans. and ed. Hessel Miedema (Doornspijk: Davaco, 1994); see especially the lives of Lucas van Leyden (vol. 1, pp. 104–5, with commentary in vol. 3, p. 2), Spranger (vol. 1, pp. 330–31; commentary in vol. 5, p. 87), and Aert Mijtens (vol. 1, p. 313; commentary in vol. 4, p. 24).

72. See William Newman, "Technology and Alchemical Debate in the Late Middle Ages," *Isis* 80 (1989): 423–45; and idem, *The "Summa perfectionis" of Pseudo-Geber* (Leiden: Brill, 1991).

73. Kemp, "From 'Mimesis' to 'Fantasia,'" p. 381.

CHAPTER TWO

1. Fritz Koreny, "A Coloured Flower Study by Martin Schongauer and the Development of the Depiction of Nature from van der Weyden to Dürer," *Burlington Magazine* 133 (1991): 588–97, esp. 597.

2. David Landau and Peter Parshall, *The Renaissance Print 1470–1550* (New Haven: Yale University Press, 1994), pp. 50–55.

3. Joseph Leo Koerner, *The Moment of Self-Portraiture in German Renaissance Art* (Chicago: University of Chicago Press, 1993), pp. 203–5.

4. Markus Nass, "Stellung und Bedeutung des Monogramms Martin Schongauers in der Graphik des 15. Jahrhunderts," in *Martin Schongauer. Druckgraphik*, ed. Harmut Krohm and Jan Nicolaisen (Berlin: Staatliche Museen Preußischer Kulturbesitz, 1991).

5. Corine Schleif, "Nicodemus and Sculptors: Self-Reflexivity in Works by Adam Kraft and Tilman Riemenschneider," *Art Bulletin* 75 (1993): 599–626, points out the multiple dimensions of this self-consciousness, including a conviction that the sculptor functioned as mediator of spiritual truths and practices.

6. See Pamela H. Smith, *The Business of Alchemy: Science and Culture in the Holy Roman Empire* (Princeton: Princeton University Press, 1994), p. 36, and the works on Nuremberg cited there. For a vivid account of the artisans of Nuremberg, see Johann Neudörfer, "Nachrichten von Künstlern und Werkleuten . . . aus dem Jahre 1547," in *Quellenschriften für Kunstgeschichte und Kunsttechnik des Mittelalters und der Renaissance*, 18 vols., transcribed from the ms. and annotated by G. W. K. Lochner (Vienna: Wilhelm Braumüller, 1875), vol. 10; and Johann Gabriel Doppelmayr, *Historische Nachricht von den Nürnbergischen Mathematicis und Künstlern* (Nuremberg: Peter Conrad Monath, 1730). See also Reijer Hooykaas, "Von der 'Physica' zur Physik," in *Selected Studies in History of Science* (Coimbra: Acta Universitatis Conimbrigensis, 1983), esp. pp. 628–32. On the art of Nuremberg, see Jeffrey Chipps Smith, ed., *New Perspectives on the Art of Renaissance Nuremberg: Five Essays* (Austin: Archer M. Huntington Art Gallery, 1985); idem, *Nuremberg: A Renaissance City, 1500–1618* (Austin: University of Texas Press, 1983).

7. Landau and Parshall, *The Renaissance Print*, pp. 38–40.

8. Jan-Dirk Müller, *Gedechtnus. Literatur und Hofgesellschaft um Maximilian I* (Forschungen zur Geschichte der älteren deutschen Literatur, 2) (Munich: W. Fink, 1982). For a fascinating discussion of the project of Maximilian's *Prayer-Book*, see Koerner, *The Moment of Self-Portraiture*, pp. 224–36. See the work of Larry Silver on Maximilian I: "Prints for a Prince: Maximilian, Nuremberg, and the Woodcut," in *New Perspectives on the Art of Renaissance Nuremberg*, ed. Smith; idem, "Paper Pageants: The Triumphs of Emperor Maximilian I," in *"All the World's a Stage . . .": Art and Pageantry in the Renaissance and Baroque*, 2 vols., ed. Barbara Wich and Susan Munshower (University Park: Pennsylvania State University, 1990), vol. 1; and idem, "Germanic Patriotism in the Age of Dürer," in *Dürer and His Culture*, ed. Dagmar Eichberger and Charles Zika (Cambridge: Cambridge University Press, 1998). Like Philip the

Good, Maximilian employed "portable propaganda," such as Maximilian's paper triumphal arch. The theater of Maximilian I provided the direct underpinnings for that of Emperor Rudolf II (ruled 1576–1612). R. J. W. Evans, *Rudolf II and His World: A Study in Intellectual History 1576–1612* (Oxford: Oxford University Press, 1973), p. 14.

9. Owing to the complexity of organization and Maximilian's continuous intervention in the details, this project, like many of Maximilian's others, was never realized in its final form. Landau and Parshall, *The Renaissance Print*, pp. 206–11.

10. Ptolemy, *Geography*, trans. and ed. Edward Luther Stevenson (New York: New York Public Library, 1932), II.x.

11. Gerald Strauss, *Sixteenth-Century Germany: Its Topography and Topographers* (Madison: University of Wisconsin Press, 1959), p. 31.

12. Tacitus, *Germania*, trans. M. Hutton (Cambridge: Harvard University Press, 1963).

13. Saxonia (Cologne, 1520), a ii verso; quoted in Strauss, *Sixteenth-Century Germany*, pp. 8–9.

14. Tacitus, *Germania*, ii.

15. The new boundaries of Germany posed a great problem for the humanists, and they solved it by basing boundaries on language or "character." For example, the historians of Alsace Sebastian Brant (ca. 1458–1521), Beatus Rhenanus (1485–1547), and Jacob Wimpfeling (1450–1528) were concerned to point out the German character of Alsace in order to establish it as belonging within the German Empire. See Beatrice Reynolds, "Latin Historiography: A Survey 1400–1600," *Studies in the Renaissance* 2 (1955): 7–66.

16. Strauss, *Sixteenth-Century Germany*, pp. 17–18. On Aventinus, see idem, *Historian in an Age of Crisis: The Life and Work of Johannes Aventinus (1477–1534)* (Cambridge: Harvard University Press, 1963).

17. On Celtis, see Leo Spitz, *Conrad Celtis: The German Arch-Humanist* (Cambridge: Harvard University Press, 1957); and Strauss, *Historian*. Willibald Pirkheimer produced *Germaniae explicatio* in 1530, and Beatus Rhenanus published *Rerum Gemanicarum libri tres* in 1531.

18. In addition to Strauss's work already quoted, see idem, "Topographical-Historical Method in Sixteenth-Century German Scholarship," *Studies in the Renaissance* 5 (1958): 87–101.

19. See, for example, *Cartographia Bavariae. Bayern im Bild der Karte*, Bayerische Staatsbibliothek Austellungskataloge 44 (Weissenhorn: Anton H. Konrad Verlag, 1988). Simon Schama, *Landscape and Memory* (New York: Knopf, 1995), has recently treated this subject, expanding on the foundational work of Larry Silver, "Forest Primeval: Albrecht Altdorfer and the German Wilderness Landscape," *Simiolus* 13 (1982–83): 4–43, and that of Christopher S. Wood, *Albrecht Altdorfer and the Origins of Landscape* (Chicago: University of Chicago Press, 1993), pp. 159–60.

20. Gerald Strauss, *Nuremberg in the Sixteenth Century*, 2nd ed. (Bloomington: Indiana University Press, 1976), p. 252.

21. On Nuremberg investment, see ibid.

22. Quoted by Smith, *Nuremberg*, p. 39.

23. Strauss, *Nuremberg in the Sixteenth Century*, p. 258.

24. See the discussion of Ryff in William Eamon, *Science and the Secrets of Nature: Books of Secrets in Medieval and Early Modern Culture* (Princeton: Princeton University Press, 1994), pp. 96–105.

25. Reijer Hooykaas, *Humanisme, science et réforme, Pierre de la Ramée* (Leiden: E. J. Brill, 1958), pp. 3–8, 125.

26. Juan Luis Vives, *De tradendis disciplinis* (1531), trans. Foster Watson (Totowa, N.J.: Rowman and Littlefield, 1971), bk. 4, chap. 6, p. 209. On this subject, see also Paolo Rossi, *Philosophy, Technology, and the Arts in the Early Modern Era*, trans. Salvator Attanasio (New York: Harper & Row, 1970); and Eamon, *Science and the Secrets of Nature*, esp. chaps. 3, 6.

27. Reijer Hooykaas, "The Rise of Modern Science: When and Why?" *British Journal for the History of Science* 20 (1987): 460–61.

28. E. H. Gombrich, "Dürer, Vives and Breughel," in *Album Amicorum J. G. van Gelder*, ed. J. Bruyn, J. A. Emmens, E. de Jongh, and D. P. Snoep (The Hague: Martinus Nijhoff, 1973), pp. 132–34. Gombrich compares this dialogue to Pieter Brueghel the Elder's well-known drawing that contrasts the "self-assertive painter and the foolish and myopic buyer who fumbles in his purse," suggesting that Brueghel may have had this dialogue in mind and perhaps the portrait of Dürer on a 1527 medallion when executing this drawing.

29. Hooykaas, *Humanisme*, pp. 95–96. For the influence of Ramus, see Walter J. Ong, *Ramus, Method and the Decay of Dialogue: From the Art of Discourse to the Art of Reason* (Cambridge: Harvard University Press, 1983). Klaas van Berkel, *Isaac Beeckman (1588–1637) en de Mechanisering van het Wereldbeeld* (Amsterdam: Rodopi, 1983), traces the influence of Ramus on Isaac Beeckman, who began life as a candle maker and ended it by explicating a mechanical philosophy that formed the basis for the theories of René Descartes. Van Berkel argues that the main influence of Ramus on Beeckman was Ramus's emphasis on visualization. "Picturability" became the most important criterion of Beeckman's philosophy, that is, only concepts that could be given a picturable representation would be allowed into his system.

30. Erwin Panofsky, *The Life and Art of Albrecht Dürer* (Princeton: Princeton University Press, 1955), pp. 44–45. The literature on Dürer has reached truly monumental proportions, but Panofsky's book in many ways remains at the core of it.

31. Koerner points out that after Dürer purchased his own printing press in 1497, his monogram indicated his role as both designer and publisher of his prints. Koerner, *The Moment of Self-Portraiture*, pp. 203–5.

32. Dürer's father, a goldsmith, had been trained in the Netherlands "with the great masters." Panofsky, *The Life and Art of Albrecht Dürer*, p. 4.

33. Ibid., pp. 51 ff.

34. Dürer, *Vier Bücher von menschlicher Proportion* (1528), trans. and quoted in ibid., p. 283.

35. Panofsky, *The Life and Art of Albrecht Dürer*, p. 285. See also the discussion of Dürer's self-consciousness as an artisan and his view that as an artisan his work was a kind of worship in Philipp P. Fehl, "Dürer's Literal Presence in His Pictures: Reflections on His Signatures in the Small Woodcut Passion," in *Der Künstler über sich in seinem Werk. Internationales Symposium der Bibliotheca Hertziana, Rom, 1989*, ed. Matthias Winner (Weinheim: VCH, Acta Humaniora, 1992).

36. Koerner, *The Moment of Self-Portraiture*, p. 32.

37. Ibid., pp. 15–19.

38. Ibid., passim, but clearly stated on pp. 55–59.

39. James S. Ackerman, "Dürer's Crab," in *Ars Auro Prior. Studia Ioanni Bialostocki sexagenario dedicata* (Warsaw: Panstwowe Wydawn. Nauk., 1981), makes the interesting point that Dürer's watercolor of a crab may have been inspired by the casting from life of Andrea Riccio and that the idea of casting such "nonsubjects" as crabs may have derived from Roman models. What might be called the "natural historical" content of Dürer's works has been treated by Fritz Koreny, *Albrecht Dürer and the Animal and Plant Studies of the Renaissance*, trans. Pamela Marwood and Yehuda Shapiro (Boston: Little, Brown, 1988); and Colin Eisler, *Dürer's Animals* (Washington, D.C.: Smithsonian Institution Press, 1991). The natural historical understanding of artists who employed naturalism is an area worthy of further study.

40. Panofsky, *The Life and Art of Albrecht Dürer*, p. 80. For the 1500 self-portrait, see the analysis by Koerner, *The Moment of Self-Portraiture*.

41. For other examples, see Pamela O. Long, "The Contribution of Architectural Writers to a 'Scientific' Outlook in the Fifteenth and Sixteenth Centuries," *Journal of Medieval and Renaissance Studies* 15 (1985): 265–98.

42. Panofsky, *The Life and Art of Albrecht Dürer*, pp. 273, 164. Panofsky notes that for Dürer, this notion of power was bound up with the wealth that he believed was the just reward of powerful artists.

43. Ibid., p. 245. He also used *Eberzähne* (boar's teeth) for angles formed by circular arcs, *ortstrich* (corner stroke) for diagonal, and *Schneckenlinie* (snail line) for spiral.

44. See, for example, Dürer, *Dürers schriftlicher Nachlass*, ed. K. Lange and F. Fuhse (Niederwalluf: Dr. Martin Sändig, 1970), pp. 254–55. Panofsky points out that the prefaces composed by Pirkheimer were not satisfactory, replicating as they did Latin composition, which must have seemed inauthentic to the subject matter to Dürer. Panofsky, *The Life and Art of Albrecht Dürer*, pp. 245–46.

45. "Auff das die unsigchtig Lini/ durch den geraden ryß im gemüt verstanden werd/ Dann durch solche weyß muß der innerlich verstand im eussern werck angetzeigt werden/ Darumb will ich alle ding/ die ich in diesem büchlin beschreib/ auch darneben auffreissen/ auff das meyn darthon/ die jungen zu einer einbildung vor augen sehen/ Unnd dest baß begreiffen." Albrecht Dürer, *Underweysung der Messung/ mit dem zirckel und richtscheyt/ in Linien ebnen unnd gantzen corporen/ durch Albrecht Dürer zu sammen getzogen/ und zu nutz allen kunstliebhabenden mit zu gehörigen figuren* (1525), fol. Aii, facsimile edition with trans. Walter L. Strauss (New York: Abaris Books, 1977), p. 41 (my translation).

46. Ibid., p. 148.

47. Panofsky, *The Life and Art of Albrecht Dürer*, p. 244.

48. From bk. 3 of *Vier Bücher*, quoted in ibid., pp. 279–80. In a contradictory passage at the end of the fourth book on human proportions, Dürer alludes directly to the difficulties an artisan might find in his book and to the problems of articulating handwork in general. This passage suggests the differences between the mode of learning in the workshop and from a book such as Dürer's *Vier Bücher von menschlicher Proportion* or the *Underweysung der Messung*: "It is difficult to write about these things and still more burdensome [verdrossener] to read and learn about them because of the many words, dots, and symbols, but it is a much more advantageous method to use in these things, because if it is not present, these things become even more difficult and hard to do. . . . Therefore it is good that a person has a master who daily gives him instruction, but to learn something from a master is six times more effort and work." Dürer, *Vier Bücher*, bk. 4, unpaginated.

49. Artisans looked to mathematics for a variety of uses; see Mary J. Henninger-Voss, "Between the Cannon and the Book: Mathematicians and Military Culture in Sixteenth-Century Italy," unpublished ms.; and Stephen Johnston, "Making Mathematical Practice: Gentlemen, Practitioners and Artisans in Elizabethan England" (Ph.D. diss., Cambridge University, 1994).

50. Dürer, *Vier Bücher*, quoted in Panofsky, *The Life and Art of Albrecht Dürer*, p. 278.

51. Ibid., p. 274; and Millard Meiss, *The Painter's Choice: Problems in the Interpretation of Renaissance Art* (New York: Harper & Row, 1976), pp. 183–84.

52. "Darumb müss man darnach suchen/ wie dann der hoch berumbt Vitruvius und ander gesucht haben/ und güt ding gefunden/ aber darmit ist nit auf gehaben/ das nit anders/ das auch gut sey gefunden müg werden/ und sunderlich in den dingen/ die nit bewissen mügen werden/ dass sie aufs best gemacht sind." Dürer, *Underweysung*, p. 194 (my translation).

53. A sixteenth-century goldsmith's manuscript treatise (ca. 1570–94) on the technique of casting from life survives in the Bibliothèque nationale. It documents these methods and is discussed by Leonard N. Amico, *Bernard Palissy: In Search of Earthly Paradise* (Paris: Flammarion, 1996), pp. 86–92.

54. The process is described by Gualterius Rivius, *De architectura* (Nuremberg, 1542), p. 95.

55. Jamnitzer's perception of himself as a designer, and his skill in drawing, is made clear in Klaus Pechstein, "Zeichnungen von Wenzel Jamnitzer," *Anzeiger des Germanischen Nationalmuseums* (1970): 81–95. Jamnitzer was probably instrumental in the requirements for the new 1572 Nuremberg Goldsmiths' Ordinance, which required the candidate to produce a work according to a drawn model. Ibid., p. 89.

56. The four emperors were Charles V, Ferdinand I, Maximilian II, and Rudolf II.

57. One of the best introductions to this phenomenon is Martin Kemp, "'Wrought by No Artist's Hand': The Natural, the Artificial, the Exotic, and the Scientific in Some Artifacts from the Renaissance," in *Reframing the Renaissance: Visual Culture in Europe and Latin America 1450–1650*, ed. Claire Farago (New Haven: Yale University Press, 1995). Jan Bialostocki, "The Renaissance Concept of Nature and Antiquity," in *The Renaissance and Mannerism: Studies in Western Art*, Acts of the Twentieth International Congress of the History of Art, 4 vols. (Princeton: Princeton University Press, 1963), vol. 2, pp. 19–30; Thomas DaCosta Kaufmann, *The Mastery of Nature: Aspects of Art, Science, and Humanism in the Renaissance* (Princeton: Princeton University Press, 1993); idem, *Court, Cloister, and City: The Art and Culture of Central Europe 1450–1800* (Chicago: University of Chicago Press, 1995); and Horst Bredekamp, *The Lure of Antiquity and the Cult of the Machine*, trans. Allison Brown (Princeton: Markus Wiener, 1995) also treat this subject. See *Prag um 1600: Beiträge zur Kunst und Kultur am Hofe Rudolfs II*, 2 vols. (Freren: Luca, 1988); and Eliska Fuciková et al., *Rudolf II and Prague: The Court and the City* (London: Thames and Hudson, 1997).

58. Giorgio Vasari, introduction to *Three Arts of Design, Architecture, Sculpture and Painting, Prefixed to the Lives of the Most Excellent Painters, Sculptors and Architects*, trans. Louisa S. Maclehose (New York: Dover, 1960), p. 166.

59. David von Schönherr, "Wenzel Jamnitzers Arbeiten für Erzherzog Ferdinand," *Mittheilungen des Instituts für Oesterreichische Geschichtsforschung* 9 (1888): 289–305, gives a good picture of some of the working practices of Jamnitzer's workshop. See also Jeffrey Chipps Smith, "Netherlandish Artists and Art in Renaissance Nuremberg," *Simiolus* 20 (1990–91): 153–67.

60. Quoted in Klaus Pechstein, "Der Goldschmied Wenzel Jamnitzer," in *Wenzel Jamnitzer und die Nürnberger Goldschmiedekunst 1500–1700*, Catalog of the Germanisches Nationalmuseum, Nuremberg (Munich: Klinkhardt & Bierman, 1985), pp. 57–58. I used the translation of the short excerpt in J. F. Hayward, "The Mannerist Goldsmiths: Wenzel Jamnitzer," *Connoisseur* 164, no. 1 (1967): 150. For more on the context of gold- and silversmiths in Nuremberg in Jamnitzer's lifetime, see Klaus Pechstein et al., eds., *Deutsche Goldschmiedekunst vom 15. bis zum 20. Jahrhundert aus dem Germanischen Nationalmuseum* (Berlin: Verlag Willmuth Arenhövel, 1987).

61. This marvel was melted down in the eighteenth century; only the Four Seasons that formed the base of this fountain still survive and are in the Kunsthistorisches Museum. See Hayward, "The Mannerist Goldsmiths"; and *Wenzel Jamnitzer und die Nürnberger Goldschmiedekunst 1500–1700*. In the 1607–11 inventory of the *Kunstkammer* of Rudolf II the fountain is described as being contained in eighteen boxes marked with a particular seal. The contents of box no. 8 included a small book in which the entire meaning of the fountain was neatly written out on parchment. In box no. 9, there were two empty drawers in which the waterwheel was to be laid if the boxes were moved "overland." This box also handily contained a screwdriver with which the waterwheel could be dismantled. These documents are reprinted in Pechstein, "Der Goldschmied," pp. 67–70.

62. "nit allein physica und metaphysica sondern auch politica mit vielen schön philosophischen und poetischen geheimnusen für die augen gestellet und fürgewiesen." This seventeenth-century account provides the basis for the foregoing description. Ms. in Germanisches Nationalmuseum, published in *Jahrbuch der kunsthistorischen Sammlungen des Allerhöchsten Kaiserhauses* 7 (1888); here quoted in Erik Forssman, "Renaissance, Manierismus und Nürnberger Goldschmiedekunst," in *Wenzel Jamnitzer und die Nürnberger Goldschmiedekunst 1500–1700*, p. 3.

63. "Litere rebus memorem caducis/ Suscitant vitam, monumenta fida/ Artium condunt revocant ad auras/ Lapsa sub umbras MDLXII." This piece is now in Dresden. See *Wenzel Jamnitzer und die Nürnberger Goldschmiedekunst 1500–1700*, p. 226.

64. Klaus Pechstein, "Der Merkelsche Tafelaufsatz von Wenzel Jamnitzer," *Mitteilungen des Vereins für Geschichte der Stadt Nürnberg* 61 (1974): 90–121.

65. "Sum terra, Mater Omnium/ Onusta caro pondere/ Nascentium ex me fructuum." See the entire hymn quoted in Pechstein, "Der Merkelsche Tafelaufsatz," pp. 95–96.

66. Gualtherus H. Rivius (Walther Ryff), *Der furnembsten/ notwendigsten/ der gantzen Architectur angehörigen Mathematischen und Mechanischen künst/ eygentlicher bericht/ und vast klare/ verstendliche unterrichtung/ zu rechtem verstandt/ der lehr Vitruvij* (Nuremberg: Johan Petreius, 1547), part I, p. XL.

67. Fire was "Ein trianglichter Kegel," Ai; air was "Ein Diamant Punct/ oder Coerper/ von acht Trianglichten Flechen," E 2; earth was "Ein Wuerffel," I 3; water was "Ein Corpus von zwaintzig Triangeln," O 4; and heaven was "Ein Corpus von Zwoelff Fuenfangeln," V 5. Wenzel Jamnitzer, *Perspectiva corporum regularium, Das ist ein fleyssige Fürweysung/ wie die Fünff Regulírten Cörper darvon Plato inn Timaeo/ unnd Euclides inn sein Elementis schreibt /etc. Durch einen sonderlichen/ newen behenden und gerechten weg/ der vor nie im gebrauch ist gesehen worden/ gar Künstlich inn die Perspectiva gebracht/ Und darzu ein schöne Anleytung/ wie auß denselbigen Fünff Cörpern one Endt/ gar viel andere Cörper/ mancherley Art und gestalt/ gemacht/ unnd gefunden werden mögen* (Nuremberg, 1568).

68. Martin Kemp, *The Science of Art: Optical Themes in Western Art from Brunelleschi to Seurat* (New Haven: Yale University Press, 1990), pp. 63–64, points out the significance of the five Platonic solids.

69. Wenzel Jamnitzer, *Perspectiva*, dedication to Emperor Maximilian II and preface.

70. "das es von der handt so änlich und gerecht zu Conterfehen/ fast unmüglich scheynen würde." Jamnitzer, *Perspectiva*, fol. aiii v.

71. Kemp, *The Science of Art*, pp. 63, 173.

72. "In einem Spiegel sehen wir die gestalt oder unser biltnis. Aber in diesem Spiegel sehen wir das bildtnuss oder gemält der ganzen Welt, daß ist die gestalt der Erden." "Das Andertheil von Beschreibung der kunstlichen Silber und Vergulten Instrumenten in dem Kunstlichen und wolgetzierten Schreibtisch fast dienstlich der Geometri und Astronomi auch anderen schönen und Nutzlichen Kunsten" (1585), fol. 68v–70v, Victoria and Albert Museum, MSL 1893/1601. This is the second part of Jamnitzer's treatise. The first part is "Ein gar Kunstlicher und wolgetzierter Schreibtisch sampt allerhant Kunstlichen Silbern und vergulten newerfunden Instrumenten so darin zufinden. Zum gebrauch der Geometrischen und Astronomischen auch andern schönen und nützlichen Kunsten. Alles durch Wentzel Jamitzer Burger und Goldschmidt in Nurnberg auffs new verfertigt. Der Erst Theil" (1585), Victoria and Albert Museum, MSL 1893/1600.

73. Gualterius Rivius, *De architectura*, p. 95; quoted in Ernst Kris, "Der Stil 'Rustique': Die Verwendung des Naturabgusses bei Wenzel Jamnitzer und Bernard Palissy," *Jahrbuch der Kunsthistorischen Sammlungen in Wien* NF 1 (1928): 141. Amico, *Bernard Palissy*, pp. 86–92.

74. Pomponius Gauricus, *De Sculptura* (ca. 1503), trans. Heinrich Brockhaus (Leipzig: F. A. Brockhaus, 1886), p. 223.

75. Martin Kemp, particularly in "From 'Mimesis' to 'Fantasia': The Quattrocento Vocabulary of Creation, Inspiration and Genius in the Visual Arts," *Viator* 7 (1977): 347–98, writes sensitively about this, esp. p. 395.

76. Carmen C. Bambach, *Drawing and Painting in the Italian Renaissance Workshop: Theory and Practice, 1300–1600* (Cambridge: Cambridge University Press, 1999), p. 33.

77. Dürer, *Vier Bücher*, bk. 4, unpaginated.

78. Lazarus Ercker, *Treatise on Ores and Assaying* (1580 ed., 1st publ. 1574), trans. Anneliese Grünhaldt Sisco and Cyril Stanley Smith (Chicago: University of Chicago Press, 1951), p. 194. Ercker sent his book to the Nuremberg City Council, who honored him with ten gulden in return. They decreed (21 March 1575) that it should first be made available to Wenzel Jamnitzer. Thomas Hampe, *Nürnberger Ratsverlässe über Kunst und Künstler im Zeitalter der Spätgotik und Renaissance*, 15 vols. (Quellenschriften für Kunstgeschichte und Kunsttechnik des Mittelalters und der Neuzeit, NF XI–XII) (Vienna: Karl Graeser, 1904), vol. 2, no. 188, p. 27.

79. Cipriano Piccolpasso, *The Three Books of the Potter's Art* (ca. 1558), 2 vols., trans. Ronald Lightbown and Alan Caiger-Smith (London: Scholar Press, 1980), vol. 2, pp. 6–7. Piccolpasso often simply refers the reader to the expertise of craftspeople, telling the reader, for example, to dig clay where the potters take it (bk. II). Paolo L. Rossi, "Sprezzatura, Patronage, and Fate: Benvenuto Cellini and the World of Words," *Vasari's Florence: Artists and Literati at the Medicean Court*, ed. Philip Jacks (Cambridge: Cambridge University Press, 1998), records the scorn with which artisans were held by the lettered

while at the same time their art was sought out (pp. 60–62). An example from the seventeenth century is in Smith, *The Business of Alchemy*, p. 81.

80. Piccolpasso, *The Three Books*, vol. 2, bk. I, p. 48.

81. Quoted in Bambach, *Drawing and Painting*, p. 33.

82. Ibid., p. 33. Martin Kemp notes that until the first quarter of the fifteenth century, scholars who spoke of the arts assumed that the ingenuity of artisans did not equal that of literary men. Kemp, "From 'Mimesis' to 'Fantasia,'" p. 387.

83. For the following sketch of Paracelsus's life, see Walter Pagel, s.v. "Paracelsus," in *Dictionary of Scientific Biography*, 18 vols., ed. Charles Gillispie, (New York: Scribner, 1970–86), vol. 10, pp. 304–13. The basis of work on Paracelsus remains Walter Pagel, *Paracelsus: An Introduction to Philosophical Medicine in the Era of the Renaissance*, 2nd ed. (Basel: Karger, 1982); and idem, *Das medizinische Weltbild des Paracelsus. Seine Zusammenhänge mit Neuplatonismus und Gnosis* (Wiesbaden: Franz Steiner Verlag, 1962). Recently, Andrew Weeks has turned his attention to Paracelsus's religious texts in *Paracelsus: Speculative Theory and the Crisis of the Early Reformation* (Albany: State University of New York Press, 1997). Paracelsus, particularly his book *Liber de imaginibus*, has been used to understand the artists of his time; for example, see Otto Benesch, *Der Maler Albrecht Altdorfer* (Vienna: Verlag Anton Schroll & Co., 1940), 3rd ed., who compares Paracelsus's statements about colors and chiromancy (judging the inner signs and virtues of people, herbs, wood, landscapes, etc., from their exterior appearance) to the paintings of Albrecht Altdorfer. He finds the *Naturgefühl* of Paracelsus in Altdorfer's paintings. G. F. Hartlaub, "'Paracelsisches' in der Kunst der Paracelsuszeit," *Nova acta Paracelsica* 7 (1954): 132–63, searches for the influence of Paracelsus on the artists of his time, mainly in the esoteric components of Paracelsus's thought. He discusses Benesch's ideas (pp. 144 ff.) and notes, for example, the correspondence of microcosm and macrocosm in Albrecht Altdorfer's *Battle of Alexander at Issus* and *St. John on Patmos* (p. 145). Hartlaub sees the commonalities between Paracelsus and the artists of his time as lying in the Paracelsian-tinged presentation of Christian material, the magical/popular religious elements, the alchemical allusions, the popular beliefs (such as the four temperaments alluded to by Dürer in *Adam and Eve*, the Sabbath depicted by Hans Baldung, the Wildes Heer, and astrological beliefs). Both Hartlaub and Benesch speak about the "correspondences" to be found in Paracelsus and the art of his time, and both see these as lying mainly in the "magical" and "superstitious" elements of Paracelsus's thought. Michael Baxandall, *The Limewood Sculptors of Renaissance Germany* (New Haven: Yale University Press, 1980), has used Paracelsus's ideas to read the work of sculptors in Renaissance Germany, as is treated below.

84. Pagel, *Paracelsus*, p. 23.

85. Paracelsus, *Astronomia Magna: oder die gantze Philosophia sagax der großen und kleinen Welt/ des von Gott hocherleuchten/ erfahrnen/ und bewerten teutschen Philosophi und Medici* (finished 1537/38; 1st publ. 1571), in *Sämtliche Werke. Medizinische, naturwissenschaftliche und philosophische Schriften*, 14 vols., ed. Karl Sudhoff (Munich: Oldenbourg, 1929), vol. 12, p. 11.

86. Ibid., p. 7; Jesus and the saints do not have the light of nature because they were given the light of God, whereas humans can only possess the light of nature (p. 24). Jamnitzer believed that God had given humans a "wonderful light in their body and heart," and had ornamented the human body with two beautiful lights in order to look upon the heavenly bodies and God's Creation and to recognize God as good. Jamnitzer, *Perspectiva*, aiii v.

87. "nun haben aber alle hantwerk der natur nachgegrünt und erfaren ir eigenschaft, das sie wissen in allen iren dingen, der natur nachzufaren und das höchst als in ir ist daraus zubringen." Paracelsus, *Das Buch Paragranum* (1530), in *Sämtliche Werke*, ed. Sudhoff (1927), vol. 8, p. 181. The model for such perfecting of matter for Paracelsus was alchemy, as is discussed below.

88. On this point, see Kurt Goldammer, *Paracelsus: Natur und Offenbarung* (Hanover: Theodor Oppermann Verlag, 1953).

89. "das heimlich zu offenbaren durch des menschen werk, sonder auch alle natürliche mysteria der elementen zu offenbaren, welches one den menschen nit het moegen beschehen. Und got wil, das die ding sichtbar werden, was unsichtbar ist. Solches sol im der mensch hoch und wol fürnemen, das got in darumb beschaffen hat und zu im gesaget: omnia subiecisti ei etc. dieweil nun das got geordnet hat, so wil er das der mensch nicht feire, nicht müssig gang, nicht stilstand, nich saufe, nicht hure und dergleichen, sonder er will, das er in teglicher übung sei, zu erforschen die heimlikeit der nature in allen den gaben, so got in die natur geschaffen hat . . . dan wo wir im liecht der natur nit das volenden, das got durch uns haben wil, es muss ein rechnung darumb gegeben werden am jüngsten tag." Paracelsus, *Astronomia Magna*, p. 59.

90. "one hent und füss, on oren und augen etc. dan durch die augen sehent wir in die natur etc. und sind instrumenta, dadurch wir das volbringen, das in uns ist und uns von got in ein natürlich gab geben, darumb als instrumenten, on die kein weisheit sein mag, sind sie geschaffen." Ibid., p. 55. Oswald Croll, preface to *Basilica Chymica* (1609), echoes this when he writes: "In this ample Machine of the World, in which the Invisible Creator exhibits himself to us to be seen, heard, tasted, smelt, and handled, is nothing else but the shadow of God."

91. Paracelsus, *Astronomia Magna*, pp. 56, 53.

92. Quoted in Pagel, *Paracelsus*, p. 18.

93. Paracelsus, *Die große Wundarznei* (1536), in *Sämtliche Werke*, ed. Sudhoff (1928), vol. 10, p. 19.

94. "künden [koennen] ist mer dan wissen, dan der es kan, der hat es in der übung." Ibid., pp. 210–11. Or, "der nichts kan, der verstehet nichts." Paracelsus, *Das Buch Labyrinthus medicorum genant* (1538, 1st publ. 1553), in *Sämtliche Werke*, ed. Sudhoff (1928), vol. 11, p. 207.

95. Paracelsus, "The Seven Defensiones," in *Four Treatises of Theophrastus von Hohenheim, Called Paracelsus,* trans. C. Lilian Temkin (Baltimore: Johns Hopkins University Press, 1941), "Fourth Defense," p. 29.

96. Paracelsus, *The Generations of the Elements*, in *The Hermetic and Alchemical Writings of Paracelsus*, 2 vols., ed. Arthur Edward Waite (Chicago: Laurence, Scott & Co., 1910), vol. 1, p. 204.

97. "wie kan ein zimerman ein ander buch haben dan sein axt und das holz? Wie kan ein maurer ein ander buch haben als stein und cement? Wie kan dan ein arzt ein ander buch haben, dan eben das buch das die menschen krank und gesunt macht? Es muss ie der verstant aus dem fliessen, aus dem er ist, und das spiegelbilt von demselbigen probirt werden." Paracelsus, *Das Buch Labyrinthus*, p. 177.

98. "sonder es ist ein gewiße kunst und ein warhafte, gleich so fertig als ein zimerman in seim zimern, der muss recht lernen zimern, so kan ers recht, darf keins rat darzu. Kan ers aber nit recht, so ratschlag er all tag und noch wird nichts guts daraus; felt am lezten alles ein." Paracelsus, *Die große Wundarznei*, pp. 21–22.

99. Joyce Pesters and Ashok Roy, "The Materials and Technique: Cennino Cennini's Treatise Illus-

trated," *National Gallery Technical Bulletin* 9 (1985): 26, make this point about woodworkers of the fifteenth and sixteenth centuries.

100. Paracelsus, *Liber de imaginibus*, in *Sämtliche Werke*, ed. Sudhoff (1931), vol. 13, pp. 375–76. I take my translation of this passage in part from Baxandall, *The Limewood Sculptors*, p. 160.

101. Paracelsus, *Liber de imaginibus*, p. 76.

102. Paracelsus, *Astronomia Magna*, pp. 92–93. I use Michael Baxandall's translation in part, although I differ on crucial phrases.

103. "also erkennet der artz die arznei, der astronomus sein astronomei, der schuster sein leder, der weber sein tuch, der zimerman das holz, der hafner den leimen, der bergman das metal." Ibid., p. 176.

104. Paracelsus uses the word "lauschen." Pagel, *Paracelsus*, p. 51. This aspect of his thought has usually been attributed to Neoplatonic influences, but two recent works on Paracelsus have suggested the vernacular nature of his ideas. For example, Stefan Rhein, "'mein bart hat mer erfaren dan alle euer hohe schulen.' Ein Zwischenruf zur Quellenfrage bei Paracelsus," in *Paracelsus. Das Werk—die Rezeption*, ed. Volker Zimmermann (Stuttgart: Franz Steiner Verlag, 1995); and Gundolf Keil, "Mittelalterliche Konzepte in der Medizin des Paracelsus," in ibid.

105. "Das sehen ist alein ein sehen wie ein baur, der ein psalter sicht, sicht alein die buchstaben; da ist weiter nichts mer von im zusagen." Paracelsus, *Das Buch Labyrinthus*, p. 184.

106. "Nun merkent ein underscheit zwischen der experientia und der scientia noch weiter dan gemelt ist. Scientia ist in dem, in dem sie got geben hat, experientia ist ein kuntschaft von dem in dem scientia probirt wird. als der birnbaum der hat sein scientiam in ime und wir, die seine werk sehen haben experientiam seiner scientia. also geben wir kuntschaft durch die experienz, das scientia perfecta im selbigen baum sei. also auf solchs zeig ich das sechts buch an, das in solcher gestalt scientia in euch kome und das euch euere kranken kuntschaft geben durch euere werk, so ir in inen verbracht haben, das ir perfectam scientiam habent. also was volkomen mit einem wissen in rechter ordnung der natur get, dasselbige ist scientia. wo nun die nit ist, das ist alein experimentum oder experientia sine scientia." Ibid., chap. 6, p. 192. Pagel, *Paracelsus*, pp. 51, 218–23, notes the Neoplatonic overtones of this passage, but in this and other essays, he also points out the multiple sources for Paracelsus's work, including popular pantheism, Salomon ibn Gebirol's (1021–1070) notion of "prime matter" (pp. 229–30), and medieval alchemical treatises (pp. 259 ff.). See also Walter Pagel, "Paracelsus and the Neoplatonic and Gnostic Tradition," *Ambix* 8 (1960): 125–68. Barbara Obrist notes that many ideas associated with the Hermetic corpus, such as the correspondence between microcosm and macrocosm and the divine power attributed to humankind, can be found in medieval alchemical treatises. Barbara Obrist, *Les Débuts de l'imagerie alchimique (XIVe–XVe siècle)* (Paris: Editions le Sycomore, 1982), p. 46.

107. Paracelsus also stated that knowledge ("erkantnus") is not in the physician but in nature, as are the disease and the cure. Paracelsus, *Das Buch Paragranum*, p. 140.

108. Paracelsus, *Das Buch Labyrinthus*, p. 193. When Paracelsus uses "experimentum," he probably refers to its use in magic, in which "experiment" meant to effect works through hidden means.

109. Ibid., p. 191.

110. Martin Kemp, ed., *Leonardo on Painting*, trans. Martin Kemp and Margaret Walker (New Haven: Yale University Press, 1989), p. 10.

111. For Leonardo's observation and theorizing about natural processes, see Alexander Perrig, "Leonardo: Die Anatomie der Erde," *Jahrbuch der Hamburger Kunstsammlungen* 25 (1980): 51–80.

112. Paracelsus, *The Generations of the Elements*, in *The Hermetic and Alchemical Writings of Paracelsus*, ed. Waite, vol. 1, p. 208.

113. Kemp, *Leonardo on Painting*, p. 13.

114. It should be noted that although Leonardo expressed these ideas about finding certainty in nature, he also clearly wished to combine mathematics and experience, thus earning himself in later accounts the anachronistic title "scientist."

115. Quoted by David Summers, *The Judgment of Sense: Renaissance Naturalism and the Rise of Aesthetics* (Cambridge: Cambridge University Press, 1987), p. 138.

116. Quoted by Kemp, "From 'Mimesis' to 'Fantasia,'" p. 376.

117. From bk. 3 of *Vier Bücher*; quoted in Panofsky, *The Life and Art of Albrecht Dürer*, pp. 279–80. This passage continues: "Therefore, never put it in thy head that thou couldst or wouldst make something better than God has empowered His created nature to produce. For thy might is powerless against the creation of God. Hence it follows that no man can ever make a beautiful image out of his private imagination unless he have replenished his mind by much painting from life. That can no longer be called private but has become 'art' acquired and gained by study, which germinates, grows and becomes fruitful of its kind. Hence it comes that the stored-up secret treasure of the heart is manifested by the work and the new creature which a man creates in his heart in the shape of a thing. This is the reason an experienced artist needs not copy from life for every picture; for, he sufficiently pours forth what he has stored up from the outside for a long time."

118. Paracelsus, *Astronomia Magna*, p. 92. To read the signs of a person, one studied the *chiromantia*, the outer form of the body, the hands, feet, veins, lines, folds, etc.; the *physionomia*, the face and the whole head; the *substantina*, the form of the whole body; and the *mos et usus*, the manner in which a man presents and holds himself (p. 176).

119. Paracelsus, *Die große Wundarznei*, p. 211. Paracelsus continues that practice is good because a person learns to make a thing so that the work comes out as planned, while experience is good because it teaches how to carry out the work in all situations.

120. Paracelsus, *Astronomia Magna*, p. 24.

121. Paracelsus regarded the Fugger family as the adoptive sons of the stars in commerce, as Dürer was in art. Ibid., pp. 109–10. In Paracelsus, *Die neun Bücher De Natura Rerum* (1537), in *Sämtliche Werke*, ed. Sudhoff, vol. 11, bk. 1, Paracelsus also remarks that a pregnant woman could form her fetus by thinking about a great musician such as Hoffhammer or about a painter such as Dürer.

122. Baxandall, *The Limewood Sculptors*, p. 160.

CHAPTER THREE

1. Paracelsus, *Das Buch Labyrinthus medicorum genant* (1538; 1st publ. 1553), in *Sämtliche Werke. Medizinische, naturwissenschaftliche und philosophische Schriften*, 14 vols., ed. Karl Sudhoff (Munich: R. Oldenbourg, 1928), vol. 11, p. 193.

2. Ibid., p. 191. Paracelsus's use of "*ablernen*" is similar to Dürer's use of "*abmachen*" to mean "reproducing nature from life" and "*abkunterfet*" to mean portraying after life or with verisimilitude.

3. Ernst Gombrich, *Speis der Malerknaben: zu den technischen Grundlagen von Dürers Kunst* (Vienna: WUV-Universitätsverlag, 1997). In his section on fresco, Cennini explains in methodical detail how to achieve the "incarnation" of living persons on the wall through the correct application of gradations of flesh tones. Indeed, Cennini called the rosy flesh tone that differentiated living from dead persons "incarnazione." Christiane Kruse, "Fleisch werden—Fleisch malen: Malerei als 'incarnazione.' Mediale Verfahren des bildwerdens in Libro dell'Arte von Cennino Cennini," *Zeitschrift für Kunstgeschichte* 63 (2000): 314 ff.

4. Cennino d'Andrea Cennini, *The Craftsman's Handbook; the Italian "Il Libro dell'Arte,"* trans. Daniel V. Thompson Jr. (New York: Dover, 1960), pp. 37–38. All subsequent references to this work are made in the text.

5. Cennini notes that "if the person whom you are casting is very important, as in the case of lords, kings, popes, emperors, you mix this plaster with tepid rose water; and for other people a tepid spring or well or river water is good enough." Ibid., p. 126.

6. Carmen C. Bambach, *Drawing and Painting in the Italian Renaissance Workshop: Theory and Practice, 1300–1600* (Cambridge: Cambridge University Press, 1999), p. 86. "good judgment [bono giuditio] is born of good understanding [bene intendere], and good understanding derives from reason expounded through good rules [bone regole], and good rules are the daughters of good experience [bona sperientia], the common mother of all the sciences and arts [scientie e arti]." Leonardo da Vinci, *Codex Atlanticus* (fol. 221 verso d); translated and quoted in Bambach, *Drawing and Painting*, p. 19. On Leonardo, also see Frank Zöllner, "'Ogni Pittore Dipinge Sé': Leonardo da Vinci and 'Automimesis,'" in *Der Künstler über sich in seinem Werk. Internationales Symposium der Bibliotheca Hertziana, Rom, 1989*, ed. Matthias Winner (Weinheim: VCH, Acta Humaniora, 1992), pp. 143–45.

7. David Summers, *The Judgment of Sense: Renaissance Naturalism and the Rise of Aesthetics* (Cambridge: Cambridge University Press, 1987), p. 74.

8. While today "*abmachen*" means to undo, Panofsky translated Dürer's use here as "reproducing nature from life." Erwin Panofsky, *Idea: A Concept in Art Theory*, trans. Joseph J. S. Peake (Columbia: University of South Carolina Press, 1968), pp. 121–26. Dürer's usage was probably closer to the modern "*abschreiben*," or copying verbatim. As noted above, Dürer also used the term "*abkunterfet*" to mean portraying after life or with verisimilitude. Paracelsus used "*ablernen*" to denote the process of learning the *scientia* from the plant itself. Paracelsus, *Das Buch Labyrinthus*, p. 191.

9. Panofsky, *Idea*, pp. 121–26, esp. p. 123, discusses the unique combination in Dürer's writings of contemporary Italian art theory (probably influenced by Neoplatonism) and Dürer's own, what Panofsky calls a "personal" and I would call an "artisanal" vision of his creative process.

10. Bambach, *Drawing and Painting*, p. 130. The apprentice was probably Antonio Mini.

11. Benvenuto Cellini, *The Two Treatises on Goldsmithing and Sculpture*, trans. C. R. Ashbee (New York: Dover, 1967), p. 126, remarks that when a master wants to do a work, he must make a trial of everything—modeling, piece-mold making, and casting. The many trials needed for producing a work also are clear in the accounts of Theophilus and Palissy, treated below.

12. James Elkins, "Michelangelo and the Human Form: His Knowledge and Use of Anatomy," *Art History* 7 (1984): 183–84.

13. See the excellent discussion of Weiditz in David Landau and Peter Parshall, *The Renaissance Print 1470–1550* (New Haven: Yale University Press, 1994), pp. 247–53.

14. Suzanne B. Butters, *The Triumph of Vulcan: Sculptors' Tools, Porphyry, and the Prince in Ducal Florence*, 2 vols. (Florence: Leo S. Olschki, 1996), vol. 1, pp. 286–87; quoting from E. Lucie-Smith, *The Story of Craft: The Craftsman's Role in Society* (Oxford, 1981), p. 85.

15. A. S. Clifton-Taylor and A. Ireson, *English Stone Building* (London, 1983), p. 90.

16. Paracelsus, *Astronomia Magna: oder die gantze Philosophia sagax der großen und kleinen Welt/ des von Gott hocherleuchten/ erfahrnen/ und bewerten teutschen Philosophi und Medici* (1537/38; 1st publ. 1571), in *Sämtliche Werke*, ed. Sudhoff (1929), vol. 12, p. 56. As quoted above: What God creates by the word, a human being creates "mit seinem leib und mit seinen instrumenten" [with his body and his instruments (senses)]. For another view of the meaning of sensory immersion for Paracelsus, see J. R. R. Christie, "The Paracelsian Body," in *Paracelsus: The Man and His Reputation, His Ideas, and Their Transformation*, ed. Ole Peter Grell (Leiden: Brill, 1998).

17. "die [arznei] muss er mit seinem leib in das werk bringen." Paracelsus, *Astronomia Magna*, p. 56.

18. Since the early 1990s, there has been a great resurgence of interest in Palissy. The most important recent works are Frank Lestringant, ed., *Bernard Palissy 1510–1590. L'Écrivain, Le Réformé, Le Céramiste* (Paris: Coédition Association Internationale des Amis d'Agrippa d'Aubigné, 1992); Leonard N. Amico, *Bernard Palissy: In Search of Earthly Paradise* (Paris: Flammarion, 1996); and the recent exhibition catalog *Une Orfèverie de Terre: Bernard Palissy et la Céramique de Saint-Porchaire: Musée National de la Reniassance, Chateau D'Écouen* (Paris: Seuil, 1997).

19. Palissy achieved this verisimilitude by molding these creatures "from life," a process that involved making plaster casts of entire freshly killed animals to form a mold for the clay. See Ernst Kris, "Der Stil 'Rustique': Die Verwendung des Naturabgusses bei Wenzel Jamnitzer und Bernard Palissy," *Jahrbuch der Kunsthistorischen Sammlungen in Wien* NF 1 (1928): 137–207; and, more recently, the extensive archaeological evidence unearthed at the site of Palissy's workshop in Paris, in the issue of *Revue de L'Art* 78 (1987) devoted to Bernard Palissy; and Amico, *Bernard Palissy*, esp. pp. 86–96.

20. Palissy, *Recepte véritable*; quoted in Henry Morley, *Palissy the Potter*, 2nd ed. (London: Chapman and Hall, 1855), pp. 317–18. It is not known if Palissy produced a garden to his design here, and it is not clear if he ever completed a grotto. For a discussion of this thorny question, see Amico, *Bernard Palissy*, chap. 2.

21. See the excellent articles by Horst Bredekamp, "Die Erde als Lebewesen," *Kritische Berichte* 8 (1981): 5–37; and Philippe Morel, "La Théâtralisation de l'alchimie de la nature. Les Grottes artificielles et la culture scientifique à Florence à la fin du XVIe siècle," *Symboles de la Renaissance* 30 (1990): 155–81.

22. Bernard Palissy, *Architecture, et Ordonnance, de la grotte rustique de Monseigneur le Duc de Monmorency, Pair, & Connestable de France*. This treatise was actually an appeal to his patron written from prison on 25 February 1563. Palissy was imprisoned for iconoclasm and blasphemy but set free through the influence of his Catholic patron.

23. The full title of the *Recepte* was Bernard Palissy, *Recepte véritable, par laquelle tous les hommes de France pourront apprendre à multiplier et à augmenter leurs thrésors. Item, ceux qui n'ont saire à tous les habitants de la terre. Item, en*

ce livre est contenu le dessein d'un jardin autant délectable et d'utile invention, qu'il en fut oncques veu. Item, le dessein et ordonnance d'une ville de forteresse, la plus imprenable qu'homme ouyt jamais parler: composé par maistre Bernard Palissy, ouurier de terre, et inventeur des rustiques figulines du Roy, et de monseigneur le Duc de Montmorency, pair et connestable de France; demeurant en la ville de Xaintes (La Rochelle: Barthélémy Berton, 1563). A persuasive view of Palissy's work as a response to the agricultural crisis and the onset of civil war can be found in Henry Heller, *The Conquest of Poverty: The Calvinist Revolt in Sixteenth-Century France* (Leiden: E. J. Brill, 1986); and idem, *Labour, Science and Technology in France 1500–1620* (Cambridge: Cambridge University Press, 1996).

24. Charles Estienne and Jean Liébault, *Maison rustique, or the countrie farme* (English translation, 1600), p. 1; quoted in Catharine Randall, *Building Codes: The Aesthetics of Calvinism in Early Modern Europe* (Philadelphia: University of Pennsylvania Press, 1999), p. 53.

25. See Alexander Bruno Hanschmann, *Bernard Palissy der Kunstler, Naturforscher und Schriftsteller* (Leipzig: Dieterich'sche Verlagsbuchhandlung, 1903); and Thomas Clifford Allbutt, "Palissy, Bacon, and the Revival of Natural Science," *Proceedings of the British Academy* (1913–14): 234–47. For a modification of this view, see Wallace Kirsop, "The Legend of Bernard Palissy," *Ambix* 9 (1961): 136–54; and H. R. Thompson, "The Geographical and Geological Observations of Bernard Palissy the Potter," *Annals of Science* 10 (1954): 149–65. Lectures for Parisian apothecaries, for example, focusing on preparations in the laboratory had existed from at least the sixteenth century and would be followed by Jean Beguin's (ca. 1550–ca. 1620) lectures of the early seventeenth century. Charles Bedel, "L'Enseignement des sciences pharmaceutiques," in *Ensignement et diffusion des sciences en France au XVIIIe siècle*, ed. René Taton (Paris: Hermann, 1964), p. 238.

26. "In proving my written reasons, I satisfy sight, hearing, and touch." Bernard Palissy, *The Admirable Discourses* (1580), trans. Aurele la Rocque (Urbana: University of Illinois Press, 1957), p. 27.

27. On salts, see ibid., p. 130; on generative waters, pp. 104–6. Palissy believed that the crystalline water of which eyeglasses, rock crystals, and mirrors were made had some affinity with the generative waters (p. 106).

28. The following dialogue is from ibid., pp. 188–203. Neil D. Kamil, "War, Natural Philosophy and the Metaphysical Foundations of Artisanal Thought in an American Mid-Atlantic Colony: La Rochelle, New York City, and the Southwestern Huguenot Paradigm, 1517–1730" (Ph.D. diss., Johns Hopkins University, 1988), makes a brilliant reading of Palissy's labors to produce the white glaze. I first encountered this passage from Palissy in Kamil's work, and I am grateful to him for allowing me to see his dissertation.

29. Paracelsus, too, said that when someone looks on at a carpenter working wood, he thinks he can do it as well, but for every correct stroke that onlooker would make, he would make a hundred false ones, for he does not have the experience. Paracelsus, *Die große Wundarznei* (1536), in *Sämtliche Werke*, ed. Sudhoff (1928), vol. 10, p. 210.

30. In Kamil's view, the artisan also underwent an internal religious experience as he labored: "The Paracelsian artisan, exploiting his special transformational relationship with materials, could . . . experience a spiritual rebirth every time he performed artisanry to externalize his internal millennial event." Kamil, "War, Natural Philosophy and the Metaphysical Foundations," p. 450.

31. Cellini, *The Two Treatises*, p. 123. In recounting the casting of another work, Cellini again emphasizes his ability to resuscitate the dead: "Owing to my thorough knowledge of the art I was here again able to bring a dead thing [un morto] to life" (p. 125).

32. Benvenuto Cellini, *Autobiography*, trans. George Bull (London: Penguin, 1956), pp. 343–48.

33. Quoted in Michael Cole, "Cellini's Blood," *Art Bulletin* 81 (1999): 215. Cole discusses the various significance that blood could have possessed for Cellini. A discussion of a rather different sort can be found in Piero Camporesi, *Juice of Life: The Symbolic and Magic Significance of Blood*, trans. Robert R. Barr (New York: Continuum, 1995). An anonymous German collection of alchemical recipes from the fifteenth or sixteenth century includes a recipe for producing the philosophers' stone from human blood. Alchemical Ms. GER 1472, Edelstein Collection, Hebrew University, fol. Lxxxiiii recto.

34. Perhaps for Cellini, the process even mimicked the preparation of an elixir of life. Cole, "Cellini's Blood," pp. 222–25.

35. Elisabeth Dalucas, "Ars erit Archetypus Naturae. Zur Ikonologie der Bronze in der Renaissance," in *Von Allen Seiten Schön. Bronzen der Renaissance und des Barock*, ed. Volker Krahn, Katalog zur Ausstellung der Skulpturensammlung der Staatlichen Museen zu Berlin—Preußischer Kulturbesitz im Alten Museum, Berlin (Heidelberg: Edition Braus, 1995), p. 72. Dalucas argues in this fine article that because bronze is an alloy invented by humans, it brings to a head the question of the relationship between art and nature. Cellini's *Perseus* proved to his contemporaries that nature could be mastered by art, as indicated in the contemporary poem in honor of the statue: "Natura Artis erat; sed postquam Persea fudit / Cellinus, Naturae Ars erit archetypus" [Nature possessed art, but after Cellini cast the Perseus, art became the model for nature] (quoted on p. 81). Benvenuto Cellini maintains that "la practica" served an artisan up to a certain point, but in order to know how to react to something unexpected, one had to possess a "deeper knowledge of the principles of the art." The example of these deeper principles he offers was his knowledge that a damp furnace gave off fumes from the earth that would prevent a metal from melting. Cellini contrasts this to the belief of an old experienced artisan with whom he was working that a devil in the furnace had caused the metal to curdle. Cellini, *The Two Treatises*, p. 130.

36. Francesca G. Bewer, "The Sculpture of Adriaen de Vries: A Technical Study," in *Small Bronzes in the Renaissance*, ed. Debra Pincus (Washington, D.C.: Center for Advanced Study in the Visual Arts, 2001), pp. 180, 182.

37. I follow the excellent treatment of this statue in Frits Scholten, ed., *Adriaen de Vries (1556–1626), Imperial Sculptor* (Zwolle: Waanders, 1998), pp. 201–5. See also Francesca Bewer, "'Kunststück von gegossenem Metall': Adriaen de Vries's Bronze Technique," in ibid.; and Bewer, "The Sculpture of Adriaen de Vries."

38. Karel van Mander, *The Lives of the Illustrious Netherlandish and German Painters from the First Edition of the Schilder-boeck (1603–04)*, 5 vols., trans. and ed. Hessel Miedema (Doornspijk: Davaco, 1994), vol. 1, p. 190. In addition to van Mander, other writers such as Abraham Ortelius equated Brueghel's ability to create to nature itself. A recent introduction to the humanistic background to such comments is provided by Tanja Michalsky, "Imitation und Imagination. Die Landschaft Pieter Bruegels d. Ä.

im Blick der Humanisten," in *Künste und Natur in Diskursen der Frühen Neuzeit*, 2 vols., ed. Hartmut Laufhütte (Wiesbaden: Harrassowitz Verlag, 2000), vol. 1.

39. "Huius ego imitator desiderans fore, apprehendi atrium agiae Sophiae conspicorque cellulam diuersorum colorum omnimoda uarietate refertam et monstrantem singulorum utilitatem ac naturam. Quo mox inobseruato pede ingressus, replui armariolum cordis mei sufficienter ex omnibus, quae diligenti experientia singillatim perscrutatus, cuncta uisu manibusque probata satis lucide tuo studio commendaui absque inuidia. Verum quoniam huiusmodi picturae usus perspicax non ualet esse, quasi curiosus explorator omnimodis elaboraui cognoscere, quo artis ingenio et colorum uarietas opus decoraret, et lucem diei solisque radios non repelleret. Huic exercitio dans operam uitri naturam comprehendo, eiusque solius usu et uarietate id effici posse considero; quod artificium, sicut uisu et auditu didici, studio tuo indagare curaui." Theophilus, *The Various Arts*, ed. and trans. C. R. Dodwell (Oxford: Clarendon Press, 1986), p. 37. I used the translation of this passage made by John G. Hawthorne and Cyril Stanley Smith in Theophilus [possibly Roger of Helmarshausen], *On Divers Arts* (Chicago: University of Chicago Press, 1963), p. 47; and I added the Latin to make Theophilus's interesting choice of words clear.

40. Svetlana Alpers, *The Making of Rubens* (New Haven: Yale University Press, 1995), chap. 3. Another example of the metaphoric use of women's fertility to symbolize male poetic creativity can be found in Katharine Eisaman Maus, "A Womb of His Own: Male Renaissance Poets in the Female Body," in *Sexuality and Gender in Early Modern Europe: Institutions, Texts, Images*, ed. James Grantham Turner (Cambridge: Cambridge University Press, 1993). Charles Dempsey discusses similar issues in "Mavors armipotens: The Poetics of Self-Representation in Poussin's 'Mars and Venus,'" in *Der Künstler uber sich in seinem Werk. Internationales Symposium der Bibliotheca Hertziana, Rom, 1989*, ed. Matthias Winner (Weinheim: VCH, Acta Humaniora, 1992). An example of engaging with matter contemporaneous with Rubens is Rembrandt van Rijn's radical and laborious reworking of the plates of his prints *Christ Presented to the People* (1655) and *The Three Crosses* (ca. 1654). Peter Parshall notes that it seems as if Rembrandt needed to engage with the image's matrix itself in order to come to a new conceptualization of the subject. Peter Parshall, "Unfinished Business: The Problem of Resolution in Printmaking," in *The Unfinished Print*, exhibition catalog (Washington, D.C.: National Gallery of Art, 2001), p. 25.

41. Erwin Panofsky, *The Life and Art of Albrecht Dürer* (Princeton: Princeton University Press: 1955), p. 243. Panofsky is here commenting on the principle, new in the Renaissance, that a work of art should be a faithful representation of a natural object. He says, "Treatises on sculpture and painting, therefore, could no longer be limited to supplying generally accepted patterns and recipes but had to equip the artist for his individual struggle with reality."

42. By the fifteenth century, painters could already buy some of these products ready-made from apothecaries, friars, spice and other merchants, as Anabel Thomas, *The Painter's Practice in Renaissance Tuscany* (Cambridge: Cambridge University Press, 1995), chap. 6, makes clear. Thomas concludes that workshop practices were fairly static from the early fourteenth until the late fifteenth century; however, by the sixteenth century, such things as buying colored paper ready-made, rather than having to spend days in preparing the drawing surface, probably changed attitudes toward drawing, for

example (pp. 180–81). By the late sixteenth century, at least in Genoa, apprenticeships had become socially stratified, with the lower-status boys (*giovani accartati*) doing more menial labor, while those of higher status (*sotto padre*) concentrated on drawing and were freed from servants' work, such as drawing water, running errands, and grinding colors. Peter M. Lukehart, "Delineating the Genoese Studio: giovani accartati or sotto padre?" in *The Artist's Workshop*, ed. Peter M. Lukehart (Studies in the History of Art, 38, Center for Advanced Study in the Visual Arts, Symposium Papers XXII, National Gallery of Art, Washington) (Hanover: University Press of New England, 1993). The new academies set up in Italy, by the Carracci brothers, for example, changed the institutional structures of teaching artists. See Gail Feigenbaum, "Practice in the Carracci Academy," in *The Artist's Workshop*, ed. Lukehart. For a thorough discussion of materials in seventeenth-century painting, see Arie Wallert, ed., *Still Lifes: Techniques and Style* (Zwolle: Waanders, 1999).

43. Cennini, *The Craftsman's Handbook*, p. 4.

44. Cellini, *The Two Treatises*, p. 113.

45. Arie Wallert, "Makers, Materials and Manufacture," in *Netherlandish Art in the Rijksmuseum 1400–1600* (Amsterdam: Waanders, 2000), p. 266.

46. Cellini, *The Two Treatises*, p. 18.

47. Quoted in Cole, "Cellini's Blood," p. 225. Michelangelo's sonnets 5 and 267 are stark in their consciousness of the body. In sonnets 152 and 153, he draws an analogy between the processes of sculpting, casting, and physical love. Michelangelo insisted on the physical character of the skill that made his art possible, as noted in Summers, *The Judgment of Sense*, p. 263.

48. Theophilus, *On Divers Arts*, p. 115. Cennini, *The Craftsman's Handbook*, also used saliva; for example, see p. 4.

49. Theophilus, *On Divers Arts*, p. 95. Butters, *The Triumph of Vulcan*, vol. 1, p. 284, comments on the "bewildering variety of ingredients, from faith in Jesus Christ to worms. . . ."

50. Cellini, *The Two Treatises*, p. 57. Other instances of urine in processes are on pp. 68, 98. Cellini also claimed that he mixed urine with brick dust to use as ink while he was imprisoned. Cellini, *Autobiography*, p. 233.

51. Cennini, *The Craftsman's Handbook*, p. 38.

52. Ibid., p. 72.

53. As indicated by the purchases made by Christoph Fugger in the making of the Resurrection altar by Hubert Gerhard. Michael Baxandall, "Hubert Gerhard and the Altar of Christoph Fugger: The Sculpture and Its Making," *Münchner Jahrbuch der bildenden Kunst*, ser. 3, vol. 17 (1966): pp. 140, 143 n. 63.

54. Bambach, *Drawing and Painting*, pp. 49–50, 80.

55. Cennini, *The Craftsman's Handbook*, pp. 97–98.

56. Cellini, *The Two Treatises*, p. 117.

57. Cennini, *The Craftsman's Handbook*, p. 94. See also Joyce Plesters and Roy Ashok, "The Materials and Technique: Cennino Cennini's Treatise Illustrated," *National Gallery Technical Bulletin* 9 (1985): 34.

58. Mummy was supposedly composed from parts of mummies imported from Egypt. Rosamond D. Harley, *Artists' Pigments c. 1600–1835: A Study in English Documentary Sources* (London: Butterworth & Co.,

1970), p. 142. According to Harley, "pigmentum" was a term for both drugs and artists' pigments (p. 8). Although Cennini regarded orpiment yellow as poisonous to humans, warning his readers to "beware of soiling your mouth with it," he claimed that it was a prophylactic against certain diseases contracted by sparrow hawks. Cennini, *The Craftsman's Handbook*, p. 29.

59. Quoted in Johannes Alexander van de Graaf, *Het De Mayerne Manuscript als Bron voor de Schildertechniek van de Barok* (Mijdrecht: Drukkerij Verweij, 1958), p. 168.

60. Palissy, *The Admirable Discourses*, p. 224.

61. Cipriano Piccolpasso, *The Three Books of the Potter's Art* (ca. 1558), 2 vols., trans. Ronald Lightbown and Alan Caiger-Smith (London: Scholar Press, 1980), vol. 2, bk. 1, p. 46.

62. For example, Cennini, *The Craftsman's Handbook*, p. 130.

63. The seventeenth-century Pekstok papers in Amsterdam include instructions and recipes for pigments, including vermilion, and also recipes for vinegars, brandies, and for medicines to cure fevers, the stone, and other sicknesses. Amsterdam Gemeentearchief, #N 90.23. See also A. F. E. van Schendel, "Manufacture of Vermilion in 17th-Century Amsterdam, The Pekstok Papers," *Studies in Conservation* 17 (1972): 70–82.

64. Cellini, *The Two Treatises*, pp. 95, 104.

65. Jacques van Lennep, *Alchemie. Bijdrage tot de geschiedenis van de alchemistische kunst* (Brussels: Gemeentekrediet, 1984), p. 296. James R. Farr, *Artisans in Europe 1300–1914* (Cambridge: Cambridge University Press, 2000), pp. 128–37, discusses the physical labor and infirmities suffered by craftsmen.

66. Robert Barclay, *The Art of the Trumpet-Maker* (Oxford: Clarendon Press, 1992), p. 100. The metalworker Theophilus advised against applying gilding when hungry. Paracelsus and Georgius Agricola also recommended butter against poisoning by mercury and lead fumes. See Baxandall, "Hubert Gerhard," p. 144 n. 64. In the detailed instructions for making vermilion in the Pekstok papers, the artisan is advised to "eat a thick piece of bread and butter" before "roasting the cinnabar" (actually mixing the mercury and sulfur together—cinnabar is the naturally occurring mineral counterpart to the vermilion synthesized from mercury and sulfur). During the process, the worker is advised to allow the smoke from the burning quicksilver and sulfur to become "as thick as possible" before extinguishing the flames. Such fumes would be quite poisonous. Schendel, "Manufacture of Vermilion," pp. 77–78.

67. Martin Kemp, "From 'Mimesis' to 'Fantasia': The Quattrocento Vocabulary of Creation, Inspiration and Genius in the Visual Arts," *Viator* 7 (1977): 370. Filarete's "precocious Neoplatonism," to which Kemp refers on p. 373, may be due as much to Filarete's attempt to articulate an artisanal epistemology as to his conversations with Francesco Filelfo.

68. Ibid., pp. 381, 397. Leonardo also used verbs such as "*fingere*" and "*figurare*," associated with fantasia. Kemp points out that Leonardo never felt there was "any possible conflict between the artist's inventiveness and the guiding principle of his art, namely the imitation of nature" (p. 381).

69. Walter S. Melion, "Love and Artisanship in Hendrick Goltzius's *Venus, Bacchus and Ceres* of 1606," *Art History* 16 (1993): 70.

70. "*Speis*" also denotes the molten metal used in casting, for example, in bell founding. Dürer's outline for the painter's manual was made in 1513. Later, of course, he changed the title to *Underweysung der Messung*. Gombrich, *Speis der Malerknaben*, p. 13.

71. Paracelsus, *Die große Wundarznei*, p. 225.

72. Lazarus Ercker, *Treatise on Ores and Assaying* (1580 ed.; first publ. 1574), trans. Anneliese Grünhaldt Sisco and Cyril Stanley Smith (Chicago: University of Chicago Press, 1951), p. 289.

73. Sounding out gold reminds us of the meanings attached to the materials themselves, for example, "speaking is silver, silence is golden." See Thomas Raff, *Die Sprache der Materialien. Anleitung zu einer Ikonologie der Werkstoffe* (Kunstwissenschaftliche Studien, vol. 61) (n.p.: Deutscher Kunstverlag, 1994), p. 61.

74. Palissy, "The Main Maxims," appended by Palissy to the *Admirable Discourses*, pp. 247–48.

75. Caroline Walker Bynum, *Fragmentation and Redemption: Essays on Gender and the Human Body in Medieval Religion* (New York: Zone Books, 1992), chap. 7. People saw "matter as pregnant, yearning stuff, filled with potential" (p. 256).

76. Michael Baxandall, *The Limewood Sculptors of Renaissance Germany* (New Haven: Yale University Press, 1980), p. 37, makes this point about the demands of carving limewood, a softer wood than oak but one that demands greater judgment of the physical idiosyncrasies of the wood. Paolo Rossi, *Philosophy, Technology, and the Arts in the Early Modern Era* (New York: Harper & Row, 1970), p. 62, comments on the material meaning of the mechanic's judgment. In a study of modern blacksmiths, Charles and Janet Dixon Keller comment that practical action of any sort must respond to the contingencies of the physical *and* social world: "Knowledge as organized for a particular task can never be sufficiently detailed, sufficiently precise, to anticipate exactly the conditions or results of actions. Action is never totally controlled by the actor but influenced by the vagaries of the physical and social world. Thus, in any given instance, knowledge is continually being refined, enriched, or completely revised by experience." Charles Keller and Janet Dixon Keller, "Thinking and Acting with Iron," in *Understanding Practice: Perspectives on Activity and Context*, ed. Seth Chaiklin and Jean Lave (Cambridge: Cambridge University Press, 1993), p. 127.

77. This runs contrary to ideas about naturalism resulting from an increased "objectification" of nature.

78. Otto Pächt, "Early Italian Nature Studies and the Early Calendar Landscape," *Journal of the Warburg and Courtauld Institutes* 13 (1950): 21–22.

79. Aristotle, *Poetics*, 1448b, 10–12; quoted in Michael Baxandall, "Guarino, Pisanello and Manuel Chrysoloras," *Journal of the Warburg and Courtauld Institutes* 28 (1965): 190. Cennini states that irrational animals have no system of proportion, thus the artist should "copy them and draw as much as you can from nature." According to Cennini, women, too, did not have any set proportion (pp. 48–49). Joanna Woods-Marsden, "'Draw the irrational animals as often as you can from life': Cennino Cennini, Giovannino de' Grassi, and Antonio Pisanello," *Studi di storia dell'arte* 3 (1992): 67–78, argues that Cennini was codifying northern Italian painters' practices when he recommended drawing the irrational animals, and that this practice led to a closer observation of nature and an ambition to give a greater sense of vitality to their drawings.

80. Marjorie Lee Hendrix, "Joris Hoefnagel and the 'Four Elements': A Study in Sixteenth-Century Nature Painting" (Ph.D. diss., Princeton University, 1984), pp. 215–62, esp. p. 219 n. 9; Psalm 145:5 at folio 6; Thomas DaCosta Kaufmann and Virginia Roehrig Kaufmann, "The Sanctification of Nature: Observations on the Origins of Trompe L'Oeil in Netherlandish Book Painting of the Fifteenth and Sixteenth Centuries," *J. Paul Getty Museum Journal* 19 (1991): 43–64. See also Marjorie Lee

Hendrix, "Of Hirsutes and Insects: Joris Hoefnagel and the Art of the Wondrous," *Word & Image* 11 (1995): 373–90, a fascinating exploration of the way in which Hoefnagel himself may have developed his own identity through his elevation of insects to the supreme example of nature's (and God's) wondrousness (see esp. p. 382).

81. *De Albums van Anselmus de Boodt (1550–1632). Geschilderde natuurobservatie an het Hof van Rudolf II te Praag* (Belgium: Lannoo, 1989), p. 75.

82. Paracelsus, *Die neun Bücher De Natura Rerum* (1537), in *Sämtliche Werke*, ed. Sudhoff (1928), vol. 11, bk. 1, p. 314.

83. Colin Eisler, *Dürer's Animals* (Washington, D.C.: Smithsonian Institution Press, 1991), p. 130.

84. Robert Koch, "The Salamander in Van der Goes' Garden of Eden," *Journal of the Warburg and Courtauld Institutes* 28 (1965): 323–26; also T. H. White, *The Bestiary: A Book of Beasts* (New York: Putnam's, 1960), pp. 182–84.

85. Cellini, *Autobiography*, p. 20.

86. *From Schongauer to Holbein: Master Drawings from Basel and Berlin* (Washington, D.C.: National Gallery of Art, Hatje Cantz Publishers, 1999), pp. 39–42.

87. Hartmut Krohm and Jan Nicolaisen, *Martin Schongauer. Druckgraphik* (Berlin: Staatliche Museen Preußischer Kulturbesitz, 1991), pp. 83–84. For the identification of the Tree of Life as a derivation of the exotic dragon tree, see Robert Koch, "Schongauer's Dragon Tree," Tribute to Wolfgang Stechow, ed. Walter Strauss, *Print Review* 5 (1976): 114–19; also Götz Pochat, *Der Exotismus während des Mittelalters und der Renaissance* (Stockholm: Almqvist & Wiksell, 1970), pp. 118–36. It may be significant that the sap from the dragon tree, which resembled blood, was used to stop the flow of blood and also as an ingredient in printing ink. Eisler, *Dürer's Animals*, p. 133. Could Schongauer and Dürer, both extremely skilled printmakers, have been alluding to their creative powers in printmaking by reference to the sap of a tree that had connections both to blood and to ink?

88. These events caused Paracelsus's strong disapproval of the abuses to which images could be subject (although he continued to believe that images had an important function in worship). He recounted that the priests in Regensburg filled the hollow head of an image of Mary with oil so that it ran out from her eyes and made it seem as if she were weeping. According to Paracelsus, the priests told the common people that she was mourning the great sins of humankind. Paracelsus, *Liber de imaginibus*, in *Sämtliche Werke*, ed. Sudhoff (1931), vol. 13, p. 365.

89. Christopher S. Wood, *Albrecht Altdorfer and the Origins of Landscape* (Chicago: University of Chicago Press, 1993), argues that the independent landscape was born of the intrusion of the German artist's personal authority into his works (p. 63). Like Dürer, Altdorfer was articulating his social position and, I would add, his knowledge and beliefs about nature, as well as his mode of working. Larry Silver, "Forest Primeval: Albrecht Altdorfer and the German Wilderness Landscape," *Simiolus* 13 (1982–83): 4–43, makes a brilliant argument about the roots of the Danube school, and Simon Schama has extended his themes somewhat in *Landscape and Memory* (New York: Knopf, 1995). See also Larry Silver, "Germanic Patriotism in the Age of Dürer," in *Dürer and His Culture*, ed. Dagmar Eichberger and Charles Zika (Cambridge: Cambridge University Press, 1998).

90. Larry Silver has examined some of these issues in Altdorfer's paintings in "Nature and Nature's God: Landscape and Cosmos of Albrecht Altdorfer," *Art Bulletin* 81 (1999): 194–214; and Larry Sil-

ver and I have examined this painting at more length in "Splendor in the Grass: The Powers of Art and Nature in the Age of Dürer," in *Merchants and Marvels: Commerce, Science, and Art in Early Modern Europe*, ed. Pamela H. Smith and Paula Findlen (New York: Routledge, 2002). I am grateful to Larry Silver for his insights about Altdorfer's paintings.

91. White, *The Bestiary*, pp. 125–28; Herbert Kessler, "The Solitary Bird in Van der Goes' Garden of Eden," *Journal of the Warburg and Courtauld Institutes* 28 (1965): 326–29. Transformation is also indicated by the arrows in Cupid's hands, one sharp, one blunt, referring to the respective shafts that were shot into both Apollo and Daphne, as recounted by Ovid (*Metamorphoses* I, 446–52).

92. Carol Purtle, *The Marian Paintings of Jan van Eyck* (Princeton: Princeton University Press, 1982), pp. 157–67; Larry Silver, "Fountain and Source: A Rediscovered Eyckian Icon," *Pantheon* 41 (1983): 95–104.

CHAPTER FOUR

1. Larry Silver treats this painting in "Nature and Nature's God: Landscape and Cosmos of Albrecht Altdorfer," *Art Bulletin* 81 (1999): 194–214; and in Larry Silver and Pamela H. Smith, "Splendor in the Grass: The Powers of Art and Nature in the Age of Dürer," in *Merchants and Marvels: Commerce, Science, and Art in Early Modern Europe*, ed. Pamela H. Smith and Paula Findlen (New York: Routledge, 2002). G. F. Hartlaub, "Albrecht Dürers 'Aberglaube,'" *Zeitschrift des deutschen Vereins für Kunstwissenschaft* 7 (1940): 183–84, asserts that the egg might well be "an alchemical image of the 'philosopher's egg,' that egg-shaped vessel for thought and matter." Hartlaub claims that the Altdorfer fountain in the Berlin painting represents the "bath of Mary" (*balneum Mariae*), which corresponds to alchemical writings that discuss distillation as an act of purification, akin to the rite of baptism. In G. F. Hartlaub, "'Paracelsisches' in der Kunst der Paracelsuszeit," *Nova acta Paracelsica* 7 (1954): 149–50, Hartlaub develops these ideas, viewing the god as signifying Saturn and the winged egg as Mercury, and the whole representing the chemical potential of the unification of Saturn (sulfur) and Mercury.

2. For "luting," Cellini used horse dung, iron filings, and brick dust in equal proportions, mixed up with an egg yolk. Benvenuto Cellini, *The Two Treatises on Goldsmithing and Sculpture*, trans. C. R. Ashbee (New York: Dover, 1967), p. 106.

3. Maurizio Calvesi, *La melencolia di Albrecht Dürer* (Turin: G. Einaudi, 1993). See also Laura Testa, "La Melencolia di Dürer e l'alchimi," *Storia dell'arte* 73 (1991): 280–96.

4. See the lucid explanation of these processes in Lawrence M. Principe, "Arbeitsmethoden," in *Alchemie. Lexicon einer hermetischen Wissenschaft*, ed. Claus Priesner and Karin Figala (Munich: C. H. Beck, 1998), pp. 51–57.

5. On the diffusion of alchemical works, see Michela Pereira, "Alchemy and the Use of Vernacular Languages in the Late Middle Ages," *Speculum* 74 (1999): 336–56; and Rudolf Hirsch, "The Invention of Printing and the Diffusion of Alchemical and Chemical Knowledge," *Chymia* 3 (1950): 115–41. Laurinda S. Dixon, "Bosch's Garden of Delights Triptych: Remnants of a 'Fossil' Science," *Art Bulletin* 63 (1981): 96–113, includes an appendix of alchemical and pharmaceutical books printed between 1460–1515 (p. 113).

6. A connection also existed between Christ and the image of the sun in Dürer's engraving *Sol Justitiae* (ca. 1500), where the judging God rides upon a lion.

7. H. J. Sheppard, "Egg Symbolism in Alchemy," *Ambix* 6 (1958): 144. See also Millard Meiss, "Ovum Struthionis: Symbol and Allusion in Piero della Francesca's Montefeltro Altarpiece," in *The Painter's Choice: Problems in the Interpretation of Renaissance Art* (New York: Harper & Row, 1976). Barbara Obrist, *Les Débuts de l'imagerie alchimique (XIVe–XVe siècle)* (Paris: Editions le Sycomore, 1982), p. 225, discusses some of the earliest egg imagery in alchemical manuscripts.

8. "Splendor Solis," Hs. Cod. 78 D3, Berlin Kupferstichkabinett, 1531–32. A later copy of this manuscript exists in the British Library. This manuscript employs a framing device to separate the world of nature from the allegorical representation of the processes being described in the text. When the illuminator depicted scenes of "daily life," he did not use the framing device. The portrayal of alchemical processes located in scenes of nature perhaps reinforced the message of this text that alchemy is an art that follows the processes of nature.

9. See the work of Allen G. Debus, B. J. T. Dobbs, and, briefly, E. J. Holmyard, *Alchemy* (1957) (reprint, New York: Dover, 1990); and John M. Stillman, *The Story of Alchemy and Early Chemistry* (1924) (reprint, New York: Dover, 1960). In the sixteenth century, Paracelsus added a third principle—salt—to sulfur and mercury, probably reflecting the importance of the production of salts beginning in the fourteenth century. Gunpowder, saltpeter (from which fertilizer was produced), and the preservative properties of common salt came to have increasing importance in the fourteenth and fifteenth centuries.

10. For an excellent discussion of the significance of mercury in alchemical theory, see Karin Figala, s.v. "Quecksilber," in *Alchemie*, ed. Priesner and Figala, pp. 295–300; see B. J. T. Dobbs, *The Foundations of Newton's Alchemy* (Cambridge: Cambridge University Press, 1975), pp. 35–37, for the matter-spirit problem in alchemy.

11. Figala, "Quecksilber," in *Alchemie*, ed. Priesner and Figala, p. 298.

12. "Hie ist geboren Solis und Lüne kindt / Desgleichen nyemant auf Erden findt / Und in die weldt doch gern erkhennt / Mercurius philosophorum ist er gennent."

13. Dobbs, *The Foundations of Newton's Alchemy*, pp. 184–85.

14. G. F. Hartlaub, "Albrecht Dürer's 'Aberglaube'"; and idem, "Arcana artis. Spuren alchemistischer Symbolik in der Kunst des 16. Jahrhunderts," *Zeitschrift für Kunstgeschichte* 6 (1937): 289–324, interprets Dürer's alchemical imagery as the manifestation of the workings of a universal human subconscious. Rudolf and Margot Wittkower, *Born under Saturn: The Character and Conduct of Artists* (New York: W. W. Norton, 1963), discuss artists interested in alchemy. Alchemy was associated with Saturn and melancholy. For other discussions of some of the connections between art and alchemy, see Arturo Schwarz, ed., *Arte e Alchimia: XLII Esposizione Internazionale d'Arte: La Biennale di Venezia* (Venice: Realizzazione, Electa, 1986); Gareth Roberts, *The Mirror of Alchemy: Alchemical Ideas and Images in Manuscripts and Books from Antiquity to the Seventeenth Century* (London: British Library Press, 1994); and Maurizio Fagiolo Dell'Arco, *Il Parmigianino. Un saggio sull'ermetismo nel Cinquecento* (Rome: M. Bulzoni, 1970). The classic analysis of alchemical imagery remains Barbara Obrist's *Les Débuts de l'imagerie alchimique*. James Elkins and Didier Kahn have recently debated the value of such research: James Elkins, "On

the Unimportance of Alchemy in Western Painting," *Konsthistorisk tidskrift* 1, nos. 1–2 (1992): 21–26; and idem, "Reply to Didier Kahn: What Is Alchemical History?" *Konsthistorisk tidskrift* 64, no. 1 (1995): 51–53; Didier Kahn, "A Propos de l'article de James Elkins: On the Unimportance of Alchemy in Western Painting," *Konsthistorisk tidskrift* 64, no. 1 (1995): 47–51.

15. Pieter Brueghel the Elder also produced one of the most widely disseminated images of the alchemist: *The Alchemist in the Peasant's Kitchen*. Alchemy had two faces throughout the early modern period: on the one hand, it was viewed as a vain and foolish search for gold, about which Petrarch and Erasmus moralized, and, on the other hand, it constituted an esoteric and exoteric search for the principles of nature. The predominant image of the alchemist for artists in northern Europe appears to have been formed by Sebastian Brandt's 1494 depiction of the foolish alchemist in his *Narrenschiff* (that may well have been illustrated by Dürer) and Pieter Brueghel the Elder's sixteenth-century engraving of *The Alchemist in the Peasant's Kitchen*. At the same time, an esoteric tradition of alchemical illustration was fully developed by the mid-sixteenth century, perhaps most famously embodied in Michael Maier's *Atalanta fugiens* (1617). For a concise discussion of these two traditions, see Thomas DaCosta Kaufmann, "Kunst und Alchemie," in *Moritz der Gelehrte. Ein Renaissancefürst in Europa*, ed. Heiner Borggrefe, Thomas Fusenig, and Anne Schunicht-Rawe (Eurasburg: Edition Minerva, 1997).

16. Quoted in Jacques van Lennep, *Alchemie. Bijdrage tot de geschiedenis van de alchemistische kunst* (Brussels: Gemeentekrediet, 1984), p. 356. On the use of *Decknamen* in alchemy, see William Newman, *Gehennical Fire: The Lives of George Starkey, an American Alchemist in the Scientific Revolution* (Cambridge: Harvard University Press, 1994).

17. Lennep, *Alchemie*, pp. 357–58.

18. Ibid., p. 325.

19. *La Tourbe des philosophes* (Paris, 1683), p. 34; quoted in Laurinda S. Dixon, "Bosch's Garden of Delights Triptych," p. 107. See also idem, *Alchemical Imagery in Bosch's Garden of Delights* (Ann Arbor: UMI Research Press, 1981).

20. Dixon, *Alchemical Imagery*, pp. 22–23.

21. Quoted in Joseph Leo Koerner, "Hieronymus Bosch's World Picture," in *Picturing Science, Producing Art*, ed. Caroline A. Jones and Peter Galison (New York: Routledge, 1998), p. 304.

22. Skepticism on ibid., p. 305. He does not cite Dixon's work.

23. The extreme polyvalence of alchemical symbolism can be made clear in a passage from a fourteenth-century alchemical writer, Petrus Bonus, in which he compares the Elixir of Life to "things heavenly, earthly, and infernal . . . to things corruptible and incorruptible . . . to the creation of the world, its elements and their qualities, to all animals, vegetables and minerals, to generation and corruption, to life and death, to virtues and vices, to unity and multitude, to male and female, to the vigorous and weak, to peace and war, white and red and all colors, to the beauty of Paradise, to the terrors of the infernal abyss." Quoted in Dixon, "Bosch's Garden of Delights Triptych," p. 113.

24. Despite the slipperiness of alchemical imagery, the subject deserves more serious study. Barbara Obrist, in *Les Débuts de l'imagerie alchimique*, provides an extremely sensitive explication of the way in which alchemical images were employed along with the words of the text as modes of gaining divine

knowledge or of illustrating alchemical processes metaphorically and allegorically in the earliest ex-
amples of illustrated alchemical treatises. Such research should be carried forward into the six-
teenth and seventeenth centuries, asking questions such as whether images formed a mode of cog-
nition for early modern people. This is suggested by Adrian Johns, "The Physiology of Reading," in
Books and the Sciences in History, ed. Marina Frasca-Spada and Nicolas Jardine (Cambridge: Cambridge
University Press, 2000), p. 296; and idem, "Transmuting the Self: The Power of Magic and the
Practice of Reading, 1550–1750," unpublished paper, 2 November 1998, where he writes that the
"need to embody multiple meaning such that they could be apprehended *at once*" was met by images.
"This suggests why alchemists created such a rich succession of illustrated books. Images sympa-
thised, and they sympathised not with Reason but with the Imagination. . . . And in addition, im-
ages expressed a simultaneous multiplicity of meanings, which could not be done in prose. So pic-
tures were not simply 'illustrations,' but an independent *and primary* means of embodying and re-
producing 'experience.'" A similar conclusion might be indicated by the fact that many alchemical
manuscripts contain rough drawings apparently carried out by the practitioner himself. See, for ex-
ample, Caspar Hartung vom Hoff, *Das "Kunstbüchlein" des Alchemisten Caspar Hartung vom Hoff* (1549),
transcribed and edited by Bernhard Haage (Göppingen: Verlag Alfred Kümmerle, 1975).

25. In the 1560s Vasari wrote that Jan of Bruges, "a painter very much esteemed for the practice which
he had acquired in becoming a master, who began to try [provare] different sorts of colors, espe-
cially those which pleased him from alchemy, to make an oil to use as a varnish and other things, ac-
cording to the notions of the learned men of that age." Giorgio Vasari, *Le Vite de' più eccellenti pittori,
scultori e architettori*, ed. Rosanna Bettarini, 6 vols. (Florence: Sansoni Editore, 1966–87), vol. 3
(1971), p. 302. It should be noted that in the mid-fifteenth century Bartolomeo Fazio, who regarded
van Eyck as "the foremost painter of our age," credited van Eyck's invention to his reading of Pliny.
Erwin Panofsky, *Early Netherlandish Painting* (1953), 2 vols. (reprint, New York: Harper & Row, 1971),
vol. 1, p. 2. Each writer superimposed upon van Eyck his own belief about the source of invention.

26. For a recent treatment of Vasari's comments and van Eyck's techniques, see William Whitney, "La
Légende de Van Eyck alchimiste," in *Alchimie: Art, histoire et mythes*, ed. Didier Kahn and Sylvain Mat-
ton (Actes du 1er colloque international de la Société d'Étude de l'Histoire de l'Alchimie) (Paris:
S.E.H.A.-Archè, 1995). As recent technical studies have also concluded, Whitney is skeptical that
van Eyck made any sort of "discovery" in the materials he used. See Ashok Roy, "Van Eyck's Tech-
nique: The Myth and the Reality, I," in *Investigating Jan van Eyck*, ed. Susan Foister, Sue Jones, and Del-
phine Cool (Turnhout, Belgium: Brepols, 2000); and Raymond White, "Van Eyck's Technique:
The Myth and the Reality, II," in ibid.

27. Cennino d'Andrea Cennini, *The Craftsman's Handbook; the Italian "Il Libro dell'Arte,"* trans. Daniel V.
Thompson Jr. (New York: Dover, 1960), lists the colors made by "alchemy" as vermilion, red lead,
orpiment yellow, arzica yellow, verdigris, and white lead (pp. 24, 25, 28, 30, 33, 34). Other colors fell
into the categories of "natural" or "artificial" but not manufactured by alchemy (e.g., p. 28). See also
A. Wallert, "Alchemy and Medieval Art Technology," in *Alchemy Revisited*, ed. Z. R. W. M. von Mar-
tels (Leiden: Brill, 1990). Other manuscripts that view color making as involving alchemical
processes can be found in Pseudo-Savonarola, *A far littere de oro. Alchimia e tecnica della miniatura in un*

ricettario rinascimentale, ed. Antonio P. Torresi (Ferrara: Liberty House, 1992). See also Robert Halleux, "Pigments et colorants dans la Mappae Clavicula," *Pigments et colorants de l'Antiquité et du Moyen Âge: Teinture, peinture, enluminure études historiques et physico-chimiques, Colloque international du CNRS* (Paris: Éditions du Centre National de la Recherche Scientifique, 1990); E. Vandamme, "Een 16e-eeuws Zuidnederlands receptenboek," *Jaarboek van het Koninklijk Museum voor Schone Kunsten* (1974): 101–37, which discusses a collection of recipes that includes color making and alchemical transmutation.

28. A. F. E. van Schendel, "Manufacture of Vermilion in 17th-Century Amsterdam, the Pekstok Papers," *Studies in Conservation* 17 (1972): pp. 77 ff. See also Daniel V. Thompson Jr., "Artificial Vermilion in the Middle Ages," *Technical Studies in the Field of the Fine Arts* 2 (1933–34): 62–70.

29. Suzanne B. Butters, *The Triumph of Vulcan: Sculptors' Tools, Porphyry, and the Prince in Ducal Florence*, 2 vols. (Florence: Olschki, 1996), vol. 1, pp. 230–34, details some of these overlappings in the case of tempering steel; others who have made this point are Robert Halleux, "L'Alchemiste et l'essayeur," in *Die Alchemie in der europäischen Kultur- und Wissenschaftsgeschichte*, ed. Christoph Meinel (Wiesbaden: Otto Harrassowitz, 1986); and Richard Palmer, "Pharmacy in the Republic of Venice in the Sixteenth Century," in *The Medical Renaissance of the Sixteenth Century*, ed. Andrew Wear and Roger French (Cambridge: Cambridge University Press, 1985), who discusses the intersections between apothecaries' practices and alchemy, as does Michela Pereira, *The Alchemical Corpus Attributed to Raymond Lull* (London: Warburg Institute, University of London, 1989). For an interesting recent meditation on the overlap between alchemy and artists' practices, see James Elkins, *What Painting Is: How to Think about Oil Painting Using the Language of Alchemy* (New York: Routledge, 1999).

30. Claus Priesner, *Bayerisches Messing. Franz Matthias Ellmayrs "Mössing-Werkh AO. 1780* (Stuttgart: Franz Steiner Verlag, 1997), pp. 99–101.

31. Martin Angerer, "Das Ornament in der deutschen Goldschmiedekunst von der Spätgotik bis zum Klassizismus," in *Deutsche Goldschmiedekunst vom 15. bis zum 20. Jahrhundert aus dem Germanischen Nationalmuseum*, ed. Klaus Pechstein et al. (Berlin: Verlag Willmuth Arenhövel, 1987), p. 63.

32. An anonymous manuscript from circa 1575 in which the transcriber has added, "Copy of a book written by hand entitled Turba that was lent to me by Messieur Guillaume le Petit, goldsmith." This indicates that this goldsmith owned the *Turba philosophorum*, an alchemical collection from the sixteenth century. Listed in R. Jansen-Sieben, *Repertorium van middelnederlandse artes-literatur* (Utrecht: HES, 1989), pp. 399–400.

33. In *Without Ceres and Bacchus, Venus Would Freeze (Self-Portrait with Venus, Ceres and Bacchus)* (probably 1606, Hermitage, St. Petersburg), Hendrik Goltzius appears to be alluding to alchemy when he depicted himself, with Amor, working over a fire. This is in keeping with the audience for this painting—Rudolf II. See Kaufmann, "Kunst und Alchemie," pp. 375–76. Goltzius was involved in gold making in 1605 and was deceived by the alchemists. See E. K. J. Reznicek, *Die Zeichnungen von Hendrick Goltzius*, 2 vols., trans. Maria Simon and Ingrid Jost (Utrecht: Haentjens Dekker & Gumbert, 1961), vol. 1, pp. 118–19. Van Mander called Goltzius a "natuerlijck Philosoph" for his ability to imitate nature (ibid., vol. 1, pp. 79–81). The documents relating to this are excerpted in A. Bredius, "Bijdragen tot de Levensgeschiedenis van Hendrick Goltzius," *Oud-Holland* 32 (1914): 139–41. See also A. S. Miedema, "Heyndrick Goltzius (1559–1617) en Trou moet Blijken," *Jaarboek Vereenigung Haerlem*

(1941): pp. 22–32, and (1942): 115–16, who discusses Goltzius's allegorical depiction of alchemy in a panel painting of 1611 as critical of alchemy, but the painting could also be read as depicting the search for truth through words (represented by Goltzius and his fellow *rederijkers* in the Chamber of Rhetoric called the Kamer der Pelicanisten) and things (represented by the personification of alchemy). Or perhaps Goltzius was equating the search of the Pelicanisten with the search embodied in the "pelican" flask of the alchemists.

34. See Giulio Lensi Orlandi, *Cosimo e Francesco de' Medici Alchimisti* (Florence: Nardini Editore, 1978); on Rudolf II, see R. J. W. Evans, *Rudolf II and His World: A Study in Intellectual History 1576–1612* (Oxford: Oxford University Press, 1973); on other prince-practitioners, see A. Bauer, *Chemie und Alchymie in Österreich bis zum beginnenden 19. Jahrhundert* (Vienna, 1883); Cristoph Meinel, ed., *Die Alchemie in der europäischen Kultur- und Wissenschaftsgeschichte* (Wiesbaden: O. Harrassowitz, 1986); Bruce T. Moran, *The Alchemical World of the German Court: Occult Philosophy and Chemical Medicine in the Circle of Moritz of Hessen (1572–1632).* (Stuttgart: F. Steiner Verlag, 1991); idem, ed., *Patronage and Institutions: Science, Technology, and Medicine at the European Court, 1500–1750* (Woodbridge: Boydell, 1991); Heiner Borggrefe, Thomas Fusenig, and Anne Schunicht-Rawe, eds., *Moritz der Gelehrte. Ein Renaissancefürst in Europa* (Eurasburg: Edition Minerva, 1997); Jost Weyer, *Graf Wolfgang II von Hohenlohe und die Alchemie* (Sigmaringen: J. Thorbecke, 1992); and Pamela H. Smith, *The Business of Alchemy: Science and Culture in the Holy Roman Empire* (Princeton: Princeton University Press, 1994).

35. "ein alchimist ist der becke in dem so er brot bacht, der rebman in dem so er den wein macht, der weber in dem das er tuch macht. also was aus der natur wachst dem menschen zu nuz, derselbige der es dahin bringt, dahin es verordnet wird von der natur, der ist ein alchimist." Paracelsus, *Das Buch Paragranum* (1530), in *Sämtliche Werke. Medizinische, naturwissenschaftliche und philosophische Schriften,* 14 vols., ed. Karl Sudhoff (Munich: R. Oldenbourg, 1927), vol. 8, pp. 181 ff.

36. Paracelsus, *Das Buch Labyrinthus medicorum genant* (1538; 1st publ. 1553), in *Sämtliche Werke,* ed. Sudhoff (1928), vol. 11, p. 189.

37. Paracelsus, *Die Neun Bücher de natura rerum* (1537), in *Sämtliche Werke,* ed. Sudhoff (1928), vol. 11, equates alchemy and generation. Alchemy is the "rechte kunst der natur." Paracelsus, *Das Buch Labyrinthus,* p. 189.

38. "nun haben aber alle hantwerk der natur nachgegrünt und erfaren ir eigenschaft, das sie wissen in allen iren dingen, der natur nachzufaren und das höchst als in ir ist daraus zubringen." Paracelsus, *Das Buch Paragranum,* p. 181.

39. Paracelsus, *Das Buch Labyrinthus,* pp. 186–87. Alchemy is whatever is done through fire, in the kitchen or in the furnace. Paracelsus saw all testing as "trying in the fire": "das ich schreib, das ist wol durchs feur probirt." Paracelsus, *Die große Wundarznei* (1536), in *Sämtliche Werke,* ed. Sudhoff (1928), vol. 10, p. 199.

40. Paracelsus writes, "So nun so vil ligt in der alchimei, dieselbige hie in der arznei so wol zu erkennen, ist die ursach der großen verborgenen tugent, so in den dingen ligt der natur, die niemand offenbar sind, allein es mache sie dan die alchimei offenbar und brings herfuer." *Das Buch Paragranum,* p. 191.

41. Lazarus Ercker, *Treatise on Ores and Assaying* (1580; first publ. 1574), trans. Anneliese Grünhaldt Sisco and Cyril Stanley Smith (Chicago: University of Chicago Press, 1951), constantly advocated the tasting of ore samples.

42. Vannoccio Biringuccio, *Pirotechnia* (1540), trans. Cyril Stanley Smith and Martha Teach Gnudi (Cambridge: Harvard University Press, 1966), pp. 396–98.

43. William Newman, "Technology and Alchemical Debate in the Late Middle Ages," *Isis* 80 (1989), 423–45; idem, "Art, Nature, and Experiment in Alchemy," in *Texts and Contexts in Ancient and Medieval Science*, ed. Edith Scylla and Michael McVaugh (Leiden: Brill, 1997), 304–17; idem, *The 'Summa perfectionis' of Pseudo-Geber* (Leiden: Brill, 1991).

44. See Elkins, *What Painting Is*, for another statement of this.

45. Paracelsus, *Volumen Medicinae Paramirum* (ca. 1520), trans. Kurt F. Leidecker (Baltimore: Johns Hopkins University Press, 1949), supplement to the *Bulletin of the History of Medicine* 11, pp. 28–29.

46. The literature on this point is large, but as examples, see Gianna Pomata, *Contracting a Cure: Patients, Healers, and the Law in Early Modern Bologna* (Baltimore: Johns Hopkins University Press, 1998), who shows the transformation in the concept of illness as defined by the patient's "subjective" reading of his/her symptoms to that of disease as an individual entity in which the patient was simply a "case." She also traces the infiltration of the horizontal relationship between healer and patient by the vertical structure of a professionalized medical hierarchy. See also Barbara Duden, *The Woman Beneath the Skin: A Doctor's Patients in Eighteenth-Century Germany*, trans. Thomas Dunlap (Cambridge: Harvard University Press, 1991); and Nancy G. Siraisi, *Medieval and Early Renaissance Medicine* (Chicago: University of Chicago Press, 1990). Managing the "non-naturals" (air, diet, sleeping and waking, exercise and rest, retentions and evacuations, and the passions) was the basis of medical practice and required careful monitoring of oneself. Artisan autobiographies in the early modern period, like the writings of other social groups, gave a large place to bodily health and sickness. James S. Amelang, *The Flight of Icarus: Artisan Autobiography in Early Modern Europe* (Stanford: Stanford University Press, 1998), pp. 117–18. This continued to be the case among experimental philosophers. Steven Shapin, "Descartes the Doctor: Rationalism and Its Therapies," *British Journal for the History of Science* 33 (2000): 131–54. Lucinda McCray Beier, "Experience and Experiment: Robert Hooke, Illness and Medicine," in *Robert Hooke: New Studies*, ed. Michael Hunter and Simon Schaffer (Woodbridge: Boydell, 1989), pp. 235–52.

47. Joseph Leo Koerner, *The Moment of Self-Portraiture in German Renaissance Art* (Chicago: University of Chicago Press, 1993), p. 220.

48. See the very cogent statement of this in a discussion of alchemy and the hexameral tradition in Betty Jo T. Dobbs, *The Janus Faces of Genius: The Role of Alchemy in Newton's Thought* (Cambridge: Cambridge University Press, 1991). See also Obrist, *Les Débuts de l'imagerie alchimique*.

49. James Bennett and Scott Mandelbrote, *The Garden, the Ark, the Tower, the Temple: Biblical Metaphors of Knowledge in Early Modern Europe* (Oxford: Museum of the History of Science, 1998).

50. Natural historical phenomena could also be deployed in a similar way; for example, the phoenix was used as a way to talk about and to prove by natural phenomena the resurrection of the flesh. Debra Hassig, *Medieval Bestiaries: Text, Image, Ideology* (Cambridge: Cambridge University Press, 1995), pp. 80–81.

51. Owen Hannaway, *The Chemists and the Word: The Didactic Origins of Chemistry* (Baltimore: Johns Hopkins University Press, 1975), esp. pp. 43–45; Dobbs, *The Foundations of Newton's Alchemy*, and idem, *Alchemical*

Death and Resurrection: The Significance of Alchemy in the Age of Newton (Washington, D.C.: Smithsonian Institution Libraries, 1990), develop this point. See Gary K. Waite, "Talking Animals, Preserved Corpses and Venusberg: The Sixteenth-Century Magical World View and Popular Conceptions of the Spiritualist David Joris (c. 1501–56)," *Social History* 20 (1995): 154–55, for the use of alchemy in popular religion.

52. John Henry, "Doctors and Healers: Popular Culture and the Medical Profession," in *Science, Culture and Popular Belief in Renaissance Europe*, ed. Stephen Pumfrey, Paolo L. Rossi, and Maurice Slawinksi (Manchester: Manchester University Press, 1991), pp. 191–221. I thank Mary Fissell for the phrase "vernacular epistemology." Roger Chartier urges historians to view knowledge in early modern Europe as held in common, but used differently, by all levels of society and to abandon the dichotomy of popular and elite. Roger Chartier, "Culture as Appropriation," in *Understanding Popular Culture: Europe from the Middle Ages to the Nineteenth Century*, ed. Steven L. Kaplan (Berlin: Mouton, 1984), pp. 230–53. Florike Egmond, "Natuurlijke historie en savoir prolétaire," in *Komenten, monsters en muilezels. Het veranderende natuurbeeld en de natuurwetenschap in de zeventiende eeuw*, ed. Florike Egmond, Erick Jorink, and Rienk Vermij (Haarlem: Uitgeverij Arcadia, 1999), indicates the tantalizing directions the project of more fully explicating the vernacular epistemology of artisans lower on the social scale than the high artisans examined in this book could take. I plan to undertake such a study in the future.

53. Henry, "Doctors and Healers," p. 197.

54. Jean Lave, *Cognition in Practice: Mind, Mathematics and Culture in Everyday Life* (Cambridge: Cambridge University Press, 1988), pp. 77–78, 182.

55. Sylvia Scribner, "Studying Working Intelligence," in *Everyday Cognition: Its Development in Social Context*, ed. Barbara Rogoff and Jean Lave (Cambridge: Harvard University Press, 1984), p. 9, views this hierarchy as based on Aristotle's disregard of the practical. Practical thinking simply did not interest him, and it was not studied among modern psychologists until the mid-1980s.

56. Stephen B. Brush, "Potato Taxonomies in Andean Agriculture," in *Indigenous Knowledge Systems*, ed. David Brokensha, D. M. Warren, and Oswald Werner (Washington, D.C.: University Press of America, 1980).

57. Deryke Belshaw, "Taking Indigenous Technology Seriously: The Case of Inter-Cropping Techniques in East Africa," in ibid.

58. Helen Watson-Verran and David Turnbull, "Science and Other Indigenous Knowledge Systems," in *Handbook of Science and Technology Studies*, ed. Sheila Jasanoff, Gerald E. Marble, James C. Peterson, and Trevor Pinch (London: Sage Publications, 1995).

59. The first statement of this was made by William M. Ivins Jr., *Prints and Visual Communication* (1953; reprint, Cambridge: MIT Press, 1969), p. 161. Especially in chapters 3 and 8, Ivins argues that visual artists, especially in areas such as botanical illustration, furthered science by making possible a new mode of visual communication. Artists developed this powerful new tool through the naturalism of their art, their "pictorial statements," and, most importantly, by the development of printmaking, which made these visual statements reproducible. As Ivins writes, "Communication is absolutely necessary for scientific and especially technological development, and to be effective it must be accurate and exactly repeatable. . . . The trying and testing cannot be done without exact repeatability

of communication. What one or two men have thought and done does not become science until it has been adequately communicated to other men" (p. 161). Samuel Y. Edgerton also makes this argument in *The Renaissance Discovery of Linear Perspective* (New York: Harper & Row, 1976). Landau and Parshall, *The Renaissance Print*, have modified Ivins's claims somewhat.

60. Georgius Agricola, preface to *De re metallica*, trans. Herbert Clark Hoover and Lou Henry Hoover (New York: Dover, 1950), p. xxx.

61. Leonhart Fuchs, preface to *De historia stirpium comentarii insignes . . . accessit iis succincta admodum difficilium obscurarum passim in hoc opere occurrentium explicatio* (Paris, 1543), pp. x–xi; quoted in James S. Ackerman, "Early Renaissance 'Naturalism' and Scientific Illustration," in *The Natural Sciences and the Arts: Aspects of Interaction from the Renaissance to the Twentieth Century*, ed. Allan Ellenius (Uppsala: Almqvist & Wiksell, 1985), p. 17.

62. James S. Ackerman, "The Involvement of Artists in Renaissance Science," in *Science and the Arts in the Renaissance*, ed. John W. Shirley and F. David Hoeniger (Washington, D.C.: Folger Shakespeare Library, 1985), p. 126.

63. Peter Parshall, "Imago contrafacta: Images and Facts in the Northern Renaissance," *Art History* 16 (1993): 554–79; and idem, "Introduction: Art and Curiosity in Northern Europe," *Word & Image* 11, no. 4 (1995): 327–31 (a special issue, entitled "Art and Curiosity," edited by Peter Parshall). See also Claudia Swan, "Ad vivum, naer het leven, from the Life: Defining a Mode of Representation," *Word & Image* 11, no. 4 (1995): 352–72.

64. See Christopher S. Wood, "'Curious Pictures' and the Art of Description," *Word & Image* 11 (1995): 332–52. See also Smith and Findlen, introduction to *Merchants and Marvels*, ed. Smith and Findlen.

65. Martin Kemp, "Wrought by No Artist's Hand: The Natural, the Artificial, the Exotic, and the Scientific in Some Artifacts from the Renaissance," in *Reframing the Renaissance: Visual Culture in Latin America 1450–1650*, ed. Claire Farago (New Haven: Yale University Press, 1995), chap. 9, shows the various and interpenetrating values assigned to objects that teetered on the edge of the nature and art divide. See also Parshall, "Introduction: Art and Curiosity."

66. Suzanne Butters, *The Triumph of Vulcan*, has done a truly masterful job of following exchanges between patrons and artisans down myriad arcane paths, to show how the expertise of the artisan came to be appropriated, both in substance and in its subsequent historical narrative, by the Medici princes. For other examples of the artisans serving as experts, see Augsburg merchant Philip Hainhofer's (1578–1647) correspondence with German princes in Oscar Doering, "Des Augsburger Patriciers Philipp Hainhofer Beziehungen zum Herzog Philipp II von Pommern-Stettin. Correspondenzen aus den Jahren 1610–1619," *Quellenschriften für Kunstgeschichte und Kunsttechnik des Mittelalters und der Neuzeit*, NF Bd. 6 (Vienna: Carl Graeser, 1894), pp. 74, 81, 107, 112, 115; and Johann Neudörfer, "Nachrichten von Künstlern und Werkleuten . . . aus dem Jahre 1547," in *Quellenschriften für Kunstgeschichte und Kunsttechnik des Mittelalters und der Renaissance*, 18 vols., transcribed from the ms. and annotated by G. W. K. Lochner (Vienna: Wilhelm Braumüller, 1875), vol. 10. Heinrich Schickhart, *Baumeister* and escort of the duke of Württemberg on the duke's travels in Italy in 1599, wrote a description of the journey that attests to Schickhart's expert status. Heinrich Schickhart von Herzenberg, *Beschreibung Einer Raiß / Welche der Durchleuchtig Hochgeborne Fürst unnd Herr / Herr Friderich Hertzog zu*

Württemberg und Teckh /. . . . Im Jahr 1599. Selfs Neundt/ auß dem Landt zu Württemberg/ in Italiam gethan. . . . Auß Hochgedachter/ Ihrer F. Gn. gnädigem Befelch/ mit sonderm fleiß . . . an tag gegeben (Tübingen: Erhard Cellius, 1603). See also Donald Posner, "Concerning the 'Mechanical' Parts of Painting and the Artistic Culture of Seventeenth-Century France," *Art Bulletin* 75 (1993): 592, for the move in the seventeenth century from artisans to "connoisseurs" as the experts to be consulted on art.

CHAPTER FIVE

1. Bernard Palissy, *Recepte véritable* (1563), ed. Frank Lestringant (Paris: Éditions Macula, 1996), p. 70.

2. Paracelsus, *Das Buch Labyrinthus medicorum genant* (1538; 1st publ. 1553), in *Sämtliche Werke. Medizinische, naturwissenschaftliche und philosophische Schriften*, 14 vols., ed. Karl Sudhoff (Munich: R. Oldenbourg, 1928), vol. 11, chap. 8, p. 202.

3. Among recent work on anatomy, see Andrea Carlino, *Books of the Body: Anatomical Ritual and Renaissance Learning*, trans. John Tedeschi and Anne C. Tedeschi (Chicago: University of Chicago Press, 1999).

4. Henrie Cornelius Agrippa, *Of the Vanitie of Artes and Sciences* (1530), trans. James Sandford (London, 1569), fol. 152v.

5. Ambroise Paré, *The Apologie and Treatise, containing the Voyages made into Divers Places* (1634 ed.), ed. Geoffrey Keynes (London: Falcon Educational Books, 1951), pp. 4–88. In this treatise, Paré defends himself from accusations that his manner of treating wounds by ligature and poultices, rather than by cauterization, was wrong by citing "Authorities," "Reason," and "Experiences."

6. Ambroise Paré, *Ten Books of Surgery with the Magazine of the Instruments Necessary for It*, trans. Robert White Linker and Nathan Womack (Athens: University of Georgia Press, 1969), pp. 73–85.

7. Paré, *The Apologie and Treatise*, p. 19.

8. Paré, "Selections from the Surgical Writings," in *Ten Books of Surgery*, p. 92.

9. Andrew Wear, "William Harvey and the 'Way of the Anatomists,'" *History of Science* 21 (1983): 223–49.

10. William Harvey, *Disputations: Touching the Generation of Animals*, trans. G. Whitteridge (Oxford: Blackwell, 1981), pp. 12–13; quoted in Catherine Wilson, *The Invisible World: Early Modern Philosophy and the Invention of the Microscope* (Princeton: Princeton University Press, 1995), p. 108.

11. Paracelsus, *Das Buch Labyrinthus*, chap. 4, p. 184. Paracelsus's use of the term "anatomy" was far broader than that by Vesalius. See Walter Pagel and Pyarali Rattansi, "Vesalius and Paracelsus," *Medical History* 8 (1964): 309–28.

12. Bernard Palissy, *The Admirable Discourses* (1580), trans. Aurele la Rocque (Urbana: University of Illinois Press, 1957), pp. 94, 148.

13. Dietlinde Goltz, "Die Paracelsisten und die Sprache," *Sudhoffs Archiv* 56 (1972): 337.

14. Ibid., pp. 337–39.

15. See Charles Webster, *The Great Instauration: Science, Medicine, and Reform 1626–1660* (London: Gerald Duckworth, 1975). Gary K. Waite, "Talking Animals, Preserved Corpses and Venusberg: The Sixteenth-Century Magical World View and Popular Conceptions of the Spiritualist David Joris (c. 1501–56)," *Social History* 20 (1995): 137–56, shows the centrality of Paracelsus and alchemy in the thought of the skilled glass painter and Anabaptist David Joris. Paracelsus's "authorizing" of these practitioners is similar to the phenomenon noted by James S. Amelang, *The Flight of Icarus: Artisan Au-*

tobiography in Early Modern Europe (Stanford: Stanford University Press, 1998), p. 134, by which Saint Teresa of Ávila's spiritual autobiography legitimated, not just interior religious experience, but also the act of writing autobiography in general.

16. Böhme's works circulated widely in manuscript; the only writings published during his lifetime were a number of short treatises published under the title *Der Weg zu Christo* in 1624. His manuscripts were published in the generation after his death.

17. Augustine, *Confessions*, bk. 13, chap. 32.

18. See James Bono, *The Word of God and the Languages of Man: Interpreting Nature in Early Modern Science and Medicine* (Madison: University of Wisconsin Press, 1995). For the Dutch context, see especially Edward G. Ruestow, *The Microscope in the Dutch Republic: The Shaping of Discovery* (Cambridge: Cambridge University Press, 1996), pp. 57–60.

19. Martin Luther, *Tischreden*, vol. 1, item 1160; quoted in Bono, *The Word of God*, p. 71.

20. Jakob Böhme, *Aurora oder Morgenröthe im Aufgang, das ist, Die Wurzel oder Mutter der Philosophie, Astrologie und Theologie aus rechtem Grunde, oder Beschreibung der Natur* (1620), in *Sämmtliche Werke*, 7 vols., ed. K. W. Schiebler (Leipzig: Johannes Ambrosius Barth, 1832), vol. 2, p. 35.

21. "Ich müß euch an eurem Leibe und an allen natürlichen Dingen zeigen, an Menschen, Thieren, Vögeln und Würmern, sowohl an Holz, Steinen, Kraut, Laub und Gras das Gleichniß der heiligen Dreiheit in Gott." Böhme, *Aurora*, p. 39.

22. Lawrence M. Principe and Andrew Weeks, "Jacob Boehme's Divine Substance Salitter: Its Nature, Origin, and Relationship to Seventeenth Century Scientific Theories," *British Journal for the History of Science* 22 (1989): 54.

23. Jakob Böhme, *De Electione Gratiae, oder von der Gnaden wahl, oder dem Willen Gottes über die Menschen* (1623), in *Sämmtliche Werke*, ed. Schiebler, vol. 4, p. 485.

24. Principe and Weeks, "Jacob Boehme's Divine Substance Salitter," p. 56.

25. Böhme, *Aurora*, p. 245.

26. Ibid., pp. 202–4.

27. Ibid., p. 29.

28. Gerrit Tierie, *Cornelis Drebbel (1572–1633)* (Amsterdam: H. J. Paris, 1932), p. 67.

29. Ibid., p. 71.

30. The self-regulating damper involved a thermostat filled with alcohol and was joined to a U-tube containing mercury. When the furnace was heated, the alcohol expanded, forcing the mercury upward to raise a rod and by means of levers to close a damper. When the heat fell too low, the action was reversed by the contraction of the alcohol. Silvio A. Bedini, "The Role of the Automata in the History of Technology," in *Patrons, Artisans and Instruments of Science, 1600–1750* (Brookfield, Vt.: Ashgate Variorum, 1999), p. 41.

31. Cornelis Drebbel, preface to *Ein kurtzer Tractat von der Natur der Elementen. Und wie sie den Windt/ Regen/ Blitz und Donner verursachen und war zu sie nutzen* (Leiden: Henrichen von Haestens, 1608). The 1604 edition was not available to me.

32. Drebbel, *Ein kurtzer Tractat von der Natur*, marginalia before and within the preface and after the last page refers to "Tinctura Drebbelii." The introduction to a later German edition of the same treatise, published as *Tractat von Natur und Eigenschafft der Elementen*, ed. Polycarpo Chrysostomo (Hoff: Jo-

hann Sigmund Strauss, 1723), compares it to the alchemical works of Paracelsus, Raymond Lull, Frederick Rosenkreuzer, and the Emerald Tablet of Hermes Trismegistus.

33. Letter to James I, printed in Drebbel, *Ein kurtzer Tractat von der Natur*, p. 56.

34. Quoted in Tierie, *Cornelis Drebbel*, p. 50.

35. Quoted in ibid., p. 68.

36. For overviews of this world in the Netherlands, see Dirk J. Struik, *The Land of Stevin and Huygens: A Sketch of Science and Technology in the Dutch Republic during the Golden Century* (Dordrecht: D. Reidel, 1981); Klaas van Berkel, *In het voetspoor van Stevin. Geschiedenis van de natuurwetenschap in Nederland 1580–1940* (Amsterdam: Boom Meppel, 1985); and Harold J. Cook, "The New Philosophy in the Low Countries," in *The Scientific Revolution in National Context*, ed. Roy Porter and Mikulas Teich (Cambridge: Cambridge University Press, 1992).

37. Berkel, *In het voetspoor*, pp. 16–19, 24. On Beeckman, see Klaas van Berkel, *Isaac Beeckman (1588–1637) en de Mechanisering van het Werelbeeld* (Amsterdam: Rodopi, 1983).

38. Berkel, *In het voetspoor*, pp. 32–33.

39. Ibid., pp. 24–25.

40. For Glauber's biography, see P. Walden, "Glauber," in *Das Buch der großen Chemiker*, 2 vols., ed. Günther Bugge (Berlin: Verlag Chemie, 1929), vol. 1; Kurt F. Gugel, *Johann Rudolph Glauber 1604–1670, Leben und Werke* (Würzburg: Freunde Mainfränkische Kunst und Geschichte, 1955); Erich Pietsch, *Johann Rudolph Glauber. Der Mensch, sein Werk und seine Zeit* (Munich: R. Oldenbourg, 1956); and Kathleen W. F. Ahonen, "Johann Rudolph Glauber: A Study of Animism in Seventeenth-Century Chemistry" (Ph.D. diss., University of Michigan, 1972). See also Allen Debus, *The Chemical Philosophy*, 2 vols. (New York: Science History Publications, 1977), vol. 2, pp. 429 ff. I have published an earlier version of this section on Glauber as "Vital Spirits: Alchemy, Redemption, and Artisanship in Early Modern Europe," in *Rethinking the Scientific Revolution*, ed. Margaret J. Osler (Cambridge: Cambridge University Press, 2000).

41. Glauber was married first to Rebecca Jacobs, whom he left after she became involved with his laboratory helper (a journeyman apothecary), and then to Helena Cornelisdr., whom he married "desto besser wartung zu haben" [in order to be better cared for], as he said, because the change of air in Holland made him sick and the Dutch food did not agree with him. Johann Rudolf Glauber, *Glauberus Redivivus* (Frankfurt a.M.: Thomas Matthias Goetzen, 1656), pp. 52–55. Helena appears to have died in 1689, when their son Johannes Glauber gave his unmarried sister Anna (probably Diana Glauber) power of attorney over their deceased mother's goods. 30 April 1689, NA 5586, fols. 497–98, film 5772, Amsterdam Gemeentearchief.

42. Johann Rudolf Glauber did not possess Amsterdam *poorterrecht*, or citizenship, and so he could not be enrolled as an apothecary in the Collegium medicum and the Collegium's records do not show that he attempted to register in any other capacity.

43. Johann Rudolf Glauber, *Reicher Schatz- und Sammel-Kasten Oder appendix Generalis über alle dessen herausgegebener Bücher . . .*, 5 parts (Amsterdam, 1660–69). For more on Glauber's chemical products, see J. R. Partington, *A History of Chemistry*, 2 vols. (London: Macmillan, 1961), vol. 2, pp. 350–60.

44. This list, entitled *Catalogus Librorum*, is bound with some copies of Glauber's *Glauberus Concentratus oder Laboratorium Glauberianum* (Amsterdam: Johan Waesberg & the widow of Elizaeus Weyerstraet, 1668). It contains about twenty-seven works of geography, forty-nine of chemistry, and twenty-two

religious works, as well as various other works of philology, history, astronomy, medicine, and encyclopedic works. It is remarkable how few classical works his library contains.

45. Johann Rudolf Glauber, *Des Teutschlandts Wolfahrt* (Amsterdam: Johan Jansson, 1656), part I, p. 79.

46. *Catalogus Librorum* attached to *Glauberus Concentratus*, pp. 14–15.

47. In *Testimonium Veritatis* (Amsterdam: Johan Jansson, 1657), p. 296, Glauber advertised his process for and the sale of *Spiritus Salis* made according to his inexpensive process.

48. Hartlib correspondence, memo from Glauber to Hartlib, undated, fol. 67/15/1A–2B.

49. Ad Clément and J. W. S. Johnsson, eds., "Briefwechsel zwischen J. R. Glauber und Otto Sperling," *Janus* 29 (1925): 210–33. This contract, pp. 216–17.

50. This is likely to have been the eldest son of Michel le Blon, a fascinating engraver, art dealer, diplomat, and spy. Michel le Blon's son Cornelis was born in 1615 or 1616 and died in 1686. H. de la Fontaine Verwey, "Michel le Blon, Graveur, Kunsthandelaar, Diplomat," in *Uit de wereld van het boek, II: Drukkers, Liefhebbers en Piraten in de Zeventiende Eeuw* (Amsterdam: Nico Israel, 1976).

51. Perhaps a child of the artist Bartholomeus Spranger (1546–1611) or of his brother Quirijn Spranger (active 1585–1617).

52. I. H. van Eeghen, "Het Grill's Hofje," *Jaarboek van het Genootschap Amstelodamum* 62 (1970): 50; C. Hernmarck, "Holland and Sweden in the Seventeenth Century, Some Notes on Dutch Cultural Radiance Abroad," *Netherlands Kunsthistorisch Jaarboek* 31 (1980): 198–99. See also D. A. Wittop Koning, "J. R. Glauber in Amsterdam," *Jaerboek van het Genootschap Amstelodamum* 44 (1950): 1–6.

53. Amsterdam Gemeentearchief, 30 April 1661, NA 2488, fols. 413–14; 10 May 1661, NA 1137, fols. 175–76, film 1302; 26 May 1661, NA 1451, film 1545; 27 May 1661, NA 1137, fol. 201, film 1302.

54. 30 April 1661, NA 2488, fols. 413–14, Amsterdam Gemeentearchief. This document is partly burnt and it is difficult to make out the entire contents of the four laboratory spaces listed.

55. 10 May 1661, NA 1137, fols. 175–76, film 1302, Amsterdam Gemeentearchief. On 27 May 1661, as duly taken down by the same notary, Justus van de Ven, Glauber reiterated that he needed the tools because he wanted to set his work in progress again and to serve the country. This was important because the wars against the Turks were ongoing and the outcome of these could be improved by his work. NA 1137, fol. 201, film 1302, Amsterdam Gemeentearchief. In *De tribus lapidibus ignium secretorum. Oder von den drey Alleredelsten Gesteinen / so durch drey Secrete Fewer gebohren werden* (Amsterdam: Johan Jansson van Waesberg & the widow of Elizaeus Weyerstraet, 1668), Glauber states that in accord with the laws of the city, the house had had to be opened to all people before the sale took place, and there had come a stream of "doctors, apothecaries, barbers, Müntzmeister, silversmiths, and all kinds of common Stocker" who wanted to buy sharp spirits and oleum vitrioli (hydrosulphuric acid), or simply to get a look at the furnaces to see if they could learn something (p. 11). The agent selling the house apparently sold Glauber's goods with the house, which impelled Glauber to take his case to court, where it lingered for two years. He claims that in the end he won the case but that all his tools and materials were ruined in the meantime (pp. 12–13).

56. Gugel, *Johann Rudolf Glauber*, p. 27.

57. Samuel de Sorbière, *Relations, lettres, et discours sur diverses matieres curieuses* (Paris: Robert de Ninville, 1660), letter IV, pp. 103–94, recounts his visit to Glauber, pp. 176–81. He noted that the house rent was four to five hundred ecus per month.

58. Johann Rudolf Glauber, *Tractatus de Natura Salium. Oder außführliche Beschreibung/ deren bekanten Salien, . . . und absonderlich von Einem/ der Welt noch gantz unbekantem wunderliche Saltze. . . .* (Amsterdam: Johan Jansson, 1658), p. 111.

59. Sorbière, *Relations*, pp. 178–79.

60. Ibid., p. 180. Sorbière was intrigued by Glauber but felt he did not stay long enough to really understand his "histoire," and he was surprised that almost no one knew where Glauber lived except Glauber's bookseller. This is almost certainly because Glauber had just moved into his new house on Looiersgracht. Sorbière ended the account on Glauber by marveling at the freedom with which "brothers of the Rosy-Cross" could pursue their great work in the Netherlands (pp. 180–81).

61. Phillip Skippon reported in June 1663 that Glauber was too sick to see him: *An Account of a Journey Made thro' Part of the Low-Countries, Germany, Italy, and France*, 6 vols. (London: 1732), vol. 6, p. 407. Monsieur de Monconys, *Journal des voyages* (Lyon: Horace Boissat, George Remeus, 1665), part 2, p. 179, said of his visit to Glauber in August 1663 that Glauber did not work anymore and had no furnaces. In 1668 Edward Brown reported that "the old Glauber the chemist" showed him his laboratory. Edward Brown, *Naukeurige en Gedenkwaardige Reysen van Edward Brown*, trans. Jacob Leeuw (Amsterdam: Jan ten Hoor, 1682), p. 23.

62. The passage from Robert Boyle, *Works*, vol. 6, p. 91; quoted in Gugel, *Johann Rudolph Glauber*, p. 29 n. 55.

63. See also the references to Glauber in the correspondence of Henry Oldenburg and Gottfried Wilhelm Leibniz. The Hartlib papers at Sheffield University contain numerous references to Glauber and some letters from him. Samuel Hartlib and his correspondents were constantly trying to ascertain whether Glauber had communicated his processes in full and if these processes worked. Hartlib's correspondents were sharply divided about whether or not Glauber was a charlatan. See the interesting analysis of one gentleman's interest in Glauber by Stephen Clucas, "The Correspondence of a XVII-Century 'Chymicall Gentleman': Sir Cheney Culpeper and the Chemical Interests of the Hartlib Circle," *Ambix* 40 (1993): 147–70, although it draws too strong a distinction between the animistic Hermetic view of nature and the practical view.

64. Hartlib correspondence 63, 14, 7. Paris, 1651; quoted in Clucas, "The Correspondence," p. 151.

65. Quoted in Clucas, "The Correspondence," p. 153.

66. Glauber, *Tractatus de Natura Salium*, p. 71. Glauber says he was in Vienna-Neustadt twenty-one years earlier, which would put the date at 1637; however, some biographers claim he was there in 1625/26. There was great interest in preservation at this time. Sorbière, *Relations*, recorded his meeting with Monsieur Bils, a Flemish surgeon and anatomist who could preserve people after death. Sorbière noted that Bils carried out such preservation for the satisfaction of the "people of quality" who wished to preserve "their parents or their friends" (pp. 123–29). For more on Bils, see Harold J. Cook, "Time's Bodies: Crafting the Preparation and Preservation of Naturalia," in *Merchants and Marvels: Commerce, Science, and Art in Early Modern Europe*, ed. Pamela H. Smith and Paula Findlen (New York: Routledge, 2002).

67. Glauber, *Tractatus de Natura Salium*, p. 74.

68. Ibid., pp. 85, 95. The salt was hydrated sodium sulphate and is still known as a bath salt in Germany under the name of Glaubersalz.

69. In *De Elia Artista. . . .* (Amsterdam: Johan Waesberg & the widow of Elizasius Weyerstraet, 1668), p. 60, Glauber states that all things get sustenance from a *Spiritus volatilis* in the air.

70. Ibid., pp. 67–70.

71. "warumb solte ein erfahrner *Artist,* wann er der sachen fleissig nachdencket/ nicht weiter damit kommen können? Einem Gelehrten ist guth predigen/ ein mehrers auff dißmal nicht." Ibid., p. 79.

72. On the *Elias artista* (the addition of the *artista* first made by Paracelsus) tradition, see Walter Pagel, "The Paracelsian Elias Artista and the Alchemical Tradition," in *Kreatur und Kosmos,* ed. Rosemarie Dilg-Frank (Stuttgart: Gustav Fischer Verlag, 1981), pp. 6–19; and Herbert Breger, "*Elias Artista*—A Precursor of the Messiah in Natural Science," in *Nineteen Eighty-Four: Science between Utopia and Dystopia,* ed. Everett Mendelsohn and Helga Nowotny (New York: D. Reidel, 1984).

73. Johann Rudolf Glauber, *Miraculi Mundi Ander Theil. Oder Dessen Vorlängst Geprophezeiten Eliae Artistae Triumphirlicher Einritt. Und auch Was der ELIAS ARTISTA für einer sey? . . .* (Amsterdam: Johan Jansson, 1660).

74. Johann Rudolf Glauber, *Kurtze Erklärung über die Höllische Göttin Proserpinam. . . .* (Amsterdam: Johan Jansson van Waesberg & Elizaeus Weyerstraet, 1667), pp. 55–56.

75. Glauber, *De Elia Artista,* pp. 3–4.

76. See, for example, Johann Rudolf Glauber, preface to *Explicatio Oder Außlegung über die Wohrten Salomonis: In Herbis, Verbis, & Lapidis Magna est Virtus* (Amsterdam: Johan Jansson van Waesberg, 1663); and idem, *Des Teutschlandts Wolfahrt,* part I, dedication.

77. Johann Rudolf Glauber, *Operis Mineralis* (Frankfurt a.M.: Heirs of Matthaeus Merianus, 1651), pp. 14–15.

78. In part 4 of the *Furni novi Philosophici,* Glauber describes a process for casting mirrors, and in the "sale catalog" of his laboratories and library that he published when he could no longer work, several burning glasses are listed, one of which has a two-foot diameter. Glauber, *Glauberus Concentratus,* p. 33.

79. See Kathleen W. F. Ahonen, s.v. "Glauber," in *Dictionary of Scientific Biography,* 18 vols., ed. Charles Gillispie (New York: Scribner, 1970–86), vol. 5, p. 422. Glauber also believed that the human soul could be known in the same way, but this aspect of his thought was never clearly articulated.

80. Glauber, *De tribus Lapidibus,* p. 10 and passim.

81. "Der *Laborant* weiß nichts/ und die *Principalen* oder Verleger noch weniger; Es ist nicht genung/ dass man ein hochgelährter verständiger Mann ist/ solche Gelehrheit oder Welt-verstandt hatt mit der *Alchimia* nichts zu thun/ die *Alchimia* erfodert Leuthe/ welche der *Metallen* arth und eigenschafften verstehen." Ibid., p. 24.

82. For other examples of the concerns that those who called themselves natural philosophers had about distancing themselves from mechanics and merchants, see William Eamon, *Science and the Secrets of Nature: Books of Secrets in Medieval and Early Modern Culture* (Princeton: Princeton University Press, 1994); Pamela H. Smith, *The Business of Alchemy: Science and Culture in the Holy Roman Empire* (Princeton: Princeton University Press, 1994); Steven Shapin, *A Social History of Truth: Civility and Science in Seventeenth-Century England* (Chicago: University of Chicago Press, 1994); and Larry Stewart, *The Rise of Public Science* (Cambridge: Cambridge University Press, 1992).

83. William R. Newman, *Gehennical Fire: The Lives of George Starkey, an American Alchemist in the Scientific Revolution* (Cambridge: Harvard University Press, 1994), p. 67.

84. Sorbière, *Relations*, pp. 179–80.

85. Hartlib correspondence, 26 August 1647, fol. 45/1/33A–34B, f. 33a.

86. Johann Siebert Kuffler, in turn, experimented with Glauber's glassware. See Clucas, "The Correspondence," p. 152.

87. Hartlib correspondence, 26 August 1647, 45/1/33A–34B, f. 33a.

88. "Wir haben nicht nöthig durch Wuchen/ und Schinderey/ oder andern zur Sünden-führenden Mittelen unsere Nothdurfft/ oder auffenthalt des Lebens zu suchen. Dann aller Kauffhandell Er sey gleich groß/ oder klein/ ohne Sünde nicht geschehen kan/ wie dann der hocherfahrene Jesus Syrach saget/ dass die Sünde zwischen dem Käuffer/ und Verkäuffer so fäst stäcke/ als ein Nagell in der Wandt; und floririt nicht allein die Sünde bey dem Käuffer/ und Verkäuffer/ sondern auch bey allen dehnen/ welche nicht ihr eygen seyn/ sondern ihren unterhalt durch das ienige so sie gelernt/ von andern zu haben suchen müssen. Darunter auch die *Medici, Chirurgi, Apotheker, Juristen/ Advocaten/* Procuratores, und dergleichen Hoch- und Nieder-Gelährten zu rechnen seyn. Wann sie allein darum *studíret* und Kunst/ oder Handwerck gelernet haben/ von andern Geldt dardurch zu gewinnen; dabey die Sünde dann durch das viel Geldt gewinnen also eingewurtzelt/ und in ein tägliche böse gewohnheit verwandelt/ dass sie auch anders nicht wohl auss zu reutten/ als durch den Todt." Glauber, *Glauberus Concentratus*, pp. 26–27.

89. Ibid., p. 66.

90. "Und ist dieses gewißlich wahr/ dass die Gottlosen nimmermehr zu der erkändtnüss dieses Saltzes/ und auch noch viel weniger zu deßen nützlichen gebrauch gelangen werden. Wie dann solches alle Philosophi bezeugen: Unter andern auch solches der hoch erfahrene Philosophus, Bonus Lambertus in seinem mit Lacinio gehaltenem Dialogo bekräfftiget/ mit diesen wortten: *Ars ipsa sancta est, & quam non nisi puros ac sanctos homines habere licet. Nam ut divi Thomae utar sententia, Ars ista vel reperit hominaem sanctum, aut reddet ejus inventio sanctum.* Die Kunst kehret nicht bey den hoffährtigen Geitzigen ein/ sondern nur bey dehnen/ welche sich mit wenig genügen lassen." Ibid., p. 28.

91. Glauber, *Glauberus Redivivus*, pp. 78–79.

92. Ibid., p. 82.

93. John T. Young, *Faith, Medical Alchemy, and Natural Philosophy: Johann Moriaen, Reformed Intelligencer, and the Hartlib Circle* (Brookfield, Vt.: Ashgate, 1998).

94. Glauber, *Des Teutschlandts Wolfahrt*, pp. 50–51.

95. The only work dedicated to an individual is Johann Rudolf Glauber, *Gründliche und warhafftige Beschreibung Wie man auss der Weinhefen einen guten Weinstein in grosser Menge extrahiren sol* (Amsterdam, 1654), which is dedicated to the archbishop and elector of Mainz and Würzburg Johann Philipp von Schönborn, who had given Glauber a privilege for producing tartaric acid when Glauber was in Wertheim and Kitzingen (1651–54).

96. Glauber, *De tribus lapidibus*, p. 23.

97. See Arnold Houbraken, *Große Schouburgh der Niederländischen Maler und Malerinnen*, trans. Alfred von Wurzbach (1880) (facs. repr. Osnabrück: Otto Zeller Verlag, 1970), pp. 375–77, for this summary of the lives of Glauber's children who became painters. Houbraken knew Johannes personally.

98. Picart himself continued to paint, and in 1640 he was admitted to the Académie de Saint Luc and in 1647 registered there as "Peintre ordinaire de Monseigneur de Metz." Elected member of the

Académie royale in 1651, he became "peintre du Roy" during that same year. He was further promoted "peintre ordinaire du Roy" in 1679. His son, Bernard Picart, became an important Enlightenment follower of Descartes. See Margaret C. Jacob, *The Radical Enlightenment: Pantheists, Freemasons and Republicans* (London: George Allen & Unwin, 1981).

99. G. J. Hoogewerff, *De Bentveughels* (The Hague: Martinus Nijhoff, 1952), pp. 108–11. The Bent was established in 1623 out of a group of Netherlandish painters, both Catholic and Protestant, who gathered around the Dutch apothecary Henricus Corvinus, who had settled in Rome and married the daughter of a Brussels painter. From 1633–37, the members of the Bent refused to pay their dues to the Guild of St. Luke in Rome and won the lawsuit that ensued. An indication of their numbers in Rome is given by the account of a general gathering of painters in Rome in 1636, in which 30 Italian, 12 French, 3 Spanish, 2 German, and 40 Netherlandish painters were present. G. J. Hoogewerff, "De Nederlandsche Kunstenaars te Rome in de XVIIe eeuw en hun Conflict met de Academie van St. Lucas," *Mededeelingen der koninklijke Akademie van wetenschappen* 62 (1926): 25.

100. Noted in Koning, "J. R. Glauber in Amsterdam," p. 3 n. 1. Johannes Glauber's will is extant in Amsterdam Gemeentearchief NA 7066, fols. 189–94 (11 October 1711), film 5830.

CHAPTER SIX

1. Samuel Hartlib correspondence, electronic version, letter, Henry Appelius to Hartlib: 26 August 1647, 45/1/33a–34b, f. 33b: "the ounce (namely mingled with Spir. Vini.) costeth, about .3. Rix dolers."

2. Poleman reported to Hartlib in 1659 that Sylvius was back in Amsterdam meeting with Glauber. Hartlib correspondence, electronic version; extracts from Poleman in Scribal Hands A, I, ? & Hartlib, in German and Latin: 15 August–10 October 1659. 60/10/1a–2b, no. 11, 10 October 1659, f. 2b. Glauber's catalog of books includes two of Sylvius's works: *Oratio inauguralis de hominis cognitione* (Leiden, 1658) and *Disputationum Medicarum, pars prima* (Amsterdam, 1663). On 23 February 1660, Sylvius wrote to Otto Sperling that he had visited Glauber the week before and had received various recipes that he had not yet had a chance to test. Quoted in Harm Beukers, "Het Laboratorium van Sylvius," *Tijdschrift voor de geschiedenis der geneeskunde, natuurwetenschappen, wiskunde en techniek* 3 (1980): 30.

3. The salt was ammonium carbonate and was viewed as a panacea. Beukers, "Het Laboratorium," pp. 31–33.

4. Sylvius's heirs were the children of his brother Jacob dele Boë, merchant in Hamburg and the children of his sister, Rachel Rouyers, in Hanau. His nephew Jean Rouyer, an Amsterdam merchant, undertook most of the legal work on behalf of his co-heirs. Leiden Gemeentearchief, NA 1073, nos. 43 (8 March 1673), 47 (14 March 1673), and 71 (18 April 1673).

5. Jacob de Bois witnessed both Sylvius's wills. Leiden Gemeentearchief, NA 1068 (22 September 1669) and NA 1068, no. 283 (21 October 1669). He testified in NA 1073, no. 43 (8 March 1673). In 1678 Jean Rouyer went bankrupt and liquidated his estate, mainly to satisfy his largest creditor, Jacob dele Boë, his uncle and a merchant in Hamburg. The inventory from this auction includes many of Sylvius's paintings (sometimes more fully described than in Sylvius's own inventory). The

paintings were evaluated and priced by Melchior de Hondecoeter. In the attic of Jean Rouyer's house were found six chests of "printed books that belonged to Professor Sylvius." Amsterdam Gemeentearchief, Desolate Boedelkamer 5072 382, fols. 245v–55. Jean seems to have regained prosperity, because when his house was inventoried on his death in 1702, he was very wealthy and still had many of Sylvius's paintings. Amsterdam Gemeentearchief, NA 5674B, fols. 1147–72. The Hamburg merchant Jacob dele Boë had a son, Franciscus dele Boë, Sylvius, who became a medical doctor and practiced in Leiden. He was very wealthy on his marriage to Margarete van Eeden in 1695. Amsterdam Gemeentearchief, NA 3374 (30 July 1695), fols. 386–88, film 3287.

6. See Roger French, "Harvey in Holland: Circulation and the Calvinists," in *The Medical Revolution of the Seventeenth Century*, ed. Roger French and Andrew Wear (Cambridge: Cambridge University Press, 1989), pp. 63–66.

7. For biographical information, see Luca Schacht, *Oratio Funebris . . . Francisci de le Boe, Sylvii* (Leiden: Joh. Le Carpentier, 1673); and E. D. Baumann, *François dele Boe, Sylvius* (Leiden: E. J. Brill, 1949), pp. 1–19. See also G. A. Lindenboom, s.v. "Sylvius, Franciscus dele Boë," in *The Dictionary of Scientific Biography*, ed. Charles Gillispie, 18 vols. (New York: Scribner, 1970–86), vol. 13; Klaas van Berkel, *In het voetspoor van Stevin. Geschiedenis van de natuurwetenschap in Nederland 1580–1940* (Amsterdam: Boom Meppel, 1985); and Harold J. Cook, "The New Philosophy in the Low Countries," in *The Scientific Revolution in National Context*, ed. Roy Porter and Mikulas Teich (Cambridge: Cambridge University Press, 1992). An earlier version of this section appeared as Pamela H. Smith, "Science and Taste: Painting, the Passions, and the New Philosophy in Seventeenth-Century Leiden," *Isis* 90 (1999): 420–61.

8. After a visit in 1669 with him in Leiden, the private physician of the Grandduke Cosimo de' Medici of Tuscany called Sylvius "a vain and self-assured man." G. J. Hoogewerff, ed., *De Twee Reizen van Cosimo de' Medici, Prins van Toscane door de Nederlanden (1667–1669)* (Amsterdam: Johannes Müller, 1919), p. 312.

9. The first lecturers in practical chemistry at Leiden who worked in this laboratory were Carel de Maets (1640–1690) and Jacob Le Mort (1650–1718), both trained by Johann Rudolf Glauber. See J. W. van Spronsen, "The Beginning of Chemistry," in *Leiden University in the Seventeenth Century: An Exchange of Learning*, ed. Th. H. Lunsingh Scheurleer and G. H. M. Posthumus Meyjes (Leiden: Brill, 1975), pp. 336–39.

10. Lester S. King, *The Road to Medical Enlightenment 1650–1695* (New York: American Elsevier, 1970), pp. 112 ff.; and Baumann, *François dele Boe*, p. 80.

11. Paracelsus, *Volumen Medicinae Paramirum* (ca. 1520), trans. Kurt F. Leidecker (Baltimore: Johns Hopkins University Press, 1949), pp. 28–29.

12. For a description of Sylvius's house (Rapenburg 31), partial transcriptions of the contract between Sylvius and the builder Willem Wijmoth, and the 1673 notarial inventory of the house, see Th. H. Lunsingh Scheurleer, C. Willemijn Fock, A. J. van Dissel, eds., *Het Rapenburg: Geschiedenis van een Leidse gracht*, 6 vols. (Leiden: Afdeling Geschiedenis van de Kunstnijverheid, Rijksuniversiteit Leiden, 1986–92), vol. 3, pp. 270–342. The full inventory (Gemeentearchief Leiden, N.A. 1073, no. 66, dated 6 April 1673) and Sylvius's final will (Gemeentearchief Leiden, N.A. 1068, no. 283, dated 21 October 1669) are still extant. Sylvius died on 15 November 1672. Hermann Boerhaave (1668–1738), Leiden Professor of Medicine and Botany from 1701–38 and author of *Elementa*

chemiae, bought Rapenburg 31 in 1730. Eric Jan Sluijter has recently analyzed Sylvius's collection in "All Striving to Adorne Their Houses with Costly Peeces: Two Case Studies of Paintings in Wealthy Interiors," in *Art and Home: Dutch Interiors in the Age of Rembrandt*, ed. Mariët Westermann (Zwolle: Waanders, 2001).

13. C. Willemijn Fock, "Kunstbezit in Leiden in de 17de eeuw," in *Het Rapenburg*, ed. Scheurleer, Fock, and Dissel, vol. 5, p. 6.

14. Scheurleer, Fock, and Dissel, *Het Rapenburg*, vol. 5, p. 25. Whether Sylvius used any of the architectural ideas in the posthumous publication of Simon Stevin (1548–1620), *Materiae politicae. Burgherlicke stoffen* (Leiden, 1649), is not known. His house does reflect one of Stevin's principles for Dutch burghers: to bring light into every room by means of a courtyard between inner rooms and have a separate bedroom and work area for the man of the house. See Heidi de Mare, "The Domestic Boundary as Ritual Area in Seventeenth-Century Holland," in *Urban Rituals in Italy and the Netherlands: Historical Contrasts in the Use of Public Space, Architecture and the Urban Environment* (Assen: Van Gorcum, 1993), pp. 108–31; and idem, "Het huis, de natuur en het vroegmoderne architectonisch kennissysteem van Simon Stevin," in *Wooncultuur in de Nederlanden: The Art of Home in the Netherlands 1500–1800*, ed. Jan de Jong, Bart Ramakers, Herman Roodenburg, Frits Scholten, and Mariët Westermann (*Nederlands Kunsthistorisch Jaarboek*, vol. 51) (Zwolle: Waanders, 2000).

15. In the second half of the seventeenth century, the Dutch elite began to follow French fashions of interior design. See Peter Thornton, *Seventeenth-Century Interior Decoration in England, France and Holland* (New Haven: Yale University Press, 1978), pp. 40–44; on beds, see pp. 159 ff. See also the information on Dutch homes in John Loughman and John Michael Montias, *Public and Private Spaces: Works of Art in Seventeenth-Century Dutch Houses* (Zwolle: Waanders, 2000). Sylvius's second wife may have assisted him in furnishing the house, although not with the building. His first wife, Anna de Ligne, had died in 1657 after eight years of marriage. He married again in 1667, two years after the rebuilding of the Rapenburg house. His second wife, Magdalena Lucretia Schletzer, died shortly after giving birth to a daughter in 1669. This child, Sylvius's only direct heir, died in 1670. Sylvius was probably the father of an illegitimate child born in 1664. Baumann, *François dele Boe*, p. 38.

16. Scheurleer, Fock, and Dissel, *Het Rapenburg*, vol. 3, p. 291.

17. Fock, "Kunstbezit," in ibid., vol. 5, p. 6. It is one of the five largest of the 120 people for whom inventories from seventeenth-century Leiden are still extant.

18. Sylvius owned six paintings by Sillemans, six by Luttichuys, eleven by Dou, and seven by van Mieris.

19. Scheurleer, Fock, and Dissel, *Het Rapenburg*, vol. 3, p. 286. Sylvius's collection is discussed in *Het Rapenburg*, vol. 3, pp. 284–95. The dates of the paintings he owned, the unity of the collection, and the absence of family portraits indicate that his collection was not inherited from his family. On art in Dutch houses, see Mariët Westermann, ed., *Art and Home: Dutch Interiors in the Age of Rembrandt* (Zwolle: Waanders, 2001).

20. The amount of porcelain and silver in the house at his death was extraordinary (at least compared to what was inventoried in his contemporaries' houses). His yearly salary was eighteen hundred guilders; on his death he had thirty-five hundred guilders in coin and silver in his house. Scheurleer, Fock, and Dissel, *Het Rapenburg*, vol. 3, p. 284.

21. Landscapes were also the most numerous works in most other collections in the Netherlands. Michael North, *Kunst und Kommerz im Goldenen Zeitalter. Zur Sozialgeschichte der niederländische Malerie des 17. Jahrhunderts* (Cologne: Böhlau Verlag, 1992), translated by Catherine Hill as *Art and Commerce in the Dutch Golden Age* (New Haven: Yale University Press, 1997), p. 131. Also John Michael Montias, *Artists and Artisans in Delft* (Princeton: Princeton University Press, 1982), p. 242. Protestants favored landscapes and seascapes over history or religious paintings. Sluijter, "All Striving to Adorne Their Houses," p. 116.

22. Sylvius's collection stands out from those in the other inventories included in Scheurleer, Fock, and Dissel, *Het Rapenburg*, for its apparently intentional and purposeful organization.

23. One can almost see in this the instructions of Samuel Quiccheberg to his patron, the duke of Bavaria, to begin a *Kunstkammer* first with sacred objects followed by portraits of the collector and his family. Samuel Quiccheberg, *Inscriptiones vel tituli amplissimi* (Munich, 1565). See also Eva Schulz, "Notes on the History of Collecting and of Museums in the Light of Selected Literature of the Sixteenth through Eighteenth Centuries," *Journal of the History of Collections* 2 (1990): 205–18; and Barbara Gutfleisch and Joachim Menzhausen, "'How a Kunstkammer Should Be Formed': Gabriel Kaltemarckt's Advice to Christian I of Saxony on the Formation of an Art Collection, 1587," *Journal of the History of Collections* 1 (1989): 3–32. About twenty-five years after Sylvius's death, Gérard de Lairesse noted various connotations of room colors. Under his scheme, Sylvius's rooms would have carried the following associations: red in the large salon signified power; green in the dining room, humility; the purple of the master bedroom meant authority; and the yellow, splendor and glory. Gérard de Lairesse, *Het groot Schilderboek*, 2 vols. (Amsterdam: Hendrick Desbordes, 1712), vol. 2, p. 208.

24. The laboratory inventory is printed in Beukers, "Het Laboratorium," pp. 35–36.

25. Inventory, Leiden Gemeentearchief, NA 1073, nr. 66.

26. The notary's description of the paintings is similarly oriented toward the objects in the paintings—a stall with horses, a decked table, a heron, a rabbit, a sea battle, an orange with a *roemer* glass, and so on.

27. Loughman and Montias, *Public and Private Spaces*, pp. 20–21. See Mariët Westermann's fine essay on Dutch domestic life, "'Costly and Curious, Full of Pleasure and Home Contentment': Making Home in the Dutch Republic," in *Art and Home*, ed. Westermann, esp. pp. 43–81.

28. Simon Schama, *The Embarrassment of Riches: An Interpretation of Dutch Culture in the Golden Age* (Berkeley: University of California Press, 1985).

29. See Pamela H. Smith, *The Business of Alchemy: Science and Culture in the Holy Roman Empire* (Princeton: Princeton University Press, 1994), esp. chap. 3.

30. Schama, *The Embarrassment of Riches*. On the basis of Dutch inventories, John Michael Montias finds that the reports of English and French visitors that even poor people in the Netherlands owned paintings were probably not accurate; they probably saw no really poor houses. The fact remains, however, that paintings were far more widely consumed in the Netherlands than in other European countries. Montias, *Artists and Artisans*, p. 269; and Loughman and Montias, *Public and Private Spaces*. See also North, *Kunst und Kommerz*, who notes that peasants in the United Provinces became noticeably richer in the seventeenth century as they were integrated into the money economy.

31. Quoted in Linda A. Stone-Ferrier, *Images of Textiles: The Weave of Seventeenth-Century Dutch Art and Society* (Ann Arbor: UMI Research Press, 1985), p. 218. In chapter 5, Stone-Ferrier maintains that as the domestic silk industry in the Dutch Republic expanded (from about 1648 to the 1690s), attitudes toward conspicuous consumption, at least in regard to attire, became more positive.

32. Thomas A. McGahagan, "Cartesianism in the Netherlands, 1639–1676: The New Science and the Calvinist Counter-Reformation" (Ph.D. diss., University of Pennsylvania, 1976). J. A. van Ruler, *The Crisis of Causality: Voetius and Descartes on God, Nature and Change* (Leiden: Brill, 1995). The dangers of materialism could even include the pseudo-Cartesian descriptions that appeared in pornographic treatises. See Margaret C. Jacob, "The Materialist World of Pornography," in *The Invention of Pornography: Obscenity and the Origins of Modernity, 1500–1800*, ed. Lynn Hunt (New York: Zone Books, 1996).

33. Susan James recounts the ways in which ideas about action and passion begin to collapse in the seventeenth century into a view that "desires are the principal passionate antecedents of action" and govern all actions. Susan James, *Passion and Action: The Emotions in Seventeenth-Century Philosophy* (Oxford: Clarendon Press, 1997), p. 291.

34. René Descartes, *The Philosophical Writings*, trans. John Cottingham, Robert Stoothoff, and Dugald Murdoch, 3 vols. (Cambridge: Cambridge University Press, 1984), vol. 1, p. 358.

35. Vannoccio Biringuccio, *Pirotechnia* (1540), trans. Cyril Stanley Smith and Martha Teach Gnudi (Cambridge: Harvard University Press, 1966), pp. 444–46.

36. Ibid., p. 396, in a discussion of the discovery of mortar.

37. The painting in Karlsruhe is now generally agreed to be a copy of Brouwer's *Quacksalver*. We do not know if it or its original (if it in fact is a copy) was the painting Sylvius owned.

38. Contantijn Huygens, "Een ontwetend Medicyn," in *Zes Zedeprinten* (Utrecht: Instituut de Vooys, 1976), pp. 52 ff.

39. Jan Steen, Gerrit Dou, Frans van Mieris, and numerous other artists used these themes in their works. More sympathetic treatment of the doctor can be found in the painting of the five images of the doctor—as the patient recovers, the doctor goes from Christ figure to saint and finally, on presentation of the bill, to devil. See *De vier gedaanten van de arts* (Leiden: Museum Boerhaave, s.d.). A succinct and persuasive account of the representation of medical practitioners as deceivers can be found in *Van Piskijkers en heelmeesters: Genezen in de Gouden Eeuw*, exhibition catalog (Leiden: Museum Boerhaave, 1991).

40. As Lorraine Daston has shown, curiosity moved from an alignment with lust and pride to one with avarice in the early modern period, and this new sensibility oriented scientific investigation toward commodity-like objects, as well as into the hidden secrets and small things of nature. Lorraine Daston, "Curiosity in Early Modern Science," *Word & Image* 11, no. 4 (1995): 391–404. See also Lorraine Daston and Katherine Park, *Wonders and the Order of Nature* (New York: Zone, 1999).

41. See Carol Jean Fresia, "Quacksalvers and Barber-Surgeons: Images of Medical Practitioners in 17th-Century Dutch Genre Painting" (Ph.D. diss., Yale University, 1991). Fresia argues that vision was in fact the focus of many Dutch seventeenth-century paintings of surgeons (pp. 162–63). Also see Margaret Pelling, "The Body's Extremities: Feet, Gender, and the Iconography of Healing in Seventeenth-Century Sources," in *The Task of Healing: Medicine, Religion and Gender in England and the*

Netherlands 1450–1800, ed. Hilary Marland and Margaret Pelling (Rotterdam: Erasmus Publishing, 1996).

42. This division was less sharp in seventeenth-century Holland than in England and France. See Harold J. Cook, *The Trials of an Ordinary Doctor: Joannes Groenevelt in Seventeenth-Century London* (Baltimore: Johns Hopkins University Press, 1994), chap. 3. See also Frank Huisman, "Medicine and Health Care in the Netherlands, 1500–1800," in *A History of Science in the Netherlands: Survey, Themes and Reference*, ed. Klaas van Berkel, Albert van Helden, and Lodewijk Palm (Leiden: Brill, 1999). Margaret Pelling, "Medicine since 1500," in *Information Sources in the History of Science and Medicine*, ed. Pietro Corsi and Paul Weindling (London: Butterworth Scientific, 1983), p. 389, discusses the variety of practitioners available.

43. Ch. Thiels, "De Leidse chirurgijns en hun kamer boven de waag," *Nederlands Kunsthistorisch Jaarboek* 31 (1980): 227.

44. Leiden Gemeentearchief, Gasthuizen 273, Stukken betreffende het verzoek van de apothekers tot uitbreiding van den gildebrief, 1669.

45. Leiden Gemeentearchief, Gasthuizen 271, Stukken betreffende de beweging van de apothekers tegen het leveren van medicamenten door de geneesheeren, 1647. For the Amsterdam apothecaries' guild, see J. G. van Dillen, ed., *Bronnen tot de Geschiedenis van het Bedrijfsleven en het Gildewezen van Amsterdam*, 3 vols. (The Hague: Martinus Nijhoff, 1929–74).

46. Amsterdam Gemeentearchief, Collegium medicum, PA 27/20, fol. 3, Register of practicing doctors; and PA 27/17, Register of the Inspectors of the Collegium medicum, 1651 and 1652.

47. Amsterdam Gemeentearchief, Collegium medicum, PA 27/63.

48. Frank Huisman, "Itinerant Medical Practitioners in the Dutch Republic: The Case of Groningen," *Tractrix* 1 (1989): 72–73. See also W. Stoeder, *Geschiedenis der Pharmacie in Nederland* (Schiedam: Schie-Pers, 1974), for example, p. 33. On quackery in other parts of Europe, see Roy Porter, *Health for Sale: Quackery in England 1660–1850* (Manchester: Manchester University Press, 1989).

49. Gouda and Rotterdam panel painters separated from other guildsmen in 1609; those in Utrecht and Delft in 1611, in Amersfoort in 1630, and in Alkmaar in 1631. In 1631 the Haarlem Guild of St. Luke was reorganized so that panel painters occupied the top of a new hierarchy. It was not until 1653 that the Amsterdam panel painters formed a separate brotherhood. See E. Taverne, "Salomon de Bray and the Reorganization of the Haarlem Guild of St. Luke in 1631," *Simiolus* 6 (1972–73): 50–66; and G. J. Hoogewerff, *De Geschiedenis van de St. Lucasgilden in Nederland* (Amsterdam: P. N. Van Kampen & Zoon, 1947).

50. Later writers followed de Lairesse's and Houbraken's assessment of Brouwer. Because sight was believed to be the most powerful of the senses, painters were often portrayed (in their own paintings and in literature) to be especially susceptible to seduction through the senses. A proverb expressed it: "hoe schilder hoe wilder" [the more a painter, the wilder]. On sense of sight, see Lairesse, *Het Groot Schilderboek*, vol. 1, p. 107; and on painters seduced by the senses, see Hans-Joachim Raupp, *Untersuchungen zu Künstlerbildnis und Künstlerdarstellung in den Niederlanden im 17. Jahrhundert* (Hildesheim: Georg Olms, 1984), p. 313. Adriaen van der Werff's father withdrew him temporarily from his painting apprenticeship after he had read Karel van Mander's *Schilder-Boeck*, apparently because the lives of some of the painters recounted by van Mander were too wild for this Dutch miller. Barbara

Gaehtgens, *Adriaen van der Werff 1659–1722* (Munich: Deutscher Kunstverlag, 1987), p. 42. On the habit of northern artists to portray themselves as rogues and profligates, see H. Perry Chapman, "Jan Steen's Household Revisited," *Simiolus* 20 (1990–91): 183–96.

51. Rubens acquired seventeen paintings by Brouwer, and Rembrandt owned eight as well as an album of Brouwer's drawings. Gerard Knuttel, *Adriaen Brouwer: The Master and His Work* (The Hague: L. J. C. Boucher, 1962), pp. 14, 23. Already in 1632 Brouwer's works were being copied, and two of his customers had him authenticate his paintings before a notary.

52. Cornelis de Bie, *Het Gulden Cabinet vande edel vry schilder Const* (Antwerp, 1661) (facs. repr. Soest: Davaco, 1971), pp. 91–92.

53. Van den Branden, quoted in Knuttel, *Adriaen Brouwer*, p. 21.

54. His patrons in Antwerp were government officials, merchants, and jurists. Horst Scholz, *Brouwer Invenit: Druckgraphische Reproduktionen des 17. bis 19. Jahrhunderts nach Gemaelde und Zeichnungen Adriaen Brouwers* (Marburg: Jonas Verlag, 1985), p. 41.

55. Scholz, *Brouwer Invenit*, pp. 33–37; this point, p. 34. According to Lyckle de Vries, "The Changing Face of Realism," in *Art in History, History in Art*, ed. David Freedberg and Jan de Vries (Santa Monica: Getty Center for the History of Art and the Humanities, 1991), p. 240 n. 40, in "Mey-clacht" Adriaen van de Venne equated poems containing peasant subjects with "genre" paintings and saw both as fulfilling didactic aims. There is a great deal of literature on how to interpret "genre" paintings. See, for example, Peter Hecht, "Dutch Seventeenth-Century Genre Painting: A Reassessment of Some Current Hypotheses," *Simiolus* 21 (1992): 85–93; Hans-Joachim Raupp, "Ansätze zu einer Theorie der Genremalerei in den Niederlanden im 17. Jahrhundert," *Zeitschrift für Kunstgeschichte* 46 (1983): 410–18.

56. G. A. Brederode, "Boeren Geselschap," *Boertigh Liedt-boeck in Groot Lied-boeck* (Amsterdam, 1622), p. 5.

57. Peter Burke, *Popular Culture in Early Modern Europe* (London: Temple Smith, 1978).

58. Franciscus dele Boë, Sylvius, *Oratio inauguralis de hominis cognitione* (1658), reprinted with facing Dutch translation in *Opuscula Selecta Neerlandicorum de Arte Medica*, 19 vols. (Amsterdam: Nederlandsch Tijdschrift voor Geneeskunde, 1907–63), vol. 6 (1927), p. 36.

59. The *vanitas* elements of flower and fruit paintings is well-trodden ground. A 1604 print by Jan Theodor de Bry, after a flower piece by Jacob Kempener, carried the inscription "Flos speculum vitae modo vernat et interit aura" [The flower is a mirror of life, she blossoms but perishes in the wind]. Ben Broos, ed., *Great Dutch Paintings from America* (Zwolle: Waanders, 1991), p. 144. See B. A. Heezen-Stoll's excellent article "Een vanitasstilleven van Jacques de Gheyn II uit 1621: Afspiegeling van neostoische denkbeelden," *Oud Holland* 93 (1979): 217–50. Jan C. Rupp, "Matters of Life and Death: The Social and Cultural Conditions of the Rise of Anatomical Theatres, with Special Reference to Seventeenth Century Holland," *History of Science* 28 (1990): 272–73, sees the ethos of the *vanitas* painting and the call for temperance as characteristic both of Leiden artists and scholars at Leiden University and finds evidence for this in the ornamentation of the Leiden anatomy theater.

60. Schama regards this message as deriving from the intersection of humanism and Calvinism in the Lowlands. Schama, *The Embarrassment of Riches*, esp. p. 42. For a recent overview, see Jonathan I. Israel, *The Dutch Republic: Its Rise, Greatness, and Fall 1477–1806* (Oxford: Clarendon Press, 1995), esp. chap. 24.

61. See Günter Abel, *Stoizismus und frühe Neuzeit* (Berlin: Walter de Gruyter, 1978); and Gerhard Oestreich, *Geist und Gestalt des frühmodernen Staates* (Berlin: Duncker & Humblot, 1969).

62. Werner Welzig, "Constantia und barocke Beständigkeit," *Deutsche Vierteljahrsschrift für Literaturwissenschaft und Geistesgeschichte* 35 (1961): 429.

63. Sylvius, *Oratio inauguralis*, p. 28.

64. Ibid., p. 40.

65. Ibid., pp. 6, 28–30, 45.

66. Ibid., p. 25.

67. Laurens J. Bol, *Die Holländische Marinemalerie des 17. Jahrhunderts* (Braunschweig: Klinkhardt & Biermann, 1973), p. 231.

68. Eric Jan Sluijter has recently argued that Sylvius owned Dou's *Quacksalver* and Dou's elegant 1663 self-portrait. Sluijter, "All Striving to Adorne Their Houses."

69. The first thorough analysis of this painting was made in 1963 by J. A. Emmens, later published as "*De Kwaksalver*: Gerrit Dou (1613–1675)," in *Kunsthistorische Opstellen*, 2 vols. (Amsterdam: van Oorschot, 1981), vol. 2. Eddy J. de Jong disseminated this interpretation in the exhibition catalog *Tot Lering en Vermaak: Betekenissen van Hollandse genrevoorstellingen uit de zeventiende eeuw* (Amsterdam: Rijksmuseum, 1976), pp. 87–89; in keeping with the "lering" (moralizing) theme of the exhibition, he sees this painting as admonishing the viewer to make a choice between right and wrong (the dead and live trees refer to the difficulty and dangers of decision making). "Right" was represented by the painter who was the honest artisan as opposed to the "wrong" and dishonest artifice of the quack and his deceptive appeal to the senses. Since then, Eric J. Sluijter has emphasized the deceptive intention and self-consciousness of the painter but still sees the painting as an appeal to an upper-class viewer looking at the innocence and stupidity of an inferior type and thus as an admonishment about the proper course of life. Eric J. Sluijter, *De lof der schilderkunst. Over schilderijen van Gerrit Dou (1613–1675) en een traktaat van Philips Angel uit 1642* (Hilversum: Verloren, 1993), pp. 72–73. In *The Art of Describing: Dutch Art in the Seventeenth Century* (Chicago: University of Chicago Press, 1983), Svetlana Alpers sees the work as descriptive rather than prescriptive, illustrating that favorite aphorism of the early modern period: "mundus vult decipi" [the world wishes to be deceived]. In his treatment of the theme, according to Alpers, Dou excepts no one—not even himself—from those who are engaging in deception and being deceived (pp. 116–18).

70. Dou's works were the costliest paintings in seventeenth-century Holland.

71. For information on *Woman at Her Toilette*, see Eric J. Sluijter, "'Een stuck waerin een jufr. voor de spiegel van Gerrit Douw,'" *Antiek* 23 (1988): 150–61, who comments on the ambiguity of this painting. A woman before a mirror could connote vanity and idleness but also self-knowledge. In the background of this painting is a portrait of a man with a resemblance to Dou's self-portrait of 1663, in which he depicts himself as a well-to-do gentleman. As we saw in *The Quack*, Dou's self-aware viewpoint and the pride in his craft in this painting are also clear. For the moral significance of the pitcher in this painting, see Ella Snoep-Reitsma, "De Waterzuchtige Vrouw van Gerard Dou en de betekenis van de lampetkan," in *Album Amicorum J. G. van Gelder*, ed. J. Bruyn et al. (The Hague: Martinus Nijhoff, 1973). In the 1678 inventory of the house belonging to Jean Rouyer (i.e., one of Sylvius's heirs), five of Dou's paintings are described as being enclosed in cases or enclosed with painted doors. Three sets of these painted doors are described: the hermit had a song painted on

the doors, a man's portrait had doors painted with a fountain and hares, and the doors of the *Woman at Her Toilette* depicted a nursing woman by candlelight.

72. The visitor to Sylvius's house also saw a night piece by Eglon van der Neer (1634?–1703) in the entryway. The Leiden followers of Dou became especially proficient at such paintings. Peter Hecht, *De Hollandse Fijnschilders van Gerard Dou tot Adriaen van der Werff* (Amsterdam: Gary Schwartz, 1989), p. 60; and Walter Melion, *Shaping the Netherlandish Canon: Karel van Mander's Schilder-Boeck* (Chicago: University of Chicago Press, 1991), pp. 73–77. See also recent exhibition catalogs, especially Roni Baer, "Life and Work of Gerrit Dou," in *Gerrit Dou 1613–1675* (Washington, D.C.: National Gallery of Art, 2000); and Annegret Laabs, *The Leiden Fijnschilders from Dresden* (Zwolle: Waanders, 2001).

73. Moreover, in these paintings of scenes lit by candles, Sylvius may have seen his own theory that human life can be compared to a torch because both need a certain kind of "oil" from the air in order to live. Sylvius, *Oratio inauguralis*, p. 20.

74. See the discussion of *A Man Holding a Large Roemer* in Otto Naumann, *Frans van Mieris (1635–1681) the Elder*, 2 vols. (Doornspijk: Davaco, 1981), vol. 2, pp. 87–88.

75. Arnold Houbraken, *De groote schouburgh der Nederlantsche konstschilders en schilderessen* (Amsterdam: 1718–19), describes the agreement between van Mieris and Sylvius. See Naumann, *Frans van Mieris*, vol. 1, pp. 25, 138. For Sylvius and the grand duke of Tuscany, see Hoogewerff, *De Twee Reizen*, pp. 251 ff, 309–12.

76. Joachim von Sandrart, *L'Academia Tedesca, oder, Teutsche Academie der Edlen Bau- Bild- und Mahlerey-Kunste*, 2 vols. (Nuremberg: Jacob von Sandrart, 1675–79), vol. 2, pp. 320–21. On Dou, see Willem Martin, *Het Leven en de Werken van Gerrit Dou* (Leiden: S. C. van Doesburgh, 1901); and idem, *Gerard Dou. Des Meisters Gemälde* (Stuttgart: Deutsche Verlags-Anstalt, 1913).

77. Willem Martin, "The Life of a Dutch Artist in the Seventeenth Century," *Burlington Magazine* 7 (1905): 125–31, 416–25; 8 (1905): 13–24; 10 (1906): 144–54, 363–70; 11(1907): 357–69. On an apprentice's training, see 7 (1905): 128; for painting landscapes from life, see 10 (1906): 363.

78. J. A. Emmens, "A Seventeenth-Century Theory of Art: Nature and Practice," *Delta* 12 (1969): 30–40. Although it is not his main point, Hessel Miedema, "Over het realisme in de Nederlandse schilderkunst van de zeventiende eeuw," *Oud Holland* 89 (1975): 2–18, brings forward a great deal of evidence about the importance of "practice" and "experience" to seventeenth-century Dutch artists. See also David Kunzle, "The Art of Pulling Teeth in the Seventeenth and Nineteenth Centuries: From Public Martyrdom to Private Nightmare and Political Struggle?" in *Fragments for a History of the Human Body*, ed. Michel Feher with Ramona Naddaff and Nadia Tazi (Cambridge, Mass.: Zone, 1989), part 3, p. 41.

79. Sandrart, *L'Academia Tedesca*, vol. 2, pp. 320–21. Mariët Westermann, *A Worldly Art: The Dutch Republic 1585–1718* (New York: Harry N. Abrams, 1996), pp. 79, 88–90, comments eloquently on the combination of verisimilitude and artifice in Dutch paintings. The paintings by the *fijnschilders* that "mirrored nature" effaced their handiwork at the same time they called attention to the painters' virtuosity. See also Eric J. Sluijter, "Hoe realistisch is de Noordnederlandse schilderkunst van de zeventiende eeuw? De problemen van een vraagstelling," *Leidschrift* 6 (1990): 5–39.

80. Sluijter, *De lof der schilderkunst*, p. 20. In his review of Peter Hecht's book, Sluijter also quotes Angel's phrases to describe the proper end of painting: "'schijn eyghentlijcke kracht,'" "'na-by-kominghe nae 't leven,'" "'schijn sonder sijn.'" In 1672 a contemporary of Dou, Van Leeuwen, wrote of his work: "'dewelke soodanige volmaaktheid . . . in seer nette kleinheid weet aan te brengen, dat sijn maaksels soo, gelyk as eygen werd, ende van het leven nauwlijks is te onderscheyden.'" Eric J. Sluijter, "Over fijnschilders en 'betekenis.' Naar aanleiding van Peter Hecht, *De Hollandse fijnschilders*," *Oud Holland* 105 (1991): 50.

81. "alsdann soll er dieselbe an natürliche Dinge legen / und sich aufs höchste befleissen / damit obigs jedes zum genauesten beobachtet werde / und alles mit der Natur völlig einstimme." Sandrart, *L'Academia Tedesca*, vol. 1, p. 61.

82. "De Schilderkonst is een wetenschap, om alle ideen, ofte denkbeelden, die de gansche zichtbaere nat-uer kan geven, te verbeelden: en met omtrek en verwe het oog te bedriegen. Zy is volmaekt, wannerze het eynde, daer Parrasius van roemde, bereikt. . . . Want een volmaekte Schildery is als een spiegel van de Natuer, die de dingen, die niet en zijn, doet schijnen te zijn, en op een geoorlofde vermakelijke en prijslijke wijze bedriegt." Samuel van Hoogstraten, *Inleyding tot de hooge Schoole der Schilderkonst: Anders de Zichtbaere Wereldt* (Rotterdam, 1678) (facs. repr., Holland: Davaco, 1969), pp. 24–25.

83. "Zag Zeuxis dit banket, hy wierd al weer bedroogen: / Hier leit geen verf, maer geest en leven op 't paneel. / Dou schildert niet, o neen, hy goochelt met 't penseel." Quoted in Sluijter, *De lof der schilderkunst*, p. 20.

84. Bie, *Het Gulden Cabinet*, p. 404. De Bie also discusses art as an imitation of nature on pp. 396–401.

85. Both quotations, the second citing van Mander, from Melion, *Shaping the Netherlandish Canon*, p. 30.

86. Hoogstraten, *Inleyding*, p. 33.

87. Willen Goeree, *Inleyding tot d'Algemeene Teykenkonst* (1668), chap. 10; quoted in Paul Taylor, "The Con-cept of *Houding* in Dutch Art Theory," *Journal of the Warburg and Courtauld Institutes* 55 (1992): 211.

88. Gaehtgens, *Adriaen van der Werff*, p. 112.

89. Hoogstraten, *Inleyding*, pp. 35, 274. On the training of Dutch artists, see Marten Jan Bok, "'Nulla dies sine linie.' De opleiding van schilders in Utrecht in de eerste helft van de zeventiende eeuw," *De zeventiende eeuw* 6 (1990): 58–68.

90. Hoogstraten, *Inleyding*, p. 36.

91. There was a fascination with the prices that could be commanded by Dou and van Mieris. All Netherlandish writers on art mentioned the prices. See Eric J. Sluijter, introduction to *Leidse Fijn-schilders van Gerrit Dou tot Frans van Mieris de Jonge 1630–1760*, ed. Eric J. Sluijter et al. (Zwolle: Waanders, 1988), pp. 26 ff. On his death, Dou was extraordinarily wealthy. Martin, *Het Leven*, p. 83.

92. Gaehtgens, *Adriaen van der Werff*, p. 70.

93. Bie, *Het Gulden Cabinet*, p. 268. Hendrik Goltzius also expressed this. His motto was "Eer boven Golt" [honor above gold], but this did not mean he scorned wealth. On the contrary, in several of his prints, he portrayed profit as the straightforward result of labor and diligence. See R. W. Scheller, "Rembrandt en de encyclopedische Kunstkamer," *Oud Holland* 84 (1969): 136.

94. Sandrart, *L'Academia Tedesca*, vol. 2, p. 321. Adriaen van der Werff continued this mode of reckoning into the eighteenth century. Gaehtgens, *Adriaen van der Werff*, p. 67.

95. See Sluijter et al., *Leidse Fijnschilders*, p. 28. "Het werckende ghedacht van Mieris als een mier is." Bie, *Het Gulden Cabinet*, p. 405.

96. Sluijter, *De lof der schilderkunst*, p. 25.

97. Hoogstraten, *Inleyding*, p. 351.

98. Netherlandish self-portraits were also the first to show the artist looking out of the picture at the beholder. Raupp, *Untersuchungen zu Künstlerbildnis*, p. 245. Out of 121 surviving paintings by Frans van Mieris, thirty-one are of his own face (although this does not make them self-portraits). Sluijter et al., *Leidse Fijnschilders*, p. 133.

99. Svetlana Alpers and her students Walter Melion and Celeste Brusati argue persuasively that Dutch painters were concerned to display their artisanal ability in their paintings. See Alpers, *The Art of Describing*, chap. 3, esp. p. 100; Melion, *Shaping the Netherlandish Canon*, pp. 37, 59, and passim; and Celeste Brusati, "Stilled Lives: Self-Portraiture and Self-Reflection in Seventeenth-Century Netherlandish Still-Life Painting," *Simiolus* 20 (1990–91): 168–82.

100. Quoted in Svetlana Alpers, *The Making of Rubens* (New Haven: Yale University Press, 1995), p. 34 n. 16.

101. De Lairesse suggested that a gray bas-relief and some realistic-looking coats of arms adorn the walls of the entryway. Sylvius displayed his own coat of arms. Lairesse, *Het Groot Schilderboek*, vol. 2, p. 72. In 1658 Sir William Sanderson prescribed rustic figures for the entry hall. Loughman and Montias, *Public and Private Spaces*, p. 40.

102. Lairesse, *Het Groot Schilderboek*, vol. 2, p. 71.

103. For a succinct discussion of the meaning of these still lifes, see Simon Schama, "Perishable Commodities: Dutch Still-Life Painting and the 'Empire of Things,'" in *Consumption and the World of Goods*, ed. John Brewer and Roy Porter (London: Routledge, 1994).

104. According to the notarial description, Sylvius's series had octagonal frames. A group of paintings, ascribed to Molenaer, apparently formed part of a series and could have been framed in such a way. Three paintings in this series are extant and in private hands. For reproductions of these three paintings, see the auction catalogs Christie's East, 17 December 1981 (for *Smell*); Bonhams, 13 December 1979, nr. 139 (*Taste*); and Sotheby Parke Bernet, New York, 13 December 1978, nr. 45 (*Hearing*). My thanks to Dennis Weller for assistance in locating this series. Dr. Weller does not believe this series is by Molenaer because its quality is not nearly as high as the Mauritshuis paintings. It is unlikely that the Mauritshuis series belonged to Sylvius, as its rectangular panels would probably not have been placed in octagonal frames. Dennis P. Weller, "Jan Miense Molenaer (c. 1609/1610–1668): The Life and Art of a Seventeenth-Century Dutch Painter" (Ph.D. diss., University of Maryland, College Park, 1992), argues that the influence or even collaboration of Molenaer's wife, Judith Leyster, is evident in the Mauritshuis series.

105. Johan de Brune, *Emblemata of Sinne-werck* (Amsterdam, 1624), p. 17.

106. Sylvius saw marriage as the foundation of society. Sylvius, *Oratio inauguralis*, p. 23n. For the tradition of the five senses in art, see Carl Nordenfalk, "The Five Senses in Flemish Art Before 1600," in *Netherlandish Mannerism*, ed. Görel Cavalli-Björkman (Stockholm: Nationalmuseum, 1985); and idem, "The Five Senses in Late Medieval and Renaissance Art," *Journal of the Warburg and Courtauld Institutes* 48 (1985): 1–22.

107. This was especially true as a result of instruments such as the microscope, which showed that the surface appearance was no indicator of the interior, a point made by Catherine Wilson, *The Invisible World: Early Modern Philosophy and the Invention of the Microscope* (Princeton: Princeton University Press, 1995), pp. 58–62.

108. On facts, see Mary Poovey, *A History of the Modern Fact: Problems of Knowledge in the Sciences of Wealth and Society* (Chicago: University of Chicago Press, 1998); and Barbara J. Shapiro, *A Culture of Fact: England, 1550–1720* (Ithaca: Cornell University Press, 2000).

109. On natural history, see Paula Findlen, *Possessing Nature* (Berkeley: University of California Press, 1994); Harold J. Cook, "The Cutting Edge of a Revolution? Medicine and Natural History near the Shores of the North Sea," in *Renaissance and Revolution: Humanists, Scholars, Craftsmen and Natural Philosophers in Early Modern Europe*, ed. J. V. Field and Frank A. J. L. James (Cambridge: Cambridge University Press, 1993); and N. Jardine, J. A. Secord, and E. C. Spary, eds., *Cultures of Natural History* (Cambridge: Cambridge University Press, 1996).

110. This proposal for curricula in different faculties was made in 1575 by a professor of theology, Gulielmus Feugueraeus; quoted in Harm Beukers, "Clinical Teaching in Leiden from Its Beginning until the End of the Eighteenth Century," *Clio Medica* 21 (1987–88): p. 139. On Leiden University, see Scheurleer and Meyjes, *Leiden University in the Seventeenth Century*; Edward G. Ruestow, *Physics at Seventeenth- and Eighteenth-Century Leiden: Philosophy and the New Science in the University* (The Hague: Martinus Nijhoff, 1973); and Anthony Grafton, "Civic Humanism and Scientific Scholarship at Leiden," in *The University and the City from Medieval Origins to the Present*, ed. Thomas Bender (Oxford: Oxford University Press, 1988).

111. "alle zijne 'tsamen vergaerde seltsaemheden, zo van cruyden, vruchten, spruytsels, gedierten, schepselen, mineralen, aerden, veninen, gesteenten, marmeren, coralen, etc. ende andere, die hy heeft." Quoted in Klaas van Berkel, "Citaten uit het boek der natuur: Zeventiende-eeuwse Nederlandse naturalienkabinetten en de ontwikkeling van de natuurwetenschap," in *De wereld binnen handbereik: Nederlandse kunst- en rariteitenverzamelingen, 1585–1735*, ed. Ellinoor Bergvelt and Renée Kistemaker (Zwolle: Waanders, 1992), pp. 185, 170. In his inventory of his collection, Paludanus constantly repeated the phrase about his objects, "as one can see in my collection," thereby marking his collection off as "demonstrated to the eye," in contrast to empty tales brought back from foreign lands (ibid. p. 175).

112. Claudia Swan, *The Clutius Botanical Watercolors* (New York: Harry N. Abrams, 1998); idem, "Lectura-Imago-Ostensio. The Role of the *Libri Picturati* Al. 18–A.30 in Medical Instruction at the Leiden University," in *Natura. Cultura. L'intepretatione del mondo fisico nei testi e nelle imagini*, ed. Guiseppe Olmi and Lucia Tongiorgi Tomasi (Florence: L. Oschki, 1999).

113. Florence Hopper, "Clusius' World: The Meeting of Science and Art," in *The Authentic Garden: A Symposium on Gardens*, ed. Leslie Tjon Sie Fat and Erik de Jong (Leiden: Clusius Stichting, 1991), p. 17.

114. Sir Robert Sibbald, the first professor of medicine in Edinburgh and founder of the Royal College of Physicians there, arrived in Leiden as a student in 1660 and stayed for a year and a half, during which time he saw twenty-three human bodies dissected by Sylvius. See *The Memoirs of Sir Robert Sibbald (1641–1722)*, ed. Francis Paget Hett (Oxford: Oxford University Press, 1932), p. 57.

115. Quoted in Allen Debus, *Man and Nature in the Renaissance* (Cambridge: Cambridge University Press, 1978), p. 135.

116. Andrew Wear, "William Harvey and the 'Way of the Anatomists,'" *History of Science* 21 (1983): 223–49.

117. Erik de Jong, "Nature and Art: The Leiden Hortus as 'Musaeum,'" in *The Authentic Garden*, ed. Tjon Sie Fat and Jong .

118. See King, *The Road to Medical Enlightenment*, p. 97; and Gerrit A. Lindeboom, "Dog and Frog: Physiological Experiments at Leiden during the Seventeenth Century," in *Leiden University in the Seventeenth Century*, ed. Scheurleer and Meyjes, p. 290.

119. Marie Boas, "Acid and Alkali in Seventeenth Century Chemistry," *Archives Internationales d'histoire des Sciences* 34 (1956): 13–28.

120. On this subject, see Steven Shapin, "Robert Boyle and Mathematics: Reality, Representation, and Experimental Practice," *Science in Context* 2 (1988): 23–58; Frances Willmoth, *Sir Jonas Moore: Practical Mathematics and Restoration Science* (Suffolk: Boydell Press, 1993); and Peter Dear, *Discipline and Experience: The Mathematical Way in the Scientific Revolution* (Chicago: University of Chicago Press, 1995).

121. In the preface of the *Micrographia* (London, 1665), and in "An Attempt to Prove the Motion of the Earth by Observations" and "Animadversions on the *Machina Coelestis* of Johannes Hevelius" (1679), in *The Cutler Lectures of Robert Hooke: Early Science in Oxford*, 15 vols., ed. R. T. Gunther (Oxford: Oxford University Press, 1931), vol. 8, Hooke argues that the senses are weak and urges the use of instruments to overcome them. In "The Present State of Natural Philosophy" and "Of the True Method of Building a Solid Philosophy, or of a Philosophical Algebra," *Posthumous Works . . . containing his Cutlerian Lectures and other Discourses* (London: Samuel Smith and Benjamin Walford, 1705), Hooke puts forward principles for overcoming the deficiencies of the senses by the use of disciplined observation and experimentation. See James A. Bennett, "The Mechanics' Philosophy and the Mechanical Philosophy," *History of Science* 24 (1986): 1–28.

122. Sylvius, *Oratio inauguralis*, p. 6. At the end of his inaugural oration, he reaffirmed his commitment to the ancients: "Erit enim ubique mihi amicus Socrates, et amicus Plato, sed magis amica veritas" [Socrates and Plato will always be my friends, but my greater friend is truth] (p. 45). Making appeal to ancient authorities was especially important at Leiden, where Aristotelianism had been reaffirmed in the violent debates over Cartesianism in the early seventeenth century, but Aristotelianism showed itself a flexible philosophy, and by the 1650s Cartesianism had become quite widespread in the Dutch universities. See Theo Verbeek, *Descartes and the Dutch: Early Reactions to Cartesian Philosophy 1637–1650* (Carbondale: Southern Illinois University Press, 1992); and McGahagan, "Cartesianism in the Netherlands."

123. Sylvius, *Oratio inauguralis*, pp. 8–10.

124. See King, *The Road to Medical Enlightenment*, pp. 96–97, for examples of this.

125. Sylvius, *Oratio inauguralis*, p. 16.

126. Henry Oldenburg, *Correspondence*, 13 vols., ed. A. Rupert Hall and Marie Boas Hall (Madison: University of Wisconsin Press, 1965–96), vol. 4, pp. 69–70.

127. Camphuysen, *Stichtelycke rymen* (1647), p. 224; quoted in Eric J. Sluijter, "Didactic and Disguised Meanings?" in *Art in History*, ed. Freedberg and de Vries, pp. 188–89.

128. Schama, *The Embarrassment of Riches*, p. 47. There was an explosion of literature and visual depictions on the passions in the late sixteenth and seventeenth centuries. See Stephen Gaukroger, ed., *The Soft Underbelly of Reason: The Passions in the Seventeenth Century* (London: Routledge, 1998).

129. Susan James recounts the ways in which ideas about action and passion began to collapse in the seventeenth century into a view that "desires are the principal passionate antecedents of action" and govern all actions. James, *Passion and Action*, p. 291. Dutch republican writers took over this view of the passions. They regarded the passions as the basis of human conduct and believed that self-interest could be a force for economic prosperity and public harmony. See Harold J. Cook, "Body and Passions: Materialism and the Early Modern State," *Osiris* 17, "Science and Civil Society," ed. Lynn K. Nyhart and Thomas H. Broman (2002): 25–48.

130. Hoogstraten, *Inleyding*, pp. 109–10. For discussions of the depiction of the passions in art, see Jennifer Montagu, *The Expression of the Passions: The Origin and Influence of Charles le Brun's 'Conférence sur l'expression générale et particulière'* (New Haven: Yale University Press, 1994); and Christopher Allen, "The *Passions de l'Âme* as a Basis for Pictorial Expression," in *The Soft Underbelly*, ed. Gaukroger.

131. Franciscus dele Boë, Sylvius, *Opera Medica* (Geneva, 1695), p. 398.

132. Ibid., pp. 398–99.

133. Ibid., p. 398.

134. Sylvius, "De Spiritum Animalium in Cerebro, Cerebelloque Confectione, per Nervos Distributio, atque Usu Vario," a disputation held by Sylvius in 1660 and printed in Franciscus dele Boë, *Disputationum Medicarum pars prima. Primarias Corporis Humani Functiones Naturales ex Anatomicis, Practicis & Chymicis Experimentis deductas complectens* (Amsterdam: Johann van den Bergh, 1663), pp. 57–58.

135. I take this phrase from James, *Passion and Action*, p. 183. See also John Sutton, "Controlling the Passions: Passion, Memory, and the Moral Physiology of Self in Seventeenth-Century Neurophilosophy," in *The Soft Underbelly*, ed. Gaukroger.

136. For discussions about the development of an "objective," impartial science in the seventeenth century, see Steven Shapin and Simon Schaffer, *Leviathan and the Air-Pump: Hobbes, Boyle and the Experimental Life* (Princeton: Princeton University Press, 1985); Steven Shapin, *A Social History of Truth: Civility and Science in Seventeenth-Century England* (Chicago: University of Chicago Press, 1994); Lorraine Daston, "Baconian Facts, Academic Civility, and the Prehistory of Objectivity," *Annals of Scholarship* 8 (1991): 337–63; Daston and Park, *Wonders and the Order of Nature*; and Wilson, *The Invisible World*, who sees instruments as central in the development of this ideal.

137. On the body, see Werner Kutschmann, *Der Naturwissenschaftler und sein Körper: Die Rolle der 'inneren Natur' in der experimentellen Naturwissenschaft der frühen Neuzeit* (Frankfurt am Main: Suhrkamp, 1986), particularly chap. 5. Simon Schaffer, "Self-Evidence," *Critical Inquiry* 18 (1992): 327–62. Lissa Roberts, "The Death of the Sensuous Chemist," *Studies in the History and Philosophy of Science* 26 (1995): 503–29, recounts the rise of the importance of the precision balance as a way to replace the bodily techniques and direct sensory engagement with matter of earlier French chemists.

138. Descartes believed that the passions were not bad by nature but must be kept under control, for which he offered various methods. Descartes, *The Passions*, in *The Philosophical Writings*, vol. 1, passim, but succinctly stated on p. 403. See also Peter Dear, "A Mechanical Microcosm: Bodily Passions,

Good Manners, and Cartesian Mechanism," in *Science Incarnate: Historical Embodiments of Natural Knowledge*, ed. Christopher Lawrence and Steven Shapin (Chicago: University of Chicago Press, 1998); Simon Schaffer, "Regeneration: The Body of Natural Philosophers in Restoration England," in ibid.; and Rob Iliffe, "Isaac Newton: Lucatello Professor of Mathematics," in ibid. For Boyle, see Shapin, *A Social History of Truth*, esp. chap. 4. Peter Harrison, "Reading the Passions: The Fall, the Passions, and Dominion over Nature," in *The Soft Underbelly*, ed. Gaukroger, argues that in the seventeenth century, particularly in Bacon's discussion of the Idols, mastery of the passions was extended from dominion over the individual self to dominion over the natural world, which had been lost at the Fall.

139. Sylvius, *Oratio inauguralis*, pp. 38–45. When in Amsterdam, Sylvius had attempted to set up a group of investigators. He underscored his hope for such groups again in *A New Idea of the Practice of Physic*, trans. Richard Gower (London, 1675), p. 405: "Which things lying hid, yet to be found out by the multitude of Observations, and to be brought to light by the help of Ingenuity, I wish the Royal Societies, appointed by the Authority of Great Kings, and without doubt abundantly instructed with necessary helps to absolve such a matter, would not forbear to take pains useful to the Commonwealth."

140. Sylvius, *A New Idea*, preface, n.p.

141. Thomas Sprat, *History of the Royal Society* (London, 1667), pp. 33–34.

142. See Shapin, *A Social History of Truth*; and J. R. Jacob, *Robert Boyle and the English Revolution* (New York: Burt Franklin, 1977).

143. Sylvius, *Oratio inauguralis*, p. 44.

144. Ibid., p. 32.

145. Ibid., pp. 34, 42.

146. Sylvius felt he had to prove to his calumniators that his chemistry and his teaching were "both profitable and useful to Mankind." Sylvius, *A New Idea*, preface. Boyle's remarks to this effect are quoted in Malcolm Oster, "The Scholar and the Craftsman Revisited: Robert Boyle as Aristocrat and Artisan," *Annals of Science* 49 (1992): 265.

147. Beukers, "Het Laboratorium," pp. 35–36, notes that the items recorded in Sylvius's laboratory indicate the preparation of medicines as well as chemical experimentation.

148. Oster, "The Scholar and the Craftsman Revisited"; Shapin, *A Social History of Truth*, chap. 8; Lawrence Principe, *The Aspiring Adept: Robert Boyle and His Alchemical Quest* (Princeton: Princeton University Press, 1998); Rob Iliffe, "Material Doubts: Hooke, Artisan Culture and the Exchange of Information in 1670s London," *British Journal for the History of Science* 28 (1995): 285–318; Klaas van Berkel, "Intellectuals against Leeuwenhoek: Controversies about the Method and Style of a Self-Taught Scientist," in *Antoni van Leeuwenhoek 1632–1723*, ed. L. C. Palm and H. A. M. Snelders (Amsterdam: Rodopi, 1982). For Becher, see Smith, *The Business of Alchemy*. See also James R. Jacob, "'By an Orphean Charm': Science and the Two Cultures in Seventeenth-Century England," in *Politics and Culture in Early Modern Europe: Essays in Honor of H. G. Koenigsberger*, ed. Phyllis Mack and Margaret C. Jacob (Cambridge: Cambridge University Press, 1987); and Margaret C. Jacob, *The Cultural Meaning of the Scientific Revolution* (New York: Alfred A. Knopf, 1988). Rebecca Bushnell, "Experience, Truth, and

Natural History in Early English Gardening Books," in *The Historical Imagination in Early Modern Britain: History, Rhetoric, and Fiction, 1500–1800*, ed. Donald R. Kelley and David Harris Sacks (Cambridge: Cambridge University Press, 1997), charts the transition in natural history by which "experience associated with local knowledge was more likely to be seen as vulgar error (by the end of the seventeenth century), in contrast with the scientists' controlled and carefully circumscribed trials" (pp. 193–94). Simon Schaffer, "Experimenters' Techniques, Dyers' Hands, and the Electric Planetarium," *Isis* 88 (1997): 456–83, shows the way in which these distinctions between natural philosophers and craftsmen continued to be important into the eighteenth century.

149. Quoted in Rosamond D. Harley, *Artists' Pigments c. 1600–1835: A Study in English Documentary Sources* (London: Butterworth & Co., 1970), p. 35.

150. Ibid., p. 35. See also William Eamon, *Science and the Secrets of Nature: Books of Secrets in Medieval and Early Modern Culture* (Princeton: Princeton University Press, 1994), p. 344, for the reluctance of artisans to participate in the history of trades project.

151. Joseph Moxon, preface to *Mechanick Exercises or the Doctrine of Handy-Works* (first published in parts in 1683, 1693, 1703), facs. repr., ed. Charles F. Montgomery (New York: Praeger Publishers, 1970).

152. Cipriano Piccolpasso, *The Three Books of the Potter's Art* (ca. 1558), 2 vols., trans. Ronald Lightbown and Alan Caiger-Smith (London: Scholar Press, 1980), vol. 2, pp. 6–7.

153. Iliffe, "Material Doubts," p. 317.

154. Robert Boyle, *The Works of the Honourable Robert Boyle*, 6 vols., ed. Thomas Birch (London: J. & F. Rivington, 1772), vol. 3, pp. 442 ff.

155. Sprat, *History of the Royal Society*, p. 396.

156. Berkel, *In het voetspoor*, p. 35.

157. Lisa Rosner, *Medical Education in the Age of Improvement* (Edinburgh: Edinburgh University Press, 1991), p. 38, notes the status consciousness of Edinburgh Professor John Gregory, a student of Herman Boerhaave (Sylvius's successor at Leiden), who feared that a practitioner might easily prove more efficacious than a physician: "A gentleman can declaim on the causes of diseases, but [if] he was never conversant with the sick, he is embarrassed with his erudition, and perplexed in cases, in which an apothecary's assistant would find no difficulty."

158. Francis Bacon, *The Great Instauration*, in *Novum Organum with Other Parts of The Great Instauration*, trans. and ed. Peter Urbach and John Gibson (Chicago: Open Court, 1994), p. 21.

159. Ibid., p. 8.

160. Bacon, *Novum Organum*, bk. I, aphorism 74, p. 84.

161. Ibid., bk. I, aphorism 73, p. 82.

162. Ibid., bk. I, aphorism 124, p. 126.

163. Ibid., bk. I, aphorism 73, p. 83.

164. Ibid., bk. I, aphorism 3, p. 43.

165. Bacon, *Great Instauration*, in *Novum Organum*, p. 24.

166. Bacon, *Novum Organum*, bk. I, aphorism 83, p. 92.

167. Ibid., bk. I, aphorism 5, p.44.

168. Ibid., bk. I, aphorism 73, p. 83.

169. Ibid., bk. I, aphorism 99, p. 108.

170. Bacon, *Great Instauration*, in *Novum Organum*, p. 12.

171. Bacon, *Novum Organum*, bk. I, aphorism 98, p. 107.

172. Bacon gives an example of his method in his investigation of the form of heat. Ibid., bk. II, aphorism 11, pp. 144 ff.

173. Ibid., bk. I, aphorism 101, p. 109.

174. Christiaan Huygens and Jonas Witsen both learned to use a lathe as part of their education. Jaap van der Veen, "Dit klain Vertrek bevat een Weereld vol gewoel: Negentig Amsterdammers en hun kabinetten," in *De wereld binnen handbereik*, ed. Bergvelt and Kistemaker, p. 255. In the eighteenth century, Lorenz Spengler (1720–1807) combined a position of instructor in lathe work to the Danish royal family in Copenhagen and director of the king's *Kunstkammer*. See Penelope M. Gouk, "The Union of Arts and Science in the Eighteenth Century: Lorenz Spengler (1720–1807), Artistic Turner and Natural Scientist," *Annals of Science* 40 (1983): 411–36.

175. See Dorothea Diemer, "Giovanni Ambrogio Maggiore und die Anfänge der Kunstdrechselei um 1570," *Jahrbuch des Zentralinstituts für Kunstgeschichte* 1 (1985): 295–342; Joseph Connors, "Ars Tornandi: Baroque Architecture and the Lathe," *Journal of the Warburg and Courtauld Institutes* 53 (1990): 217–36; and Klaus Maurice, *Der Drechselnde Souverän* (Zurich: Verlag Ineichen, 1985). For a wonderful treatment of artisanship and lathe working, see Walter S. Melion, "Love and Artisanship in Hendrick Goltzius's *Venus, Bacchus and Ceres* of 1606," *Art History* 16 (1993): 60–94. As Thomas DaCosta Kaufmann points out, Goltzius was probably making a reference to alchemy rather than lathe turning in *Without Ceres and Bacchus, Venus Would Freeze (Self-Portrait with Venus, Ceres and Bacchus)* but Melion's points about Goltzius's artisanry and the lathe remain valid. Thomas DaCosta Kaufmann, "Kunst und Alchemie," in *Moritz der Gelehrte. Ein Renaissancefürst in Europa*, ed. Heiner Borggrefe, Thomas Fusenig, and Anne Schunicht-Rawe (Eurasburg: Edition Minerva, 1997), pp. 375–76. See also Silvio A. Bedini, "A Renaissance Lapidary Lathe," in *Patrons, Artisans and Instruments of Science, 1600–1750* (Brookfield, Vt.: Ashgate, 1999).

176. This is indicated in the exchange of telling epithets by Descartes and Pierre Gassendi, Descartes calling Gassendi "flesh" for his bodily empiricism and Gassendi calling Descartes "mind" for his rationalism. Lisa Sarasohn, *Gassendi's Ethics: Freedom in a Mechanistic Universe* (Ithaca: Cornell University Press, 1996), p. 86. Sylvius seems to have shared this ambivalence to Descartes's philosophy, publicly criticizing him but at the same time incorporating Cartesian ideas into his medical theory. See McGahagan, "Cartesianism in the Netherlands," p. 13; and Verbeek, *Descartes and the Dutch*, pp. 72–73. Descartes's own ideas on the interaction of body and mind were not those of the pure rationalist that he has been made out to be since at least the eighteenth century. See Stephen Gaukroger, *Descartes: An Intellectual Biography* (Oxford: Clarendon Press, 1995).

177. Harm Beukers, "Mechanistische Principes bij Franciscus dele Boë, Sylvius," *Tijdschrift voor de geschiedenis der geneeskunde, natuurwetenschappen, wiskunde en techniek* 5 (1982): 6–15. For the discomfort the vital principle in matter aroused among experimental philosophers in the seventeenth century, see John Henry, "Occult Qualities and the Experimental Philosophy: Active Principles in Pre-Newtonian Matter Theory," *History of Science* 24 (1986): 335–81.

CONCLUSION

1. Stephen Gaukroger, *Francis Bacon and the Transformation of Early-Modern Philosophy* (Cambridge: Cambridge University Press, 2001), pp. 226, 221.

2. Edwin Hutchins, *Cognition in the Wild* (Cambridge: MIT Press, 1995); and G. Salomon, ed., *Distributed Cognitions: Psychological and Educational Considerations* (Cambridge: Cambridge University Press, 1993). See also Seth Chaiklin and Jean Lave, eds., *Understanding Practice: Perspectives on Activity and Context* (Cambridge: Cambridge University Press, 1993); and Yrjö Engeström and David Middleton, eds., *Cognition and Communication at Work* (Cambridge: Cambridge University Press, 1996).

3. Jean Lave and Etienne Wenger, *Situated Learning: Legitimate Peripheral Participation* (Cambridge: Cambridge University Press, 1991), p. 122.

4. As discussed in chapter 4. See the essays in David Brokensha, D. M. Warren, and Oswald Werner, eds., *Indigenous Knowledge Systems* (Washington, D.C.: University Press of America, 1980).

+++

Bibliography

Abel, Günter. *Stoizismus und frühe Neuzeit*. Berlin: Walter de Gruyter, 1978.

Ackerman, James S. "Dürer's Crab." In *Ars Auro Prior. Studia Ioanni Bialostocki sexagenario dedicata*. Warsaw: Panstwowe Wydawn. Nauk., 1981.

———. "Early Renaissance 'Naturalism' and Scientific Illustration." In *The Natural Sciences and the Arts: Aspects of Interaction from the Renaissance to the Twentieth Century: An International Symposium*, edited by Allan Elle- nius. Uppsala: Almqvist & Wiksell, 1985.

———. "The Involvement of Artists in Renaissance Science." In *Science and the Arts in the Renaissance*, edited by John W. Shirley and F. David Hoeniger. Washington, D.C.: Folger Shakespeare Library, 1985.

———. "Science and Art in the Work of Leonardo." In *Leonardo's Legacy*, edited by C. D. O'Malley. Berkeley: University of California Press, 1969.

———. "Science and Visual Art." In *Seventeenth Century Science and the Arts*, edited by Hedley Howell Rhys. Princeton: Princeton University Press, 1961.

Agricola, Georgius. *De re metallica*. Translated by Herbert Clark Hoover and Lou Henry Hoover. New York: Dover, 1950.

Agrippa, Henrie Cornelius. *Of the Vanitie of Artes and Sciences*. 1530. Translated by James Sandford. London, 1569.

Ahonen, Kathleen W. F., s.v. "Glauber." In *Dictionary of Scientific Biography*, 18 vols., edited by Charles Gillispie, vol. 5. New York: Scribner, 1970–86.

———. "Johann Rudolph Glauber: A Study of Animism in Seventeenth-Century Chemistry." Ph.D. diss, University of Michigan, 1972.

AHR Forum on the Renaissance, *American Historical Review* 103, no. 1 (1998).

Aikema, Bernard, and Beverly Louise Brown. *Renaissance Venice and the North: Crosscurrents in the Time of Bellini, Dürer and Titian.* Milan: Bompiani, 1999.

Ainsworth, Maryan W. "The Business of Art: Patrons, Clients, and Art Markets." In *From Van Eyck to Bruegel: Early Netherlandish Painting in the Metropolitan Museum of Art,* edited by Maryan W. Ainsworth and Keith Christiansen. New York: Harry Abrams, 1998.

Ainsworth, Maryan W., and Keith Christiansen, eds. *From Van Eyck to Bruegel: Early Netherlandish Painting in the Metropolitan Museum of Art.* New York: Harry Abrams, 1998.

Alberti, Leon Battista. *On Painting.* 1436. Translated by John R. Spencer. New Haven: Yale University Press, 1966.

De Albums van Anselmus de Boodt (1550–1632). Geschilderde natuurobservatie an het Hof van Rudolf II te Praag. Belgium: Lannoo, 1989.

Allbutt, Thomas Clifford. "Palissy, Bacon, and the Revival of Natural Science." *Proceedings of the British Academy* (1913–14): 234–47.

Allen, Christopher. "The *Passions de l'Âme* as a Basis for Pictorial Expression." In *The Soft Underbelly: The Passions in the Seventeenth Century,* edited by Stephen Gaukroger. London: Routledge, 1998.

Alpers, Svetlana. *The Art of Describing: Dutch Art in the Seventeenth Century.* Chicago: University of Chicago Press, 1983.

———. *The Making of Rubens.* New Haven: Yale University Press, 1995.

———. "No Telling, with Tiepolo." In *Sight and Insight: Essays on Art and Culture in Honour of E. H. Gombrich at 85,* edited by John Onians. London: Phaidon, 1994.

Amelang, James S. *The Flight of Icarus: Artisan Autobiography in Early Modern Europe.* Stanford: Stanford University Press, 1998.

Ames-Lewis, Francis. *The Intellectual Life of the Early Renaissance Artist.* New Haven: Yale University Press, 2000.

Amico, Leonard N. *Bernard Palissy: In Search of Earthly Paradise.* Paris: Flammarion, 1996.

Angerer, Martin. "Das Ornament in der deutschen Goldschmiedekunst von der Spätgotik bis zum Klassizismus." In *Deutsche Goldschmiedekunst vom 15, bis zum 20. Jahrhundert aus dem Germanischen Nationalmuseum,* edited by Klaus Pechstein et al. Berlin: Verlag Willmuth Arenhövel, 1987.

Anon. Alchemical Ms. GER 1472, Edelstein Collection, Hebrew University.

Anon. "De arte crucifixi Pelagij Solitarij," sixteenth-century, British Library, Harleian MS 181.

Aristotle. *Meteorologica.* Translated by H. D. P. Lee. Cambridge: Harvard University Press, 1952.

———. *Physics.* Translated by P. H. Wicksteed and F. M. Cornford. Cambridge: Harvard University Press, 1929.

Bacon, Francis. *Novum Organum with Other Parts of The Great Instauration.* Translated and edited by Peter Urbach and John Gibson. Chicago: Open Court, 1994.

Baer, Roni. "Life and Work of Gerrit Dou." In *Gerrit Dou 1613–1675.* Washington, D.C.: National Gallery of Art, 2000.

Baker, Malcolm. "Limewood, Chiromancy and Narratives of Making: Writing about the Materials and Processes of Sculpture." *Art History* 21 (1998): 498–530.

Bambach, Carmen C. *Drawing and Painting in the Italian Renaissance Workshop: Theory and Practice, 1300–1600*. Cambridge: Cambridge University Press, 1999.

Bandman, Günter. "Bemerkungen zu einer Ikonologie des Materials." *Städel-Jahrbuch*, NF 2 (1969): 75–100.

Barclay, Robert. *The Art of the Trumpet-Maker*. Oxford: Clarendon Press, 1992.

Barker, Emma, Nick Webb, and Kim Woods, eds. *The Changing Status of the Artist*. New Haven: Yale University Press, 1999.

Bauer, A. *Chemie und Alchymie in Österreich bis zum beginnenden 19. Jahrhundert*. Vienna, 1883.

Baumann, E. D. *François dele Boe, Sylvius*. Leiden: E. J. Brill, 1949.

Baumann, Felix Andreas. *Das Erbario Carrarese und die Bildtradition des Tractatus de herbis*. Bern: Benteli Verlag, 1974.

Baxandall, Michael. "The Bearing of the Scientific Study of Vision on Painting in the 18th Century: Pieter Camper's De Visu (1746)." In *The Natural Sciences and the Arts: Aspects of Interaction from the Renaissance to the 20th Century*, edited by Allan Ellenius. Stockholm: Almqvist & Wiksell, 1985.

———. "Guarino, Pisanello and Manuel Chrysoloras." *Journal of the Warburg and Courtauld Institutes* 28 (1965): 183–204.

———. "Hubert Gerhard and the Altar of Christoph Fugger: The Sculpture and Its Making." *Münchner Jahrbuch der bildenden Kunst*, ser. 3, vol. 17 (1966): 127–44.

———. *The Limewood Sculptors of Renaissance Germany*. New Haven: Yale University Press, 1980.

———. *Painting and Experience in Fifteenth-Century Italy*. Oxford: Oxford University Press, 1972.

Bedel, Charles. "L'Enseignement des sciences pharmaceutiques." In *Ensignement et diffusion des sciences en France au XVIIIe siècle*, edited by René Taton. Paris: Hermann, 1964.

Bedini, Silvio A. *Patrons, Artisans, and Instruments of Science, 1600–1750*. Brookfield, Vt.: Ashgate Variorum, 1999.

———. "The Role of the Automata in the History of Technology." In *Patrons, Artisans, and Instruments of Science, 1600–1750*. Brookfield, Vt.: Ashgate Variorum, 1999.

Beier, Lucinda McCray. "Experience and Experiment: Robert Hooke, Illness and Medicine." In *Robert Hooke: New Studies*, edited by Michael Hunter and Simon Schaffer. Woodbridge: Boydell, 1989.

Bellucci, Roberto, and Cecilia Frosinini. "Piero della Francesca's Process: Panel Painting Technique." In *Painting Techniques: History, Materials and Studio Practice*, edited by Ashok Roy and Perry Smith. London: International Institute for Conservation of Historic and Artistic Works, 1998.

Belozerskaya, Marina. *Rethinking the Renaissance: Burgundian Arts across Europe*. Cambridge: Cambridge University Press, 2002.

Belshaw, Deryke. "Taking Indigenous Technology Seriously: The Case of Inter-Cropping Techniques in East Africa." In *Indigenous Knowledge Systems*, edited by David Brokensha, D. M. Warren, and Oswald Werner. Washington, D.C.: University Press of America, 1980.

Belting, Hans, and Christiane Kruse. *Die Erfindung des Gemäldes: Das erste Jahrhundert der niederländischen Malerei*. Munich: Hirmer Verlag, 1995.

Benesch, Otto. *Der Maler Albrecht Altdorfer*. 3rd ed. Vienna: Verlag Anton Schroll & Co., 1940.

Bennett, James A. "The Challenge of Practical Mathematics." In *Science, Culture, and Popular Belief in Renaissance Europe*, edited by Stephen Pumfrey, Paolo Rossi, and Maurice Slawinski. Manchester: Manchester University Press, 1991.

——. "The Mechanics' Philosophy and the Mechanical Philosophy." *History of Science* 24 (1986): 1–28.

Bennett, James A., and Scott Mandelbrote. *The Garden, the Ark, the Tower, the Temple: Biblical Metaphors of Knowledge in Early Modern Europe*. Oxford: Museum of the History of Science, 1998.

Berkel, Klaas van. "Citaten uit het boek der natuur: Zeventiende-eeuwse Nederlandse naturalienkabinetten en de ontwikkeling van de natuurwetenschap." In *De wereld binnen handbereik: Nederlandse kunst- en rariteitenverzamelingen, 1585–1735*, edited by Ellinoor Bergvelt and Renée Kistemaker. Zwolle: Waanders, 1992.

——. *In het voetspoor van Stevin. Geschiedenis van de natuurwetenschap in Nederland 1580–1940*. Amsterdam: Boom Meppel, 1985.

——. "Intellectuals against Leeuwenhoek: Controversies about the Method and Style of a Self-Taught Scientist." In *Antoni van Leeuwenhoek 1632–1723*, edited by L. C. Palm and H. A. M. Snelders. Amsterdam: Rodopi, 1982.

——. *Isaac Beeckman (1588–1637) en de Mechanisering van het Werelbeeld*. Amsterdam: Rodopi, 1983.

Beukers, Harm. "Clinical Teaching in Leiden from Its Beginning until the End of the Eighteenth Century." *Clio Medica* 21 (1987–88): 139–52.

——. "Het Laboratorium van Sylvius." *Tijdschrift voor de geschiedenis der geneeskunde, natuurwetenschappen, wiskunde en techniek* 3 (1980): 28–36.

——. "Mechanistische Principes bij Franciscus dele Boë, Sylvius." *Tijdschrift voor de geschiedenis der geneeskunde, natuurwetenschappen, wiskunde en techniek* 5 (1982): 6–15.

Bewer, Francesca G. "'Kunststück von gegossenem Metall': Adriaen de Vries's Bronze Technique." In *Adriaen de Vries (1556–1626), Imperial Sculptor*, edited by Frits Scholten. Zwolle: Waanders, 1998.

——. "The Sculpture of Adriaen de Vries: A Technical Study." In *Small Bronzes in the Renaissance*, edited by Debra Pincus. Washington, D.C.: Center for Advanced Study in the Visual Arts, 2001.

Bialostocki, Jan. "The Renaissance Concept of Nature and Antiquity." In *The Renaissance and Mannerism: Studies in Western Art*, 4 vols., Acts of the Twentieth International Congress of the History of Art, vol. 2. Princeton: Princeton University Press, 1963.

Bie, Cornelis de. *Het Gulden Cabinet vande edel vry schilder Const*. Antwerp, 1661. Facs. repr. Soest: Davaco, 1971.

Biringuccio, Vannoccio. *Pirotechnia*. 1540. Translated by Cyril Stanley Smith and Martha Teach Gnudi. Cambridge: Harvard University Press, 1966.

Blockmans, Wim, and Walter Prevenier. *The Promised Lands: The Low Countries under Burgundian Rule, 1369–1530*. Translated by Elizabeth Fackelman. Philadelphia: University of Pennsylvania Press, 1999.

Blumenberg, Hans. "Nachahmung der Natur." *Studium Generale* 10 (1957): 266–83.

Boas, Marie. "Acid and Alkali in Seventeenth Century Chemistry." *Archives Internationales d'histoire des Sciences* 34 (1956): 13–28.

Boë, Franciscus dele. *Disputationum Medicarum pars prima. Primarias Corporis Humani Functiones Naturales ex Anatomicis, Practicis & Chymicis Experimentis deductas complectens*. Amsterdam: Johann van den Bergh, 1663.

——. *A New Idea of the Practice of Physic*. Translated by Richard Gower. London, 1675.

——. *Opera Medica*. Geneva, 1695.

——. *Oratio inauguralis de hominis cognitione*. 1658. Reprinted with facing Dutch translation in *Opuscula Selecta Neerlandicorum de Arte Medica*. 19 vols. Vol. 6 (1927). Amsterdam: Nederlandsch Tijdschrift voor Geneeskunde, 1907–63.

Böhme, Jakob. *Aurora oder Morgenröthe im Aufgang, das ist, Die Wurzel oder Mutter der Philosophie, Astrologie und Theologie aus rechtem Grunde, oder Beschreibung der Natur.* 1620. In *Sämmtliche Werke.* 7 vols. Edited by K. W. Schiebler, vol. 2. Leipzig: Johannes Ambrosius Barth, 1832.

———. *De Electione Gratiae, oder von der Gnaden wahl, oder dem Willen Gottes über die Menschen.* 1623. In *Sämmtliche Werke.* 7 vols. Edited by K. W. Schiebler, vol. 4. Leipzig: Johannes Ambrosius Barth, 1832.

Bok, Marten Jan. "'Nulla dies sine linie.' De opleiding van schilders in Utrecht in de eerste helft van de zeventiende eeuw." *De zeventiende eeuw* 6 (1990): 58–68.

Bol, Laurens J. *Die Holländische Marinemalerie des 17. Jahrhunderts.* Braunschweig: Klinkhardt & Biermann, 1973.

Bono, James. *The Word of God and the Languages of Man: Interpreting Nature in Early Modern Science and Medicine.* Madison: University of Wisconsin Press, 1995.

Borggrefe, Heiner, Thomas Fusenig, and Anne Schunicht-Rawe, eds. *Moritz der Gelehrte. Ein Renaissancefürst in Europa.* Eurasburg: Edition Minerva, 1997.

Boström, Antonia. "Daniele da Volterra and the Equestrian Monument of Henry II of France." *Burlington Magazine* 137 (1995): 809–20.

Boyle, Robert. *The Works of the Honourable Robert Boyle.* 6 vols. Edited by Thomas Birch. London: J. & F. Rivington, 1772.

Bredekamp, Horst. "Die Erde als Lebewesen." *Kritische Berichte* 8 (1981): 5–37.

———. *The Lure of Antiquity and the Cult of the Machine.* Translated by Allison Brown. Princeton: Markus Wiener, 1995.

Brederode, G. A. *Boertigh Liedt-boeck in Groot Lied-boeck.* Amsterdam, 1622.

Bredius, A. "Bijdragen tot de Levensgeschiedenis van Hendrick Goltzius." *Oud-Holland* 32 (1914): 137–46.

Breger, Herbert. "*Elias Artista*—A Precursor of the Messiah in Natural Science." In *Nineteen Eighty-Four: Science between Utopia and Dystopia,* edited by Everett Mendelsohn and Helga Nowotny. New York: D. Reidel, 1984.

Brewer, John, and Roy Porter, eds. *Consumption and the World of Goods.* London: Routledge, 1994.

Brokensha, David, D. M. Warren, and Oswald Werner, eds. *Indigenous Knowledge Systems.* Washington, D.C.: University Press of America, 1980.

Broos, Ben, ed. *Great Dutch Paintings from America.* Zwolle: Waanders, 1991.

Brown, Edward. *Naukeurige en Gedenkwaardige Reysen van Edward Brown.* Translated by Jacob Leeuw. Amsterdam: Jan ten Hoor, 1682.

Brune, Johan de. *Emblemata of Sinne-werck.* Amsterdam, 1624.

Brusati, Celeste. "Stilled Lives: Self-Portraiture and Self-Reflection in Seventeenth-Century Netherlandish Still-Life Painting." *Simiolus* 20 (1990/91): 168–82.

Brush, Stephen B. "Potato Taxonomies in Andean Agriculture." In *Indigenous Knowledge Systems,* edited by David Brokensha, D. M. Warren, and Oswald Werner. Washington, D.C.: University Press of America, 1980.

Buettner, Brigitte. "Past Presents: New Year's Gifts at the Valois Courts, ca. 1400." *Art Bulletin* 83 (2001): 598–625.

Burke, Peter. *Popular Culture in Early Modern Europe.* London: Temple Smith, 1978.

Bushnell, Rebecca. "Experience, Truth, and Natural History in Early English Gardening Books." In *The Historical Imagination in Early Modern Britain: History, Rhetoric, and Fiction, 1500–1800*, edited by Donald R. Kelley and David Harris Sacks. Cambridge: Cambridge University Press, 1997.

Butters, Suzanne B. *The Triumph of Vulcan: Sculptors' Tools, Porphyry, and the Prince in Ducal Florence*. 2 vols. Florence: Leo S. Olschki, 1996.

Bynum, Caroline Walker. *Fragmentation and Redemption: Essays on Gender and the Human Body in Medieval Religion*. New York: Zone, 1992.

———. *Jesus as Mother: Studies in the Sprituality of the High Middle Ages*. Berkeley: University of California Press, 1982.

Calvesi, Maurizio. *La melencolia di Albrecht Dürer*. Turin: G. Einaudi, 1993.

Camille, Michael. "Visual Art in Two Manuscripts of the Ars Notoria." In *Conjuring Spirits: Texts and Traditions of Medieval Ritual Magic*, edited by Claire Fanger. Phoenix Mill: Sutton, 1998.

Campbell, Lorne. *The Fifteenth Century Netherlandish Schools*. London: National Gallery Publications, Yale University Press, 1998.

Camporesi, Piero. *Juice of Life: The Symbolic and Magic Significance of Blood*. Translated by Robert R. Barr. New York: Continuum, 1995.

Carlino, Andrea. *Books of the Body: Anatomical Ritual and Renaissance Learning*. Translated by John Tedeschi and Anne C. Tedeschi. Chicago: University of Chicago Press, 1999.

Carpo, Mario. *Architecture in the Age of Printing*. Cambridge: MIT Press, 2001.

———. *L'architettura dell'età della stampa. Oralità, scrittura, libro stampato e riproduzione meccanica dell'imagine nella storia delle teorie architettoniche*. Milan: Jaca Book, 1998.

Carter, D. G. "Reflections on Armor in the 'Canon van der Paele Madonna.'" *Art Bulletin* 36 (1954): 60–62.

Cartographia Bavariae. Bayern im Bild der Karte. Bayerische Staatsbibliothek Austellungskatalogue 44. Weissenhorn: Anton H. Konrad Verlag, 1988.

Cassirer, Ernst. *The Individual and the Cosmos in Renaissance Philosophy*. Translated by Mario Domandi. Philadelphia: University of Pennsylvania Press, 1963.

Cellini, Benvenuto. *Autobiography*. Translated by George Bull. London: Penguin, 1956.

———. *The Two Treatises on Goldsmithing and Sculpture*. Translated by C. R. Ashbee. New York: Dover, 1967.

Cennini, Cennino d'Andrea. *The Craftsman's Handbook; the Italian "Il Libro dell'Arte."* Translated by Daniel V. Thompson Jr. New York: Dover, 1960.

Chaiklin, Seth, and Jean Lave, eds. *Understanding Practice: Perspectives on Activity and Context*. Cambridge: Cambridge University Press, 1993.

Chapman, H. Perry. "Jan Steen's Household Revisited." *Simiolus* 20 (1990/91): 183–96.

Chartier, Roger. "Culture as Appropriation." In *Understanding Popular Culture: Europe from the Middle Ages to the Nineteenth Century*, edited by Steven L. Kaplan. Berlin: Mouton, 1984.

Christie, J. R. R. "The Paracelsian Body." In *Paracelsus: The Man and His Reputation, His Ideas, and Their Transformation*, edited by Ole Peter Grell. Leiden: Brill, 1998.

Claussen, Peter Cornelius. "materia und opus—Mittelalterliche Kunst auf der Goldwaage." In *Ars naturam adiuvans. Festschrift für Matthias Winner*, edited by Victoria V. Flemming and Sebastian Schütze. Mainz: Verlag Philipp von Zabern, 1996.

——. "Nachrichten von den Antipoden oder der mittelalterliche Künstler über sich selbst." In *Der Künstler über sich in seinem Werk. Internationales Symposium der Bibliotheca Hertziana, Rom, 1989*, edited by Matthias Winner. Weinheim: VCH, Acta Humaniora, 1992.

Clegg, Arthur. "Craftsmen and the Origin of Science." *Science and Society* 43 (1979): 186–201.

Clément, Ad, and J. W. S. Johnsson, eds. "Briefwechsel zwischen J. R. Glauber und Otto Sperling." *Janus* 29 (1925): 210–33.

Close, A. J. "Commonplace Theories of Art and Nature in Classical Antiquity and in the Renaissance." *Journal of the History of Ideas* 30 (1969): 467–86.

Clucas, Stephen. "The Correspondence of a XVII-Century 'Chymicall Gentleman': Sir Cheney Culpeper and the Chemical Interests of the Hartlib Circle." *Ambix* 40 (1993): 147–70.

Cole, Michael. "Cellini's Blood." *Art Bulletin* 81 (1999): 215–35.

Connors, Joseph. "Ars Tornandi: Baroque Architecture and the Lathe." *Journal of the Warburg and Courtauld Institutes* 53 (1990): 217–36.

Cook, Harold J. "Body and Passions: Materialism and the Early Modern State." *Osiris* 17, "Science and Civil Society," edited by Lynn K. Nyhart and Thomas H. Broman (2002): 25–48.

——. "The Cutting Edge of a Revolution? Medicine and Natural History near the Shores of the North Sea." In *Renaissance and Revolution: Humanists, Scholars, Craftsmen and Natural Philosophers in Early Modern Europe*, edited by J. V. Field and Frank A. J. L. James. Cambridge: Cambridge University Press, 1993.

——. "The New Philosophy in the Low Countries." In *The Scientific Revolution in National Context*, edited by Roy Porter and Mikulas Teich. Cambridge: Cambridge University Press, 1992.

——. "Time's Bodies: Crafting the Preparation and Preservation of Naturalia." In *Merchants and Marvels: Commerce, Science, and Art in Early Modern Europe*, edited by Pamela H. Smith and Paula Findlen. New York: Routledge, 2002.

——. *The Trials of an Ordinary Doctor: Joannes Groenevelt in Seventeenth-Century London*. Baltimore: Johns Hopkins University Press, 1994.

Croll, Oswald. *Basílica Chymica*. Frankfurt, 1609.

Crombie, A. C. "Science and the Arts in the Renaissance: The Search for Truth and Certainty, Old and New." *History of Science* 18 (1980): 233–46.

——. *Styles of Scientific Thinking in the European Tradition*. 3 vols. London: Duckworth, 1994.

Crosby, Alfred W. *The Measure of Reality: Quantification and Western Society, 1250–1600*. Cambridge: Cambridge University Press, 1997.

Crossick, Geoffrey, ed. *The Artisan and the European Town, 1500–1900*. Brookfield, Vt.: Ashgate, 1997.

Dalucas, Elisabeth. "Ars erit Archetypus Naturae. Zur Ikonologie der Bronze in der Renaissance." In *Von Allen Seiten Schön. Bronzen der Renaissance und des Barock*, edited by Volker Krahn. Katalog zur Ausstellung der Skulpturensammlung der Staatlichen Museen zu Berlin—Preußischer Kulturbesitz im Alten Museum, Berlin. Heidelberg: Edition Braus, 1995.

Daston, Lorraine. "Baconian Facts, Academic Civility, and the Prehistory of Objectivity." *Annals of Scholarship* 8 (1991): 337–63.

——. "Curiosity in Early Modern Science." *Word & Image* 11, no. 4 (1995): 391–404.

——. "The Nature of Nature in Early Modern Europe." *Configurations* 6 (1998): 149–72.

Daston, Lorraine, and Katharine Park. *Wonders and the Order of Nature*. New York: Zone, 1999.

Dear, Peter. *Discipline and Experience: The Mathematical Way in the Scientific Revolution*. Chicago: University of Chicago Press, 1995.

———. "A Mechanical Microcosm: Bodily Passions, Good Manners, and Cartesian Mechanism." In *Science Incarnate: Historical Embodiments of Natural Knowledge*, edited by Christopher Lawrence and Steven Shapin. Chicago: University of Chicago Press, 1998.

Debus, Allen. *The Chemical Philosophy*. 2 vols. New York: Science History Publications, 1977.

———. *Man and Nature in the Renaissance*. Cambridge: Cambridge University Press, 1978.

Dell'Arco, Maurizio Fagiolo. *Il Parmigianino. Un saggio sull'ermetismo nel Cinquecento*. Rome: M. Bulzoni, 1970.

Dempsey, Charles. "Mavors armipotens: The Poetics of Self-Representation in Poussin's 'Mars and Venus.'" In *Der Künstler über sich in seinem Werk. Internationales Symposium der Bibliotheca Hertziana, Rom, 1989*, edited by Matthias Winner. Weinheim: VCH, Acta Humaniora, 1992.

Dennis, Michael A. "Historiography of Science: An American Perspective." In *Science in the Twentieth Century*, edited by John Krige and Dominique Pestre. Amsterdam: Harwood Academic Publishers, 1997.

Descartes, René. *The Philosophical Writings*. 3 vols. Translated by John Cottingham, Robert Stoothoff, and Dugald Murdoch. Cambridge: Cambridge University Press, 1984.

Didi-Huberman, Georges. *L'Empreinte*. Paris: Centre Georges Pompidou, 1997.

Diemer, Dorothea. "Giovanni Ambrogio Maggiore und die Anfänge der Kunstdrechselei um 1570." *Jahrbuch des Zentralinstituts für Kunstgeschichte* 1 (1985): 295–342.

Dierick, A. L. "Jan van Eyck's Handwriting." In *Investigating Jan van Eyck*, edited by Susan Foister, Sue Jones, and Delphine Cool. Turnhout, Belgium: Brepols, 2000.

Dillen, J. G. van, ed. *Bronnen tot de Geschiedenis van het Bedrijfsleven en het Gildewezen van Amsterdam*. 3 vols. The Hague: Martinus Nijhoff, 1929–74.

Dixon, Laurinda S. *Alchemical Imagery in Bosch's Garden of Delights*. Ann Arbor: UMI Research Press, 1981.

———. "Bosch's Garden of Delights Triptych: Remnants of a 'Fossil' Science." *Art Bulletin* 63 (1981): 96–113.

Dobbs, B. J. T. *Alchemical Death and Resurrection: The Significance of Alchemy in the Age of Newton*. Washington, D.C.: Smithsonian Institution Libraries, 1990.

———. *The Foundations of Newton's Alchemy*. Cambridge: Cambridge University Press, 1975.

———. *The Janus Faces of Genius: The Role of Alchemy in Newton's Thought*. Cambridge: Cambridge University Press, 1991.

Doering, Oscar. "Des Augsburger Patriciers Philipp Hainhofer Beziehungen zum Herzog Philipp II von Pommern-Stettin. Correspondenzen aus den Jahren 1610–1619." *Quellenschriften für Kunstgeschichte und Kunsttechnik des Mittelalters und der Neuzeit*, NF Bd. 6. Vienna: Carl Graeser, 1894.

Doppelmayr, Johann Gabriel. *Historische Nachricht von den Nürnbergischen Mathematicis und Künstlern*. Nuremberg: Peter Conrad Monath, 1730.

Drebbel, Cornelis. *Ein kurtzer Tractat von der Natur der Elementen. Und wie sie den Windt/ Regen/ Blitz und Donner verursachen und war zu sie nutzen*. Leiden: Henrichen von Haestens, 1608.

———. *Tractat von Natur und Eigenschafft der Elementen*. Edited by Polycarpo Chrysostomo. Hoff: Johann Sigmund Strauss, 1723.

Duden, Barbara. *The Woman Beneath the Skin: A Doctor's Patients in Eighteenth-Century Germany*. Translated by Thomas Dunlap. Cambridge: Harvard University Press, 1991.

Dürer, Albrecht. *Dürers schriftlicher Nachlass*. Edited by K. Lange and F. Fuhse. Niederwalluf: Dr. Martin Sändig, 1970.

———. *Etliche Underricht zu Befestigung der Stett, Schloss und Flecken*. Nuremberg, 1527.

———. *Underweysung der Messung/ mit dem zirckel und richtscheyt/ in Linien ebnen unnd gantzen corporen/ durch Albrecht Dürer zu sammen getzogen/ und zu nutz allen kunstliebhabenden mit zu gehörigen figuren*. 1525. Facs. ed. Translated by Walter L. Strauss. New York: Abaris Books, 1977.

———. *Vier Bücher von menschlicher Proportion*, 1528. Facs. repr. Ünterschneidheim: Verlag Walter Uhl, 1969.

Eamon, William. *Science and the Secrets of Nature: Books of Secrets in Medieval and Early Modern Culture*. Princeton: Princeton University Press, 1994.

Edgerton, Samuel Y., Jr. *The Heritage of Giotto's Geometry: Art and Science on the Eve of the Scientific Revolution*. Ithaca: Cornell University Press, 1991.

———. *The Renaissance Discovery of Linear Perspective*. New York: Harper & Row, 1976.

Eeghen, I. H. van. "Het Grill's Hofje." *Jaarboek van het Genootschap Amstelodamum* 62 (1970): 49–86.

Egmond, Florike. "Natuurlijke historie en savoir prolétaire." In *Komenten, monsters en muilezels. Het veranderende natuurbeeld en de natuurwetenschap in de zeventiende eeuw*, edited by Florike Egmond, Erick Jorink, and Rienk Vermij. Haarlem: Uitgeverij Arcadia, 1999.

Eisler, Colin. *Dürer's Animals*. Washington, D.C.: Smithsonian Institution Press, 1991.

Elkins, James. "Histoire de l'art et pratiques d'atelier." *Histoire de l'Art* 29/30 (1995): 103–12.

———. "Michelangelo and the Human Form: His Knowledge and Use of Anatomy." *Art History* 7 (1984): 176–86.

———. "On the Unimportance of Alchemy in Western Painting." *Konsthistorisk tidskrift* 1, nos. 1–2 (1992): 21–26.

———. "Reply to Didier Kahn: What Is Alchemical History?" *Konsthistorisk tidskrift*. 64, no. 1 (1995): 51–53.

———. *What Painting Is: How to Think about Oil Painting Using the Language of Alchemy*. New York: Routledge, 1999.

Ellenius, Allan, ed. *The Natural Sciences and the Arts: Aspects of Interaction from the Renaissance to the 20th Century*. Stockholm: Almqvist & Wiksell, 1985.

Emmens, J. A. "*De Kwaksalver*: Gerrit Dou (1613–1675)." In *Kunsthistorische Opstellen*. 2 vols. Vol. 2. Amsterdam: van Oorschot, 1981.

———. "A Seventeenth-Century Theory of Art: Nature and Practice." *Delta* 12 (1969): 30–40.

Engeström, Yrjö, and David Middleton, eds. *Cognition and Communication at Work*. Cambridge: Cambridge University Press, 1996.

Ercker, Lazarus. *Treatise on Ores and Assaying*. 1580 ed., first publ. 1574. Translated by Anneliese Grünhaldt Sisco and Cyril Stanley Smith. Chicago: University of Chicago Press, 1951.

Eusterschulte, Anne. "Imitatio naturae. Naturverständnis und Nachahmungslehre in Malereitraktaten der frühen Neuzeit." In *Künste und Natur in Diskursen der Frühen Neuzeit*, 2 vols., edited by Hartmut Laufhütte, vol. 2. Wiesbaden: Harrassowitz Verlag, 2000.

Evans, R. J. W. *The Making of the Habsburg Monarchy*. Oxford: Clarendon Press, 1984.

———. *Rudolf II and His World: A Study in Intellectual History 1576–1612*. Oxford: Oxford University Press, 1973.

Falkenburg, Reindert, Jan de Jong, Dulcia Meijers, Bart Ramakers, and Mariët Westermann, eds. *Kunst voor de Markt, 1500–1700*. Zwolle: Waanders, 2000.

Farr, James R. *Artisans in Europe 1300–1914*. Cambridge: Cambridge University Press, 2000.

————. *Hands of Honor: Artisans and Their World in Dijon, 1550–1650*. Ithaca: Cornell University Press, 1988.

Fehl, Philipp P. "Dürer's Literal Presence in His Pictures: Reflections on His Signatures in the Small Woodcut Passion." In *Der Künstler über sich in seinem Werk. Internationales Symposium der Bibliotheca Hertziana, Rom, 1989*, edited by Matthias Winner. Weinheim: VCH, Acta Humaniora, 1992.

Feigenbaum, Gail. "Practice in the Carracci Academy." In *The Artist's Workshop*, edited by Peter M. Lukehart. Studies in the History of Art, 38, Center for Advanced Study in the Visual Arts, Symposium Papers XXII, National Gallery of Art, Washington. Hanover: University Press of New England, 1993.

Ferguson, Eugene S. *Engineering and the Mind's Eye*. Cambridge: MIT Press, 1992.

————. "The Mind's Eye: Nonverbal Thought in Technology." *Science* (1977): 827–36.

Field, J. V. *The Invention of Infinity: Mathematics and Art in the Renaissance*. Oxford: Oxford University Press, 1997.

Field, J. V., and Frank A. J. L. James, eds. *Renaissance and Revolution: Humanists, Scholars, Craftsmen and Natural Philosophers in Early Modern Europe*. Cambridge: Cambridge University Press, 1993.

Findlen, Paula. *Possessing Nature*. Berkeley: University of California Press, 1994.

Floerke, Hanns. *Die Formen des Kunsthandels, das Atelier und die Sammler in den Niederlanden vom 15.–18. Jahrhundert*. Munich: Georg Müller, 1905.

Fock, C. Willemijn. "Kunstbezit in Leiden in de 17de eeuw." In *Het Rapenburg: Geschiedenis van een Leidse gracht*, 6 vols., edited by Th. H. Lunsingh Scheurleer, C. Willemijn Fock, and A. J. van Dissel, vol. 5. Leiden: Afdeling Geschiedenis van de Kunstnijverheid, Rijksuniversiteit Leiden, 1986–92.

Foister, Susan, Sue Jones, and Delphine Cool, eds. *Investigating Jan van Eyck*. Turnhout, Belgium: Brepols, 2000.

Foister, Susan, and Susie Nash, eds. *Robert Campin: New Directions in Scholarship*. Turnhout, Belgium: Brepols, 1996.

Forssman, Erik. "Renaissance, Manierismus und Nürnberger Goldschmiedekunst." In *Wenzel Jamnitzer und die Nürnberger Goldschmiedekunst 1500–1700*. Catalog of the Germanisches Nationalmuseum, Nuremberg. Munich: Klinkhardt & Bierman, 1985.

Freedberg, David. *The Power of Images: Studies in the History and Theory of Response*. Chicago: University of Chicago Press, 1989.

————. "Science, Commerce, and Art: Neglected Topics at the Junction of History and Art History." In *Art in History, History in Art: Studies in Seventeenth Century Dutch Culture*, edited by David Freedberg and Jan de Vries. Santa Monica: Getty Center for the History of Art and the Humanities, 1991.

French, Roger. "Harvey in Holland: Circulation and the Calvinists." In *The Medical Revolution of the Seventeenth Century*, edited by Roger French and Andrew Wear. Cambridge: Cambridge University Press, 1989.

Fresia, Carol Jean. "Quacksalvers and Barber-Surgeons: Images of Medical Practitioners in 17th-century Dutch Genre Painting." Ph.D. diss., Yale University, 1991.

From Schongauer to Holbein: Master Drawings from Basel and Berlin. Washington, D. C.: National Gallery of Art, Hatje Cantz Publishers, 1999.

Fuciková, Eliska, et al. *Rudolf II and Prague: The Court and the City*. London: Thames and Hudson, 1997.

Gaehtgens, Barbara. *Adriaen van der Werff 1659–1722*. Munich: Deutscher Kunstverlag, 1987.

Gaukroger, Stephen. *Descartes: An Intellectual Biography*. Oxford: Clarendon Press, 1995.

————. *Francis Bacon and the Transformation of Early-Modern Philosophy*. Cambridge: Cambridge University Press, 2001.

——, ed. *The Soft Underbelly of Reason: The Passions in the Seventeenth Century*. London: Routledge, 1998.

Gauricus, Pomponius. *De Sculptura*. Ca. 1503. Translated by Heinrich Brockhaus. Leipzig: F. A. Brockhaus, 1886.

Geoghegan, Arthur. *The Attitude toward Labor in Christianity and Ancient Culture*. Washington, D.C.: Catholic University of America Press, 1945.

Ginzburg, Carlo. *The Cheese and the Worms: The Cosmos of a Sixteenth-Century Miller*. Translated by John Tedeschi and Anne C. Tedeschi. Reprint, Baltimore: Johns Hopkins University Press, 1992.

Glauber, Johann Rudolf. *De Elia Artista. . . .* Amsterdam: Johan Jansson van Waesberg & the widow of Elizasius Weyerstraet, 1668.

——. *Explicatio Oder Außlegung über die Wohrten Salomonis: In Herbis, Verbis, & Lapidis Magna est Virtus*. Amsterdam: Johan Jansson van Waesberg, 1663.

——. *Glauberus Concentratus oder Laboratorium Glauberianum*. Amsterdam: Johan Waesberg & the widow of Elizaeus Weyerstraet, 1668.

——. *Glauberus Redivivus*. Frankfurt a.M.: Thomas Matthias Goetzen, 1656.

——. *Gründliche und warhafftige Beschreibung Wie man auss der Weinhefen einen guten Weinstein in grosser Menge extrahiren sol*. Amsterdam, 1654.

——. *Kurtze Erklärung über die Höllische Göttin Proserpinam. . . .* Amsterdam: Johan Jansson van Waesberg & Elizaeus Weyerstraet, 1667.

——. *Miraculi Mundi Ander Theil. Oder Deßen Vorlängst Geprophezeiten Eliae Artistae Triumphirlicher Einritt. Und auch Was der ELIAS ARTISTA für einer sey? . . .* Amsterdam: Johan Jansson, 1660.

——. *Operis Mineralis*. Frankfurt a.M.: Heirs of Matthaeus Merianus, 1651.

——. *Reicher Schatz- und Sammel-Kasten Oder appendix Generalis über alle dessen herausgegebener Bücher . . .* 5 parts. Amsterdam, 1660–69.

——. *Testimonium Veritatis*. Amsterdam: Johan Jansson, 1657.

——. *Des Teutschlandts Wolfahrt*. Amsterdam: Johan Jansson, 1656.

——. *Tractatus de Natura Salium. Oder außführliche Beschreibung/ deren bekanten Salien, . . . und absonderlich von Einem/ der Welt noch gantz unbekantem wunderliche Saltze. . . .* Amsterdam: Johan Jansson, 1658.

——. *De tribus Lapidibus Ignium Secretorum. Oder von den drey Alleredelsten Gesteinen/ so durch drey Secrete Fewer gebohren werden*. Amsterdam: Johan Jansson van Waesberg & the widow of Elizaeus Weyerstraet, 1668.

Goldammer, Kurt. *Paracelsus: Natur und Offenbarung*. Hanover: Theodor Oppermann Verlag, 1953.

Goldthwaite, Richard. *Wealth and the Demand for Art in Italy, 1300–1600*. Baltimore: Johns Hopkins University Press, 1993.

Goltz, Dietlinde. "Die Paracelsisten und die Sprache." *Sudhoffs Archiv* 56 (1972): 337–52.

Gombrich, E. H. "Dürer, Vives and Breughel." In *Album Amicorum J. G. van Gelder*, edited by J. Bruyn, J. A. Emmens, E. de Jongh, and D. P. Snoep. The Hague: Martinus Nijhoff, 1973.

——. *Speis der Malerknaben: Zu den technischen Grundlagen von Dürers Kunst*. Vienna: WUV-Universitätsverlag, 1997.

——. "The Style All' Antica: Imitation and Assimilation." In *The Renaissance and Mannerism: Studies in Western Art*, 4 vols., Acts of the Twentieth International Congress of the History of Art, vol. 2. Princeton: Princeton University Press, 1963.

Gouk, Penelope M. "The Union of Arts and Science in the Eighteenth Century: Lorenz Spengler (1720–1807), Artistic Turner and Natural Scientist." *Annals of Science* 40 (1983): 411–36.

Graaf, Alexander van de. *Het De Mayerne Manuscript als Bron voor de Schildertechniek van de Barok*. Mijdrecht: Drukkerij Verweij, 1958.

Grafton, Anthony. "Civic Humanism and Scientific Scholarship at Leiden." In *The University and the City from Medieval Origins to the Present*, edited by Thomas Bender. Oxford: Oxford University Press, 1988.

Gramaccini, Norberto. "Das genaue Abbild der Natur—Riccios Tiere und die Theorie des Naturabgusses seit Cennini." In *Natur und Antike in der Renaissance*. Exhibit catalog. Frankfurt: Frankfurt Liebighaus, 1985.

Gugel, Kurt F. *Johann Rudolph Glauber 1604–1670, Leben und Werke*. Würzburg: Freunde Mainfränkische Kunst und Geschichte, 1955.

Gutfleisch, Barbara, and Joachim Menzhausen. "'How a Kunstkammer Should Be Formed': Gabriel Kaltemarckt's Advice to Christian I of Saxony on the Formation of an Art Collection, 1587." *Journal of the History of Collections* I (1989): 3–32.

Hall, A. R. "The Scholar and the Craftsman in the Scientific Revolution." In *Critical Problems in the History of Science*, edited by Marshall Clagett. Madison: University of Wisconsin Press, 1959.

Hall, Bert S. "Der Meister sol auch kennen schreiben und lesen: Writings about Technology ca. 1400–ca. 1600 A.D. and Their Cultural Implications." In *Early Technologies*, edited by Denise Schmandt-Besserat. Malibu: Undena Publications, 1979.

Halleux, Robert. "L'Alchemiste et l'essayeur." In *Die Alchemie in der europäischen Kultur- und Wissenschaftsgeschichte*, edited by Christoph Meinel. Wiesbaden: Otto Harrassowitz, 1986.

———. "Pigments et colorants dans la Mappae Clavicula." In *Pigments et colorants de l'Antiquité et du Moyen Age: Teinture, peinture, enluminure études historiques et physico-chimiques*, Colloque international du CNRS. Paris: Éditions du Centre National de la Recherche Scientifique, 1990.

Hamburger, Jeffrey F. *Nuns as Artists: The Visual Culture of a Medieval Convent*. Berkeley: University of California Press, 1997.

———. *The Rothschild Canticles: Art and Mysticism in Flanders and the Rhineland circa 1300*. New Haven: Yale University Press, 1990.

———. "The Visual and the Visionary: The Image in Late Medieval Monastic Devotions." *Viator* 20 (1989): 161–82.

Hampe, Thomas. *Nürnberger Ratsverlässe über Kunst und Künstler im Zeitalter der Spätgotik und Renaissance*. 15 vols. Quellenschriften für Kunstgeschichte und Kunsttechnik des Mittelalters und der Neuzeit, NF XI–XII. Vienna: Karl Graeser, 1904.

Hannaway, Owen. *The Chemists and the Word: The Didactic Origins of Chemistry*. Baltimore: Johns Hopkins University Press, 1975.

Hanschmann, Alexander Bruno. *Bernard Palissy der Kunstler, Naturforscher und Schriftsteller*. Leipzig: Dieterich'sche Verlagsbuchhandlung, 1903.

Harley, Rosamond D. *Artists' Pigments c. 1600–1835: A Study in English Documentary Sources*. London: Butterworth & Co. 1970.

Harrison, Peter. "Reading the Passions: The Fall, the Passions, and Dominion over Nature." In *The Soft Underbelly: The Passions in the Seventeenth Century*, edited by Stephen Gaukroger. London: Routledge, 1998.

Hartlaub, G. F. "Albrecht Dürers 'Aberglaube.'" *Zeitschrift des deutschen Vereins für Kunstwissenschaft* 7 (1940): 167–96.

———. "Arcana artis. Spuren alchemistischer Symbolik in der Kunst des 16. Jahrhunderts." *Zeitschrift für Kunstgeschichte* 6 (1937): 289–324.

———. "'Paracelsisches' in der Kunst der Paracelsuszeit." *Nova acta Paracelsica* 7 (1954): 132–63.

Hartung vom Hoff, Caspar. *Das "Kunstbüchlein" des Alchemisten Caspar Hartung vom Hoff.* 1549. Transcribed and edited by Bernhard Haage. Göppingen: Verlag Alfred Kümmerle, 1975.

Hassig, Debra. *Medieval Bestiaries: Text, Image, Ideology.* Cambridge: Cambridge University Press, 1995.

Hayward, J. F. "The Mannerist Goldsmiths: Wenzel Jamnitzer." *Connoisseur* 164, no. 1 (1967): 148–54.

Hecht, Peter. *De Hollandse Fijnschilders van Gerard Dou tot Adriaen van der Werff.* Amsterdam: Gary Schwartz, 1989.

———. "Dutch Seventeenth-Century Genre Painting: A Reassessment of Some Current Hypotheses." *Simiolus* 21 (1992): 85–93.

Heezen-Stoll, B. A. "Een vanitasstilleven van Jacques de Gheyn II uit 1621: Afspiegeling van neostoische denkbeelden." *Oud Holland* 93 (1979): 217–50.

Heller, Henry. *The Conquest of Poverty: The Calvinist Revolt in Sixteenth-Century France.* Leiden: E. J. Brill, 1986.

———. *Labour, Science and Technology in France 1500–1620.* Cambridge: Cambridge University Press, 1996.

Hendrix, Marjorie Lee. "Joris Hoefnagel and the 'Four Elements': A Study in Sixteenth-Century Nature Painting." Ph.D. diss., Princeton University, 1984.

———. "Of Hirsutes and Insects: Joris Hoefnagel and the Art of the Wondrous." *Word & Image* 11 (1995): 373–90.

Henninger-Voss, Mary J. "Between the Cannon and the Book: Mathematicians and Military Culture in Sixteenth-Century Italy," unpublished ms.

Henry, John. "Doctors and Healers: Popular Culture and the Medical Profession." In *Science, Culture and Popular Belief in Renaissance Europe,* edited by Stephen Pumfrey, Paolo L. Rossi, and Maurice Slawinksi. Manchester: Manchester University Press, 1991.

———. "Occult Qualities and the Experimental Philosophy: Active Principles in Pre-Newtonian Matter Theory." *History of Science* 24 (1986): 335–81.

Hermens, Erma, ed. *Looking through Paintings: The Study of Painting Techniques and Materials in Support of Art Historical Research.* Leids Kunsthistorisch Jaarboek. Vol. 11. London: Archetype Publications, 1998.

Hernmarck, C. "Holland and Sweden in the Seventeenth Century, Some Notes on Dutch Cultural Radiance Abroad." *Netherlands Kunsthistorisch Jaarboek* 31 (1980): 194–203.

Herzenberg, Heinrich Schickhart von. *Beschreibung Einer Raiß/ Welche der Durchleuchtig Hochgeborne Fürst unnd Herr/ Herr Friderich Hertzog zu Württemberg und Teckh /. . . . Im Jahr 1599. Selfs Neundt/ auß dem Landt zu Württemberg/ in Italiam gethan. . . . Auß Hochgedachter/ Ihrer F. Gn. gnädigem Befelch/ mit sonderm fleiß . . . an tag gegeben.* Tübingen: Erhard Cellius, 1603.

Hirsch, Rudolf. "The Invention of Printing and the Diffusion of Alchemical and Chemical Knowledge." *Chymia* 3 (1950): 115–41.

Holmyard, E. J. *Alchemy.* 1957. Reprint, New York: Dover, 1990.

Hoogewerff, G. J. *De Bentveughels.* The Hague: Martinus Nijhoff, 1952.

———. *De Geschiednis van de St. Lucasgilden in Nederland.* Amsterdam: P. N. Van Kampen & Zoon, 1947.

———. "De Nederlandsche Kunstenaars te Rome in de XVIIᵉ eeuw en hun Conflict met de Academie van St. Lucas." *Mededeelingen der koninklijke Akademie van wetenschappen* 62 (1926): 117–50.

———, ed. *De Twee Reizen van Cosimo de' Medici Prins van Toscane door de Nederlanden (1667–1669)*. Amsterdam: Johannes Müller, 1919.

Hoogstraten, Samuel van. *Inleyding tot de hooge Schoole der Schilderkonst: Anders de Zichtbaere Wereldt*. Rotterdam, 1678. Facs. repr., Holland: Davaco, 1969.

Hooke, Robert. *The Cutler Lectures of Robert Hooke: Early Science in Oxford*. 15 vols. Edited by R. T. Gunther, vol. 8. Oxford: Oxford University Press, 1931.

———. *Micrographia*. London, 1665.

———. *Posthumous Works . . . containing his Cutlerian Lectures and other Discourses*. London: Samuel Smith and Benjamin Walford, 1705.

Hooykaas, Reijer. *Humanisme, science et réforme, Pierre de la Ramée (1515–1572)*. Leiden: E. J. Brill, 1958.

———. "The Rise of Modern Science: When and Why?" *British Journal for the History of Science* 20 (1987): 453–73.

———. "Von der 'Physica' zur Physik." In *Selected Studies in History of Science*. Coimbra: Acta Universitatis Conimbrigensis, 1983.

Hopper, Florence. "Clusius' World: The Meeting of Science and Art." In *The Authentic Garden: A Symposium on Gardens*, edited by Leslie Tjon Sie Fat and Erik de Jong. Leiden: Clusius Stichting, 1991.

Houbraken, Arnold. *De groote schouburgh der Nederlantsche konstschilders en schilderessen*. Amsterdam, 1718–19.

———. *Große Schouburgh der Niederländischen Maler und Malerinnen*. Translated by Alfred von Wurzbach, 1880. Facs. repr., Osnabrück: Otto Zeller Verlag, 1970.

Huisman, Frank. "Itinerant Medical Practitioners in the Dutch Republic: The Case of Groningen." *Tractrix* 1 (1989): 63–83.

———. "Medicine and Health Care in the Netherlands, 1500–1800." In *A History of Science in the Netherlands: Survey, Themes and Reference*, edited by Klaas van Berkel, Albert van Helden, and Lodewijk Palm. Leiden: Brill, 1999.

Huizinga, Johan. *The Autumn of the Middle Ages*. Translated by Rodney J. Payton and Ulrich Mammitzsch. Chicago: University of Chicago Press, 1996.

Hunter, Michael, and Simon Schaffer, eds. *Robert Hooke: New Studies*. Woodbridge: Boydell, 1989.

Hutchins, Edwin. *Cognition in the Wild*. Cambridge: MIT Press, 1995.

Huygens, Contantijn. "Een ontwetend Medicyn." In *Zes Zedeprinten*. Utrecht: Instituut de Vooys, 1976.

Iliffe, Rob. "Isaac Newton: Lucatello Professor of Mathematics." In *Science Incarnate: Historical Embodiments of Natural Knowledge*, edited by Christopher Lawrence and Steven Shapin. Chicago: University of Chicago Press, 1998.

———. "Material Doubts: Hooke, Artisan Culture and the Exchange of Information in 1670s London." *British Journal for the History of Science* 28 (1995): 285–318.

Israel, Jonathan I. *The Dutch Republic: Its Rise, Greatness, and Fall 1477–1806*. Oxford: Clarendon Press, 1995.

Ivins, William M., Jr. *Prints and Visual Communication*. 1953. Reprint, Cambridge: MIT Press, 1969.

Jacob, James R. "'By an Orphean Charm': Science and the Two Cultures in Seventeenth-Century England." *Politics and Culture in Early Modern Europe: Essays in Honor of H. G. Koenigsberger*, edited by Phyllis Mack and Margaret C. Jacob. Cambridge: Cambridge University Press, 1987.

———. *Robert Boyle and the English Revolution.* New York: Burt Franklin, 1977.

Jacob, Margaret C. *The Cultural Meaning of the Scientific Revolution.* New York: Alfred A. Knopf, 1988.

———. "The Materialist World of Pornography." In *The Invention of Pornography: Obscenity and the Origins of Modernity, 1500–1800,* edited by Lynn Hunt. New York: Zone, 1996.

———. *The Radical Enlightenment: Pantheists, Freemasons and Republicans.* London: George Allen & Unwin, 1981.

James, Susan. *Passion and Action: The Emotions in Seventeenth-Century Philosophy.* Oxford: Clarendon Press, 1997.

Jamnitzer, Wenzel. "Das Andertheil von Beschreibung der kunstlichen Silber und Vergulten Instrumenten in dem Kunstlichen und wolgetzierten Schreibtisch fast dienstlich der Geometri und Astronomi auch anderen schönen und Nutzlichen Kunsten." 1585. Victoria and Albert Museum, MSL 1893/1601.

———. "Ein gar Kunstlicher und wolgetzierter Schreibtisch sampt allerhant Kunstlichen Silbern und vergulten newerfunden Instrumenten so darin zufinden. Zum gebrauch der Geometrischen und Astronomischen auch andern schönen und nützlichen Kunsten. Alles durch Wentzel Jamitzer Burger und Goldschmidt in Nurmberg auffs new verfertigt. Der Erst Theil." 1585. Victoria and Albert Museum, MSL 1893/1600.

———. *Perspectiva corporum regularium, Das ist ein fleyssige Fürweysung/ wie die Fünff-Regulirten Cörper darvon Plato inn Timaeo/ unnd Euclides inn sein Elementis schreibt/ etc. Durch einen sonderlichen/ newen behenden und gerechten weg/ der vor nie im gebrauch ist gesehen worden/ gar Künstlich inn die Perspectiva gebracht/ Und darzu ein schöne Anleytung/ wie auß denselbigen Fünff Cörpern one Endt/ gar viel andere Cörper/ mancherley Art und gestalt/ gemacht/ unnd gefunden werden mögen.* Nuremberg, 1568.

Jansen-Sieben, R. *Repertorium van middelnederlandse artes-literatur.* Utrecht: HES, 1989.

Jardine, Lisa. *Worldly Goods: A New History of the Renaissance.* New York: W. W. Norton, 1996.

Jardine, N., J. A. Secord, and E. C. Spary, eds. *Cultures of Natural History.* Cambridge: Cambridge University Press, 1996.

Johns, Adrian. "The Physiology of Reading." In *Books and the Sciences in History,* edited by Marina Frasca-Spada and Nicolas Jardine. Cambridge: Cambridge University Press, 2000.

———. "Transmuting the Self: The Power of Magic and the Practice of Reading, 1550–1750." Unpublished paper.

Johnston, Stephen. "Making Mathematical Practice: Gentlemen, Practitioners and Artisans in Elizabethan England." Ph.D. diss., Cambridge University, 1994.

Jones, Caroline, and Peter Galison. *Picturing Science Producing Art.* New York: Routledge, 1998.

Jong, Eddy J. de. *Tot Lering en Vermaak: Betekenissen van Hollandse genrevoorstellingen uit de zeventiende eeuw.* Amsterdam: Rijksmuseum, 1976.

Jong, Erik de. "Nature and Art: The Leiden Hortus as 'Musaeum.'" In *The Authentic Garden: A Symposium on Gardens,* edited by Leslie Tjon Sie Fat and Erik de Jong. Leiden: Clusius Stichting, 1991.

Kahn, Didier. "A Propos de l'article de James Elkins: On the Unimportance of Alchemy in Western Painting." *Konsthistorisk tidskrift* 64, no. 1 (1995): 47–51.

Kamil, Neil D. "War, Natural Philosophy and the Metaphysical Foundations of Artisanal Thought in an American Mid-Atlantic Colony: La Rochelle, New York City, and the Southwestern Huguenot Paradigm, 1517–1730." Ph.D. diss., Johns Hopkins University, 1988.

Kaufmann, Thomas DaCosta. *Court, Cloister, and City: The Art and Culture of Central Europe, 1450–1800*. Chicago: University of Chicago Press, 1995.

——. "Kunst und Alchemie." In *Moritz der Gelehrte. Ein Renaissancefürst in Europa*, edited by Heiner Borggrefe, Thomas Fusenig, and Anne Schunicht-Rawe. Eurasburg: Edition Minerva, 1997.

——. *The Mastery of Nature: Aspects of Art, Science, and Humanism in the Renaissance*. Princeton: Princeton University Press, 1993.

Kaufmann, Thomas DaCosta, and Virginia Roehrig Kaufmann. "The Sanctification of Nature: Observations on the Origins of Trompe L'Oeil in Netherlandish Book Painting of the Fifteenth and Sixteenth Centuries." *J. Paul Getty Museum Journal* 19 (1991): 43–64.

Keil, Gundolf. "Mittelalterliche Konzepte in der Medizin des Paracelsus." In *Paracelsus. Das Werk—die Rezeption*, ed. Volker Zimmermann. Stuttgart: Franz Steiner Verlag, 1995.

Keller, Charles, and Janet Dixon Keller. "Thinking and Acting with Iron." In *Understanding Practice: Perspectives on Activity and Context*, edited by Seth Chaiklin and Jean Lave. Cambridge: Cambridge University Press, 1993.

Kemp, Martin. *Behind the Picture: Art and Evidence in the Italian Renaissance*. New Haven: Yale University Press, 1997.

——. "From 'Mimesis' to 'Fantasia': The Quattrocento Vocabulary of Creation, Inspiration and Genius in the Visual Arts." *Viator* 7 (1977): 347–98.

——. *Leonardo da Vinci: The Marvellous Works of Nature and Man*. Cambridge: Harvard University Press, 1981.

——. "'The Mark of Truth': Looking and Learning in Some Anatomical Illustrations from the Renaissance and Eighteenth Century." In *Medicine and the Five Senses*, edited by W. F. Bynum and Roy Porter. Cambridge: Cambridge University Press, 1993.

——. *The Science of Art: Optical Themes in Western Art from Brunelleschi to Seurat*. New Haven: Yale University Press, 1990.

——. "'Wrought by No Artist's Hand': The Natural, the Artificial, the Exotic, and the Scientific in Some Artifacts from the Renaissance." In *Reframing the Renaissance: Visual Culture in Europe and Latin America 1450–1650*, edited by Claire Farago. New Haven: Yale University Press, 1995.

——, ed. *Leonardo on Painting*. Translated by Martin Kemp and Margaret Walker. New Haven: Yale University Press, 1989.

Kessler, Herbert. "The Solitary Bird in Van der Goes' Garden of Eden." *Journal of the Warburg and Courtauld Institutes* 28 (1965): 326–29.

Kieckhefer, Richard. *Forbidden Rites: A Necromancer's Manual of the Fifteenth Century*. University Park: Pennsylvania State University Press, 1997.

King, Catherine. "Effigies: Human and Divine." In *Siena, Florence and Padua: Art, Society and Religion 1280–1400*, 2 vols., edited by Diana Norman, vol. 2. New Haven: Yale University Press, 1995.

King, Lester S. *The Road to Medical Enlightenment 1650–1695*. New York: American Elsevier, 1970.

Kirsop, Wallace. "The Legend of Bernard Palissy." *Ambix* 9 (1961): 136–54.

Knuttel, Gerard. *Adriaen Brouwer: The Master and His Work*. The Hague: L. J. C. Boucher, 1962.

Koch, Robert. "The Salamander in Van der Goes' Garden of Eden." *Journal of the Warburg and Courtauld Institutes* 28 (1965): 323–26.

———. "Schongauer's Dragon Tree." *Print Review* 5 "Tribute to Wolfgang Stechow," edited by Walter Strauss (1976): 114–19.

Koerner, Joseph Leo. "Hieronymus Bosch's World Picture." In *Picturing Science, Producing Art*, edited by Caroline A. Jones and Peter Galison. New York: Routledge, 1998.

———. *The Moment of Self-Portraiture in German Renaissance Art*. Chicago: University of Chicago Press, 1993.

Koning, D. A. Wittop. "J. R. Glauber in Amsterdam." *Jaerboek van het Genootschap Amstelodamum* 44 (1950): 1–6.

Koreny, Fritz. *Albrecht Dürer and the Animal and Plant Studies of the Renaissance*. Translated by Pamela Marwood and Yehuda Shapiro. Boston: Little, Brown, 1988.

———. "A Coloured Flower Study by Martin Schongauer and the Development of the Depiction of Nature from van der Weyden to Dürer." *Burlington Magazine* 133 (1991): 588–97.

Kris, Ernst. "Die Charakterköpfe des Franz Xaver Messerschmidt. Versuch einer historischen und pyschologischen Deutung." *Jahrbuch der Kunsthistorischen Sammlungen in Wien* NF 6 (1932): 169–227.

———. "Georg Hoefnagel und der wissenschaftliche Naturalismus." In *Festschrift für Julius Schlosser zum 60. Geburtstag*, edited by Arpad Weixlgärtner and Leo Planscig. Zurich: Amalthea, 1927.

———. "Der Stil 'Rustique': Die Verwendung des Naturabgusses bei Wenzel Jamnitzer und Bernard Palissy." *Jahrbuch der Kunsthistorischen Sammlungen in Wien* NF 1 (1928): 137–207.

Krohm, Hartmut, and Jan Nicolaisen. *Martin Schongauer. Druckgraphik*. Berlin: Staatliche Museen Preußischer Kulturbesitz, 1991.

Kruse, Christiane. "Fleisch werden—Fleisch malen: Malerei als 'incarnazione.' Mediale Verfahren des bildwerdens in Libro dell'Arte von Cennino Cennini." *Zeitschrift für Kunstgeschichte* 63 (2000): 305–25.

Kuhn, Thomas. "Mathematical versus Experimental Traditions in the Development of the Physical Sciences." In *The Essential Tension*. Chicago: University of Chicago Press, 1977.

Kunzle, David. "The Art of Pulling Teeth in the Seventeenth and Nineteenth Centuries: From Public Martyrdom to Private Nightmare and Political Struggle?" *Fragments for a History of the Human Body*, edited by Michel Feher with Ramona Naddaff and Nadia Tazi. Cambridge: Zone, 1989.

Kusukawa, Sachiko. "Leonhart Fuchs on the Importance of Pictures." *Journal of the History of Ideas* 58 (1997): 403–27.

Kutschmann, Werner. *Der Naturwissenschaftler und sein Körper: Die Rolle der 'inneren Natur' in der experimentellen Naturwissenschaft der frühen Neuzeit*. Frankfurt am Main: Suhrkamp, 1986.

Laabs, Annegret. *The Leiden Fijnschilders from Dresden*. Zwolle: Waanders, 2001.

Lairesse, Gérard de. *Het Groot Schilderboek*. 2 vols. Amsterdam: Hendrick Desbordes, 1712.

Landau, David, and Peter Parshall. *The Renaissance Print 1470–1550*. New Haven: Yale University Press, 1994.

Lave, Jean. *Cognition in Practice: Mind, Mathematics and Culture in Everyday Life*. Cambridge: Cambridge University Press, 1988.

Lave, Jean, and Etienne Wenger. *Situated Learning: Legitimate Peripheral Participation*. Cambridge: Cambridge University Press, 1991.

Le Goff, Jacques. *Time, Work, and Culture in the Middle Ages*. Translated by Arthur Goldhammer. Chicago: University of Chicago Press, 1980.

Lennep, Jacques van. *Alchemie. Bijdrage tot de geschiedenis van de alchemistische kunst*. Brussels: Gemeentekrediet, 1984.

Lestringant, Frank, ed. *Bernard Palissy 1510–1590. L'Écrivain, Le Réformé, Le Céramiste.* Paris: Coédition Association Internationale des Amis d'Agrippa d'Aubigné, 1992.

Liebmann, Michael J. "Künstlersignatur im 15.–16. Jahrhundert als Gegenstand soziologischer Untersuchung." In *Lukas Cranach. Künstler und Gesellschaft*, edited by Peter H. Feist et al. Wittenberg: Staatliche Lutherhalle, 1972.

Lindberg, David C. *Theories of Vision from Al-Kindi to Kepler.* Chicago: University of Chicago Press, 1976.

Lindeboom, Gerrit A. "Dog and Frog: Physiological Experiments at Leiden during the Seventeenth Century." In *Leiden University in the Seventeenth Century: An Exchange of Learning*, edited by Th. H. Lunsingh Scheurleer and G. H. M. Posthumus Meyjes. Leiden: E. J. Brill, 1975.

———, s.v. "Sylvius, Franciscus dele Boë." *The Dictionary of Scientific Biography*, 18 vols., edited by Charles Gillispie, vol. 13. New York: Scribner, 1970–86.

Long, Pamela O. "The Contribution of Architectural Writers to a 'Scientific' Outlook in the Fifteenth and Sixteenth Centuries." *Journal of Medieval and Renaissance Studies* 15 (1985): 265–98.

———. *Openness, Secrecy, Authorship: Technical Arts and the Culture of Knowledge from Antiquity to the Renaissance.* Baltimore: Johns Hopkins University Press, 2001.

———. "Power, Patronage, and the Authorship of Ars: From Mechanical Know-How to Mechanical Knowledge in the Last Scribal Age." *Isis* 88 (1997): 1–41.

Loughman, John, and John Michael Montias. *Public and Private Spaces: Works of Art in Seventeenth-Century Dutch Houses.* Zwolle: Waanders, 2000.

Lukehart, Peter M. "Delineating the Genoese Studio: giovani accartati or sotto padre?" In *The Artist's Workshop*, edited by Peter M. Lukehart. Studies in the History of Art, 38, Center for Advanced Study in the Visual Arts, Symposium Papers XXII, National Gallery of Art, Washington. Hanover: University Press of New England, 1993.

Mander, Karel van. *The Lives of the Illustrious Netherlandish and German Painters from the First Edition of the Schilder-boeck (1603–04).* 5 vols. Translated and edited by Hessel Miedema. Doornspijk: Davaco, 1994.

Mare, Heidi de. "The Domestic Boundary as Ritual Area in Seventeenth-Century Holland." In *Urban Rituals in Italy and the Netherlands: Historical Contrasts in the Use of Public Space, Architecture and the Urban Environment.* Assen: Van Gorcum, 1993.

———. "Het huis, de natuur en het vroegmoderne architectonisch kennissysteem van Simon Stevin." In *Wooncultuur in de Nederlanden: The Art of Home in the Netherlands 1500–1800*, edited by Jan de Jong, Bart Ramakers, Herman Roodenburg, Frits Scholten, and Mariët Westermann. Nederlands Kunsthistorisch Jaarboek, vol. 51. Zwolle: Waanders, 2000.

Marrow, James H. "Symbol and Meaning in Northern European Art of the Late Middle Ages and the Early Renaissance." *Simiolus* 16 (1986): 150–69.

Martin, Willem. *Gerard Dou. Des Meisters Gemälde.* Stuttgart: Deutsche Verlags-Anstalt, 1913.

———. *Het Leven en de Werken van Gerrit Dou.* Leiden: S. C. van Doesburgh, 1901.

———. "The Life of a Dutch Artist in the Seventeenth Century." *Burlington Magazine* 7 (1905): 125–31, 416–25; 8 (1905): 13–24; 10 (1906): 144–54, 363-70; 11 (1907): 357–69.

Maurice, Klaus. *Der Drechselnde Souverän.* Zurich: Verlag Ineichen, 1985.

Maus, Katharine Eisaman. "A Womb of His Own: Male Renaissance Poets in the Female Body." In *Sexuality and Gender in Early Modern Europe: Institutions, Texts, Images*, edited by James Grantham Turner. Cambridge: Cambridge University Press, 1993.

Mauss, Marcel. *Sociology and Psychology: Essays*. 1950. Translated by Ben Brewster. London: Routledge & Kegan Paul, 1979.

McGahagan, Thomas A. "Cartesianism in the Netherlands, 1639–1676: The New Science and the Calvinist Counter-Reformation." Ph.D. diss., University of Pennsylvania, 1976.

Medick, Hans. *Weben und Überleben in Laichingen, 1650–1900: Lokalgeschichte als allgemeine Geschichte*. Göttingen: Vandenhoeck & Ruprecht, 1997.

Meinel, Cristoph, ed. *Die Alchemie in der europäischen Kultur- und Wissenschaftsgeschichte*. Wiesbaden: Otto Harrassowitz, 1986.

Meiss, Millard. *The Painter's Choice: Problems in the Interpretation of Renaissance Art*. New York: Harper & Row, 1976.

Melion, Walter S. "Love and Artisanship in Hendrick Goltzius's *Venus, Bacchus and Ceres* of 1606." *Art History* 16 (1993): 60–94.

———. *Shaping the Netherlandish Canon: Karel van Mander's Schilder-Boeck*. Chicago: University of Chicago Press, 1991.

Michalsky, Tanja. "Imitation und Imagination. Die Landschaft Pieter Bruegels d. Ä. im Blick der Humanisten." In *Künste und Natur in Diskursen der Frühen Neuzeit*, 2 vols., edited by Hartmut Laufhütte, vol. 1. Wiesbaden: Harrassowitz Verlag, 2000.

Miedema, A. S. "Heyndrick Goltzius (1559–1617) en Trou moet Blijken." *Jaarboek Vereenigung Haerlem* (1941): 22–32; (1942): 115–16.

Miedema, Hessel. "Over het realisme in de Nederlandse schilderkunst van de zeventiende eeuw." *Oud Holland* 89 (1975): 2–18.

Monconys, Monsieur de. *Journal des voyages*. Lyon: Horace Boissat, George Remeus, 1665.

Montagu, Jennifer. *The Expression of the Passions: The Origin and Influence of Charles le Brun's 'Conférence sur l'expression générale et particulière.'* New Haven: Yale University Press, 1994.

Montias, John Michael. *Artists and Artisans in Delft*. Princeton: Princeton University Press, 1982.

Moran, Bruce T. *The Alchemical World of the German Court: Occult Philosophy and Chemical Medicine in the Circle of Moritz of Hessen (1572–1632)*. Stuttgart: F. Steiner Verlag, 1991.

———, ed. *Patronage and Institutions: Science, Technology, and Medicine at the European Court, 1500–1750*. Woodbridge: Boydell, 1991.

Morel, Philippe. "La Théâtralisation de l'alchimie de la nature. Les Grottes artificielles et la culture scientifique à Florence à la fin du XVIe siècle." *Symboles de la Renaissance* 30 (1990): 155–81.

Morley, Henry, *Palissy the Potter*. 2nd ed. London: Chapman and Hall, 1855.

Moxon, Joseph. *Mechanick Exercises or the Doctrine of Handy-Works*. First published in parts in 1683, 1693, 1703. Fasc. repr., edited by Charles F. Montgomery. New York: Praeger, 1970.

Müller, Jan-Dirk. *Gedechtnus. Literatur und Hofgesellschaft um Maximilian I*. Forschungen zur Geschichte der älteren deutschen Literatur, 2. Munich: W. Fink, 1982.

Nass, Markus. "Stellung und Bedeutung des Monogramms Martin Schongauers in der Graphik des 15.

Jahrhunderts." In *Martin Schongauer. Druckgraphik*, edited by Harmut Krohm and Jan Nicolaisen. Berlin: Staatliche Museen Preußischer Kulturbesitz, 1991.

Naumann, Otto. *Frans van Mieris (1635–1681) the Elder*. 2 vols. Doornspijk: Davaco, 1981.

Neudörfer, Johann. "Nachrichten von Künstlern und Werkleuten . . . aus dem Jahre 1547." In *Quellenschriften für Kunstgeschichte und Kunsttechnik des Mittelalters und der Renaissance*. 18 vols. Transcribed from the ms. and annotated by G. W. K. Lochner, vol. 10. Vienna: Wilhelm Braumüller, 1875.

Newman, William. "Art, Nature, and Experiment in Alchemy." In *Texts and Contexts in Ancient and Medieval Science*, edited by Edith Scylla and Michael McVaugh. Leiden: Brill, 1997.

———. *Gehennical Fire: The Lives of George Starkey, an American Alchemist in the Scientific Revolution*. Cambridge: Harvard University Press, 1994.

———. *The "Summa perfectionis" of Pseudo-Geber*. Leiden: Brill, 1991.

———. "Technology and Alchemical Debate in the Late Middle Ages." *Isis* 80 (1989): 423–45.

Nordenfalk, Carl. "The Five Senses in Flemish Art Before 1600." In *Netherlandish Mannerism*, edited by Görel Cavalli-Björkman. Stockholm: Nationalmuseum, 1985.

———. "The Five Senses in Late Medieval and Renaissance Art." *Journal of the Warburg and Courtauld Institutes* 48 (1985): 1–22.

North, Michael. *Art and Commerce in the Dutch Golden Age*. Translated by Catherine Hill. New Haven: Yale University Press, 1997.

———. *Kunst und Kommerz im Goldenen Zeitalter. Zur Sozialgeschichte der niederländische Malerie des 17. Jahrhunderts*. Cologne: Böhlau Verlag, 1992.

North, Michael, and D. Ormrod, eds. *Art Markets in Europe, 1400–1800*. Brookfield: Ashgate, 1998.

Obrist, Barbara. *Les Débuts de l'imagerie alchimique (XIVᵉ–XVᵉ siècle)*. Paris: Editions le Sycomore, 1982.

Oestreich, Gerhard. *Geist und Gestalt des frühmodernen Staates*. Berlin: Duncker & Humblot, 1969.

Oldenburg, Henry. *Correspondence*. 13 vols. Edited by A. Rupert Hall and Marie Boas Hall. Madison: University of Wisconsin Press, 1965–96.

Ong, Walter J. *Ramus, Method and the Decay of Dialogue: From the Art of Discourse to the Art of Reason*. Cambridge: Harvard University Press, 1983.

Onians, John, ed. *Sight and Insight: Essays on Art and Culture in Honour of E. H. Gombrich at 85*. London: Phaidon, 1994.

Une Orfèverie de Terre: Bernard Palissy et la Céramique de Saint-Porchaire: Musée National de la Reniassance, Chateau D'Écouen. Paris: Seuil, 1997.

Orlandi, Giulio Lensi. *Cosimo e Francesco de' Medici Alchimisti*. Florence: Nardini Editore, 1978.

Oster, Malcolm. "The Scholar and the Craftsman Revisited: Robert Boyle as Aristocrat and Artisan." *Annals of Science* 49 (1992): 255–76.

Ovitt, George. *The Restoration of Perfection: Labor and Technology in Medieval Culture*. New Brunswick: Rutgers University Press, 1987.

Pächt, Otto. "Early Italian Nature Studies and the Early Calendar Landscape." *Journal of the Warburg and Courtauld Institutes* 13 (1950): 13–46.

———. *Van Eyck and the Founders of Early Netherlandish Painting*. Translated by David Britt. London: Harvey Miller, 1994.

Pagden, Anthony. *European Encounters with the New World: From Renaissance to Romanticism.* New Haven: Yale University Press, 1993.

Pagel, Walter. *Das medizinische Weltbild des Paracelsus. Seine Zusammenhänge mit Neuplatonismus und Gnosis.* Wiesbaden: Franz Steiner Verlag, 1962.

———. "The Paracelsian Elias Artista and the Alchemical Tradition." In *Kreatur und Kosmos*, edited by Rosemarie Dilg-Frank. Stuttgart: Gustav Fischer Verlag, 1981.

———, s.v. "Paracelsus." In *Dictionary of Scientific Biography*, 18 vols., edited by Charles Gillispie, vol. 10. New York: Scribner, 1970–86.

———. *Paracelsus: An Introduction to Philosophical Medicine in the Era of the Renaissance.* 2nd ed. Basel: Karger, 1982.

———. "Paracelsus and the Neoplatonic and Gnostic Tradition." *Ambix* 8 (1960): 125–68.

Pagel, Walter, and Pyarali Rattansi. "Vesalius and Paracelsus." *Medical History* 8 (1964): 309–28.

Palissy, Bernard. *The Admirable Discourses.* 1580. Translated by Aurele la Rocque. Urbana: University of Illinois Press, 1957.

———. *Architecture, et Ordonnance de la grotte rustique de Monseigneur le Duc de Montmorency, Pair & Connestable de France.* La Rochelle: Barthélémy Berton, 1563.

———. *Recepte véritable.* 1563. Edited by Frank Lestringant. Paris: Éditions Macula, 1996.

Palissy, Bernard. *Recepte véritable, par laquelle tous les hommes de France pourront apprendre multiplier et augmenter leurs thrésors. Item, ceux qui n'ont saire tous les habitans de la terre. Item, en ce livre est contenu le dessein d'un jardin autant délectable et d'utile invention, qu'il en fut oncques veu. Item, le dessein et ordonnance d'une ville de forteresse, la plus imprenable qu'homme ouyt jamais parler: composé par maistre Bernard Palissy, ouurier de terre, et inventeur des rustiques figulines du Roy, et de monseigneur le Duc de Montmorency, pair et connestable de France; demeurant en la ville de Xaintes.* La Rochelle: Barthélémy Berton, 1563.

Palmer, Richard. "Pharmacy in the Republic of Venice in the Sixteenth Century." In *The Medical Renaissance of the Sixteenth Century*, edited by Andrew Wear and Roger French. Cambridge: Cambridge University Press, 1985.

Panofsky, Erwin. "Artist, Scientist, Genius: Notes on the 'Renaissance-Dämmerung.'" In *The Renaissance: A Symposium.* New York: Metropolitan Museum of Art, 1953.

———. *Early Netherlandish Painting.* 1953. 2 vols. Reprint, New York: Harper & Row, 1971.

———. *Idea: A Concept in Art Theory.* Translated by Joseph J. S. Peake. Columbia: University of South Carolina Press, 1968.

———. *The Life and Art of Albrecht Dürer.* Princeton: Princeton University Press, 1955.

———. *Meaning in the Visual Arts.* New York: Doubleday, 1955.

———. *Perspective as Symbolic Form.* Translated by Christopher S. Wood. Cambridge: MIT Press, 1991.

Paracelsus. *Astronomia Magna: oder die gantze Philosophia sagax der großen und kleinen Welt/ des von Gott hocherleuchten/ erfahrnen/ und bewerten teutschen Philosophi und Medici.* 1537/38; 1st publ. 1571. In *Sämtliche Werke. Medizinische, naturwissenschaftliche und philosophische Schriften.* 14 vols. Edited by Karl Sudhoff, vol. 12. Munich: R. Oldenbourg, 1929.

———. *Das Buch Labyrinthus medicorum genant.* 1538; 1st publ. 1553. In *Sämtliche Werke. Medizinische, naturwissenschaftliche und philosophische Schriften.* 14 vols. Edited by Karl Sudhoff, vol. 11. Munich: R. Oldenbourg, 1928.

———. *Das Buch Paragranum*. 1530. In *Sämtliche Werke. Medizinische, naturwissenschaftliche und philosophische Schriften*. 14 vols. Edited by Karl Sudhoff, vol. 8. Munich: R. Oldenbourg, 1927.

———. *Four Treatises of Theophrastus von Hohenheim, Called Paracelsus*. Translated by C. Lilian Temkin. Baltimore: Johns Hopkins University Press, 1941.

———. *Die große Wundarznei*. 1536. In *Sämtliche Werke. Medizinische, naturwissenschaftliche und philosophische Schriften*. 14 vols. Edited by Karl Sudhoff, vol. 10. Munich: R. Oldenbourg, 1928.

———. *The Hermetic and Alchemical Writings of Paracelsus*. 2 vols. Edited by Arthur Edward Waite. Chicago: Laurence, Scott & Co., 1910.

———. *Liber de imaginibus*. In *Sämtliche Werke. Medizinische, naturwissenschaftliche und philosophische Schriften*. 14 vols. Edited by Karl Sudhoff, vol. 13. Munich: R. Oldenbourg, 1931.

———. *Die neun Bücher De Natura Rerum*. 1537. In *Sämtliche Werke. Medizinische, naturwissenschaftliche und philosophische Schriften*. 14 vols. Edited by Karl Sudhoff, vol. 11. Munich: R. Oldenbourg, 1928.

———. *Volumen Medicinae Paramirum*. Ca. 1520. Translated by Kurt F. Leidecker. Baltimore: Johns Hopkins University Press, 1949.

Paré, Ambroise. *The Apologie and Treatise, containing the Voyages made into Divers Places*. 1634 ed. Edited by Geoffrey Keynes. London: Falcon Educational Books, 1951.

———. *Ten Books of Surgery with the Magazine of the Instruments Necessary for It*. Translated by Robert White Linker and Nathan Womack. Athens: University of Georgia Press, 1969.

Parshall, Peter. "Imago contrafacta: Images and Facts in the Northern Renaissance." *Art History* 16 (1993): 554–79.

———. "Introduction: Art and Curiosity in Northern Europe." *Word & Image* 11 no. 4 (1995): 327–31.

———. "Unfinished Business: The Problem of Resolution in Printmaking." In *The Unfinished Print*. Exhibition catalog. Washington, D.C.: National Gallery of Art, 2001.

Partington, J. R. *A History of Chemistry*. 2 vols. London: Macmillan, 1961.

Peacham, Henry. *The Compleat Gentleman*. London, 1622.

Pechstein, Klaus. "Der Goldschmied Wenzel Jamnitzer." In *Wenzel Jamnitzer und die Nürnberger Goldschmiedekunst 1500–1700*. Catalog of the Germanisches Nationalmuseum, Nuremberg. Munich: Klinkhardt & Bierman, 1985.

———. "Der Merkelsche Tafelaufsatz von Wenzel Jamnitzer." *Mitteilungen des Vereins für Geschichte der Stadt Nürnberg* 61 (1974): 90–121.

———. "Zeichnungen von Wenzel Jamnitzer." *Anzeiger des Germanischen Nationalmuseums* (1970): 81–95.

Pechstein, Klaus, et al., eds. *Deutsche Goldschmiedekunst vom 15. bis zum 20. Jahrhundert aus dem Germanischen Nationalmuseum*. Berlin: Verlag Willmuth Arenhövel, 1987.

Pekstok papers. Amsterdam Gemeentearchief, #N 90.23.

Pelling, Margaret. "The Body's Extremities: Feet, Gender, and the Inconography of Healing in Seventeenth-Century Sources." In *The Task of Healing: Medicine, Religion and Gender in England and the Netherlands 1450–1800*, edited by Hilary Marland and Margaret Pelling. Rotterdam: Erasmus Publishing, 1996.

———. "Medicine since 1500." In *Information Sources in the History of Science and Medicine*, edited by Pietro Corsi and Paul Weindling. London: Butterworth Scientific, 1983.

Pereira, Michela. *The Alchemical Corpus Attributed to Raymond Lull*. London: Warburg Institute, University of London, 1989.

———. "Alchemy and the Use of Vernacular Languages in the Late Middle Ages." *Speculum* 74 (1999): 336–56.

Pérez-Ramos, Antonio. *Francis Bacon's Idea of Science and the Maker's Knowledge Tradition*. Oxford: Clarendon Press, 1988.

Perrig, Alexander. "Leonardo: Die Anatomie der Erde." *Jahrbuch der Hamburger Kunstsammlungen* 25 (1980): 51–80.

Piccolpasso, Cipriano. *The Three Books of the Potter's Art*. Ca. 1558. 2 vols. Translated by Ronald Lightbown and Alan Caiger-Smith. London: Scholar Press, 1980.

Pietsch, Erich. *Johann Rudolph Glauber. Der Mensch, sein Werk und seine Zeit*. Munich: R. Oldenbourg, 1956.

Pincus, Debra, ed. *Small Bronzes in the Renaissance*. Washington, D.C.: Center for Advanced Study in the Visual Arts, 2001.

Platt, Peter G., ed. *Wonders, Marvels and Monsters in Early Modern Culture*. Newark: University of Delaware Press, 1999.

Plesters, Joyce, and Ashok Roy. "The Materials and Technique: Cennino Cennini's Treatise Illustrated." *National Gallery Technical Bulletin* 9 (1985): 26–37.

Pochat, Götz. *Der Exotismus während des Mittelalters und der Renaissance*. Stockholm: Almqvist & Wiksell, 1970.

Pomata, Gianna. *Contracting a Cure: Patients, Healers, and the Law in Early Modern Bologna*. Baltimore: Johns Hopkins University Press, 1998.

Poovey, Mary. *A History of the Modern Fact: Problems of Knowledge in the Sciences of Wealth and Society*. Chicago: University of Chicago Press, 1998.

Porter, Roy. *Health for Sale: Quackery in England 1660–1850*. Manchester: Manchester University Press, 1989.

Posner, Donald. "Concerning the 'Mechanical' Parts of Painting and the Artistic Culture of Seventeenth-Century France." *Art Bulletin* 75 (1993): 583–98.

Pötzl-Malikova, Maria. *Franz Xaver Messerschmidt*. Vienna: Jungend und Volk, 1982.

Prag um 1600: Beiträge zur Kunst und Kultur am Hofe Rudolfs II. 2 vols. Freren: Luca, 1988.

Priesner, Claus. *Bayerisches Messing. Franz Matthias Ellmayrs "Mössing-Werkh AO."* 1780. Stuttgart: Franz Steiner Verlag, 1997.

Priesner, Claus, and Karin Figala, eds. *Alchemie. Lexicon einer hermetischen Wissenschaft*. Munich: C. H. Beck, 1998.

Principe, Lawrence M. "Arbeitsmethoden." In *Alchemie. Lexicon einer hermetischen Wissenschaft*, edited by Claus Priesner and Karin Figala. Munich: C. H. Beck, 1998.

———. *The Aspiring Adept: Robert Boyle and His Alchemical Quest*. Princeton: Princeton University Press, 1998.

Principe, Lawrence M., and Andrew Weeks. "Jacob Boehme's Divine Substance Salitter: Its Nature, Origin, and Relationship to Seventeenth-Century Scientific Theories." *British Journal for the History of Science* 22 (1989): 53–61.

Prown, Jules David. "Mind in Matter: An Introduction to Material Culture Theory and Method." *Winterthur Portfolio* 17 (1982): 1–19.

Ptolemy. *Geography*. Translated and edited by Edward Luther Stevenson. New York: New York Public Library, 1932.

Purtle, Carol J. "Assessing the Evolution of van Eyck's Iconography through Technical Study of the Washington *Annunciation*, II: New Light on the Development of van Eyck's Architectural Narrative." In

Investigating Jan van Eyck, edited by Susan Foister, Sue Jones, and Delphine Cool. Turnhout, Belgium: Brepols, 2000.

———. *The Marian Paintings of Jan van Eyck*. Princeton: Princeton University Press, 1982.

Quiccheberg, Samuel. *Inscriptiones vel tituli amplissimi*. Munich, 1565.

Raff, Thomas. *Die Sprache der Materialien. Anleitung zu einer Ikonologie der Werkstoffe*. Kunstwissenschaftliche Studien, vol. 61. N.p.: Deutscher Kunstverlag, 1994.

Randall, Catharine. *Building Codes: The Aesthetics of Calvinism in Early Modern Europe*. Philadelphia: University of Pennsylvania Press, 1999.

Raupp, Hans-Joachim. "Ansätze zu einer Theorie der Genremalerei in den Niederlanden im 17. Jahrhundert." *Zeitschrift für Kunstgeschichte* 46 (1983): 410–18.

———. *Untersuchungen zu Künstlerbildnis und Künstlerdarstellung in den Niederlanden im 17. Jahrhundert*. Hildesheim: Georg Olms, 1984.

Raven, Diederick, Wolfgang Krohn, and Robert S. Cohen, eds. *Edgar Zilsel: The Social Origins of Modern Science*. Dordrecht: Kluwer Academic Publishers, 2000.

Revue de L'Art 78 (1987) (volume devoted to Bernard Palissy).

Reynolds, Beatrice. "Latin Historiography: A Survey 1400–1600." *Studies in the Renaissance* 2 (1955): 7–66.

Reznicek, E. K. J. *Die Zeichnungen von Hendrick Goltzius*. 2 vols. Translated by Maria Simon and Ingrid Jost. Utrecht: Haentjens Dekker & Gumbert, 1961.

Rhein, Stefan. "'mein bart hat mer erfaren dan alle euer hohe schulen.' Ein Zwischenruf zur Quellenfrage bei Paracelsus." In *Paracelsus. Das Werk—die Rezeption*, ed. Volker Zimmermann. Stuttgart: Franz Steiner Verlag, 1995.

Rivius, Gualterius (Walther Ryff). *De architectura*. Nuremberg, 1542.

———. *Der furnembsten / notwendigsten / der gantzen Architectur angehörigen Mathematischen und Mechanischen künst / eygentlicher bericht / und vast klare / verstendliche unterrichtung / zu rechtem verstandt / der lehr Vitruvij*. Nuremberg: Johan Petreius, 1547.

Roberts, Gareth. *The Mirror of Alchemy: Alchemical Ideas and Images in Manuscripts and Books from Antiquity to the Seventeenth Century*. London: British Library Press, 1994.

Roberts, Lissa. "The Death of the Sensuous Chemist." *Studies in the History and Philosophy of Science* 26 (1995): 503–29.

Rogier van der Weyden: St. Luke Drawing the Virgin. Selected Essays in Context. Turnhout, Belgium: Brepols, 1997.

Rosner, Lisa. *Medical Education in the Age of Improvement*. Edinburgh: Edinburgh University Press, 1991.

Rossi, Paolo. *Philosophy, Technology, and the Arts in the Early Modern Era*. Translated by Salvator Attanasio. New York: Harper & Row, 1970.

———. "Sprezzatura, Patronage, and Fate: Benvenuto Cellini and the World of Words." In *Vasari's Florence: Artists and Literati at the Medicean Court*, edited by Philip Jacks. Cambridge: Cambridge University Press, 1998.

Rotstein, Bret. "Vision and Devotion in Jan van Eyck's *Virgin and Child with Canon Joris van der Paele*." *Word & Image* 15 (1999): 262–75.

Roy, Ashok. "Van Eyck's Technique: The Myth and the Reality, I." In *Investigating Jan van Eyck*, edited by Susan Foister, Sue Jones, and Delphine Cool. Turnhout, Belgium: Brepols, 2000.

Roy, Ashok, and Perry Smith, eds. *Painting Techniques: History, Materials and Studio Practice*. London: International Institute for Conservation of Historic and Artistic Works, 1998.

Ruestow, Edward G. *The Microscope in the Dutch Republic: The Shaping of Discovery*. Cambridge: Cambridge University Press, 1996.

———. *Physics at Seventeenth- and Eighteenth-Century Leiden: Philosophy and the New Science in the University*. The Hague: Martinus Nijhoff, 1973.

Ruler, J. A. van. *The Crisis of Causality: Voetius and Descartes on God, Nature and Change*. Leiden: Brill, 1995.

Rupp, Jan C. "Matters of Life and Death: The Social and Cultural Conditions of the Rise of Anatomical Theatres, with Special Reference to Seventeenth Century Holland." *History of Science* 28 (1990): 263–87.

Ryff, Walther. See Rivius, Gualterius.

Safley, Thomas M., and Leonard N. Rosenband, eds. *The Workplace before the Factory: Artisans and Proletarians, 1500–1800*. Ithaca: Cornell University Press, 1993.

Salomon, G., ed. *Distributed Cognitions: Psychological and Educational Considerations*. Cambridge: Cambridge University Press, 1993.

Sandrart, Joachim von. *L'Academia Tedesca, oder, Teutsche Academie der Edlen Bau- Bild- und Mahlerey-Kunste*. 2 vols. Nuremberg: Jacob von Sandrart, 1675–79.

Santillana, Giorgio. "The Role of Art in the Scientific Renaissance." In *Critical Problems in the History of Science*, edited by Marshall Clagett. Madison: University of Wisconsin Press, 1959.

Sarasohn, Lisa. *Gassendi's Ethics: Freedom in a Mechanistic Universe*. Ithaca: Cornell University Press, 1996.

Pseudo-Savonarola, *A far littere de oro. Alchimia e tecnica della miniatura in un ricettario rinascimentale*. Edited by Antonio P. Torresi. Ferrara: Liberty House, 1992.

Scandella, Domenico. *Domenico Scandella Known as Menocchio: His Trials before the Inquisition (1583–1599)*. Edited by Andrea Del Col. Translated by John Tedeschi and Anne C. Tedeschi. Binghamton, N.Y.: Medieval and Renaissance Texts and Studies, 1996.

Schacht, Luca. *Oratio Funebris . . . Francisci de le Boe, Sylvii*. Leiden: Joh. Le Carpentier, 1673.

Schaffer, Simon. "Augustan Realities: Nature's Representatives and Their Cultural Resources in the Early Eighteenth Century." In *Realism and Representation: Essays in the Problem of Realism in Relation to Science, Literature, and Culture*, edited by George Levine. Madison: University of Wisconsin Press, 1993.

———. "Experimenters' Techniques, Dyers' Hands, and the Electric Planetarium." *Isis* 88 (1997): 456–83.

———. "Regeneration: The Body of Natural Philosophers in Restoration England." In *Science Incarnate: Historical Embodiments of Natural Knowledge*, edited by Christopher Lawrence and Steven Shapin. Chicago: University of Chicago Press, 1998.

———. "Self-Evidence." *Critical Inquiry* 18 (1992): 327–62.

Schama, Simon. *The Embarrassment of Riches: An Interpretation of Dutch Culture in the Golden Age*. Berkeley: University of California Press, 1985.

———. *Landscape and Memory*. New York: Knopf, 1995.

———. "Perishable Commodities: Dutch Still-Life Painting and the 'Empire of Things.'" In *Consumption and the World of Goods*, edited by John Brewer and Roy Porter. London: Routledge, 1994.

Scheller, Robert W. *Exemplum: Model-Book Drawings and the Practice of Artistic Transmission in the Middle Ages (ca. 900–ca. 1470)*. Translated by Michael Hoyle. Amsterdam: Amsterdam University Press, 1995.

———. "Korte bijdragen: ALS ICH CAN." *Oud Holland* 83 (1968): 135–39.

———. "Rembrandt en de encyclopedische Kunstkamer." *Oud Holland* 84 (1969): 81–147.

Schendel, A. F. E. van. "Manufacture of Vermilion in 17th-Century Amsterdam, The Pekstok Papers." *Studies in Conservation* 17 (1972): 70–82.

Scheurleer, Th. H. Lunsingh, C. Willemijn Fock, and A. J. van Dissel, eds. *Het Rapenburg: Geschiedenis van een Leidse gracht.* 6 vols. Leiden: Afdeling Geschiedenis van de Kunstnijverheid, Rijksuniversiteit Leiden, 1986–92.

Scheurleer, Th. H. Lunsingh, and G. H. M. Posthumus Meyjes, eds. *Leiden University in the Seventeenth Century: An Exchange of Learning.* Leiden: E. J. Brill, 1975.

Schleif, Corine. "Nicodemus and Sculptors: Self-Reflexivity in Works by Adam Kraft and Tilman Riemenschneider." *Art Bulletin* 75 (1993): 599–626.

Schlosser, Julius von. *Lorenzo Ghiberti's Denkwürdigkeiten (I Commentarii).* 2 vols. Berlin: Julius Bard, 1912.

Scholten, Frits. "The World of the Late-Medieval Artist." In *Netherlandish Art in the Rijksmuseum 1400–1600,* by Henk van Os, Jan Piet Filedt Kok, Ger Luijten, and Frits Scholten. Amsterdam: Waanders, 2000.

———, ed. *Adriaen de Vries (1556–1626), Imperial Sculptor.* Zwolle: Waanders, 1998.

Scholz, Horst. *Brouwer Invenit: Druckgraphische Reproduktionen des 17. bis 19. Jahrhunderts nach Gemaelde und Zeichnungen Adriaen Brouwers.* Marburg: Jonas Verlag, 1985.

Schönherr, David von. "Wenzel Jamnitzers Arbeiten für Erzherzog Ferdinand." *Mittheilungen des Instituts für Oesterreichische Geschichtsforschung* 9 (1888): 289–305.

Schulz, Eva. "Notes on the History of Collecting and of Museums in the Light of Selected Literature of the Sixteenth through Eighteenth Centuries." *Journal of the History of Collections* 2 (1990): 205–18.

Schwarz, Arturo, ed. *Arte e Alchimia: XLII Esposizione Internazionale d'Arte: La Biennale di Venezia.* Venice: Realizzazione, Electa, 1986.

Scribner, Bob. "Ways of Seeing in the Age of Dürer." In *Dürer and His Culture,* edited by Dagmar Eichberger and Charles Zika. Cambridge: Cambridge University Press, 1998.

Scribner, Sylvia. "Studying Working Intelligence." In *Everyday Cognition: Its Development in Social Context,* edited by Barbara Rogoff and Jean Lave. Cambridge: Harvard University Press, 1984.

Sewell, William. *Work and Revolution in France: The Language of Labor from the Old Regime to 1848.* Cambridge: Cambridge University Press, 1980.

Shapin, Steven. "Descartes the Doctor: Rationalism and Its Therapies." *British Journal for the History of Science* 33 (2000): 131–54.

———. "Robert Boyle and Mathematics: Reality, Representation, and Experimental Practice." *Science in Context* 2 (1988): 23–58.

———. *The Scientific Revolution.* Chicago: University of Chicago Press, 1996.

———. *A Social History of Truth: Civility and Science in Seventeenth-Century England.* Chicago: University of Chicago Press, 1994.

Shapin, Steven, and Simon Schaffer. *Leviathan and the Air-Pump: Hobbes, Boyle and the Experimental Life.* Princeton: Princeton University Press, 1985.

Shapiro, Barbara J. *A Culture of Fact: England, 1550–1720.* Ithaca: Cornell University Press, 2000.

Sheard, Wendy Stedman. "Verrocchio's Medici Tomb and the Language of Materials." In *Verrocchio and Late Quattrocento Italian Sculpture,* edited by Steven Bule et al. Florence: Casa Editrice Le Lettere, 1992.

Sheppard, H. J. "Egg Symbolism in Alchemy." *Ambix* 6 (1958): 140–48.

Sibbald, Sir Robert. *The Memoirs of Sir Robert Sibbald (1641–1722)*. Edited by Francis Paget Hett. Oxford: Oxford University Press, 1932.

Silver, Larry. "Forest Primeval: Albrecht Altdorfer and the German Wilderness Landscape." *Simiolus* 13 (1982–83): 4–43.

———. "Fountain and Source: A Rediscovered Eyckian Icon." *Pantheon* 41 (1983): 95–104.

———. "Germanic Patriotism in the Age of Dürer." In *Dürer and His Culture*, edited by Dagmar Eichberger and Charles Zika. Cambridge: Cambridge University Press, 1998.

———. "Nature and Nature's God: Landscape and Cosmos of Albrecht Altdorfer." *Art Bulletin* 81 (1999): 194–214.

———. "Paper Pageants: The Triumphs of Emperor Maximilian I." In *"All the World's a Stage . . .": Art and Pageantry in the Renaissance and Baroque*, 2 vols., edited by Barbara Wich and Susan Munshower, vol. I. University Park: Pennsylvania State University, 1990.

———. "Prints for a Prince: Maximilian, Nuremberg, and the Woodcut." In *New Perspectives on the Art of Renaissance Nuremberg: Five Essays*, edited by Jeffrey Chipps Smith. Austin: Archer M. Huntington Art Gallery, 1985.

Silver, Larry, and Pamela H. Smith. "Splendor in the Grass: The Powers of Art and Nature in the Age of Dürer." In *Merchants and Marvels: Commerce, Science, and Art in Early Modern Europe*, edited by Pamela H. Smith and Paula Findlen. New York: Routledge, 2001.

Siraisi, Nancy G. *Medieval and Early Renaissance Medicine*. Chicago: University of Chicago Press, 1990.

Skippon, Phillip. *An Account of a Journey Made thro' Part of the Low-Countries, Germany, Italy, and France*. 6 vols. London, 1732.

Sluijter, Eric Jan. "All Striving to Adorne Their Houses with Costly Peeces: Two Case Studies of Paintings in Wealthy Interiors." In *Art and Home: Dutch Interiors in the Age of Rembrandt*, edited by Mariët Westermann. Zwolle: Waanders, 2001.

———. "Didactic and Disguised Meanings?" In *Art in History, History in Art*, edited by David Freedberg and Jan de Vries. Santa Monica: Getty Center for the History of Art and the Humanities, 1991.

———. "'Een stuck waerin een jufr. voor de spiegel van Gerrit Douw.'" *Antiek* 23 (1988): 150–61.

———. "Hoe realistisch is de Noordnederlandse schilderkunst van de zeventiende eeuw? De problemen van een vraagstelling." *Leidschrift* 6 (1990): 5–39.

———. *De lof der schilderkunst. Over schilderijen van Gerrit Dou (1613–1675) en een traktaat van Philips Angel uit 1642*. Hilversum: Verloren, 1993.

———. "Over fijnschilders en 'betekenis.' Naar aanleiding van Peter Hecht, *De Hollandse fijnschilders*." *Oud Holland* 105 (1991): 50–63.

Sluijter, Eric J., et al. *Leidse Fijnschilders van Gerrit Dou tot Frans van Mieris de Jonge 1630–1760*. Zwolle: Waanders, 1988.

Smeyers, Maurits, and Bert Cardon. "Campin and Illumination." In *Robert Campin: New Directions in Scholarship*, edited by Susan Foister and Susie Nash. Turnhout, Belgium: Brepols, 1996.

Smith, Cyril Stanley. "The Texture of Matter as Viewed by Artisan, Philosopher, and Scientist in the Seventeenth and Eighteenth Centuries." In *Atoms, Blacksmiths, and Crystals: Practical and Theoretical Views of the Structure of Matter in the Seventeenth and Eighteenth Centuries*, by Cyril Stanley Smith and John G. Burke. Los Angeles: William Andrews Clark Memorial Library, 1967.

Smith, Jeffrey Chipps. "The Artistic Patronage of Philip the Good, Duke of Burgundy (1419–1467)." Ph.D. diss., Columbia University, 1979.

———. "Netherlandish Artists and Art in Renaissance Nuremberg." *Simiolus* 20 (1990–91): 153–67.

———. "Portable Propaganda: Tapestries as Princely Metaphors at the Courts of Philip the Good and Charles the Bold." *Art Journal* 48 (1989): 123–29.

———. "Venit Nobis Pacificus Dominus: Philip the Good's Triumphal Entry into Ghent in 1458." In *"All the World's a Stage . . .": Art and Pageantry in the Renaissance and Baroque*, 2 vols., edited by Barbara Wich and Susan Munshower, vol. 1. University Park: Pennsylvania State University, 1990.

———, ed. *New Perspectives on the Art of Renaissance Nuremberg: Five Essays.* Austin: Archer M. Huntington Art Gallery, 1985.

———, ed. *Nuremberg: A Renaissance City, 1500–1618.* Austin: University of Texas Press, 1983.

Smith, Pamela H. *The Business of Alchemy: Science and Culture in the Holy Roman Empire.* Princeton: Princeton University Press, 1994.

———. "Science and Taste: Painting, the Passions, and the New Philosophy in Seventeenth-Century Leiden." *Isis* 90 (1999): 420–61.

———. "Vital Spirits: Alchemy, Redemption, and Artisanship in Early Modern Europe." In *Rethinking the Scientific Revolution*, edited by Margaret J. Osler. Cambridge: Cambridge University Press, 2000.

Smith, Pamela H., and Paula Findlen. "Introduction: Commerce and the Representation of Nature in Science and Art." In *Merchants and Marvels: Commerce, Science, and Art in Early Modern Europe*, edited by Pamela H. Smith and Paula Findlen. New York: Routledge, 2002.

Smith, Pamela H., and Paula Findlen, eds. *Merchants and Marvels: Commerce, Science, and Art in Early Modern Europe.* New York: Routledge, 2002.

Snoep-Reitsma, Ella. "De Waterzuchtige Vrouw van Gerard Dou en de betekenis van de lampetkan." In *Album Amicorum J. G. van Gelder*, edited by J. Bruyn et al. The Hague: Martinus Nijhoff, 1973.

Sorbière, Samuel de. *Relations, lettres, et discours sur diverses matieres curieuses.* Paris: Robert de Ninville, 1660.

Spitz, Leo. *Conrad Celtis: The German Arch-Humanist.* Cambridge: Harvard University Press, 1957.

"Splendor Solis." Hs. Cod. 78 D3. Berlin Kupferstichkabinett, 1531–32.

Sprat, Thomas. *History of the Royal Society.* London, 1667.

Spronsen, J. W. van. "The Beginning of Chemistry." In *Leiden University in the Seventeenth Century: An Exchange of Learning*, edited by Th. H. Lunsingh Scheurleer and G. H. M. Posthumus Meyjes. Leiden: Brill, 1975.

Stafford, Barbara. *Voyage into Substance: Art, Science, Nature, and the Illustrated Travel Account, 1760–1840.* Cambridge: MIT Press, 1984.

Stevin, Simon. *Materiae politicae. Burgherlicke stoffen.* Leiden, 1649.

Stewart, Larry. *The Rise of Public Science.* Cambridge: Cambridge University Press, 1992.

Stillman, John M. *The Story of Alchemy and Early Chemistry.* 1924. Reprint, New York: Dover, 1960.

Stoeder, W. *Geschiedenis der Pharmacie in Nederland.* Schiedam: Schie-Pers, 1974.

Stoichita, Victor I. *L'Instauration du Tableau.* Paris: Méridiens Klincksieck, 1993.

Stone, Richard E. "Antico and the Development of Bronze Casting in Italy at the End of the Quattrocento." *Metropolitan Museum Journal* 16 (1982): 87–116.

Stone-Ferrier, Linda A. *Images of Textiles: The Weave of Seventeenth-Century Dutch Art and Society*. Ann Arbor: UMI Research Press, 1985.

Strauss, Gerald. *Historian in an Age of Crisis: The Life and Work of Johannes Aventinus (1477–1534)*. Cambridge: Harvard University Press, 1963.

———. *Nuremberg in the Sixteenth Century*. 2nd ed. Bloomington: Indiana University Press, 1976.

———. *Sixteenth-Century Germany: Its Topography and Topographers*. Madison: University of Wisconsin Press, 1959.

———. "Topographical-Historical Method in Sixteenth-Century German Scholarship." *Studies in the Renaissance* 5 (1958): 87–101.

Struik, Dirk J. *The Land of Stevin and Huygens: A Sketch of Science and Technology in the Dutch Republic during the Golden Century*. Dordrecht: D. Reidel, 1981.

Stürmer, Michael. "Luxusgüter in der Knappheitsgesellschaft. Handwerkskultur und höfisches Leben im 18. Jahrhundert." *Francia* 8 (1978): 319–66.

Summers, David. *The Judgment of Sense: Renaissance Naturalism and the Rise of Aesthetics*. Cambridge: Cambridge University Press, 1987.

———. *Michelangelo and the Language of Art*. Princeton: Princeton University Press, 1981.

———. "Pandora's Crown: On Wonder, Imitation and Mechanism in Western Art." In *Wonders, Marvels and Monsters in Early Modern Culture*, edited by Peter G. Platt. Newark: University of Delaware Press, 1999.

Sutton, John. "Controlling the Passions: Passion, Memory, and the Moral Physiology of Self in Seventeenth-Century Neurophilosophy." In *The Soft Underbelly: The Passions in the Seventeenth Century*, edited by Stephen Gaukroger. London: Routledge, 1998.

Swan, Claudia. "Ad vivum, naer het leven, from the Life: Defining a Mode of Representation." *Word & Image* 11, no. 4 (1995).

———. *The Clutius Botanical Watercolors*. New York: Harry N. Abrams, 1998.

———. "Lectura-Imago-Ostensio. The Role of the *Libri Picturati* Al. 18–A.30 in Medical Instruction at the Leiden University." In *Natura. Cultura. L'intepretatione del mondo fisico nei testi e nelle imagini*, edited by Guiseppe Olmi and Lucia Tongiorgi Tomasi. Florence: L. Oschki, 1999.

Swanson, Heather. *Medieval Artisans: An Urban Class in Late Medieval England*. Oxford: Basil Blackwell, 1989.

Sylvius. See Boë, Franciscus dele.

Tacitus. *Germania*. Translated by M. Hutton. Cambridge: Harvard University Press, 1963.

Taverne, E. "Salomon de Bray and the Reorganization of the Haarlem Guild of St. Luke in 1631." *Simiolus* 6 (1972–73): 50–66.

Taylor, Paul. "The Concept of *Houding* in Dutch Art Theory." *Journal of the Warburg and Courtauld Institutes* 55 (1992): 210–32.

Testa, Laura. "La Melencolia di Dürer e l'alchimi." *Storia dell'arte* 73 (1991): 280–96.

Theophilus. *On Divers Arts*. Translated by John G. Hawthorne and Cyril Stanley Smith. Chicago: University of Chicago Press, 1963.

———. *The Various Arts*. Edited and translated by C. R. Dodwell. Oxford: Clarendon Press, 1986.

Thiels, Ch. "De Leidse chirurgijns en hun kamer boven de waag." *Nederlands Kunsthistorisch Jaarboek* 31 (1980): 215–29.

Thomas, Anabel. *The Painter's Practice in Renaissance Tuscany*. Cambridge: Cambridge University Press, 1995.

Thomas, Keith. *Man and the Natural World: Changing Attitudes in England, 1500–1800*. London: Penguin, 1984.

Thompson, Daniel V., Jr. "Artificial Vermilion in the Middle Ages." *Technical Studies in the Field of the Fine Arts* 2 (1933–34): 62–70.

Thompson, H. R. "The Geographical and Geological Observations of Bernard Palissy the Potter." *Annals of Science* 10 (1954): 149–65.

Thorndike, Lynn. *A History of Magic and Experimental Science*. 8 vols. New York: Columbia University Press, 1923–58.

Thornton, Peter. *Seventeenth-Century Interior Decoration in England, France and Holland*. New Haven: Yale University Press, 1978.

Tierie, Gerrit. *Cornelis Drebbel (1572–1633)*. Amsterdam: H. J. Paris, 1932.

Tomasi, Lucia Tongiorgi. "Ghirardo Cibo: Visions of Landscape and the Botanical Sciences in a Sixteenth-Century Artist." *Journal of Garden History* 9 (1989): 199–216.

Vandamme, E. "Een 16e-eeuws Zuidnederlands receptenboek." *Jaarboek van het Koninklijk Museum voor Schone Kunsten* (1974): 101–37.

Van Piskijkers en heelmeesters: Genezen in de Gouden Eeuw. Exhibition catalog. Leiden: Museum Boerhaave, 1991.

Vasari, Giorgio. *Three Arts of Design, Architecture, Sculpture and Painting, Prefixed to the Lives of the Most Excellent Painters, Sculptors and Architects*. Translated by Louisa S. Maclehose. New York: Dover, 1960.

———. *Le Vite de' più eccellenti pittori, scultori e architettori*. Edited by Rosanna Bettarini. 6 vols. Florence: Sansoni Editore, 1966–87.

Veen, Jaap van der. "Dit klain Vertrek bevat een Weereld vol gewoel: Negentig Amsterdammers en hun kabinetten." In *De wereld binnen handbereik: Nederlandse kunst- en rariteitenverzamelingen, 1585–1735*, edited by Ellinoor Bergvelt and Renée Kistemaker. Zwolle: Waanders, 1992.

Verbeek, Theo. *Descartes and the Dutch: Early Reactions to Cartesian Philosophy 1637–1650*. Carbondale: Southern Illinois University Press, 1992.

Verwey, H. de la Fontaine. "Michel le Blon, Graveur, Kunsthandelaar, Diplomat." In *Uit de wereld van het boek, II: Drukkers, Liefhebbers en Piraten in de Zeventiende Eeuw*. Amsterdam: Nico Israel, 1976.

De vier gedaanten van de arts. Leiden: Museum Boerhaave, s.d.

Vives, Juan Luis. *De tradendis disciplinis*. 1531. Translated by Foster Watson. Totowa, N.J.: Rowman and Littlefield, 1971.

Vos, Dirk de. "Nogmaals ALS ICH CAN." *Oud Holland* 97 (1983): 1–4.

Vries, Lyckle de. "The Changing Face of Realism." In *Art in History, History in Art*, edited by David Freedberg and Jan de Vries. Santa Monica: Getty Center for the History of Art and the Humanities, 1991.

Waite, Gary K. "Talking Animals, Preserved Corpses and Venusberg: The Sixteenth-Century Magical World View and Popular Conceptions of the Spiritualist David Joris (c. 1501–56)." *Social History* 20 (1995): 137–56.

Walden, P. "Glauber." In *Das Buch der großen Chemiker*, 2 vols., edited by Günther Bugge, vol. 1. Berlin: Verlag Chemie, 1929.

Wallert, Arie. "Alchemy and Medieval Art Technology." In *Alchemy Revisited*, edited by Z. R. W. M. von Martels. Leiden: Brill, 1990.

———. "Makers, Materials and Manufacture." In *Netherlandish Art in the Rijksmuseum 1400–1600*. Amsterdam: Waanders, 2000.

———, ed. *Still Lifes: Techniques and Style*. Zwolle: Waanders, 1999.

Warnke, Martin. "Filaretes Selbstbildnisse: Das geschenkte Selbst." In *Der Künstler uber sich in seinem Werk: Internationales Symposium der Bibliotheca Hertziana, Rom, 1989*, edited by Matthias Winner. Weinheim: VCH, Acta Humaniora, 1992.

Watson-Verran, Helen, and David Turnbull. "Science and Other Indigenous Knowledge Systems." In *Handbook of Science and Technology Studies*, edited by Sheila Jasanoff, Gerald E. Marble, James C. Peterson, and Trevor Pinch. London: Sage Publications, 1995.

Wear, Andrew. "William Harvey and the 'Way of the Anatomists.'" *History of Science* 21 (1983): 223–49.

Webster, Charles. *The Great Instauration: Science, Medicine, and Reform 1626–1660*. London: Gerald Duckworth, 1975.

Weeks, Andrew. *Paracelsus: Speculative Theory and the Crisis of the Early Reformation*. Albany: State University of New York Press, 1997.

Weller, Dennis P. "Jan Miense Molenaer (c. 1609/1610–1668): The Life and Art of a Seventeenth-Century Dutch Painter." Ph.D. diss., University of Maryland, College Park, 1992.

Welzig, Werner. "Constantia und barocke Beständigkeit." *Deutsche Vierteljahrsschrift für Literaturwissenschaft und Geistesgeschichte* 35 (1961): 416–32.

Wenzel Jamnitzer und die Nürnberger Goldschmiedekunst 1500–1700. Catalog of the Germanisches Nationalmuseum, Nuremberg. Munich: Klinkhardt & Bierman, 1985.

Westermann, Mariët. "'Costly and Curious, Full of Pleasure and Home Contentment': Making Home in the Dutch Republic." In *Art and Home: Dutch Interiors in the Age of Rembrandt*, edited by Mariët Westermann. Zwolle: Waanders, 2001.

———. *A Worldly Art: The Dutch Republic 1585–1718*. New York: Harry N. Abrams, 1996.

———, ed. *Art and Home: Dutch Interiors in the Age of Rembrandt*. Zwolle: Waanders, 2001.

Weyer, Jost. *Graf Wolfgang II von Hohenlohe und die Alchemie*. Sigmaringen: J. Thorbecke, 1992.

White, Lynn, Jr. "Natural Science and Naturalistic Art in the Middle Ages." *American Historical Review* 52 (1947): 421–35.

White, Raymond. "Van Eyck's Technique: The Myth and the Reality, II." In *Investigating Jan van Eyck*, edited by Susan Foister, Sue Jones, and Delphine Cool. Turnhout, Belgium: Brepols, 2000.

White, T. H. *The Bestiary: A Book of Beasts*. New York: Putnam's, 1960.

Whitney, Elsbeth. "Paradise Restored: The Mechanical Arts from Antiquity through the Thirteenth Century." *Transactions of the American Philosophical Society* 80 (1990).

Whitney, William. "La Légende de Van Eyck alchimiste." In *Alchimie: Art, histoire et mythes*, edited by Didier Kahn and Sylvain Matton. Actes du 1er colloque international de la Société d'Étude de l'Histoire de l'Alchimie. Paris: S.E.H.A.-Archè, 1995.

Willmoth, Frances. *Sir Jonas Moore: Practical Mathematics and Restoration Science*. Suffolk: Boydell Press, 1993.

Wilson, Catherine. *The Invisible World: Early Modern Philosophy and the Invention of the Microscope*. Princeton: Princeton University Press, 1995.

Wilson, Jean C. *Painting in Bruges at the Close of the Middle Ages*. University Park: Pennsylvania State University Press, 1998.

Wittkower, Rudolf, and Margot Wittkower. *Born under Saturn: The Character and Conduct of Artists*. New York: W. W. Norton, 1963.

Wood, Christopher S. *Albrecht Altdorfer and the Origins of Landscape.* Chicago: University of Chicago Press, 1993.

———. "'Curious Pictures' and the Art of Description." *Word & Image* 11 (1995): 332–52.

Woods-Marsden, Joanna. "'Draw the irrational animals as often as you can from life': Cennino Cennini, Giovannino de' Grassi, and Antonio Pisanello." *Studi di storia dell'arte* 3 (1992): 67–78.

———. *Renaissance Self-Portraiture: The Visual Construction of Identity and the Social Status of the Artist.* New Haven: Yale University Press, 1998.

Young, John T. *Faith, Medical Alchemy, and Natural Philosophy: Johann Moriaen, Reformed Intelligencer, and the Hartlib Circle.* Brookfield, Vt.: Ashgate, 1998.

Zambelli, Paola. "'Uno, due, tre, mille Menocchio'?" *Archivio Storico Italiano* 137 (1979): 51–90.

Zilsel, Edgar. "The Origin of William Gilbert's Scientific Method," *Journal of the History of Ideas* 2 (1941): 1–32.

———. "The Sociological Roots of Science." *American Journal of Sociology* 47 (1942): 544–62.

Zimmermann, Volker, ed. *Paracelsus. Das Werk—die Rezeption.* Stuttgart: Franz Steiner Verlag, 1995.

Zöllner, Frank. "'Ogni Pittore Dipinge Sé': Leonardo da Vinci and 'Automimesis.'" In *Der Künstler über sich in seinem Werk. Internationales Symposium der Bibliotheca Hertziana, Rom, 1989*, edited by Matthias Winner. Weinheim: VCH, Acta Humaniora, 1992.

Illustrations

Index

Page references in italics refer to illustrations.

The Annunciation (van Eyck), 140–41, *plate 21*

The Annunciation Triptych (Mérode Altarpiece) (Campin), 51, 52, 234, *plate 9*

Apelles, 119

The Apocalypse (Dürer), 68

Apollo, 129, 131, 282n6

apothecaries, 196. *See also* medical practice

Appelius, Henry, 173–74

Apprentices Fighting (Schongauer), 130, *131*

Arab influence on botanical illustration, 33–34

archeiropoíetos, 41

architecture, 32, 69, 124

Aristotle, 7, 117, 166, 221, 244–45n15, 309n122

Arm Operation (Brouwer), 197, *199*

ars, 27, 67, 107

ars imitatur naturam, 16

art and nature, relationship of, viii, 36, 62–63, 76, 150–51, 234, 275n35

artisans, 6–8, 27, 37–51, 243–44n7; apprenticeships, 7–8, 81–82, 95–98, 156–57, 212; claims of legitimacy, 38, 42–47, 151; communication among, 163–64; humor, 36–37; imitations of creation, 51–55, 259n63, 260nn69–70; influence on Scientific Revolution, 21, 239–41; knowledge of matter, 6–8, 16, 26, 108, 126–27, 142–49, 245n18, 288n52; lack of perspective construction, 38; light, shadow, and highlighting, 33, 95–96, *plates 14 and 15*; literacy of, 7–8, 245n16; mediation of the divine, 47–51, *50*, *plate 8*; political culture, 35–37; popularity of portraiture, 47; power of, 36–37, 151, 289–90n66; religious aspects of work, 13–14, 47–51, *50*, *plate 8*; role of carpentry, 51, *52*, 234; role of self-portraiture, 41, 257n35, *plate 6*; scholars' views of, 61–62, 66–67, 142, 253n6; signatures, 41; social status of, 7, 24–25, 27, 244–45n15; *technē*, 17–20; transformation through production of objects, 14, *15*, 16; understanding of their own processes, 21–22, 250n53; use of mirrors, 42–44, *43*, *46*–47, *plate 7*; uses of alchemy, 14, 16, 140–49; uses of sensory investigation, 47–51, 55. *See also* epistemology of artisans; illusionism/specificity and particularism; knowledge; self-consciousness of artisans; sensory investigation; texts by artisans

artists of the seventeenth century. *See* painters of the Netherlands

Ast, Balthasar van der, 190

"Astonishment" (Le Brun), 227

Astronomer by Candlelight (Dou), 205, *207*

astronomical instrument makers, 65–66

Atalanta fugiens (Maier), 120, 283n15

Augustine (saint), 160

authority of artisans, 42–47, 151

authors. *See* texts by artisans

autoptic authority, 42–47. *See also* bodily engagement with nature

Aventinus, Johannes, 65

Averlino, Antonio, 32

Back Operation (Brouwer), 197, *199*

Bacon, Francis, 18–19, 102, 230–33; Scientific Revolution, 239–41; transformation of philosophy into science, 238–39

Bailly, David, 214

Baldini, Baccio, *15*

Baldung, Hans, called Grien, 124

Barbari, Jacopo de', 69

Baxandall, Michael, 21–22, 93, 251n61, 253n6

Becher, Johann Joachim, 230

Beeckman, Isaac, 21, 164, 263n29

Belles Heures (Limburg brothers), 37

Belting, Hans, 53

Berchem, Nicolaes, 177, *178*

Besson, Jacques, *235*

Bialostocki, Jan, 260nn69–70

Bie, Cornelis de, 198, 210, 212

Binchois, Gilles, 36

Biondo, Flavio, 64–65

Biringuccio, Vannoccio, 143–44, 192–93, 236

Bitter Medicine (Brouwer), 197, *199*

Blaeu, Willem Jansz., 164

Blon, Cornelis le, 167, 292–93n44

bodily engagement with nature: acquisition of knowledge through labor, 59, 95–99, 103–6, 110, 272n11, 276n40; Böhme's religious views of, 161; creation of materials, 110–14, 276–77n42, 278n66; disease and injury of artisans, 113; fallacies of learning through reading, 103; mastery of active matter, 114–20, 279n77; Palissy's Practice and Theory, 100–6; Paracelsus's theory of bodily union, 100; parturition